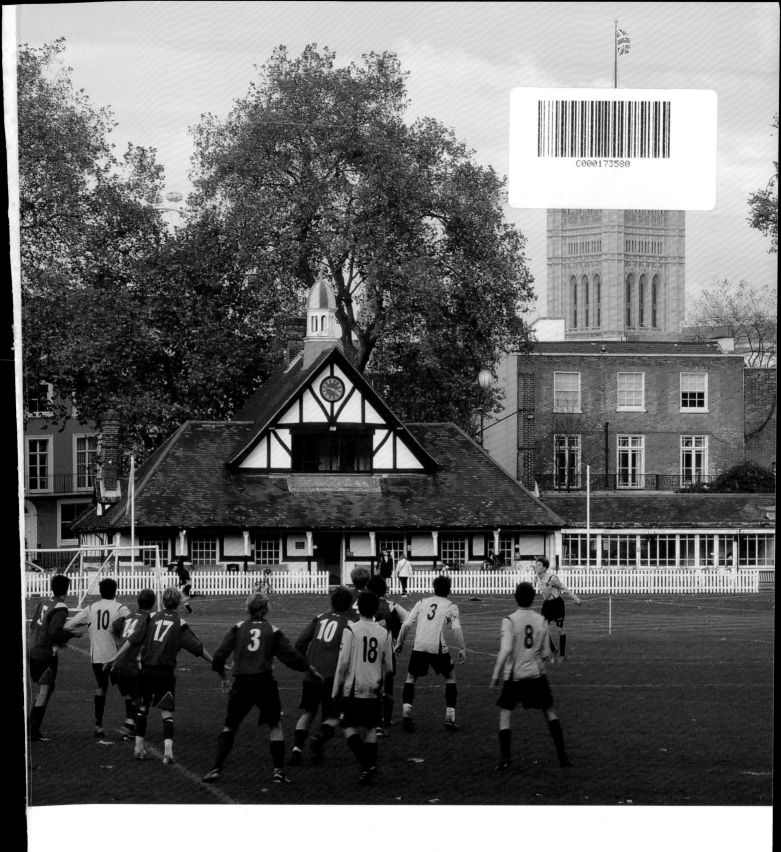

Played in London

Charting the heritage of a city at play

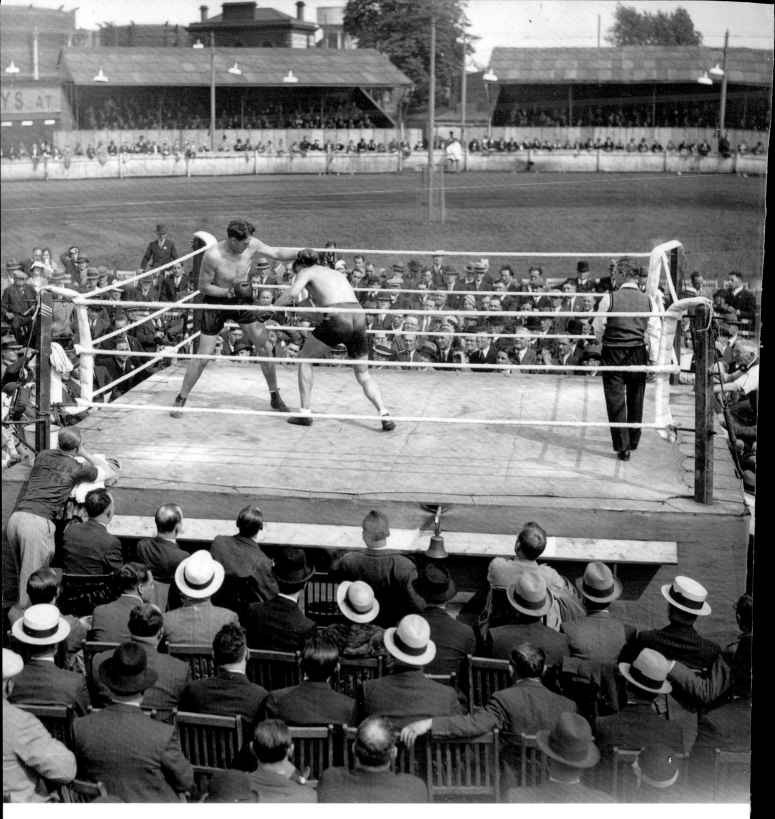

Played in London
© English Heritage 2014

English Heritage
is the government's statutory
advisor on all aspects of the
historic environment

Fire Fly Avenue
Swindon SN2 2EH
www.english-heritage.org.uk

Design by Doug Cheeseman

Production by Jackie Spreckley
Maps by Mark Fenton
For image credits see page 348

Malavan Media is a creative
consultancy responsible
for the Played in Britain series
www.playedinbritain.co.uk

Printed by Butler Tanner & Dennis
Frome, Somerset BA11 1NF

ISBN: 978 1 84802 057 3
Product code: 51537

Played in London

Charting the heritage of a city at play

Simon Inglis

with additional research by Jackie Spreckley

ENGLISH HERITAGE

POPULOUS

A business development manager from Perth, Australia (*right*) enjoys a spot of 'barefoot bowling' on the green at Hyde Park in 2013. While most private bowls clubs struggle to attract younger members, public greens in London parks have gained a new lease of life thanks to an influx of casual players, not only from Australia but also from New Zealand and South Africa – one example among many of how sports in the capital find themselves being continually reinvigorated by incomers.

Page Two In use from 1928–38, the Lea Bridge Speedway Stadium staged a series of boxing nights in 1933. On June 25 German heavyweight Walter Neusel, 'Der Blonde Tiger', squared up to Jack Pettifer from King's Cross (on the left in the ring). Over 6' 7" tall and over 17 stone in weight, Pettifer had been spotted as a likely champion whilst washing dishes in a Lyons Corner House. Although Neusel knocked him out on this occasion, Pettifer boxed as a pro for seven years before finding work in a foundry in Slough. The site of the Lea Bridge stadium is now an industrial estate.

Page One London's second oldest enclosed sports ground, Vincent Square, laid out by Westminster School in 1810, is the setting two centuries later in November 2010 for possibly the oldest continuously played Association football fixture in the world. The earliest recorded match between Westminster (in the pink) and Charterhouse took place on the same ground on December 3 1863, a few weeks after the formation of the Football Association and before either school adopted the FA rules. Westminster won 2-0 on a 'wet and sloppy' pitch which, according to the visitors' captain, made dribbling 'no easy task'.

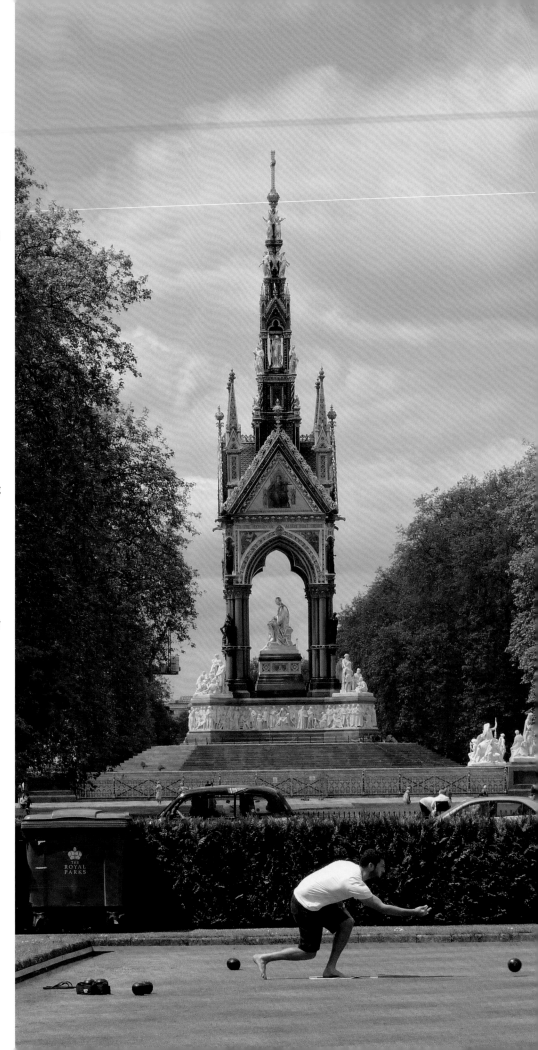

Contents

Foreword by Rod Sheard
Introduction

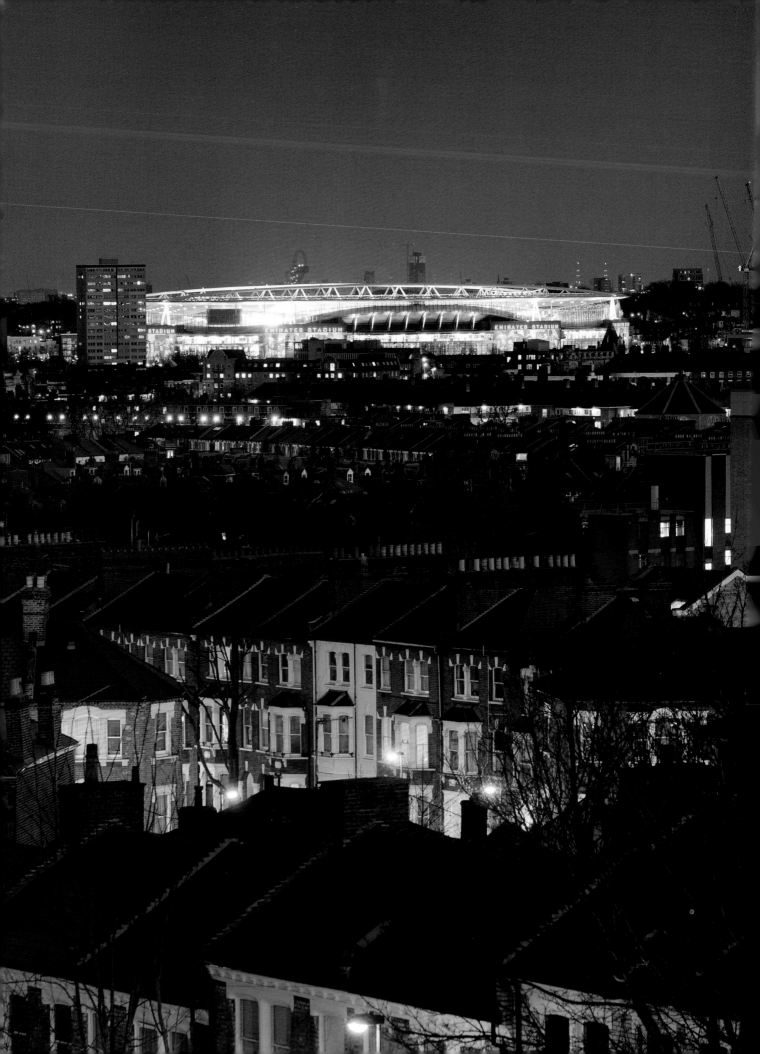

Foreword

by Rod Sheard, Senior Principal, Populous architects

For a sports mad lad growing up on the other side of the planet in Brisbane, listening on a crackly radio to commentaries from Wimbledon, Twickenham and Wembley, London was never less than the world capital of sport.

All those venues held such a place in my imagination, which is why, as a young architect setting off to see the world in 1975, my first stop was Rome, to see the Colosseum, and the next was London, where I have lived and worked ever since.

Luck is a key ingredient in sport, and it was luck that found me a job with one of the few firms involved in sports projects at the time.

Howard Lobb had, since the war, built up a diverse practice, mixing commercial projects with such high profile public works as the Festival of Britain in 1951 and the 1958 World Expo in Brussels.

The Lobb Partnership then went on to work at a number of racecourses in the 1970s.

In those days sports architecture had a low profile. Other than the specialist trade press, no one took much interest, while few people in sports management showed much interest in innovation.

The stadium tragedies at Bradford and Brussels in 1985, followed by Hillsborough in 1989, were major catalysts in shifting that complacency. More recently the digital revolution has fuelled further advances. Encouraged to think differently, designers now place far more emphasis on comfort, as well as safety, which in turn has led to venues that welcome women and children as well as the core traditional audience of men, and which stand out as buildings in their own right.

The stadia of today have, as a result, regained much of the iconic status that they once enjoyed in ancient Greece and Rome.

To have worked in this sector throughout these changing times has been a privilege, and even more so to have worked at so many venues in and around London.

For me this lucky streak started in the early 1980s with my involvement at Twickenham, and has since extended for myself and my colleagues to the two great cricketing venues of the capital, the Oval and Lord's. In football we have designed stands for Chelsea and Arsenal, and in the latter case, the Emirates Stadium. Our current portfolio includes Tottenham and West Ham. Meanwhile one of our greatest challenges has been to design the retractable roof over Centre Court at Wimbledon.

Modernising any historic venue whilst retaining its magic is an immense responsibility.

Similarly humbling was to take on the challenge, with Foster + Partners, of designing the new Wembley, to create a more functional and financially viable stadium, yet also, by replacing the much loved twin towers with the great arch, to create an identity symbolic of sporting excellence.

In 2007 I was in a taxi on the Embankment when I received a call to say that we had won the competition to design the main stadium for the London Olympics.

Few architects ever get to work on one Olympic Stadium, so for me to have been involved with two – having previously worked on Sydney's Olympic Stadium in 2000 – has been an extraordinary blessing, despite all the pressures.

Thanks to a supportive client and an encouraging attitude throughout, the London Games proved to be the most successful summer Games in history.

But then how could it be otherwise in a city that so many sports consider to be their spiritual home; a city where so many sports were codified and where so many have based their headquarters. In that sense London is unrivalled.

Then there is the city's sheer scale, its financial base and its culturally diverse population.

But for me the greatest factor of all is the enthusiasm that Londoners demonstrate for almost every kind of sporting spectacle, as was shown so movingly during the summer of 2012.

As an adopted Londoner I can readily identify with that passion.

As a designer, to honour the expectations of fans, players and the wider world, I also know that we have to understand how sport and sports architecture have evolved. We at Populous are therefore delighted to have played a part in bringing to the public's attention this, the most comprehensive book in the *Played in Britain* series.

A city with a special sporting heritage demands a special book.

Unquestionably, *Played in London* has risen to that challenge.

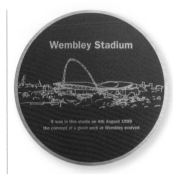

A plaque at the London office of Populous recalls the day on which the concept of the 'great arch' at Wembley Stadium evolved in August 1999. Senior Principal Rod Sheard first came to prominence in 1995 when, as chairman of the Howard Lobb Partnership, he designed the McAlpine Stadium in Huddersfield, winner of the Stirling Prize for Architecture in 1995 (the first sports building ever to be honoured at this level). Soon after Sheard took a lead role in the design of the Sydney Olympic Stadium, before in 1998 Lobb merged with the Kansas-based HOK Sport. The practice consequently designed London's three largest stadium projects of the modern era, Wembley, the Emirates Stadium and the 2012 Olympic Stadium (*below left*). During that period in 2009 the company went through a management buyout and, as an an employee owned architectural practice under the new name of Populous has become widely acknowledged as a world leader in sport, with offices in ten cities across four continents.

London colosseums – seen from Dartmouth Park Hill, the 60,000 capacity Emirates Stadium, designed for Arsenal by Populous and opened in 2006, is firmly in the urban tradition of its predecessor in ancient Rome. Peeping behind its floodlit roof can be seen the ArcelorMittal Orbit, next door to another London colosseum, four miles to the east in Stratford (*right*).

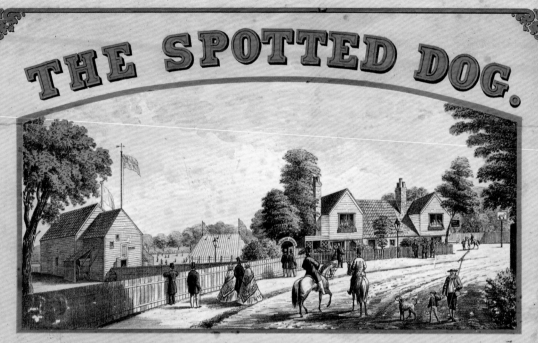

THE SPOTTED DOG.

ESTABLISHED UPWARDS OF 250 YEARS & SITUATED IN ONE OF THE MOST PLEASANT PARTS OF ESSEX

GOOD ACCOMMODATION FOR CRICKET & OTHER FIELD SPORTS

A SPACIOUS DINING ROOM & BILLIARDS,

DINNERS & TEAS PROVIDED ON THE SHORTEST NOTICE FOR LARGE OR SMALL PARTIES,

WINES & SPIRITS OF THE BEST QUALITY.

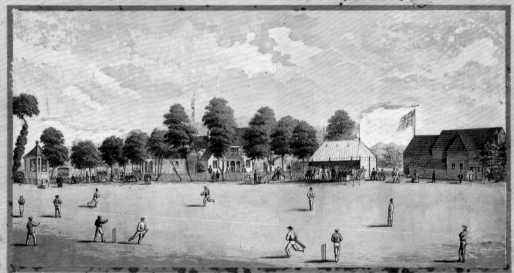

TRAINS RUN FROM FENCHURCH S.T TO PLAISTOW & FROM BISHOPSGATE S.T TO STRATFORD BRIDGE, FREQUENTLY THROUGHOUT THE DAY ACCESSIBLE FROM EITHER STATION, BY A TEN MINUTES WALK

WILLIAM VAUSE, PROPRIETOR.
UPTON.

LEWIS & COMPANY 15, COLEMAN ST BANK E.C.

Introduction

If, in the end, it really does boil down to bread and circuses, Juvenal's *panem et circenses*, there is not a city on the planet to match what London has on offer.

In earlier urban studies within the *Played in Britain* series we saw how, for example in Birmingham, provision for sports and recreation was powered by metal-bashing and manufacturing, and how in Liverpool, shipping and trade were the great drivers.

So what drives London?

The short, and unoriginal answer is finance, and culture.

And what is an important element of culture?

Physical culture. Sport and recreation. Participating in it, obviously. Watching it, clearly.

But in London's case, organising it too, governing it, staging it, marketing it, selling it, broadcasting it, reporting on it.

Sport is deeply ingrained within the everyday life of the capital, trumpeting its might on the back pages, beavering away at the grass roots, flexing its muscles in the gym and working up a sweat in the local park. Sport feeds into London's great obsessions – style, celebrity, news, architecture, the property market and, of course, big business. Always business (not forgetting its frothy concomitant, corporate hospitality).

So when, in the summer of 2012, London became the first city in the world to have staged three modern Olympics, this was no accident.

For when it comes to sport, London has form.

An abundance too: over 3,200 clubs spread across 50 sports, including 14 professional football clubs (more than any city apart from Buenos Aires), and eleven clubs playing at a senior national level in both codes of rugby.

Plus there are the two county cricket clubs based in the capital, Middlesex and Surrey, both playing at grounds that rank among the 22 venues in London holding 10,000 spectators or more (the largest being Wembley Stadium, with 90,000 seats).

Seat for seat, no other city can match this level of provision, not even football crazy Rio or sports mad Melbourne. Indeed if we add up the capacities of all the venues that currently cater for sport in the capital, the aggregate totals an astonishing 780,000.

This compares with 123,000 seats at London's 100 cinemas, and 43,000 seats in its 52 theatres (not including the fringe).

Of course cinemas and theatres are open six or seven days a week, so comparisons with sports venues are not necessarily valid.

But as a broad illustration, 14 million tickets were sold at London's theatres in 2013. This was roughly twice the number sold over the same period for sporting events, 3.6 million of which were for Premier League matches at the capital's six leading football clubs.

But if we take 2012, a year of so many happenings in London, combined ticket sales for the Olympics and Paralympics alone (bearing in mind that around a tenth of sales were for events

outside the capital), still exceeded 10 million, a new record for the Olympic movement.

So no matter how the figures are presented, the conclusion remains the same; that London earns a lot of its bread from circuses of one sort or another.

Much of this income, inevitably, derives from overseas. For it is also the case that while many of the 16 million foreign tourists a year who visit London (as of 2013) are drawn by its historic treasures, its museums and art galleries, its theatres and shops, many come here because of sport.

Although separate figures for London do not exist, it has been reported that in 2008, three million foreign tourists played or watched sport in Britain, 1.2 million of whom attended football matches. Horse racing and golf were the next most popular.

When Martial visited the Colosseum in 80AD he looked around him and asked 'if there was any race so remote, so barbarous' that it was not represented in the crowd? There was a Thracian, he noted, a Sarmatian, an Arab, a Sygambrian and an Ethiopian. And one man from a land 'whose shore the wave of farthest Tethys beats', by which it is thought Martial meant Britannia.

And so it is today in the colosseums of London, where the babel of voices in the stands is nowadays an echo of those spoken down on the pitch, or on the track, or on the court.

Not all these foreign circus-goers are passive observers. »

Since the Royal Society of Arts erected London's first plaque in 1867 (to Lord Byron, in Holles Street, long since lost), nearly 900 others have followed. Charles Burgess Fry, arguably England's most gifted all-round sportsman ever – a first class cricketer, footballer and athlete, a brilliant journalist but also an often deeply troubled individual – has two. The above plaque, placed in 2005, can be seen at 114 St James's Road in Croydon, while his final place of residence, in Lyndale Avenue NW2, bears an earlier plaque put up by Hendon Corporation. All told currently 48 sportsmen and women have plaques in their honour dotted around the capital, erected by a variety of agencies, most notably English Heritage since 1986. And yet when the London County Council unveiled its first plaque – to Lord Macaulay, in Campden Hill W8 (also long lost), in 1903 – Lord Rosebery declared that he hoped such plaques would force on the minds of young people that there existed 'other avenues of fame' than 'the Olympian games'.

From the collection of Newham Heritage & Archives, this 1860s poster advertises a venue best known in east London as 'the Dog'. Laid out in *c*.1840 by William Vause, licensee of the Spotted Dog, and since 1888 home to amateurs Clapton FC, it is the fourth oldest enclosed ground in the capital. The adjoining Grade II listed pub, alas, is boarded up and on the Heritage at Risk Register.

▲ Sporting heritage is not only manifested in buildings, plaques, trophies and such like. Think of classic track suits, 1970s trainers, baseball caps, and of course that old favourite of the varsity male, the rugby shirt, modelled here by the dashing Russian and Muswell Hill resident, **Prince Alexander Obolensky**, during his spell with **Rosslyn Park** in the late 1930s.

This look reached its apotheosis in 2011 when Ralph Lauren launched a store in Covent Garden called 'Rugby', artfully kitted out with sporting ephemera straight out of a 1930s school pavilion.

It closed two years later, but the look lives on in other outlets and collections, beloved by chaps and chapesses alike for barbecues in the beer garden and outings on the river.

The sportification of fashion and of London lifestyles is hardly a new phenomenon. A number of writers in the Victorian period lamented the burgeoning influence of physical culture on the nation's youth. And yet by the 20th century, in such centres as the **Walworth Clinic**, built in 1937 (*below*), fresh air and exercise were being actively promoted in the crusade for a fitter London. The words are those of Cicero, from the 1st century BC.

» Many wear the colours. They know the players. They really do 'support' Chelsea. They always have dreamed of seeing the Centre Court at Wimbledon. They grew up to become familiar with the names Twickenham and the Oval.

To them Wembley is not a suburb. It is Xanadu.

All this is of course known, and understood, and trotted out in a million press releases. There really is no other city as good as London when it comes to self-adulation.

Which is not to say that London has it all. Lord's and the Oval are small by the standards of India and Australia. The capital is not strong in horse racing (for reasons explained in the first chapter), nor in the north American sports of ice hockey, basketball or volleyball.

London does not (yet) have a Madison Square Gardens; that is, a city centre arena that combines boxing, ice hockey and basketball, although The O2 Arena out in North Greenwich is a rather more elegant building.

Plus, it might as well be said, it sells more tickets than any other indoor arena in the world.

In addition, as most readers will be only too aware, the capital is, on the whole, better at staging events than its players and athletes are at winning them (with the honourable exception of 2012, in which athletes born in or based in London won more medals than all the Australians put together).

But, what sport in London does have in spades, to put it one way, the familiar way, is 'tradition'.

Put another way, we might say that the capital's sporting culture has provenance.

Unrivalled provenance.

Forty six clubs in London have strong grounds for claiming to be 150 years old or older. Eighteen grounds or buildings may claim a similar longevity.

Another way of expressing it, therefore, is to say that where London outscores every other city in the world is in terms of its sporting heritage.

The subject of this book.

Now heritage, it has to be emphasised, is not the same as history, as historians are only too quick to remind anyone who might unwittingly blur the distinction. As is easily done.

This book is *not* a history of London sport.

History is the study of the past. It is bound by facts, by records, by documentation, by events, great and small. It is a discipline; some would say a social science.

Heritage, by contrast, whilst taking full cognizance of history, is about how we, in the present day, seek to celebrate and honour our past, in order to enrich how we live in the modern world.

After all, there is nothing any of us can do about the past. But we can shape the here and now, and if surveys of attitudes are to be believed, a substantial majority of us in England, at least, agree that conserving elements of the historic environment is desirable.

London, a city of churches and squares, terraces and parks, monuments and markets, railway stations and wharves, offers a prime example of heritage's wider benefits. It is partly because of the city's rich and varied historic environment that so many people seek to live here and visit.

All are instinctively drawn to, and inspired by what some commentators have called 'the power of place'.

No-one in the world of sport needs to be persuaded of the 'power of place'.

All our sports are shaped by place, whether they are played in a Victorian rackets court in west Kensington or in a 1970s skatepark in Hornchurch.

No-one in the world of sport, furthermore, needs to be persuaded that their particular discipline has a distinctive heritage of its own. It might even be said that the measure of a true sports fan is someone who has a working knowledge of the history of their sport and of their club, and a strong sense of how that history has shaped their heritage.

This heritage might be manifested in a number of ways; the 'home' ground and its local context, a pavilion or a grandstand, the club colours, its badge, its songs, its rivalries, its collective heroes.

A number of sports also claim connections with London that run deeper still, to their very existence.

In 2013, for example, as featured in Chapter 22, football marked the 150th anniversary of the formation of the Football Association, in Holborn, in 1863, whilst cricket celebrated the 150th edition of

the *Wisden Cricketers' Almanack*, launched in London in 1864 and the longest running publication of its kind in the world. As can be seen in Chapter 20, the office from which *Wisden* was once produced can still be identified, above a fast food outlet in Cranbourn Street.

Meanwhile in 2014, Lord's cricket ground celebrates its 200th anniversary. Then in 2015, the Rugby Football Union, founded in Cockspur Street in 1871, hosts the Rugby Union World Cup.

Also that year the Lee Valley Hockey and Tennis Centre will stage the European Hockey Championships, fifteen miles east of where the rules of hockey were first drawn up, 144 years earlier in Teddington.

Threads such as these lead to all corners of London; archery takes us to a park in Shoreditch, real tennis to the back door of Downing Street, lawn tennis to a shop in Westminster, now a Vietnamese restaurant, and athletics to a scrapyard by a railway embankment in Hackney Wick.

Sporting heritage, as this book seeks to demonstrate, is not just about the Wembleys and Wimbledons, or the world famous clubs. It is, perhaps more than anything, about the patterns of ordinary lives. London lives.

Let us, in that spirit, take an imaginary swoop over the playing fields of, say, Beckenham in the 1950s. Who, based on contemporary records, might we see at play?

On one pitch, insurance clerks from the City. On another, print workers from Fleet Street. Next to them, civil servants from Westminster, and a team of actors and theatre workers on their day off from the West End, facing up to a team from Ealing Studios.

Next we move north to a large swathe of council pitches on the Great Cambridge Road in Enfield. Who do we find there?

Postal workers playing against London bus drivers. Staff from Decca (record makers if ever there were) versus their counterparts from Debenhams. Rego v. Belling (or clothing v. cookers).

The sporting ethos of this world, in which whole weekends were lost to games and to staff socialising, and in which tens of thousands of ordinary Londoners were engaged, had more or less

disappeared by the 1980s. But what a legacy it left, as will be seen in Chapter 12.

Not all aspects of London's sporting culture can be celebrated.

The lack of opportunities for women to participate in sport before the 1920s is one. It must also be acknowledged that casual and occasionally overt racism and homophobia infected sporting culture just as deeply as it did other areas of everyday life.

Also perhaps unsettling is the conservatism of sport, evoked in the safe, often nostalgia driven architectural form taken by many of the historic buildings featured on these pages.

This conservatism was surely one of the reasons why Nikolaus Pevsner chose so pointedly to ignore sport in *The Buildings of England* series (*see Links*), the first volumes of which appeared in 1951 (although Pevsner did at least acknowledge that the Empire Pool at Wembley exhibited 'a bold show of concrete supports').

But if so many aspects of our sporting past sit uncomfortably with our sensibilities in the 21st century, are we right to put such emphasis on sporting heritage?

This is perhaps not the right forum in which to address such a lofty question in full. It touches upon so many other aspects of how we live today that go beyond sport and recreation.

Yet there are certain basic issues at play that do feed directly into this area of life.

London, as no-one will need reminding, is currently undergoing tumultuous change. Its population of 8.3 million is said to be rising by 1,000 every week.

Property prices are escalating. Skyscrapers funded by foreign investors are heading skywards whilst down below, recourse to food banks has reached levels unprecedented in most people's lifetime. Meanwhile, one of the severest threats to grassroots sport in the capital derives from cuts in the budgets of local authorities.

The idea that sport and politics are somehow not linked is, in this respect, demonstrably false.

In such times of uncertainty, it is natural that people should seek refuge and comfort in the past.

Sport, its clubs, its institutions, its headline events – the Boat Race, the Marathon, the Cup Final, Test matches, Wimbledon Fortnight, the Calcutta Cup, the King George VI Chase on Boxing Day – all represent continuity.

Involvement in sport is a pathway to belonging. In a city where cultures are so diverse and identities so fragmented, playing tennis at the local club or supporting the local football team is a way to fit in, to establish one's credentials as a Londoner.

This is no different today than it was during all previous waves of expansion. In the 19th century the single largest minority in London consisted of Germans, which explains why, outside St Pancras, there is a German Gymnasium.

In the 1950s Irish immigrants gravitated towards Arsenal, just as is the case today with French Londoners, drawn by the presence of manager Arsène Wenger.

Modern London, it is said, has more French inhabitants – in the region of 300-400,000 – than all but five of the largest cities in France. So might we one day see *boules* take over from bowls in the capital? Why not?

With each generation, and with each new wave of immigrants, sporting culture shifts and adjusts.

Today, six of London's nine leading football clubs are in foreign ownership. London's largest club stadium, that of Arsenal, is named after a Middle Eastern airline.

Elsewhere in Britain we have seen one football club change its colours at the behest of its Malaysian owner (in Cardiff), and another apply to change its name, at the insistence of its Egyptian-born chairman (in Hull).

Developments such as these have forced fans to decide where they stand, what is important.

Does heritage constitute an asset or an obstacle to progress?

And yet it is also the case that a number of foreign investors in English clubs (in rugby and cricket as well as in football) have demonstrated a highly developed sense of their clubs' heritage, even more so in certain instances than their English predecessors.

For example it took the wealth of another Egyptian-born businessman, Mohamed Al Fayed, one time proprietor of Harrods, to save London's oldest senior football club, Fulham, from years of asset stripping at the hands of developers, all of them British.

Finally, on a personal note, although the *Played in Britain* series was launched in 2004, *Played in London* is a book which, in a very real sense, I have been researching since my earliest dabblings in football grounds, starting in 1980 (after three years as a student here in the 1970s), but especially since settling in the capital, in 1984.

Being Birmingham born, and also having studied and worked in Leeds and Manchester, I have tried always to maintain an impartial stance on all matters London. I have never supported or followed any London team, and never will.

But there is no denying that the total immersion that this book has required, the vast amount of travelling involved (all by public transport and via shanks's pony since my old banger caught fire on Highgate Hill in 2009), has turned me, gradually but ineluctably, into a local. And a happy one at that.

A huge debt of gratitude is owed to English Heritage for their support for the *Played in Britain* series, both financial and moral.

I am also grateful to my fellow *Played in Britain* authors (*see Links*) for sharing their knowledge so freely, and to Jackie Spreckley, who has worked alongside me since the beginning, and whose Oyster card has taken an equal hammering.

Any author who takes on the magnitude of London and expects to capture it all, I have discovered, is on a fool's errand. I therefore feel I can do no better than to concur with the sentiments of Henry Morley, in the preface to his book in 1874, *Memoirs of Bartholomew Fair*.

Like Morley I present this book 'with a lively sense of its shortcomings.

'Conscious of what such a book might have been, and ought to be, I feel how much of crudity there is in this, and know only too well how dimly the soul of it glimmers through its substance.'

But if this book helps even remotely in the cause of London's sporting heritage, then it will have served its purpose.

One thing is for sure. Heritage assets, in whatever form they take, represent a finite resource. Once lost they are gone for good. And in London, as in every British city, they are vulnerable.

Simon Inglis, March 2014

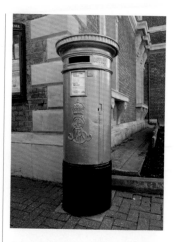

▲ Londoners are used to hearing the word 'legacy' in conjunction with the Olympic and Paralympic Games. But whatever else happens over at Stratford, as long as there is a postal service there should always be reminders of 2012.

Before the Games, **Royal Mail** announced it would repaint one post box for every Brit winning gold.

By the end of the year, 110 boxes had been resprayed, fifteen of them in London. Of these, two commemorate the Games themselves, outside Westminster Abbey and the Post Office on The Broadway, Stratford. Four in Wallington honour David Weir. Two in Cheam and Carshalton honour Joanna Rowsell. Mo Farah's pair are in Isleworth and Teddington.

The one seen here, on **Heathfield Terrace**, **Chiswick**, commemorates the gold of naval officer and local resident **Pete Reed**, in the coxless fours.

How long these boxes will retain their glow is impossible to predict. Nor can we know what will occur if and when pillar boxes are eventually rendered obsolete. Will the public demand that the Olympic boxes at least remain?

That will be up to them of course. But if they are reading this, may they be quite assured, 2012, like the postman, did deliver.

Chapter One

Played in London

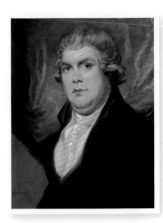

Born near Chelmsford in 1749, Joseph Strutt came to London as an engraver in the 1760s but, in his own words, finding the 'study of antiquities... both amusing and useful' was increasingly drawn to the manuscripts room of the British Museum. Between bouts of asthma and retreats to the countryside from his home just off Portland Place, Strutt created a substantial body of reference works, each illustrated with his own engravings. He started off with *Regal and Ecclesiastical Antiquities*, followed by *The Manners and Customs, Arms and Habits of the Inhabitants of England* and then *The Dresses and Habits of the People of England*. Strutt is best known, however, for his final piece of research, published in 1801, two years after Ozias Humphry painted this portrait. It was *The Sports and Pastimes of the People of England* that inspired the *Played in Britain* series, work on which started in 2002, on the 200th anniversary of Strutt's death, in Hatton Garden.

During the course of his investigations into the sports and pastimes of the English, Joseph Strutt rarely strayed beyond the confines of the British Museum. Not for him the skittle alley or the tennis court, village cricket on the green at Richmond or wrestling at Bartholomew Fair.

Whereas, in order to chart the sporting heritage of London in the 21st century, a rather more proactive approach is in order.

For sure the British Museum remains an important repository of knowledge, along with its offshoot, the British Library, as is also true of the Museum of London, the London Metropolitan Archives, the Guildhall Library and the local studies departments of all 32 London boroughs.

We must also call to mind the various sports-related collections of London's local museums, in the likes of Brent, Islington and Bromley, and the sterling work of numerous local history societies currently active in the capital.

Then there are London's five specialist sports museums, attracting between them nearly 400,000 visitors a year.

Two are club museums, those of Arsenal and Chelsea. Those at Lord's cricket ground (where Britain's first sports museum opened in 1953), at the All England Lawn Tennis Club at Wimbledon, and at Twickenham rugby stadium, are doubly important for having comprehensive libraries and archives too.

But glass cabinets and library shelves can serve the cause of heritage only so far. This is because, like sport itself, sporting heritage, in all its manifest forms, tangible and intangible, is best understood out in the field, out in the everyday world.

In place names, for example.

During Strutt's lifetime, until well into the 19th century, the word 'sport' referred not, as it does today, to activities such as bowls and cricket, which the Georgians described as 'games', but to hunting, shooting and fishing.

For those medieval Londoners privileged enough to hold the right to hunt deer, the 'chase' was the place; that is, that part of the forest set aside for the 'nourishyng, generacion and feeding of beastes' (as defined by an Act of Parliament in 1536). Walls and fences prevented the deer from escaping, which is why Londoners today might still pass through Southgate on their way to Enfield Chase.

Back in town, since at least the 1630s another former hunting ground takes its name from the medieval cry of 'So Ho!', called out when a hare was spotted.

('Tally-Ho!' was the 18th century equivalent for fox hunters.)

These connections may seem distant, but they remind us that as long as there have been Londoners there have been sports.

And games.

The Romans did not only bring gladiators to these shores (*see opposite*). They played ball games.

The Saxons, noted Strutt, were fond of gambling, and of trials of strength. In east London, Plaistow is one of at least a dozen English places taking its name from the Saxon 'pleg stow', or 'play place'. This, it is believed, was a field or natural amphitheatre set aside for wrestling, sword play and performances. There is another Plaistow in south London, just north of Bromley.

One of the great intangibles of sporting heritage is local rivalry.

At the time of the Magna Carta the grudge match in the capital was wrestling, contested between youths from the City of London and their neighbours in Westminster. In 1222 this rivalry reached boiling point when, after a major punch up at a contest in Clerkenwell, a group of Londoners retaliated by pulling down several houses in Westminster, including that of the Abbot. For their sins, three of the ringleaders were executed.

(As noted in the next chapter Clerkenwell would be the scene of further violence by wrestlers from the City in 1301 and 1405.)

None of today's sporting rivalries go back quite that far, or are as bitter. Even so, teams from Middlesex and Essex have been playing each other at cricket since at least 1787. London Rowing Club and Thames Rowing Club have been rivals (and near neighbours) since 1860, while Westminster School and Charterhouse, in football (*see page 1*), and Richmond and Blackheath, in rugby, have been playing each other since 1863 and 1864 respectively.

Arsenal and Tottenham, by comparison, played each other first only in 1887.

> In order to form a just estimation of the character of any particular people, it is absolutely necessary to investigate the Sports and Pastimes most generally prevalent among them.

Joseph Strutt sums up the *Played in Britain* ethos in his seminal work, *The Sports and Pastimes of the People of England*.

Organised competition is in itself a crucial component of sporting heritage in the capital.

As featured in Chapter 3, the oldest continually staged sports event in London today, the Doggett's Coat and Badge Race, initiated in 1715, is also the oldest rowing race in the world.

The rather more famous 'Boat Race' has been staged in London since 1836, and despite being contested by two crews of amateurs representing institutions that only a minority of Londoners connect with, manages to draw crowds of over 200,000 every year.

These traditions, these rivalries, these events, the whole panoply of sporting heritage that finds expression in club names, colours, songs and jibes, in territories and in trophy counts, in days out and in the changing light of the seasons – these manifestations of heritage are threaded throughout the chapters that follow.

That said, the core of this book is focused upon more tangible manifestations of sporting heritage. It is concerned primarily with the places of sport, the 'sportscapes', and with the built heritage of sport and recreation, from the Roman amphitheatre of the first century to the Olympic venues of the 21st.

This chapter should be considered as a scene setter; the equivalent of a match programme even, to be read as a primer for the main event.

In the foreword to the 1903 edition of Strutt, its editor Charles Cox could not help but reflect upon 'the simply astounding changes' that had taken place in the 100 years since the first edition; above all, the rise in the 'extraordinary devotion' of all classes of the English 'to every conceivable kind of sport and pastime'.

Cox pointedly avoided saying whether this devotion was 'a sign of national decay or of national progress'.

For his part, all Strutt expressly hoped for was that his work might prove 'amusing and useful'.

As does the present writer. With the added hope that *Played in London* will entice readers out of the library, and into the city where all these stories have unfolded.

Sporting heritage is a living entity. Here are the best examples of where to look.

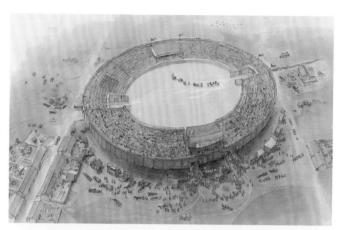

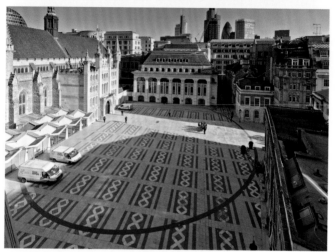

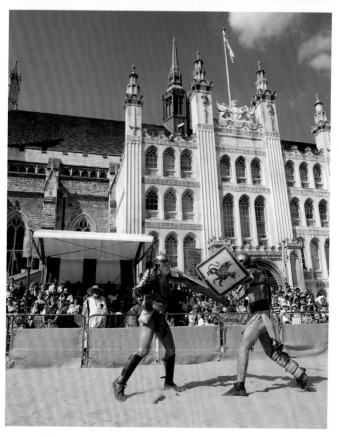

◀ Historians had always assumed that London, in common with Dorchester, Silchester and Chester, had some form of amphitheatre where gladiatorial contests took place. But they were never sure where until, in 1988, routine excavations prior to the building of a new art gallery at the Guildhall unearthed walls that by chance revealed its whereabouts.

Analysis of timbers surviving on the site date the amphitheatre's construction to c.70-75 AD, making it an exact contemporary of the Colosseum in Rome (which was nearly ten times larger). It was then upgraded in stone in c.120-130 AD, and remained in use until around 350 AD.

This artist's impression shows how the amphitheatre might have appeared in around 120 AD, with seating for an estimated 6,000 (at a time when London's population was in the region of 25-30,000), and occupying an overall footprint roughly the size of a football pitch.

Today, a stunning underground gallery displays the remains of the amphitheatre, while directly above, the arena's outline is marked on the Guildhall courtyard (*left*).

Apart from the obvious links between Roman amphitheatres and the multi-purpose indoor arenas of today, the spectacle of Greek-style wrestling, and even of armed combat, if not to the death, then certainly until blood was spilled, carried on in London for centuries.

Schools for men wielding swords and bucklers existed in the 13th century (Edward I tried to ban them in 1286). Centuries later sword fights were held in the Bear Garden at Clerkenwell, watched apparently with great enthusiasm by women.

Rather like modern day wrestling bouts, however, as *The Spectator* warned in 1712, the authenticity of these encounters could not always be assured.

Courtesy of the Museum of London, members of the Britannia re-enactment society demonstrate the skills and accoutrements of Roman gladiators in a display outside the Guildhall in July 2011. The surface laid is a reminder that the word *arena* derives from the Latin for sand, used in amphitheatres for its capacity to absorb blood and gore and be quickly raked between contests.

Sports and paſtimes of old time vſed in this Citie.

Cock fighting.

Ball play.

Exercise of war like feates on horsebacke with disarmed launces.

Battailes on water.

Leaping, dancing, shooting wreſtling.

foȝs haue wȝought, oȝ repȝeſentations of toȝmentes wherein the conſtancie of Martirs appeared. Euery yeare alſo at Shȝouetuſeday (that we may beginne with childȝens ſpoȝts, ſeing we al haue beene childȝen) the ſchoole boyes do bȝing cockes of the game to their Mayſter, and all the forenone they delight themſelues in cockfighting : after dinner all the youthes goe into the fieldes, to play at the ball. The ſchollers of euery ſchoole haue their ball (oȝ baſtion) in their hands: the auncient and wealthy men of the Citie come foȝth on horſebacke to ſee the ſpoȝt of the young men, and to take parte of the pleaſure in beholding their agilitie. Euery Fryday in Lent a freſh company of young men comes into the fielde on horſebacke, and the beſt horſemen conduɕteth the reſt. Then march foȝth the citizens ſonnes, and other young men with diſarmed launces and ſhieldes, and there they pȝactiſe feates of warre. Many Courtiers likewiſe when the king lyeth nere, and attendants of noble men do repayȝe to theſe exerciſes, and while the hope of victoȝie doth inflame their mindes, do ſhew good pȝoofe how ſeruiceable they would bee in martiall affayȝes. In Eaſter holidaies they fight battailes on the water, a ſhield is hanged vpon a pole, fixed in the midſt of the ſtreame, a boat is pȝepared without oares to be carryed by violence of the water, and in the foȝe-part thereof ſtandeth a young man, readie to giue charge vpon the ſhield with his launce : if ſo be he bȝeaketh his launce againſt the ſhield, and doth not fall, he is thought to haue perfoȝmed a woȝthy dæde. If ſo be (without bȝeaking his launce, hee runneth ſtrongly againſt the ſhield, downe hee falleth into the water, foȝ the boate is violently foȝced with the tide, but on each ſide of the ſhielde ride two boates furniſhed with young men, which recouer him that falleth as ſoone as they may. Vpon the bȝidge, wharfes, and houſes, by the riuers ſide, ſtand great numbers to ſee; and laugh thereat. In the holy dayes all ſommer the youths are exerciſed in leaping, dancing, ſhooting, wȝaſtling, caſting the ſtone, and pȝactizing their ſhieldes.

▲ This, the earliest known account of sport in London, was written in c.1174 by **William Fitzstephen**, a clerk to Thomas Becket, as part of his *Descriptio Nobilissimi Civitatis Londoniae*. The version reproduced here, from **The Survey of London** by **John Stow**, published in 1598 and held by the **British Library**, is the earliest English translation known to have appeared in print, albeit over 400 years after it was written.

Because the copy of Fitzstephen on which Stow's translation was based has not been identified – only two Latin copies survive to this day – we must be wary of its finer detail. Inevitably Stow, and other later translators, added their own interpretations, for example in some instances by substituting the word 'football' for 'ball', when in truth the exact nature of the ball game cited by Fitzstephen is unknown.

Fitzstephen nevertheless provides enough description and colour to make it clear that sport and games played an important part in 12th century London life.

As such, his text and this Stow original must rank as valuable heritage assets in their own right.

Starting on the second line, the text reads, in modern English: 'Every year also at Shrovetide day (that we may begin with children's sports, seeing we all have been children) the schoolboys do bring cocks of the game to their master, and all the forenoon they delight themselves in cockfighting: after dinner all the youths go into the fields, to play at the ball.'

Stow adds that each group of scholars had their own ball, while other versions state that this was also the case for workers (some say apprentices), representing each of the city crafts.

As detailed in Chapter 22, Fitzstephen was almost certainly referring to a Shrovetide custom that survived in the London area until as late as the 19th century.

In Chapter 2 we will return to Fitzstephen for his description of 'battles' on the River Thames.

But one other extract, not shown here, is also of interest in a sporting context.

This describes how every Friday outside the city gates, at the 'smooth field' (that is, Smithfield), crowds, including earls, barons and knights, formed to watch horses being put throught their paces.

As presented in a version translated by HT Riley in 1860, it reads: 'On occasions when a race is about to be held... the fact is loudly proclaimed and a warning goes up to clear lesser horses out of the way.

'Two or sometimes three boys prepare themselves to take part as riders in such contests between the fleet-footed creatures. Skilled in controlling horses, they "curb their untamed mouths with jagged bits"; their biggest challenge is to prevent one of their competitors from taking the lead in the race...

'The riders, eager for glory and hoping for victory, try to outdo one another in using spurs, switches or cries of encouragement to urge the horses to go faster. You start to believe that "all things are in motion", as Heraclitus put it..'

We in 21st century London know that feeling only too well.

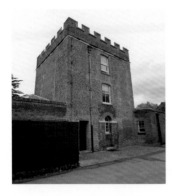

▲ London's earliest surviving buildings for sport and recreation all date back to the reign of **Henry VIII** (1509-47). For a king who was only too quick to ban his lowlier subjects from enjoying sport, he really was a man obsessed, building not one but two major sports complexes during the 1530s, at **Hampton Court** and **Whitehall**.

The latter, the construction of which required the obliteration of what had been until then a thriving suburb, is said by HJM Green and Simon Thurley (*see Links*) to have amounted to the largest complex of secular buildings yet seen in Europe.

Equally pertinent is that for all their state-of-the-art sports facilities, both palaces were, in design terms, exercises in nostalgia, harking back to a medieval idyll of castles, gothic halls and chivalric knights.

The yen for heritage is by no means a modern phenomenon.

Above is an example. Built in 1538 it is the sole survivor of five crenellated **viewing towers** built at **Hampton Court Palace** overlooking the **tiltyard**, an open space used to stage jousts and pageants.

(The Tudors urged that courtiers and gentlemen should not merely play a roster of approved sports, they should also be seen to play.)

As it transpired this particular viewing tower saw little action, most royal tournaments of the period taking place at Greenwich and elsewhere. But at least the tower survives, and can be visited, having become a restaurant and café.

No such public access is allowed to the remains of Henry's other leisure resort at **Whitehall**.

This is because after a major fire in 1698 the site was gradually taken over by state offices. In fact most of the remaining structures, revealed by excavations carried out in the early 1960s, now fall within the **Cabinet Office**.

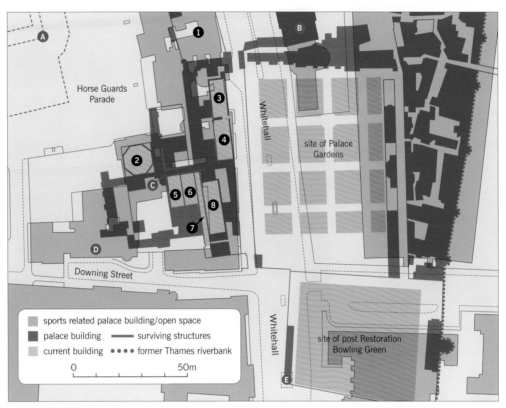

Horse Guards Parade

Whitehall

site of Palace Gardens

Downing Street

Whitehall

site of post Restoration Bowling Green

- ▨ sports related palace building/open space
- ▨ palace building — surviving structures
- ▨ current building •••• former Thames riverbank

0 50m

As shown on the plan above, on the east side of the thoroughfare now known as **Whitehall** stood the palace's residential quarters. Sports facilities were concentrated on the west side and were known collectively as the **'Cockpit'**.

A passageway that ran through the complex's core, known as **Cockpit Passage**, still provides a direct link between Whitehall and 10 Downing Street.

One of Henry's many sporting passions was tennis (what we now call 'real tennis'). He built four 'plays' or courts at Whitehall, two smaller ones for the older version of the game known as *jeu quarré*, and two larger ones for the version that would eventually prevail, *jeu à dedans* (*see Chapter 24*). For each version there was an 'open' play (uncovered) and a 'close' play (covered).

West of the Cockpit lay St James's Park, then reserved for Henry as a hunting ground.

The plan, extracted from various sources and by necessity much simplified, shows Whitehall as it existed between 1532, when construction began, and 1670, after Charles II had laid out a bowling green and rebuilt and covered a tennis court known as the 'Brake'. This was the last court to remain in use, before its demolition in 1809.

A. Horse Guards Parade, site of 2012 beach volleyball (*overleaf*)
B. Banqueting House (1622-)
C. Cockpit Passage (1533-)
D. 10 Downing Street (1677-)
E. Cenotaph (1920-)

1. **Tiltyard** (1533-1664) also used for bull and bear baiting
2. **Cockpit** (1533-1675) but staged plays post 1629
3. **Great Open Tennis Play** (1533-c.1650) wall section remains
4. **Great Close Tennis Play** (1533-1663) window, wall section and corner turret (*right*) remain
5. **Small Close Tennis Play** (1534-1604) northern wall, windows, foundations remain (*overleaf*)
6. **Small Open Tennis Play** (1534-1604) foundations remain
7. **Bowling alley** (c.1534-1660)
8. **'Brake'/Great Open Tennis Play** (c.1550) **Covered** (1662-1809)

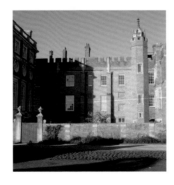

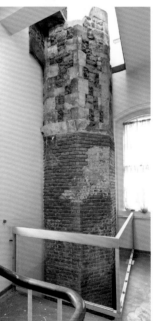

Surviving from the Great Close Tennis Play (4) and now part of the Cabinet Office is this octagonal brick turret (*above*). The court's exterior would have looked similar to that of the surviving east wall of Hampton Court's second tennis court (*left*), built at the same time as Whitehall but converted into living quarters in c.1661. More on real tennis at Hampton Court follows in Chapter 24.

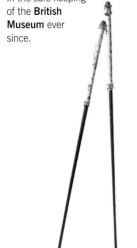

▲ One of sport's best known contributions to London's built environment lies north of Whitehall.

Originally forming part of St James's Park before it became a public thoroughfare in 1661, **Pall Mall** was an 850 yard long alley, set out for the French game of *paille maille* (literally ball and mallet) and with a surface of crushed shells.

First brought to London by James I, 'pell mell', as Pepys called it, was described by one writer as 'virile croquet'. The aim was to take the fewest possible hits to reach from one end of the alley to the other (not so difficult), before driving or perhaps chipping the boxwood ball up into the air and through an iron ring mounted high on a post, like a basketball hoop.

If an etching from the period is accurate and the hoop really was about two feet in diameter, it must have required exceptional accuracy (although not if we believe a later rendition, *see page 24*).

Either way, even though one of its keenest exponents, Charles II, laid out a replacement alley in St James's Park after 1661, pall mall appears to have withered after his death, leaving behind no written rules and seemingly just one surviving set.

Found in a clockmaker's house in Pall Mall in 1854 this unique sporting curio (*below*) has remained in the safe keeping of the **British Museum** ever since.

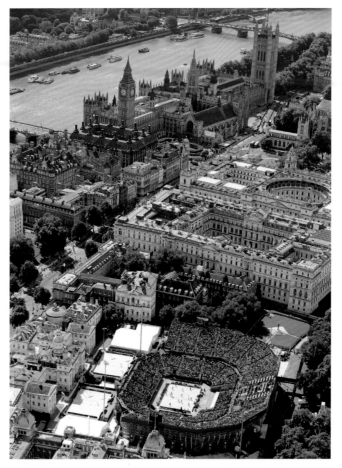

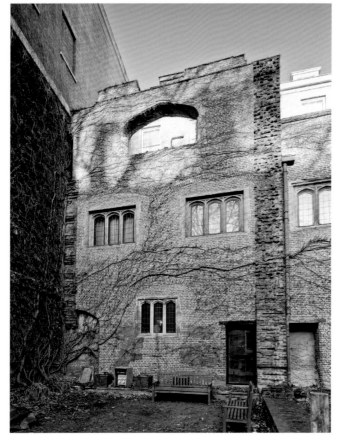

◀ Of all the many wonderful juxtapositions of old and new served up during the staging of the **2012 Olympic Games**, the siting of **beach volleyball** on **Horse Guards Parade** surely resonated the most within the context of sporting history (even if few people at the time made the connection).

Here, in the backyard of Henry VIII's giant leisure complex, just yards from the site of his cockpit, his four tennis courts and from the tiltyard where considerable crowds – estimates suggest in the region of 8-12,000 – had once gathered for jousting tournaments, was erected a temporary stadium holding 15,000 people, the equivalent of the Centre Court at Wimbledon.

All this so that scantily-attired athletes from parts of the globe of which the Tudors knew nothing could cavort on 5,000 tonnes of sand brought in from a quarry in Surrey (sand that was later redistributed to five sports centres, including one coincidentally in Eltham, where Henry had another tiltyard, *see back cover*).

It is of course pointless to speculate as to what Henry might have made of this scene, five centuries on from his pomp.

But it does rather remind us that for all our supposed modern sophistication, we too can have no idea whatsoever as to how sport, let alone Whitehall might look, 500 years from now.

On the other hand, if Henry were to stand in **Treasury Green** today – a courtyard garden accessed from Downing Street and seen in the centre left of the aerial view (and where number 5 is marked on the preceding plan of Whitehall) – he would perhaps have no problem at all finding his bearings.

For there stands the northern wall of his **Small Close Tennis Play** (*left*), complete with its opening at the top to light the court, and two first floor windows accessed from **Cockpit Passage**, from which spectators could watch games in comfort, place bets and generally admire the king's manly form and his finely woven tennis attire.

Legend has it that Anne Boleyn was watching a game of tennis at Whitehall in 1536 when she was arrested, only to beg that she might stay to the end because she had a wager on the outcome. Could one of these windows have been where she sat on that fateful day?

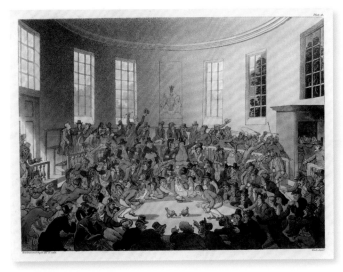

It was not only schoolboys on Shrove Tuesday and Henry VIII who enjoyed '**cocking**'. Although both Edward III and Oliver Cromwell tried to ban the sport – for encouraging gambling rather than out of any concern for animal welfare – cockfighting was an English favourite for centuries, at least until it was banned by the Cruelty to Animals Prevention Act in 1849.

Like horse racing, a cockfight, or 'main', brought together, in the words of Sir Walter Gilbey (*see Links*), 'the highest of nobility and the humblest peasant'.

In tandem with cricket, cocking was also one of the first sports to have been contested on a county basis (for example the Gentlemen of Essex pitting their cocks against the Gentlemen of Suffolk). It was highly regulated too, at least in formal venues such as the **Royal Cockpit** on **Birdcage Walk** (*above right*).

Portrayed here by **Thomas Rowlandson** (who drew the figures) and **Augustus Pugin** (responsible for the architectural detail) for *The Microcosm of London,* published by Rudolph Ackermann in 1808-10, the cockpit was built by Charles II in c.1671 to replace the earlier one at Whitehall Palace.

Certainly it was the smartest of any for which visual records survive (compared, for example, to the more typically crude cockpit depicted by Hogarth in his celebrated print of 1759, thought to show one at Newmarket).

In common with all the known London cockpits, at least seven of which existed between 1600-1849, no structural elements remain of this particular Royal Cockpit. The building was demolished shortly after Ackermann's print was published, and superceded by another in Tufton Street in 1816.

But the curve of its outer wall does at least live on in the form of the Grade II listed **Cockpit Steps** (*above left*), which lead down from Old Queen Street and have done since at least the 1780s.

Elsewhere, Cockpit Yard in Holborn has featured on maps since 1685, while we can be reasonably sure that Cockspur Street (which links Whitehall with Pall Mall) also derives its name from the sport.

Less certain is the provenance of a circular hollow on Chislehurst Common, which has been described as a former cock pit for many years, but may have been a gravel pit. Similarly, the Cockpit pub in St Andrew's Hill, Blackfriars, known originally as the Three Castles and rebuilt in the 1860s, adopted its current name only in the mid 20th century. It has nevertheless been fitted out to resemble a cockpit of sorts, and is one of at least 70 buildings and locations in England and Wales to claim a link, in itself a testament to cockfighting's enduring hold upon the public's imagination.

By comparison, evidence of another favourite bloodsport, is less common. **Baiting** was a practice whereby chained-up bulls or bears were attacked by dogs (hence 'bulldogs'), the aim being to bet on which dog could clamp itself onto the beast's snout for the longest period. Pepys called it 'a very rude and nasty sport'.

Butchers claimed it made the meat of a bull taste better.

Most baiting took place in public places, called in some towns 'bull rings'. But in London, from c.1540–1680, baiting was focused on a series of small, enclosed arenas, known as 'gardens', built amongst the alehouses and brothels on Bankside, Southwark, as depicted on the well known Agas map of 1633 (*below*).

In 1583 part of one such arena, known as Paris Garden, collapsed, killing eight spectators (said to have been God's punishment for their bloodlust).

Baiting remained good business nevertheless (as noted in Chapter 7), especially as the Bankside's last 'woodden O', as Shakespeare called it, was equally used as a playhouse and as an arena for staged 'gladiator' fights.

Bear Gardens (*below left*) marks its location. After it staged its last baiting in c.1682, the sport continued in Hockley-in-the-Hole (now Ray Street, Farringdon) until c.1728, before baiting was finally banned by Parliament in 1835.

On the edge of Epping Forest, on **Rangers Road**, **Chingford**, the Grade II* listed **Queen Elizabeth's Hunting Lodge** is a real enigma.

For a start there is no evidence that Elizabeth ever used it. Also, it was built during the reign of her father, Henry VIII, in 1542-43.

But most intriguing of all is what it was built for and how it would have appeared originally.

The clue is in its original name, the **Great Standing**.

Henry, even when he was still athletic and able to ride, liked to hunt, not in the wild but in enclosed parks stocked with deer. All told 200 such enclosures were created, Hyde Park being one of them.

Imagine then that the Chingford lodge had no wattle and daub infilling but was instead a timber platform, still with its tiled roof but otherwise open to the elements.

Historians believe that the upper floor was for courtiers and visiting dignitaries invited to watch the proceedings, whilst on the first floor the 'hunters' assembled with crossbows, ready to fire as the deer were herded towards them.

Since the 17th century the frame has been infilled, altered and restored several times, most recently by the **Corporation of London**, who took it over in 1878.

Since 1895 it has been a museum, its current theme being the building itself, its sporting origins and its varied life since, including as a popular attraction for daytrippers from the East End.

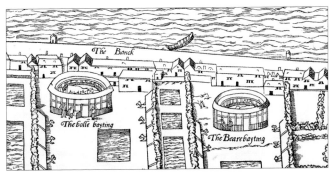

▲ One of the developments that reflected a gradual switch in tastes from bloodsports to the sports and games that we know today was the formation of clubs and societies, starting in the 18th century.

More of these historic clubs have survived in London than in any other city in the world.

Of the 3,250 or so clubs in the capital as of 2014, spread amongst the 50 most popular club-oriented sports, from American football to wrestling, 46 may claim to be **150 years old or more**, 27 of them cricket clubs.

Over the next decade a further 32 hope to join this august roster.

As the list on the right shows, however, precise dating of a club's formation is not always straightforward. Many clubs do possess documentation – a minute book, handbill or a newspaper report for example – as evidence.

But many do not. Even the venerable **Marylebone Cricket Club** (*above*) has at times had to insist that it was formed in 1787, when Thomas Lord's cricket ground was opened, rather than 1788, when its first match there was recorded.

Had the MCC's early records not been destroyed in a fire of 1825 this issue might not have arisen. But alas such losses of club records are all too common, if not owing to fires or wartime bombs then from plain negligence. Added to which a number of other factors conspire to muddy the waters.

The most common is that clubs claim to have been formed in the year when their particular sport was first recorded in the vicinity, rather than when the club was formally constituted. **Mitcham Cricket Club**, arguably London's oldest sports club, is an example.

A cricket team representing Mitcham is first recorded in 1707. A Mitcham XI is billed as a 'club' in 1813. Yet not until 1901 do records exist of club officials being appointed (*see page 199*).

Croydon Bowling Club dates its formation to 1749, even though there is no clear indication of a club structure until the 1850s.

Concerning **Royal Blackheath Golf Club**, the earliest documented evidence of there being a club, as opposed to a group of men playing on the same course, dates from 1766. This still makes Royal Blackheath by far the oldest golf club in England, and probably the fourth oldest in the world (three Scottish clubs claim to be older).

Yet in 2008 the club celebrated its 400th anniversary, based on a statement in 1831 that the club had been 'instituted' in 1608, that being a seemingly random date when Scots in the court of James I might first have played golf on Blackheath.

Another case is that of **Guy's Hospital Rugby Club**. For years this claimed to be the oldest rugby club in the world, formed in 1843. But recent research has found that although the hospital did have an athletic section in 1843, they were not recorded as playing rugby until 1866.

There are other examples of where clubs, in desperate need of a quick cash injection, have invented a formation date purely in order to stage a centenary celebration.

Another issue is continuity. Several clubs have gaps in their records, either through losses or because the original club disbanded, only for a new one with the same name, or similar, to pick up the pieces. But can it be described as the same club?

Then there arises the issue of what form of game was played.

In the world of hockey, two London clubs claim to be the oldest. Seen here in 1894 (*right*), **Blackheath Hockey Club** formed in 1861, but initially played a form of the game that did not live on. Thus **Teddington Hockey Club**, formed in

Oldest sports clubs and organisations formed in London
undocumented dates in italics *current club constituted at later date

1608	*Royal Blackheath Golf Club* *(but see 1766)*
1707	Mitcham cricket recorded* (CC constituted by 1901 at least)
1735	*Woodford Green CC* *
1743	Addington CC * (club re-formed several times)
1749	*Croydon Bowling Club* * (constituted by 1907)
1750	The Jockey Club
1766	Royal Blackheath Golf Club (earliest documented date)
1775	Cumberland Sailing Society (renamed Royal Thames Yacht Club)
1781	Royal Toxophilite Society (relocated to Burnham in 1968)
1787	Marylebone Cricket Club
1789	Uxbridge CC*
1805	*Barnes Bowling Club* * *(claims also of 1725 and 1755)*
1805-6	Streatham CC (now Streatham & Malborough CC)
1812	Princes Plain/West Kent CC (Chislehurst & W Kent CC since 1980)
1813	Westminster School Boat Club
1815	Ham & Petersham CC (formed as Albion CC, renamed 1891)
1818	Royal Tennis Court Club (at Hampton Court)
1833	Twickenham CC
1834	Hillingdon CC (now Hillingdon Manor CC)
1842	Roehampton CC
1845	Surrey County CC
1850-1	Ickenham CC
1853	Turnham Green CC (now Turnham Green & Polytechnic CC)
	Stanmore CC
1854	Wimbledon CC
	Poplar, Blackwall and District Rowing Club *
1855	Southgate CC
1856	London Rowing Club
	Enfield CC
1857	Sutton CC* (reconstituted 1864)
1858	Kingston Rowing Club
1860	Thames Rowing Club
	Twickenham Rowing Club
	Cray Wanderers FC
1861	Richmond FC (rugby)
	Blackheath Hockey Club
1862	Blackheath FC (rugby, from B'heath Proprietary School f.1858)
	Walthamstow CC
	Richmond CC
1863	The Football Association
	Teddington CC (but earliest Teddington match 1827)
	Beddington CC
	Civil Service FC and RFC (single club, divided since c.1870s)
	Nat West CC (formed as London & Westminster CC)
	St George's Hospital Medical School Rugby FC
	Hampton Wick Royal CC
1864	Cheam CC (but no records for 1889-1919)
	Middlesex County CC
	Serpentine Swimming Club

1871, also claim to be the oldest, because it was their members who pioneered the rules as played today.

To outsiders all these caveats may seem petty. But to members of historic sports clubs they are not. Sport being the competitive business that it is, any claim, any fact, any piece of evidence that can be brought to the table is treated as fair game, if only to steal a march on a rival.

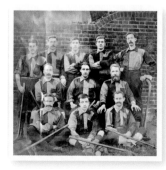

▶ Graves, memorials and plaques form an important element of sporting heritage, and in no sport more so than **boxing**, in which the emphasis, understandably, is on the individual rather than on a club or a building. Indeed with the exception of York Hall in Bethnal Green (*see pages 23 and 178*), no historic buildings designed or adapted for boxing survive (the best known of which was The Ring, a converted chapel on Blackfriars Road, hit by a bomb in 1940 but recalled by a bar of the same name across the road).

The earliest grave associated with boxing, or rather **pugilism**, as bare knuckle fighting was known before the gloves came on, is that of **John 'Jack' Broughton** (c.1703-89), in the West Cloister of **Westminster Abbey** (*top right*).

In fact it was Broughton who is credited with the introduction of mufflers (forerunners of boxing gloves) for the use of those gentlemen who, whilst learning the 'fistic arts' at his Oxford Street Amphitheatre, wished to avoid the inconvenience of 'black eyes, broken jaws, and bloody noses'.

Originally a waterman based at Hungerford Stairs – in 1730 he won the Doggett's Coat and Badge race (*see page 40*) – Broughton was buried in the Abbey cloister not because he was a pugilist, heaven forfend, but for his role as Yeoman of the Guard. As such if you look closely at the inscription, the words 'Champion Prizefighter of England' were inserted later, in 1988.

Back in 1789 the Dean had insisted that no reference be made to Broughton's career as 'a public bruiser' (as one obituary put it).

Of all the great public bruisers of the bare knuckle era, Gloucestershire born **Tom Cribb** has the most commemorations.

A coal porter in Wapping who won his first fight in 1805, in Wood Green, Cribb has a blue plaque in **Panton Street** (*below*). Dedicated

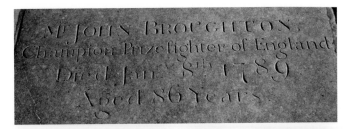

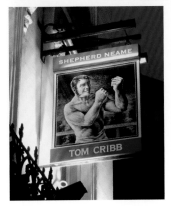

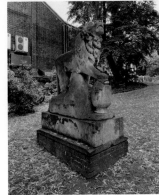

in 2005, this is mounted on the wall of the pub which, since 1960 has borne his name (*above*).

Rebuilt in 1878, it was originally called the **Union Arms**. Cribb had been its landlord from 1825-34, a role taken on by many a pugilist and boxer in later life.

But not always happily.

When Cribb beat the black American, Tom Molineaux, in front of 20,000 spectators in Leicestershire in 1811, the crowds that greeted him on his return brought Holborn to a standstill.

But as a publican Cribb fell into gambling, lost all his money, and the pub, before ending his days in the modest home of his son, a baker, at 111 Woolwich High Road (now a Chinese takeaway).

In the nearby churchyard of **St Mary's** stands a monument to Cribb, depicting a grieving lion (*above*), while there is Tom Cribb Road, also in Woolwich.

One of the best sources of information about both the Jewish boxer Ted 'Kid' Lewis (whose blue plaque, *below*, is at Nightingale House in Clapham), and Sir Henry Cooper (whose plaque is at his childhood home at 120 Farmstead Road SE6), together with many other aspects of the capital's rich boxing heritage, is the website of the London Ex-Boxers Association. For one of the most remarkable aspects of a sport in which two parties assail each other for public amusement is the deeply felt respect and camaraderie that boxers have for each other outside the ring. Formed in 1971 and now with over 600 members, LEBA has also collected data on nearly 70 boxing venues around east London, including the many public baths used during the winter and other, now largely forgotten hotspots, such as Wonderland in Whitechapel, a 'rough and ready' hall where undercover bookies and jellied eel vendors mingled before it 'mysteriously' burnt to the ground in 1911.

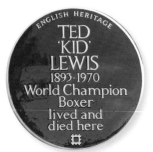

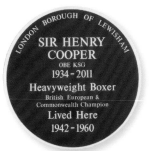

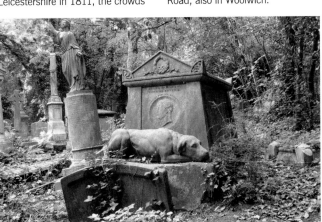

▲ Such was the celebrity of **Tom Sayers**, Britain's last bare knuckle champion before the Queensberry Rules were enforced in 1867, that his funeral was said to have attracted almost as much public interest as that of the Duke of Wellington. Some reports noted how **Highgate Cemetery** had been overrun by all manner of 'foullest scum' and 'slow-eyed' roughs, and that the procession, which filled the streets from Tottenham Court Road up to Highgate, had been led by Sayers' faithful mastiff, **Lion**, a gift from Lord Derby, no less. That is Lion above, recumbent on the grave.

Before finding fame, Sayers, who was illiterate, had been a bricklayer, said to have helped build the Roundhouse in Chalk Farm.

Nearby is this blue plaque (*right*), on the house of his friend, a boot maker, at **257 Camden High Street**.

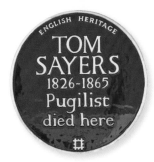

▲ Unfortunately for its creator, John Whyte, the **Hippodrome** in **Notting Hill** did not become the 'racing emporium' he had quite envisaged.

Before it opened in 1837, still some way west of the expanding West End, on nearly 200 acres of farmland (stretching westwards from what is now Portobello Road, towards Clarendon Road, and northwards from Ladbroke Square up to Lancaster Road), the Hippodrome had to be fenced in to spare racegoers from views of all the piggeries and brickfields in the district (though Whyte could not shut out the smell).

And when local residents, reportedly in their thousands, then tore down said fences because they blocked a public right of way to Kensal Green, Whyte had to appease them by offering free admission to the main viewing area in the centre of the course.

That spot was the summit of Notting Hill, on which now stands the church of St John's. Known in its early years as the Hippodrome Church, it was built shortly after the course closed in 1841. All told, Whyte had managed to stage just 23 days of racing in four years.

There were many John Whytes in 18th and 19th century London.

To appreciate why, imagine how London might appear today if every car were replaced by a horse, and every bus by a team of horses. Imagine all the manpower needed to service this horsepower, and then imagine all the men who, as a result, liked to think of themselves as a bit of an expert on the old 'gee-gees'.

By 1900, at the dawn of the automobile era, according to one estimate there were 300,000 working horses in London.

During the preceding 100 years, within the boundaries of modern day London, there had been at least 62 racecourses.

Most, in outlying districts such as Ealing, Hornsey and Cheam, were simply marked out across fields, as and when races were held, on only a few days a year.

Only a few, the likes of Temple Fortune, Streatham, Woolwich and Croydon, had permanent stands.

None had the pedigree of their country cousins; Ascot, where racing was first recorded in 1711, or Epsom, maybe a century earlier.

Strictly, neither of these courses fall within the boundaries of London (although Epsom does lie within Zone Six). But then neither would have survived without Londoners.

Epsom, in particular, from 1780 onwards sucked the life out of the capital once a year on the occasion of the Derby. Even Parliament shut up shop for the day, as 'the nose of every metropolitan horse, mare, mule and ass' and up to 200,000 'nobs and nobodies' (or half a million according to one observer) headed to Epsom Downs for what the French writer Hippolyte Taine described in the 1860s as 'a day of jollification'.

It began for him amongst the crowds at a sunlit Waterloo Station, and was still carrying on twelve hours later when, tired and dusty from the chalk of the Downs, and with revellers vomiting at Hyde Park Corner, his party headed off for a late night drinking session at Cremorne Gardens in Chelsea.

But it was not the fault of the motor car that only three racecourses managed to operate in London beyond 1900, or that none would stay the course beyond 1970, thereby ending a tradition that went back 800 years to those regular Friday races at Smithfield, described by William Fitzstephen.

The prime reasons for racing's retreat from the capital were both social – the sport simply encountered too much opposition from a powerful alliance of religious and political factions – and economic. Any large expanse of metropolitan land was invariably worth far more as housing than as an occasional venue for racing.

Other factors were at play too, factors that were to have a pivotal effect, not only on racing but on how most forms of sport were organised and packaged before the 19th century was out.

These changes marked the transition of 'sport' from an activity primarily focused on gambling and animals (whether hunted, baited or ridden), to one of 'games', clubs, results, rules and regulations.

'Rational recreation', as this new form of sport came to be termed, replaced brute strength and base instinct with notions of fair play and respectability. As far as most middle and upper class Londoners were concerned, the principal of amateurism lay equally at its heart.

Much of what follows in this book chronicles the consequences of this transition. But the case of horse racing allows us to appreciate yet another 19th century trend which was to have an equally profound impact. In Chapter 22 it is noted how Shrovetide football, again described in the 1170s by Fitzstephen, found itself increasingly subject to banning orders, following a succession of Police Acts designed to clamp down on public assemblies.

The game at Barnes was the first to be outlawed, in 1836. Kingston was the last, in 1867.

In Chapter 28 we will see how the 1835 Highways Act and various Turnpike Acts conspired to prevent running and walking races taking place on public roads, thereby creating a need for tracks to be laid within enclosed grounds.

Perhaps one of the most telling episodes in this transitional period came in March 1868.

Hunting a stag out of Denham, near Uxbridge, 500 or so members of the Queen's Hounds, the Prince of Wales included, embarked on a 22 mile chase through the fields of Pinner and Willesden and across Wormwood Scrubs before finally landing the stag (though not killing it), in Charles Mews, at the side of Paddington Station (now Chilworth Mews).

This, it is believed, was the last time hunters on horseback would penetrate so deeply into urban London.

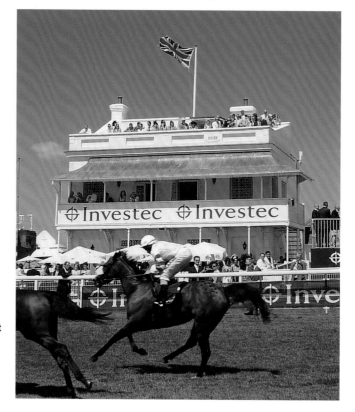

Epsom Racecourse on Derby Day in 2011 and just past the finishing line the Grade II listed Princes Stand (right) – a smaller version of the stand depicted in William Frith's famous depiction of the event in 1858 – is one of the oldest grandstands in Britain. It was built in 1879, the same year that the introduction of licensing forced most of Epsom's metropolitan competitors out of business.

For 'men of the turf' the turning point came in 1879.

Responding to mounting complaints about lawlessness and race fixing at various London racecourses, allied to concerns over the quality of horses taking part, the 1879 Racecourses Licensing Act required every course operating within a ten mile radius of Charing Cross to be licensed.

This crackdown led to the termination of racing at Kingsbury, Eltham, Bromley and Streatham (leaving in its wake a horse ramp at Norbury Station, still in use today but by two legged travellers only).

Croydon hung on until 1890.

Also symptomatic of changing trends was the opening, in 1875, of Sandown Park racecourse in Esher (13 miles from Charing Cross).

Sandown was the first 'park' racecourse in Britain, which is to say that until then only racegoers wishing to enter a stand or reserved enclosure had to pay admission. Otherwise courses remained entirely open to the public.

Sandown, by contrast, was completely fenced in (as Whyte had attempted at Notting Hill).

Now everyone paid. Almost as radically, Sandown admitted women as members.

And so, inch by inch, measure by measure, the field narrowed.

By 1871 London's population had topped three million, almost quadruple that of 1801. Yet that figure would then double to over seven million by 1914.

Modern commentators are fond of describing sport as having been 'commodified' in recent years. But we only have to look at the aerial views of two of the most centrally located sports grounds in London to see how the conditions which led inexorably to this process began early in the 19th century.

Top right is the sports ground of **Westminster School** at **Vincent Square** (featured elsewhere in more detail). Laid out in 1810, this is all that remains of a once large expanse called **Tothill Fields**.

The so-called 'March of Bricks and Mortar' (an expression coined in 1829) exerted one pressure on recreational space. As portrayed by *Punch* in December 1890 (*right*), the railways represented another.

In the end the MCC was able to fight off plans to drive a line through Lord's (and without the assistance of the bearded WG Grace). But many other clubs and sporting promoters were not so fortunate, leaving most with a simple choice.

Either sink or swim like any other business in town. Or, as was to happen in the case of horse racing, leave town altogether.

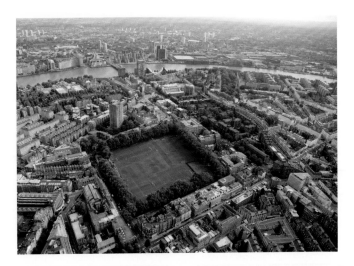

LORD'S IN DANGER. THE M. C. C. GO OUT TO MEET THE ENEMY.
["Sir EDWARD WATKIN proposes to construct a Railway passing through Lord's Cricket Ground."]

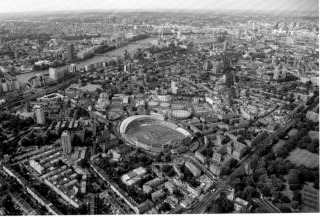

▲ When longer horse races were held at **Hurst Park**, in action from 1890-1962, these iron gates, in **Graburn Way**, were swung aside to give the horses a clear run. Laid out on the banks of the Thames on what had earlier been **Hampton Racecourse** (featured in *Nicholas Nickleby*), and before that **Molesey Hurst**, a favourite spot for cricket and prize fights, Hurst Park was one of several British racecourses to

be rendered unviable by changes to betting legislation in the early 1960s. Housing now occupies 70 of its former acres. The rest survive as a public park, with a useful set of interpretation boards explaining the site's varied sporting past.

London's other lost racecourses of the 20th century were at Alexandra Palace, in use from 1868-1970 (*see page 33*), and Northolt Park, from 1929-40 (*page 110*).

Like Vincent Square amidst the streets of Westminster, south of the river the Oval in Kennington, once a market garden set in an almost rural environment, finds itself walled in against the encroaching city (*above*). But this pressure is hardly new. The Oval opened its doors in 1845. Five years later construction started on the gasworks that have overlooked the ground ever since.

GEO. G. BUSSEY & CO.,
36 & 38,
QUEEN VICTORIA STREET,
LONDON.
Manufactory—PECKHAM, S.E.

Made in London – next time you approach Peckham Rye station from London Bridge look out for the name Bussey on a factory building on the south side of the line. Originally a gun maker, George Bussey was one of many entrepreneurs to take advantage of the voracious demand for sporting goods in Victorian and Edwardian London. This advert (*above*) dates from 1906. Other London suppliers included FH Ayres, Lillywhites, Prosser, John Jaques and Gamages, whose vast emporium on Holborn traded until 1972.

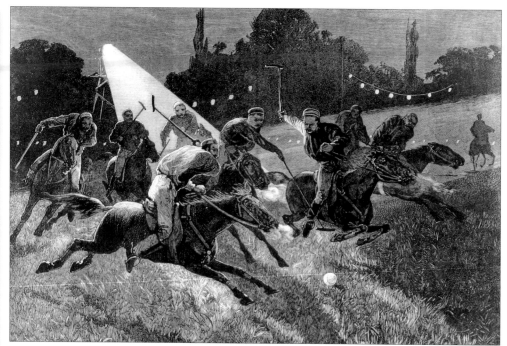

▲ So well endowed is London with historic clubs and sporting bodies that this book cannot help but be peppered with the words 'first', 'oldest' and 'earliest'.

But here comes a new and unexpected entry to the capital's already lengthy roll of honour.

For years it has been known that the world's first football match to have been played under electric light took place at Bramall Lane in Sheffield, on October 14 1878.

However, it now transpires that this was not the very first sporting event to have been floodlit.

That distinction must now belong to the once fashionable **Ranelagh Club** in **Fulham**, who on July 18 1878 staged a **floodlit polo match** at their new ground immediately east of what is now Putney Bridge station, against their friends and neighbours, the **Hurlingham Club**.

Ranelagh intended only for London's smart set to attend, as was made clear by the presence of the Prince of Wales and by entrance fees fixed at ten shillings (compared with 1s to attend that year's FA Cup Final at the Oval).

As to how it went, among only a handful of brief reports – none surprisingly found in the London press – *The Telegraphic Journal & Electrical Review* noted that the three lights used, set up by Edward Paterson of Bedford Court, Covent Garden, had allowed 'spectators to follow the course of the ball easily, and the players to see it

even more clearly than by day light'. The experiment, it noted, had been 'highly successful, and is likely to be repeated soon.'

As indeed it was. Ranelagh staged a second floodlit match, also v. Hurlingham, on July 26 1878 (with even less press coverage).

After Bramall Lane's experiment in October, followed by a spate of football and rugby matches staged under lights in late 1878, all in the north and Midlands, Ranelagh staged its third floodlit polo match on May 29 1880.

This one did get noticed, by *The Times*, by the *London Daily News* – who reported a 'singularly picturesque' scene in which 'a very numerous assemblage' had gathered under 'a complete ring of Chinese lanterns' – and by the ***Illustrated London News***, in its edition of June 5 (*above*).

After Ranelagh left Fulham in 1884 the site of these historic encounters was built over by **Ranelagh Gardens** (see page 119).

But if ever there was a candidate for a plaque, this, surely is one.

And yet as it happened, floodlit sport failed to take off in the late Victorian period. Not until the 1930s would it be revisited.

But entrepreneurs did take advantage of another advance in technology, and that was the availability of iron-framed buildings with a clear internal span.

Opened in **Islington** in 1862, the **Agricultural Hall** was London's first multi-purpose indoor arena, the Earls Court and O2 of its era.

Some promotions at 'the Aggie' were deliberately attention-seeking and provocative, such as a bull fight in 1870 and, in 1878, a six day walking race whose finish was reportedly witnessed by a crowd of 20,000. Less contentious were cycle races and wrestling bouts.

Since those early days the Grade II listed Aggie has changed little in appearance, but greatly in its tone.

Today it is known as the **Business Design Centre** (*below*).

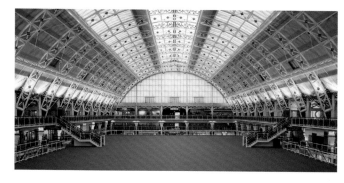

▶ **The Great Indoors** – there was almost no limit to the uses a clear span shed could be put to when it came to sport and recreation.

Easily erected, here was one of the most ubiquitous by-products of the Industrial Revolution, ideal for stations, markets and factories, but also for swimming baths, drill halls, billiard halls, gymnasiums and, as seen here in 1910, on **Delaware Road**, **Maida Vale**, for roller skating rinks.

Britain, along with France, Germany and the USA, positively brimmed with ideas of how new technology could be harnessed for sport and recreation. Cycling was one innovation (from France). Vulcanised rubber (from America) paved the way for air-filled balls (from Germany) to be used in the creation of lawn tennis (in England).

Mass production of inflatable rubber bladders transformed football's prospects too.

'Rincomania' hit London in the 1870s, also via America, thanks to a leap forward in roller skate design, combined with advances in the production of asphalt.

Meanwhile various attempts had been made to create a substitute for ice. One early offering, at the Baker Street Bazaar in 1841, consisted of hog's lard, soda salt, crystallised alum and melted sulphur.

Apparently it felt like hardened cheese and smelled even worse.

Finally a breakthrough was made in 1870, when John Gamgee, an Italian-born veterinary surgeon who in later life called Wimbledon home, took out a patent for a new type of refrigeration process.

His intention had been to freeze meat safely. But keen to capitalise on 'rincomania' in 1874 he turned his thoughts to skating. So it was that on January 7 1876, Gamgee's 'Glaciarium', the world's first operational, man-made ice rink, measuring just 24' x 16', opened on Kings Road in a canvas-lined shed.

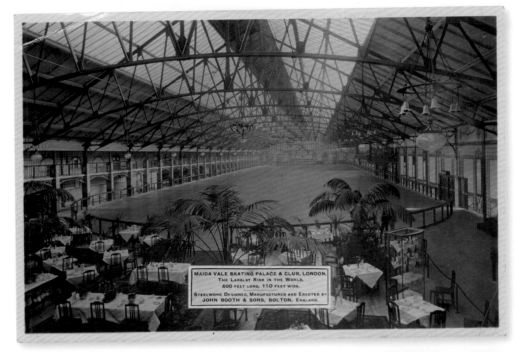

Safer than asphalt, pronounced *The Lancet*. 'Rollers are child's play after real skates,' said the *Standard*.

Within weeks Gamgee opened a larger Glaciarium, nearby at 379 King's Road, complete with Alpine decor and an orchestra gallery.

But would it survive the summer? August 9 1876 was one of the hottest days yet recorded in London. Yet to widespread acclaim, Gamgee's ice survived.

'There is a brilliant future for Glaciaria,' predicted the *Illustrated Sporting and Dramatic News*.

But not yet. The technology needed more tweaking, and in any case, London's skaters had plenty of freezing winters in the late 19th century and hardly needed artificial ice. So when 'Rincomania' struck a second time in the 1890s, once again it was largely wheelbound.

Once again it came via the USA, this time in the form of improved roller skate design, accompanied by the introduction of sprung maple flooring.

Between 1893-1914 at least 55 new roller rinks opened within the boundaries of modern London, five of which were owned by the American Roller Rink Company.

But, as would happen with two other, later American imports – tenpin bowling in the 1960s, itself a mechanised version of a game introduced to London in 1849, and skateboard parks in the 1970s – rincomania part two rapidly imploded before the market was allowed to settle.

Maida Vale, 'the largest rink in the world', lasted barely three years. By 1925 its vast interior was being used by the Ministry of Health to store paperwork.

Since then, like the Aggie, it has changed little in form, at least on the outside (*see page 295*). But its interior is now filled by an almost self-contained building created in 1934. Perhaps its output will be familiar, for it became, and remains the renowned **Maida Vale Studios** of the **BBC**.

Opened in 1896, the Princes Club ice rink on Trevor Place, Knightsbridge, was from 1904–07 the only ice rink in Britain. Heavily subsidised by the Duchess of Bedford, it staged the skating events at the 1908 Olympics before closing in 1917. There was then a gap until eleven London rinks opened between 1927–36. Only one from that era survives; Queen's, on Queensway, dating from 1930, but five more have been built since. As of 2014, however, none were offering curling, as seen above.

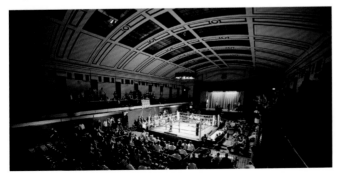

Boxing at Bethnal Green in 2011 (*left*). Opened in 1929 (*see page 178*), York Hall was one of many swimming baths boarded over during the winter in order to stage boxing, dances and other community events. Note how more streamlined and therefore acoustically superior was this new generation of clear span building. For local councils, multi-functionality was all.

Instantly recognisable around the globe is the 'London Trebles' dartboard, also known as the 'Clock'. Adopted as the standard in 1924, ironically its popularity led to demise of the traditional London Fives board, only a few of which remain in use today in east London pubs. Having emerged in around 1900 as a pub game, top level darts at Alexandra Palace and The O2 Arena can nowadays draw crowds of up to 10,000 spectators.

▼ From the collection of the **London Transport Museum**, the story so far, as summed up by one of London Underground's leading poster artists of the inter war period, **Richard T Cooper**.

From boar hunting at Bermondsey (at the time of King Canute's death), to air racing at Croydon (in the year that a national Keep Fit campaign was launched from a hotel in Victoria), here unfolds a pageant of delights that must have led many a commuter and schoolboy to miss his train, lost in a reverie of jousts and jollity, blood and thunder.

Of course it does not tell the whole story. Golf gets two frames, bowls gets none. Absent too is quoits, that once great favourite of London dockers, while only in the latter frames do we see women actually participating, one on a golf course, another at Wimbledon.

But as a comic strip rendition of sporting history, Cooper's general thrust is bang on target, as he brings his cavalcade of thrills right up to the minute with those marvels of the modern age; the electric hare, the methanol-powered dirt bike and the refrigerated ice pad.

Eighty years on, the poster retains its narrative impact.

As noted in later chapters, there are still archers wielding their longbows in the vicinity of Finsbury Fields, still golfers playing under the banner of Blackheath.

But as for those modern marvels of 1935, ice hockey, imported from north America, has still to establish itself fully in London as a major spectator sport after numerous bright starts and relaunches.

Greyhound racing, introduced from the USA in 1926, is now down to three London tracks.

In 1935 there were 22.

But most sobering of all, speedway racing, which roared its way onto the London scene in 1928, from Australia via Essex, and once threatened to topple football as the people's favourite, has been neither seen nor heard in the capital since 2005.

Sporting heritage in London is all the richer for the ephemera that, like this poster, has been gathered in various museums and collections, public and private. But the poster itself offers a warning of how sports themselves can be ephemeral.

For while we all know that 'pell mell' is just a memory, and that warmer winters have put paid to skating on the frozen Serpentine, who now is aware that skittles, played by at least 60 clubs in the London area in the early 20th century, is down to only one functioning alley in the capital, in a pub in Hampstead (*see page 338*).

London's boundaries since 1965 showing the current 32 boroughs, the City of London and the former county boundaries

Note:
H&F: Hammersmith & Fulham
K&C: Kensington & Chelsea
—— boundary of **London County Council** (1889-1965)

▲ Before moving on, in order to understand the broader context of the coming chapters it is vital to establish what we mean at any given time in history by **'London'**.

In William Fitzstephen's time, London meant solely the **City of London**, often referred to nowadays as the 'Square Mile'.

To its west, Westminster remained a separate entity.

Beyond both, a scattering of villages and towns fell within the jurisdiction of four counties: **Middlesex** and **Essex**, **Surrey** and **Kent**.

It is no exaggeration to say that probably the only Londoners today who still care about these old county boundaries, other than historians, are those with a close interest in sport.

Bowls, cricket, rugby, hockey, boxing, lawn tennis, grass roots football and several other sports are still, despite all the changes to local government in the capital over the last 160 years, proudly organised along county lines, and rivalries between them remain strong.

In an administrative sense, modern London traces its roots to the Metropolis Management Act of 1855. Excluding the City, this gave powers to a network of 41 **vestries** (the equivalent of civic parishes) and **district boards**. The Act also created the **Metropolitan Board of Works** (MBW) to deal with wider services such as roads, sewerage, the fire brigade, and, in the context of this book, parks and open spaces.

In 1889 the MBW was replaced by an elected body, the **London County Council** (LCC).

Its jurisdiction extended to the area denoted by the red line above, and was broadened to cover education, planning and housing.

It also took on the provision of sports facilities in certain parks, including the construction of open air swimming pools.

In 1899 the old vestries within the LCC, but still not the City itself, were re-organised into 28 new **Metropolitan Boroughs**.

Each did what they could afford and believed in, for example in providing libraries, cemeteries, swimming baths and wash-houses.

Beyond the LCC, extending into what became known as Greater, or Outer London, support for sport and recreation was echoed, to a greater and lesser extent by the **county councils**, complemented by a mixed array of **urban district, municipal** and even **county borough councils**.

These anomalies were then swept away in 1965 when, under the terms of the London Government Act of 1963, the 28 Metropolitan Boroughs were reorganised to create twelve new **London Boroughs** (such as Camden and Greenwich). These were supplemented by a further 20 outer London Boroughs (such as Brent and Bromley), each of which had also been created by merging smaller existing entities.

At the same time the LCC was superceded by the **Greater London Council** (GLC), which in turn was abolished in 1986 and replaced by the **Greater London Authority** (GLA). This has fewer powers than either the GLC or LCC, having for example devolved its responsibilities for sport and leisure to the borough councils.

Note that only one borough, Richmond upon Thames, straddles both sides of the river, and that parts of Barnet were originally not in Middlesex but in Hertfordshire.

When heritage calls this book will stray beyond the boundaries of the 32 boroughs (as indeed does the London Underground), to the likes of Eton and Epping, Copped Hall and Kempton.

Otherwise, this is our area of study; a city of over eight million people, covering 611 square miles, and, *never* forget, four counties.

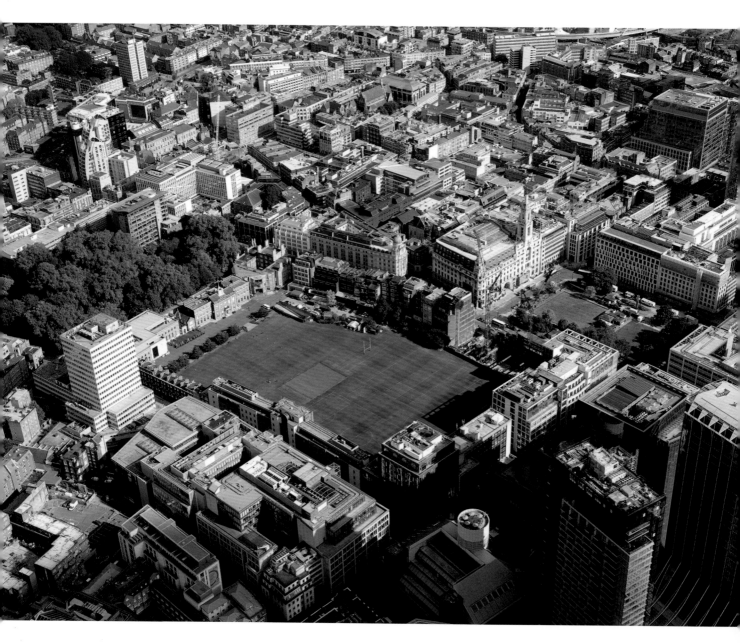

London's oldest enclosed sports ground is the Artillery Garden, first occupied by the Honourable Artillery Company in 1641. This, together with the adjoining Finsbury Square (centre right), laid out in the 18th century and with a public bowling green added in the 1960s, and nearby Finsbury Circus, is a remnant of Finsbury Fields and Moorfields, London's earliest sportscapes.

SPORTSCAPES

Every Londoner has his or her own mental map of the capital, fashioned from years of getting around, accumulated emotional baggage always in tow.

On this mental map are traced familiar routes and cherished landmarks, interspersed with buildings and places that, for better or worse, are loaded with personal meaning.

This section of the book seeks to show that for individuals with an interest in physical culture, the 'sportscapes' of the capital form a map layer of their own, both in the mind and in a very practical sense.

In other words, that to be engaged with sport is in itself to be engaged with the city.

Mostly when we go to the theatre or cinema, to a museum or gallery, we sample prepared works that could be staged, and probably will be staged in any equivalent space, in any town or city. A sporting encounter, on the other hand, is a one-off happening that in most instances is place specific.

Travelling across London to attend such a one-off event, experiencing the sportscape at first hand, and possibly also interacting with people from other parts of London, invests the occasion with an immediacy rare in other areas of cultural life. Be it Surrey v. Middlesex, Arsenal v. Chelsea or Blackheath v. Richmond, knowing that such events have been staged for a century or more adds further to the experience.

'Sportscape' is a relatively recent coinage, introduced by Professor John Bale in his seminal work of 1989, *Sports Geography*, the first book of its kind in Britain to address the study of sport and place. Bale defined a sportscape as 'a mono-functional site given over only to sport'.

Other academics have since picked up on Bale's lead, each adding their own interpretation.

To an extent, *Played in Britain* is a by-product of this discourse.

As is the conclusion that if considered in isolation, individual sportscapes, be they stadiums, athletics tracks, bowling greens or whatever, can tell us only so much. The same is true if placing sportscapes within the context only of one sport (which, understandably in view of most fans' passions, is typically how their stories are told).

For a deeper understanding, one that attempts to locate a sportscape within the wider urban and historical context, experience has shown that taking a step back and looking at a larger area, or at clusters of sportscapes, offers a more useful set of insights.

With this in mind, Chapters 3-8 map selected parts of the capital, to show both how sportscapes shape the city, and how for those whose mental maps are informed by sport, London is a web of territories and boundaries of which others might be quite oblivious.

Had space permitted there might easily have been double the number of areas and themes covered. But as the section's opening chapter sets out, on the actual map of London, space is the most precious commodity of all.

London's oldest sportscapes

This is a selected list of historic sportscapes still in use for sport, excluding parks originating in the public sector, by date of earliest reference to organised sport (excluding hunting and jousting) ★ denotes enclosed ground

1373	Blackheath *wrestling, golf, cricket, rugby, hockey*
1659	Tothill Fields *golf, bowls, stoolball, later Vincent Square★ (1810-)*
1666	Richmond Green *cricket, rugby*
1707	Duppas Hill, Croydon *cricket, football*
1720	HAC Artillery Garden★ *cricket, rugby, football, archery*
1723	Moulsey Hurst/later Hurst Park *cricket, boxing, horse racing*
1730	Mitcham Green *cricket (but claim also for 1685)*
1735	Woodford Green *cricket*
1737	Kew Green *cricket*
c.1775	Sun Inn, Barnes *bowling green (but claim also for 1725)★*
1814	Lord's★ *cricket, athletics, real tennis*
1822	Chislehurst Common *cricket*
1833	Twickenham Green *cricket*
1844	Spotted Dog ground★ *cricket, football*
1845	The Oval★ *cricket, football*
1848	Outdoor Gymnasium, Primrose Hill
1857	Crystal Palace Park★ *cricket, athletics, football, cycling, rugby*
1858	Gander Lane, Sutton★ *cricket*
1863	Bushy Park Teddington & Hampton Wick Royal CCs *cricket*
	Beddington Park *cricket*
1865	Old Deer Park★ *cricket, rugby, archery, hockey, bowls*
	Wimbledon Common: *golf*
1866	Foxgrove Road, Beckenham★ *cricket, tennis, hockey*
1869	Hurlingham Club *pigeon shooting, polo, croquet, cricket, tennis*
1870	Worple Road★ *tennis (former AELTC), now school sports ground*
1875	Alexandra Park *cycling, horse racing, cricket, football, swimming*
1876	Rectory Field, Blackheath★ *cricket, rugby, tennis*
1877	Stamford Bridge★ *athletics, football, greyhound racing, speedway*
	Lymington Road★ Hampstead CC *cricket, hockey, tennis*
1885	Burbage Road, Dulwich★ *cricket, croquet, tennis, football*
1886	Richmond Athletic Ground★ *athletics, cricket, rugby*
	Epping Forest *golf*
1888	Paddington Recreation Ground *athletics, cycling, cricket, bowls*
1891	North London Bowling Club, Fitzroy Park★ *bowling green*
	Mitcham Common *golf*
	Herne Hill★ *cycling, athletics, rugby*
1893	Stanmore Golf Club
1894	Wembley Park★ *cricket, athletics, golf, football*

Chapter Two

Open space

'All persons who value open spaces are earnestly invited to help!' urged the Fortune Green Preservation Society in West Hampstead in 1893. Three years later their pleas were met when the Vestry of Hampstead, the LCC, the Worshipful Companies of Skinners and Goldsmiths and sundry other benefactors raised the £7,000 needed to purchase the two and a quarter acre green, thereby preserving it for public use. During the legal proceedings, thirteen elderly residents testified that the green had been used since at least the 1830s for rounders, quoits, trap ball and cricket. In 2013 the further support of the Skinners, Goldsmiths and ten other livery companies was acknowledged on the shield above, marking Fortune Green's newfound status as a Queen Elizabeth II Field. Over 75 sites in London have been similarly protected 'in perpetuity' by Fields in Trust, a charity set up in 1925, originally as the National Playing Fields Association.

When asked what should be the foundation stone of the new towns being planned in the aftermath of the Second World War, the architect and planner Don Ritson did not hesitate. He advised, 'Start with the park!'

And so shall we, if not specifically in the park, at least in the wider realm of open space.

Virtually every sport featured in this book has, at some point in its evolution, made the transition from open space to a form of delineated sportscape: from a rough field to a level pitch marked out with lines, ropes or flags; from a common or a village green to a ground surrounded by railings, fences or walls; from the open countryside to a racecourse or golf course; from a road to a track; even from a street or a churchyard to a standardised court.

Equally, some of our greatest clubs, our finest athletes and players, took their first steps to fame on a local park or 'rec'.

But there is a further reason to 'start with the park', and that is because one of the most consistent strands in the story of London has been the determination of its citizens to fight for, and establish laws to protect open space.

This resolve has defined the city as we know it today.

Modern London, according to a report commissioned in 2013 by the City of London Corporation, is the world's third greenest city, behind Singapore and Sydney.

Of its 611 square miles, public green space takes up 38.4 per cent, amounting to 35,000 acres.

From other sources we find that this space is made up of 122 heaths, commons and greens, around 600 public parks – 'the lungs of London' as William Pitt the Elder was said to have called them – 1,500 playing fields, 125 recreation grounds, plus garden squares, churchyards, cemeteries and cemeteries now used as parks.

The varied topographical characteristics and diversity, or rather biodiversity, of London's open spaces shouts out from their names. Consider this roster, or even better, picture it: Mitcham Common, Hampstead Heath, Highgate Wood, Epping Forest, Duppas Hill, Kew Green, Ladywell Fields, Hackney Marsh, Hackney Downs, Wormwood Scrubs, Wanstead Flats and, just outside London, Moulsey Hurst.

Each a subtly different landscape. Each a sportscape, in one form or another.

Not of course that this is their sole function. Far from it. For it must be acknowledged that for every lobbyist keen to push the case for sport, another argues for more wildlife habitats, another is bent on preserving the beauty of a traditional park, and yet another sees open space merely as lettable space, for hire.

And while one man looks with pride on pristine pitches laid out for sport, another, to use a phrase from a planning consultant in 2004, sees only a 'deadened mono-cultural prairie,' a large expanse 'of over-nitrated perennial rye-grass...'

Londoners have been arguing the toss for quite a while.

In 1301 the Prioress of Clerkenwell was powerless as men from the City, on foot and on horseback, trampled her crops and broke down hedges in order to assert what they deemed was their right to stage wrestling matches.

They went further in 1405 and set fire to gates, posts and hedges.

Ten years later, access to 'the great marsh that laps up against the northern walls,' as described by William Fitzstephen (page 14), was made easier by the construction of a new gate, Moor Gate, and of causeways leading to the villages of Hoxton, Islington and Shoreditch.

Gradually, as the marsh was drained, to the east Spital Fields, to the north Finsbury Fields, and to the south Moorfields came into their own, ideal for country walks and crucially, for archery practice too (see Chapter 19).

So when, as retold by John Stow in 1598 (dressing up the original account published half a century earlier in Hall's Chronicles), villagers started enclosing Moorfields with ditches and hedges, just as the Prioress had done, and erecting summer houses – 'with towers, turrets, and chimney-tops... for show and pleasure, betraying the vanity of men's minds' – further conflict seemed inevitable.

Some archers reportedly had their bows broken. Some were arrested for straying off the road.

Not for the first time, and not for the last, in 1514 Londoners rallied. They were called to action by 'a tumbler in a fool's coat' crying out across the city, 'Shovels and spades! Shovel and spades!'

Opened in 1892, Brockwell Park is one of 600 London parks offering a range of sports and recreations, most famously its Grade II listed lido, opened in 1937 (page 161), and most recently its cycle track, home of the Brixton BMX Club, formed in 1981. 'As a general rule,' noted Francis Bacon in 1623, 'exercise in the open air is better than under cover'.

So diligently did the assembled posse set about its task that before anyone could intervene, 'all the hedges about the city were cast down, and the ditches filled up'.

The incursions would continue, nevertheless, requiring James I to issue a decree demanding that Finsbury Fields remain clear of obstacles to allow free reign to the archers. Charles I had to repeat the order, even though archers were by now outmoded in battle.

Meanwhile next to Moorgate, a part of Moorfields extending to around thirteen acres, having been bequeathed to the City in c.1606 by two sisters, Mary and Catherine Fiennes, took on a different role.

It was landscaped to form the capital's first public park.

Not that it was called as such. One map labelled it as 'Lower Walkes'. But 'Moorfields' it remained in popular usage, even though it was now thoroughly tamed and neatly parcelled into four sections by tree-lined paths and railings. Samuel Pepys and his wife walked there often, as did distinguished local residents such as the Duke of Norfolk and the Spanish Ambassador.

Indeed this being before the West End existed, the park became a focal point of London life, high and low, combining elements of present day Leicester Square, Covent Garden and Speakers' Corner, with the odd hanging or whipping of a thief thrown in.

Other attractions included wrestling, jugglers, Punch and Judy, men with telescopes for hire and stalls selling gingerbread and secondhand books.

After the Great Fire of 1666, when Moorfields acted as a refuge, the completion along its south side of Bethlem Hospital, or Bedlam, in 1676, brought in even greater numbers of visitors; 'holiday ramblers' as William Cowper described them, paying twopence to gawp at the 'tragicomical' antics of its inmates.

Another open space to have been protected from developers was Lincoln's Inn Fields, used for the 'common walks and disports' of students, clerks and apprentices. When, in c.1376, one Roger Leget attempted to scare them off by laying iron traps he was sent to Fleet Prison and fined.

Numerous attempts to build on the fields followed, all challenged by the Society of Lincoln's Inn, so that although by the 1650s houses had been erected on all sides, the fields in the centre survived.

But only for the use of residents, as was also the case at Bloomsbury Square and St James's Square, both developed in the 1660s.

Further west lay the royal parks, Hyde Park and St James's Park. Both were former hunting grounds to which the public had been allowed access, with caveats, in the early 17th century.

These developments were followed after the Restoration by a new form of commercialised open space, the pleasure garden.

New Spring Garden, opened on the south bank of the Thames in 1661 and later renamed Vauxhall Gardens, was the largest and most fashionable. But as many as 60 smaller versions opened around the city's perimeter, especially in the Islington area, where spas, such as Sadler's Wells, tea gardens and ale houses offered all manner of outdoor diversions for stressed out or merely idle Londoners.

Most offered bowls, skittles, or trap ball, or from the late 18th century, the newly popular games of fives (at Copenhagen House, near what is now King's Cross), rackets (at the Belvidere, Pentonville) and cricket, at White Conduit House, Islington.

But for most ordinary Londoners these resorts were still too far off, and seemed more so after 1815 when the fields north of the New Road (later Marylebone Road) were swallowed up by the newest royal park, Regent's Park, where until the mid 19th century the only sport allowed was archery, and even then only for members of the elite Toxophilite Society.

A correspondent in *Bell's Life* on March 26 1826 pulled no punches.

'The daily increasing size of the City of London and its dependencies, requires that some new means of exercise should be afforded to those persons who live in the central divisions of it.

'All the fields and wastegrounds – west, north and south – which used to be crowded every afternoon with cricket and football players, even so recently as 20 years ago, are now built over, covered with streets and squares; the Mary-la-bonne fields, which furnished means of recreation to thousands, are shut up under the title of the »

▲ **Finsbury Circus** – London's first public park, an island of green and all that survives of Lower Moorfields, the southernmost stretch of William Fitzstephen's 'great marsh'.

Moorgate, the main exit route to the marsh, stood in the lower right hand corner. From 1676-1815 the area formed by the two quadrants on the right was occupied by Bethlem Hospital, or Bedlam.

Finsbury Circus started to take its current form in 1817, after the hospital was demolished, the park being reduced and encircled by a housing development planned by George Dance the Younger.

Like most London squares the gardens in the centre were fenced off for residents only, until in 1900 the City of London Corporation acquired them for public benefit.

Consequently the gardens became known as **Morton's Park**, named after **Alpheus Morton**, the Liberal alderman responsible for leading the campaign (against the wishes of certain residents, who, according to *The Times*, feared the Circus would become a 'noisy place of public resort' and perhaps 'too attractive for a smoking clerk in the middle of the day').

Each year Morton made a point of presenting to the Mayor of London the first crop of mulberries from the gardens. He later played a lead role in prompting the City to take an interest in Crystal Palace Park (*see Chapter 4*), of which he became a trustee in 1918.

Morton died in 1923, just a few months before a group of residents met to form the **City of London Bowling Club**. Their green, opened in 1926, can just be seen amidst the trees in the centre.

Not be confused with the later green at Finsbury Square (*page 191*), the Finsbury Circus green became the home green of the London Parks Bowling Association.

Much cherished too, set as it was within a Grade II listed park – at five acres the largest open space in the Square Mile – with an adjoining bandstand and a pre-fab pavilion erected for the club in 1967.

Really there was nothing like it, this *Circus Minimus* in the midst of a dense, bustling city.

And then in 2010 the shovels and spades returned, in the form of contractors working on the Crossrail development. The bowls club have been promised they will be able to return to the Circus in around 2017-18.

Whether there will be any mulberries remains to be seen.

» Regent's Park; and a man who lives at the Mechanics' Institute in Southampton buildings would have two miles to walk, in the readiest direction, before he could put his foot upon turfed ground...

'The result is that a mechanic, when his work is done, adjourns to some public-house to sit over a game at dominoes, or lose his day's wages in a smoky skittle-shed; when, if he had the opportunity of meeting his shopmates and comrades in any open, active and inspiring diversion, the sport would be amusement enough...'

London was not alone in suffering from this want. Hence in 1833 Parliament formed a Select Committee on Public Walks, one of whose early recommendations was for a new park in east London.

But because local government in the capital was split between a scattering of vestries, with no overall authority, it was left to government and to the crown to provide the next wave of parks.

Victoria Park was first, in 1845, followed by Battersea Park in 1858.

Both schemes, initially, were royal parks until taken under the wing of the Metropolitan Board of Works. Both parks reflected the middle class aspirations of their promoters. That is, the accent was on 'walks' rather than 'sports'.

Not that that stopped the

Another of London's QE II Fields, on Campdale Road, Tufnell Park.

public. As soon as Victoria Park opened, its boating lake was colonised by thousands of small boys swimming there naked every morning, while Battersea Park was similarly swamped by cricketers.

Thereon the story of London's open spaces was shaped by a succession of Acts aimed at providing a balance between the voracity of developers seeking to build houses on every available estate, farm or market garden, and the needs of the people who came to live in them.

Before even a conservation movement started for buildings, in 1865 the Commons Preservation Society formed (since renamed the Open Spaces Society). Its first victory, the Metropolitan Commons Act of 1866 allowed vestries to allocate funds for the preservation of commons, thereby helping to save huge tracts such as Wimbledon Common, Blackheath and Hampstead Heath (all in 1871) and Wormwood Scrubs (1879).

Other enabling Acts included the 1847 Towns Improvement Act, the 1859 Recreation Grounds Act and the 1875 Public Health Act.

The formation of the London County Council in 1889, taking over from the Metropolitan Board of Works, also, at last, gave London a democratically accountable, centralised form of local government such as was the norm in every other British city.

The result was that while municipal parks in Manchester, Liverpool and the north east all had football pitches and bowling greens by popular demand from the 1870s onwards, London parks caught up only in the 1890s.

But it was not politicians alone who saved London's open spaces.

As in earlier centuries, legions of activists formed to protect open spaces from enclosure. Over two days in 1876 estimated crowds of 10,000 swarmed over Plumstead Common, tearing down fences, setting fire to furze and battling with the police. In Honor Oak in 1896, riots broke out in defence of One Tree Hill. On one occasion, reported crowds of over 15,000 gathered to assert public rights to the land. Ironically, their enemy was not a developer but a golf club.

In that instance, and in dozens of others, the dispute ended with the LCC stepping in to buy the land, backed by the boroughs and

public spirited benefactors.

When the London Playing Fields Society formed in 1890, the first organisation of its kind in the country, it too was as dependent on favours as it was on legislation.

An appeal in The Times yielded around 3,000 used tennis balls, distributed among schools in the East End. The MCC donated a horse to help maintain a west London playing field. Thomas Wall, founder of the ice cream company, loaned funds for fields on Whitchurch Lane, Edgware.

In Merton Park, John Innes bequeathed a recreation ground alongside a park bearing his name.

Philanthropy continued after the First World War. In West Barnes and Morden Sir Joseph Hood endowed playing fields and a rec.

Other funds came from the City Parochial Charities, the Carnegie Trust UK and the Metropolitan Public Gardens Association.

Without such help the National Playing Fields Association, formed in London in 1925, could not have made any headway. At the same time, the LCC and various County and Urban District Councils themselves invested heavily in open space, while in 1938 London became the first city to agree the principle of a Green Belt.

Since the war, further checks to the planning system have resulted in added layers of protection.

Alexandra Park, for example, has four such layers; being protected by an Act of Parliament, being designated as Metropolitan Open Land, forming part of a Conservation Area and being listed Grade II as an historic park.

John Ruskin is famously quoted as writing, 'The measure of a city's greatness is to be found in the quality of its public spaces, its parks and squares.' But a measure of Britain's current economic woes are that most local parks face funding cuts of up to 60 per cent.

Meanwhile nowhere in London meets the target of six acres of open space per 1,000 residents set by the NPFA in 1934.

That total is in the process of being reconsidered. But whatever the adjustment, with London's population predicted to reach 10 million by 2031 – more than six times what is was in 1831 – it will need all of Londoners' grit, and ingenuity, to keep London as green as we know and enjoy it today.

▶ Whether viewed from the air or on the ground, there appear to be few hints as to the richness of Blackheath's sporting heritage. Like the few remaining patches of gorse clinging onto this exposed plateau of some 275 acres, it is as if its sporting echoes have been swept up by the breeze, or else drowned out by the traffic on Shooters Hill Road (the A2, seen angling from the lower left up into the middle distance, where lies Charlton).

Nowadays Blackheath is best known in sporting circles as one of the starting points for the London Marathon. The other is in Greenwich Park, whose wooded edges can be seen on the left.

And yet Blackheath is a reminder that for many a prominent sports club, their stories also 'start with the park'.

As has been noted, many an open space in London survives because public pressure has led to it being protected by legislation.

Blackheath itself came under the Metropolitan Commons Act in 1871. However until then, as Neil Rhind has chronicled (see Links), the Heath – classified as a 'manorial waste' rather than as a common – had escaped cultivation or development owing to the poor quality of its soil and the fact that large tracts had been dug for deposits of gravel, chalk and sand, which in turn resulted in a landscape pockmarked with pits and plagued by subsidence.

Its high water table had also resulted in few trees taking root.

Ideal then for windmills and fairs, for mass gatherings of militia and rabble-rousers, and also for sport.

The earliest reference to sporting activity on the Heath is a wrestling match in 1373, which resulted in the death of John Northwode, a London mercer.

But Blackheath's most celebrated sporting link concerns golf.

According to early histories of the Royal Blackheath Golf Club, Scots forming part of James I's entourage brought 'goff' to the Heath in 1608, whilst staying at Greenwich Palace.

Even if no firm evidence for this account can be found, it is for certain that at some point during the mid 18th century a Blackheath golfing society was formed (see page 215), and a five hole course laid out, extended to seven holes in 1843. Until 1864 this was the only golf course in England.

Blackheath was in addition the scene of pedestrian challenges, the most celebrated of which was that of 51 year old George Wilson, dubbed the 'Blackheath Pedestrian' (although he was actually a Geordie). In 1815 Wilson's attempt to walk 1,000 miles in 20 days drew huge crowds and earned a daily update in *The Times* before the nervous authorities called a halt with just four days remaining.

Cricket was the next sport to establish itself. Three clubs stood out: Blackheath Dartmouth, formed by gentlemen in c.1829, took their name from Dartmouth Row, a new terrace built on the Heath's west side; Blackheath Paragon in c.1840 (The Paragon is a Georgian crescent on the east side), and Blackheath Morden, formed in 1863, also on the east side.

Paragon and Morden merged in 1885 to form **Blackheath CC**,

and a year later left the Heath for **Rectory Field**, an enclosed ground in Charlton, where they shared facilities with another club to have formed on the Heath, but also to have outgrown it.

Set up in 1862 by old boys from Blackheath Proprietary School, one of several schools established on the Heath's perimeter for the area's burgeoning middle class population, this was **Blackheath Football Club**, a club that went on to play a key role in the emergence of rugby as a distinct code (*see Chapter 23*). All told at least 22 rugby clubs are recorded as having played on Blackheath.

Of further note is the emergence of hockey. An early Gaelic form of the game, shinty, also brought to London by Scots, was played on Blackheath as early as the 1840s.

This led in 1861 to the formation of the **Blackheath Hockey Club**.

So to recap, here on Blackheath came into existence the oldest golf club in England, the oldest 'open' rugby union club (as opposed to one with closed membership), and the oldest hockey club in the world.

One of London's oldest athletics club was also based there for a while too, although **Blackheath Harriers** (now Blackheath & Bromley) started out in 1869 as the Peckham Hare and Hounds and moved to Blackheath only in 1878.

This was around the same time that a Riding Ring (Blackheath's version of Hyde Park's Rotten Row) was laid out on one of the eastern fields (at the top of the aerial view).

Last used in around 1912, no trace of the Ring exists.

The same too of the clubs.

Blackheath FC, its support growing to the point where it needed a ground of its own, moved on in 1877 (after an unruly crowd of 5,000 turned out for the visit of Richmond). In 1895 the hockey club moved to Kidbrooke, and

in 1923 the golf club relocated to Eltham Lodge (golf balls and members of the public having become an uncomfortable mix).

Thereafter amateur football, cricket and rugby continued, and indeed gained extra ground after World War Two when most of the remaining gravel pits were infilled using rubble from bomb sites (as occurred also at Hackney Marsh).

At its peak, the LCC was able to offer 22 cricket wickets on various parts of the Heath.

Today, there is not one. Indeed apart from bowls and tennis by the walls of Greenwich Park, and children's football on Saturdays, little organised sport takes place at all, local clubs preferring to hire pitches at sites with more facilities.

So what may seekers of heritage find at Blackheath?

Running from left to right in the foreground of the aerial view is **Goffers Road**, named as such in 1933. Above this, the largest field on the left is West Kent Field, named after **West Kent Wanderers Cricket Club**, formed in 1859 by the landlord of the Hare and Billet and active until the 1970s.

A corner of the **Hare and Billet** itself can just be seen on the lower right edge of the photograph, facing the pond, while above it, on **Montpelier Row** (top right), is the **Princess of Wales**. It was in this pub that Blackheath FC and the hockey club used to change. Memorabilia and images from those years can be seen on its walls and in a display cabinet (*page 261*).

Otherwise, it is to history and guide books that we must turn to find out more. That is how it is with public sportscapes. Most teams leave few records. Most traces are lost to the landscape; leaving, it has to be said, the most precious commodity of all.

The open space.

And, of course, the possibility of games yet to come.

Cricket on Blackheath in c.1905 (*left*), with All Saints' Church and the Georgian terraces of Montpelier Row in the background (visible also on the right of the aerial view above). This same part of the Heath was used by Blackheath Hockey Club from 1861-95. Each sports club based itself at one of the pubs, creating a lively scene on Saturdays and tremendous local rivalries.

▶ There is currently a great debate as to how public parks should be managed, especially whether or not they should be hired out for major events, concerts or even, in the case of **Hyde Park**, for triathlons that can draw six figure crowds.

This debate is hardly new.

Viewed from the west in 2006, with **Kensington Gardens** and the **Round Pond** nearest the camera, Hyde Park is, at 350 acres, the largest reminder we have in London that a 'park' was originally land that was enclosed for sport; sport, that is, in the sense of hunting, fishing or shooting.

In the case of Hyde Park it was enclosed by Henry VIII for deer hunting, in 1536.

But although hunting continued until 1768, Hyde Park has staged a succession of 'sports', in the modern sense, since the 17th century.

One was coach racing – the Grand Prix of its time – reserved for the rich and reckless and staged on a course called The Ring. One such race in 1654 nearly did for Oliver Cromwell when he fell out of his coach at high speed.

In 1660 Samuel Pepys saw two footmen race three laps of the park, possibly along a route similar to that followed by modern day triathletes.

As detailed in Chapter 16, the **Serpentine** lake (in the top right of the aerial view), created in the 1730s, was where some of Britain's earliest organised swimming races were staged, and has been the base of London's oldest swimming club, the **Serpentine SC**, since 1864.

Other sporting activity today includes bowls (*page 4*), tennis and horse riding on **Rotten Row**, itself laid out in the 1690s. The **Hyde Park Stables** on Bathurst Mews, near Lancaster Gate, occupy premises opened in 1835.

In 1930 Hyde Park was the focus of a bitter debate on park usage when George Lansbury turned part of the Serpentine into a lido, and almost as controversially, sanctioned mixed bathing.

Lansbury was however carrying on a process of democratisation of public space that began in the mid 19th century with the emergence of Victoria Park, in 1845 (*see page 82*), the staging of the Great Exhibition in Hyde Park in 1851, and the creation a few years later of **Battersea Park** (*above right*).

Known formerly as Battersea Fields and notorious as a place for

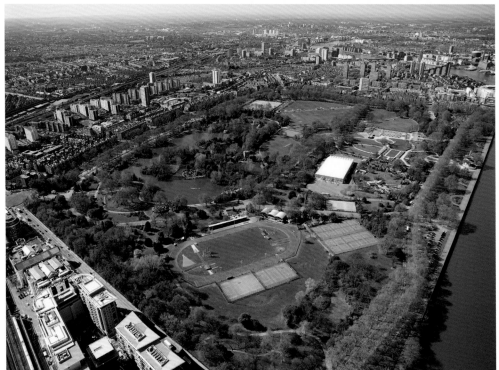

pigeon shooting and carousing, the park opened in 1858 and acted as a magnet to the growing band of young male office workers eager to play the games they had learnt at school. Cricket came first, with staff from the Prudential playing their first match in the park in 1860. Then on January 9 1864 the cricket ground, where the athletics track now lies, staged what is said to have been only the second match

played under the newly drafted laws of the Football Association. The park was a cradle for the emerging code of rugby too, and in 1891 became the first park under the LCC's control to provide a bowling green and tennis courts. Also in the 1890s the park became a focal point for cycling; not for racing but as a place where thousands of Londoners, particularly middle class women, learned to ride.

In the 1920s a cinder athletics track was laid, since renamed the **Millennium Arena** and now home to **Belgrave Harriers**, who formed across the river in Belgravia in 1887 (*page 311*).

Both Hyde Park and Battersea Park are on English Heritage's Register of Parks and Gardens of Special Historic Interest; Hyde Park at Grade 1, Battersea Park at Grade II*.

▲ Sportscapes can be waterscapes too. The **Welsh Harp** reservoir, seen here from the east, with the **M1** in the foreground and **Wembley Stadium** beyond, was created in the 1830s as a feeder for the Regent's Canal. Today, under the control of the Canal and River Trust (formerly British Waterways) its official title is **Brent Reservoir**.

Its nickname derives not from from the reservoir's shape but from a large pub, the Old Welsh Harp, that had stood on the West Hendon side since 1736. Rebuilt after the reservoir's completion it was leased by a new and ambitious tenant, William Warner, in c.1858.

A veteran of the Crimean War, it was Warner who turned the Welsh Harp into one of London's most popular pleasure resorts.

From 1868-77 he staged horse racing on the fields to the north, known as **Kingsbury Racecourse**. The first trials of a mechanical hare, a forerunner of greyhound racing, were conducted on this course in 1876 (page 322). There was also a sports ground, rented from 1900-06 by **London Welsh** rugby club.

Other attractions were a 500 seat music hall, boxing matches, cycle races, ballooning, quoits, archery, swimming, skating, pigeon shooting, a rifle range, bowling, billiards, skittles and above all, angling (said to have attracted all classes, from cowmen to bishops).

So popular were these activities and the grounds generally that on Bank Holidays crowds of over 25,000 were reported. There was even a Welsh Harp railway halt built in 1870 to bring in day trippers.

As a popular ditty of the day rejoiced 'There's no mistake about it, it's the jolliest place that's out'.

But as the area became increasingly urbanised and visitor numbers declined, in 1903 the station closed. A further blight was the completion of the North Circular alongside the reservoir, in 1927.

Welsh Harp continued to host water sports nevertheless. Between the wars it staged motor boat racing, followed in 1960 by the Women's European Rowing Championships, and in 1979 by the final rounds of the first World Water Ski Racing Championships.

Activity on the water is nowadays more sedate, limited to sailing, canoeing and windsurfing, largely because the reservoir and its surrounds have been designated a Site of Special Scientific Interest.

Two of the resident clubs, formed shortly after the Second World War by the staff associations of British Transport and Smiths Industries (based in nearby Cricklewood), merged in 2014 to form the **Welsh Harp Sailing Club**. Another is **Wembley Sailing Club**, formed in 1953.

On the north bank, the **Phoenix Canoe Club**, formed in 2004.

Back on the West Hendon side, visitors may spot a pub on the corner of Cool Oak Lane, now an Indian restaurant. Once called the Upper Welsh Harp, it is not the original. The original Old Welsh Harp, having been rebuilt in 1938, but with Warner's music hall still standing, was demolished to make way for a slip road leading from the Staples Corner flyover, in 1971.

▲ Another once privately owned pleasure ground now within the public realm is **Alexandra Park**, seen above right from Muswell Hill, with its hilltop centrepiece on the left, **Alexandra Palace.**

'Ally Pally' has a history almost as eventful as the south London venture that inspired its creation, Crystal Palace (the subject of Chapter 4). It burnt down sixteen days after its opening in 1873. There then followed a series of loss making attractions until, in 1900, ownership was transferred to a trust, required by Act of Parliament to retain it 'for the free use and recreation of the public forever'.

In 1980 this trust was transferred to the care of Haringey Council. Six months later another fire resulted in the Palace being closed for the next eight years.

Without its Palace, Alexandra Park might have been merely another public park (albeit with great views). Instead, Ally Pally presents one of London's greatest challenges; how to make a Victorian entrepreneurial gamble pay in the 21st century with no tube station close at hand, and yet equally, how to honour its unique history.

Television broadcasting, starting in 1936, forms a major element of that narrative (and may yet be part of its future, as a visitor attraction).

But sport has been a presence since the very beginning, as was the case at Crystal Palace, Wembley Park and indeed at most other speculative pleasure grounds of the 19th century.

In the 1870s and 1880s there was a mile long cycle track, and from 1875 until the 1920s an open air swimming pool (see page 157).

In the Palace itself, in between concerts and events there has been an indoor cycle track (in 1902-03), an ice rink (in use since 1990 by various ice hockey teams), and darts, most recently in the form of the World Darts Championships, held there since 2007.

Above all, Ally Pally was famous for horse racing.

Squeezed into the narrow belt of turf seen above between the Palace slopes and the housing on the right, the course predated the Palace, staging its first race in 1868.

Known because of its shape as the Frying Pan it was compact, often dangerous, and frequently atmospheric, especially after evening racing began in 1955. It was also the last racecourse within the boundaries of London before its licence was withdrawn in 1970.

At the time of writing the future of the Palace hinged on a £17 million bid for lottery funding. Down in the park, meanwhile, two hardy survivors play on, **Alexandra Park Cricket Club** (formed in 1888) and **Alexandra Park FC** (1898).

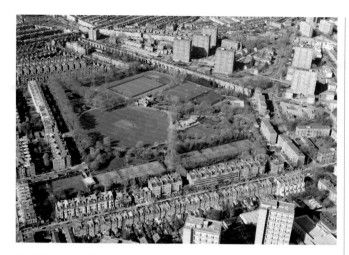

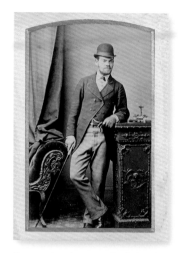

▲ While speculative ventures such as Alexandra Palace were prey to commercial pressures, and public parks were always likely to be expensive to establish and maintain, the 1859 Recreation Grounds Act gave London vestries a third option.

Not that it is nowadays easy to tell the difference between a park and a 'rec'. Passing through the stately gates of **Paddington Recreation Ground**, seen here with Randolph Avenue in the foreground, a classic Victorian park appears to unfold, with flower beds, shaded groves, a bandstand and café. But actually the bulk of its 27 acres are given over to sport, namely athletics, football, cricket, tennis, bowls, netball and basketball.

Its pavilion (see page 106) also houses a fitness centre, while the main artificial pitch plays host to **Hampstead and Westminster HC**, one of the capital's most important hockey clubs, formed in 1894.

In addition, as noted in Chapter 29, a cycle track on what is now the cricket pitch was for years a venue for national championships, and from the 1920s until its removal in 1987 was the only cycle track north of the river.

Credit for the establishment of Paddington Rec lies with Richard Beachcroft, a solicitor and treasurer

of Paddington Cricket Club. The club had played on the site since at least 1860 and was concerned at how rapidly the Maida Vale area was being swallowed up by housing. Other nervous clubs locally included two formed by the staff at Whiteley's and Liberty's.

Next to the cricket ground, on Randolph Avenue (where the green tennis courts are now), was a roller skating rink, one of London's first.

After proposals for a public park on the site fell through owing to a dispute over the finances, in 1887 a frustrated Beachcroft took a gamble by leasing part of the ground, at his own expense, in order to stage a celebration of Queen Victoria's Golden Jubilee, hoping to demonstrate how the area needed a communal open space.

The event was a great success, attended by the Duke of Cambridge.

The following year, answering a call by the local MP, Lord Randolph Churchill, to find work for the unemployed, Beachcroft rented a further eleven acres, and hired 500 men to lay out the site as a sports ground, opened in April 1888.

In its first year 36 cricket, cycling and athletic clubs rented the facilities, with some days seeing up to 15,000 people in the grounds.

But with only an annual tenancy, Beachcroft still needed to raise £45,000 to buy the land and save the Rec. It took five years to achieve this, gathering funds from benefactors, the LCC, the vestries of Paddington, St Marylebone and Willesden, plus an an Act of Parliament, passed in 1893.

Today Paddington Rec is enjoyed by just over one million people a year, many of them entering through those stately gates, recently named after Beachcroft and Churchill.

▶ As the great and the good continued their quest for parks and recreation grounds in inner London, out in rural Middlesex a different model of provision presented itself, courtesy of this dapper fellow.

Known to the press as the 'Playing Fields King', and to his intimates as 'Pa', **Albert Toley** was a rare individual.

Born in Devon in 1855 he entered service as a page boy at the age of ten, but by studying in his spare time managed to gain a post as a pupil teacher at St Paul's in Lorrimore Square, Southwark, when he was 17. Four years later he was appointed to teach at the United Westminster School on Palace Street (now Westminster City School), where he took on the role of sports master.

Realising how difficult it was to find playing fields within easy reach, Toley, presumably with backing from the school or benefactors, rented a 28 acre site in Willesden and soon found that other schools were keen to rent the fields too.

Patently Toley loved sport and thrived in company. He was a keen cricketer and golfer, and a top rate marksman with the Middlesex (Artists') Rifle Volunteer Corps, whose drill hall survives on Dukes Road (see page 142). He was also active in the Freemasons.

Even so, quite how Toley financed his deals is not known. Certainly his salary would not have made him rich.

But in 1893 he gave up teaching and took out a lease on both Old Oak and Wormholt Farms in Shepherd's Bush, plus a nearby plot on part of which the Great Stadium at White City would later be built in 1908.

These deals he followed up by leasing tracts of farmland in Park Royal, Sudbury, Boston Manor and Harrow, until, it was said, his portfolio extended to between 800–1,000 acres in total.

On each site Toley laid out sports pitches, built pavilions, and then let out the facilities to schools or sports clubs, including several set up by the staff of London stores. Another tenant was Wasps, the rugby club, who hired various grounds from Toley in the Wormwood Scrubs and East Acton areas from 1895-1923.

Toley also laid out at least six golf courses. One of them was used by **Brent Valley Golf Club**, formed in 1909 and based at his house, The

Grove, a handsome and substantial mansion on Church Road, Hanwell, later renamed Dublin House.

As far as is known, no-one had ever done this before; that is, make a business out of sports grounds.

But then, never before had the economic or social climate been more suited to such speculations.

London was now bursting with men keen to enjoy their leisure time. Affordable, mass-produced sports gear was available from the likes of Gamages and Whiteley's, while the rail network could transport Londoners out into the fields of Middlesex in no time.

Above all, Toley set out to cater for men 'of moderate means' (as the Middlesex County Times put it).

Members were asked to pay only modest annual subscriptions, and no entrance fee at all (as was the norm at more exclusive clubs).

Moreover, once a member joined, his subscription would not go up.

Consequently Toley received much praise as a benefactor. But as we learn from the history of one club he helped to establish, **Ilford Golf Club** (see Links), he could also be a brusque businessman.

By the time of Toley's death in 1925 sports provision had moved on. Local authorities were now more pro-active. Brent Valley Golf Club, for example, was purchased by Ealing Council in 1938. Regrettably, Dublin House was demolished in 1966.

But the 'Playing Fields King' is not quite forgotten.

Worthing Golf Club, which his grandson bought, still play for a Toley Cup, while in Wembley there is a **Toley Avenue**, close to a ground he owned in Sudbury, which he sold to one of his oldest clients, Wasps, in 1923 (see page 261).

▲ Addressing the inaugural meeting of the **National Playing Fields Association** (NPFA) at the Albert Hall in July 1925, the Rev Frank Gillingham, an Essex cricketer, spoke of a recent outing he had led to the country with a group of East End children. When he proposed a game of cricket, one boy, said Gillingham, piped up, 'Sorry guv'nor, I can't play cricket in that field, there ain't any lamp posts.'

For despite all the efforts of the Victorians and Edwardians, for poor children in London's most densely populated districts, there were still precious few green spaces to play.

Photographs such as this, therefore, taken in April 1930, although reproduced in a spirit of journalistic whimsy, usually to herald the start of the cricket season, carried a stark message.

Nor was this lack of space a matter of just fun and games. When the Army started recruiting for the Boer War in 1899, four in every ten applicants were found to be unfit for service. During the First World War that figure rose to 50 per cent.

Added to which, the period coincided with a steep rise in the popularity of team sports, amongst East End boys fed especially by graduates of Oxford and Cambridge volunteering in philanthropic institutions such as Oxford House in Bethnal Green and Eton Mission in Hackney Wick.

In 1892 the recently formed **London Playing Fields Society** (LPFS), reported that for every acre of cricket field in the capital at least 1,000 players were queuing to play on it. By 1905 it was able to count 450 pitches in the public realm. But now there were 1,500 teams vying for bookings (at a time when no play was permitted on Sundays).

Football was no better served. In 1923-24, two seasons before the NPFA formed, the LCC received 973 applications to use just 205 football pitches.

Over the next fifteen years, largely as a result of significant land purchases by local authorities – Ealing alone bought up 370 acres of open space between 1934-39 (Brent Valley golf course included) – that shortfall was to be eased.

For its part, by 1934, thanks to numerous grants and donations, the LPFS had assembled its own holding of 308 acres, spread between ten playing fields.

Since renamed the **London Playing Fields Foundation** (LPFF), its holding today amounts to 170 acres across seven sites. Three of them, in Redbridge, Greenwich and Greenford, have been bought since 1999 with help from the London Marathon Charitable Trust.

The oldest, in Walthamstow dates back to 1896.

In 1989 this was refurbished and renamed the Douglas Eyre Playing Fields, in memory of its original benefactor, a leader of the Oxford House mission. Since then at least six lads to have played on the fields, David Beckham, Sol Campbell and Paul Ince among them, have gone on to play for England.

▶ Known chiefly for designing much of the coinage circulated within Britain and the Commonwealth between the wars, **George Kruger Gray** was the artist responsible for this Portland stone, heraldic panel, bearing the fading inscription 'George V – AD 1910-1936'.

Mounted on a gateway forming an entrance to **Mile End Park**, on **Rhodeswell Road**, the panel signifies that the park is one of 471 sites around the UK designated as **King George's Fields**, 31 of which can be found in the London area.

As in the 1920s much of the impetus behind the scheme derived from concerns as to the health of the nation, at a time when war with Germany was once again on the horizon. Shortly after the memorial fund was launched the Physical Training and Recreation Act of 1937 sought to address the same issue.

Coincidentally the gates to Mile End Park, declared open in 1952 by the Duke of Edinburgh, stood almost exactly on what had been Edinburgh Road, a terrace of Victorian houses. In other words, it was thanks to the Luftwaffe as much as to the Abercrombie Plan that London had gained this extra green lung.

At the time of its opening Mile End Park covered 62 acres. This made it the third largest of Greater London's new King George's Fields.

Second largest, at 102 acres, were the fields on Barnet Lane, New Barnet. Larger still – in fact the largest of any site endowed in the entire country – were the playing fields on Carterhatch Lane, Enfield.

Covering 128 acres, these fields were opened in October 1939, five weeks after the outbreak of war. (A post war grandstand built on the site is featured on page 113.)

No memorial gates appear to have survived at Enfield, nor at Barnet Lane (if indeed any were erected). But among other examples around the capital are those at the King George's Fields on Ham Street,

Richmond (*see map on page 58*), Delhi Road, Lower Edmonton (*page 88*), and **Well Hall Road**, opposite Eltham Common (*below left*).

These and all other gateways at King George's Fields were designed by WH Ansell and Arthur Bailey.

When the fund was finally wound up in 1965 responsibility for the fields passed to the NPFA.

Renamed in 2007 as **Fields in Trust**, the organisation protects nearly 150 open spaces in London overall, including those now commemorating the Diamond Jubilee of George V's grand-daughter.

Which is where we came in, with one of the Queen Elizabeth II Fields in West Hampstead.

To illustrate how vulnerable London's playing fields remain, in 2014 the **LPFF** reported that 20 per cent of London's football pitches and 40 per cent of cricket wickets had been lost over the last 20 years.

A report in 2006, meanwhile, found that despite housing 16 per cent of the UK's population, London had only eight per cent of its playing fields. In 2014 at least 20 of those fields were on the LPFF's Fields at Risk Register.

To borrow a phrase from 1893, all Londoners who value open space are earnestly invited to help.

In other words, to watch that space... quite literally.

Chapter Three

River Thames

London has claims aplenty to sporting renown. But one of its greatest is also one of its least known. In 2015 the Thames will stage the 300th Doggett's Coat and Badge Race. Such races, held between wherrymen on the river (the black cab drivers of their era), were common in the 17th and 18th centuries. But only Doggett's has survived, so that it is today both the oldest rowing race in the world and the longest running sporting event in London. Thomas Doggett (c.1670-1721), an Irish comic actor and theatre manager (*above*), endowed the race in 1715 because, like many Londoners, he travelled by wherry almost daily, especially between the South Bank and his lodgings in Chelsea, and so came to know and respect professional watermen. Rowing is a sport based entirely on what was, in essence, an exceptionally tough way to earn a crust.

Known to Londoners simply as 'the River', the Thames is so easily overlooked as we head for the likes of Wimbledon and Wembley, Twickenham or Lord's.

Yet the very lifeblood of the city... the conduit for thousands of years of trade and of people... 'the silver streaming Themmes' of Edmund Spenser... the turbid waters of JM Turner, plumbed by Dickens and tamed by Bazalgette... the liquid vortex that both defines the capital and divides it... is also, demonstrably and delightfully, the most enduring, most public of all sporting arenas in London town.

Some 46 miles in length as it winds its way through the capital (out of a total length of 215 miles), it is one of the busiest too; home to 98 boat clubs, mainly for rowing, and sailing, but also canoeing and punting, based in 65 boathouses and watersports centres.

Between them these clubs – the majority open to all-comers, but a significant number linked to youth schemes, cadet groups, schools, universities and teaching hospitals – have an estimated active membership in the region of 10-15,000 individuals.

True, there is not a single grandstand from which to watch them in action (although several riverside pubs do their best to make up for this). Most of the boathouses are utilitarian, and few of the clubs are household names. Nor on the river are there sportsmen or women who might be considered celebrities, let alone professionals (although the odd Olympian can be spotted).

Even on the one day of the year that the Thames really does upstage the likes of Wembley or Twickenham, the estimated quarter of million spectators who line the banks from Putney to Mortlake for the University Boat Race, without, that is, having had to buy a ticket or pass through a turnstile, do so in the knowledge that they are watching virtually unknown students compete for two institutions, neither of which represents London.

At the same time, sailing and rowing are among the few sports (along with golf, swimming and horse racing), whose main national and international events are routinely staged *outside* the capital. In rowing, for example, a Metropolitan Amateur Regatta was instigated in 1866, but it has never enjoyed the status of Henley, 40 miles upriver, where the elite of the sport have gathered since 1839.

For most Londoners, then, the Thames is of passing interest only; a place for boat trips or riverside walks, or more often than not a boundary between that half of London, north or south, in which they live, and the other half that is by definition manifestly inferior.

Perhaps the majority of such Londoners will know a hatchback from a saloon, or a Ford from a Jaguar. But sculls or skiffs, fours or eights, Merlins or Lasers – these are mysterious craft that inhabit a liminal world, beyond the bank, below the bridge.

Yet before the coming of turnpikes and the railways, the river and its ways were as familiar to Londoners as the Underground is today. For work, rest and play.

In the 12th century, William Fitzstephen (*see page 14*) described Easter frolics by London Bridge during which youths wielding lances would be paddled towards a quintain. Below is a 14th century woodcut of this sport, reproduced by Joseph Strutt in 1801 (*see Links*).

The aim was to strike the target hard enough to splinter the lance, and yet remain upright in the boat.

Those who failed were 'cast into the fast flowing river' and left to swim ashore, or if necessary, be plucked out by a support boat, watched by crowds gathered on the bridge or in galleries, 'ready to laugh their fill'.

In Fitzstephen's time, even until that of Strutt's, the Thames presented a quite different prospect to the river of today.

It was wider and lined mostly with mudbanks. It was shallower too. Indeed at low tide in certain stretches, such as at Chelsea, Chiswick or Brentford, it could even be crossed on foot.

At all other times, until Putney Bridge was built in 1729, the only way to cross the river between London Bridge and the next bridge over the Thames, in Kingston, was by ferry, or like Thomas Doggett, by wherry.

Now wherrymen were a hardy lot. Competitive too, hovering around the various steps leading down to the river in their bright coats, trying to drum up fares (as so wickedly caricatured by Thomas Rowlandson, at Wapping Old Stairs in 1812).

29. THE WATER QUINTAIN—XIV. CENTURY.

But watermen were also regulated, first by an Act of 1514, followed by one of 1555, which established the Company of Watermen and a system of apprenticeship. In 1700 membership of the Company was extended to Lightermen – those who conveyed goods rather than passengers – to create the body to which all workers on Thames vessels still belong today.

When not on duty, watermen and lightermen were the pioneers of modern rowing on the Thames. Apart from Doggett's, there were dozens of other 'wager races' and regattas, many of which drew considerable crowds and heavy betting. Which in time, inevitably, persuaded gentlemen amateurs that they too should have a go.

London's first rowing clubs in the early 19th century were formed either by scholars – the oldest surviving club being Westminster School Boat Club, whose records go back to 1813 – or groups of friends who clubbed together to hire boats from one of the many boatyards along the river.

Only one club in the latter category has survived from that period, Leander RC, formed strictly for gentlemen in c.1818 and based at Searle's boatyard, Lambeth (now the site of St Thomas' Hospital).

From there Leander moved to Putney in 1860, but since 1897 have operated mainly out of Henley.

By then, the Thames was a quite different proposition.

Firstly, to the ire of wherrymen, the number of bridges rose from nine in 1777 to 29 by 1894 (including railway bridges). The replacement of the old London Bridge by one with wider arches, in 1831, also improved the flow (and in doing so helped put an end to the famous Frost Fairs).

However the steady increase in industry, river traffic and effluent that also characterised the mid 19th century was hardly conducive to rowing or sailing. As one Leander member put it in 1857, the Thames had become 'the largest navigable sewer in the world'.

On the plus side, the extension of railways out to the new suburbs, and to Putney in particular, meant that those who could afford it, meaning both gentlemen and the rapidly growing numbers of clerks and office workers in the City, could now whizz out west after a day's

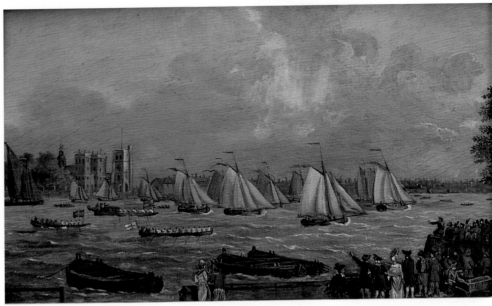

work and manage an hour or two of rowing on summer evenings.

Some then decided to keep their clubs together all year round by taking up other sports. Hence rowers were to figure prominently in the early years of the Football Association – Ebenezer Morley of the London RC and Herbert Thomas Steward of Leander were founding members – and of both the Amateur Athletic Association and the Rugby Football Union.

Three developments in the late 19th century were also material.

As part of Joseph Bazalgette's sewer building programme for the Metropolitan Board of Works, massive embankments were built along various stretches of the river, starting with the Victoria Embankment in 1865, and reaching Putney by the 1880s.

These solid masonry cliffs not only realigned the boundaries between land and water. They also made the river narrower, and therefore deeper and faster.

Newfound dredging capabilities enhanced the flow even more.

Finally, the building of locks at Teddington and Richmond in stages between 1810 and 1905 ensured that the river was now navigable right through London, at all times, in all tides.

These developments affected the non-tidal river too. In 1885 the Thames Preservation Act formally recognised that the river beyond Teddington had largely become 'a place of public recreation and resort...' For Kingston boathouses this heralded a golden era.

But here the story takes a twist, at least in the world of rowing.

In a move that would be mirrored in athletics and rugby, in 1879 the stewards at Henley decided to exclude from their competitions any individual they deemed to be a 'professional'.

Apart from obvious out-and-out professional rowers, Henley's definition extended to anyone who had ever entered a race in which professionals had appeared, anyone who made money from coaching, and crucially, anyone who worked as a waterman or 'in or about boats', even if they chose to compete without reward.

And just to make sure that no other working men might slip through the net, Henley further classified as 'professional' any 'mechanic, artisan or labourer'.

In London these deeply divisive rules were adopted by the newly formed Metropolitan Rowing Association, which in 1882 became the Amateur Rowing Association (ARA).

All across the country rowing clubs split along class lines. Those excluded by the ARA's elitist position formed the National Amateur Rowing Association (NARA), in 1890. Also formed was a body for tradesmen, which included Thames watermen.

The divide, so damaging to the sport, persisted until 1937. But it was not until 1956 that all obstacles were dropped and rowing was at last able to re-unite under the reformed ARA (since 2009 known as British Rowing). »

▲ When the **Cumberland Sailing Society**, since renamed the **Royal Thames Yacht Club** (RTYC), organised its first race in 1775, the Thames was much wider and windier than today.

This view of the race, by **Francis Swaine**, held at the RTYC headquarters in Knightsbridge, was taken from Millbank, looking towards **Lambeth Palace**. (Although still based in London the RTYC have, since the 1850s, concentrated their sailing activities on the Solent.)

In common with many sports, English sailing owes much to foreign influences. Yachts were introduced from Holland by Charles II, who had learned to sail whilst in exile. He and his brother competed in the first race recorded on the Thames, from Greenwich to Gravesend and back, in 1662.

Meanwhile the term **'regatta'** was first recorded in Venice in 1274. As of 2013 there were 14 sailing or rowing regattas on the Thames. Another, the Metropolitan Amateur Regatta, first staged at Putney in 1866, has been held on Dorney Lake, Eton, since 2001.

» Yet even today, over half a century later, the rift remains indelibly woven into the heritage of several London clubs, and to a certain extent, inevitably, it has dominated historical discourse.

As for the present – throughout this book there are tales of sports whose participation levels are dropping, and whose heritage is at risk. But while it would be wrong to suggest that all is perfect on the Thames – there are for example fears that intensive development on the riverside will stymie sailing – it is nevertheless true that both rowing and sailing are enjoying unprecedented levels of popularity; so much so that some clubs are having to turn away newcomers because they do not have enough boats or coaches.

That for the time being British rowers rule the waves, as it were, with the sailors being not far behind in the medal count, is undoubtedly one factor.

So too is the significant rise in the number of women competing, a trend started on the Thames in the 1890s, but accelerated since the 1970s as clubs slowly, and in some cases reluctantly, dropped their male-only policies.

Concerning the heritage of boating, there are many positive indicators.

Opened in 1998, the River and Rowing Museum at Henley is now the first point of reference for anyone interested in the Thames.

There is also renewed interest in the preservation and active use of historic boats, combined with a flurry of books, blogs and websites on Thames clubs and boating.

What this indicates is perhaps a simple truth; that as long as there is a River Thames, and as long as there is a London, there will always be at least two Londoners trying to outdo each other out on the water.

Human nature will make sure of that.

London's oldest sporting-related pavilion (*right*) is at Syon House (*see page 262*). Grade I listed and now in residential use, it was designed by Robert Mylne for the Duke of Northumberland in 1803, as a surprise for his wife so that she could enjoy regattas in comfort. A boathouse on the floor below was rendered unusable when river levels rose following the creation of Teddington Lock.

◄ Held by the **Royal Thames Yacht Club** at their London headquarters in **Knightsbridge**, and crafted by **Garrard** of **Threadneedle Street**, the oldest sporting trophy in the capital – and one of the oldest pieces of sporting silverware in the world, for there are slightly older golf trophies in Scotland – is this, the **Cumberland Cup**, donated by the errant brother of George III, the Duke of Cumberland, in 1776.

(The cup for the 1775 race, depicted on the previous page, was lost in a fire.)

At the time, George III was losing his grip both on the Americas and on the Duke, who also bore the grand title of Vice Admiral of the Blue, and of whom it was said politely, '...his irregular life has overshadowed his naval career'.

Costing 20 guineas, the cup was presented, brimming with claret, to Thomas Taylor, the winning captain, after a race from the new Blackfriars Bridge to Putney and back again.

After the race the partying began, Vauxhall Gardens being handily placed for the purpose. Indeed with its royal patrons and aristocratic members, the Cumberland Sailing Society – the only one of its kind in the world at the time – brought such jollity to the Gardens that in 1786 the Cumberland Cup was superceded by the Vauxhall Cup (a reminder that sponsorship in sport is hardly new).

Taylor went on to win several more trophies and become Commodore of the Society. But it was only in 1955, courtesy of his great, great grandson, that the 1776 cup was returned to the RTYC for safekeeping.

Another Cumberland Cup, dating from 1777, was discovered at Buckingham Palace, while that of 1782 was bequeathed by a man in Massachusetts.

(Incidentally the oldest trophy still competed for in international sport is also for sailing – the America's Cup, first awarded in 1851 – and was also made by Garrard, who are still in the silverware business today, in Albemarle Street.)

Also at the RTYC's headquarters – a 1963 building designed by Guy Morgan & Partners – is a collection of **'half models'** (*above left*). Dating back to 1834, each is a work in its own right, produced by boat builders to show clients before full scale construction commenced.

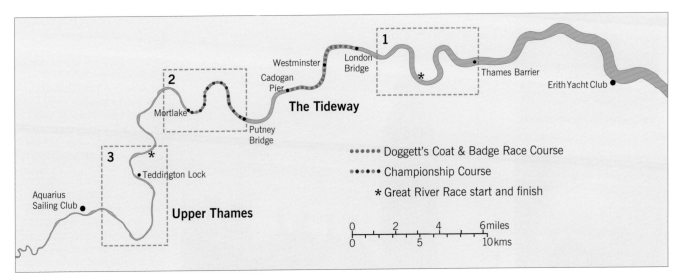

Mortlake · 2 · Putney Bridge · Cadogan Pier · Westminster · London Bridge · 1 · Thames Barrier · Erith Yacht Club

The Tideway

Aquarius Sailing Club · 3 · * · Teddington Lock

Upper Thames

●●●●● Doggett's Coat & Badge Race Course
●●●●● Championship Course
* Great River Race start and finish

0 2 4 6 miles
0 5 10 kms

▲ With its twists and turns and succession of S-bends the **Thames** could hardly offer a more circuitous challenge as it courses through the capital. From London's westernmost boat club, **Aquarius SC**, on the edge of the Borough of **Richmond**, to **Erith YC**, out east in **Bexley**, is a distance of 46 miles on the water, yet only 25 as the crow flies.

Note that this stretch is only a fifth of the river's entire length, from its source in Gloucestershire to the Estuary beyond Gravesend.

As detailed above, apart from occasional long distance challenges and charity events, all official races take place along shorter routes, and only one – the **Devizes to Westminster International Canoe Race** – spans both sides of **Teddington Lock** (where the tidal Thames, or **'Tideway'** ends and the non-tidal **Upper Thames** begins).

First contested in 1948, the canoe race covers 125 miles, a distance typically completed by the winner in around sixteen hours.

Otherwise, as already noted, the oldest Thames race is for the **Doggett's Coat and Badge**.

This is what is known as a race for individual 'scullers'. In 'sculling' each oarsman uses two oars, or 'blades', whereas in what is strictly called 'rowing' each member of a crew of two, four or eight, rows with a single blade.

London's second oldest race is also for individual scullers.

Established in 1830 by barrister Henry Wingfield, the **Wingfield Sculls** was originally raced east of Putney, but since 1849 has been one of numerous races held west of Putney, on what is referred to as the **Championship Course**.

Of these, the best known is the **University Boat Race**, first held on the course in 1845, having previously been staged in Henley in 1829, and from 1836-42 between Westminster and Putney.

The Thames is also the venue for two of the world's largest rowing events. These are the **Head of the River Race**, initiated in 1926, from Mortlake to Putney, and the more recent **Great River Race** (below).

Concerning boat clubs, most of the 100 or so based on the London stretch of the Thames are clustered in three areas, delineated above and mapped in detail later in the chapter.

Each cluster has a distinct character, determined by the width of the river, its currents, the prevailing winds, the bridges and the nature of development on the banks – banks, incidentally, known not as north or south but according to which county they are in (for example Middlesex or Surrey).

Most of all, in order to fully appreciate the nature of racing on the Tideway it is vital to have a basic understanding of the tides.

Each phase – the flood tide coming in from the sea, the ebb tide going out – lasts between six to seven hours, with a 30 minute period of 'slack water' between.

During each tide water levels can rise or fall by as much as 7.5m.

Thus the Tideway is in a state of continual flux, and that is before considering other such niceties as buoys, bridges, barges, passing cruisers and driftwood.

In short, whereas at purpose-built courses such as Dorney Lake, or on non-tidal stretches such as at Henley, rowers can pretty much concentrate on keeping straight and beating their opponents, rowing, or indeed any form of boating on the Tideway, is an ongoing battle of wits against the river itself.

Not for the faint-hearted, that is for sure.

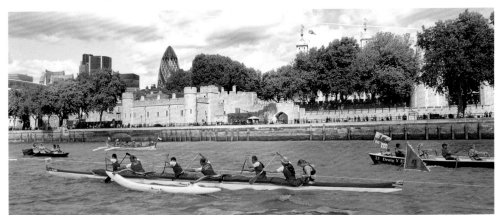

▲ Covering a distance of 21 miles, the longest race staged purely on the **Tideway** is also one of the youngest fixtures on the river's sporting calendar. First run in 1988, the **Great River Race** sees over 300 boats of all shapes and sizes race against the clock from Westferry in the east to Ham in the west.

Awards are given in nearly 40 different categories, but the crew with the fastest time of all – usually of between two and two and a half hours – wins a Challenge Cup in the form of a Waterman's Badge originally awarded to one William Savage of Gravesend in 1803.

Apart from the sheer spectacle, the Great River Race offers an unrivalled opportunity to see the extraordinary diversity of boats raced on British waters; among them skiffs and gigs, cutters and shallops, and also more traditional types that have recently gained in popularity, such as Celtic longboats and Chinese dragon boats.

Seen here being paddled past the **Tower of London** in the 2009 race, is a **Hawaiian Outrigger**, an ultra-modern boat based on ancient design principles, crewed by members of the oldest canoe club in the world, the **Royal Canoe Club**, formed in 1866 at the Star and Garter in Richmond.

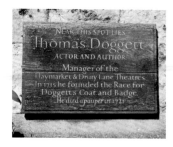

▲ Assuredly **Thomas Doggett** did not die a pauper, as stated in the churchyard of **St John's** in **Eltham** (*top*). The once renowned comic actor made generous provision for his family and his servants, plus £350, no less, to ensure that the **Coat and Badge** race he had initiated in 1715 would continue to be staged after his death, in 1721.

Organised ever since by the Fishmongers' Company, the expenditure, as set out in Doggett's will, allowed five pounds for the provision of a silver badge (*above*), this to bear the word 'Liberty' over a rampant horse (the symbol of the Hanoverian George I, whose accession to the throne Doggett wished the race to celebrate).

To this was added 18s for 'orange' cloth, 21s for the coat to be made up with buttons, and 30s for the Watermen's Company Clerk.

With appropriate dramatic effect, a further stipulation required that the race be held annually, 'forever'.

So far, so good. The odd break for wars apart, the run continues.

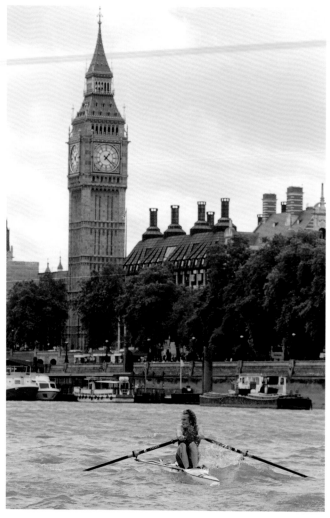

Flanked by his predecessors, the 2010 race winner, Daniel Arnold, parades his new Doggett's Coat and Badge at the Fishmongers' Hall, London Bridge (*above*). A member of the Tideway Scullers in Chiswick, like many current watermen Arnold works aboard Thames cruise boats. Alongside him in the darker uniform of a Bargemaster is Bob Prentice, a fourth generation waterman from

Wapping. Prentice joined Poplar, Blackwall & District RC at the age of ten, worked as a lighterman delivering Ford motor components to various docks, and now skippers tourist boats. His winning time of 23 minutes 22 seconds in the 1973 race has yet to be beaten. Another Doggett's record is that of the Phelps family. Boatbuilders of Putney, the Phelps provided ten winners from 1860–1938.

◀ Watching a single sculler plough through the waters of central London can at times resemble a child in a pedal car who has strayed onto a motorway. But like all entrants in the **2010 Doggett's Coat and Badge Race**, Dean Pettipher from Gravesend, seen here midway through the four miles and seven furlong course between London Bridge and Cadogan Pier, knows the score. He is, after all, a waterman.

Today, as in 1715, entry to the Coat and Badge race is restricted to a maximum of six watermen whose apprenticeships have just ended. By 1799 there were around 2,000 apprentices, and none was allowed more than one try. Today the total is around 125, and each is allowed to enter the race three times (that is if they do not win at the first or second attempt).

As can be seen, they are also now allowed to race in purpose-built, lightweight boats, whereas before 1906 they had to compete in standard wherries, clinker built, wide-bottomed and seating four.

Not only that but before 1873 Doggett's races were contested *against* the ebb tide, requiring entrants to row for over two punishing hours to reach Chelsea.

Yet despite the race now going with the flow, lasting barely 30 minutes and drawing the interest of only a handful of spectators and passing tourists – largely because it takes place midweek in July – Doggett's remains a genuine test of watermanship. This is particularly so given that the race is observed closely by fellow watermen and by the entrants' families (who are often one and the same), following in a small flotilla of boats, watching every move.

In that sense, the Doggett's Coat and Badge may be London's oldest sporting event, but it remains an essentially internal affair.

Here are individuals who spend their working lives on the river, yet are so drawn to it, and to their heritage, that they choose to spend their free time mastering an art which has been all but redundant in their professional lives since the advent of powered boats.

For a waterman to don the Coat and Badge is akin to an athlete gaining a gold at the Olympics.

Once a Coat and Badge winner, always a Coat and Badge winner. Forever.

▲ On the riverside frontage of the **Westminster School Boat Club** on **Putney Embankment** (*see map 2, page 46*), the name of **John Hawks Clasper** (1836-1908), known as Jack, is a reminder that one of the great sporting rivalries of mid 19th century England lay between the professional watermen of the Thames and their counterparts on the River Tyne; a rivalry played out not only between oarsmen but also between boatbuilders.

Jack Clasper's father Harry was a legend in the north east on both counts. Illiterate and sent down the mines at the age of fifteen, by his mid 20s Harry Clasper was running a pub, building boats and racing them to great effect, often crewed by his brothers.

In 1842, having been stung by defeat on the Tyne at the hands of Thames watermen, Clasper and his fellow Tynesiders set about a radical redesign of racing boats, perfecting a new form of outrigger, combined with inboard keels and narrower, lightweight shells. Three years later they gained revenge with victory at the Thames Regatta.

Young Jack, the eldest of thirteen Clasper children, notched up his first aquatic honour when, at the age of 13, he coxed his father's four to victory at Henley in 1849. He then moved to London in 1854 to be apprenticed as a waterman and to make his own name as a rower.

He did well, winning several titles. But it was as a boat builder that Jack Clasper really excelled.

By 1864 he had established a yard in Durham, to which he added a second on Putney Embankment in 1868 (possibly the building we see here), followed by a third in Oxford.

Like his father, Clasper was forever experimenting; for example perfecting a form of sliding seat that had been invented in the USA and first seen on the Tyne in 1871, and creating longer, narrower shells.

Five times a Clasper-built boat secured victory in the Boat Race, a link that lives on in that his Putney premises now serve as the base of the Oxford crew on race days.

Clasper also coached, one of his charges being fellow Geordie professional Bob Chambers, winner of five national sculling titles. Such was Chambers' repute that when he was struck down by tuberculosis at the age of 37 in 1868, an estimated 50-60,000 turned out for his funeral in Newcastle.

But then, two years later double that number were reportedly on the streets to pay their respects to Harry Clasper. This was followed only months later by the third major funeral of a Tyneside rower, James Renforth, who died after a race in Canada, aged just 29.

All three are commemorated by magnificent memorials (featured in *Played in Tyne and Wear, see Links*). Renforth's in particular, in Gateshead, has a carving of the rower expiring in the arms of his fellow English crewman, Harry Kelley, from Putney.

Lavishly sentimental in the best Victorian tradition, it is possible that the three memorials were inspired by an earlier one in London.

Robert Coombes (1808-60), whose tomb at **Brompton Cemetery** (*top right*) was unveiled in 1866, was born in a Vauxhall pest house, apprenticed as a waterman in his teens, and in 1842 was one of the London four who humbled Harry Clasper's crew on the Tyne.

Four years later he became the first sculler to win the national championships on the Putney to Mortlake course. On the Thames and on the Tyne Coombes then defended this title twice. In later life he also coached both Oxford and Cambridge, winning the Boat Race on two occasions, before the tide of opinion turned against the use of professionals in amateur races.

Coombes' final days were spent in poverty, in a Maidstone lunatic asylum. But as would later occur on Tyneside his rowing pals and admirers rallied and commissioned the memorial we see here.

Listed Grade II, the tomb is surmounted by an upturned wherry, over which is draped a Doggett's Coat and Badge. In each corner stands an oarsman, thought to have been modelled on Coombes or his contemporaries, but alas now sadly headless. The figure nearest the camera wears the traditional buttoned coat of a Thames waterman.

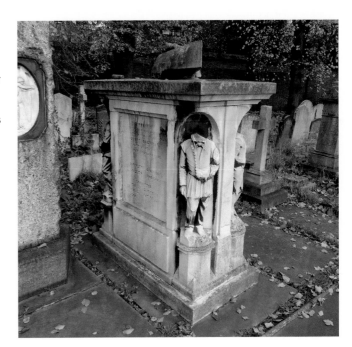

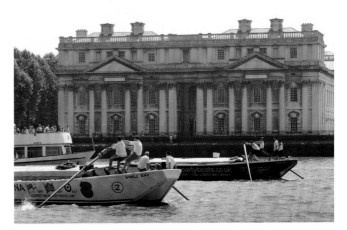

Between them, the likes of Coombes, the Claspers, Chambers, Renforth and Kelley laid the foundations for modern rowing.

Yet as noted earlier, by the 1880s their ilk found themselves ostracised by the Amateur Rowing Association, who refused to compete against professionals, a rift only finally settled in 1956.

During the interim years watermen continued to take part in competitions organised by the Tradesmen's Rowing Association, plus the Doggett's of course, and the Christmas Handicap on Tyneside, last staged in 1938.

More recently in 1975 another Thames race emerged, this to celebrate the traditional skills of lightermen.

In the **Thames Barge Driving Race**, seen above passing Sir Christopher Wren's **Royal Hospital** at **Greenwich** in 2010, crews of between four to eight lightermen and/or watermen race unpowered barges, using 20 foot long oars, or 'sweeps' for rowing.

Given that the winning time for completing the gruelling seven mile course from Greenwich to Westminster is usually around 90 minutes, this is perhaps one river sport best left to professionals.

▶ Starting by the **Thames Barrier**, this is the first of three cluster maps showing the location of boathouses that host watersports, mainly rowing and sailing, within the boundaries of London. Centres for training are also shown. Private boathouses, marinas and clubs formed for leisure cruising are not.

Until the 1970s this part of the Tideway was dominated by working wharves, docks and boatyards.

From 1513 until the 1820s **Deptford** served as the nation's main naval dockyard. This period was followed by the construction of vast, inland docks, starting with the **West India Docks** (now Canary Wharf) in 1802, and culminating in the **Royal Albert Dock** (*3 on map*) in 1880 and its adjoining **King George V Dock** in 1921.

Sporting activity on this stretch (known as 'below bridge', because there were no other bridges east of London Bridge) was mainly confined to sailing amongst the elite, and to rowing by working watermen.

But as commercial traffic built up during the 19th century, several rowing clubs either moved to quieter waters, for example to the River Lea (*see Chapter 6*) or upstream beyond Putney (*map 2*).

Sailing also became less tenable between here and Westminster as more bridges were erected and taller buildings built on both banks, thereby affecting wind patterns.

Since the reinvention of the **Docklands** in the latter part of the 20th century, both these trends have been reversed, so that several clubs, including **Poplar** (6), **Globe** (*5 and below right*) and **Greenwich** (*4 and opposite*) are in finer fettle than for many years.

Improvement in the water quality has played a part, as has the rise in the local residential population, and, not least, the surge in popularity of rowing and sailing inspired by Great Britain's recent successes in the Olympics.

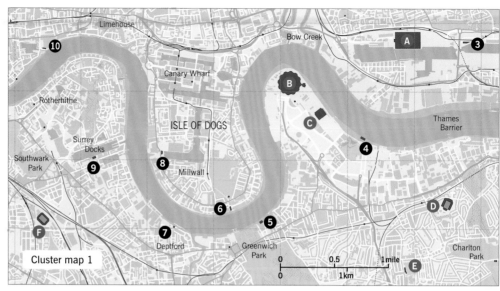

Cluster map 1

Contains Ordnance Survey data © Crown copyright and database right (2014)

Notes: where club identified, date refers to when it was founded.
Key: bh: boathouse and date (if known), **RC**: Rowing Club
YC: Yacht Club

Not shown are two clubs further east in the Borough of Bexley:

1. **Erith YC** (1900) Manor Rd DA8
2. **Erith RC** (1943) High St DA8
3. **London Regatta Centre** (2000) Royal Albert Dock E16
4. **Greenwich YC** (1908, bh 2000) Peartree Way SE10
5. **Trafalgar Rowing Centre** Crane St SE10 (bh *c.*1830s as a building), since occupied by **Curlew RC** (1866) and **Globe RC** (1923)
6. **Poplar, Blackwall & District RC** (*c.*1854, bh 1970) Ferry St E14
7. **Ahoy Centre** (2004) Borthwick St SE8
8. **Docklands Sailing & Watersports Centre** (1989) Westferry Rd E14
9. **Surrey Docks Watersports Centre** (1990) Rope St SE16
10. **Shadwell Basin Outdoor Activity Centre** (1976)

Between **Tower Bridge** and **Wandsworth Bridge** are two centres not shown on cluster maps:

11. **Westminster Boating Base** (1975) Grosvenor Rd SW1
12. **Cremorne Riverside Centre** (2008) Lots Rd SW10

Other sports-related sites on map (*see index for further references*):

A. **ExCel London** Royal Victoria Dock E16 (2000)

B. **The O2 Arena** (opened as Millennium Dome 2000, re-opened as arena 2007)
C. **London Soccerdome** (2010) East Parkside SE10
D. **The Valley, Charlton Athletic FC** (1919-85, 1992) Floyd Rd SE7
E. **Rectory Field, Blackheath Cricket, Football and Lawn Tennis Club** (1883) Charlton Rd SE7
F. **The New Den, Millwall FC** (1993) Zampa Rd SE16

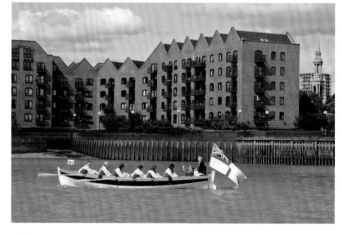

▲ Along with vintage cars and steam locomotives, historic boats are highly prized. Seen during the **Great River Race** of **2009**, this is a replica of **HMS Victory's cutter**, one of 1,200 boats on the **National Register of Historic Vessels**. Also dedicated to preservation is the **Thames Traditional Boat Society**.

One rule of the Great River Race is that each boat must carry one passenger, in this case the Mayor of Merton, seen here, aptly, as the cutter passes **Trafalgar Court**, **Shadwell**. Also apt is that on the right is **St Paul's Shadwell**. Built in 1820 and Grade II* listed, St Paul's is said to have 75 sea captains buried in its churchyard.

It is also one of 146 so-called Commissioners' Churches in London, part funded by Parliament to celebrate victory at the Battle of Waterloo in 1815.

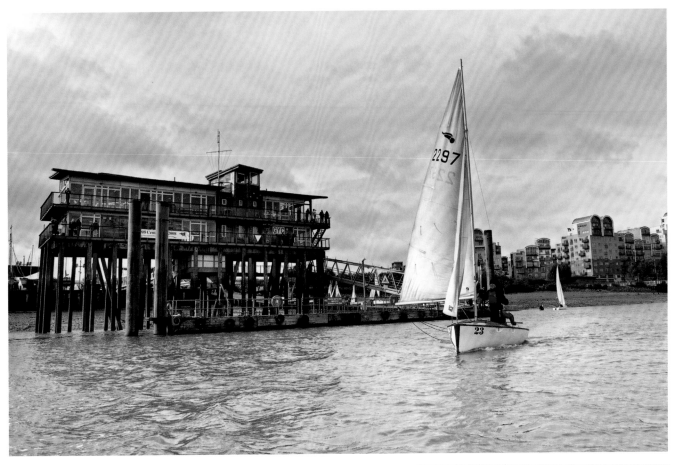

In certain light and from certain angles the headquarters of the **Greenwich Yacht Club** (*4 on map 1*) can take on the appearance of a battered, colourless old shack, marooned upon a tangle of piles.

But close to, and as the light changes (as it does so majestically around Greenwich), the building comes into brilliant focus – crisp, orderly, playful in aspect.

The club was offered this prominent spot in the 1990s when English Partnerships sought to build the Millennium Dome on the Greenwich Peninsula, where the club had been based in various, much humbler boathouses since its formation in 1908, at the **Yacht Tavern**, next door to the Trafalgar Rowing Centre (*5 on map 1*).

Designed by Frankl + Luty Architects and opened in 2000, the main clubhouse seen here is accessed via a walkway from the shore and sits on piles originally erected in the 1930s as the base of Peartree Wharf (used to load freight and materials such as tar and asphalt).

Two other buildings within the £3.5 million complex, both onshore, comprise a sailing loft, workshops and offices, behind which lies the Greenwich Peninsula Ecology Park, on the site of the former Redpath Brown steelworks.

Steel features prominently in the clubhouse, echoing its industrial neighbours to the east; cement works dominated by cranes, chutes and mounds of sand and gravel.

But in the clubhouse the structure's harder edges are softened by timber cladding, pine floors, and by an airy interior, ideally suited to social gatherings and to viewing proceedings on the water.

'Serious' water it is too, according to members. In this stretch, once called The Cape of Rough Waters, westerly winds blow hard. The currents are fierce. Commercial vessels loom large and unyielding.

Then two to three times a year the Port of London Authority (PLA) closes the Thames Barrier, creating the equivalent of a giant lake. This is the GYC's opportunity to host the **London Regatta**, seen here in 2011. Some 90 sailing dinghies compete from over a dozen clubs (whom, lest we forget, include those based at London's other sailing centres, such as Welsh Harp and South Norwood Lake).

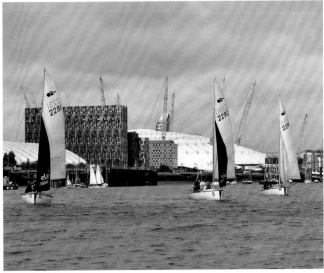

For young sailors, mastering this patch of the river is akin to a rite of passage, while for the GYC's 400 or so members, a total unparalled in the club's history, this is the closest to central London where one can genuinely sense salt in the air.

As for Londoners happier on the Thames Path, the GYC's clubhouse offers a bracing statement of modern intent, putting wind in our sails as we now venture upriver.

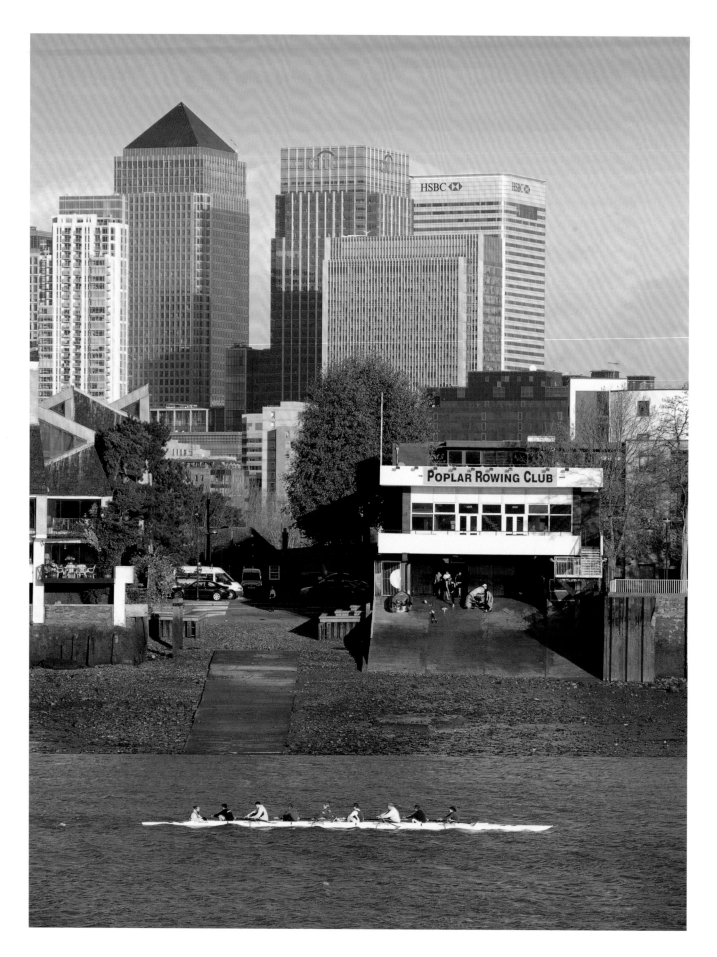

◀ Seen from Greenwich Pier in 2011, the **Poplar, Blackwall and District Rowing Club** (*6 on map 1*) might appear from its setting to have been tailor made for workers and executives in the financial sector. Instead of which, since its former neighbours Millwall FC crossed the river in 1910, the PBDRC has remained the oldest and proudest 'blue collar' sporting institution on the Island.

Competitive rowing on this part of the river dates back to at least the 1830s. On display at the **River and Rowing Museum** at Henley, for example, is a **decorated backboard** from a wherry (*below*), given as a prize at the 1852 **Poplar and Blackwall District Regatta**. The backboard (which is on loan from **The Company of Watermen and Lightermen**) states that this was the 15th anniversary of the regatta.

As to how far back the PBDRC goes, sources differ, offering various dates between 1835 and 1900.

In 1966 club stalwart Dorothea Woodward-Fisher, the PBDRC's chain smoking, whisky drinking, monocle wearing president, aka 'Dolly' (whose husband Bill, 'the Governor', won the Doggett's in 1911) gave the club's foundation date as c.1854. Yet in 1968 the club celebrated its centenary.

However to compound matters further, it then went on to mark its 150th anniversary... in 1985.

What does seem certain, from archive material collected by club captain Chris Spencer, is that the PBDRC's roots were in Blackwall, at the Lifeboat Inn (since demolished), that it was essentially a club for dockers and their sons, and that the club has been on its current site since 1937.

At that time it was called Calder's Wharf, behind which lay North Greenwich station (not to be confused with the modern station of that name across the river). This, since 1872, had been the terminus of the Millwall Extension Railway, from which passengers alighted to take the ferry to Greenwich. Or at least they did until the opening of the Blackwall Tunnel in 1897 and the Greenwich Foot Tunnel in 1902.

Conditions were primitive. The ticket office, closed in 1928, served as makeshift changing rooms, with only a barrel of water for washing. The club's clinker boats, known as 'rum tums,' were heavy and leaked, while once out on the river, members had to dodge all manner of shipping, large and small.

Even on shore they were not safe, because the adjoining slipway, known as Johnson's Draw Dock (seen in the gap between the boathouse and its neighbours) was in use as a breakers' yard, and debris often fell onto the boats.

(Island Gardens, on the club's eastern boundary, where the foot tunnel emerges, had itself been known as 'Scrap Iron Park' until it was cleared by the LCC in 1895.)

But these were tough lads, backed by a strong community of watermen, lightermen, publicans, politicians and philanthropists.

In 1956 the PBDRC made history. This was the first year since the 1870s that tradesmen had been allowed to compete at Henley. The press were therefore delighted when the PBDRC's crew beat two universities to reach the semi final of the Thames Cup.

This was followed in 1962 by member Charlie Dearsley winning the Wingfield Sculls, an event hitherto dominated by elite amateur clubs. Poplar stalwart Kenny Dwan, a waterman from Rotherhithe, then won the Wingfield seven times, while also representing Great Britain at the 1968 and 1972 Olympics.

These successes were matched in 1964 when, after years of negotiations led by Dolly and 'the Governor', the PBDRC secured from the LCC a 60 year lease on their riverside plot, at just £100 a year.

Hectic fund raising ensued, until in 1970 the current three storey boathouse was completed.

Designed by ES Boyer & Partners and recently upgraded, its location, so radically transformed in recent decades, has made the boathouse much in demand for corporate events and functions.

But changes on the Isle of Dogs have brought their own challenges.

In 1970 the club managed with 25 boats. Now, with 150 active members and post-Olympic fever attracting ever more novices, over 70 boats are needed. The club also now attracts white collar members who came to Docklands to work but have since set up home there.

Not that there is any danger of the PBDRC forgetting its roots.

It has provided more junior sculling champions than any other club, and more Doggett's winners; 45 to date, the last in 2013.

Once flanked by wharves and railways, the PBDRC may never accrue the cachet of its rivals upstream, or enjoy their calmer waters. But rowing remains as much in the blood on the Island as it is in Putney or Kingston, and, some would argue, the views are better too.

Londoners of every generation have swum in the Thames, even if most have chosen rather less hazardous stretches than these boys in 1934, at Rotherhithe. That same year, with the blessing of George V, 1,500 bargeloads of sand had been dumped to create a beach in front of the Tower of London embankment, just past Tower Bridge. Hugely popular it proved too, each summer attracting some 100,000, mainly East Enders, even though it was accessible for only a few hours a day. Tower Beach was finally closed in 1971 owing to concerns over water quality. For the same reason, despite all the measures taken since, the PLA now requires anyone wishing to swim on any part of the Tideway up to Putney Bridge to seek written permission in advance. As a campaign group called Rowers Against Thames Sewage has testified, the Tideway still has its dangers. In the meantime, Tower Beach can still be made out at low tide, and even visited on select days of the year, courtesy of the City of London Archaeological Society. More on outdoor swimming may be found in Chapter 16.

Cluster map 2

Contains Ordnance Survey data © Crown copyright and database right (2014)

▲ This second cluster map of the **Tideway** shows the location of boathouses from **Putney** to **Kew**, and includes the **Championship Course**. The course runs for 4.2 miles in either direction between **Putney Bridge** (at the point marked **S**), where both the **Boat Race** and the **Wingfield Sculls** start, and **Mortlake** (**F**), where they end.

This route is reversed for the various **Head of the River** races.

Notes: where club identified, first date refers to when it was founded.

Key: bb: boatbuilders, **bh:** boat house and date (if known), **BC:** Boat Club, **RC:** Rowing Club, **SC:** Sailing Club, **SG:** Sports Ground, **YC:** Yacht Club
• Denotes individual boat house within numbered group, listed from east to west. Where more than one club in residence, selected clubs only are listed.

13. **Hurlingham YC** (1913, bh 1929) Deodar Rd SW15
14. **Putney Embankment SW15:**
 after Glendarvon Street
 • **London RC** (1856, bh 1871)
 • **King's College School BC** (1890, bh 1970 by Barclays Bank, KCSBC 1993)
 * *bh used by Cambridge crew*
 • **HSBC RC** (1878, bh 1955)
 • **Dulwich College BC** (1991)
 • **Crabtree BC** (1997, bh c.1923 for Lensbury RC)
 • **Westminster School BC** (bh c.1860-80s for JH Clasper bb, WSBC (c.1813, bh c.1930)
 * *bh used by Oxford crew*
 • **Ranelagh SC** (1889, bh c.1870s as Unity bh for Phelps bb)
 • **Vesta RC** (1871, bh 1890)
 after Rotherwood Road:
 • **Thames RC** (1860, bh 1879)
 • **Imperial College BC** (1919, bh 1938)
15. **Wandsworth Youth River Club** (bh c.1890s) Ashlone Wharf
16. **Barn Elms SW13:**
 • **South Bank SC** (1952, bh 1977)
 • **Barn Elms BH** (1968), inc. **Parr's Priory RC** (formed as Westminster Bank RC 1872)
17. **Lower Mall, Hammersmith W6:**
 • no. 6 HQ of **British Rowing** inc. (bh c.1898, Nat Prov Bank RC 1916-72)

• no 14 (bh c.1869 for Biffen bb) **Kensington RC** (1872), **Auriol RC** (1896); **Auriol Kensington RC** (merged 1981)
• no. 19 **Furnivall Sculling Club** (1896, bh 1912)
18. **Upper Mall, Hammersmith W6:**
 • **Latymer Upper School BC** (1937, bh 1964)
 • **Linden House** (c. early C18 as house): **London Corinthian SC** (1894, at bh 1962) and **Sons of the Thames RC** (1886, at bh 2001)
19. **St Paul's School BC** (1881, bh 1973) Lonsdale Rd SW13
20. **Chiswick Pier Canoe Club** (1999) Corney Reach W4
21. **The Promenade W4:**
 • **Civil Service BH** (1930): **Cygnet RC** (1890)/**Barnes Bridge Ladies RC** (1927)
 • **Emanuel School BC** (1914, bh 1960)
22. **Chiswick Boat House** (1973) on site of Tom Green's bb, Dan Mason Drive W4: **Thames Tradesmen's RC** (1897)
23. **Tideway Scullers School** (1957) Dan Mason Drive W4
24. **Ibis Lane, Chiswick W4:**
 • **Univ of Westminster BH** (1924) for **Polytechnic RC** (1875)/**Quintin BC** (1907)
 • **Ibis Boathouse** (1915) for **Ibis RC/Prudential** (1871-1992) / from 1999 **Mortlake**

Anglian & Alpha BC formed by 1962 merger of **Mortlake RC** (1877) and **Anglian BC** (1878); merged 1984 with **Alpha RC** (1927)
25. **Putney Town RC** (1922, bh 1995) Kew Meadows TW9
26. **University of London BH** (1936) Hartington Rd W4 inc. **Univ of London BC** (1877)
27. **Strand on the Green SC** (1946) Strand on the Green W4
28. **Brentford Boating Arch** (2007) Kew Bridge W4

Not shown on maps, on either side of **Richmond Bridge**:

29. **Richmond Bridge BC** (2013) Richmond Bridge
30. **Landsdowne BH** (c.1880s for Messum bb) Petersham Rd **Richmond Canoe Club** (1944)

Other sports-related sites on map (see *index for further references*):

A. **Queen's Club** (1886) Palliser Rd W14
B. **Craven Cottage, Fulham FC** (1896) Stevenage Rd SW6
C. **Hurlingham Club** (1869) Ranelagh Gdns SW6
D. site of **Putney Velodrome** (1891-1905)
E. **Putney Town Bowls Club** (1914) Commondale SW15

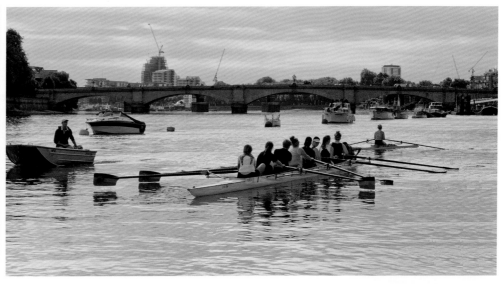

▲ A familiar scene at **Putney**, in 2013, as a rowing coach bellows out instructions across the silvery surface to a novice crew of eight.

Once a rural outpost, Putney emerged as a centre for rowing not only because the Tideway was more benign by this point, but also because the original **Putney Bridge**, built in 1729, had such narrow openings that it was tricky for rowers (or indeed most wide boats) to pass through.

Hence races such as the Wingfield Sculls, inaugurated in 1830, were originally run from Westminster to the east side of Putney Bridge, as was the University Boat Race, from 1836-42.

Then in 1846 the completion of **Putney Station** opened up the area, thereby allowing rowers an escape route from the increasingly polluted waters downriver.

Most races now started from the west side of the bridge, heading towards Mortlake, thereby establishing the pattern that continues to the present day.

But although the old bridge acted as a form of barrier, not everyone was happy when it was replaced by the current **Putney Bridge** in 1886 (designed by Joseph Bazalgette), or by the developments that accompanied it.

From an 1898 book *Rowing* (see *Links*), this is how a grumpy RPP Rowe and CM Pitman described the scene at Putney in the 1890s:

'Rowing upon the tideway is not by any means an unmixed pleasure.

'To begin with, the locality is the reverse of picturesque, if not absolutely hideous. Many of the fine old elm trees which not so many years ago adorned the banks both on the Middlesex and Surrey sides of the river have been removed, either to make room for buildings, or for the purposes of a roadway, and the picturesque Craven Cottage... has also disappeared.

'... neither is the state of affairs improved by the wash of frequently passing steamers, which, always disconcerting, has become much worse of late... owing to the extent of steep stone embankment which has replaced the former natural, gradually sloping foreshore, with its numerous inlets and masses of rushes. The waves rebound from this wall and create a nasty lipper, which takes a long time to subside and

is carried up for some distance by the flowing tide. This is trying to the most expert crew, but its effect upon a crew of novices... is absolutely demoralising.'

'From this it will be seen that the man who makes up his mind to go in seriously for rowing at Putney or Hammersmith must have his heart and soul in it, and must be prepared to put up with many inconveniences...

No doubt the water at Putney, within the hour or so immediately preceding and following high water, is more lively than is the case in non-tidal localities; but at other times it presents serious hindrances... which are of an irremediable nature, and are unknown except on broad tidal waters...

'Metropolitan clubs have neither sufficient funds to enable them to hire steam-launches for coaching purposes, nor sufficient leisure to allow of their selecting the best state of the tide for practising. Coaching must, consequently, be carried on either from the stern – which is only possible in tub-boats – or else from the bank, which can only be done at certain states of the tide; inasmuch as, when the water is low, it becomes necessary to take the boat so far out from the bank that the most stentorian tones can hardly be made to reach the offending oarsman.'

Easily missed between Putney Bridge and Putney Pier, this is the University Stone, marking the start of the Championship Course (*S on map 2*). Putney Bridge is said to be the only bridge in Britain that has a church at each end. On the far bank can be seen the 15th century tower of All Saints Church, Fulham. On the near bank, the tower of St Mary's, Putney, is of a similar age.

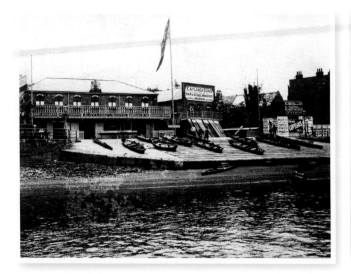

▲ Boatyards such as this, on **Putney Embankment** in *c.*1898 – owned at that time by **E Ayling & Sons** but previously by **Simmons** – played a vital role in nurturing rowing clubs. Further west stood three smaller yards, run by family firms, the Easts, the Phelps and, as seen earlier, by Jack Clasper.

Between them these businesses hired out boats, storage space, and provided changing rooms. To the annoyance of rowers some of them also hired out boats to the general public and ran day trips for sightseers.

Even after clubs started moving into their own premises, boatyards continued to perform repairs, to build racing boats to order, and to provide much needed technical expertise to amateur rowers.

The Ayling building, just before **Glendarvon Street**, remains in business today. Listed locally and still recognisable, it provides boating services under its present owners, **Chas Newens Marine**, and is now the only boatyard of its kind remaining on the Embankment.

In addition to boatyards, and in common with many other sports in their formative years, rowing depended also on pubs.

Looming large opposite the start of the Championship Course, the **Star and Garter** served as the headquarters of the **London Rowing Club** from its inception in 1856 until its new clubhouse was ready a few yards down the Embankment in 1871 (*above right*).

West of the Star and Garter stands the Grade II listed **Duke's Head**, where the basement is now a music and comedy venue known as The Rowing Club. That is because, as commemorated by a small *bas relief* above its door (*below*), from 1929-86 it served as the base of **Putney Town RC**.

Now any sports club in London that has the word 'Town' in its title is likely to have started out as a tradesmen's club.

As noted earlier, even though its members were amateurs when it came to sport, together with

watermen, and all 'mechanics, artisans and labourers', they were bracketed by the Amateur Rowing Association as 'professionals'.

Putney Town fell into that category because its members mostly worked in boatyards. Their family names were well known locally; the Corderys, the Greens (from Duke's Meadows), the Gibsons and the Cobbs. The Phelps we have already noted as having won more Doggett's Coat and Badge races than any other family. In the 1930s Ted Phelps was World Professional Champion Sculler, while in 1957, following in the wake of Poplar, Blackwall and District RC's first appearance at Henley in 1956, Putney Town went one better by becoming the first tradesmen's club to reach a Henley final.

The club is still racing today, having moved upriver to Kew

Meadows (*25 on map 2*) in 1986, and built a new boathouse in 1995.

Another Putney pub of note, in music as well as in sport, is the **Half Moon**. From 1877-91 the **Half Moon Cricket Ground**, between the pub on Lower Richmond Road and the boathouses on the Embankment (*14 on map 2*), was home to the rugby club, **Wasps** (who used **Thames RC's** boathouse as their base). They were followed by **Fulham FC** from 1891-95, before the ground was built over by housing between Glendarvon Street and Rotherwood Road.

Yet despite all the development pressures on Putney at that time, the boathouses not only survived but their amenity value formed a key element in plans drawn up by the Vestry of Putney's surveyor, JC Radford, when the Embankment was remodelled in the late 1880s.

Extending to Ashlone Wharf (*15 on map 2*) and designated a Conservation Area in 1971, as may be judged from the 1913 image above Radford's promenade has retained its character well, listed iron bollards and all.

Elsewhere in the world, comparable clusters of historic boathouses are to be found on the Yarra in Melbourne, and on the Schuylkill River in Philadelphia.

But in Britain there is nothing to equal Putney Embankment, as an early example of town planning geared specifically around the needs of boating and recreation, as a focal point for rowing, and perhaps most importantly of all, as an historic sporting cluster that all Londoners can enjoy at any time of the year, whether in, or out of the water.

▶ It is no coincidence that when strolling westwards from Putney Bridge, the first club boathouse in the cluster is also the oldest.

Seen before the start of the **2013 Boat Race** as **Cambridge** take to the water, this is the headquarters of the **London Rowing Club** (LRC), whose formation by gentlemen amateurs in 1856, and their choice of Putney as a base, paved the way for others to follow. There are today nine more boathouses along the strip, within 250 yards.

In terms of rank and prestige, the LRC is among the top rowing clubs in the country. In the south the others include the aforementioned Leander (formerly a neighbour of the LRC at Putney but nowadays ensconced in Henley), Thames RC (the LRC's oldest rivals, a few doors down), and the University Boat Clubs of Oxford and Cambridge.

Although hardly distinguished architecturally, the LRC boathouse reflects this status perfectly and is accordingly listed locally.

Designed by club member George Dunnage and opened in 1871, it has been much altered since the image seen opposite was taken, more recently to cater for the needs of female members (since 2002) and corporate hospitality.

In addition, any building that combines wet and dry use in all weathers requires constant and usually costly attention. The last major series of works in 2006 cost the club an estimated £1.4 million.

As is standard in boathouse design, boats are stored at ground level, with clubrooms and a viewing balcony above. There is also living accommodation on the upper floors and space at the rear for offices and a gymnasium.

But the building's crowning glory, literally, is its rooftop terrace.

This is a form more typically seen on racecourse grandstands of the 19th century, only three of which remain in use, at Kelso, Ludlow and Epsom.

Back inside at the LRC, a wonderful collection of paintings, photographs, decorated oars, even Doggett's badges vie for wall space.

One portrait (*page 225*) is of Ebenezer Morley, the founding spirit of the Football Association, while hanging from the ceiling of the Long Room is a 30' long sculling boat from the 1850s. This was used by founder LRC member Alexander Alcée Casamajor, who won the

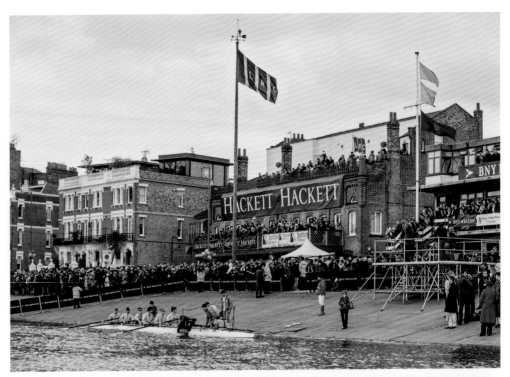

Wingfield Sculls six years in a row but died suddenly of a burst blood vessel at the age of 27, in 1861.

Months earlier 'AA' had featured amongst a group of rowers depicted in an engraving, a modern copy of which now hangs on the far wall of the **Members' Room** (*above*).

Yet while the professional Robert Coombes was, as we saw, granted an elaborate memorial at Brompton, poor Casamajor,

despite having been a popular man and aquatics editor of *The Field*, was buried, according to club historian Chris Dodd (*see Links*), in a pauper's grave in Kensal Green.

Clearly, there is no denying the LRC's roots as a gentlemen's club. It was at the vanguard of attempts to exclude professionals in the 1870s. But AA's story is a reminder that not all 'gentlemen' were wealthy or well connected.

Instead, what bound these oarsmen together and laid the foundations of Putney's overriding amateur ethos, was the spirit we see on this page, on Boat Race day and around the table at the club's monthly committee meeting.

That is, a serious commitment to a demanding sport, and to winning, combined with a deep attachment to the river that flows just beyond their threshold.

▶ Glowing in the morning light after its £1.1 million revamp by Panter Hudspith Architects in 2011, this is the last but one boathouse within the **Putney Embankment** cluster, that of the **Thames Rowing Club**.

Formed in 1860, for the first two years the TRC was known as the **City of London RC**, a reflection of the fact that its founders worked in drapery warehouses in the City.

Frederick Catty, the first captain, who also rowed for the LRC, was a clerk at the Bank of England.

Again it becomes apparent that the status of being a 'gentleman' was not as clear cut as we imagine it from today's perspective.

Initially TRC's members were interested only in 'organised pleasure or exercise rowing'. But they soon caught the racing bug and by 1870, having achieved their first honours at Henley, became the LRC's closest rivals (a rivalry that is now one of the oldest in London sport).

In common with the LRC, the TRC's boathouse is listed locally, and oozes with history. But as a structure it is quite different.

Designed by HT Sugden and opened in 1879, it takes the form of a typical Victorian, colonial-style summer house (perhaps influenced by Sugden's early years in Bangalore). Boating activity is concentrated on the ground floor and in the **Burrough Building** at the rear, opened in 2005 and housing gyms, a workshop and an indoor rowing tank. Thames were the first club to have installed such a training aid, in 1905.

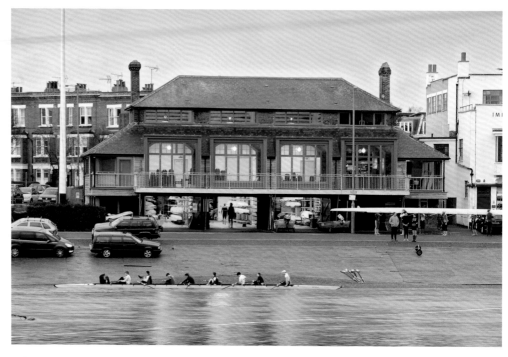

The first floor is dominated by the **Great Hall**, light and airy thanks to its clerestory openings and wide French windows that open out onto the modern verandah (*below left*).

Managing historic buildings of this nature demands sensitivity, and discipline. On one hand here is a functioning clubhouse for members who wish to feel at ease and for whom, after a hard session out on the water, tidiness or decorum may not be paramount. Yet for the books to balance, the function rooms must be kept neat and tidy for hiring out to third parties.

Even the display of memorabilia becomes a balancing act; between the historical significance of an artefact and its aesthetic merits, and between the desire to reflect the club's heritage across all periods (not only the more picturesque Victorian and Edwardian eras), yet also not to clutter interiors that may be hosting a wedding one day and a business reception the next.

One fixture in the Great Hall is the TRC's **war memorial** (*right*), centred around Hugh G Riviere's evocative work, *In the Golden Days*.

Among the names of the fallen from the First World War is Eric Fairbairn, nephew of the Australian **Steve Fairbairn**, who first rowed for Thames in 1884 whilst at Cambridge and who went on to become the world's most influential rowing coach. His portrait hangs near the bar, and there is a side room named after him too.

Fairbairn left Thames to coach rivals LRC in 1926 after a bust up with Julius 'Berry' Beresford (whose son Jack we will come to later).

Berry is another character whose story challenges our notions of how social divisions operated within amateur sport. Born in Poland as Julius Wiszniewski, he established a furniture factory near Old Street – yet was not considered a tradesman – and in 1912 rowed for Great Britain at the Stockholm Olympics. Two years later when war broke out he changed his name to Beresford.

Amongst many achievements in rowing, Berry coached various TRC crews to a record run of successes at Henley in 1927 and 1928.

Meanwhile, as at many clubs, rowing was not the only sport pursued at the TRC. Boxing nights were a regular attraction, at least until Steve Fairbairn stopped them, to avoid hands being damaged.

Rowers were also active in athletics. Most notably, in 1867 TRC member Walter Rye organised London's first ever steeplechase, which in turn led to the formation of what is now London's oldest running club, the **Thames Hare & Hounds** (*see page 310*).

Rye was another great advocate of amateurism, but like most of his contemporaries would sooner have acknowleged a professional than he would a woman in a boat.

How different is life at Putney today. In 1972 the TRC were one of the first male-only clubs to admit women, so that together with the men, veterans and novices, female rowers now make up a substantial proportion of the TRC's active membership of around 200, the largest overall in British rowing.

The club would love to enrol more, but this being London there is of course barely an inch to expand.

▶ Across Rotherwood Road from the TRC, **Vesta Rowing Club** was formed in 1870 at the Baynard Castle Tavern, Blackfriars (now the Cos Bar), by staff at the same drapery warehouses where the TRC founders worked, in the vicinity of St Paul's. The story goes that they chose the name Vesta from the first ship they saw passing on the river.

In its early years Vesta rowed from the Feathers Boathouse, Wandsworth, by the mouth of the Wandle (now the site of a waste transfer centre). Next to this, the Feathers Tavern was run by Jack Clasper's family, who, according to the Census, had as their lodger in 1881 the celebrated professional swimmer Willie Beckwith, one of the celebrated Beckwith Frogs.

It really was a close knit world amongst those who made their living on the Thames.

By 1875 Vesta had moved to Putney, to rent space in the Unity Boathouse (now Ranelagh SC), which was run by the Phelps family, next door to Jack Clasper's boatyard.

Finally, in 1890, Vesta settled in their current boathouse, which they shared for many years with George Sims & Son, the boatbuilders.

Among many noted members have been Harry Blackstaffe (a butcher, boxer, distance runner and gold medallist in the single sculls at the 1908 Olympics), Harry Tate (a music hall star said to have discovered his calling at an impromptu concert staged by Vesta on a rainy Boat Race day in the 1890s), and Ted Phelps (whose 1938 Doggett's Coat and Badge are on display in the clubroom).

On the TRC's west side stands the boathouse of **Imperial College** (*centre*). With its wavy rendering and Crittall windows it was opened by Lord Desborough in 1938 and designed by Brian Sutcliffe, architect of an equally Moderne grandstand in Isleworth (*page 112*). To the right is an extension by John McAslan & Partners, opened in 2000.

From here, a short distance upstream on the Middlesex bank stands **Craven Cottage** (*right*), where Fulham's plans for a larger Riverside Stand have led to fears at two sailing clubs, Ranelagh and South Bank (*16 on map 2*) that wind patterns will be adversely affected.

Calm though it appears on this stretch of the river, there is always something in the water at Putney.

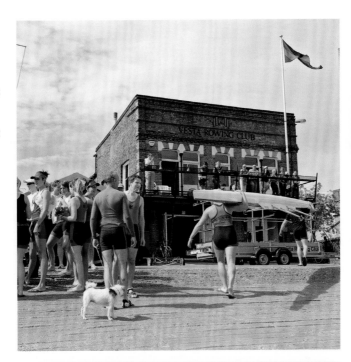

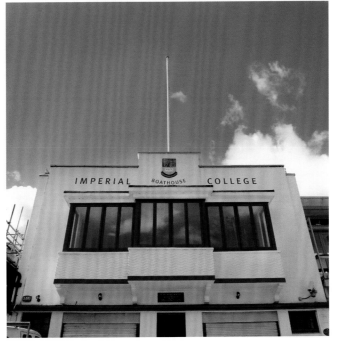

▲ Backing onto the **Wetlands Centre** on the Surrey bank, just past Craven Cottage and Barn Elms, is the **Steve Fairbairn Memorial**.

Erected by the four clubs that he coached – the TRC, LRC, Jesus College, Cambridge and Leander – the memorial acts as marker exactly **one mile** from the start of the Championship course.

Born in Melbourne and often called the father of modern rowing, Fairbairn (1862-1938) was a big man with a big voice and ideas that ran counter to orthodox thinking in English rowing. Oarsmen, he believed, should relax. He said, 'If you can't do it easy, you can't do it at all'.

Reflecting this mindset, recent published histories of the LRC and TRC (*see Links*) both take as their titles phrases from a poem by Fairbairn, *The Oarsman's Song*. In this he writes of the 'water boiling aft' as the oarsman drives his blade through, and in doing so 'hears the boat sing'.

Yet Fairbairn was no laid-back Aussie, for he also argued that 'mileage makes champions'. That was one reason why, in 1926, he initiated the first **Head of the River Race**, a race against the clock, to encourage more clubs to train throughout the winter.

For the men's eights the trophy is a bust of Fairbairn, sculpted in 1931 by George Drinkwater, himself a rowing coach and eloquent writer.

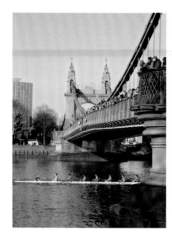

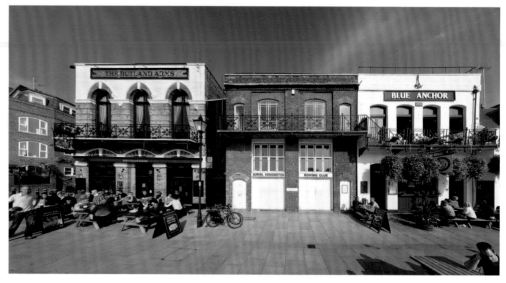

▲ As one of the 299 entries to the 2011 **Women's Eights Head of the River Race** rows towards Putney, we cross over to the Middlesex bank via Sir Joseph Bazalgette's Grade II* listed **Hammersmith Bridge** – a prime vantage point on race days since its opening in 1887 – and head upstream along **Lower Mall** (*17 on map 2*).

Here, according to Pevsner, is Hammersmith's finest street, lined by Georgian houses and nowadays, thankfully, car free.

Close to the bridge at number six (not illustrated) is **The Priory**, a Grade II listed, late 18th century house in which **British Rowing** (formerly the Amateur Rowing Association) has been based since 1974. Formerly home to the National Provincial Bank RC, its boathouse is under a prominent bow window adjoining the offices.

A few doors up are two pubs, both heaving on Boat Race days; the **Blue Anchor**, which claims to have been first licensed in 1722, then the Victorian **Rutland Arms**.

In between (*above right*), stands number 14 Lower Mall. This was built in c.1869 as the **Anchor Boathouse** for **William Biffen**, boatbuilder, whose family also ran the Blue Anchor and who operated a second boatyard a few doors away (now flats).

In his 1885 *Dictionary of the Thames,* Charles Dickens Jnr listed seven clubs based at Biffen's. One of them, with club rooms at the Blue Anchor, was **Kensington RC**, formed in 1872.

Then in 1896 **Auriol RC** formed, and made its base the Rutland.

After Biffen's closed, Auriol bought number 14 in 1948 and turned the first floor into its club room, while renting the second floor to Kensington, until in 1981 the two merged to form **Auriol Kensington RC**.

Also of interest is the former **Rutland Boatyard**, still extant behind the Rutland pub, where in 1947, a rare occurence, George Sims built both the boats used in the University Boat Race that year.

Back on Lower Mall, not visible in the image above, a modern, third storey, set back from the roof, was added to number 14 in 2004, while above the white side door on the right a plaque commemorates Scottish sculler **William 'Wally' Kinnear** (1880–1974), who won a gold at the 1912 Olympics and was a Kensington member for 69 years.

Kinnear took up rowing whilst working at Debenhams, the

department store, which as it happens was just the sort of place where members of another club formed in 1896 were likely to have worked; there, or in other stores, or places like the ABC café in Bloomsbury, where an old bearded gentleman, **Frederick James Furnivall** (*see below*) used to hold court in between researching manuscripts at the British Museum.

A philologist first and foremost – he co-founded the Oxford English Dictionary – Furnivall fervently believed that working people should have access to education. Thus with Charles Kingsley and Thomas Hughes he helped set up the Working Men's College in 1854.

The river was another passion. In 1896, Furnivall, now aged 71, created the **Hammersmith Sculling Club for Girls**, based in a former coffee house that is now number 19 Lower Mall. One of the club's first boats was a gift from Furnivall's friend, George Bernard Shaw.

This was not London's first club for women. Homerton College set up a rowing club on the River Lea three years earlier, and the Polytechnic RC would also soon have a women's section.

But in any case, in its early years Furnivall was mainly concerned for the members, most of them shopgirls, waitresses and students, not to race but simply to enjoy their day off, even if that meant shocking other clubs by meeting on Sundays.

Their routine was to scull in a group from Lower Mall to Richmond and back, a distance of 14 miles, stopping for a picnic along the way.

In 1901 men were admitted, although they were not allowed to be captain, while Furnivall himself continued to scull every Sunday until just before his death in 1910.

In his honour the club was renamed the **Furnivall Sculling Club for Girls and Men**, and the premises purchased in 1912.

By the time the image (*opposite top*) was taken in the 1920s, the few women's clubs that existed had combined to form the Women's Amateur Rowing Association in 1923. This, in turn, led to the first women's Head of the River Race in 1927. Only two crews entered, one from Weybridge, and the Ace RC from Barnes.

Most of the men observing that day expected the women to struggle to complete the Putney to Mortlake course, or at best to complete it in a state of exhaustion.

Instead of which, as reported in the *Daily Express*, Miss Brewer, captain of the Ace crew, said breezily afterwards, 'We are not in the least tired. After tea is over we are all going to a dance.'

Old fun loving Furnivall would have been thrilled, although women still had to wait until 1976 before being allowed to row in the Olympics, and until 1981 at Henley.

Said to have been the inspiration for Kenneth Grahame's Ratty, in *Wind of the Willows*, Frederick Furnivall was a scholar, sculler, vegetarian and teetotaller, who sported pink ties, despised 'narrow class humbug', and was always happy in the company of women. Apart from the sculling club, also bearing his name are gardens next to Lower Mall, laid out in 1951 on the site of Hammersmith Creek.

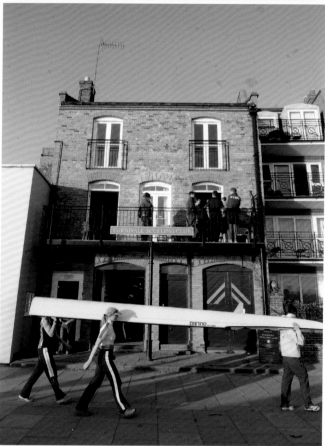

Membership of the Furnivall Sculling Club, still at number 19 Lower Mall, is nowadays evenly split between the sexes. But as told by Elizabeth Carter (*see Links*), in the post war years women deserted the club. Fortunately this neglect of its heritage was rectified in the 1980s, culminating in the appointment of the club's first female captain since the 1930s, in 2001.

▲ Continuing to **Upper Mall** (*18 on map 2*) we now enter the territory of another champion of women's rights, the MP and writer **AP Herbert** (1890-1971) who lived in **Hammersmith Terrace**, where he has a blue plaque, and was a regular at both the **Black Lion** (where famously he played and promoted skittles) and **The Dove**.

Herbert was also a member of the **London Corinthian Sailing Club**.

Formed in 1894, the club is based at **Linden House** (*above*), an early 18th century Grade II listed house, part of which had been rented by the J Lyons & Co rowing club between the wars.

The LCSC moved there in 1962 but could hardly be expected to maintain such a large, historic property. In 2001 the **London Corinthian Trust** was therefore set up to run it as a charity, with the sailing club as tenants, along with another rowing club, the **Sons of the Thames**, formed by watermen in c.1886.

Because like Linden House most of **Upper Mall** is Georgian or Victorian in character, two modern buildings in its midst stand out.

The first, erected in 1964 by Hammersmith Council, is a **Race Starter's Box** (*above centre*), winner of a Civic Trust award, while further east is the boathouse of **Latymer Upper School** (*above right*).

Designed by Richard Seifert & Partners and also completed in 1964, this forms part of a school campus that stretches back to the Great West Road and, via a private subway, to King Street beyond (and which includes a 1930s former squash court, *see page 291*).

On the front of the boathouse a plaque honours former pupil **Andy Holmes**, who won Olympic golds in 1984 and in 1988, and in later life was Director of Rowing at Furnivall. Much admired and always modest, Holmes died in 2010, aged 51, from Weil's disease, a rare, waterborne bacterial infection whose deadly effects are a reminder that for all its delights, the river is never without its dangers too.

▶ Crowds perch on the slipway of **St Paul's School** (*19 on map 2*) as both crews heave around the **Surrey Bend** during the 156th **Boat Race** in April 2010. Hammersmith Bridge is hardly more than 140 strokes back, and yet already it feels as if London is being left behind.

Other than current and former Oxbridge students, rowers and gamblers, precious few onlookers care who wins or loses. Yet still they come back, year after year, packing the embankments and bridges, peering out from balconies, windows and rooftops.

Others huddle along the tree-lined banks, as here, where there are no barriers, physical or social.

Trousers are muddied. Shoes get dunked as the flood tide seeps in, catching out the unaware.

It is on this next stretch that two otherwise inconsequential features gain their annual moment of fame.

On the Middlesex bank is the **Blue Window** (*BW on map 2*).

This looks out from the former Durham Wharf studio of artists Julian Trevelyan and Mary Fedden, whose Boat Race parties were once legendary.

The window marks almost exactly the course's half way point.

Then past the Eyot come the **Chiswick Steps** (*CS on map 2*). These, despite their name, are on the Surrey bank, where until the 1930s they acted as the stepping off point for the ferry from Chiswick Church, on the other side.

For crews the steps mark the point where, following the Surrey Bend, the advantage can start to switch to the crew on the Middlesex station. As such they constitute one of four key points along the course at which the crews' times are officially logged. (The others are the Mile Post, Hammersmith Bridge and Barnes Bridge.)

Once passed, the steps slip back into anonymity as the hubbub builds towards the final push.

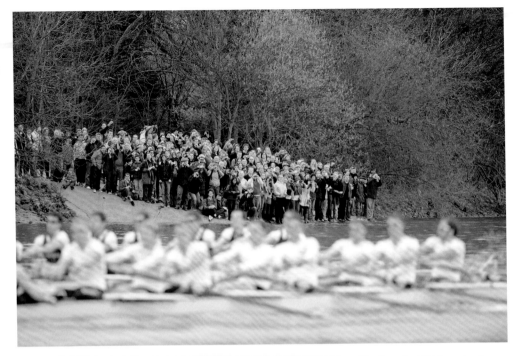

◀ Back on the Middlesex bank, lying between two further Boat Race landmarks – the **bandstand** at **Duke's Meadows** and **Barnes Bridge** – are two boathouses in contrasting styles (*21 on map 2*).

The earlier (*left*) was built in 1930 by the **Civil Service Rowing Association**, as an adjunct to the Civil Service Sports Ground, opened four years earlier (*R on map 2, see also page 130*).

Staff from the Civil Service, who had taken part in rowing since at least 1864, invited **Cygnet RC** to move into the new boathouse and by the 1950s were competing under Cygnet's name.

Cygnet itself had formed in 1890, originally as a club for white collar staff at the General Post Office. Before coming to Duke's Meadows they had been based first at Ayling's in Putney, with clubrooms in the Duke's Head, then Biffen's in Hammersmith, with rooms at the Rutland.

Today Cygnet share the boat house with **Barnes Bridge Ladies RC**, formed by female civil servants in 1927 and now one of only two women-only rowing clubs in Britain (the other being at Weybridge).

Next door, belonging to the **Emanuel School Boat Club**, formed in 1914, is the **Wates Boathouse** (*left*), named after its benefactors.

Opened in 1960, it was designed by Laurence King & Partners and remains one of finest examples of its period on the Tideway.

▶ Viewed from the south in the 1920s, this is **Tom Green's Boathouse**, eerily isolated on the tip of **Duke's Meadows**, with only passing boats and trains for company, plus the twinkle of lights from Barnes on the opposite bank of the river.

Born into a family of watermen, Green established the boathouse in 1876, four years after he won the Doggett's Coat and Badge race.

Unlike his rivals at Putney and Hammersmith, Green had no pubs, nor even roads within the immediate vicinity.

Chiswick station, opened in 1849 and serving the growing but exclusive **Grove Park** estate to the north, lay nearly a mile away across open fields.

Instead, unless arriving by water it was quicker to take the train to Barnes, then cross the river to Green's via a pedestrian walkway that the London & South Western Railway had thoughtfully provided when building **Barnes Bridge** in 1846.

Jolly popular this walkway was too on Boat Race days, when the company sold thousands of tickets to the public, even though the view was apparently much obscured.

The current Barnes Bridge, dating from 1895, also has a walkway, but this has been closed to spectators in recent years on safety grounds.

By the 1930s access to Green's had improved, largely thanks to Chiswick Urban District Council's decision to spend £150,000 on buying up some 200 acres of the meadows from the Duke in question, the Duke of Devonshire, thereby saving the area from wholesale development.

As seen on map 2, and outlined further on page 130, Duke's Meadows subsequently emerged as one of London's most important focal points for amateur sport; home, *inter alia*, to the Civil Service, the Polytechnic, the Prudential's Ibis Sports Club and the Masonian Athletic Club, formed for workers at the Cherry Blossom factory, whose co-founder is commemorated by **Dan Mason Drive**, now running along the river bank seen above.

Green's Boathouse blossomed too. In 1939, by which time Green's son, also Tom, was in harness, sixteen clubs were based there, representing mostly schools and companies, including Emanuel School (before their own boathouse opened on the

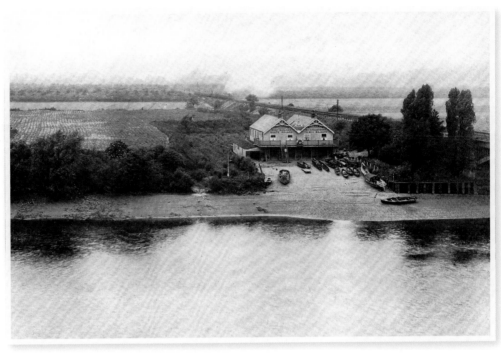

other side of Barnes Bridge in 1960, *see opposite*), Times Newspapers, the News Chronicle & Star, and Odham's Press.

After Tom Green Junior retired in 1950, aged 77, his wife 'Ma Green' kept up the business, until finally she died and Hounslow Borough Council built the current boathouse on the site.

Seen at the time of its opening in 1973 (*below*), with the familar bowstring trusses of Barnes Bridge beyond, **Chiswick Boathouse** (*22 on map 2*) was designed in reinforced concrete by the Borough Architect, George A Trevett.

Serving also as a pavilion for the adjoining playing fields, it remains in use by various local community groups and schools, and by the **Thames Tradesmen's RC**, formed in 1897 and previously based at Strand on the Green.

Nowadays most Londoners bypass Duke's Meadows on the A4 or speed through them on the Great Chertsey Road.

They miss a treat; if not quite as bucolic as above, a magical place of recreation, and of retreat all the same.

Boat Race day in 2010 as the White Hart, Barnes, one of ten riverside pubs along the Championship Course, fills up in anticipation. Located opposite the Chiswick Boathouse, the original pub on the site was a favourite haunt of local solicitor Ebenezer Morley, founder of the FA and member of the London RC. The current building dates from 1899.

▶ **Mortlake** is known primarily for marking the end of the **Boat Race**, and for being home to the **Stag Brewery**, whose prominent eight storey **maltings** were built in 1902.

Much to the chagrin of the BBC, who started televising the race in 1938, huge banners on the side of the maltings used to convey such messages as 'We Want Watneys,' leaving viewers in no doubt as to its owners. (Nowadays Budweiser lager is brewed on the site.)

In the 2010 Boat Race, as seen here, **Cambridge** triumphed, in front of the usual masses crammed onto **Thames Bank**, just before Chiswick Bridge. By this stage of the afternoon space on the bank is shrinking almost as fast as the light is fading, as the flood tide nudges the crowds ever further back.

(More wet toes. More reminders to wear wellies next year.)

Meanwhile staff in **The Ship**, the Regency-style pub in the centre, prepare for the post-race rush, as they have done since the 1840s.

But pubs are not the only beneficiaries of the race. For community groups the likes of St Mary's, Mortlake, and the 5th Putney Scouts, earnings from tea and biscuits, bacon rolls and loo access make Boat Race day one of the most lucrative in the calendar.

Hardly surprising. Recent reports claim that crowds of up to 250,000, more than three times the capacity of Wembley Stadium, line the course from Putney to Mortlake, a distance of four miles and 374 yards. Millions more in Britain and in at least 120 countries watch live on television.

Not bad for a contest that rarely lasts more than 18 minutes and is more often than not decided by the time the crews pass Barnes Bridge.

As of 2013 the fastest time on the course was 16.19 minutes, by Cambridge in 1998, while the closest ever finish, by Oxford, was by just one foot, in 2003.

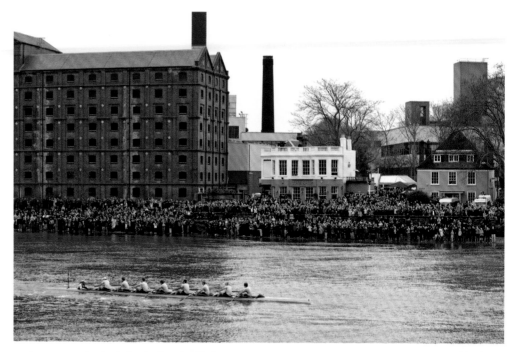

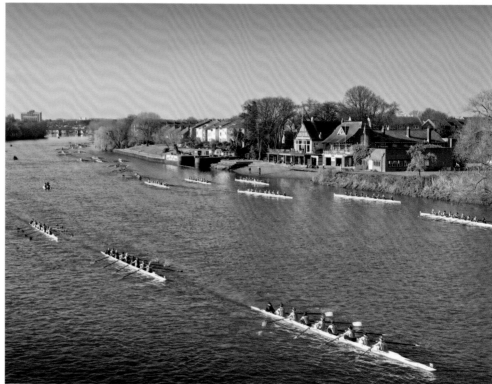

▲ For the Boat Race thousands line the Thames to watch two eights race from Putney to Mortlake on the flood tide. For the **Head of the River Race** (also for men's eights) and its counterpart for women's eights, for fours, pairs and scullers, it is the exact reverse. Thousands of oarsmen and women race between Mortlake and Putney on the ebb tide, watched only by friends, family and curious passers-by.

Yet amongst rowers, the Tideway Heads have never been more popular. In the men's eights, initiated by Steve Fairbairn in 1926, an entry cap of 420 crews – that is 3,780 oarsmen and coxes – has been in force since 1979. For the women's eights the limit is 320.

Crews race not against each other but against the clock, meaning that rigorous organisation is vital. Having found their allocated slipway

(if coming from out of town) crews have to prepare their boats, row to the marshalling point, as seen above from **Chiswick Bridge** in 2011, set off at ten second intervals, and then, after their exertions – the record time for the men's eights stands at 16.37 minutes in 1987, and for the women 18.06 in 2000 – row back from Putney to their original base.

You need a lot of heart, and good lungs, to compete in the Heads.

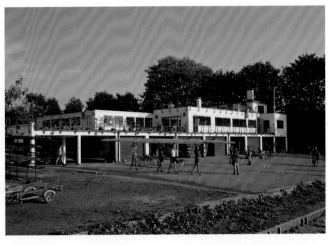

▲ Once a year this adjoining pair of boathouses on **Ibis Lane** (*24 on map 2 and opposite below*) host the ceremonials at the end of the **Boat Race** against a backdrop of popping corks, sponsors' banners and frenzied television crews.

The rest of the year they enjoy a rather less frenetic existence.

Nearest the camera, the **University of Westminster Boathouse** was built in 1924 for the rowing club of the University's predecessor, the **Polytechnic.**

However, in form the building closely resembles the Poly's original timber boathouse, built on the site in 1888 at a cost of £800 and paid for, along with a full complement of rowing boats, by the Poly's founder and benefactor **Quintin Hogg.**

An Old Etonian sugar merchant and devout Christian, Hogg died in 1903 and is commemorated by a statue in Portland Place and by the **Quintin Hogg Memorial Sports Ground** (*O on map 2*), laid out on the north side of Ibis Lane in 1906.

The following year the Poly formed a second rowing club at the boathouse.

Still operating today, the **Quintin Boat Club** was set up specifically for Poly members whose work status allowed them to compete as amateurs (whereas other

Poly members were deemed by the ARA to be professionals).

As noted earlier, this distinction was eventually dropped in 1938, and so in 1951, after the boathouse had been patched up following war damage, the original **Polytechnic RC** (which had formed in 1875) effectively merged with Quintin.

But if the founder's name had been kept alive, so had his founding spirit. For example the Polytechnic's governors deliberated long and hard before acceding to Quintin's request to set up a bar in the boathouse.

Just as well too, for the takings on Boat Race days have provided a tonic for Quintin ever since.

The feeling is the same next door at the **Ibis Boathouse.**

Formed by clerical staff at the Prudential in *c.*1878, the **Ibis Rowing Club** took over the site in 1886 and built the core of the current boathouse, unusually, during the First World War, in 1915. It was then extended during the 1980s, only for the Prudential to sell it in 1991 to North Thames Gas.

This was so the gas company could rehouse its own rowing club, **Horseferry RC**, whose boathouse by Kew Bridge had been sold for redevelopment. (The club took its name from Horseferry Road, where the Gas Board offices had been.)

Meanwhile, on the Surrey bank changes were afoot at another historic club, the **Mortlake Anglian & Alpha Boat Club** (MAABC) which, as its name suggests, evolved from a series of mergers.

Mortlake RC had formed in 1877 at The Ship, but had moved west along the bank to a spot opposite Ibis in the early 1900s (*close to 25 on map 2*).

In 1962 Mortlake were joined by **Anglian RC**. Formed in 1878, Anglian had previously been at Maynard's boathouse on Strand on the Green, Kew, then after 1937 at Tom Green's, on Duke's Meadows.

Also based at Tom Green's was **Alpha RC**, a women's club formed in 1927. This merged with Mortlake Anglian in 1984 and, by attracting an influx of female rowing talent, effectively saved the club and gave it the character it enjoys today, with over 200 members.

For years MAABC members looked out jealously from their modest boathouse, built by Barnes Council in 1963 next to the local crematorium, to the facilities on the opposite bank. Then in 1999 their wish came true. North Thames Gas decided to sell the Ibis Boathouse, while a bequest from a member meant that the MAABC was in a position to buy it.

Being handily placed for the end of the Boat Race is undoubtedly a bonus for both the MAABC and Quintin. Another occurred back in 1933, with the completion of the Great Chertsey Road and the opening of Chiswick Bridge.

Until then both boathouses had been almost as remote as Tom Green's. Now, with easier access, developers such as Kinnaird Park Estates (set up by the former amateur footballer and canoeist, Lord Kinnaird) moved in to build houses on the empty plots in and around Grove Park.

One such plot, just past Kinnaird Road on Hartington Road, was filled in 1936 by the **University of London Boathouse** (*26 on map 2 and above*).

Designed by Thompson & Walford, architects also of the University's Motspur Park grandstand (*page 113*), and extended in 1937 and again in the 1950s, this splendid Modernist boathouse was in development at the same time as the Polytechnic's similarly Modernist grandstand, opened in 1936, at the other end of Hartington Road (*page 112*).

Listed Grade II, as is the grandstand, the boathouse is well worth looking out for when crossing Kew Railway Bridge.

ENGLISH HERITAGE

JACK BERESFORD 1899-1977 Olympic Rowing Champion lived here 1903-1940

Before Messrs Redgrave and Pinsent came along, Britain's greatest Olympic rower was Jack Beresford, whose blue plaque may be seen at 19 Grove Park Gardens W4, a short stroll from the University of London boathouse. Beresford was the son of Julius Wiszniewski, the Polish-born furniture manufacturer who, as noted earlier, rowed for Great Britain at the 1912 Olympics.

Jack preferred rugby, but after being wounded in the leg in battle in 1918 he joined his father at Thames RC and went to work in the family business. All told he competed in five Olympics and won five medals, the last being a gold at Berlin in 1936 where, to the annoyance of Adolf Hitler in the stands, he and fellow west Londoner Dick Southwood pipped the Germans in the double sculls.

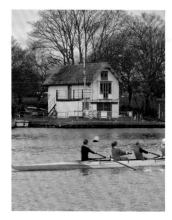

▶ Our third cluster map shows where the **Tideway** meets the lock at **Teddington** (or 'Tide End Town' as Rudyard Kipling so aptly called it) and where the gentler, non-tidal Thames begins; the river of Jerome K Jerome, of Henley, and of the **Twickenham Sea Cadets** (*above and 38 on map*), whose corrugated iron boathouse belongs to one of around 30 such units in London.

The Corps was first established in Whitstable in the 1850s for boys orphaned during the Crimean War.

Just north of Teddington Lock, an obelisk erected in 1909 marks the point where control of the river passes from the PLA to the Environment Agency.

As the map shows, notions of a city split between 'north' and 'south' of the river become redundant.

Moreover, while on the Surrey bank, west of **Thames Sailing Club** (*42*), the boundary of Kingston, and therefore of London, gives way to the Borough of Elmbridge (in Surrey), on the Middlesex bank London (in the form of the Borough of Richmond), carries on westwards beyond Bushy Park, as far as Kempton Park.

And so the river meanders on, still confounding our geographic assumptions; calmer, less urban, yet still busy with sporting activity and very much a focal point of the capital's sporting heritage.

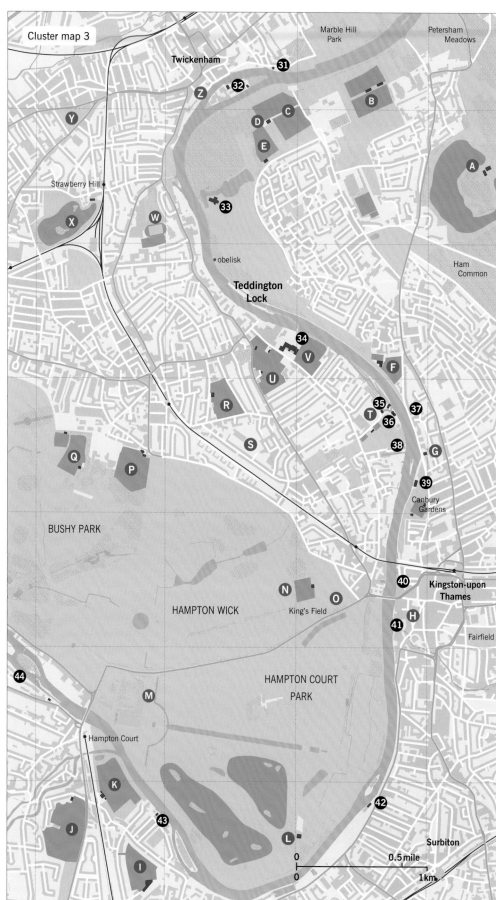

Contains Ordnance Survey data © Crown copyright and database right (2014)

Notes: where club identified, date refers to when it was founded
Key: bh: date of boat house (if known) **BC:** Boat Club **RC:** Rowing Club **SC:** Sailing Club **SG:** Sports Ground **YC:** Yacht Club
• Denotes individual boathouse within group at named location, listed from north to south.

31. **Twickenham YC** (1897, bh c.1900) Riverside TW1
32. **Twickenham RC** (1860, bh 1880) Eel Pie Island TW1
33. **Thames Young Mariners Outdoor Learning Centre** (c.1951) Riverside Dr TW10
34. **Lensbury Watersports Centre** (c.1938)
35. **Trowlock Way TW11**, inc. **Rob Roy bh** (c.1901) and former **BP bh** (1961), shared by: **Royal Canoe Club** (1866), with own bh on Trowlock Island (2008)/**Skiff Club** (1895)/**Walbrook RC** (1961)/**Kingston Royals Dragon BC** (1988)
36. **Trowlock Way TW11:**
 • **Tamesis SC** (1885, bh 1903)
 • **Ariel SC** (1934, bh 1988)
37. **Lower Ham Road KT2:**
 • **Leander (Kingston) Sea Scouts** (1909, bh 1987)
 • **Albany Park Canoe & Sailing Centre** (1986)
38. **Twickenham SeaCadets** (1932, bh c.1950s) Fairways TW11
39. **Canbury Boathouse** (1968) Lower Ham Rd KT2 **Kingston RC** (1858)/ **Tiffin School BC** (1890)
40. **Kingston & District Sea Cadets** (1912, bh 1998) Steadfast Rd KT1
41. **Minima YC** (1889, bh c.1896 as Neilson's sail loft, club 1969) High St KT1
42. **Thames SC** (1870, bh 1870) Portsmouth Rd KT6
43. **Queen's Road KT7:**
 • **Dittons Skiff & Punting Club** (1923, bh 1997)
 • **River Club** (1934, bh 1982)
 • **Kingston Grammar School BC** (1890, bh 1980)
44. **Molesey BC** (1866, bh 1901) Barge Walk KT8

Not shown on map are two further boathouses to west, on Middlesex Bank within Borough of Richmond:

45. **Hampton SC** (1944, bh 1962) Benn's Island TW12
46. **Aquarius SC** (1948, bh 1952) Sunnyside, Lower Sunbury Rd TW12

Other sports-related sites on map (*see index for further references*):

A. **Richmond Golf Club** (1891)
B. **Ham Polo Club** (1926)
C. **King George's Field** (1936)
D. **Ham & Petersham Rifle & Pistol Club** (1903) Ham St TW10
E. **Kew & Ham Sports Association** Ham Playing Fields, TW10 inc. **Kew AFC** (1906)/**Old Blues FC** (2011)/**Richmond Baseball Club** (1992)
F. **YMCA Hawker Centre** Lower Ham Rd KT2 (c.1944 for Leyland Motors, later Hawker Aircraft/British Aerospace)
G. former **Albany Boathouse** of **RJ Turk & Son** boatbuilders (1893), Lower Ham Rd, also **Royal Canoe Club** (1893-97)/**The Skiff Club** (1897-1972)/**Kingston RC** (1935-68) now offices
H. **Kingston Market Square** site of Shrove Tuesday football
I. **Old Pauline Club SG** (1930) St Nicholas Rd KT7
J. **Old Tiffinians, Grist Memorial SG** (1944) Summer Ave KT8
K. **Kingston Grammar School SG, Ditton Field** (1965) KT8
L. **Hampton Court Palace Golf Club** (1895) Home Park KT1
M. **The Royal Tennis Court** (1625) Hampton Court KT8
N. **Hampton Wick Royal Cricket Club** (1863) Park Road KT1
O. **Kings Field Skate Park** (1998) Hampton Court Rd KT1
P. **National Physical Laboratory SG** (c.1930) Queens Rd TW11
Q. **Bushy Park TW11** inc: **Teddington CC** (c.1827)/ **Teddington Town CC** (1891)/ **Teddington RFC** (1966)
R. **Imperial College SG** (1988) Udney Park Rd TW11
S. site of **Harlequin FC** ground Fairfax Rd TW11 (1925-70) now Collis Primary School
T. **Teddington School** Broom Rd TW11, inc. **Teddington Hockey Club** (1871)
U. **St Mary's College, Teddington Lock SG** Broom Rd TW11 also **Teddington HC** (*as above*)
V. **Lensbury Club** (1920, clubhouse 1938) Broom Rd TW11
W. **St Mary's College** Strawberry Hill TW1 (1925)
X. **Strawberry Hill Golf Club** (1902) Wellesley Rd TW2
Y. **Twickenham Green TW2** **Twickenham CC** (1833)
Z. site of **Twickenham Lido** (1935-80) now gardens

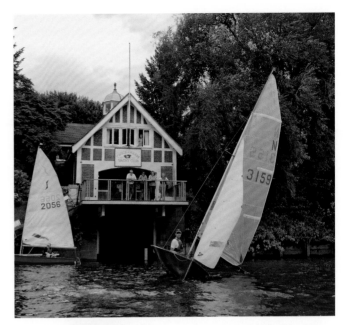

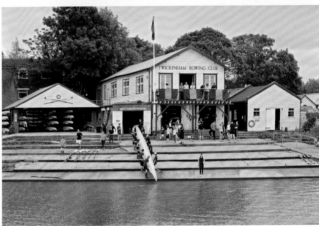

▲ Accessed through a gate on a narrow back lane called **Riverside**, and visible only from the river, the idyllic boathouse of **Twickenham YC** (*top, and 31 on map 3*), was built by the pretender to the French throne, the Duc d'Orleans, owner of the nearby York House, in c.1900.

It was actually one of his final acts before leaving the area, having annoyed locals by building high walls that obscured views and by expressing pro-Boer sentiments.

In 1924 York House was bought by the local council – it is now Richmond Council's Civic Centre – while the boathouse was leased out to the yacht club, who have treasured it ever since.

Formed at the nearby White Swan in 1897, as the Swan Sailing Club, during the 1950s the club installed a mezzanine floor within the former dock, from which, as seen above, an extended balcony was added in 2013.

This feature, with the wood panelled bar and lounge area on the upper floor, top lit by the central cupola, makes this one of the homeliest of boathouses in town.

Across from it lies **Eel Pie Island** (so called after the pies formerly sold here to daytrippers).

Close to the footbridge that connects the island to the Embankment is the **Twickenham RC** (*32 on map, and above*), formed in 1860 and therefore the third oldest club of its kind in London, together with Thames RC.

Its boathouse is also historic, occupying land gifted to the club by the father of the Duc d'Orleans in 1876, and with its central section dating back to 1880.

On the south side of the island, in the grounds of the former Eel Pie Hotel (once a famous music venue) is the 1962 boathouse of Richmond Yacht Club, formed in 1934, but nowadays a club for motorboats.

▲ On the Middlesex bank below Teddington Lock, **Trowlock Way** leads to a group of boathouses (*35 on map 3*) shared by four clubs, two of whom are the oldest of their kind in the world.

The senior partner in the quartet is the **Royal Canoe Club** (RCC).

Formed in 1866, since 1897 this has been based on Trowlock Island, where its current timber clubhouse (*above*) was rebuilt in 2009.

Other than by boat, access to the clubhouse, and to the 30 other houses on the island, is via a small, hand operated chain ferry, like a raft, which is pulled from the riverbank across the narrow channel in a matter of seconds.

But if, today, this charming riverside enclave appears a long way from the hustle and bustle of 'The Smoke', older RCC members recall a rather different picture.

Until the late 1940s there was a sewage works and refuse incinerator on Trowlock Way, while on the Surrey bank stood a factory. Built originally in 1917 to produce Sopwith aircraft and later owned by Hawker and British Aerospace, from 1920-48 the factory was run by Leyland Motors, who laid out what is now the **YMCA Hawker Centre** sports ground (*F on map 3*) in c.1944.

The factory closed in 1992 and is now housing. Similarly, in Kingston, south of Canbury Gardens, a coal-fired power station spewed out smuts across the river until it too was closed, in 1980, and later replaced by housing.

▶ Backing onto Teddington School, this is the oldest of the boathouses on the **Trowlock Way** site (*35 on map 3*). Built around 1901, probably by boatbuilder Harry Gibbs, and later run by a Mr Carter, the boathouse is now known as **Rob Roy House**.

Rob Roy was the name given to a type of canoe popularised by the founder of the **Royal Canoe Club**, the remarkable **John MacGregor** (1825-92).

A barrister, philanthropist and traveller, MacGregor designed the Rob Roy after being introduced to canoeing in North America.

On his return he had Searle & Co of Lambeth build him a prototype, which he then used on various epic journeys across the rivers and lakes of Europe and the Middle East, all of which he described and illustrated in a series of best selling books.

Within a year of the Canoe Club's formation over 200 Rob Roys had been built, mainly for gentlemen seeking to emulate MacGregor in a spirit of escape and adventure.

No doubt sales were further helped when in 1867 the Prince of Wales became the Canoe Club's Commodore, and after the *Illustrated London News* reported enthusiastically on the first regatta, at Thames Ditton. The main event was won by Arthur, later Lord Kinnaird, then a 20 year old undergraduate at Cambridge.

Another event of note, first staged in 1874 – a year after the club gained its royal imprimature – was the **Paddling Challenge Cup**.

Still contested each October on a course between Trowlock Island and Kingston Bridge, this is now the oldest canoe race in the world.

Among recent winners was RCC member Tim Brabants, who won Britain's first gold medal in canoeing at the 2008 Olympics.

Returning to Trowlock Way, apart from the 1901 boathouse there is a second, larger, utilitarian clubhouse. This was built in 1961 by **British Petroleum** for their rowing club, **Walbrook RC** (named after the address of the company's head office).

In 1993 BP decided to sell the site, a move that prompted the RCC to join forces with Walbrook – who evolved into an open rowing club – and a third local club, in order to set up the trust that now owns and manages the site.

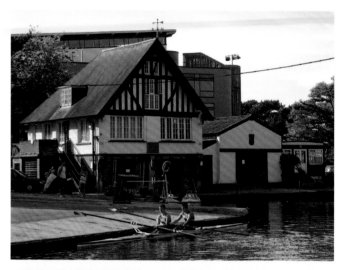

That third club is **The Skiff Club**.

Formed in Kingston in 1895 and based for many years at the Albany Boathouse on the Surrey bank (*see opposite*), the club takes its name from a traditional boat (*below right*) that is probably the closest in form to the ubiquitous wherry of the 18th and 19th centuries.

Which is to say that it is a traditional sculling boat, clinker built, from overlapping timber planks, riveted together.

Unlike modern rowing boats the seats are fixed and the oars slot not into outriggers but, as seen above, between 'thole pins'.

To ease the sculling action the oar is, at this point along its length, bound in leather and greased, either with tallow or, if there is any lying around in the clubhouse kitchen, old butter or fat.

Some of the club's skiffs are over a century old, built by Messum's at Richmond. A modern one can cost over £20,000.

As is the case at the six other skiff clubs upriver, members of The Skiff Club may be identified by the colour combination of

their striped shirts. Another common factor is that each skiff club also offers punting.

But that is not all that may be seen down Trowlock Way.

In addition to canoeing, rowing, sculling and punting, the youngest of the four clubs based there is the **Kingston Royals Dragon BC**.

Once again one of the first of its kind, in London at least, the club was formed in 1988 by members of the RCC and Kingston RC, keen to adopt this ancient form of racing.

Canoes from North America, dragon boats from China; the Thames has always been open to the world.

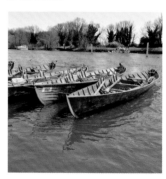

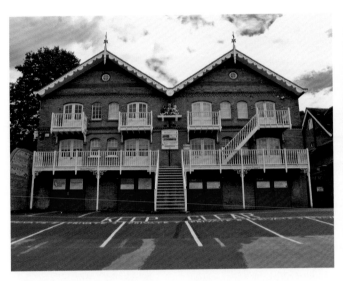

▲ Built in 1893 and now offices, the **Albany Boathouse** on **Lower Ham Road** (*G on map 3*), was until the mid 1970s owned by **RJ Turk**, a Kingston company which today, under the name of **Turks**, is not only the oldest boat business operating on the Thames, but also one of the oldest firms in Britain still under the same family ownership.

As a wages book in the family archive testifies, the Turks were in business on the Albany site from at least 1710. However, they have also found records of a shipbuilder called Thomas Turk in the 12th century.

Kingston itself has an even longer history. It was where Saxon kings were crowned, and where the first bridge over the Thames west of London Bridge was built in the 14th century. Not until Putney Bridge went up in 1729 would there be one in between.

Kingston was equally to the fore in sporting matters. Its first regattas were held during the 1820s in honour of Adelaide, William IV's consort, then resident at Bushy House. These were followed from 1857 onwards by the Kingston Amateur Regatta, and, for local tradesmen, the Town Regatta, in 1865.

The town also awarded its own Coat and Badge (the former being in blue, rather than scarlet serge).

In the 1850s the Turks created a second boatyard next to their family home on **Thames Side**, on the site now called **Turk's Pier,** next to the base of the Kingston & District Sea Cadets (*40 on map 3*).

Partly this was to have a base closer to the centre of Kingston, where day trippers would be besieged by offers of boat hire and river cruises, not only from Turk's but from rivals such as Burgoine's, Eastland's, Pope's and Mould's, all eager to profit from the growing number of Londoners taking to the river, for sport or for leisure.

In the latter category was Jerome K Jerome, whose hugely popular *Three Men in a Boat*, published in 1889, starts with him hiring a skiff from Turk's, and was later credited with increasing the number of boating enthusiasts even further.

So much so that local vicars complained that Sunday worship was in decline not owing to the devil, but to the lure of the river.

One of the first tenants at the new Albany Boathouse in 1893 was the **Royal Canoe Club**. But the relationship was soon to turn

sour after the club refused Turk membership, despite him being a Queen's Waterman (hence the royal crest on the boathouse's façade).

For all his standing in the local community, Turk was, after all, a professional waterman.

After the RCC moved over to Trowlock Island in 1897, as noted opposite, **The Skiff Club** moved in, and stayed there until 1972.

Two further tenants were the **Tiffin School Boat Club** and the **Kingston Rowing Club** (KRC).

The latter, formed in 1858 and therefore the capital's second oldest amateur club after the London RC, were initially based at one of Turk's rivals, Messenger's Boathouse, before building new headquarters on Raven's Ait, an island south of Kingston, opposite Hampton Court.

It was from there that KRC shot to prominence by winning the Wyfold Cup at Henley six years in a row, from 1863-68, and the Grand Challenge Cup in 1864 and 1865.

They then moved to the Albany Boathouse in 1935. But as their numbers grew during the post war years it became apparent that both they and Tiffin needed more space.

As a reporter in the *Kingston & Malden Borough News* later recalled

indignantly, 'I once waited half an hour for a drink at the tiny bar!'

Fortunately in 1966 the newly formed Kingston upon Thames Borough Council allocated a site bordering Canbury Park, where the current **Canbury Boathouse** (*above*) was opened in 1968 at a cost of £55,000.

Designed by the Borough Architects it received a Civic Trust Commendation in 1970, and indeed still looks the part, particularly since major works to the slipway funded by Kingston Council and the Veolia Environmental Trust, and to the clubhouse, funded by both the KRC and Tiffin (who share a 99 year lease), and by British Rowing.

As for Turks, more can be learned of their history from exhibits on display at Kingston Museum.

Meanwhile they continue to run river cruises from Turk's Pier, with offices at Town End Pier, south of Kingston Bridge, and boat building based at Chatham in Kent.

Michael Turk is now the senior family member. He is also an honorary member of the RCC, the club having conferred the title in order, as they stated, 'to put right the wrong which we now felt was done to his Grandfather'.

Taking its title from the river's Roman name, Tamesis SC formed at Burgoine's boathouse, Hampton Wick, before moving to Trowlock Way (*36 on map 3*) in 1901. Its members have long been active in the design of racing dinghies, while another member and benefactor was architect Howard Lobb. The club's 1903 boathouse, extended in the 1970s, adjoins Ariel SC, formed by BBC staff in 1934.

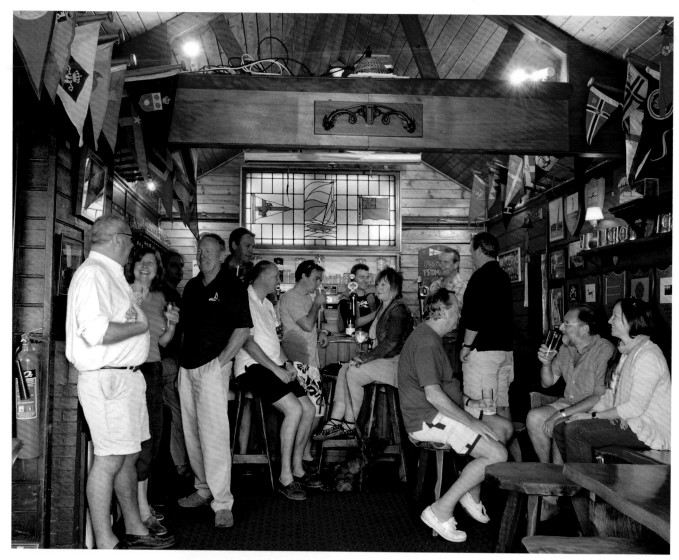

Every Sunday after a morning on the river, members of the Thames Sailing Club (*42 on map 3*) – Britain's oldest river sailing club, formed in 1870 – meet up for lunch in their chalet-style boathouse, also dating from 1870 and therefore the oldest of its kind in London (although, like the TSC's classic boats, most of the timbers have been renewed at one time or another). Tuesday night suppers are another regular attraction.

◄ Horses for courses – when inland sailing grew in popularity in the late 19th century a number of designers set out to create a small, lightweight but fast and affordable boat that could prosper in the shallow waters and light winds to be had above Teddington Lock.

This is the result, the distinctive **Thames A Rater**, with its 'skimming dish' of a hull and its narrow main sail, tall enough to catch whatever breezes might waft its way.

Alfred Burgoine at Hampton Wick is credited with building one of the most influential early versions, called *Ulva*, in 1898.

Amazingly she is still being raced today, from the **Thames Sailing Club** (TSC), more beautiful than ever following a £30,000 refit.

The TSC is home also to *Vagabond*, an A Rater designed in 1907 by Linton Hope, another figure revered by Thames sailors, but modified in the 1930s to

go even faster, by a mercurial American, Beecher Moore.

A bon viveur whose mornings were spent running the family's stationery business, Moore's Modern Methods, on Farringdon Street, followed by afternoons under sail, Moore is credited with several crucial innovations, some developed in tandem with boatbuilder Jack Holt, who had bought his first boat second hand from AP Herbert, a neighbour in Hammersmith.

After the Second World War Holt went on to design a series of hugely popular racing dinghies from his Putney boathouse, ideally suited for mass production.

The A Rater gained a makeover too, being produced from the 1960s onwards, as seen here near Ravens Ait, with fibreglass hulls.

That said, the mould used was, and remains one based on *Ulva*.

As Beecher Moore himself might have said, 'If it ain't broke...'

▲ Never mind those images of romantic dalliances and student revelries in Oxford and Cambridge. For five boat clubs on the Thames, including here at the **Dittons Skiff & Punting Club** (*43 on map 3*), **punting** is a serious sport, and has been since the Thames Punting Club was formed in Sunbury in 1885 to lay down the rules.

Until then punts had been used largely by fishermen or by watermen for transporting goods, although there is a record of two watermen racing punts in 1793 at Windsor.

In the late 19th century the Oxford University boatman, Abel Beesley, was the acknowledged professional champion.

But it was gentlemen's clubs that ensured its continuance, and particularly that great lover of the Thames, Lord Desborough, who started punting at Oxford, was amateur champion from 1888-90, and from 1904-37 Chairman of the Thames Conservancy.

Apart from Dittons, who formed in 1923, four other clubs still compete; the aforementioned Skiff Club, plus three others up river at Walton, Sunbury and Wraysbury. (The Thames Punting Club lives on purely as a governing body.)

Singles compete in narrow punts, barely a foot wide, in what are known as 'best and best' races (because each punter chooses his or her own preferred boat).

Doubles, as with skiffs, race in 'matched pairs', that is punts built to the same design.

Why are there not more punters on the river? Firstly because punting is only possible where the river 'shelf' is shallow enough, and with a good gravel bed, as is the case at Thames Ditton.

Secondly, because it is not half as easy as it looks.

▲ From Greenwich to Hampton, from salt water to fresh, from silver to gold, the River Thames steers us always, irresistibly, towards the muse of history and the sound of hurrahs at the finishing line.

Even here, where a member of the **Dittons Skiff & Punting Club** sculls contentedly past the Tudor glow of Hampton Court Palace, and all seems at peace, there are races to run, trophies to win.

Passing by here each March over 200 eights will battle it out in the **Kingston Head of the River**. Every summer, over 1,200 intrepid swimmers will chop and chase over two miles from the Palace to Kingston Bridge.

Were we to continue upriver, we would find at Hurst Park the former site of one of London's favourite racecourses, and the scene of epic cricket matches and

prize fights on Moulsey Hurst, a magnet for punters of a different ilk.

For scullers and sailors, captains and commodores, for Doggett's men and McGregor's Rob Roys, for Frederick Furnivall's blue stockings and Varsity oarsmen, the Thames has tested Londoners for centuries.

One can race on it, one can play on it, but no-one can ever be its master. Therein lies the challenge. Therein lies its timeless lure.

Chapter Four

Crystal Palace Park

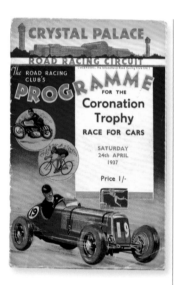

Five months after the Crystal Palace burnt to the ground in 1936 – 'Let's build another one!' piped up John Betjeman as the smoke dispersed – 30,000 people gathered in the adjoining park to witness London's newest sporting attraction (*above*). But popular though motor racing was to become, on the only bespoke circuit ever to have operated in the capital and with crowds sometimes topping 60,000, a few days of racing a year was never enough to compensate for all the other uncertainties affecting Crystal Palace Park after the fire. From a world renowned, groundbreaking exhibition centre and manicured landscape to a bruised but beloved Grade II* listed public park, the big question in SE19 today remains the same as it was in 1936. 'What *is* to become of Crystal Palace Park?'

London has always been adept at putting on a show, a pageant, an exhibition or a sporting spectacular. But the capital has a mixed record when it comes to sorting out the aftermath.

This is the first of three chapters focusing on areas of London where historic happenings have transformed the locality, each with different outcomes.

Starting with Crystal Palace Park – a 200 acre expanse straddling Sydenham, Penge and Norwood, a park in which there is no longer a palace and where the football club known as Crystal Palace has not played since 1915 – we go north to Wembley Park where, as the result of the British Empire Exhibition of 1923-4 there is no longer a park (unless we count the business and retail parks), and from there move out east to the Lea Valley, which now has in its midst the Queen Elizabeth Olympic Park.

There might have been a chapter in this sequence featuring White City, venue for the Franco-British Exhibition and Olympic Games of 1908, but the site's heritage assets are now so few and tokenistic that references to them have been left to later chapters on athletics and greyhound racing.

Although entirely different in character, Crystal Palace Park, Wembley Park and the Lea Valley have the following in common.

Each has been subject to a series of masterplans in which the promise of sporting legacy has ranked highly, but the delivery of which has proved problematic.

Each currently has a stadium of

architectural note, together with a swimming pool and/or an indoor arena of outstanding design.

Each has staged a range of sports at national and international level, and each, in 1866, 1948 and 2012 respectively, has hosted a modern version of the Olympics.

An Olympics, at Crystal Palace?

Before explaining this, a reminder that the Crystal Palace was originally designed by Sir Joseph Paxton for the 1851 Great Exhibition in Hyde Park, and that in common with the Shard and Gherkin, its title was actually a nickname. In July 1850, before building work had begun, *Punch* magazine described the design as a 'castle of glass'. This was amended a month later to 'glass palace' before, in the edition of November 2 1850, the playwright Douglas Jerrold came up with 'Crystal Palace' (although he may well have borrowed the term from Shelley's *Prometheus Unbound*, published 30 years earlier).

The name was then formalised when the Palace was rebuilt and extended on Sydenham Hill in 1852-54 by a group of investors led by Paxton and incorporated as the Crystal Palace Company.

The new Palace and its grounds were an instant success, drawing on average two million visitors annually over its first three decades, including regular visits from Queen Victoria, who opened it in 1854, and foreign royalty.

Crystal Palace was no mere amusement park. Rather, it was designed to become a 'Home of Science, Art, Literature and Music', for the education and delight of 'all classes of people'.

In the park today the clearest manifestation of this mission to 'educate and delight' are the 30 or so lifesize models of dinosaurs, created in the 1850s by Benjamin Waterhouse Hawkins, now collectively listed Grade I.

Further evidence of the directors' aspirations was the type of sporting provision on offer, there being a ground for archery (a sport confined to the upper and middle classes), outdoor and indoor gymnasiums, and a cricket ground, opened in 1857, where a Crystal Palace CC soon formed.

It was on the cricket ground that on August 1 1866 the inaugural athletic meeting of the National Olympian Association was staged, in front of a 10,000 crowd.

As detailed in Martin Polley's *The British Olympics* (see Links), the National Olympian Association was the world's first national Olympic body of the modern era, formed 29 years before the International Olympic Committee.

Usually when the NOA Games of 1866 are referenced it is in relation to the winner of the 440 yard hurdles, an 18 year old from Bristol who had popped over from the Oval, having just notched up 224 not out for England.

His name? WG Grace, the bearded wonder who, over 30 years later would return to the Palace in a rather different capacity.

On a secluded path running west from the Fisherman's Gate on the north side of Crystal Palace Park, this lone turnstile is thought to have provided entry to the park from the garden of one of the villas on Crystal Palace Park Road. The houses, several of which survive but with altered boundaries, were built on parkland sold by the Crystal Palace Company in the 1870s, in order to ease its debts.

After the day's athletics a dinner in the Palace itself was followed by a speech on Muscular Christianity by a founder of the NOA, William Penny Brookes, later to be a seminal influence on the founder of the IOC, Pierre de Coubertin.

Crystal Palace was chosen partly because it was the place to be in 1860s London, but also because one of the organisations belonging to the NOA, the German Gymnastic Society (based at King's Cross), had held their annual sports there since 1862.

Another sport associated with the park's early years is football.

The first Crystal Palace FC (no relation to the current club) is thought to have been formed as an adjunct of the cricket club, in 1861, and was a founder member of the Football Association in 1863.

One of its number, James Turner, a wine merchant from Croydon, served as FA treasurer for four years. Another, Charles Chenery, who also played cricket for Surrey, played in England's first three internationals, before the club finally disbanded in 1876.

Given that the Palace directors took pride in offering a showcase for innovation, two other modern recreations found a ready home there. In 1866 a roller skating rink was set up, offering the latest American skates patented by James Plimpton. In May 1869, again courtesy of the German Gymnastic Society, the Palace grounds hosted Britain's first recorded cycle race, albeit it was called at the time a 'Velocipede Derby' (see page 314).

The park also proved ideal for the staging of one of the earliest set of time trials for motor cars in Britain, in 1896 (during which a 44 year old woman from Croydon became the first pedestrian to be killed in a motor accident). In 1903 the Palace hosted the nation's first Motor Show too.

But in truth, by that stage the directors were open to almost any activity. For although the Palace was now nearly half a century old, its finances had never recovered from start up costs of £1.35 million, or from a ruinous fire in the north transept in 1866.

Nor had the sale of plots for housing around the perimeters provided more than a temporary reprise, so that in 1887 the company needed further bailing out by a government keen to

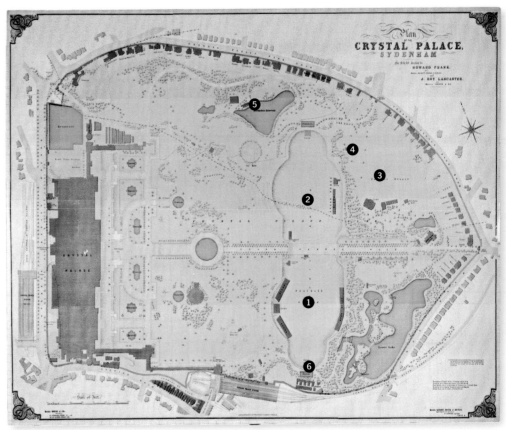

avoid embarrassment during the Queen's Golden Jubilee.

Added to this, the Palace was not allowed to open on Sundays, the only full day that most working people had free.

Hence in the 1890s the directors felt they had no choice but to offer what one correspondent to The Times in 1911 decried as 'football matches and other attractions for vulgar mobs' (by which he meant switchback railways, fairground rides and the like).

One key factor in the introduction of football had been the decision by Surrey CCC in 1892 to stop hiring out the Oval for the FA Cup Final, which by then was on its way to becoming England's biggest sporting draw after the Derby at Epsom. After staging the 1893 Final unsatisfactorily in Manchester and the 1894 Final in Liverpool, the FA was determined to find a London venue, and one, moreover, that, in the cause of fair play, would be neutral.

As will be noted, the turf bowl created to meet this need was hardly ideal. But with admission to matches also allowing access to the Palace and park, it was certainly an attractive proposition.

As The Sportsman, a pro-FA

London daily crowed in 1900, 'Not only is the arena unsurpassably adapted for such an encounter, but a visit to London, even in the expiring days of the 19th century, has unmistakable attraction for the average provincial.'

And so it proved. From a gate of 42,560 at the Palace's first Final in April 1895 the numbers grew steadily to top 110,000 in 1901, when Tottenham became the first professional club from London to win the treasured trophy.

To the north of the Cup Final ground a second arena, opened in 1896, boasted a much admired cycle track, on which the World Cycling Championships took place in 1904 (see page 319).

Less successful was the attempt to attract first class cricket.

As recorded by Brian Pearce (see Links), apart from local club cricket the ground had hosted occasional matches featuring Kent and the Australians. But in 1898, no doubt emboldened by the takings from football and cycling, the company took the decision to form a new club, the London County Cricket Club, and hire WG Grace as its secretary-manager on £600 a year.

For sure this was a coup, even if WG was past his best. But it »

Drawn up by auctioneers Knight, Frank & Rutley in advance of the proposed sale of the Palace and park in 1911, this plan shows that much of Paxton's layout remained intact, apart from the building of houses on the perimeter. Also, on either side of the Grand Centre Walk, both fountain basins were infilled in 1894–95, to form the main, or south sports ground (1), where Cup Finals were staged, and the north ground (2), used for football, cycling and athletics. Other sporting facilities included the cricket ground (3), bowling greens (4), a pavilion for skaters on the Intermediate Lake (5), and stabling for polo ponies (6). Apparently the damage caused to the turf by polo had driven away the archers a few years earlier.

▶ **England v. Scotland 1905** – the main, or south ground at **Crystal Palace** was, from 1895-1914, the *de facto* national stadium, hosting 20 FA Cup Finals, four internationals and, also in 1905, England rugby's first international v. the All Blacks.

But while it was undoubtedly the largest arena in the land – the gate of 120,081 for the 1913 Final was a world record – barely half those attending had decent views, and compared with Stamford Bridge (post 1905) and the 1908 Olympic Stadium at White City, the stands and terraces were remarkably basic.

As seen here, with the Palace and its North Tower in the distance, there was a central pavilion on the west side, built in 1895, flanked by stands with multi-span roofs added in 1905, offering around 5,000 covered seats. Everyone else stood on turf banks or, behind the north goal, on timber terracing.

Yet rarely were there complaints (in print at least), and only one serious injury was recorded, in 1899, when a fan fell from a tree.

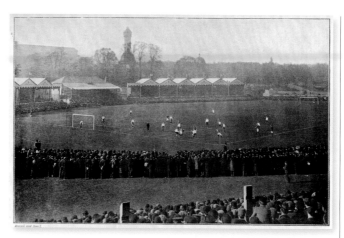

As *The Graphic* put it in 1895, the 'happy holiday' atmosphere at the Palace offered 'ample proof of the internal peace of the kingdom'.

The Cup Final ground can also be seen in the postcard below, dating from the early 1920s, together with the north ground on the right. It was on this ground that the second **Crystal Palace FC**, 'the Glaziers', formed in 1905 with help from the company, mainly played during

their first decade. However as Ian Bevan *et al* have shown (*see Links*), both the north and south grounds were used by various other clubs and sports, often on the same day.

After the First World War and the loss of the FA contract to Wembley, the main ground continued to stage amateur football, including the Varsity matches in 1923 and 1924 and those of the **Corinthians** and the **Casuals** from 1922-36.

≫ was not enough. As both Kent and Essex found when they tried to establish county grounds at Catford and Leyton, tempting fans away from Lord's or the Oval was no easy matter.

So it was that London CCC managed only five full seasons at county level before the Company closed it down in April 1908.

That was just thirteen months before the entire Palace complex finally went into receivership.

There would be one last gamble to restore the Palace's fortunes, the staging of the Festival of Empire in 1911.

During this lavish exhibition which, frustratingly for the organisers clashed with a similarly spectacular rival event at White City, a sporting tournament was staged in the park under the aegis of Lord Desborough, organiser of the 1908 Olympics. Teams from Britain, Canada, Australasia and South Africa competed in athletics, boxing, wrestling and swimming, in a tournament that has since been credited as the forerunner of the Empire Games.

Yet before the Festival had even ended in October 1911 the Palace's future appeared to hang in the balance, as Knight, Frank & Rutley prepared to sell the site at auction in late November. For a few weeks there seemed the very real prospect that the Palace itself might be taken down, and much of the park sold off for housing.

At which point, enter the hero of the hour, Robert Windsor-Clive, aka Lord Plymouth.

A fabulously wealthy landowner, Tory politician and lover of art and architecture – he played a lead role in the laying out of The Mall – Lord Plymouth had overseen, and subsidised, the 1911 Festival of Empire. His wife and children had even appeared in one of the pageants, and he was determined not to let the Palace fall into the hands of speculators.

Before the auction he therefore put down a deposit of £20,000, and, with the Lord Mayor of London, challenged the nation to come up with the remaining £210,000, so that the Palace could be transferred to the public realm.

It took two years to find the funds. *The Times* raised £90,000 from its readers, including £2,500 from Harrods. The LCC and several London boroughs also

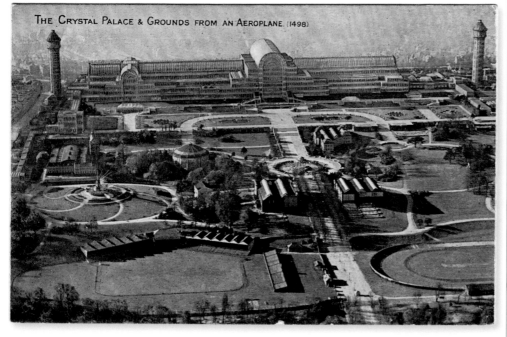

THE CRYSTAL PALACE & GROUNDS FROM AN AEROPLANE. (1498)

Still standing some 40 years after George V sat in it as the first reigning monarch to attend a Cup Final, in April 1914, this is the 450 seat central pavilion at the Palace's main ground (*right*). In another age perhaps its historic significance might have helped to save it. Instead, it was torn down in the late 1950s and replaced by the west stand of the new athletics stadium, opened in 1964.

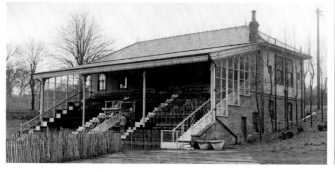

donated, with the exception of Camberwell (according to *The Times*). Yet Plymouth still had to add another £5,000 to the pot, and write off a further £10,000 from the original purchase price.

So it came about that an aristocrat with 37,000 acres of his own, saved 200 more for the nation in south east London, and in doing so heralded a new chapter in the Palace story.

For the next 38 years the Palace and its grounds were run by a board of trustees, during which time Henry Buckland acted as general manager (and grew to love the place so much that he named his daughter 'Chrystal').

But what a task he faced.

During the First World War the park was commandeered by the Royal Navy, and though peace returned in 1918, the FA Cup Final did not. Nor did Crystal Palace FC, who in 1924 bought their own ground at Selhurst Park.

Up in the Palace itself, the opening of the Imperial War Museum in 1920 appeared to offer hope of new life, until the museum relocated in 1924. Buckland nevertheless found ways to make enough profit to start patching up the now draughty and ageing Palace structure.

In the park, tennis courts covered the cricket pitch, while on the Cup Final ground, in 1927 Buckland considered introducing the new sport of greyhound racing, only to be met by a petition signed by over 43,000 people opposed to gambling (whereas the owners of Wembley and White City managed to sidestep all opposition).

A year later Buckland did manage to lay on speedway, with some initial success. But it was a noisy sport for an otherwise quiet suburban neighbourhood, and when the trust turned down a request from the promoters to install floodlights, as existed at other tracks, the riders packed up and moved to New Cross (*page 334*).

In the meantime, as noted opposite, amateur football clubs carried on using the grounds, especially when drawn against big clubs in the FA Cup. One tie, pitting the Corinthians against Newcastle in January 1927, drew over 56,000, and was only the second football match broadcast on the radio (the first having been at Highbury a week earlier). »

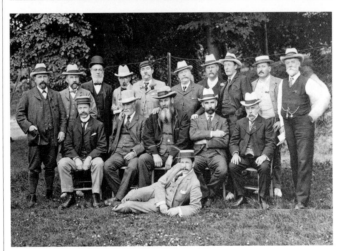

▲ **England v. Scotland** – only this time the sport is **lawn bowls**, a Scottish form of the game made popular down south thanks to its enthusiastic adoption by **WG Grace**, seen above at the Palace (*front row centre*) in July 1903, as captain in the first ever international.

Grace, who had arrived at the Palace four years earlier to head up the **London County CC** and set up home in nearby Lawrie Park Road (*page 211*), was 55 at the time and had just helped found the English Bowling Association, which remains the governing body to this day. His influence extended further when in 1905 the pioneering **Crystal Palace Indoor Bowling Club** was established, playing on matting laid on one of the gallery floors.

The club is still in action, playing at a centre built on Anerley Road in 1937 (*page 190*).

▲ This stepped **concrete wall**, together with stretches of tarmac snaking around **Crystal Palace Park**, are all that remain of what motor racing fans still call **'London's Own Circuit'**. The wall, built in 1937 on the eastern side of the north basin ground, and now facing the rear of the National Sports Centre, can be seen (*top left*) in the distance, during a practice session in 1938. Alongside it are the pavilion and stand built originally for the cycle track in 1896.

Seeing the circuit now, narrower, shorter and lined by trees and undulating parkland, it is hard to imagine the likes of Graham Hill and Jackie Stewart whipping around it in Formula 2 cars. Yet in the circuit's final year of racing in 1972, before the GLC pulled the plug (not surprisingly given the safety implications), Mike Hailwood recorded a fastest ever lap speed of 103mph (compared with 54mph notched up in 1937).

The story does not end in 1972, however. In 2010 the **Sevenoaks & District Motor Club** inaugurated a Bank Holiday programme of time trials for cars old and new, known as **Motorsport at the Palace**.

Seen at the 2012 event (*centre*) is a **1962 Austin Healey**, passing the Italian terraces where, in 1899, the best average speed recorded during the first motor car time trials had been 36mph. Thus may Crystal Palace Park claim to be the oldest motor racing venue in Britain.

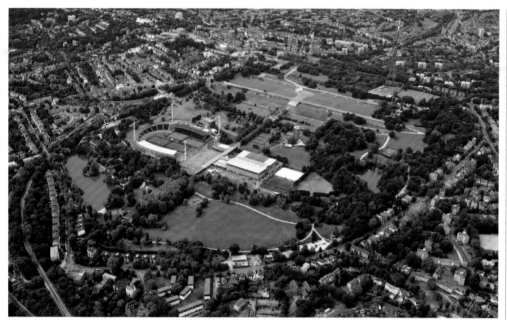

▲ Viewed from the east in 2006, **Crystal Palace Park** is one of the most protected and sensitive plots in the capital. Most of its 200 acres are designated as Metropolitan Open Land and are considered of Archaeological Significance, and most fall within a conservation area. The park itself is listed Grade II*, but contains nine other listed structures or groups of structures, including the Grade II* **National Sports Centre (NSC)**, seen facing the athletics stadium.

At the park's upper level, 58m higher than the eastern end, lies the mostly overgrown site of the Palace, on which can be seen, top right, one of London's most prominent structures, the **television transmitter**, completed in 1956-57.

One level down are the turf covered **Italian terraces**, in front of which ran the motor racing circuit until 1972. The terraces are split by Paxton's **Grand Centre Walk**, which leads down to the main lake (where the dinosaurs hang out) and the former cricket ground, seen in the foreground. An elevated section of this central axis, built in the 1960s, provides an entrance to the NSC and forms a bridge over the former **motor racing circuit**.

Just above the NSC stands the eleven storey **Lodge Tower**, built in the 1960s to accommodate athletes and coaches. To its right is a smaller lake (home to an angling club formed in 1924), a maze and a concert bowl, while in the top right corner lies one of London's few Caravan Club and camping sites.

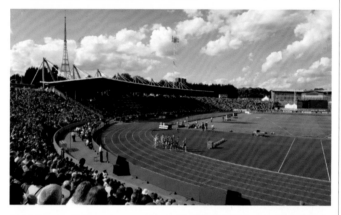

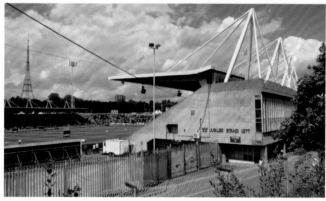

▲ Opened in 1964 and designed by the LCC's architects department, the **athletics stadium** of the **NSC** occupies the same footprint as the Cup Final ground but has only 16,500 permanent seats. Its cantilevered canopy (*above centre*) shelters a tier built into the hillside, where the old pavilion sat, while the **Jubilee Stand** (*above*), added in 1977, backs onto the former motor racing circuit.

In 1984-85 and 1990-93 the stadium was used by **Fulham RLFC** and in 2012 was subject to a proposal by **Crystal Palace FC** to turn it into a football ground, an idea not welcomed by local community groups. But the club does at least now have a presence in its birthplace, using parts of the NSC for its youth academy.

More on the stadium's athletics use can be found in Chapter 28.

» But, as ever, sporadic pay days could hardly sustain the Palace as a first class venue, so that by the time of the fire, in November 1936, both the north and south sports grounds were in a sorry state.

Sport, nevertheless, was seen immediately as a means of redemption in the post fire gloom.

In 1937, as the motor racing circuit throbbed into life, architect Horace Parnacott drew up plans that included a 25,000 capacity athletics stadium, an ice rink and a huge, 300' long swimming pool.

In 1945 the trustees launched a design competition for an even more ambitious scheme based on a 100,000 capacity stadium, an exhibition hall, two concert halls, theatres and an amphitheatre.

How anyone thought a stadium holding 100,000 could possibly be viable was never explained, although in retrospect, had the funds been available, what a setting the park might have made for the 1948 Olympics.

But there were no resources available at the time, and even when ownership of the now derelict park was transferred to the London County Council in 1951, it took nine years of planning and four more of construction before the sporting element of the park, to be known as the National Recreation Centre, was formally opened by the Duke of Edinburgh in July 1964.

Costing £2.75 million, the NRC (since renamed the National Sports Centre) was designed by a team of LCC architects under the initial leadership of Sir Gerald Barry, who had earlier been the director of the Festival of Britain.

Barry's plans for the creation of exhibition halls on the former Palace site never did come to fruition. Poor road access to the park, plus the closure of the High Level station in 1954 made Birmingham's bid for a National Exhibition Centre take precedence during the 1970s.

The park's location and access issues were also to play a part in restricting the NRC's ability to act as a true national centre.

Added to which, when the NRC had been conceived in the early 1950s, Britain's sporting prowess was at a low ebb and its facilities considered parlous by international standards. Yet within a decade of the NRC opening a

flood of public investment led to the creation of new running tracks and sports centres all over Britain. The NRC thus found itself in the spotlight once or twice a year for national competitions, but otherwise led a low profile existence as a well used, but mainly regional and local facility.

Which, as it transpired, suited its environment perfectly well.

Because as the years passed and memories of the Palace faded, Crystal Palace Park, for all its crumbling terraces and unresolved issues, was to become treasured for its tranquility and green space as much as for its past.

Moreover, as was demonstrated in the 1990s when plans for an entertainment complex on the Palace site were vehemently opposed by local residents, its fate has become a major political issue, even more so since the abolition of the GLC in 1986 resulted in control of the park passing to Bromley Borough Council.

At the last count there were at least 30 stakeholders with an interest, including Bromley and four other neighbouring boroughs (Southwark, Lambeth, Lewisham and Croydon), plus the GLA, English Heritage (on whose Heritage at Risk Register the park remains in 2013), and a dozen or so community groups and Friends groups for the park, for the subway that used to serve the High Level station, and, formed in 2013, for the dinosaurs too.

So many friends, so much love. And yet so many disagreements as to how the park might improve.

In 2007 a comprehensive masterplan was drawn up by the London Development Agency and landscape architects Latz & Partner, and approved by Bromley in December 2008.

Applauded in some circles for its sensitive approach and respect for the park's heritage, once again elements of it were challenged by local groups, principally the proposal that the anticipated £100 million costs of the masterplan would be offset by building homes and flats on two sites within the park (echoing events of the 1870s).

Meanwhile £20 million had to be spent on making sure that the NSC could serve elite athletes, swimmers and divers for another five years or so until such time as the athletics and aquatic facilities in

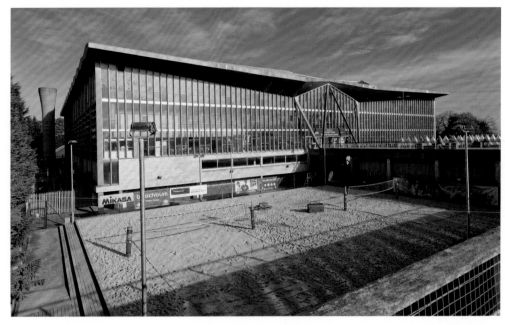

the Queen Elizabeth Olympic Park in Stratford were made available from 2014 onwards. After that, as noted on the right, a pared down NSC would focus on local needs.

But then, just as an application for £7m worth of Heritage Lottery funding was being made to kick start certain basic elements of the masterplan, in October 2013, out of the blue, it was revealed that a Chinese developer was proposing to build a modern replica of the Crystal Palace on the original site.

A mind boggling proposition. But a realistic one, or even a welcome one?

At the time of going to press it was impossible to predict what will be the outcome of the Chinese proposal, other than that, whatever happens, in the rest of the park grass roots sport will almost certainly be safeguarded.

And that, from a wider heritage perspective, largely thanks to historians, conservationists and the Crystal Palace Foundation, formed in 1979, so much of the site's history has been recorded and made available (see Links), an informed approach can now be taken, based on a modern interpretation of the social and educational aspirations of the park's Victorian creators.

Not least, this includes the provision of an enhanced museum and visitor centre.

As will become apparent at our next two ports of call, such provision cannot, alas, ever be taken for granted.

▲ Beach volleyball had yet to make its mark when Sir Leslie Martin and his colleagues at the LCC sat down in 1954 to design the **National Recreation Centre** (now **NSC**), billed as Britain's first modern sports centre, incorporating wet and dry sports within the same building.

In fact this juxtaposition had started with Victorian baths, designed with pools that could be boarded over in winter (see Chapter 17). But the idea of creating a single internal space and then dividing it down the centre, using an A frame of concrete struts to support the roof (below), with a pool on one side and a sports hall on the other, was without precedent.

Some consider the NSC an outdated hulk. But they are wrong. This is a magical building, the only post war sports building to have been listed Grade II*, and one that evokes the egalitarian, hope-filled spirit of the post war years. Together with the Wembley Arena, it is one of the finest examples of 20th century

sports architecture in London.

For sure it has design flaws. It has proved difficult to balance the higher temperatures required on the pool side with the cooler air needed on the sports hall side. The elevated entrance way, originally designed for those attending events – whilst users entered via an unwelcoming basement door – and its sunken surrounds, cut off the building from the park.

That is why the 2007 masterplan for Crystal Palace Park and the centre's original engineers Arup Associates, who also oversaw its recent renovation, recommend that the 'moat' be infilled and the pool converted into a dry sports area, with a new, more energy efficient pool to be built close by.

Until that happens, the centre remains open for swimming, or basketball, or boxing or squash, not to forget beach volleyball, or simply just to enjoy its glazed light and polished teak walkways.

A fuller account of the NSC can be read in a sister publication, Great Lengths (see Links).

Chapter Five

Wembley Park

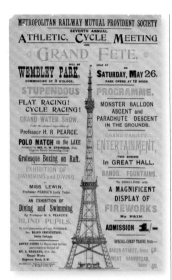

Easter 1894 and north west London's answer to Crystal Palace is set to open with a Grand Fete organised by the Metropolitan Railway. Work had already begun erecting the tower that the Metropolitan's chairman, Sir Edward Watkin, hoped would give Wembley Park its unique selling and vantage point. By 1896 the first stage was completed, 47m high, providing a view towards Wembley Park Station and Barn Hill (*below right*). But Watkin's Folly, as the tower was dubbed, stood on shifting ground. The funds ran out, work halted and, in 1907, the unfinished structure was dynamited. Had it reached its full height of 358m, the tower would have been taller than the Eiffel Tower and the Shard, and nearly three times the height of the Wembley Stadium arch that now occupies the same site.

After the fading glories of Crystal Palace, seekers of heritage might expect much richer pickings at Wembley Park.

Here, after all, is the Palace's dazzling heir; not merely its successor as the venue for FA Cup Finals but Britain's largest sports and entertainment complex, with a stadium of world renown and an arena, built in 1934, that is arguably the most successful sports building of its era.

Most readers will be familiar with Wembley's back catalogue; the Olympics in 1948 plus a major role in 2012, the World Cup in 1966, the European Championships in 1996 and seven European Cup and Champions League Finals, more than any other stadium.

To which must be added such domestic highlights as the 'White Horse Final' of 1923, the 'Matthews Final' of 1953, annual Rugby League Challenge Cups since 1929, and, for local audiences, thrice weekly greyhound races (without which the stadium would not have survived) and weekly speedway races which, at their peak in the late 1940s, drew regular crowds of 60-80,000 (*see page 334*).

Plus, to pick at random, ice hockey, showjumping, boxing (Henry Cooper flooring Cassius Clay in 1963 may ring a few bells), American football and, since 1950, annual appearances by the Harlem Globetrotters (still packing them in at the arena to this very day).

And that is without even dipping into Wembley's list of greatest hits in music, Live Aid in 1985 *et al*.

Now the simplest thing at this juncture would be to direct readers to the on site museum at Wembley. Such an amazing history, such a wealth, surely, of artefacts and memorabilia. How could tourists and school groups possibly resist?

Except that there is no museum.

And therein lies perhaps the most telling aspect of all when it comes to the heritage of Wembley Park. Fans of rugby and athletics may baulk at the term 'national stadium' for a venue that owes its existence to football (and dogs). But Wembley is absolutely a reflection of sport in England and its place in the body politic.

How so? In brief, from 1894-1912 the park was run as a sports and pleasure ground. From this period only the name 'Wembley Park' survives, although there is a Watkin Road within the complex and a pub called Watkin's Folly.

In 1912 a golf course occupied the park, the presumption being that, in time, housing would be built there. Instead, in 1920 the park was chosen as the site for the British Empire Exhibition (BEE).

Initially interest was muted, until in June 1921 the Prince of Wales announced at a dinner of the Royal Colonial Institute in Northumberland Avenue that a new 'national sports ground' would form part of the exhibition site, a decision that he knew would appeal 'to all Britishers'.

The Football Association, it emerged, were keen, and without even knowing who might operate the stadium after the BEE, were willing to sign a 21 year contract.

For its part, the government stake was just £100,000; the rest of the BEE costs, eventually amounting to £12 million, derived from donations and sponsors.

After the stadium opened in 1923 the BEE ran for two seasons and proved the most popular exhibition ever staged in Britain, drawing 17.25 million visitors (compared with six million to the 1851 Great Exhibition, eight million to the 1908 Franco-British Exhibition at White City, and ten million to the 1951 Festival of Britain).

But after 1925 the government washed its hands of Wembley Park and ever since the site has been prey to market forces. Even in 1999 when a Lottery grant allowed the FA, finally, to buy the stadium site, the government's contribution amounted to only some 13 per cent of the total reconstruction costs.

In most countries national stadiums are built with state aid and run with ongoing subsidies. Wembley Park, in contrast, is in effect a business park, in which sport, and more recently music, is its stock in trade. Heritage, in such a commercial environment, comes some way down its agenda.

There is, moreover, a twist in this tale. As will later be shown, Wembley Park is in the process of adjusting its business plan yet again, as a result of which, following the demolition of the stadium's famed twin towers, the last remaining BEE structures have also been demolished.

But no time to mourn. As they say in the business, the show must go on.

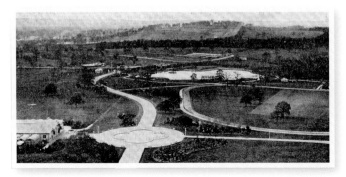

▶ When the **Metropolitan Railway** from Baker Street was extended from Willesden Green to Harrow-on-the-Hill in 1880 there was no reason for it to stop at **Wembley Park.** Apart from a few houses the area was mainly parkland, albeit parkland that had been landscaped for a local landowner by Humphrey Repton in the 1790s.

As in other parts of London, suburbs would inevitably emerge along the new line, but in this part of Middlesex there was a difference. For the Metropolitan Railway not only laid the rails and ran the trains. It acted as a developer too.

'Metro-land' promised 'pure air' and an antidote to 'jaded vitality' for thousands of new homeowners, and Wembley Park, all 280 acres of it, bought by the Metropolitan in 1887, was to be their playground.

As shown on this **1896 map**, two years after the park and its station opened, the tower occupied the southern corner of the site.

To the north was a cricket ground, on which the Australians played in June 1896, surrounded by a track on which, two weeks later, WJ Sturgess of the Polytechnic Harriers broke the two mile walking record. In later years trotting races and polo also featured.

Near the station a boating lake was fed by **Wealdstone Brook**, as it meandered south east before meeting up with the River Brent, close to the Welsh Harp Reservoir.

Following the failure of Watkin's tower, and of a plan to lay out a racecourse, plans were drawn up to build houses within the park, with in its centre a golf course, that staple of Middlesex life (*see Chapter 21*) laid out in 1912.

But then came the war, and as already noted, the decision that Wembley Park would host the **British Empire Exhibition** (BEE).

The Prince of Wales was right. 'Britishers' were enthused. Glaswegians alone chipped in with £105,000, so that by 1923-24 the park was transformed into a mini-city of pavilions showcasing the Empire and also the new wonder material, concrete.

The second map on this page shows Wembley Park in **1935**, a decade after the closure of the BEE.

Still extant were the gardens (1), the Palaces of Arts (2), Industry (3) and Engineering (4) and the lake (6).

Between the gardens and Palace of Arts, there was now a cinema

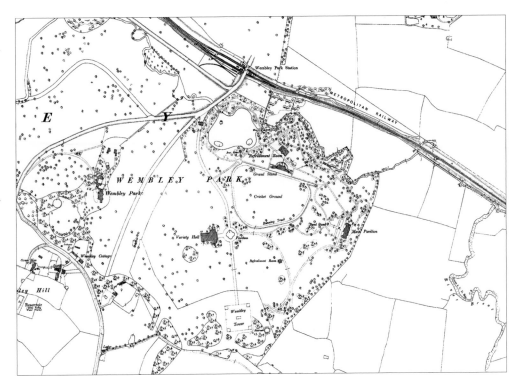

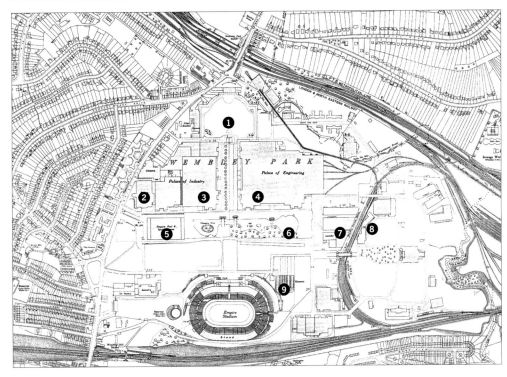

and film studios. On the east side, light industry gradually took over.

In addition to football and rugby league finals, the **Empire Stadium** was by this time staging greyhound racing three nights a week, serviced by kennels for 360 dogs (9), plus weekly speedway in the summer.

As for the surrounding fields that, as John Betjeman wrote, 'were once bright with buttercups', housing now dominated.

Between 1911-51 Wembley's population increased eightfold.

Of the BEE buildings, the Palace of Engineering, which hosted fencing in the 1948 Games, was demolished in 1980 (the Wembley Retail Park now occupies the site) while the Palaces of Arts and Industry, although both listed, were demolished between 2007-10.

This leaves only two much altered blocks of the India pavilion,

one of which houses Latif Rugs on First Way (7), and two Lyons' cafés (8), one of which is now Rubicon Drinks on Second Way.

Otherwise, the only other major surviving elements from the 1935 map are the **Wembley Arena** (5), and the remains of the BEE's street grid, most notably **Engineers Way** running east-west, and **King's Way**, remodelled as the **Olympic Way** in 1948, running north-south.

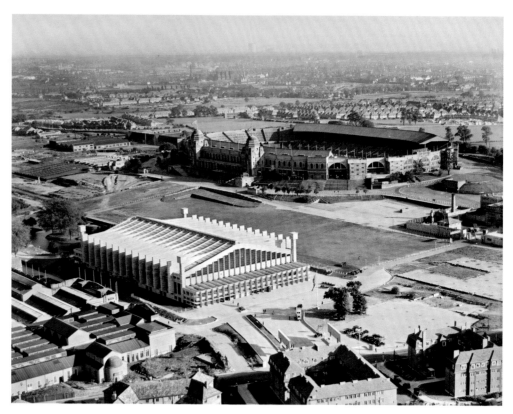

▲ As recorded above its entrance, **Wembley Park Station** was reconstructed by the Metropolitan Railway in 1923, just in time for Wembley's inaugural Cup Final on April 28, the day that an estimated 200,000 sightseers and fans crammed into the stadium, that had been designed to hold 126,000, eager to behold this eighth wonder of the world and, of course, to see West Ham face Bolton Wanderers.

Famously the game was rendered playable owing to a dozen or so police horses nudging back the crowds. Only one of the horses is remembered, however. 'Billy' and his rider PC George Scorey had been summoned at short notice from Rochester Row police station in Westminster and had to hoof it nine miles north by road before nudging into action.

Although he was grey rather than white, being lighter than the other horses, Billy stood out in all the press coverage and so ended up becoming part of Wembley folklore.

Now he is part of the furniture too. Next to Wembley Stadium Station is the **White Horse Bridge** named following a poll in 2006.

Also, after his death in 1930, one of Billy's hooves was mounted in silver and turned into an inkwell as a memento for George Scorey. It is now on display at the Metropolitan Police Museum at Imber Court.

▲ In the 1920s Sir Owen Williams, a concrete specialist hailing from Tottenham, acted as the consulting engineer to the **British Empire Exhibition**, working in conjunction with the contractors Sir Robert McAlpine – whose chairman was nicknamed 'Concrete Bob' – and the architects John Simpson and Maxwell Ayrton. It was the latter pair who gave the **Empire Stadium** and its monumental twin towers the distinct style described by one commentator as Indian Baroque.

Most of the exhibition buildings were built using in-situ concrete, with V-shaped grooves added to the stadium to give it the appearance of having been built in stone.

A decade later Williams returned to Wembley, as an architect, to demonstrate with the **Empire Pool** (now **Wembley Arena**) just how concrete technology had moved on.

Seen above, shortly after the Pool's opening in 1934 – the year it hosted the aquatic events of the **Empire Games** (the forerunner of the Commonwealth Games) – the contrast in styles between it and the stadium speaks for itself.

Note also the Palace of Arts in the lower left corner, with its basilica facing **Empire Way**.

Opinion was divided over the stadium. The engineer Oscar Faber wrote that the exterior looked fine from a distance but that the interior 'was the roughest looking concrete job I had seen for some time'. This was perhaps understandable given that the stadium had been built in a mere 300 days. But this unfinished look persisted throughout its life.

The stadium's design was criticised too, especially by a Home Office committee appointed to study the shambolic events surrounding

the opening day. Questioned by the committee, Maxwell Ayrton admitted that he had visited only one stadium, Stamford Bridge, before drawing up the designs.

It showed. Apart from various technical deficiencies, some of which were addressed before the 1924 Cup Final, most fans were exposed and far from the touchlines, as seen below, during the **1961 Cup Final**.

Furthermore, however much the stadium was modernised – most radically it was reroofed on all sides in 1963, and made all seated in 1990 – its essential deficiencies could never be fully ameliorated.

The twin towers apart, listed in 1976, nothing else, frankly, was worth saving. Except the site, of course, and the brand. In both those respects Wembley had more than earned its spurs.

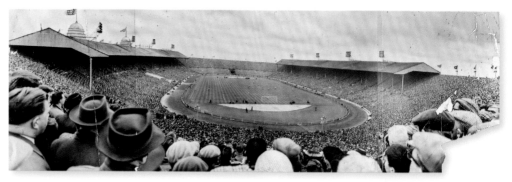

▶ Thanks to the close collaboration between Arthur Elvin, chairman of Wembley Stadium Ltd., which assumed control of the site in 1927, and the engineer/architect Owen Williams – both sticklers for detail – the **Empire Pool** emerged as the most advanced multi-purpose sports and entertainment centre yet seen in Britain (at least until Earls Court opened three years later).

Built in just ten months, it operated as a commercial swimming pool during the summer. Although entry cost twice as much as for public baths, no pool in London could rival its size, 200' x 60', or the fact that it had a wave machine (the first in Britain).

Also, as seen here, large doors opened out onto sunbathing terraces and the lake, retained from the BEE. On hot days up to 5,000 people paid to spend time in the pool, eating and drinking at the poolside bars and cafés.

Then in winter, as was common also at public pools, the water was emptied and the building turned into a dry sports arena, offering flexible configurations of 5-10,000 seats.

Unlike in the stadium all enjoyed uninterrupted views thanks to what was described as the largest clear span roof in the world, 236 feet wide. Its tapering cantilevered concrete beams supported 56,000 square feet of glazing.

As it transpired, public swimming in the pool ended with the outbreak of war in 1939, and only twice thereafter was it filled; for the 1948 Olympics – the first Olympics at which the aquatic events were held indoors – and for an Aqua Show starring Esther Williams in 1956.

Partly this limited use was owing to leaks in the pool tank, caused by war time bombs in the vicinity (the kennels were hit by a buzz bomb).

But in any case the building was more profitable as an arena, a role it continues today as it approaches its 80th birthday in July 2014.

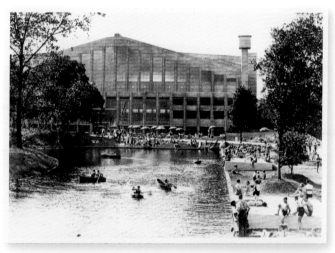

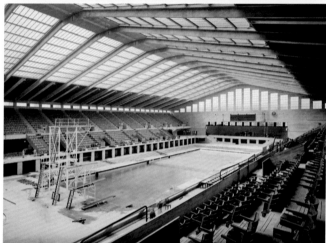

▲ So popular was **ice hockey** in the 1930s that the **Empire Pool** played host to two teams, the **Wembley Lions** and the **Wembley Monarchs**.

Other teams of that era were based at rinks in Millbank, Earls Court, Queensway, Streatham, Harringay and Purley (of which only Queensway survives).

In the summer a speedway team also called the **Wembley Lions** (*see page 334*) shared the stadium with the dogs. (The name Lions derived from the lion logo of the British Empire Exhibition.)

Wembley's ice bound Lions last appeared in 1968, their two-wheeled namesakes in 1981.

Of further note is that the Pool/Arena is the only venue to have been used during both the 1948 Olympics (for swimming, diving, water polo and boxing) and the 2012 Games (for badminton and rhythmic gymnastics).

Plus, it was the venue of the Beatles' last ever public concert in Britain, held in May 1966 (ten weeks before the World Cup kicked off in the stadium), and, in 1993, the first arena in Britain to stage stand up comedy, when Messrs Newman and Baddiel set a new trend by playing to a sell out crowd of 12,000.

▲ Renamed the **Wembley Arena** in 1976, the Empire Pool has seen several of its neighbours come and go. Shown here soon after opening in 1962, this was the **Wembley Stadium Bowl**, one of 15 tenpin bowling alleys built in London after the first opened at Stamford Hill in 1960. The craze soon faded but the Wembley Bowl stayed in business until 2004. A block of flats, **Forum House**, now occupies the site.

On the adjoining site to the south was the **Wembley Conference Centre** (b.1977), designed by R Seifert & Partners, which often hosted snooker tournaments and boxing, while between it and the stadium stood the **Wembley Exhibition Centre**, added in 1987.

Yet by 2007 both centres had made way for Wembley's next boxes of tricks, a **Hilton Hotel** and the **London Designer Outlet**.

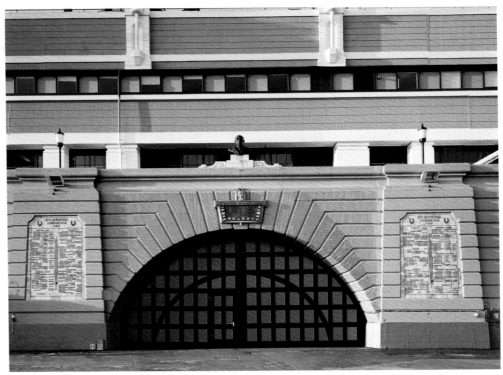

▲ In the entrance hall of the new **Wembley Stadium** sits this bust of **Sir Arthur Elvin** (1899-1957) by AJ Banks. At the old stadium, as seen right in 1996, the bust was placed above the gates to the **royal tunnel**, facing **Olympic Way**, the route that Elvin built at Wembley's expense for the 1948 Olympics.

A workaholic and a disciplinarian, but also a great party animal, Elvin was one of the showmen of his day, along with Alfred Critchley (at White City and Harringay), Claude Langdon (Earls Court) and Bill Cearns (Wimbledon and West Ham). Each saw in the new imported sports of greyhound racing, speedway and ice hockey a chance to lure Londoners out at night to savour floodlit spectacles.

Compared with his rivals Elvin mostly followed trends, rather than set them, although he did pioneer the fostering of supporters' clubs to boost loyalty.

But with Wembley Stadium and the Empire Pool at his disposal, plus extensive car parking and good transport links, he also had the inbuilt advantage of overseeing the biggest and most prestigious entertainment empire in town.

Moreover, he knew his audience, having come up from the ranks.

The son of a Norwich policeman, Elvin, or 'Ginger' to his mates, had joined the Royal Flying Corps during the Great War, but after being shot down was captured. He later said that one reason he was keen to build a swimming pool was that his inability to swim had prevented him from escaping.

Penniless after the war Elvin worked in a scrap yard, then, courtesy of a charity for ex-officers, was given work manning a tobacco kiosk at the BEE (where he met his future wife, who was working in the Palace of Industry).

What happened next has been often recounted. After the BEE closed in 1925 a speculator called Jimmy White bought the site for a knockdown £300,000. (Despite the fact that the whole enterprise had cost £12 million, no-one else bid.)

Elvin then secured from White the contract to demolish and sell off the surplus buildings, a task he performed so well that he then offered to buy the stadium from White for £122,500.

Before the deal could be done White was declared bankrupt and took an overdose, meaning that Elvin now had to deal with the Official Receiver instead. Given just two weeks Elvin somehow raised the funds, installed himself as chairman of a new Wembley Stadium company, and raised a further £100,000 to equip the stadium for greyhound racing, starting in December 1927 (six months after White City's first races, see Chapter 30).

Had Elvin not done this, with only one annual football match guaranteed (the FA Cup Final), and one international every two years (v. Scotland), the stadium would have been bulldozed.

Instead, its demolition waited until September 2000.

When that happened, apart from Elvin's bust, four other artefacts seen above were preserved.

The plaque recording the

Queen's attendance at the **1966 World Cup** (*below left*) is now on display inside one of the new stadium concourses. Also relating to 1966, the **crossbar** used in the Final, and memorials to both **Sir Alf Ramsey** and **Bobby Moore** can be seen on page 256.

The **foundation stone** (*above*), which marked the turning of the first turf at Wembley by the Duke of York on January 10 1922, is now under wraps in the new stadium's vaults.

Rather harder to store were the **tunnel gates**, each 16' square and made from solid timber in an iron frame, as if designed for a gaol. These were sold at auction at Sotheby's in November 2011 for £5,000, rather surprisingly to the *Museo de la Moda* in Santiago, Chile, where they now form part of the museum's sporting collection.

Otherwise, much of the rubble from the demolished stadium was transported four miles along the A40 to help create four 85' high mounds known as **Northala Fields** – ideal vantage points, it has to be said, for views of the new stadium.

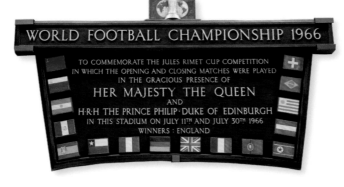

WORLD FOOTBALL CHAMPIONSHIP 1966

TO COMMEMORATE THE JULES RIMET CUP COMPETITION
IN WHICH THE OPENING AND CLOSING MATCHES WERE PLAYED
IN THE GRACIOUS PRESENCE OF
HER MAJESTY THE QUEEN
AND
H·R·H THE PRINCE PHILIP·DUKE OF EDINBURGH
IN THIS STADIUM ON JULY 11TH AND JULY 30TH 1966
WINNERS : ENGLAND

▲ 'A warm flame of hope... in the world which has burned so low...'

These were the words of Lord Burghley at the opening ceremony of the **1948 Olympics**, only a few years after virtually half the houses in Wembley had suffered damage during air raids.

▲ Removing the **1948 Olympic Rolls of Honour** from either side of the royal tunnel gates (*opposite*) proved a delicate task. Each plaque consisted of nearly 250 embossed, ceramic tiles and weighed 18 tons.

After their £60,000 restoration in Lincolnshire it was therefore decided to display the plaques at the new stadium lying almost flat, and within a sheltered concourse next to the stadium store, so that they are no longer exposed to the elements and can be seen by the public at all times.

Fanny Blankers-Coen, the 'Flying Housewife' from Holland, who won four golds in 1948, is the name most visitors look for.

Rather more sensitive during the demolition was the fate of the famous **twin towers** (*below*).

Because the footprint of the stadium's 90,000 seat replacement was to be almost twice as large as the original, and there was

room for this expansion only on the north side – on the south side lies a railway cutting – the towers were deemed to be in the way.

Moving them, as one firm proposed, on giant platforms, was likely to cost dearly; not least, there was little structure to support each tower on three sides once the stands were demolished, while, thanks to Owen Williams' expertise, sections of the domes were only 75mm thick, and therefore potentially fragile if moved.

Another consideration was to build replicas elsewhere on the site. But this too was rejected, and so in 1999, amid a considerable furore, listed building consent was sought and given for their demolition.

Four years later, on February 7 2003, watched by a thousand or so onlookers, a giant excavating machine called Goliath began the task of toppling the towers. That Goliath had been built in Germany only added to the poignancy of the moment. (But then the Germans already had the satisfaction of being the last nation to score a goal at the stadium during its final match, v. England, on October 7 2000.)

A banner on the day expressed the mood perfectly, 'They think it's all over... it is now!'

Goliath was not entirely destructive however. One of the flagpole bases, from the west tower, has been kept in storage, while the

other can be seen a short distance south of Wembley in **Brent River Park**, near Pitfield Way (*below*). At nearly 1.5m tall and four tonnes in weight, it is surprisingly large.

Meanwhile both flagpoles and their crowns were also kept intact and are now on display in the grounds of **Fawley Hill**, the estate of Sir William McAlpine, the great grandson of 'Concrete Bob' himself.

One other piece of Wembley history, also in store at the new stadium, is a floor section from the Royal Box, complete with studs embedded in the concrete, to show winning captains where to stand when lifting the FA Cup.

So there is no lack of artefacts from the old stadium, just an absence of any museum or heritage centre in which to reunite and display them all, where they should be, within Wembley Park.

Something concrete for visitors to see, and touch.

For years after 1948, the Rolls of Honour apart, all traces of the Games were removed from Wembley until, in 1977, the flame's pedestal and bowl were rediscovered and placed on the balcony, alongside the bust of Sir Arthur Elvin (*see opposite*). Now, following their restoration, both artefacts face each other across the vast lobby of the new stadium.

Also on display, but in the Club Wembley section, is the Olympic flag that flew during the Games from one of the towers. Ironically it had been found rotting in a storeroom inside one of the towers, shortly before the demolition.

Again, these are important treasures, commendably restored. But they are scattered, and not all can be seen by the public or as part of the stadium tours (which attract 140,000 people a year).

Otherwise, more details of Wembley's Olympic heritage may be found in *The British Olympics*, also part of the *Played in Britain* series (*see Links*).

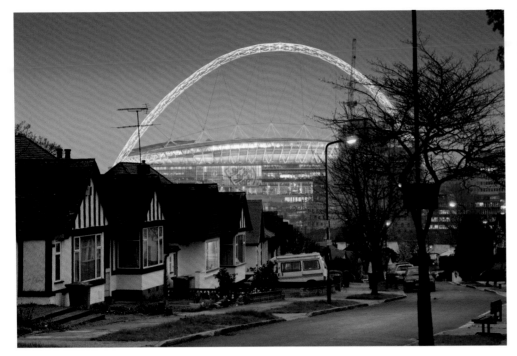

▲ Overlooking **Wembley Park**, 1920s bungalows line **Barn Hill**. Once these slopes were part of Repton's park. From 1896-1927 they played host to **Wembley Golf Club** (which was separate from the shortlived Wembley Park Golf Club, down the hill.) Today, from the open space at the summit of Barn Hill, panoramic views can still be had across Betjeman's 'lost Elysium'.

Metro-land endures. And yet, how its southern horizons have shifted.

When consent was given to demolish **Wembley Stadium** it was on the basis that a 'contemporary design' of 'outstanding quality' would take its place. However in stadium architecture, designing a seating bowl that will stand out aesthetically is a tough proposition, meaning that stadiums that catch the eye tend to do so, above all, because of their roof structures.

In this respect the new Wembley stands out, and how. Spanning 315m, longer than any other clear span roof structure in the world, its

arch is 133m tall at its apex, three times the height of the twin towers, and, because the stadium sits on a rise, some 185m above sea level.

Moreover, whereas most tall structures, such as the Shard, point skywards and invite us to ascend them in order to look outwards, Wembley's arch, like a pearly tiara, draws us to what lies below, to the giant bowl and the spectacles that await within.

After the new stadium opened in March 2007 so many fans stopped outside Wembley Park station on match days to take photographs of the arch that the police handed out postcards in order to keep the crowds moving.

Planners in Brent, meanwhile, have adopted policies to ensure that views of the arch will not be compromised by tall buildings in the vicinity; a rare example, it could be said, of instant heritage protection.

But the arch is no mere structural conceit. Whereas the twin towers were purely decorative, the arch,

leaning at 68 degrees, supports the entire roof on the stadium's north side, and 60 per cent of it on the south. Yet it consists of only 1,750 tonnes of steelwork; an extraordinarily efficient and elegant feat of engineering.

In other respects the stadium has been designed with traditional values in mind; for example, as noted below, configuring the roof so that it facilitates the maintenance of a high quality turf pitch – a pitch which, incidentally lies 4m lower than the original.

(During its excavation there were hopes that a steam engine reputed to have been abandoned during the stadium's construction in 1922-23 would have been revealed. But as with so many burial myths, nothing was found.)

Another facet of the old stadium that the FA insisted on replicating was the tradition of presenting cups and medals from a centrally placed Royal Box, rather than adopt the more usual international practice

of making presentations on the pitch. At the old Wembley, famously 39 steps led up from the pitch to the Royal Box. Now players have a more sapping 107 to mount.

Rather less desirable was the FA's further insistence that the new stadium be fitted with seats in the same, unsubtle shade of red used at the old stadium, and that the name 'Wembley' be spelt out at each end.

As if anyone needed reminding.

Otherwise, happily, the new Wembley exhibits none of the faults of its predecessor. It is, at last, a stadium fit for purpose, with excellent sightlines, decent legroom, spacious concourses and, huge relief all round, toilets aplenty (2,618 to be precise, compared with around 360 in the old stadium).

Which is not to say that all fans have embraced the new Wembley.

In particular fans unable to source or afford tickets to watch their team resent that 17,500 corporate seats have been set aside on a ten year licence (on the basis that, as in the airline industry, 80 per cent of the profits emanate from 20 per cent of the seats).

Also, in order to help the FA repay its £426 million debt for the stadium, both semi-finals of the FA Cup, traditionally played at neutral club grounds, are now staged at Wembley, thereby downgrading the allure of the Final.

For supporters in the north and Midlands already angered by the staging of England matches exclusively at Wembley, this policy serves as yet more evidence of London's dominance.

No doubt a winning England team and a few epic Cup Finals would help to ease these concerns. But in the meantime, the stadium management has to focus on packing the schedules, filling the seats and paying the debts – for if there is no spare cash for a museum, there sure is no room for sentiment either.

London's largest colosseum, the new Wembley, was designed by Foster + Partners, together with HOK Sport and the Lobb Partnership (since merged and renamed Populous). During events all 90,000 seats are covered. At other times, as seen here, roof panels at both ends and on the south side retract to ensure the turf gets as much sunlight and ventilation as possible.

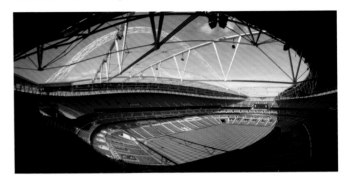

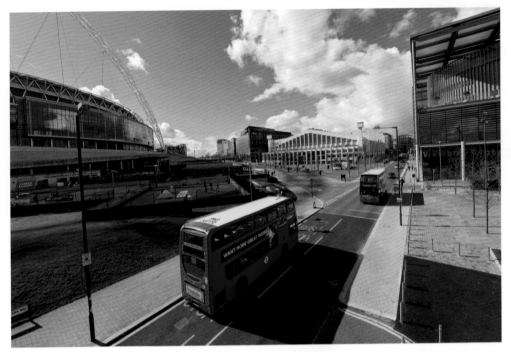

▲ Half hidden from passing pedestrians, this is one of two lions embedded within the walls of the **Fountain Studios** on **Wembley Park Drive**. The lions, thought to have been rescued from the BEE gardens that lay close by (*see page 71*), are now the only decorative elements of the exhibition left within the site, along with some tiles in the Arena.

It is true that other BEE artefacts may be seen elsewhere. These include drinking fountains in nearby Barham Park and two more lions at Woburn Abbey. By the time you read this there may also be a lion's head from the Palace of Industry on a green further up Empire Way, at the foot of Wembley Hill Road.

But for a small patch of London in which so much history has been packed, these are slim pickings.

If Wimbledon, Twickenham and Lord's each can manage museums, surely, between the FA, Quintain and Brent a means could be found to showcase Wembley Park's unique heritage, for the benefit of visitors, but also for Wembley Park's new residents.

Building a community around a national stadium is an intriguing prospect, one that has never been attempted before in Britain.

All the more reason therefore to understand its past. From Repton to Watkin to Elvin, from Billy to Bobby Moore, the home of Lions has an important tale to tell, for Wembley Park, for London, and lest we forget, for England too.

▲ Finally, for readers who may not have visited Wembley Park recently, the twist in the tale. This is the scene in late 2013, as **Wembley Arena**, resplendent after its £35 million revamp in 2006, finds itself with yet another set of neighbours.

To its right, where stood the Palace of Industry, is **Brent Civic Centre**, by Hopkins Architects, while on its southern flank, rising up in the distance, can be seen the new **Hilton Hotel** and **London Designer Outlet**.

What we see here are the early phases of the first masterplan to have been drawn up for Wembley Park since the BEE.

Designed by the Richard Rogers Partnership and approved by Brent Council in 2004, this masterplan is a consequence of a change of ownership at Wembley Park. Until 1999 both the stadium, arena and much of the site were under the control of a single entity, the company originally set up by Elvin. Although profitable, to say the least

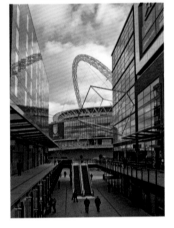

the complex and its appoaches presented a jumbled, tawdry backdrop to the national stadium.

When the FA, through its subsidiary, Wembley National Stadium Ltd, purchased the stadium in 1999, it was reluctant to take on the rest of the site. This was then bought up in 2002 by Quintain Estates, who commissioned the masterplan.

Expected to cost £2.5 billion, the masterplan will essentially turn Wembley Park into a place where people live as well as visit. In the process the stadium will become more like a traditional British club stadium; that is, hemmed in by its surrounds rather than standing in windswept isolation.

Counter intuitively, so far this proximity is having the effect of adding to, rather than detracting from the visual impact of the stadium and its arch, as can be judged when viewed from the **London Designer Outlet** (*left*).

In a future phase, the five-a-side football centre, seen above, will be replaced by flats, as will the car park on the north east side of the stadium, so that by 2030 there could be up to 30,000 residents within Wembley Park, and 12 million visitors a year to its various amenities.

There are even plans for a small park, ironically to replace the retail park built in the 1980s.

By the simple expedient of switching its main entrance from the west to the east, and laying out a new pedestrian area in front – called Arena Square – the venerable Grade II listed Wembley Arena at last has the setting it merits. One aim of the Wembley Park masterplan is to create a 'strong evening economy'. Could we be about to witness the return of the Wembley Lions?

Chapter Six

Lea Valley

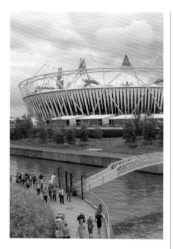

Enabling the public to negotiate the labyrinthine network of rivers and canals that weave their way through the urban archipelago that is now the Queen Elizabeth Olympic Park required the construction of 30 bridges. But how to refer to the waterways themselves? For centuries the river flowing some 58 miles from Bedfordshire (near Luton) to the Thames (via Leyton), was known variously as the Lea, Lee and Ley. When stretches of it were canalised in the 1760s, the name Lee Navigation was adopted. Two centuries later the Lee Valley Regional Park Authority was formed, even though the name Lea persisted when referring to the natural river and its crossings. Or at least that is one theory. Rather like the Haringey/Harringay question, this is one anomaly that most Londoners choose not to question and, Lea or Lee, just go with the flow instead.

Most British cities have at least one or two areas in which sporting facilities are to be found clustered together. London, not surprisingly, has several, each with a character of its own.

In previous *Played in Britain* city studies we have sought to show that an understanding of how a cluster has formed can yield useful insights into the sporting heritage of the city as a whole. Studying a cluster also often uncovers historical links between different sporting cultures that might otherwise not have been obvious.

Topography is the most common factor identified in the formation of sporting clusters, as is the case in the Lea Valley (and the Brent Valley, and indeed in many a river valley where the land is prone to flooding).

As featured elsewhere in this book, clusters also arise as the result of interventions made, for example, by estate owners (as in Dulwich), by planners (as in Duke's Meadows, Chiswick) or by commercial interests and governments (as in Crystal Palace Park and Wembley Park).

Or they may form along roads or railways (as in Catford and Beckenham, as seen in Chapter 12).

What makes the Lea Valley cluster so distinct is that *all* these factors have come into play, at various times during the last two hundred years.

There are two further reasons why sport in the Lea Valley is worthy of our attention.

Firstly, if you are a council tax payer in London you are a direct

stakeholder in the Valley. This is because, uniquely, the Lee Valley Regional Park Authority (LVRPA) – created in 1966 to manage the Valley's assets – is funded by a levy not only on those councils in Hertfordshire, Essex and the six 'riparian' London boroughs through which the Valley runs (those being Enfield, Hackney, Haringey, Newham, Tower Hamlets and Waltham Forest), but on all other London boroughs, even Hillingdon, for whom the Colne Valley Regional Park is much closer to hand.

To residents of non-riparian boroughs the Lee Valley Regional Park might seem far away. But they are helping to fund it nevertheless, in the year 2012-13 to the tune of nearly £12 million.

This brief summary and the two maps that follow could therefore be considered as an invitation to all Londoners to get to know the Lea Valley better, and to take a greater interest in its place in London life, sporting or otherwise.

Secondly, all British taxpayers have a direct, vested interest in the Lower Lea Valley, since the expenditure of £9.3 billion worth of public funds since 2005 on creating the nation's most sophisticated sporting cluster of modern times, centred on Stratford, Hackney Wick and Temple Mills.

Further north there also lies the Lee Valley White Water Centre at Waltham Cross. This however lies outside our remit, as does the entire upper half of the Valley, north of the M25.

By a long chalk the 2012 Olympics constituted the costliest and most comprehensive piece of intervention yet seen in the Lea Valley. And although its proponents have emphasised that three quarters of the costs were devoted to infrastructure that ultimately was not sport-related – for example, transport links and environmental improvements – it should never be forgotten that the catalyst for these works was, in the first place, sport.

As Ken Livingstone, London's mayor at the time the Olympic bid was won in July 2005, later admitted, boasted even, after decades of government neglect and underinvestment, the Games offered a once in a lifetime carrot to secure unprecedented levels of public funding for east London.

Livingstone was, however, by no means the first politician to see sport and recreation as a vehicle for improvements in the Lea Valley.

Throughout its history the Valley has been exploited by man, as a source of water and of power (for milling); as a means of communication, and for its natural assets (fish, peat, sand, gravel and so on). The River Lea itself has been narrowed, its circuitous meanderings tamed, its more intractable stretches bypassed by canals. Along its length bridges have been built, reservoirs created and marshes drained.

Had railways and industry not swamped large areas of the Valley, it is conceivable that Leyton might nowadays be comparable with Barnes, and Clapton with

Old Ford, Stratford, Chingford; Coppermill, Pudding Mill, Three Mills; Picketts Lock, Lea Bridge, Bow Creek; Marsh Lane, Spring Lane, Ferry Lane... the Lea Valley's liquid assets may not be as celebrated as those of the Thames Valley, but they have percolated London's sporting culture for three hundred years, and now, courtesy of the Olympics, find themselves at a watershed.

Richmond. But because certain manufacturing processes needed a reliable water supply, and because, as we are so often told, the prevailing winds made it more acceptable to locate noxious industries in the east, the pressure on open space on both sides of the Valley intensified throughout the 19th and 20th centuries.

Squeezed out in the process were the nurseries and market gardens that lined the Valley from Enfield to Tottenham. (Tottenham Hotspur's White Hart Lane, opened in 1899, stood on the site of one such nursery.) In their place arrived factories whose products fuelled technological advancement – electronics, plastics, chemicals, explosives – but whose legacy in terms of pollution and toxic waste, much of it crudely dumped, was to have lasting consequences. On the Olympic site at Stratford alone, 1.4 million cubic tonnes of soil had to be decontaminated before construction could commence.

On the other hand, it was those same polluting industries that brought tens of thousands of workers and their families to the area, all of whom needed housing and access to parks and recreation.

And so the story of the Lea Valley – if indeed a coherent narrative can be forged of such an extended and diverse area – is dominated by change, and above all by changes in land use, often accompanied by conflict between interest groups.

These include campaigners representing social, charitable and environmental causes, user groups, various planning authorities (the riparian councils, the London County Council and its successors, and most recently the Olympic Delivery Authority), the LVRPA and local businesses who have viewed the Valley primarily in terms of development and profit.

Each and every one could be said to have taken a position on sport at one point or another, from the missionaries of the Victorian period to the present day London Legacy Development Corporation, whose role it is to oversee the post 2012 development of the Lower Lea Valley.

Because of the Olympics the buzzword in the area is now 'legacy'. But what about heritage?

Starting in around 1800, records cite over 40 types of sport taking place in the Lea Valley, from

angling, championed by Izaak Walton in the 17th century, to yachting in the chain of reservoirs created since the mid 19th century. Lying in parts beyond the reach of magistrates, the marshes in Hackney, Leyton and Walthamstow in particular proved ideal for trap shooting, illegal bare knuckle prize fights, dog fights and bull baiting. (Dick Turpin was said to have been a regular at the White House, an isolated pub by the footbridge which still links the East Marsh with Hackney Marsh).

As late as 1906, in the area around Gilwell Hall, just north of Chingford, hunting was said to take place on four days a week.

In the 1850s, meanwhile, Hackney Wick and Bow became strongholds of pedestrianism, to which crowds of up to 10,000 were drawn before the boom ended in the 1880s. As our map shows on page 82, within a one mile radius of the track on which the likes of Mo Farah and David Weir won Olympic golds in 2012, no fewer than six Victorian running grounds have been identified, out of a total of 13 former and current athletics tracks overall between Mile End and Walthamstow.

Already a haven for anglers, in the 1860s the Lea, dotted with riverside pubs and boatyards, pleasure craft and ferries, became a focal point for rowing. But then came an outrage; the complete failure of Tottenham's sewerage system. All seemed lost until the Lee Purification Act of 1886 came into force and the rowers returned.

Shortly after this, footballers from the Eton Mission Boys Club were chased off Hackney Marshes by the 'drivers'. It was their job under the prevailing lammas laws to restrict access to non-rights holders at certain times of the year. So it was that in 1890 the LCC resolved to save the open space for public recreation, 'for ever'.

Thus was sown the seed of an idea; that of maintaining not only the marshes but all the other undeveloped parts of the Lea Valley as a 'green lung'.

It would take many years for this notion to be embodied into any form of planning policy, however.

After the First World War the Hackney Labour politician, Herbert Morrison, raised the idea of a 'Lea Valley Park'. No-one took this further, but all the

same, bit by bit between the wars the Valley's sporting credentials were enhanced as, in addition to Hackney Marshes, successive tracts of undeveloped land were set aside; for local authority playing fields, such as Mabley Green and Low Hall, for private sports grounds, such as Eton Manor, and for allotments, such as Manor Gardens, whose site was gifted by Arthur Villiers, benefactor also of Eton Manor.

But there were losses too, including the taking over of part of Hackney Marsh for the Kingsmead Estate in 1937, a development for which Morrison, by then the MP for Hackney, was cast as the villain of the piece.

The next individual to propose protecting the Valley was Professor Patrick Abercrombie. In his 1944 blueprint for the post war planning of Greater London (see Links), Abercrombie envisaged a Lea Valley Park acting as 'a great open-air lung to the crowded East End'.

Once again the idea lay on the table, until in 1961 another senior Labour figure in Hackney, the then mayor, Lou Sherman, took what turned out to be decisive action.

A London cab driver by trade, Sherman hired a boat and invited his counterparts from the other riparian authorities to cruise up and down the Lea and consider the possibilities of co-operation.

Two years later the Civic Trust was invited by these authorities to draft a report on how a Lea Valley Regional Park might be developed (see right).

Today some of the Trust's proposals appear overblown and outdated. They nevertheless offered a basis for discussion and in 1966, after lengthy negotiations, particularly over London-wide funding arrangements, the Lee Valley Regional Park Authority was set up by Act of Parliament. »

▲ 'We are on the threshold of the age of leisure,' the Duke of Edinburgh told the National Playing Fields Association in 1963. A year later, amongst the proposals outlined by the **Civic Trust** for a **Lea Valley Regional Park** (see Links) was this complex straddling the Lee Navigation canal, consisting of 65,000 capacity football stadium east of **Northumberland Park**, with an integrated swimming pool, tenpin bowling alley and restaurant spanning the waterway.

Further south there was to be a Fun Palace at Mill Meads (a concept hatched by architect Cedric Price and theatre director Joan Littlewood, then based at Stratford East). At Lea Bridge a permanent circus and fairground were to offer a rival to the Tivoli Gardens in Copenhagen.

To the north would be footpaths and cycle paths, camping grounds, a lake for power boating and water ski-ing... the wish list went on, up to the planned 'weekend resort' of Waltham Abbey and beyond.

Some of the Trust's ideas did take root, such as a cycle track at Eastway, and a golf course, riding centre and ice rink. Others were quietly forgotten. In 1969, after the formation of the LVRPA, one study recommended a four lane dual carriageway linking the various recreational centres. 'For the average Londoner,' it was noted, 'a "pleasant drive" is hard to find.'

»The Lee Valley Park, stated the Act, was to be 'a place for the occupation of leisure, recreation, sport, games or amusements or any similar activity, for the provision of nature reserves and for the provision and enjoyment of entertainments of any kind'.

The story of how the LVRPA set about this task is a complex one, best extracted from the Authority's own documentation (available online), and from the work of such commentators as Laurie Elks (*see* Links). But in brief, since the early 1970s the LVRPA has built or helped to build, and has operated several sports and recreational centres along its 26 mile jurisdiction.

In the London section, the Lee Valley Riding Centre (1973) and Ice Centre (1984) are well established. Further south, the Eastway Cycle Circuit (1975) made the provision of the Olympic Velodrome and Velo Park on the same site appear a natural and popular progression.

Similarly, in 1964 the Civic Trust report envisaged 'a great urban park, of Hyde Park scale', exactly where the Queen Elizabeth Olympic Park now lies. The scale and type of sporting provision within the park might be different, but the principle of the park was laid down half a century ago.

Other outcomes have been less predictable. At Picketts Lock a £2.5 million state-of-the-art leisure centre opened in 1973 was a success in its early years but, like several of its ilk from that period, proved uneconomic over the long term and closed in 2003.

Before it did, in 2000 there were plans for a 50,000 seat athletics stadium on the site. Had this gone ahead as planned, for the 2005 World Championships, it is likely that political support for an Olympic Stadium only a few miles south would not have been forthcoming. But the Picketts

Lock stadium was not built. In 2005 London won its bid for the Olympics, and in 2007 a training facility, the Lee Valley Athletics Centre, was built instead.

If there is therefore one lesson that can be learnt from the Lea Valley experience prior to 2012 it is that long term strategic planning in sport and recreation is an inexact science, forever subject to changing political priorities.

In which context, the provision of five permanent venues for the 2012 Games – namely the Hockey and Tennis Centre at Eton Manor, the Velodrome and Velo Park, the Aquatics Centre, Copper Box arena and Olympic Stadium – can be said to represent a major legacy, but equally, a giant leap of faith.

After all, the London section of the Lea Valley was home to six open air swimming pools in the 20th century, all since closed by their local authorities. In 1925 no-one in London had ever seen track-based greyhound racing or speedway.

Yet by 1933 there were five tracks in the Valley. Today there are none (although one operates in the north of the Valley, at Rye House).

There is also the issue of how sporting and recreational needs are defined. In 1944 Patrick Abercrombie wrote that 'The Lea Valley gives an opportunity for a great piece of constructive, preservative and regenerative planning'. But as events have shown, those three goals are not always reconcilable.

Most notably there remains a gulf between those keen to conserve the Valley's green spaces and to maintain free access, and those who see revenue-earning sports facilities and visitor attractions as the priority.

A further question is that of the Lea Valley's identity. In the ninth century it formed a border between the Saxons and the Danes. Since then it has separated Middlesex from Essex; in parts as great a divide as the Thames presents

between Middlesex and Surrey. But in the Lower Lea Valley, rather like the gradual closing of a zip, the bridging of the waterways has blurred the distinction between east and west, a process that will accelerate once the five proposed residential districts in the Olympic Park have been completed and, with great symbolism, granted their new postcode (E20).

Therein lies the Olympics' most assured legacy; that is, that the map of east London has been completely redrawn, as if a lost land had been plucked from its midst.

In 1964 the Civic Trust described London's second river as 'an ignoble stream' and the Lea Valley as 'London's backyard'. Nowadays the term 'edgeland' is favoured.

As the aerial images on these pages illustrate, a backyard or an edgeland can be a dumping ground, but also a playground.

What it cannot be any longer, it would seem in 21st century London, is a no man's land.

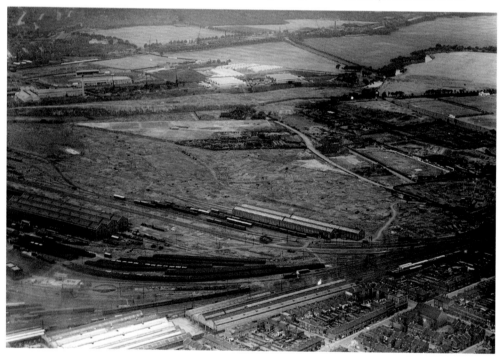

▲ With **Leyton Road** and **Stratford railway works** in the foreground, this is the site of the **Olympic Park**, as seen in 1935, looking north west. The **Olympic Village** and **Chobham Academy** now occupy the site of the railway sidings.

Top left is the **Hackney Wick Stadium** (26 on the map overleaf). Centre right on **Temple Mill Lane** is an enclosed 'flapper' track (25) for unlicensed greyhound

racing. In 1984 this site was redeveloped as the Clays Lane Estate (demolished in 2007). To the right of the track lies a piggery, a tip and allotments, re-landscaped in 1974 as the **Eastway Cycle Circuit** (H), now the site of the **Velodrome and Velo Park**.

On the far right can be seen a corner of the **Eton Manor Boys Club** sports ground (I), with the **Lea** snaking between **East Marsh**

and **Hackney Marsh** (31) in the top right. At the top of the image, centre left, is **Mabley Green** (30) to the right of which is the sliver of Hackney Marsh built over by the **Kingsmead Estate** in 1937.

Post war the area became increasingly industrialised and intersected by roads. Of the various allotment sites only **Manor Gardens** survived before being cleared for the Olympics.

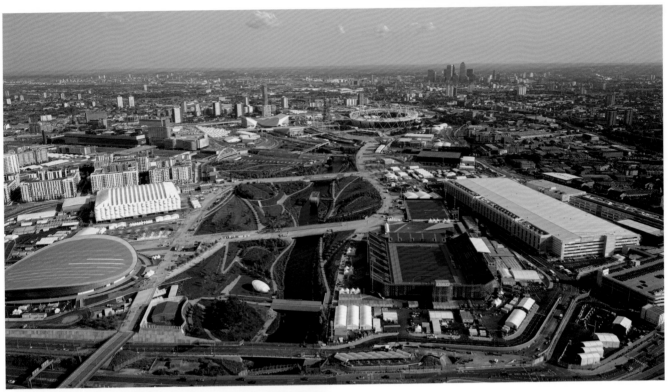

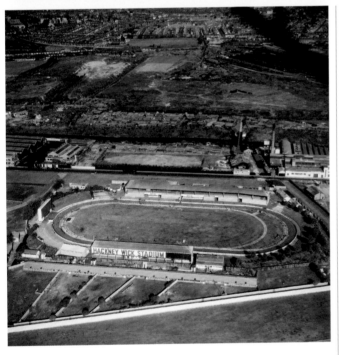

▲ Taken before the start of the **2012 Olympics**, this view, looking south down the **Lea Valley**, with the A12 and Eastway running from left to right in the foreground, shows the scale of development in **Stratford** since 2007. It also shows how the Lea, still the boundary between Essex and Middlesex, is now bridged at regular intervals, and forms the spine of the new **Queen Elizabeth Olympic Park**.

Not visible is the **Channel Tunnel Rail Link** which cuts through the site from west to east, tunnelled under the Lea before emerging at the new Stratford International station. This lies behind the **Olympic Village** (left centre), since renamed East Village.

There are other areas in London where dramatic comparisons can be made between how they appeared in 1935 (as opposite) and how they are today; Croydon or Docklands, for example.

But never before, not even at Shepherd's Bush (after the Franco-British exhibition and Olympics of 1908), or at Wembley Park (after the 1924 Empire Exhibition), has such a concentrated cluster of large scale, spectator sports venues been built in the capital.

During the 2012 Games the combined seating capacity of the nine venues on this site amounted to 161,500. In post Olympic mode, between the five permanent venues at least 73,000 seats are expected to remain available.

And this is before accounting for the 8,000 homes planned within the area or the 6,500 jobs promised at the former Media Centre alone.

As the Hackney writer Iain Sinclair has caustically noted (*see Links*), Stratford's main cash crop in recent years has been statistics.

Nevertheless, a prediction that 9.3 million visitors could pass through the Olympic Park annually after 2016 hints at the potential scale of this development and its possible impact on east London.

Sport has been the making of the Lower Lea Valley to an extent that even the authors of the 1964 Civic Trust report could never have imagined. No doubt by 2064 historians will be able to determine how lasting that legacy has been.

▲ Looking east in 1959, **Hackney Wick Stadium** on **Waterden Road** (26) opened for greyhounds in 1932 and for speedway in 1935, at a time when, as shown opposite, there was virtually no development between the Lee Navigation and Leyton. Even in 1959 there was still very little east of Waterden Road.

In the centre, the **River Lea** flows from left to right, with **Manor Gardens** allotments on the far bank.

A football pitch has been laid out on the site of the **Temple Mills flapper track** (25 and opposite). In the top centre, **Drapers Field** (24) was gifted by the Drapers' Company to Queen Mary College in 1894.

In the mid 1990s Hackney Wick Stadium was given an ill-conceived £10m refit, only to close for good in 1997 (*see page 333*). The former 2012 Media Centre (since renamed iCity) now occupies the site.

▶ This map shows the sports-related sites within the **southern section** of the **Lea Valley**.

South of the **Olympic Stadium** (A) relatively little organised sport is recorded, this area having been largely dominated by industry.

North of the stadium, the River Lea and Lee Navigation flow either side of three marshes; Hackney (31), Leyton and Walthamstow.

Since the mid 19th century rowing has been concentrated in this stretch of the Lee Navigation (between nos. 27 and 51), and up to Ferry Lane.

As industry colonised the valley, an intense, localised sporting culture emerged. Pedestrianism was particularly strong, as manifested by various running grounds, most attached to public houses, including **Bow** (4) and **Hackney Wick** (15).

From the 1920s this track-based betting culture switched to greyhounds, at **Clapton** (33) **Hackney Wick** (26), **Temple Mills** (25) and **Walthamstow** (*shown on map on page 88*).

Amateur athletics maintained a presence, in the form of the **Victoria Park Harriers** (14 and above), **Thornton Field** (23) and at **Mile End Stadium** (6).

Before the **Olympic Stadium**, the area's most prominent first class venues were those of **Leyton County Cricket Club** (45) and **Leyton Orient FC** (44), who until 1937 played on the Middlesex side of the valley, as Clapton Orient.

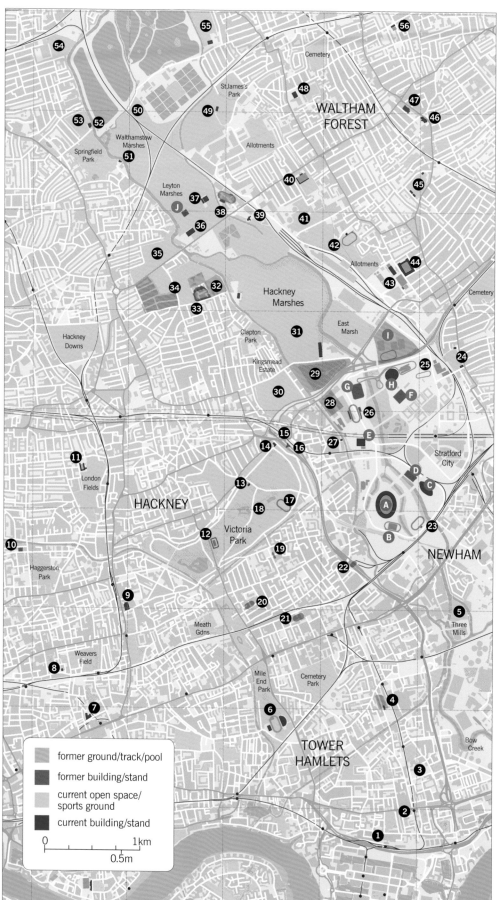

Key:
- former ground/track/pool
- former building/stand
- current open space/ sports ground
- current building/stand

0 0.5m 1km

Contains Ordnance Survey data © Crown copyright and database right (2014)

Notes: where club is identified, date refers to when it first occupied the site, *not* the date of its foundation.

Key: AC: Athletics Club; **BC**: Bowls Club, **FC**: Football Club, **GC**: Golf Club, **LC**: Leisure Centre, **PF**: Playing Fields, **Rec**: Recreation Ground, **RG**: Running Grounds, **SC**: Sports Centre, **SG**: Sports Ground, **TC**: Tennis Club
* denotes run by LVRPA

2012 Olympic/Paralympic venues:
A. **Olympic Stadium** (2016-)
B. **training track** relocated from adjacent site of 2012 warm-up
C. **London Aquatics Centre** (2014-)
D. site of **Waterpolo Arena**
E. **Copper Box** (2013-)
F. site of **Basketball Arena**
G. site of **Hockey Arena**
H. **Velodrome** and **Velo Park*** (2013-) site of **Eastway Cycle Circuit** (1975-2006)
I. site of **Eton Manor SG** (1923-67)/**Paralympics tennis arena/ Lee Valley Hockey and Tennis Centre*** (2014-)
J. site of **basketball training centre**

Other existing and former venues:
1. **Workhouse LC** Poplar High St (1998-)
2. **Poplar Baths** East India Dock Rd (1934-88) future pending
3. **Langdon Park LC (**2006-)
4. site of **Bow RG (**1859-63), **Prince of Wales Olympia & RG / Old Bow RG** (1863-c.1908) / **Poplar Open Air Baths** Violet Rd (1924-36)
5. site of **Three Mills SC / cycle speedway track** Bisson Road (1970-c.1985)
6. **King George's Field** (1952-) / **East London Stadium** (1967), renamed **Mile End Stadium** (1990-) / **Mile End Park LC** (2006-)
7. **Whitechapel SC** Durward St (1997-)
8. **Cheshire Street Wash-house** (1899-1974) / **Repton Boxing Club** (1975-)
9. **York Hall LC** Old Ford Rd(1929-)
10. **Haggerston Baths** Whiston Rd (1904-2000) future pending
11. **London Fields Lido** (1932-88, 2006-)
12. site of **Victoria Park Lido** Grove Rd (1936-89)
13. **Victoria Park BC** (1900-)
14. **St Augustine's Hall** Victoria Park / Cadogan Terrace **Victoria Park Harriers & Tower Hamlets AC** clubhouse (1962-)

15. site of **Hackney Wick / White Lion RG** (1857-75)
16. site of **Eton Manor Boys Club clubhouse** Riseholme St (1913-67) now A12 slipway
17. **Victoria Park running track** (c.1926-)
18. **Victoria Park Boating Lakes** (for swimming 1846-1934) extant as lakes
19. site of **Royal Olympian Gardens RG** Old Three Colts, Old Ford Rd (1859-60)
20. site of **Victoria Gardens RG** Victoria Tavern, Grove Rd (1850-51)
21. site of **East London RG** Coborn Rd (1870s)
22. site of **Clay Hall RG** Old Ford Rd (1857-61)
23. site of **Great Eastern Railway SG**, Thornton Field Warton Rd (1921-c.1939)
24. **Drapers Field PF** (1894-)
25. site of **Temple Mills greyhound / flapper track** Clays Lane (c.1932-55)
26. site of **Hackney Wick Greyhound Stadium** (1932-97)
27. **Eton Mission Rowing Club** Wallis Rd (1934-)
28. site of **Arena Field Rec** (1894) / **2012 Media Centre**
29. site of **Wick Field SG** (c.1960-1990) now **Wick Woodland**
30. **Mabley Green Rec** (1922-)
31. **Hackney Marshes** (1894-) and **pavilion** (2010-)
32. site of **Whittles Athletic Gd / Clapton Orient** (1896-1900)
33. site of **Millfields Road, Clapton Orient** (1900-30) / **Clapton Greyhound Stadium** (1928-74) now Orient Way (*above right*)
34. **South Mill Fields** inc **Crusaders / Saracens RFC** (1877-85) / **Clapton CC/Upper Clapton RFC** (1892–1901)
35. **North Mill Fields** inc **Clapton FC** (1880-88)
36. **Lee Valley Ice Centre*** (1984-)
37. **Lee Valley Riding Centre*** (1973-)
38. site of **Lea Bridge Speedway Stadium** (1928-38) / **Clapton Orient** (1930-37)
39. **WaterWorks Golf Centre*** (1972-) and nature reserve
40. **Hare and Hounds Ground** Lea Bridge Rd / **Leyton FC** (1901-2012) future pending
41. **Seymour Road / Marsh Lane playing fields** / former **Gas Board SG** (1930s-)
42. **Ive Farm SG** (c.1920-)
43. **Score Centre** Oliver Rd (2006-) site of **Leyton BC** (1924-2005)

▲ While most of the sports facilities within the London part of the Lea Valley belong to local authorities, those established by the LVRPA have been designed to meet cross-borough needs. There are, in close proximity on either side of Lea Bridge Road, the **Lee Valley Riding Centre** (*above*), **Lee Valley Ice Centre** (*below left and below*) and the **WaterWorks Golf Centre** (*left*), which doubles as a Nature Reserve Centre and acts as a gathering point for running clubs.

One of the LVRPA's toughest balancing acts is to meet its remit for sport and recreation whilst seeking to preserve the character of the Valley's natural assets; in this area primarily **Walthamstow Marsh**, a site of Special Scientific Interest, and **Leyton Marsh**, where a prolonged campaign took place against the siting of an Olympic basketball training facility (J) in 2012.

44. **Matchroom Stadium, Brisbane Road** (1905-) **L. Orient** (1937)
45. **Leyton County Cricket Ground** Crawley Rd (1885-) / **West Essex BC** (1923-2010)
46. **Leyton Lagoon LC** (1991-)
47. site of **Leyton Baths** Leyton High Rd (1934-91), now Tesco
48. **Kelmscott LC** (1984-)
49. **Low Hall SG** (c.1930s-)
50. site of **Coppermill PF** (c.1950-c.1998) now nature reserve

51. **Leaside Canoe Club** Spring Lane (1963-)
52. **Verdon's / Tyrell's Boathouse**, Spring Hill (c.1870s) / **Lea Rowing Club** (1980-)
53. **Springhill SG** (1870s-) inc **Upper Clapton RFC** (1879-87) and **Great Universal Stores SG** (post war)
54. **Markfield Rec** (1938-)
55. **Douglas Eyre PF** (1896-)
56. **Orford House BC** (1921-)

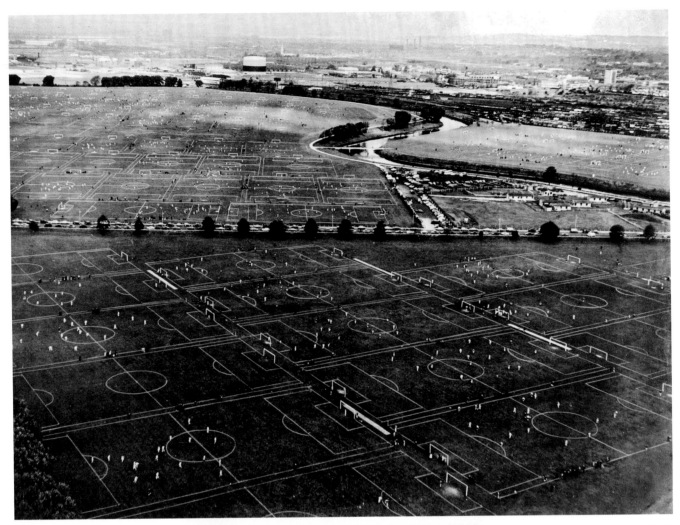

East Marsh score board:

ROOM	TEAM			PITCH	REFEREE	
1	Cock Tavern	v	AFC Knights	1	I. Yearwood	
2	Hare & Hounds	v	Jay Cubed	2	L. O'Gara	
3	FC Lockers	v	FC Storm (London)	3	W. Campbell	
4	Delta	v	Cosmopolitan	4	S. Stout	
5	O.K.J.H.	v	Red Devils	5	K. Hughes	
6	Eureka	v	Clapton Rangers	6	S. Collier	
7	Bancroft United	v	Iyawo Reds (D/6)	7	G. Griffiths	
8	Royal Oak (Essex)	v	Comet	8	H. Ali	
9	Lammas	v	Midfield (Hackney)	9	N. Spyrou	
10	Real Romania	v	Army & Navy (nsw)	S/F	10	M. Smith (P. Harris + R. Evans)
11	Mile End	v	Lapton	S/F	11	J. Griffiths (G. Smith + J. Tace)
12	Tottenham Avenue	v	FC Big Kahuna	12	P. Andrew	
13						
14						
15						HACKNEY

PLEASE DO NOT WASH BOOTS IN THIS SINK

▲ Billed as the spiritual home of Sunday football, at their peak in the 1960s and '70s **Hackney Marshes** consisted of five areas offering a total of around 120 pitches, the largest concentration in the world.

Above are three images of the former LCC pavilion on **East Marsh**, built in 1936 with a £10,000 gift from the charitable trust set up by Arthur Villiers, benefactor also of the Eton Manor Boys Club,

whose ground lay across the road. Serving a section of twelve pitches between the River Lea and the Temple Mills Sidings (now New Spitalfields Market and the Eurostar depot), the East Marsh pavilion was demolished in 2010 to make way for a temporary transport hub for the Olympics.

Two other sets of pitches forming part of Hackney Marshes were at **Mabley Green** (30 on

the preceding map) and **Arena Field** (28), now built over by the Queen Elizabeth Olympic Park.

In this classic aerial view from October 1962 (*top*), East Marsh is top right, with the main **Hackney Marsh** top left. In the foreground is **Wick Field**. This came into use for sport only in c.1960 after its levels were raised ten feet – to alleviate flooding – by the dumping of rubble from wartime bombsites

in east London. In the 1990s it was decided to abandon these pitches and create a woodland instead.

Although clearly the photograph has been touched up, it does not misrepresent the size of the 80 or so pitches visible. As veterans recall, they really were that small, well below the regulation minimum, with only a yard or so between the touchlines. It was the only way to meet the demand.

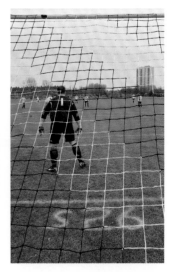

▲ There may be fewer pitches on **Hackney Marshes** these days – 65 on the main marsh, twelve on the East Marsh and eight on Mabley Green – but they are at least of a regulation size, and after a series of improvements, much less prone to waterlogging.

Seen in 2011, with the distant **Olympic Park** in mid-construction, this view from the north shows the main **Hackney Marsh** flanked on the right by the Lee Navigation and on the left by the River Lea. In the lower left is the **WaterWorks Nature Reserve and Golf Course** (39), laid out on part of the marshes taken over by the East London Water Company in 1830.

At that time the Lea was more meandering and the marshes less delineated, forming an amorphous expanse from Stratford to Clapton. Much of it was lammas land, used for grazing and cultivation by specific rights holders during allocated times of the year.

The marshes were also popular for rabbit coursing and shooting.

Most famously in 1791 a crowd of 3,000 gathered for a bull-baiting, during which the bull tossed a nine year old girl and an elderly man (both of whom survived). Also on the bill was a prize fight between a chimney sweep and a butcher.

By the 1870s the Metropolitan Board of Works had started to consider how the Marshes might be transferred to public ownership.

It took three Acts of Parliament and almost three decades to secure this goal. But as noted earlier, it was the eviction of young footballers from the Eton Mission in Hackney Wick in 1889 that led finally to the LCC and the Hackney District Board purchasing 337 acres of the marshes for £75,000.

'By no stretch of the imagination can they be called picturesque or rural; they are simply green islands in the midst of bricks and mortar', wrote the LCC's Parks Superintendent, John James Sexby, in 1898.

Two years earlier the Great Eastern Railway had established wagon works on the east side.

Close by, next to the bridge linking East Marsh with the main marsh, in 1917 the four hundred year old White House Inn, once Dick Turpin's haunt, closed.

Since then, although the marshes have never entirely cast off their reputation for mysteries and misdemeanours, they are at least a little more picturesque, thanks largely to planting around their margins and the creation of wildlife corridors, much of this work having been carried out in recent years by the Hackney Marshes Users Group and the Tree Musketeers.

More recently, there was great unease when in preparation for the Olympics the entire East Marsh was concreted over (as seen above) – it is to be returfed by autumn 2014 – and in June 2012 when the main marsh was given over to a two day concert that drew 100,000 people.

Hackney Marsh is otherwise largely perceived as a football fiefdom, and has been since the late 1940s when, as mentioned opposite, tons of rubble from east London bombsites were scattered over the area as a means of reducing the flood risk.

This substantially increased the area able to accommodate pitches, and in 1947 led to the formation of the **Hackney and Leyton Football League**, the organisation that still oversees the majority of the 50-60 matches that take place there every Sunday in the season.

In 2012-13 the League had 58 teams in five divisions; their names and line-ups reflecting

the changing demographics of east London. Pub teams still dominate, although the closure of pubs has had a worrying effect on sponsorship. Teams of Poles, Turks, Romanians and Ghanaians are also now part of the scene.

And are heard. For there is no better place to see and hear modern London in action, and to be reassured that amid all the cursing and shouting, most common of all is the sound of someone calling out 'Sorry mate!' as another tackle is mis-timed or a pass sent astray.

Designed by architects Stanton Williams and clad in Corten steel, the award winning Hackney Marshes Centre was opened in 2011 and serves the southern section of the Marsh. Separate new facilities are planned for the north section. Sunday football dominates, but Saturday matches, rugby and cricket are also played, and the Marsh equally serves walkers and runners.

▶ Designed by HS Goodhart-Rendel (architect also of the splendid St Olaf House in Tooley Street) and opened in 1913, this was the headquarters of the **Eton Manor Boys Club** on **Riseholme Street, Hackney Wick** (16 on the map).

With a gymnasium, games rooms, rifle range, library, canteen and bathrooms – few local residents had their own – the building formed one of the most important social hubs in Hackney Wick, not only for members but also for their friends and families, until its demolition in 1967 to make way for the East Cross Route.

But its name lives on.

The Eton of its title refers to Eton College, whose Old Boys established the original **Eton Mission** in Hackney Wick in 1880; an area, it was noted, roughly the same size as the playing fields of Eton but housing some 6,000, mostly poor, inhabitants. On average, it was noted, Eton boys were a foot taller than their contemporaries in the Wick.

Although spiritual guidance remained central to the Mission's role – the Grade II* listed St Mary of Eton, built in 1892, still stands on Eastway – the promotion of sporting activity quickly became paramount, as occurred at most other public school and university missions elsewhere in London. There was, after all, no state provision for school sport at the time, while membership of a sports club was still largely confined to the middle classes or to working adults.

There was also a concern that boys might be deterred from the Mission if there was, in the words of one club leader, 'too much parson'.

The leader in question was Gerald Wellesley, the 7th Duke of Wellington, who in 1909 decided to form a separate club for members who had turned fourteen and who would otherwise have had nowhere to go after work other

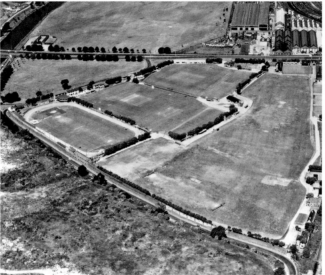

than pubs or music halls. As the new premises on Riseholme Street occupied the site of Manor Farm, the name Eton Manor was adopted.

In 1922 another Old Etonian, **Arthur Villiers**, took over the reins.

An investment banker at Barings, Villiers set up the Manor Charitable Trust in order to purchase 30 acres on **Temple Mill Lane** (I on the map), where there would be laid out pitches for football, rugby and cricket, plus six tennis courts, a bowling green, an open air swimming pool and a full sized athletics track.

So attached did Villiers become to **The Wilderness**, as the ground became known, that he also built for himself a modest house, often commuting from there into the City and somehow leading a double life between the business and social elite of the capital and this exposed sports ground.

Above the ground's entrance Villiers had carved the inscription, 'A game's a game at Temple Mill'.

Seen above during the 1950s, **Temple Mill Lane** runs in the foreground, with the **East Marsh** in the distance beyond **Ruckholt Road** and the **River Lea** on the left.

(As noted earlier, Villiers also gifted funds from the Trust for the pavilion on the East Marsh, seen in the top left of the image, and for allotments, known thereafter as Manor Gardens.)

Eton Manor developed serious sporting credentials during Villiers' stewardship. Most notably after the 1948 Olympics the shale track from Wembley Stadium was dug up and transferred to The

Wilderness (a story told in another *Played in Britain* title, *The British Olympics, see Links)*. In 1951 the track became the first in Britain to be floodlit. Roger Bannister, Chris Brasher and Gordon Pirie all appeared there, while on the adjacent pitches Eton Manor's cricket XI was coached by the former England captain Douglas Jardine and the football XI by a recently retired Tottenham and England player, Alf Ramsey.

Villiers' commitment was not to last. A complex character, generous and autocratic in equal measure, in around 1968 after the closure of Riseholme Street he suddenly withdrew funding and transferred the remaining trust funds into the Villiers Park Educational Trust, which continues to support youth programmes today. He died in 1969.

In the 1970s the LVRPA ran a sports centre on part of the Wilderness, but it was by then cut off by the new A12 and had lost its character. Finally, after years of dereliction it was cleared in 2006 to make way for the Paralympian hockey and tennis centre. This in turn became the **Lee Valley Hockey and Tennis Centre** in 2014.

On one wall are displayed the Eton Manor war memorials, on another a poem dedicated to the club by Carol Ann Duffy.

But the Eton Manor name lives on in other ways too. The **Eton Manor Athletic Club**, an offshoot of the original, is based at **Walthamstow** (60 on the map on page 88). The former Eton Manor Otters swimming club now compete as the **Eastern Otters** in Dagenham. **Eton Manor Football Club** play at Waltham Abbey while **Eton Manor Rugby Club** play at a ground in Wanstead known as **The New Wilderness**, where a fine display of memorabilia may be seen.

However, the most extensive collection of Eton Manor archive material, including the recorded memories of 41 former club members, is held by the Bishopsgate Institute and by the Villiers Park Educational Trust.

For Eton Manor was never just a sports club. For its most dedicated members it truly was a way of life, in some cases a life saver.

What matters to these veterans now is that the Eton Manor spirit lives on, and more than just in name.

▲ Tucked between industrial units at the end of **Wallis Road, Hackney Wick**, on part of the Lee Navigation known as the **Hackney Cut**, this is the modest boathouse of the **Eton Mission Rowing Club** (27 on the map). Formed in 1885, it is the Lee Valley's oldest surviving rowing club and one of the Valley's oldest sports clubs overall.

By contrast, a few hundred yards away on the opposite bank of the canal lies the Queen Elizabeth Olympic Park and the Copper Box Arena (E), a world apart except for the fact that a footbridge built shortly after this photograph was taken in 2011 now links the two.

When the Eton Mission was set up in 1880 (*see opposite*), several of the volunteers were by chance 'wet bobs', as rowers were called at Eton. As well as setting up the rowing club they organised swimming lessons in the Cut, starting at four in the morning in order to give the boys time to get to work. Participants were instructed to keep their mouths firmly shut whilst in the water, owing to the proximity of a dye factory.

In the rowing club's early years its boats were stored in the Mission church, St Mary of Eton, until in 1911 a boathouse was built on the canal's east bank and dedicated to **Gilbert Johnstone**,

the club president. On a shield held by the club are inscribed the names of 46 benefactors, Old Etonians to a man. They include an archbishop, a count, two lords, the newspaper proprietor Waldorf Astor and several prominent names from the annals of rowing, such as Rupert Guinness, who was also the MP for Haggerston, and Stanley Muttlebury, who in the 1880s won a record four Varsity boat races in succession whilst at Cambridge.

A local member of the club in 1911 was Henry Allingham, later to achieve celebrity as the oldest surviving veteran of the First World War, at the age of 113.

Seen above, Eton Mission's current boathouse was built on the west bank of the canal in 1934 and also dedicated to Johnstone.

On the lintel over the main door are dedications to his three recently deceased 'wet bob brothers', Francis, Cecil and Sir Alan.

When London won the Olympic bid in 2005 Eton Mission appeared perfectly placed to gain from the organisers' commitment to benefit local sports clubs and to promote one of the nation's favourite Olympic sports. Moreover, the scene of so many triumphs for British rowers in 2012, Dorney Lake, is owned by Eton College, while at the time of the Games

the London Mayor, Boris Johnson, was himself an Old Etonian.

But, returning to that footbridge. On a site already hemmed in on both sides, the construction of the bridge and its access points reduced the rowers' ability to manoeuvre their boats into and out of the water so greatly that at the time of going to press it was unclear as to whether Eton Mission would stay (perhaps using only smaller boats), move to a new site, or survive at all.

A three mile row upriver, meanwhile, past the marshes and under Lea Bridge takes us to an almost rural idyll.

Here at **Springhill** (52 on the map), where the Riverside Café comes alive at weekends, with Springfield Park and Upper Clapton rising to the west and, on the opposite bank, the Springfield Marina – operated since 1969 by the LVRPA on the site of Radley's boatyard – is the ideal spot to imagine the Lea as it was in the mid 19th century. Springhill then was nicknamed the 'Henley of the Lea'. There were four pubs between Lea Bridge and here. The Jolly Anglers, the Beehive and Robin Hood have all closed. Now only the aptly named Anchor and Hope survives.

In 1881, when the Lea Amateur Rowing Association was formed, 22

clubs were active on this stretch. A tradesmen's association then formed the following year, because amateurs were forbidden from competing against working men.

In 1893 these clubs were joined by the London area's first ever rowing club for women, formed by students at Homerton College, shortly before its move to Cambridge. By 1899 the number of clubs had risen to 39.

By 1980, however, only five remained at Springhill, and so they merged to form the present day **Lea Rowing Club**.

The main boathouse, the large white one in the centre (*see below*), dates from 1970. But the main historic interest concerns the single storey brick building on the left. Known originally as **Verdon's Boathouse** it dates from the 1870s, and was certainly in use by 1879, when it was listed as a receiving house for the Royal Humane Society.

Springhill today appears a far cry from the vision of concrete wharves and swooping walkways as envisaged by the Civic Trust in 1964. It reflects instead the years of voluntary effort and make do and mend that is the hallmark of British grassroots sport. For better or worse, it is a reminder that in some instances, less really is more.

Adjoining Leyton Marsh and Lea Bridge station, the Lea Bridge Speedway Stadium (*left*, 38 on map) operated from 1928-38, was home to Clapton Orient from 1930-37, and also staged boxing (*see page 2*). After the war the site became an industrial estate, leaving no trace of the stadium (despite rumours that the terrace cover had survived). The station closed in 1985.

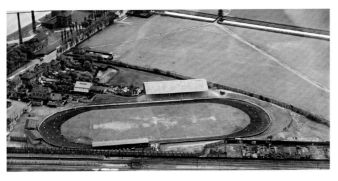

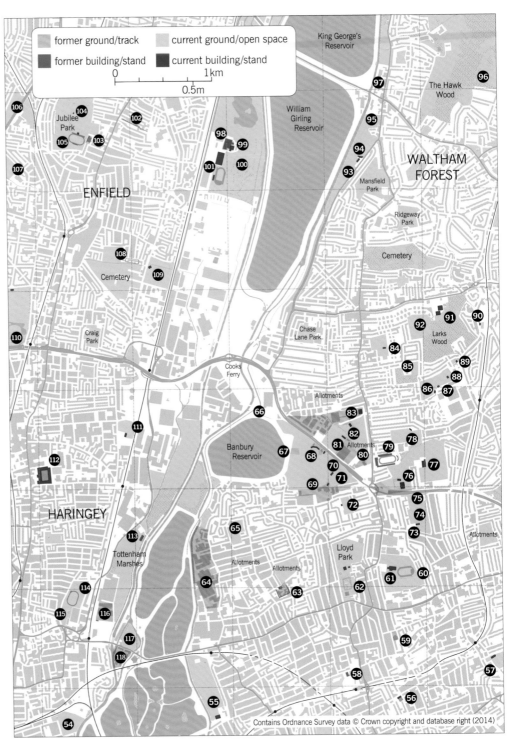

Heading north and we are invited by the Borough of Waltham Forest to embark on the **David Beckham Trail**. Born in 1975 and raised in Leytonstone, Beckham, seen here with **Ridgeway Rovers** at the age of 10, played on several local grounds before heading to Manchester, including, inevitably, Hackney Marshes. In 2005 Beckham played a lead role in bringing the Olympics to his former backyard.

Compared with the Lower Lea Valley this section has seen fewer major changes since the post war period, the most significant being the opening of the **William Girling Reservoir** in 1951, the loss of the sports ground of the **Harris Lebus** furniture company (116) to an industrial park in 1980, and the closure in 2008 of **Walthamstow Greyhound Stadium** (79), where Beckham worked as a teenager, collecting glasses.

The area's most senior sports venue is **White Hart Lane** (112).

Harking back to that 1960s plan for a scenic drive linking leisure facilities in the Valley: between the North Circular at Cooks Ferry and the **Lee Valley Athletics Centre** (101) lies the only stretch that was ever completed. Called **Lee Park Way**, symbolically or not, it remains blocked to through traffic.

Map legend:
- former ground/track
- former building/stand
- current ground/open space
- current building/stand

0 — 0.5m — 1km

Contains Ordnance Survey data © Crown copyright and database right (2014)

For notes on key, dates and numbers 54-56, see page 83

57. Walthamstow Cricket, Tennis & Squash Club Buck Walk, Greenway Ave (1910-)

58. site of **Walthamstow Baths** High Street (1900-68)

59. site of **Rectory Manor TC & BC** (1897-1971), now school

60. Waltham Forest Track (1986-) **Eton Manor AC / W'stow AC**

61. Waltham Forest Pool (1966-)

62. Lloyd Park (1900-), inc. **Walthamstow Avenue FC** (1905-10), **Walthamstow BC** (1912-) / **Aveling BC** (1930-)

63. site of **Green Pond Road**, **Walthamstow Avenue FC** (1921-88) / **Leytonstone & Ilford FC** (1988-89)

64. site of **four sports grounds** (c.1900-c.1960), inc. **Potter & Clarke SG** (c.1925-c.1950)

65. Higham Hill Rec and **Higham Hill BC** (1912-)

66. site of **Lee Valley Watersports Centre** (1972-2003)

67. ex **Gun Site PF** (c.1930-98) now cemetery

68. Fairways Driving Range Southend Rd (1989-)

69. Britannia SG Academy Rd, inc **Britannia Club** (Bank of England printing works club, 1930-51) / Essex County Council (1951-)

/**Tyne Acre PF**, Mann Crossman & Paulin Brewery SG, site now part of **Walthamstow Academy**
70. **Broadfields PF**
71. ex **Kingfisher SG** / **Wrighton's Furniture SG** (c.1930s-1996)
72. **George White SG** (1923-) Billet Rd / **Globe Rangers FC** (2000-)
73. **Wadham BC** (1930-)
74. **Wadham Lodge SG** Kitchener Rd (c.1930) inc. **Hale End FC** (c.1952)/**W'stow Pennant FC** /**Leyton Pennant FC/Waltham Forest FC** (1983-2008)
75. former **LPTB W'stow SG** now **Kitchener Rd Park** (2010-)
76. **Hale End SG** Wadham Rd, ex **London Hospital Medical College SG** (c.1900-2001), now **Arsenal FC Academy** (2001-), inc. **David Rocastle Indoor Centre** (2006-)
77. **Wadham Lodge PF** (1930s-)/ **Peter May SC** (2000-)
78. former **Rowden Pk SG** Nelson Rd (c.1919-23), **Old Parmiters CC & FC** (1923-78), **Parmiters FC / Cavendish SG** (c.1978-)

79. site of **Walthamstow Grange FC** (1921-31) / **Walthamstow Greyhound Stadium** Chingford Rd (1931-2008) *see page 330*
80. former **Hoxton Manor Boys Club SG** (c.1930-39) now allotments (1957-)
81. **Salisbury Hall PF** W'stow Ave/ **Puma 2000 FC** (1999-)
82. former **Blades, East & Blades SG** Chingford Rd (c.1930s), now **Goals Centre** (2009-)
83. site of **London Co-operative Society SG** (c.1930s-2000) now **Bannatyne's Health Club** Morrison Ave (2002-)
84. **Chingford BC** Memorial Pk (1929-)
85. **Ainslie Wood Rec** (c.1930s)
86. **Rolls SG / West Essex CC** Hickman Ave (1921-)
87. **E4 Fitness Club** (1992-) / **Waltham Forest Boxing Club**
88. **Rolls SG**, inc. **Halex BC** (1919-) / **Rover & Lyndhurst TC** (1989-) / **Chingford Tennis School** (2000-)
89. **Silverthorn BC** Inks Green, Ropers Ave (1938-)

90. **Whitehall TC** Larkshall Rd (1956-)
91. site of **Larkswood Lido** (1936-88), **Larkswood LC** (2002-)
92. **Larkswood PF** (c.1950s)
93. **Lee Valley PF/ Chingford RFC** (1950s-)
94. **Chingford Golf Range** (1973-)
95. **St Egberts PF** (c.1950s-)
96. **Chingford Golf Course** (1888-) **Royal Epping Forest GC**
97. **King George Sailing Club** Yardley Lane (1972-)
98. site of **Picketts Lock LC** (1973-2003)
99. **Picketts Lock Indoor BC*** (1973-)
100. **Lee Valley Golf Course*** (1972-)
101. **Lee Valley Athletics Centre*** Picketts Lock (2007-)
102. site of **Edmonton Straights greyhound training track** (1930s), now Elizabeth Ride
103. site of **Houndsfield Lido** (1927-80) now Water Lane
104. **Jubilee Pk BC** (1939-2012)
105. **Henry Barrass Stadium** Houndsfield Rd (1927-) /

Old Edmontonians FC (1929-)
106. **King George's Field** (1938-)
107. **Churchfield Rec** (c.1958-) / **Old Tottonians RFC** (1992-)
108. site of **Edmonton Greyhound track** (c.1933-48) now Barrowfield Close
109. **Montagu Rec** (c.1960s-)
110. **Pymmes Park BC** (1906-)
111. former **Tottenham Gas Board Club** (1924- 86), re-opened 1996, renamed **Fred Knight SG**, inc. **Crystall Pavilion** (1999)/ **Powerleague Centre** /**Tottenham Hotspur Ladies FC** (1991-)
112. **White Hart Lane, Tottenham Hotspur FC** (1899-)
113. site of **Tottenham Marsh Open Air Pool** (1905-39)
114. **Down Lane Rec** (1907-)
115. **Tottenham Hale BC** (1906-)
116. **Harris Lebus SG** (1954-82) now Lockwood Industrial Park
117. **Harris Lebus SG** Ferry Lane (1936-c.1950) now Paddock nature reserve (2000-)
118. **Ferry Lane SG** (c.1930s-54) now Bream Close housing

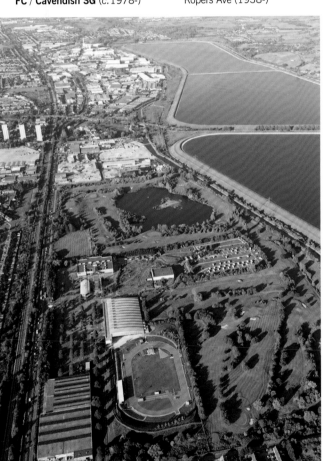

◄ Viewed in 2011, **Pickett's Lock** offers an absorbing case study for historians of leisure in the late 20th century. In 1973 the LVRPA opened its first leisure centre on the 60 acre site (98), a former gravel pit next to a sewage works. But for all its modernity – its leisure pool, sauna, crèche, multi-use hall and discotheque – in time it lost out to local centres in more accessible locations before eventually closing in 2003, leaving intact only its **indoor bowling club** (99), **golf course** (100) and curiously, a slab of London Bridge placed by the entrance to mark its opening.

In 2000 plans for a 50,000 capacity athletics stadium on the site were aborted, to be superceded in 2007 by the £16m **Lee Valley Athletics Centre**. Designed by

David Morley Architects this features London's only 200m indoor track (*above*), an outdoor track and, as well as providing a regional centre of excellence, serves as the home of the **Enfield & Haringey Athletic Club**.

Given its proximity to the new athletics facilities in Stratford might this be considered an over provision? Not if we consider this part of London's tradition of track and field sport, and allow the LVRPA its original premise, of creating a regional park. But then these are issues which extend equally beyond the Lea Valley Road to the north, where lies another 13 mile stretch of the Valley, and a host of other questions that no doubt will exercise historians of leisure for many years to come.

Chapter Seven

Dulwich

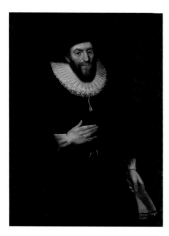

On stage as one of the finest actors of his generation, but also as the co-owner of several London theatres; in high society as an impresario for the royal court, and in low life as the purveyor of bull and bear baiting in the depths of Southwark (not to mention his mixing with the likes of Will Shakespeare); as a patron of the church, yet as a keeper of brothels, Edward Alleyn (1566–1626) was a player in every sense of the word. Critics called his charitable works self-aggrandisement (not to mention a means of avoiding death duties). Admirers lauded his generosity and craved his good company. Either way, having bought an estate in Dulwich in 1605, Edward Alleyn succeeded in achieving immortality by endowing a foundation which, four centuries later, still oversees a number of schools and charities and, by the by, has facilitated the creation of one of the most extraordinary sporting clusters in urban Britain.

When Edward Alleyn endowed his College of God's Gift for twelve poor scholars in the early 17th century, with the proviso that it should 'endure and remain for ever', organised sport was decidedly not on the curriculum, and Dulwich was a sleepy village set amid acres of meadows and ancient woodland.

Yet had it not been for Alleyn's foundation, and for the policies adopted by those tasked with its continuance, Dulwich today would almost certainly have been indistinguishable from the south London sprawl that surrounds it.

Instead of which, in addition to its many distinct characteristics and quirks, social, historical and architectural, the Dulwich Estate, as Alleyn's foundation is now called, offers a haven of amateur sport unlike any other in London.

Much of this is owing to the existence of well endowed schools and clubs who, directly or indirectly owe their origins to Alleyn and his successors.

But more intriguing is the unusual extent to which the grounds and playing fields they occupy have not only survived, but reflect field boundaries, paths and roadways that have barely altered for two hundred years or more.

A Dulwich farmer of 1800 or 1850 returning today, although no doubt bemused by the intrusion of the railways and by greenswards now covering his hayfields and pastures, would surely be able to find his way around much of the area, field by field, fence by fence.

Much less easy for him to comprehend would be who these schools and clubs are, and how they all fit in with each other.

Again, all roads lead back to Edward Alleyn. Despite two happy marriages he had no offspring. But he did have a curious sense of morality (or even conceit), because in specifying how the College of God's Gift should be run after his death he stipulated that both the Master and Warden 'shall be single persons and unmarried, of my blood and surname and for want of such my surname only.'

In fact both his heirs, each cousins, were married and did take on the roles of Master and Warden. But in later years this clause meant recruiting bachelors not on the basis of their talent but of their having the name Alleyn or similar.

The ramifications of this clause, combined with other aspects of the foundation's later conduct, would lead to it being overhauled twice, by Parliament in 1857 and again in 1882, the aim being to curb abuses and both improve and extend the foundation's educational and philanthropic outreach.

Even if confining one's interest to the sporting scene alone, a basic understanding of what emerged during that period is essential.

From the restructuring in 1857 arose the present day institution of Dulwich College. Since 1870 this has been housed in an imposing range of neo-Gothic buildings, designed by Charles Barry Junior. Once a small, parochial school, the College now set out to emulate the likes of Eton, Harrow, Westminster and Charterhouse.

Meanwhile in 1886, a few fields away in East Dulwich Grove, another school to have new premises was James Allen's Girls School. This institution's origins went back to 1741 when James Allen, the then Master of the College of God's Gift (selected for the post for obvious reasons) set up schools for local poor children, where boys were taught to read and write and girls to read and sew. The boys' section also achieved status as a local grammar school. But instead of naming it also after James Allen when it moved into new premises in 1887, it was renamed Alleyn's School.

As if this were not complicated enough, when it came to alumni associations, the one formed by Dulwich College Old Boys called itself not the Old Dulwichians but the Old Alleynians.

Not to be outdone, the old boys of Alleyn's School then formed their own association, the Alleyn's Old Boys, which, after girls started to be admitted to the school in the 1970s, was then confusingly renamed the Edward Alleyn Club.

Each of the three schools and the two alumni clubs maintain a sporting presence within or close to the Estate, as do several other educational establishments based locally (although there are not as many as in the late 19th century when no fewer than 64 private schools were listed in the area). In fact in recent years, when other outside organisations have decided not to renew their leases on sports grounds within the Estate, the grounds have soon

To football fans Dulwich is best known as the home of the once mighty amateurs, Dulwich Hamlet FC, whose aptly named Champion Hill ground lies at the end of this road. Locally born Edgar Kail (1900–76), a drinks salesman by trade, scored over 400 goals for his beloved club, won three caps for England and refused all offers to turn professional. Even today Hamlet fans chant Kail's name.

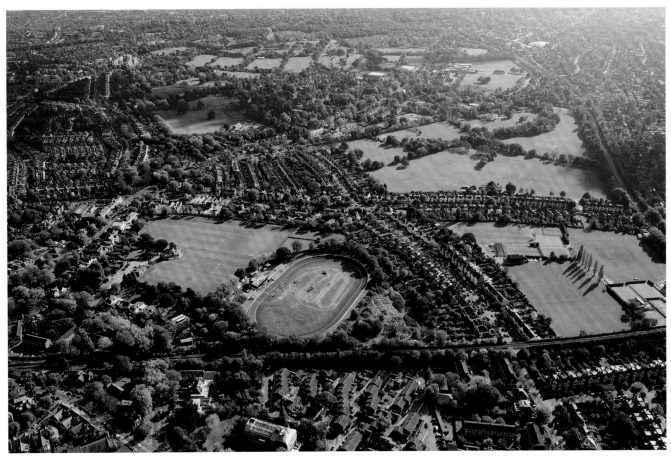

been snapped up by these schools, such is their demand. For example Dulwich Preparatory School London now leases two grounds, one of which had been for years the ground of Lloyd's Register.

But the Estate schools are not the only kids on the block.

When the London South Bank University suddenly gave up its 77 year old tenure of the Turney Road ground, it was community activists who stepped in to set up a trust in order to run the site for the benefit of local clubs and state schools.

Backing onto this ground is another leased to a charity for inner-city youths, while next to Dulwich Park – itself handed over by the Estate for public use in the 1880s – a former insurance company ground has, since 1977, served as the sports and social club of workers at Southwark Council.

In short, the green patchwork we see above is not entirely given over to the wealthy and privileged.

That said, there is no guarantee that the open spaces of Dulwich will themselves 'endure and remain for ever'. As local historian Brian Green has pointed out (see Links), one of the reasons why the

fields were turned over to sporting use in the first place was that it was becoming increasingly difficult for the Estate to get a good return from farming. In 1800 it could get £4 an acre for pasture or £10 an acre for arable. By 1901 some fields were yielding only £2.15 an acre.

So why not sell off the land for housing, as happened in so many other areas? Because, as the Trustees make clear, although their prime duty is to raise funds, it is the open spaces that help maintain the value of the Estate's existing holdings, and which help to attract families to the area, thereby ensuring that the schools continue to thrive.

If this sounds perfect, inevitably there are frictions; between the aims of the Estate and the needs of local residents and the public realm. Which is why, in order to understand how this remarkable sporting enclave has survived, readers are directed to discover more, for example via the works of the Dulwich Society.

Even better, however, is to visit in person. Choose the right time and you might even find yourself getting a game.

▲ Viewed from the north west, looking towards the ancient woodland of **Sydenham Hill**, and with the **Dawson Heights Estate** (built on the site of a Roman fort) prominent in the extreme top left, **SE21** is one of south London's most verdant postcodes. Within the boundaries of the 1,500 acre **Dulwich Estate**, but also around its immediate edges, there may be found 26 distinct sports grounds or sets of playing fields, five tennis clubs, three public parks and an 18 hole golf course.

In the foreground, nudging up against the railway line that runs between North Dulwich and Tulse Hill, **Herne Hill Velodrome** has been staging cycling since 1891, plus at times athletics and rugby too (see page 320).

To its immediate left (or east) lies **the Griffin Ground,** leased by **King's College London** but for many years the sports ground of J Sainsbury.

To its right (or west), accessed from Burbage Road, is the **Edward Alleyn Club** and its neighbour, the **Dulwich Sports Club**. These three grounds alone are home to 15 clubs representing nine sports.

On the right, bordered by the railway from Herne Hill to Sydenham Hill, the patchwork of sports grounds continues a mile and a half southwards, via **Belair Park**, passing through the trim expanses of **Dulwich College** – interrupted briefly by London's only remaining tollgate, on College Road – before coming to a halt on the edge of Dulwich Wood, beyond which lies Upper Sydenham and Crystal Palace Park.

In the centre of this view, where stands the Dulwich Picture Gallery – the oldest public gallery in England – Dulwich Village's chestnut lined roads fan out southwards towards **Dulwich Park**. Opened in 1890, this occupies 72 acres of the former Dulwich Court Farm, where it is believed the medieval manor court of Dulwich once stood.

Finally, at the top of the photograph can be seen the range of sports grounds occupying the gentle slopes of **Dulwich Common**; their boundaries barely altered since the land was used for dairy grazing in the 19th century.

So much green to savour. What we need now is a map...

This map shows the sports-related sites within, and on the borders of the **Dulwich Estate**. The dates below relate to the period in which clubs or organisations were known to be in occupation of that particular ground or location, *not* to their foundation dates (although is some instances these are the same). Where dates are unknown estimates from map data appear.
Key: AC: Athletic Club; **AG**: Athletic Ground; **BC**: Bowling Club; **CC**: Cricket Club; **FC**: Football Club; **HC**: Hockey Club; **LB**: London Borough; **PF**: Playing Fields; **SG**: Sports Ground; **TC**: Tennis Club

Within the Dulwich Estate:

1. **Dulwich Sports Club** (1885-) inc **Dulwich CC** (1885-), **Dulwich Croquet Club** (1912-) **Tulse Hill & Dulwich HC** (1907-) **Dulwich Squash Club** (c.1930-) **Dulwich TC** (c.1890s-)
2. *Edward Alleyn Club* (1884-) inc **Alleyn Old Boys FC** (1888-) **Edward Alleyn & Honor Oak CC** (1884-), **Edward Alleyn TC**, **Dulwich Runners AC** (1980-)
3. **Herne Hill Velodrome** (1891-)
4. **Griffin Ground**, ex J Sainsbury SG (1922-90), Cambridge AG, Causton's AG, **Dulwich Village BC** (1971-2003), **King's College SG** (1990-2012)
5. **North Dulwich TC** (c.1903-)
6. site of **Greyhound Inn** SG and leisure gdns (c.1776-1898), inc **Dulwich CC** (1879-1885), now Pickwick/Aysgarth Rds. *nb* inn was across road from **Crown & Greyhound** pub (c.1900-) *see page 148*
7. ex **Westminster City School PF** (c.1910-33) / **Borough Poly** / **South Bank Univ SG** (1933-2010), **Southwark Community Sports Trust** (2011-)
8. **Rosendale PF**, LB Lambeth (c.1900-)
9. **Belair House** and grounds (1785-), **Belair Park** (1965-)
10. former **Lloyd's Register SG** (1900-2000) now **Dulwich Preparatory School SG** (2002-)
11. former **Alleyn / Christ Church / Hollington / Dulwich College Mission SG** now **PELO SG** (2004-)
12. **College Gdns Recreation Field**
13. **Old College Lawn Tennis & Croquet Club** (c.1919-)
14. **Dulwich Preparatory School Nursery** Gallery Rd (1969-)
15. **Dulwich Park BC** (1899-)

Contains Ordnance Survey data © Crown copyright and database right (2014)

Legend:
- former ground/course
- current open space
- current ground/pitch
- current building/stand
- **····** Dulwich Estate

16. former **Samuel Jones & Co SG** (c.1930s-77), now **LB Southwark SG** (1977-), inc **Peckham Town FC** (1982-)
17. former **Samuel Jones & Co BC** (1952-77) now **Southwark Sports BC** (1977-)
18. **Dulwich Riding School** (1961-)
19. **Camber Tennis Club** (1939-)
20. former **Marlborough CC** (1919-) Cox's Walk, now **Streatham & Marlborough CC** (2003-)

21. former **Honor Oak CC** (1930s-) now **Dulwich College, Trevor Bailey** SG (2000-), **Dulwich Park Runners**
22. **Old Alleynian FC (Rugby)** Dulwich Common (1905-)
23. former **Wilson's Grammar School SG** (c.1930s), now **Pynners Close PF** LB Southwark
24. site of **Toksowa Hotel / indoor tennis courts** (c.1930s-70s) now Hambledon Place

25. **Dulwich & Sydenham Hill Golf Club** (1894-)
26. **Dulwich Preparatory School SG** Grange Lane (1895-)
27. former **Johnson Mathey / Alexander Howden SG** inc. former **Northwood BC**, now **Dulwich College, Eller Bank SG** (c.1990-) / **Dulwich College** Kindergarten (DUCKS)
28. **Dulwich College Tank Field** (c.1880-) inc. **track** (c.1950-)

29. former **Dulwich College Covered Courts** (*c.*1890) now **Dulwich College Sports Centre** (1966-) and **Swimming Pool** (2002-)
30. **Dulwich College SG** (1881-)
31. **Mary Datchelor Playing Fields** (*c.*1909-81) now **Dulwich Preparatory SG** and **Kingsdale Foundation School**

Sports related locations outside boundaries of Dulwich Estate (see index for further references)

A. **Brockwell Lido** (1937-)
B. **Temple BC** (1931-)
C. site of **Bessemer Golf Club** *c.*1930s, now Denmark Hill Estate
D. **James Allen's Girls School SG** (1912-) and **JAGS Sports Centre** (1986-)
E. **St Saviour's & St Olave's School SG** (1917-)
F. former **Champion Hill C&TC** (1891-1931), inc **Dulwich Hamlet FC** (1912-31), **Mary Datchelor School for Girls PF/ Cleve Hall TC** (1930s), now **Greendale PF**
G. within former **Champion Hill C & TC** (see F), **Dulwich Hamlet FC** (1902-12, 1931-)
H. former **Denmark Hill TC** (*c.*1930s-70s)
I. former **King's College Hospital SG** (1921-90) now **St Francis Park**
J. **Dulwich Constitutional BC** (1914-)
K. **Dulwich Leisure Centre** (1892-)
L. **Alleyn's School SG** (1887-)
M. former **Woodwarde Rd** ground of **Dulwich Hamlet FC** (1893-1902), now **Alleyn's School SG** (1914-)
N. former **Courage Brewery SG** (*c.*1930s-1950) now Lordship Lane Estate
O. **National Recreation Centre** (1964-)
P. former **Gallery TC** (*c.*1910-39)

THE PLAYING FIELDS DULWICH COLLEGE

▲ Net practice at **Dulwich College** in 1907. In the distance, Joseph Paxton's **Crystal Palace** had transformed this part of London since its relocation from Hyde Park in the 1850s, attracting some two million visitors a year.

Dulwich College itself, opened on its present site in 1870, was funded by the £100,000 paid by two railway companies for 100 acres of foundation land. However the adjoining fields (30 on map) remained out of bounds until, according to the author and former pupil AEW Mason, the boys tore down the fences and laid out their own pitches. Taking the hint, the Estate Governors ceded the 13.5 acre area to the College, which in 1881 built the pavilion seen above.

On the same site, overlooked by the Crystal Palace transmitter mast, the **current College pavilion**, designed by Francis Danby Smith in 1934 (*left*), is lined with honours boards listing every cricket and football captain from 1860, and every first XI and first XV player since 1871, among them Trevor Bailey, later of Cambridge University, Essex and England.

In contrast to the clipped formality of the private schools, the grounds on the southern side of Dulwich Common retain a more rustic charm. At Cox's Walk (*far left*), the pavilion of Streatham & Marlborough CC earns the club rent as a children's nursery, as does the clubhouse of the Old Alleynians Football Club, two fields to the west (*left*), on what used to be known as Potash Farm.

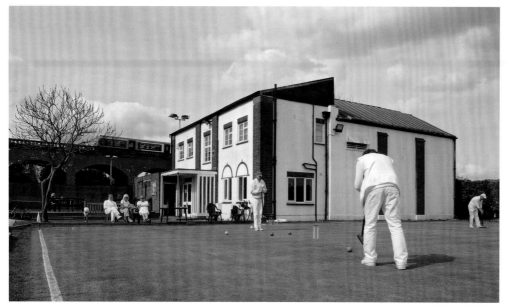

▶ **Dulwich and Sydenham Hill Golf Club** prides itself on having the closest 18 hole golf course to the City of London, being just over five miles away as the crow flies (although Highgate Golf Club is marginally closer to Charing Cross).

Another great asset is having a clubhouse over 300 feet above sea level. Dubbed the 'Caravan on the Hill' – it is a flat-roofed, timber-clad structure built in 1966 to replace a traditional pavilion destroyed in 1944 by a flying bomb – its upper lounges offer stunning panoramic views over the city, from Harrow on the Hill in the west to Canary Wharf in the east.

It was views like this, clean air, a still rural setting and, in 1863, the arrival of the London, Chatham & Dover Railway, which made Sydenham Hill a magnet for affluent businessmen seeking to build grand mansions within reach of the City.

They in turn were infected by the golf bug that swept London in the 1890s (*see Chapter 21*), and so colluded with a farmer to set up a course on secluded fields between Dulwich Wood and the College.

As recounted in Tom Brennand's entertaining club history (*see Links*), when the Dulwich Estate found out, and it transpired that a faction of Dulwich residents also wanted to establish a course, a year long battle of wits ensued, only finally resolved when the Estate forced the two factions to combine in 1894.

Hence the name – as prescribed by the Estate – the Dulwich and Sydenham Hill Golf Club.

Noted members have included

Henry Cotton, Peter Oosterhuis and Denis Thatcher (who persuaded his wife that they should retire to a house in Hambledon Place, backing onto the course).

But most treasured of all by the club's 850 or so playing members is that the oak-lined course was designed by the famed Harry Colt, in 1910; so treasured that on occasions members have fought to ensure that its original layout

and beauty should be preserved.

Self sufficiency is another asset. In 1991 a bore hole was drilled through 145m of clay, sand and chalk. The resulting gush yielded 7,000 gallons per hour of water so pure that the club considered selling the surplus. But that would have needed a bottling plant on site, not a prospect that would have pleased anyone, on the Dulwich side of the hill, at least.

◀ Clubs set up to cater for a variety of sports on one site were much in vogue in Victorian and Edwardian suburbs but now are relatively rare. **Dulwich Sports Club** on **Burbage Road** is thus unusual in currently hosting five sections.

Laid out in 1885 next door to the Edward Alleyn Club, and bound on its north side by the viaduct of the London, Brighton and South Coast Railway (which cut through Dulwich in 1866, thus helping to pay for Dulwich College), its first members were drawn from **Dulwich Cricket Club**.

Formed in 1867, the cricket club moved over to Burbage Road from the Greyhound Inn ground.

A **tennis** section was set up in the 1890s, followed by **hockey** in 1907 and **croquet** in 1912. A bowls section has however disbanded, enabling its green to be used by the **croquet** players, who already had two lawns. (Usually it was the other way round, with bowls or tennis taking over croquet lawns once the game, which had been introduced to the country house set during the 1850s, fell out of fashion from the 1870s onwards).

Dulwich is one of three croquet clubs in the area, the others being the Old College Lawn Tennis and Croquet Club on Gallery Road, and Sydenham Croquet Club on Lawrie Park Road.

A pavilion dating from 1974 serves as the Dulwich Sports Club's main hub, but rather more noteworthy is the block seen here.

Squash enjoyed a boom following its standardisation in 1923. Nevertheless this pair of courts, built by Grays of Cambridge during the 1930s, with interior cement rendering by the noted Bickley company of Battersea, is an unusual survivor, the majority of courts from this era having been replaced during the second squash boom of the 1970s and 1980s.

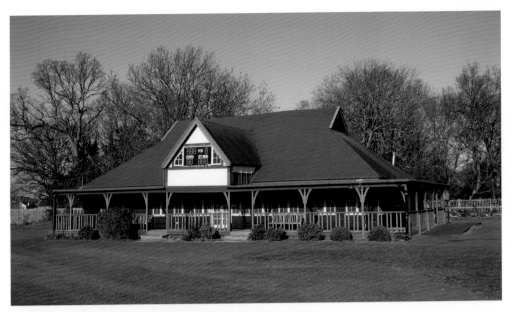

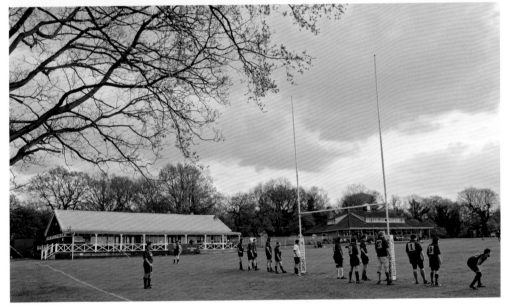

◀ For all its abundance of grounds and parks, clubs and schools, in common with most London suburbs Dulwich has relatively few pavilions or clubhouses of architectural note.

These three do deserve mention, however. On **Gallery Road** the former pavilion of the **Lloyd's Register Sports Club** (*top*) appears to date from the late Victorian or Edwardian period. In fact it was opened in June 1936, yet further evidence that, as shown in previous *Played in Britain* studies, most sports clubs, like housebuilders, clung on to safe, traditional styles right up until the Second World War.

That said, since the pavilion was taken over and superbly restored by **Dulwich Preparatory School** in 2002, it has a timeless quality.

Less imposing, but still full of charm, is the clubhouse of the **Old Alleynians rugby club** on **Dulwich Common** (*centre*), which stands to the east (or left) of a more prosaic block of changing rooms, dating from 1961. The clubhouse's core was completed in 1931, but war time damage and several refurbishments since, including a neat tin roof and a restored wooden verandah, have given it a fresh lease of life. The main bar is especially welcoming, watched over by a portrait of one of the founders, McCulloch Christison (1880-1972). A dour Scottish bachelor who played over 300 games for the club and was also a tea planter in India, Christison was nicknamed 'Slacker' because he seemed to take on every job going at the club.

Every club needs such slackers.

Finally, the **Dulwich Sports Ground** pavilion on **Turney Road** (*bottom*) was built by the **Borough Polytechnic**. Restored in 2012 by the **Southwark Community Sports Trust**, a consortium of five local bodies, it has a splendidly light and airy octagonal central hall.

Its date? Also 1936.

Chapter Eight

Westway

After six years of street clearances, demolition, heavy construction and widescale disruption to their lives, residents of North Kensington showed their anger by blocking the Westway on its opening day in July 1970. 'Get us out of hell – rehouse us now!' read one banner, draped from the rooftops of terraced houses on Acklam Road, barely 20 feet from this concrete behemoth. Two and a half miles in length and soon throbbing with 47,000 vehicles a day, the new Westway, or A40(M), cut the journey time between White City, where the A40 had previously come to an abrupt halt, and Marylebone, from as much as an hour to a matter of minutes. At last, residents in those parts of west London where the through traffic had been channelled before, and where road accidents had been common, found some respite. But for those whose lives and communities were now overshadowed by Westway, a much tougher road lay ahead.

Heritage is as much about ideas and values as it is about buildings, places or objects.

When the mainly working class residents of North Kensington organised themselves in the 1960s against the ruination of their neighbourhood by Westway, many of them were already close to the edge, in more ways than one.

This was hardly a new situation in a part of London carved through by the Great Western Railway in the 1830s, and then further opened up to speculative development by the Hammersmith and City Line in 1864. In their wake, pockets of wealth emerged amongst the piggeries, potteries and brick fields that had fostered some of the most squalid conditions recorded in the capital.

By the late 1950s, when the area was further blighted by the Notting Hill riots, 75 per cent of its housing was privately rented, and in a parlous state, made worse when the 1957 Rent Act paved the way for unscrupulous landlords to sub-divide properties further.

But if there was hope that the creation of the Royal Borough of Kensington and Chelsea (as part of local government reorganisation in 1965) would address the stark contrast that existed between the affluent southern districts and the deprived north, those hopes appeared to be dashed by Westway.

What has this to do with sport? As it transpired, a great deal.

According to the GLC's own standards, there should have been at least 173 acres of open space available to the community around the new motorway. Instead there was roughly a tenth of that. So when the GLC then proposed to turn most of the new space created underneath Westway into car parking, there was outrage.

In Chapter 2 we look at how Londoners have, over the centuries, fought for the right to maintain open spaces for sporting and recreational use. In this chapter the total space up for grabs amounted to 23 acres.

How that space was saved and then utilised is a complex tale, but one that was to have long term ramifications, not just in west London but nationwide.

It started, modestly enough, amid the Westway construction site in 1967, when local parents formed the North Kensington Playspace Group and against all the odds persuaded the GLC to drop the car parking scheme. For the next three years the group, now calling itself the Motorway Development Trust, fought for recognition from the Tory led Borough Council, until finally in 1971 a compromise was reached. A new organisation, the North Kensington Amenity Trust, was formed to lease and manage the 23 acres, its membership split equally between community representatives and councillors, under an independent chair. As summarised by Andrew Duncan (see Links), here was 'a unique experiment' in 'combining the energy and resources of the public,

private and charity (or voluntary) sectors, alongside an active and engaged local community'.

Even in the language we can see the foundations of the political world which we now inhabit.

The process too will be familiar. Rather than bankroll the NKAT, the Council handed over £25,000 to cover start-up costs, expecting the Trust to then raise all further funds from other sources.

Matched funding and public private partnerships have of course since become familiar concepts in modern Britain.

Adopting this approach back in the 1970s was hardly without its tensions. Opinion then was highly polarised, with on one side Conservative interests both at the GLC and Kensington and Chelsea, and on the other a loose alliance of community activists, squatters and militants seeking to defend their rights. Beyond North Kensington they were joined by campaigners desperate to halt the GLC's plan for an Inner Motorway Box (or ring), of which Westway was planned as merely the first phase.

When someone daubed the name of one of the more politicised punk bands of the time, The Clash, in large letters across one of the stanchions of Westway, to be seen by millions of passing motorists, they could hardly have summed up the turbulence of the situation any more succinctly.

Looking back on this period, there are some obvious legacies.

Like the arches of a Victorian railway viaduct, the 67 bays under Westway opened up a world of possibilities. Go karting was one of several events trialled during the 1970s before the current mix of indoor and outdoor sports was arrived at. Other bays came to house offices, shops, businesses, performance spaces, even a night club. Underneath, the noise of traffic is surprisingly muted.

The detested motorway plan was indeed stymied, as much by its rising costs as by its opponents. The GLC swung to the left under a rising young councillor, Ken Livingstone. The conservation movement gained valuable momentum (although too late to save Silchester Road Baths, just south of Westway, built in 1888 and demolished in 1985, despite the pleadings of John Betjeman).

The Notting Hill Carnival grew in stature to become the beacon of a new philosophy that would come to be known as multi-culturalism.

But in the present context, the most significant legacy of the Westway conflict was the NKAT itself, the harbinger of a new breed of community-led, not-for-profit organisation which, although seen in some quarters at the time as dangerously radical, has since become an integral part of the provision of all kinds of public amenities, sport included.

The NKAT, since renamed the Westway Development Trust, would itself play a part in this trend. In 1993 it helped found the Development Trusts Association (now called Locality), which has grown to encompass over 600 similar bodies, owning and managing their own assets.

Satisfying disparate interests within any community is no easy task. The WDT now supports a wide range of initiatives in health, housing, education and the arts, while also having to play the role of landlord, earning rents from businesses and organisations based under the motorway.

What had not been predicted, however, was just how important sport would become in the mix. By the 1990s sports facilities were occupying a third of the WDT's land, taking up over half the staff's time, and representing the single largest area of expenditure.

Visiting Westway today, the integration of sport within the motorway's undercroft appears hardly radical. In some areas it appears even a natural fit. Equally, the range of sports on offer, as we shall see, is as surprising as it is diverse. But most of all, it is the ideas and values embodied here that merit a place in history; fought for by ordinary west Londoners, while the rest of the world hurtled by above their heads, concerned only at arriving somewhere else.

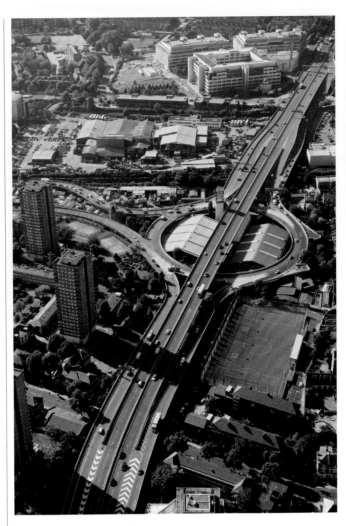

▲ When construction of Western Avenue, the A40, started from White City in 1920, heading out towards Park Royal, the largest building in sight was the **White City Stadium**, built on Wood Lane for the 1908 Olympics on what was then the outskirts of west London (*see page 323*). The stadium site is now covered by the **BBC's Media Village**, seen in the top right of this view, taken in 2010, looking west.

Where industrial units can be seen beyond the roundabout, on the east side of Wood Lane, were fields where travellers' horses grazed. Now, squeezed between the approach roads there is a small travellers' site, with stables directly under the roadway (of which more overleaf).

North Kensington was otherwise dominated by terraced housing, mostly run down and multi-occupancy, interspersed with workshops and small factories.

The idea had always been to extend the A40 towards central London. But until that happened

the dual carriageway came to an abrupt halt at its junction with Wood Lane, forcing traffic either north towards Kensal Rise or south to Shepherd's Bush.

Seen here forty years after the completion of the elevated section of Westway, patently the scene is much altered.

In the middle of the White City roundabout, stands the indoor element of the **Westway Sports Centre**, a £10 million development completed in two stages in 1994 and 2001. Designed by Sproson Barrable Architects and run by the **Westway Development Trust** (WDT), this features eight indoor tennis courts and reportedly the most sophisticated and busiest climbing centre in England. Those able to reach the summit of some of the 350 different climbing routes find themselves directly under Westway's canopy (*above right*).

The outdoor elements of the Westway Sports Centre are split between three areas linked by pedestrian routes. Between the

roundabout and the tower blocks of the Silchester Estate (centre left) are four outdoor tennis courts – the only public clay courts in London – a basketball court, and another, unexpected set of courts, featured overleaf.

Hidden from view under Westway are a further five artificial football pitches and, on the north side of the motorway, seen on the lower right, a full size floodlit pitch with small stand (above, top), which sits above an underground car park.

Some 8-10,000 people use the sports centre every week, with all profits being reinvested in the WDT.

On the north (or right) of the roundabout can be seen two incomplete spurs. These were intended to continue the motorway to meet up with the East Cross Route in Hackney, only a short section of which, the A102(M), was ever completed. Had the 37 mile long 'Motorway Box' been completed, whole swathes of London would now resemble this section of Westway.

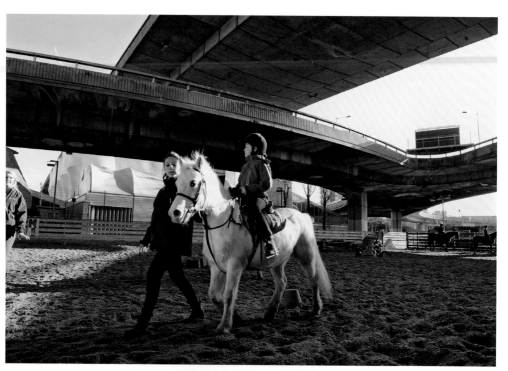

▲ Meet **Mr Quelch**, a bay pony who, along with his grey stablemate **Danny** (*right*) and 18 other horses, offer an unlikely contrast to the thundering traffic above their heads.

Unlikely, but not surprising, for although **West London Stables** has offered lessons under Westway since 1997, the area's equine links are of longer standing. South of the stables is an Irish Travellers' site, a reminder that gypsies have camped in the area since at least the 19th century. This part of west London was also long associated with rag and bone men, as immortalised by the BBC's 1960s series *Steptoe and Son*, said to have been based on actual totters in the Notting Dale and Latimer Road area (handy for the BBC, whose Television Centre on Wood Lane opened in 1960).

Compared with the Steptoe nag Hercules, Westway's horses enjoy a more cosseted life. They are allowed annual holidays in the country, occasional canters across Wormwood Scrubs and retire at the age of 25. In the 'manege' or riding ring seen here they tread only on equestrian grade silica sand.

Their riders may be children from neighbouring estates, the offspring of local celebrities or actors training for equestrian roles, such as in the film *War Horse*.

London has 40 stables, including those in Hyde Park, Vauxhall and on the Isle of Dogs. But Westway is the most accessible, forming part of a pedestrian route linking Walmer Road with all points south.

As such, Mr Quelch, Danny and their workmates are familiar and much stroked local characters.

◄ A hundred yards south of the riding ring, and for those who know their sporting history arguably even more of a shock, is this block of **Eton Fives courts**, also forming part of the **Westway Sports Centre**.

Eton fives, as the name suggests, is a form of handball, developed by pupils at Eton College in the 19th century and played almost exclusively in public schools and universities. For the full story see Chapter 25, but suffice it to say here that its presence in the shadow of a towerblock (Markland House), with a motorway interchange on one side, appears incongruous in the extreme.

And yet that is precisely why the English Fives Association pushed hard to have the courts – the only public fives courts in Britain – built at Westway; to broaden interest in the game, and to counteract its elitist reputation. After all, fives was a game traditionally played by street kids and Irish navvies against the walls of churches and public houses.

For the first few years after they opened in 2002 the Westway courts were used mainly by existing players. More recently, local schoolchildren and residents have seen the appeal, and there is now a thriving league in place.

As a result, the real mystery is not why the courts were built, but why there are not more like them in the capital.

▼ Wheels up top, wheels down below – skateboarding arrived from the USA in the late 1970s (see Chapter 15), and caught on immediately in the Westway area. In fact older skateboarders still speak reverentially of a steel half-pipe under the White City roundabout during the 1980s, while close by one of Britain's earliest concrete skateparks, built in 1977,

can still be seen at Meanwhile Gardens, a reclaimed wasteground between Elkstone Road and the Grand Union Canal. Revamped in 2000, Meanwhile Gardens is open air and free to the public.

In contrast, under Westway between Acklam Road and the tube line, **Bay Sixty6** (below) is a commercial skatepark, opened in 1996 and also recently revamped,

courtesy of Nike, in 2012. Bay Sixty6 is modular; that is, its features are fashioned above ground, mostly from plywood. This allows for more flexibility but requires more maintenance than concrete. It also suits the fact that the WDT rents out the bay only on short term leases.

With its music system, accessory shop and sponsored

events (BMX nights included), Bay Sixty6 is a prime example of how sports that were born on the streets (such as fives, football and tennis) can readily be commodified, and, in the case of Bay Sixty6, plugged back into the urban environments from which they sprang. Parkour, featured below, is another current example.

Concrete public skateparks still predominate, however, and a further example lies under Westway close to Lord Hills Bridge, where **Meanwhile 2** (below), an offshoot from the original, was built in the early 1980s.

▲ Immediately west of the Meanwhile 2 skatepark lie two other sports centres.

The **Harbour Club, Alfred Road** is a private members club, built in 2002. Adjoining it on **Torquay Street** is **Academy Sport**, part of **Westminster Academy**, opened in 2007.

Used by students and the public alike, the Academy Sport complex includes an outdoor multi-use

games area (MUGA), a beach volleyball court for summer use, and three artificial football pitches, each filling one bay of Westway.

Seen here from the footbridge leading from Westbourne Park Villas is the centre one, with Paddington Basin in the distance.

But most futuristic of all on the site is the **London Experience of Art du Deplacement and Parkour**, or **LEAP**, billed as the

world's first managed outdoor parkour facility (above right).

Developed in France during the 1990s, parkour is a form of free-running in which street fittings and fixtures are traversed like an obstacle course. How apt that, like the skateparks, this most modern of pursuits should find a home in the shadow of a structure originally perceived as an obstacle, but now turned instead into an opportunity.

Dedicated to those 'champions of liberty' who laid down their lives in the Great War – as inscribed in Latin on the frieze – the pavilion of the City of London School on Marvels Lane, Grove Park, was opened in 1925. Like many a school pavilion it was designed without charge by two old boys, Ralph Knott and ES Collins, best known otherwise as architects of County Hall.

SPORTS BUILDINGS

As Londoners may have noticed during the run up to the 2012 Olympics, the architecture of sport is nowadays deemed by the media to be worthy of its place in the cultural mainstream.

This is a recent phenomenon, however, dating from the 1990s when it became almost impossible for commentators to ignore the rush of grandstands and stadiums being built in the wake of the 1989 Hillsborough disaster. One major turning point came in 1995 when the McAlpine Stadium in Huddersfield became the first sports building to win the Royal Institute of British Architects' coveted Building of the Year award.

Whereas in the past someone with an interest in the subject had to trawl through specialist journals for reports on the latest stand or pavilion, swimming pool or sports hall – the choice of buildings featured dictated often by the status of the client rather than the potential level of public interest – today we expect the media, and the clients themselves to keep us up to date with every new development.

It is also now not uncommon for sports fans and regular users of facilities to lobby for or against proposals, and, in the context of *Played in Britain*, to campaign to save grounds and structures of historic interest.

As of 2013 there were 70 listed buildings or structures in London purpose-built for sport (41 of them still in use for sport, and a further 29 either derelict or converted to other uses). Five of the total have been listed as a result of research

emanating from this book, with one more pending and a handful of others waiting to be assessed.

As the list on the right shows there is a higher survival rate in predominantly amateur sports. In professional sport, where crowd safety is paramount and amenity levels crucial, historic buildings come under much greater scrutiny.

Equally it is acknowledged that in professional sport less emphasis has traditionally been placed on architectural quality.

Yet even this longstanding trend has been bucked in the last decade or so, as clubs and clients have realised that functionality need not exclude aesthetic considerations. Indeed, now that the public is better informed, sports fans expect higher quality than ever.

In today's hectic rush towards modernity it becomes all too easy to dismiss historic buildings as unsustainable or uneconomic, when often the opposite is true.

It has also to be noted that in their time, buildings such as the German Gymnasium and the Lord's pavilion were cutting edge.

Needless to add, their continued presence adds lustre and variety to the London scene. 'Much loved' is a heartfelt term often heard in this area of conservation.

Alas the constraints of space have meant that not all building types can be included in this book; indoor arenas and skating rinks, for example. What follows is, rather, an introduction to those building types most prevalent in sport, and in London sport most especially.

London's oldest extant purpose-built sports buildings/structures
listed by date of likely completion, unless otherwise stated
excludes buildings such as golf clubhouses built originally for other uses and buildings such as clubs and institutes which house facilities such as pools/gyms
★denotes still in use for sport/recreation † denotes listed building

c.1533 Whitehall Palace remains of tennis court, *Cockpit Passage* †
1538 Hampton Court Palace tiltyard tower *(now part of cafe)* †
1543 Queen Elizabeth's Hunting Lodge, Chingford *(now museum)* †
1625 Hampton Court Palace walls of current real tennis court ★†
1803 Syon House pavilion/boathouse *(now residential)* †
1851 Addiscombe Military Academy gymnasium, Croydon *(now flats)* †
1860 High Elms, Orpington fives court †
1865 Harrow School rackets court ★
 German Gymnasium, St Pancras *(to be converted to restaurant)* †
c.1869 Auriol & Kensington Rowing Club, Lower Mall boathouse ★
 Verdon's Boatyard, Spring Hill, Clapton boathouse ★
1870 Regents Park, Skaters' Pavilion now tennis pavilion ★
 Worple Road All England Croquet Club pavilion *(now Wimbledon High School pavilion)* ★
 Thames Sailing Club, Portsmouth Road boathouse ★
1871 London Rowing Club, Putney Embankment boathouse ★
c.1870s Ranelagh Sailing Club, Putney Embankment boathouse ★
 Westminster School Boat Club, Putney Embankment boathouse ★
1879 Thames Rowing Club, Putney Embankment boathouse ★
1880 Twickenham Rowing Club, Eel Pie Island boathouse ★
1886 Richmond Athletic Ground pavilion ★†
 Rectory Field, Blackheath rugby and cricket club pavilion ★
1887 Queen's Club main pavilion, East and West real tennis courts ★
1888 Queen's Club East and West covered lawn tennis Courts ★
 Paddington Recreation Ground pavilion ★ *(with later additions)*
1889 Vincent Square, Westminster School pavilion ★
1890 Lord's cricket ground pavilion ★†
 Vesta Rowing Club, Putney Embankment boathouse ★
1891 Herne Hill Velodrome grandstand *(awaiting redevelopment)*
c.1896 Beckenham Tennis Club pavilion ★†
1898 The Oval pavilion ★ *(central core, with later additions)*
 British Rowing HQ, Lower Mall boathouse ★
c.1890s Chislehurst Common cricket club pavilion
1899 Lord's Cricket Ground base of Mound Stand ★
1900 Lord's real tennis court ★ *(but flagstones 1866)*
1905 Craven Cottage, Fulham FC pavilion and grandstand ★†
1906 Copped Hall rackets court *(now cafe and visitor centre)* †

Chapter Nine

Pavilions

Putting an accurate date on the hundreds of timber frame pavilions still in use at sports grounds all over London is not always easy, so little have the designs changed since the late 19th century and so easily are such buildings patched up, expanded and remodelled (which is of course part of their attraction). This one, with its colonial-style verandah, is the men's bowls clubhouse at the Brentham Club in Ealing, thought to have been built between 1916–30. A more accurate dating might have been possible had it not been for the fact that weeks after this photograph was taken, the pavilion was set alight by three teenagers, destroying the building and all its contents, the club archives included. To replace the building with an almost exact replica cost around £20,000, and so delighted were members that a second replica was built alongside it, for visiting players. Two more replicas were then added, backing onto this pair, for the club's football section. The appeal of such simple structures, it would seem, remains as timeless as their design.

The most ubiquitous of all building types associated with sport, the pavilion is where the heart and soul of a club resides; a home from home for its players, officials, its nearest and dearest.

A pavilion is more than a social centre. It often serves as the club's office, as its museum, and as its main source of revenue.

Pavilions have been around for centuries. Taking their name from the Latin for a butterfly or moth, the French described a form of tent, with a pointed, winged appearance, as a *pavillon*.

Such tents were put up to shelter attendees at pageants and parades, country fairs, even battles, or to serve refreshments (the 'beer tent') or store munitions (to keep the gunpowder dry).

Probably the word's first usage in relation to English sport was in the context of cricket, for example in reports of 1825 that the pavilion at Lord's had been destroyed by fire (a misfortune that has since become all too common, as at the Brentham Club).

During the 19th century pavilions became most common for bowls, croquet, archery, lawn tennis and rugby, though less so in football. Some pavilions were called clubhouses, yet not all clubhouses are pavilions.

Meanwhile boathouses fulfil a similar role, but as was seen in Chapter 3, are not quite the same in design terms.

So what are the defining features of a sports pavilion?

In their 1957 design guide to sports buildings (*see* Links), R Sudell and D Tennyson Waters listed no fewer than 40 needs that a large pavilion should meet. Most were of a service nature: toilets, laundry, first aid and so on. But before these, came certain essentials.

Firstly, and most obviously, changing rooms, for the home and away teams, followed by a clubroom, preferably in the centre of the building.

The authors specified a separate club room for 'lady members', which may no longer apply today but was important at the time, in architectural as well as social terms. For there are countless Victorian and Edwardian pavilions whose core structure was built for men only, and which in later years had to be extended to cater for women. Added to all the other extensions typically required as clubs evolve, the outcome is that precious few pavilions survive as originally designed.

Even the most celebrated example of all, the Grade II* listed pavilion at Lord's (*see page 202*), had its first extension added within 16 years of its opening in 1890.

As at Lord's, to be a true pavilion the building must have some sort of viewing area, overlooking the pitch (which is why not all golf clubhouses fit the description).

An elevated balcony or upper gallery is always an added bonus.

But undoubtedly the most important facility of all is the bar.

No need to elaborate further on the reasons for this, but it is as well to remind ourselves that many a London sports club started out playing on a village green or field overlooked or attached to a public house (The Cricketers on Richmond Green being a good example, *page 198*). Nor was the bar the only attraction. Pubs provided rooms for changing. Landlords acted as promoters for matches. Spectators needed toilets. Visiting teams needed sustenance.

A pavilion may therefore be considered in many respects a tavern with a viewing terrace.

This chapter offers merely an introduction, because examples of historic pavilions abound throughout the book. The one at Lord's may be the finest, but it is not the only listed example. Those at Leyton (*page 208*), the Richmond Athletic Ground (*page 263*) and Beckenham Tennis Club (*page 297*) are also of special note.

Our resumé of the life and times of Bexley Tennis Club (*page 296*) also tells a story that is common to many a club pavilion.

Not every period or architectural style is represented.

Most noticeably, compared with other British cities relatively few pavilions built in the 1960s appear to have remained in favour. Only two are included here, those of the Civil Service (*page 107*) and the Old Deer Park (*page 209*).

Instead, London's stock of historic pavilions is largely characterised by pre-1939 examples of a conservative appearance; homes from home, built for a clientele who desired little more than fun and games and a sense of belonging.

Here are buildings that on the whole fit in, rather than stand out.

▶ Archers belonging to the **Royal Toxophilite Society** (RTS) gather for their centenary shoot in October 1881 at the Society's six and a half acre grounds within **Regent's Park.**

Based there from 1834-1922, the RTS was one of three bodies allowed to rent portions of the park, the others being the Royal Botanical Society (wound up in 1932) and the Zoological Society, very much still in residence.

The half-timbered building seen here, so typical of Victorian pavilions, was not the headquarters of the RTS. Known as Archers' Hall, that lay a hundred yards or so to the south. Rather this was the **Skaters' Pavilion**, a structure built in 1869 in the wake of one of Victorian London's worst tragedies.

On January 15 1867, 40 skaters drowned in the Regent's Park lake, having ignored warnings that they were literally skating on thin ice.

After the disaster the depth of the lake, now reserved for boating, was reduced to a safer four feet.

For its part **The Skating Club** (formed in 1830), several of whose members had been present as 'icemen' or stewards on the day of the tragedy, decided in conjunction with the RTS to create a much safer skating rink next to Archers' Hall.

Based on a simple method pioneered by Scottish curlers in the 1830s, this involved levelling the archery lawns and surrounding them with low banks so that, in freezing temperatures the turf could be flooded to a depth of six inches and turned into a safe and easily accessible rink.

For this access The Skating Club paid the RTS £50 a year, plus a further £300 for groundworks and, it is assumed, the construction of the pavilion, formally opened by the Prince of Wales, the future Edward VII, on February 12 1870.

(That same week an estimated 8,000 people had skated on the park's lake, 20 of them falling through the ice, but surviving.)

For the next half century the RTS enclave continued to offer a haven for archers and skaters. So cold were the winters in the 1890s that skating was possible for 16-17 days a year on average.

But in 1913 campaigners led by the London Reform Union started to lobby against the RTS's presence. As Peter Gerrie's history relates (*see Links*) this culminated in 1922 in the Society not only being

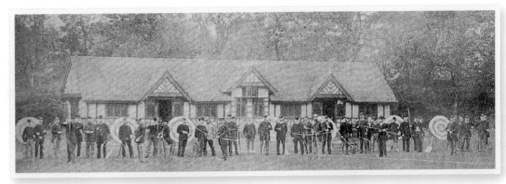

evicted but also having to pay the park authorities £350 towards the restitution of the Skaters' Pavilion.

Off went the RTS, fuming, to Bayswater in 1924 (*see Chapter 19*), leaving Archers' Hall to be demolished. (It stood on the lake's north eastern extremity, by York Bridge, and according to the RTS housed the finest archery collection in the world, including the Braganza Shield, *see page 193*).

The Skaters' Pavilion, meanwhile, was adapted to serve ten new hard tennis courts laid out on the archery lawns, a use that, as seen above, continues to this day.

Although its interior has been remodelled, clearly, if compared with the image from 1881, much of the original exterior appears to have survived. But it is also possible that rebuilding works may have taken place in 1895 and in 1922.

More research is therefore needed, for if this is indeed the original building, it is the oldest functioning sports pavilion in London, and one of the oldest in Britain to boot.

Before 1914 corner pavilions were often built by British football clubs. But this one, widely referred to as 'The Cottage', at Fulham FC's Craven Cottage ground, is the sole survivor. Designed by Archibald Leitch and opened in 1905, it sits alongside the Johnny Haynes Stand (*page 109*), also by Leitch and also Grade II listed. On its ground floor are dressing rooms for match officials and both sets of players

– a real culture shock for visiting superstars – while the upstairs houses offices and a viewing balcony. Interestingly, the building is similar in form to the Polytechnic boathouse, originally built in 1888 in Chiswick (*page 57*), where the Kinnaird Park Estates Company was active. From 1918-34 its chairman was Henry Norris, a director also of Fulham and the man responsible for hiring Leitch.

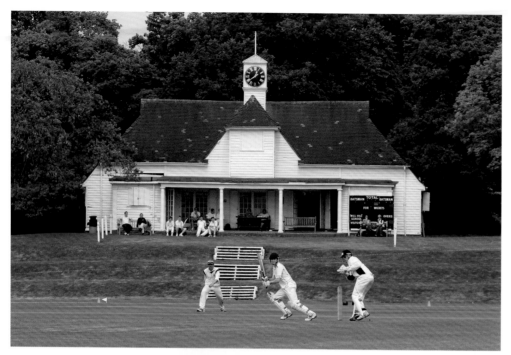

▲ Among the most characterful pavilions in London are those built by public schools in the 1920s, both as memorials to the fallen of the Great War and in recognition of the positive influence on fitness and discipline that sport was thought to have yielded on the battlefield.

(Whether the Duke of Wellington ever actually said that Waterloo was won on the playing fields of Eton has never been proven, but certainly that sentiment was oft repeated.)

In addition, following the awful privations of the trenches, there existed a view that better facilities, if not actual pampering, would lead at least to a more efficient approach to sport and coaching generally.

One example, backing onto **Wills Grove**, is the timber clad pavilion of **Mill Hill School** (which some readers may recognise as a location in a 1989 Inspector Morse episode, *Deceived by Flight*. It also appears in *We Are the Lambeth Boys*, Karl Reisz's documentary in 1959, see page 123).

Opened in 1926, in common with the City of London School pavilion featured on page 100, it was designed by an old boy, RSB Wyld, along tried and tested lines.

That is, the pavilion sits above pitch level (good for viewing and for fields where flooding is a risk). There is a clock tower, a sheltered terrace for players and spectators, and dressing rooms on either side of a central club room. Note also the provision of a scorer's box under the

clock tower, a feature often seen in cricket pavilions but seldom used.

Also common to school pavilions are **honours boards**, listing past members of the first XI or XV. At Mill Hill the names go back to 1869.

At the pavilion of **Westminster School**, **Vincent Square** (*page 1*) they go back even earlier. Four of the eleven listed in 1861 (*right*) went onto to play first class cricket.

Above and above right, backing onto **Hampstead Lane**, **Highgate School's** pavilion dates from 1930. (Old Cholmeleians were named as such after the school's 16th century founder, Sir Roger Cholmeley).

Symmetrical, with pantile roofs and patterned brickwork, it typifies the synthesis of vernacular styling and institutional conservatism that was common to pavilion design before the 1960s.

► You can tell a lot about a club from its pavilion. Is it well run? Does it welcome guests? Is the noticeboard tidy? Is the bar well stocked? Are the trophies polished? And, in the context of this book, is this a club mindful of its history?

Ticking all these boxes is the **North London Bowling Club** in **Fitzroy Park**, some 500 yards south of the Highgate School pavilion, across Hampstead Heath (*see also page 155*).

Formed in 1891 the club used an old cowshed for its first pavilion before building the current one in 1910, with this simple, multi-functional main hall at its heart.

Like many a pavilion it has grown in phases, most recently in the 1970s when, having finally admitted ladies to full membership (in 1966), extra dressing rooms and toilets were provided in an extension. Another add on, paid for in memory of a former member, by his wife, became a new kitchen. The beer store was upgraded too.

Naturally the building work was carried out by a firm owned by a member, 'mates rates' being as vital a component of club finances as bar takings, subscriptions, quiz nights and raffles.

On which note, on the far right, below the Presidents' Gallery, the tombola drum awaits, while in the centre hangs a mirror ball (party hire being another crucial element of the pavilion's functionality). Note also the piano against the far wall.

Among the photographs the familiar visage of WG Grace looks out, as does former club stalwart, Leslie Compton, the Arsenal winger and Middlesex cricketer who, in later life, ran a pub in Highgate.

In 1940 FAM Webster wrote that nothing does more 'for the building of a proper club spirit than a jolly room in a good pavilion'.

This is one, but London has many others, their tea urns simmering, ready for a break in play.

◄ Like all buildings in the public realm, pavilions in London's parks and recreation grounds are having to adapt to leaner times, and also to changes in sporting culture.

Most susceptible of all to change are those pavilions specifically designed to serve bowling greens.

Built in 1936, the pavilion seen here at **Acton Park** – typical of the restrained, bungalow style adopted by parks departments between the wars (Battersea Park has another example) – is leased by Ealing Borough Council to **Acton Park Bowls Club** (formed in 1910).

Should membership numbers fall, as has occurred at so many other parks clubs (*see Chapter 18*), the question will arise of how this, and other historic bowls pavilions, might function in the future.

(Its end bay, it should be noted, already houses a small café.)

One model is to emulate what is common practice for tennis provision in parks, as at Regent's Park's pavilion for example; that is to cater not for exclusive club use but for 'pay and play'.

This is the approach adopted at **Brockwell Park** (*left*), where the bowls club recently disbanded.

Its simple, flat-roofed pavilion, incidentally, is a characteristic LCC design of the 1960s (seen also at Normand Park, West Kensington).

Another option is the adaptive re-use of a pavilion, but with no sporting element. Examples of this are the bowls pavilions at Clissold Park, now an education centre, and Wandsworth Park, now a café.

At the other end of the spectrum, larger pavilions with multiple dressing rooms increasingly face being mothballed, or demolished.

Or, in the case of the pavilion at **Paddington Recreation Ground** (*left*), being completely remodelled.

As detailed on two plaques on the pavilion walls, Paddington Rec was opened in 1888, largely thanks to the efforts of Richard Beachcroft, and Lord Randolph Churchill (*see page 34*).

As commemorated by two further plaques, it is also associated with athlete **Sir Roger Bannister** (*see page 312*) and cyclist **Sir Bradley Wiggins**, who grew up in the neighbourhood.

The Paddington pavilion originally faced west, with a balcony overlooking a cricket pitch, while on its east side it backed onto a banked cycle track.

Since 1987, however, the Rec has changed completely.

The old cricket pitch has been covered by an athletics track and an artificial hockey pitch. Where the cycle track lay – taken up just before Wiggo's time – is now a turfed expanse, curiously called the **Village Green**.

For its part the pavilion, as part of a £3.5 million renovation, now has a balcony on its east side, overlooking the Green (as shown here during a cricket match in 2011), flanked by two new bays and gables, to create a mirror image of how the west elevation looked previously.

Only the roof, clock tower and chimney are as before.

Inside, the pavilion's ground floor still houses dressing rooms, while the former club rooms upstairs are used as offices for the City of Westminster's Sports Unit.

The **Beachcroft Pavilion**, as it was renamed in 2010, is now a round the week operation.

Run on Westminster's behalf by GLL, since the latest renovations the number of active sports users at the Rec has more than doubled annually from 125,000 in 2006 to 273,000 in 2013.

This includes users of the gym, which forms part of an extension at the rear of the pavilion, cricket nets, tennis courts and a bowling green (which has its own pavilion).

The pavilion has thus become the hub, not of a club, nor of a conventional leisure centre, but of a reinvented rec; a complete turnaround in an operational sense as well as a structural one.

Our fourth example represents another route for parks pavilions.

Also dating from 1936, but in a stripped Art Deco style, this is the pavilion at the **Sir Joseph Hood Memorial Playing Field** on **Marina Avenue**, **Motspur Park** (*below left*).

Dusted down and revitalised by a combination of a Friends group, Merton Council and various funding bodies, the pavilion serves sport at the weekend but during the week is hired out as a nursery.

Poignantly, on display in the main hall, its floor cluttered with toys, are the honours boards of two former bowls clubs based at the playing field; Motspur Park (1937-81) and West Barnes (1944-96).

And so the old give way to the young. But the pavilion moves with the times.

▲ In Chapter 12 we will show how London is especially well endowed with pavilions built by companies, institutions and public bodies for the benefit of their workforces. These pavilions were mostly built to high specifications and so continue to render good service, although rarely for their original owners.

On **Lindisfarne Road, West Wimbledon** (*above*), is the former pavilion of **George Brettle & Co.**, makers of hosiery, built in 1931 for its sports and social club, the **Oberon Athletic Club** (named after Brettle's best selling range of underwear and socks).

Designed by George & TS Vickery architects, it is a classic institutional pavilion of its period; once again offering an elevated view, a terrace sheltered under an extended concrete balcony – which proved its worth when torrential rain fell during the opening ceremony – a clocktower (bearing the date 1931), and extensive club rooms for all those staff events that were later written up in the company's staff journal, *Yarns*.

During the war the Oberon pavilion served as an isolation hospital, until in 1945 both it and the nine acre playing fields were donated by Brettle to the local education authority.

For the next 65 years Raynes Park High School were tenants, while in recent years the pavilion housed a judo school.

Its current owners, who bought the site in 2013, are the **Hall School, Wimbledon**.

Quite a contrast is the former concrete and glass pavilion of the **Civil Service Sports Ground** on **Duke's Meadows** (*top right*).

Designed by Adie, Button & Partners and opened in 1969 – the building it replaced is on page 130 – since 2010 the pavilion has been operated by **King's House School** in Richmond.

Full marks to them then, because whereas numerous pavilions from the 1930s are extant, in London this is actually one of the few major examples from the 1960s that is still intact, and still in use for sport.

Following a trend set in the early 1960s, the former Civil Service pavilion at Duke's Meadows has its changing rooms in a single storey block on the right, thereby keeping muddy boots away from the hospitality areas in the main block. Offsetting the pavilion's horizontal emphasis, access to the upper lounges is via concrete spiral stairs, one external, the other internal... and quite wonderful (*left*).

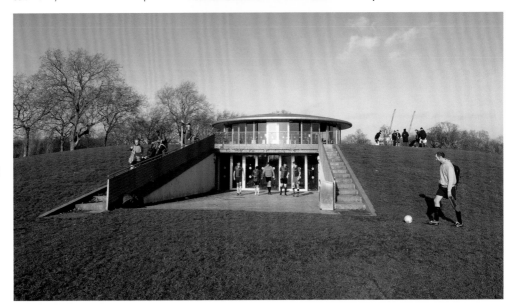

Contemporary pavilions of note are surprisingly rare too, but 'The Hub' at Regent's Park definitely stands out. Or rather, does not. Designed by David Morley Architects and opened in 2005, its reception area, dressing rooms and function rooms are submerged under a turf mound, topped by a rotunda housing a café. Seen above in 2014 emerging from its depths are the boys from Mazars, about to see **action in the London Accountants Football League, Division Three. As they do so, 500 runners are circling The Hub as part of a 10k run. Regent's Park, a Grade I listed parkland and central London's largest sports facility, already has the capital's oldest functioning pavilion, over at the tennis centre. Now, arguably it has the most innovative, and yet also the most discreet. Not even a clocktower.**

Chapter Ten

Grandstands

There may appear to be nothing terribly grand about the stand at the Chislehurst Sports Ground, home of Queen Mary University of London RFC on Perry Street. Seating 200 on timber benches, under a steel framed, sheeted roof, the stand, dating from 1938, could hardly be more basic. And yet to lovers of sport this is a creosote-encrusted building of magical grandeur. Every up-and-coming football or rugby club aspires to a grandstand. A pavilion may signify that a club has inner strength, but a grandstand tells the world that here is a club worth watching. For the players of Streatham-Croydon RFC, based on Frant Road, Thornton Heath, building a stand was all part of the training regime back in 1957. In this fund raising cartoon issued by the club (*below right*), the sign reads, 'Give them the money and they'll finish the job!' A barely legible scrawl in one corner adds, 'Guinness Gives Me Strength'. As well it must have done because the stand remains in regular use today, looking finer than ever after a £70,000 refit in 2013.

Some dictionaries would have us believe that the term 'grandstand' was coined in the United States, in the 1830s.

This seems plausible enough. After all, what could be more rip roaring than a 'grandstand' finish?

But actually the earliest known mention of a 'stand' in the sense of a structure designed to accommodate spectators appears in relation to Doncaster racecourse in 1615, while in 1756 John Carr's plans for York racecourse are clearly labelled 'grandstand'.

Stands had been around for a long time prior to that, however, as we know largely from reports of mishaps. The earliest occurred in 1331 when, in the words of John Stow, 'a wooden scaffold... like unto a tower', on which stood Philippa, wife of Edward III, and 'many other ladies, richly attired', collapsed during a jousting tournament on Cheapside.

'Grievous hurt' befell the knights underneath, causing Edward to vent his wrath on the carpenters, until Philippa, on her knees, begged him to show mercy, an act whereby she 'purchased great love of the people'.

Stow adds that as a result of the accident the king had 'a sheed to be strongly made of stone' from which jousts could be viewed in safety, by the church of St Mary le Bow.

An example of how it may have looked is the tiltyard tower at Hampton Court, built in 1538 (*see page 15*). Five years later, the 'Great Standing', a three storey timber platform in Epping Forest, performed a dual purpose,

accommodating both spectators and deer hunters (*page 17*).

As also noted in Chapter 1, eight died when a section of the bear garden on the South Bank gave way in 1583. In May 1726, a 'scaffold' erected at Tyburn collapsed as the reviled Catherine Hayes was burnt at the stake. As many as six spectators predeceased her as a result. Over 20 more died in 1747 when a scaffold by the Ship Inn, near the Tower of London collapsed just before the Jacobite, Lord Lovat, lost his head.

It was at racecourses that the first permanent structures that we might recognise today as grandstands were built. Before the Racecourses Licensing Act of 1879 there were dozens of racecourses in the London area. But only one grandstand from that era survives, the Prince's Stand at Epsom, built, coincidentally in 1879 (*see page 20*).

In fact only two other stands survive from before 1914 in the capital; at Herne Hill Velodrome and Fulham (*see opposite*).

One reason for this is that as the business of sport consolidated, ground owners came under pressure to improve and extend facilities. Another factor was the vigilance of local authorities. Under the 1894 London Building Act and its successors, both the LCC and district surveyors viewed grandstands as temporary buildings, typically granting licences for periods of between one and five years.

It is not so much that control was stricter in London than in other cities – although clearly it was strict – but that because there were so many different grounds and venues, a significant level of expertise and shared knowledge accumulated in the capital.

This may be one reason why there were not accidents at London venues in the 20th century approaching the severity of those occurring elsewhere in Britain.

These eventually culminated in the Safety of Sports Grounds Act of 1975 (arising from the Ibrox disaster in 1971), and more recently the banning of standing terraces at major venues following the Hillsborough disaster in 1989.

Under the 1975 Act any 'designated' venue (that is one holding over 5,000 or 10,000 spectators, according to the club's status) must gain an annual safety certificate from the local authority.

In addition, as a result of the fire at Bradford City's football ground in 1985, any covered stand holding 500 or more must be licensed under the Fire Safety and Safety of Places of Sport Act 1987.

In short, all grandstands by definition have a limited lifespan, either through regulation or because they fall behind in terms of amenity and modernity.

Dozens of important stands have thus been demolished over the years. But as the following selection shows, there are some intriguing survivors too.

◀ Looking resplendent following a series of refurbishment works between 2004-13, **Fulham FC's Stevenage Road Stand** at **Craven Cottage** – built in 1905 and renamed after club stalwart **Johnny Haynes** on its centenary in 2005 – is the only listed grandstand in senior English football.

Listed Grade II in 1987, at a time when Craven Cottage's future was under threat from developers, it is also the oldest operational grandstand in London as a whole.

Herne Hill Velodrome's stand is older, dating from 1891, (*see page 320),* but is currently unused and awaiting redevelopment.

Fulham's stand is, in addition, the oldest surviving stand to have been designed by the prolific Scottish engineer **Archibald Leitch** (1865-1939), who worked on at least 30 British grounds, including eleven in London (*see Chapter 22*).

Remarkably, from initial planning to completion took just five months, from May-September 1905, and more remarkably still, Leitch was at the time working on an almost identical stand for Fulham's new arch rivals, Chelsea, down the road at Stamford Bridge.

For speed and economy of erection the stand's basic structure comprised steel latticework, using a range of standard, lightweight elements, bolted and riveted together, a system used by Leitch in his main business, that of industrial buildings and factories.

As seen on the left, the seating deck was formed in timber, with wooden tip-up seats on iron brackets supplied by James Bennet of Glasgow. It is a testament to their design that so many of the originals (3,668 in total) have survived.

Only on the lower deck, where until the 1990s there was a terrace for standing spectators, have plastic seats been installed, to create the overall capacity of 5,879.

This is a building that showcases the two great talents of Leitch and his team.

Pitchside the structure is pure engineering, with few trimmings; effectively a factory shed with one side removed. Its street façade, on the other hand, is an architectural statement, designed to fit in with, yet dignify its residential surrounds. No doubt this was at the behest of Fulham's chairman, Henry Norris (of whom more later), who was also responsible for building many of the houses in the vicinity.

In another sense the stand is unique. Main stands, then and now, are usually designed to house changing rooms, club offices and hospitality areas, to form in effect both a stand and a pavilion. At Craven Cottage however, the lack of space between Stevenage Road and the pitch, and the height constraints imposed by the houses opposite, meant that there was no spare room for added facilities.

Instead, a pavilion was built in the corner, the building now referred to as 'the Cottage' and also listed Grade II (*page 103*).

There was nothing especially innovative about Leitch's work, other than its efficient use of modern materials. Several similar stands would follow, of which one other survives in London, albeit much altered, at Crystal Palace's Selhurst Park.

But none is as well preserved as Fulham's. It is, as a result, one of sporting London's greatest treasures, and a credit to the club.

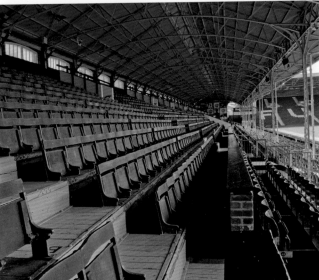

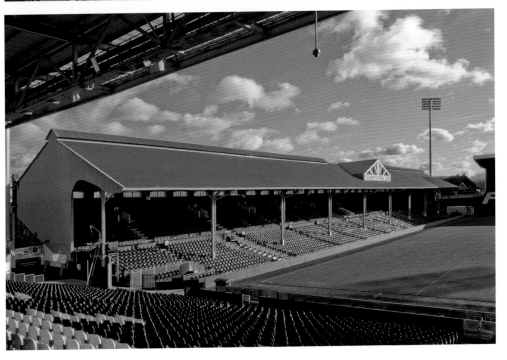

▶ At **Northolt Park Racecourse**, reported *The Architect & Building News* of July 19 1929, 'Dr Oscar Faber has given us something both new and interesting in grandstand design.' He most certainly had.

Opened in May 1929, this fine pair – the Grandstand (seating 2,000) and Members' Stand (500) – were, for their time, by far the most advanced stands in Britain.

They were built, as the journal noted, 'on the cantilever principle', whereby the loading on the roof beams was carried to the rear of the stand, thus eliminating the need for supporting columns.

In stand design this was a major breakthrough, seen first, it is thought, at the Hippodrome du Tremblay, Paris, in 1906, and developed further at other French racecourses during the 1920s.

Faber (1880-1956), a brilliant engineer, born in Brixton to Danish parents, had worked on two earlier cantilevered stands at Lord's cricket ground in 1924-25, with architect Herbert Baker. Sited where the Compton and Edrich Stands are now (*page 202*), each consisted of a roof-less seating deck cantilevered over a lower deck.

At Epsom Racecourse a stand with two projecting cantilevered balconies had opened in 1927.

By comparison, Northolt Park's stands were much more adventurous, and elegant. Although appearing to be in reinforced concrete they were formed of steel, encased in concrete, with curved braces between each roof truss and, in the larger stand, an arched concourse at the rear (each arch containing a private box).

The actual roofs were composed

of basic timber purlins covered with ply bitumen sheeting.

Compared with the cantilevered roofs of today they were modest, the larger of the two projecting just 19m (whereas, for example, the roofs at Twickenham project 41m).

Faber set a new benchmark, all the same, as did the course facilities. Designed to be a national showcase for the **Pony Turf Club** (that is, racing for horses under 15 hands tall), Northolt Park cost £250,000, half of which was spent on the two stands and on four simpler public stands alongside (seen below in 1934).

At first the course struggled, the Wall Street Crash coming shortly after its opening. Then in 1934 a flamboyant New Zealander, WA Read, took over its management.

Taking his lead from the new breed of showmen then busily promoting greyhound and speedway racing, Read courted a stream of celebrities. (George

Formby's *Come on, George* was shot there in 1939). There was parking for 6,000 cars, and entry remained comparatively cheap.

Such was Read's confidence that in 1935 the course's seventh stand was built over the Tote block (the white building seen below, just beyond the largest stand). It was from the roof of this new stand that running commentaries were broadcast, the first time this had been offered at a British course.

Other innovations included the installation of a large electric race timer, and a starting gate system imported from South Africa.

All this, plus a schedule of 50-60 meetings a year, more than any other course, helped to attract a course record aggregate gate of nearly 236,000 in 1937.

But even this was not enough to claw back the massive outlay. Read made his exit to Jamaica, and for the next three years Northolt was in the hands of the Official Receiver.

The last race took place in June 1940. Then, following a bitter public inquiry in 1946, the 147 acre site was taken over by Ealing Borough Council.

Had Northolt Park survived there can be little doubt that Faber's two stands would have become highly treasured. Instead, with no-one but racegoers to plead their case, they were demolished in 1955 (the steelwork from one being re-erected at Brands Hatch), to make way for the new Racecourse Estate. Houses now took priority over horses.

Looking back, one measure of how advanced the stands were, and also of how cautious were the majority of clients in British sport, is that although small cantilevered stands would follow at amateur clubs in the 1930s (*see opposite*), no professional club commissioned a stand of a similar scale until Scunthorpe United FC in 1958.

That is, nearly 30 years after Faber's stands were built, and three years after their demolition.

Considered in this context, and as rare examples of European Modernism in 1920s London, Northolt Park's stands can be ranked amongst the city's most grievous losses of the 20th century.

Where Northolt Park's largest stand stood are now houses on Grandstand Way. Other roads on the Racecourse Estate include Newmarket Avenue, Haydock Avenue, Kempton Avenue and Thirsk Close. A section of the course remains as open space running parallel with Mandeville Road, while the original entrance gates can be seen where Dabbs Hill Lane meets Petts Hill.

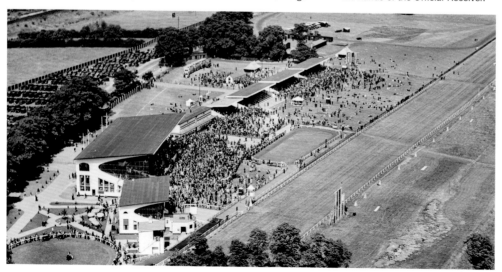

▶ Local authorities did much to promote outdoor recreation in the aftermath of the Great War, one of the most ambitious being **Finchley Urban District Council**. In 1925 it purchased 100 acres of glebe land between **Summers Lane** and a newly completed stretch of the **North Circular Road**, and had its Council Engineer Percival Harrison draw up plans for extensive sports facilities and a civic centre.

The latter did not reach fruition, but the sports facilities did, and this extraordinary double sided grandstand was the first to appear.

Opened on December 20 1930 by Sir Frederick Wall, Secretary of the Football Association, it was one of the earliest stands in Britain both to be formed in reinforced concrete and to have been built 'on the cantilever principle'.

Archibald Leitch had by that time built several stands in reinforced concrete, at Liverpool and Sheffield, for example (the core structures of which remain in place). But none had column free roofs. Other than Lord's and Northolt Park, a small cantilevered stand also appeared at the Braintree Recreation Ground in 1928 (demolished in 1990).

Double-sided stands were hardly new either. One was built at Headingley, Leeds, in 1890. Leitch designed another in Bradford in 1907. But never had there been anything as finely tuned or symmetrical as this one at Finchley.

Seating 500 on each side, the east elevation, seen here in 1930 (*top right*), became the home of **Finchley Rugby Club** (formed in 1925), while the identical west side housed **Finchley Football Club** (whose roots went back to 1874).

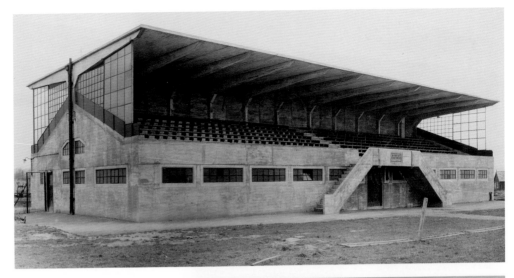

It seems unlikely that Harrison designed the stand, given the neo-classical approach he took for the lido complex built on the adjoining site in 1931-34 (as featured in *Liquid Assets, see Links*), but demolished in 1994.

There was however some input from no less an engineer than Sir Owen Williams, who had worked on Wembley Stadium. His advice led to changes in the cement mix and the raising of the seating deck by six inches, for better sightlines.

Thereafter the stand was completed by William Moss & Sons at a cost of just under £3,200.

But the original designer's identity remains unknown.

As seen on this page, various additions have since compromised the stand's appearance. The football side, which in 1950 held a record 9,555 for a cup tie, is now completely separate. The merger of Finchley FC with **Wingate FC** in 1991 has in turn led to further

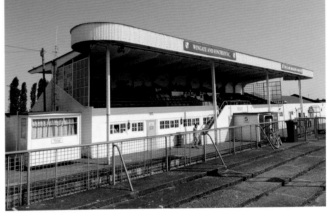

alterations, and the setting up of a trust to safeguard the ground.

As for the stand, its best safeguard is that in 2013 it was listed Grade II, in recognition of its unique design and the fact that it is now the oldest stand 'on the cantilever principle' to remain in Britain, and therefore also amongst the oldest in the world.

On the Summer Lane stand's west side, in the early 1950s, Finchley FC added the canopy seen above – a clumsy extension but understandable given the original design's exposure to the elements. The rugby club, meanwhile, removed the glazed screen at the northern end of their side to improve visibility. (One of the screens at Northolt was removed for the same reason). Seen here in 2013 (*left*) the rugby side also now has 450 plastic seats, donated by Arsenal when their West Stand at Highbury was decommissioned in 2006.

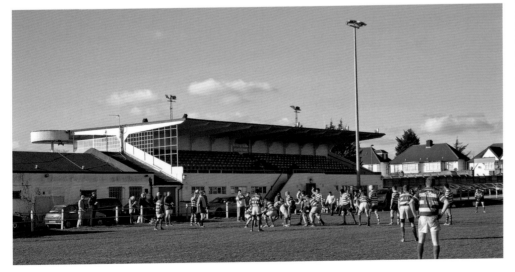

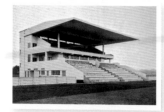

▲ As architects and engineers became more confident in their use of reinforced concrete, a new wave of grandstands appeared at British sportsgrounds during the 1930s.

This one, at the **Polytechnic Stadium** on **Hartington Road, Chiswick**, was designed by Joseph Addison, Head of the Polytechnic's School of Architecture, and opened in 1938 for the use of the **Polytechnic Harriers** and other clubs associated with the Regent Street institution.

Listed Grade II, the stand's roof is supported by a beam 78 feet long by 7 feet deep, supported by two octagonal pillars. The roof's front section then projects 30 feet over the lower seating deck, which itself acts as a load bearing element within the overall structure.

Seating 658 and looking out over a cinder athletics track, the stand offered substantial accommodation underneath – offices, club rooms and dressing rooms for up to 500 athletes – which made it ideal for hosting meetings and events, including, until 1972, the finishing stages of the annual Polytechnic Marathon (the precursor of the modern London Marathon).

Fulham Rugby League Club were also based there from 1885-90.

Thereafter the stand and its track fell into steady decline, before the **University of Westminster** (as the Poly was renamed in 1992) gave it a complete makeover. The price of this upgrade was, however, that a fitness centre and health club now flank the stand somewhat awkwardly (*top right*), while the stand's main use is as a nursery.

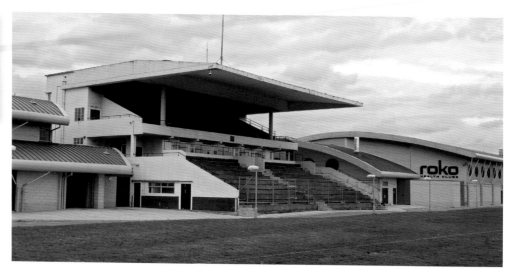

At the same time, while all the other pitches at the sports ground appear to be in regular use, the one in front of the stand is currently unused, which means the seating area is unused also, a great shame.

But not a unique situation.

Seen above is the stand built for the **University College School Old Boys RFC** (the 'Old Gowers') on **MacFarlane Lane, Isleworth**.

Opened in 1935, it was designed by club members Brian Sutcliffe (architect also of Imperial College's boathouse, *see page 51*), and HC Farmer, who would die in action during the Second World War.

After the Old Gowers departed in 1979 (they now play in West Hampstead), the stand served Centaurs RFC before they too left and the stand fell into disrepair.

Listed Grade II in 2001, two years later it was placed on the Heritage at Risk Register.

Finally in 2005 the five-a-side company **Goals Soccer Centres** took over the ground, and after a

£1.5 million refurbishment carried out by Aedeas architects, the stand and its pavilion at the rear (*below left*) re-opened in 2010.

Alas, however, as at Chiswick, there is little action to watch from its seats. This is because, in order to preserve the stand's setting, the new five-a-side pitches (each enclosed and floodlit) were sited elsewhere, leaving the turf in front of the stand for occasional football use only, or as a picnic area.

That said, it must be conceded that viewing from the upper tier was never ideal, particularly from the back rows, because of the roof's overhang, while its column-free design was from its earliest days compromised by the necessity for down pipes in each corner.

The building has been beautifully restored nevertheless, Crittall windows and all, and if only as a surviving curio from a period of bold experimentation, is great to look at, if not from.

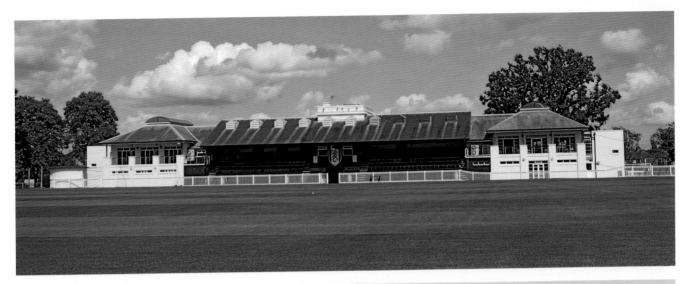

▲ Another 1930s grandstand to have enjoyed a recent makeover is this one at **Motspur Park**, south west London (directly opposite the former sports ground of the BBC).

Laid out by the **University of London** in 1931, Motspur Park's athletics track was, until the 1970s, arguably the finest in London, graced by the likes of Sydney Wooderson, who set a world record for the mile on it in 1937 (*see page 309*), and Roger Bannister. Other notable uses have been as the venue for the annual 'Laundry Sports', staged for the capital's laundry workers during the 1930s, and as the backdrop for three films, *The Games* (1970), *Chariots of Fire* (1981), and *The Four Minute Mile* (1988).

The grandstand is not listed, but is of interest nevertheless.

Designed by Thompson & Walford, architects also of the University of London's boathouse on Hartington Road (*page 57*), it originally accommodated 500 spectators, and is characterised by its prominent roof vents, servicing the changing rooms at the rear.

In 1996 the athletics track was grassed over. Then three years later the ground was sold to its current owners, whose logo is just about visible in the centre of the stand.

Not content with owning one historic stand, Motspur Park is now the training ground of **Fulham FC**.

As may be seen, the stand – used today during youth and training matches, and still with 250 or so of its original wooden tip-up seats – is flanked by two pavilions. The one on the right was built by the University, the one on the left has since been added by Fulham,

who have also sympathetically modernised the interior, while also restoring the building's façade, including its Art Deco clocktower.

If footballers signing for Fulham might baulk at their cramped quarters at The Cottage, by comparison Motspur Park has the air of a suburban country club.

Our final example from the 1930s is another illustration of a grandstand that might equally be described as a pavilion, and which almost certainly would

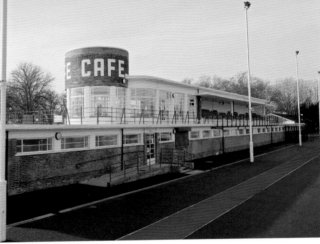

have been demolished had it not been listed Grade II in 2003.

Accessed from **Carterhatch Lane, Enfield**, the **Queen Elizabeth Stadium** was actually designed in 1939, but because of the war was not completed and opened until, as its name suggests, 1953 (the year of the Coronation).

A long, narrow brick construction with curved ends and a prominent glazed bar area and staircase tower on the roof, the viewing area at the west end seats just 105.

For years the building and track were in a desperate state until in 2010 a £2.3 million refurbishment took place. Seb Coe, who had trained on the original track in the 1980s, cut the ribbon.

Apart from athletics the stadium's main use is now as home to **Enfield Town FC**.

Also on the site, serving the adjoining **Enfield Playing Fields** – second in extent only to Hackney Marshes – is a 1938 pavilion housing dressing rooms.

Three cantilevered grandstands were built in London in the late 1950s; the Warner Stand at Lord's, London Welsh's stand at the Old Deer Park (*page 262*) and this elegant one at the Richmond Athletic Ground. Seating 960 and costing £30,000, it was designed by architects Manning & Clamp, with engineers Jenkins & Potter, and formed using in-situ concrete. For a pitchside view see page 263.

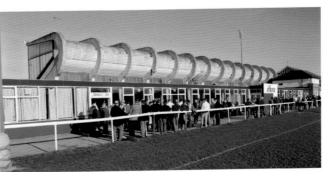

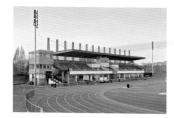

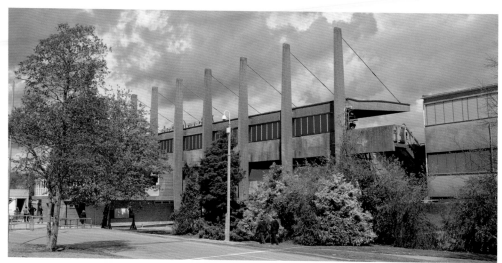

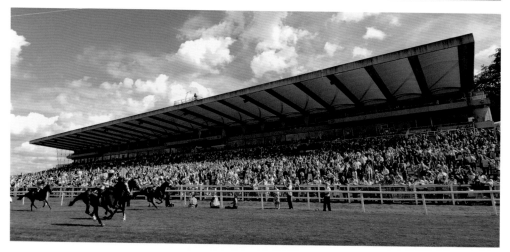

▲ After years of post war restraint, the 1960s saw a rush of new sports facilities in London. Above and right is one of them, **Copthall Stadium**, in **Mill Hill**.

Built at a cost of £219,000 by **Hendon Borough Council** (shortly before its absorption into Barnet), it was officially opened on July 17 1964 by the Duke of Edinburgh, four days after he had performed the same duty at the National Recreation Centre, Crystal Palace.

As at the NRC (*see page 313*), the Copthall stand's roof is cable-stayed; that is, the load is tied back to a line of pre-cast concrete masts.

For such a substantial structure the seating tier holds relatively few spectators, only 650. This however was indicative of the stand's prime function, as a venue for occasional athletics meetings, but on a daily basis as a multi-use facility for local sports clubs and the public.

PJ Whittle was the architect, working under Hendon's Borough Engineer, FJ Cave.

In 2013 Copthall was reinvented as **Allianz Park**, following £24m worth of improvements funded by **Saracens Rugby Club** (*see opposite*). As such, the 1964 stand may be on borrowed time.

Meanwhile, pre-cast concrete continued to gain favour amongst stand builders. Quick to erect and low in maintenance costs, its utility and surprising elegance was amply demonstrated at **Sandown Park Racecourse** in 1973 (*above right*).

A familiar sight to rail passengers approaching Esher, en route to Waterloo, the 150m long stand cost £1.75 million, and accommodates 1,600 seats and a row of private boxes at the rear, plus terracing for over 5,000 standing at the front.

The structural engineers were the Twickenham-based Jan Bobrowski & Partners, who would soon become specialists in stand design. In particular, their use of pre-cast concrete roof beams, as seen at Sandown Park, fitted with vaulted, translucent pvc roof panels, would be repeated at several other stands, including

those they worked on with the Lobb Partnership at Cheltenham and Goodwood Racecourses (1978 and 1980), at Twickenham (the South Stand, 1981, *see page 267*) and at Watford FC (the Rous Stand, 1986).

Sandown Park's stand was also a sign of things to come in that its architects, the Fitzroy Robinson Partnership, better known for offices and commercial buildings, incorporated a range of unusually large and flexible hospitality areas, designed to be hired out on non-race days.

A grandstand was no longer just a platform for seats. It now had to generate income all year round.

Compared with the world of racing and cricket, football came relatively late to this approach.

Seen on the right in 1992 is one of the reasons why.

In 1971 **Chelsea** had intended that their proposed new **East Stand**, designed by architects Darbourne & Darke (who had never designed a stand before), and engineers FJ Samuely & Partners, would

be the first phase of a complete remodelling of **Stamford Bridge**.

Built to replace the original Leitch stand of 1905, and with 11,500 seats, it was the first triple decker stand in London and when completed in 1974, a year late, drew plaudits all round from the architectural press. Its Corten-steel frame (designed to rust on the outside to create a protective layer) was especially admired. But the residue from this clogged the drains and stained the cladding, while other flaws in the circulation areas provided further headaches.

As did the stand's £2m costs, sending Chelsea's finances into a downward spiral that nearly killed the club. (Fulham's Riverside Stand in 1972 and Tottenham's West Stand in 1982 were almost as ruinous.)

Despite this, the East Stand is still in use, just recognisable in the presence of three quite different stands built since 1993 (*page 231*).

But back in the 1970s and '80s it stood as a warning sign to football clubs all over Britain. Concrete or steel, making a stand could make a club. But it could also break it.

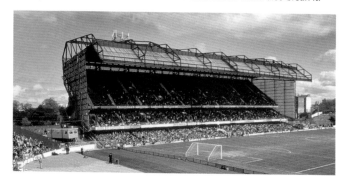

▶ It was in the midst of this period of great uncertainty in football – when the building of fences to cage in fans took priority over the improvement of facilities – that the Bradford fire in 1985, followed by the Hillsborough disaster in 1989, led to a complete overhaul of safety management in England and Wales.

Down came the last remaining timber stands in senior sport. In the top two divisions of English football all standing terraces were closed.

By 2014, more than one third of all professional football clubs in England and Wales had moved into new stadiums, while the rest embarked upon a stand building spree unprecedented since the Edwardian era.

Football may have been the sport most affected, but it was not alone. Cricket and rugby grounds, greyhound stadiums and racecourses; any venue with a stand or a terrace came under stricter regulation than ever before.

Just as significantly, as clubs and stadium operators faced up to the enormity of the challenge, they finally embraced the notion, already ingrained in the USA, that higher levels of comfort and amenity would yield higher attendances, and boost that other all important factor, 'spend-per-head'.

Spectators were no longer mere fans. Now they were customers.

From a design perspective, a selection of the most innovative stands to have emerged during those transformative years appears in later chapters; among them the Mound Stand at Lord's (1987), one of several stands in Britain to use as its roof covering a new and flexible form of tensile fabric (*page 203*).

Yet although built to cater for the burgeoning market in corporate hospitality, the Mound Stand and others like it were predicated equally on a very British tradition.

That is, rather than create seamless, uniform stadium bowls, the heritage of certain grounds was best honoured by continuing to build individual grandstands.

Besides which, in many locations, there simply was not room enough to slot in anything other than individual stands; each responding to its own set of limitations (height restrictions, street access and so on).

Ironically one of the finest stands to emerge during this period proved also to be the most shortlived.

Opened in 1993, the **North Bank Stand** at the **Arsenal Stadium, Highbury**, seen on the right from the back gardens of **Gillespie Road** was another collaboration between the Lobb Partnership and Jan Bobrowski & Partners.

Its lightweight steel roof was supported by a truss 103m long, held up by two columns placed *outside* the lower tier. A simple way of offering column-free viewing, this was dubbed a 'goalpost' roof.

But the stand's most impressive engineering feat was that its entire upper seating deck was cantilevered from the rear structure, so that no supporting columns obstructed views from the lower tier.

Seating 12,400 overall, and costing an eye-watering £16.5 million – the most costly stand yet in British football – the stand won further praise for its retro detailing (to match the stadium's two 1930s stands, *see page 238*) and for its unusually high level of amenities.

It even housed a club museum.

And yet the North Bank Stand saw action for only thirteen seasons before making way for a new block of flats as part of the Highbury Square development (*page 240*).

Messrs Lobb and Bobrowski also chose a 'goalpost' roof for their £8 million overhaul of the stand at **Kempton Park Racecourse**, just beyond Hampton, famous for its King George VI Chase on Boxing Day, as seen above right in 2012.

Much of the brick base of the original stand, designed by Yates, Cook & Derbyshire in 1932-33, was retained, with internal areas redesigned both for race days and for hiring out for exhibitions and conferences. The unusual upward sweep of its steel framed roof supports not only floodlighting for Kempton's new all-weather track but also the commentary boxes underneath, so that the glass fronted restaurant below need have no obstructive columns.

Our final and most up-to-date example (*right*) is the **East Stand** at **Allianz Park**, as Copthall Stadium has been rebranded since Saracens took it on in 2013.

Facing the 1964 stand (*see opposite*) across an artificial pitch, this simply articulated 4,800 seat stand, designed by Roberts Limbrick, has demountable seats at the front that are removed in the summer to allow the athletics track underneath to be used (*page 265*).

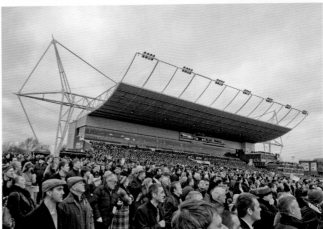

Also unusually the exterior of the stand is clad in western red cedar, used by the same architects at Forest Hill Pools (*page 172*).

Might any of this new crop of stands be one day deemed worthy of preservation? After all, London's youngest listed stand is the one featured at Enfield, opened in 1953.

Something to discuss over the half-time Bovril perhaps. Or glass of bubbly, for those in the VIP seats.

Chapter Eleven

Membership clubs and institutes

Opened in 1887, the Queen's Club in West Kensington is best known today for lawn tennis. But as detailed in later chapters it also hosts real tennis, rackets and squash – that is, four main sports. However in its early years, according to Evan Baillie Noel, club secretary from 1914-28, Queen's hosted 25 sports in total. Although some appeared only fleetingly, such a diverse, multi-sport approach was common to elite membership clubs in 19th century London. Even at Lord's the MCC offered eleven sports other than cricket at various points during the mid 19th century. EB Noel personified the all-round character of these clubs. As well as tennis he played cricket for the MCC, was sports editor of *The Times*, and won a gold at the 1908 Olympics, in rackets (the very first gold at the Games, as it happens). But then he was on home turf, as it were. The matches were played at Queen's, on the same courts still in use today.

Writing in the 1720s, the Scottish spy and inveterate traveller, John Macky, ascribed to London 'an infinity of clubs or societies for the improvement of learning and keeping up good humour and mirth'.

In particular he commended the Kitt-Catt Club (with its roster of 39 high profile Whigs), and the Mug House Club on Long Acre (ale only consumed, singing encouraged, politics taboo).

Everyone who was anyone in 18th century London belonged to a club or society of one sort or another. Peter Clark, in his history of the phenomenon (see Links) identified 130 different associational categories, among them music, art, debating, science and horticulture.

Some gentlemen's clubs in London did, apart from their usual offerings of billiards and cards, dabble in 'sport' as we know it today, for example organising regattas on the Thames (even if their motivation was perhaps to create further opportunities for gambling and drinking).

But as noted on page 18, one by one clubs emerged whose first priority genuinely was sport (albeit still closely followed by gambling and drinking). Two of the earliest, formed at the fashionable Star and Garter tavern on Pall Mall, were the Jockey Club in 1750, and the White Conduit Club, which in 1787 morphed into the Marylebone Cricket Club. Also in this period appeared the Cumberland Sailing Society, in 1775, and in archery, the Toxophilite Society, in 1781.

All these clubs were confined to, or at least dominated by aristocrats and gentlemen. But by the mid 19th century the middle classes had taken to organised sport with, if anything, even greater enthusiasm, and it was around this time that different types of formalised clubs, and therefore different types of grounds and facilities emerged.

The classic 19th and 20th century model of a team-based club is one that starts humbly, then gradually builds itself up, by developing 'good humour and mirth' but also by winning games and gaining status in their one, chosen sport.

Take Harlequins for example.

Currently approaching their 150th anniversary, even if Quins were to have a few poor seasons it is unthinkable that they might drop rugby and take up another sport instead. The club exists, first and foremost, for the playing of rugby.

But as noted by the example of the Queen's Club, there are other models of development; that is, clubs formed first and foremost to meet a particular social agenda, and who are therefore able and willing to swap and change which sports they offer according to the needs and wants of their membership, and if necessary, to changing economic circumstances.

A prime example of this is the Hurlingham Club in Fulham (of which more later). Set up in 1869, originally for pigeon-shooting, Hurlingham soon became

identified with polo. Yet since the 1950s the club has dropped polo, diversified, and now hosts five main sports, of which tennis dominates.

The Roehampton Club has gone through a similar transition.

This preparedness to adapt is demonstrated by clubs across the spectrum, from swanky, high-end clubs in west London to working class Boys' Clubs in the East End, playing football in one century, basketball in another.

At one end of the scale, social exclusivity, at the other, social inclusion. But in both cases, the members come first, the nature of the sport on offer being secondary.

Inevitably this approach has a bearing on the type of grounds and of buildings required to fulfill that role. Not least, rather than concentrating resources on pavilions or grandstands, more often than not such clubs invest in multi-purpose buildings, some of which, as at Hurlingham, where the clubhouse is an 18th century mansion, started out life in another guise altogether.

Or, as at the Regent Street Polytechnic, its sports facilities are buried within larger buildings and possess no separate identity.

In such instances it is less the heritage of a building or of a sports ground that invites interest so much as the intangible heritage of the club or institute itself.

Why did it form? How has it evolved? And most tellingly of all, which elements of its heritage, if any, are treasured and celebrated by its current members?

▶ Most accounts of the **National Club**, London's first genuinely multi-sport membership club, based in Chelsea from 1831-43, tend to focus on its creator, the self-styled **Baron de Berenger**, a character who might easily have stepped off the pages of a gothic novel.

Or they skip to the period after his departure in 1843 when the 24 acre site, running from King's Road down to the Thames, was re-styled as **Cremorne Gardens**.

In this later incarnation Cremorne was considered a successor to Vauxhall Gardens, offering fêtes, balloon ascents, an American bowling saloon, battle re-enactments and firework displays, plus, after 1862, extravaganzas staged in a large pavilion called Ashburnham Hall, able to host equestrian displays and accommodate up to 8,000 people.

Visitors included royalty and foreign dignitaries, but were mostly ordinary Londoners, up for a bit of fun.

In its final years, however, as had occurred at Vauxhall, Cremorne became, as described by one local resident, a 'nursery of every kind of vice'. This ultimately led to its closure, in 1877, after which terraced houses were built on the site, joined after 1902 by Lots Road Power Station. All that was saved were Cremorne's ornate iron gates, re-erected at the entrance to Watney's Brewery in Mortlake.

But it is the gardens' earlier incarnation that interests us here.

Baron de Berenger was no ordinary promoter. As a young man, known as Charles Random, he had worked as a colourist for Ackermann's, the printmakers. It was there that he befriended the illustrator George Cruikshank, with whom he shared an interest in gymnastic exercises.

Later Random married a German widow, Baroness Berenger. Not only did he take her name, he also now claimed to have been himself of noble Prussian descent.

In 1814 Berenger achieved national notoriety for attempting to manipulate the stock market by spreading rumours of Napoleon's death. Naval hero Lord Cochrane was also implicated, although eventually exonerated.

After serving a prison term (and publishing his own self-serving and long-winded account of the hoax), Berenger continued to make the

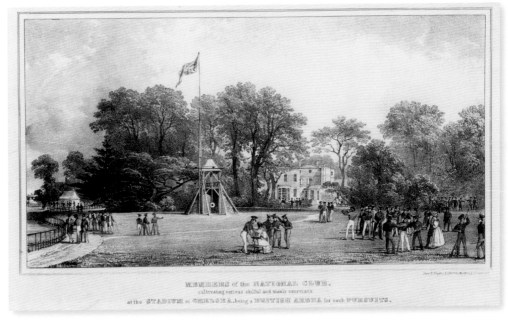

MEMBERS of the NATIONAL CLUB, cultivating various skilful and manly exercises, at the STADIUM at CHELSEA, being a BRITISH ARENA for such PURSUITS.

news. In 1827 he took court action against his neighbour in Kentish Town for shooting 29 of his ducks. Yet he himself was equally known for his marksmanship – he called his house Target Cottage – and for patenting a number of firearms, a double barrel shotgun included.

Berenger was in his sixties when, in around 1830, he came into an inheritance sufficiently large to fund his purchase of Cremorne Farm. There he took up residence in its early 18th century mansion, remodelled in the 1780s by James Wyatt.

Inspired no doubt by the craze for gymnasiums during the 1820s (*see Chapter 13*) and by the popularity of 'Gentleman' John Jackson's boxing academy on Bond Street, Berenger transformed Cremorne Farm into a sporting paradise.

As inscribed on the lithograph seen above, published by Day & Haghe in 1831, it was billed as the **British Arena for Manly and Defensive Exercises, Equestrianism, Chivalric, Aquatic games, and Skilful and Amusing Pastimes**.

But mostly Berenger referred to it simply as '**The Stadium**'.

Although it had no spectator accommodation as such, this is thought to have been the first use of the word to denote any sports venue in Britain.

Most impressive of all was the sheer range of 'manly' pursuits on offer, the likes of shooting, archery, wrestling, boxing, cricket, football, bowling, trap-ball, golf,

running, jumping, throwing the javelin, fencing, rackets, billiards and various equestrian disciplines.

In 1839 he also laid out a track for horse racing, 650 yards long.

Equally noteworthy was Berenger's commitment to swimming at the Stadium. He set up one of Britain's first schools for swimming, adapting a creek fed by the Thames to offer a sheltered environment for tuition.

He also organised several high profile races across the Thames and promoted the work of the National Swimming Society, which was active also at the Serpentine in the 1830s (*page 155*).

Another Berenger idea was for a floating bath on the Thames, an idea only eventually realised at Charing Cross in 1875. He also penned an idiosyncratic tract on self defence, in 1835.

Berenger may further be credited for staging London's first sports meetings to be billed as 'Olympic' Festivals. Each lasted six days, the first in 1832, the second in 1838 at the time of Victoria's Coronation.

The Royal Borough of Kensington and Chelsea
STADIUM STREET. S.W.10

Ultimately the National Club failed; perhaps partly owing to Berenger's reputation, but also because, before the coming of suburban rail links, Cremorne was still too far from town. So as the years went by Berenger had increasingly to resort to gimmicks (a tale echoed at later ventures such as Crystal Palace and Alexandra Palace).

It is tempting therefore to dismiss Berenger as just another failed speculator. But in many respects his main failing was simply to be ahead of his time. London in the 1830s may not have been ready for such a venture, yet within half a century there would be several such clubs.

Berenger died in 1845.

Of Cremorne Gardens, only a small remnant survives as an open space, in the form of a riverside park laid out on Lots Road in 1982.

In pride of place are the original gates from Cremorne House, brought back from Mortlake.

Nearby, meanwhile, stands **Stadium Street** (*left*), in memory of the site's sporting past.

Another token from Berenger's era is a piece of artwork known as the Chelsea Stadium Shield.

Drawn in 1834 by George Cruikshank, it depicts all the activities on offer and is inscribed with the National Club's motto, *Volenti nihil difficile* (nothing is difficult for he who has the will).

Also inscribed is a familiar phrase from Juvenal, *mens sana in corpore sano*. Once again, it would seem, Berenger was ahead of his time...

▲ Unlike Baron de Berenger, Frank Heathcote did not feel the need to quote Juvenal when he established the **Hurlingham Club** in 1869. His sole aim was to create 'an agreeable country resort' where he and his chums could shoot pigeons.

(The 'sport' had lost its traditional London base when the Red House tavern in Battersea closed in 1854.)

Originally Hurlingham fell within the Bishop of London's estate, centred on Fulham Palace and extending as far as Craven Cottage.

Hurlingham House itself dated from 1760. It was then extended with the neo-classical frontage we see here (*above right*), in 1797, amid parkland landscaped with the help of Sir Humphrey Repton.

Under the Hurlingham Club's ownership the house would be improved by Sir Edwin Lutyens in the 1900s. Since 1954 it has been listed Grade II* and further extended in 2004.

It is a fine example of a building not designed for sport, and yet which has served as a sporting, as well as a social hub, for generations of London's elite.

In fact within five years of the club forming, the pigeon shooters were outnumbered by social members, drawn to Hurlingham's riverside setting and its relative proximity to town (certainly easier to reach than Cremorne had been 40 years earlier). This popularity gave the club confidence to purchase the freehold for £27,500 in 1874.

Another key decision, also taken in 1874, was to try out a sport quite new to London.

Polo had been imported by cavalry officers serving in India in 1870 and played first in Britain on Hounslow Heath, then in Richmond Park, and later at Lillie Bridge.

For Hurlingham to even host the game required a major outlay, on clearing and levelling land. But it paid off. A crowd of 5,000 attended the first match in June 1874, royalty included, and within a few years, such was the demand for playing time and space – always in contention with the pigeon shooters – that a group of members formed their own club in the adjoining grounds of Ranelagh House (*see opposite*).

Sensing that polo was the way forward, Hurlingham's response was to expand, starting with its takeover of the Mulgrave House estate to the west, followed by that of Broom House to the east.

By 1912 Hurlingham had grown to 75 acres and was now quite different in character. Following a members' vote, pigeon shooting had been dropped in 1905 (a reversal that its exponents spent six days contesting in court).

This freed up more space for tennis and croquet, games that had been introduced at the club in 1877 and 1901 respectively.

Hurlingham's rivals developed along similar lines. Indeed by 1900 membership of the Ranelagh Club outstripped that of Hurlingham.

Roehampton opened in 1902, also for polo (*see opposite*).

There was briefly a Wimbledon club too, but this and attempts to establish polo at Crystal Palace and Wembley Park failed, all being far too suburban to attract members with the wealth necessary to carry on the sport.

Hurlingham, for its part, established an influence over polo as dominant as that of the MCC over cricket. The sport's governing body made its base at the club and even became known as the Hurlingham Polo Association (a name it retains to this day, despite being based in Oxfordshire).

Hurlingham's status was further confirmed in 1935 by the construction of a £10,000 grandstand seating 2,600 on the west side of its No 1 Polo Ground.

And yet only four years later the outbreak of war brought this era to an unexpected end. The No 1 polo ground was turned over for allotments. The No 2 ground housed an anti-aircraft battery.

But when the war ended, instead of polo resuming, a whole new agenda presented itself.

Fulham Borough Council wanted the No 2 ground for much needed public housing, a claim the club proved unable to resist.

Work started on the Sulivan Court estate (*seen below*) in 1949.

More controversial was an LCC proposal to compulsorily purchase the rest of the club grounds for conversion into a public park.

Reflecting the political climate of the post war years, a bitter tussle ensued. In one corner, Hurlingham, a bastion of privilege (its chairman was the owner of *The Times*). In the other, the LCC, a champion of the people. Yet there

The Hurlingham Club – 41 tennis courts, ten croquet lawns, two bowling greens, squash courts, a cricket pitch, outdoor pool, a lake, gardens and Hurlingham House itself. Hurlingham Park, top centre, is where the No 1 polo ground lay before 1951. To its right, the Sulivan Court estate occupies the former No 2 ground. On the far left are flats and houses on the site of the Ranelagh Club from 1877-84.

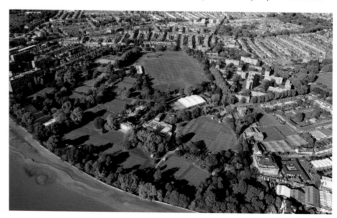

were also divisions amongst club members, many of whom were quite prepared to sacrifice polo if it meant saving the rest of the club.

In the end, this is what occurred. In 1951 the No 1 ground became **Hurlingham Park**, with the almost new polo grandstand now overlooking public pitches. Alas the stand ended up derelict and and covered in graffiti, until finally it was replaced by the current, ultra-vandal proof pavilion in 2003.

Meanwhile, behind its adjusted eastern boundary, the Hurlingham Club, ironically, went from strength to strength. Facilities for tennis and croquet were extended (resulting in the Croquet Association making Hurlingham its home from 1959-2002). In addition to squash courts built in 1934 and two bowling greens laid out in 1935, a cricket pitch was created in 1951.

In that sense it could be said that the LCC had inadvertently made Hurlingham even stronger. After all, a single polo pitch, on which no more than four a side can play at any one time, covers the equivalent area of 75 tennis courts.

Thus since 1951 Hurlingham has increased its membership from 2,000 to some 12,000 today. It has also played a wider role in sport by staging such events as the 2011 World Croquet Championships and a pre-Wimbledon men's tennis tournament, held every June.

Yet it is in the day-to-day life of Hurlingham that its character as a club is perhaps best illustrated; still a quiet, well tended and exclusive resort of 42 acres, but equally a venue whose programme of drama, music, bridge, country dancing, lectures, yoga and so on would be the envy of any club or community centre.

At present there is a fifteen year waiting list for full membership.

For those unable to wait, free tours laid on during Open House weekends are highly recommended.

Plus, since 2009, 'hockey on horseback', as polo was once dubbed, has made a return, if not to the club, at least to Hurlingham Park. Staged over a long weekend, also in June, the 'Polo in the Park' beanfeast offers the public a taster of the game (and of champagne and cream teas if you can afford the right package). Not quite what the LCC intended back in 1951 perhaps, but a glimpse of the old world amid the glitz of the new.

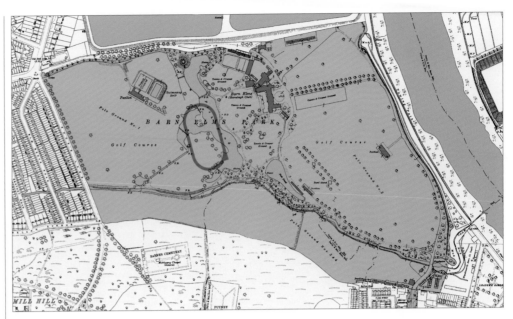

▲ Crossing **Barn Elms** playing fields today there is not a hint that from 1884-1939 this was the site of what was for a time the largest polo club in the world.

Formed in 1877 by players frustrated by the lack of playing time at Hurlingham, the **Ranelagh Club** was originally based over the river by Ranelagh House, just west of Hurlingham (where a road called Ranelagh Gardens now lies).

It was on this ground, as noted on page 22, that the world's earliest recorded floodlit sports event, a polo match, took place, in July 1878.

(Oddly, the club never sought credit for this, although they did claim, erroneously, to have links with another Ranelagh Gardens, a fashionable 18th century resort three miles away, now part of the grounds of the Royal Hospital Chelsea.)

As shown on the map (based on data from 1936), after moving to Barn Elms in 1884 Ranelagh expanded to occupy a site covering 130 acres, with **Barn Elms House** (marked in brown, top centre), a Georgian mansion, becoming their clubhouse.

Other buildings marked in brown represent pavilions built to service four polo grounds, an 18 hole golf course, tennis courts and croquet lawns, while the outline of the present day running track can be seen in the centre, where the club had an ornamental lake.

Ranelagh was said by some to have outshone Hurlingham, not only in terms of its polo facilities but also in the social status of its members.

But it too now had a rival. A mile to the south, the Roehampton Club, opened in 1902, also initially for polo, was soon boasting its own celebrity members; the King of Spain, Winston Churchill, the Aga Khan and numerous Maharajahs.

Roehampton was also able to match Ranelagh's facilities. It too laid out an 18 hole golf course and lawns for tennis and croquet, plus squash courts, built in 1925.

In 1934 Roehampton then constructed an Art Deco lido complex on the corner of Upper Richmond Road and Priory Lane housing two outdoor pools, one for the public, one for members.

The difference was that whilst Ranelagh ran out of steam and disbanded in 1939, Roehampton rode out the war and emerged as London's largest multi-sport club, occupying 100 acres in total.

Like Hurlingham Roehampton gave up polo, in 1956. In 1957 it leased one of its old polo grounds to Rosslyn Park FC (see page 264), and in the 1960s sold its pool complex for a housing development.

Since then, using the proceeds, topped up by regular injections from members, Roehampton's original buildings have all been replaced, so that there is now little to note of heritage value.

Instead, again like Hurlingham, it has a waiting list for membership and a thriving social scene.

Whereas of the Ranelagh Club, nothing remains. Not even Barn Elms House, demolished after a fire in 1954.

Ranelagh's Number 1 Polo Ground in 1930. Its colonial-style pavilion, built in 1898, is marked in brown in the upper left of the map above, in front of an outdoor pool added in 1933. Hurlingham and Roehampton also built outdoor pools at that time, but only that of Hurlingham survives. Behind the pavilion the reservoirs of the Metropolitan Water Board are now the London Wetland Centre.

▲ Built in 1858 on the corner of **Ridgway** and **Lingfield Road**, the Grade II listed **Wimbledon Village Club**, designed by the prolific church architect SS Teulon, is thought to be England's oldest purpose-built community club still fulfilling its original function. (Older club premises exist, such as those of the Orford House Social Club, based in a listed, early 19th century villa in Walthamstow. But all are conversions of existing buildings, mostly detached houses.)

The aim of the Wimbledon Village Club was to offer residents, but 'especially the working and middle classes... opportunities of intellectual and moral improvement, and rational and social enjoyment, through the medium of a reading room and library, lectures and classes.'

Those who could afford Honorary membership paid 10s per annum or donated at least five pounds.

'Artisans or labourers' could become Ordinary members for 1s 6d a quarter or 8d a month.

Membership gave access to a refreshment room, a reading room – this was before the local public library opened in 1887 – and to

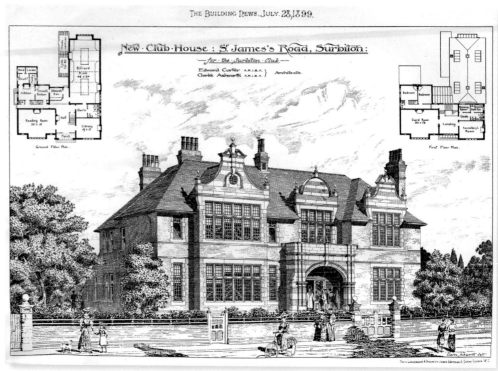

a variety of activities, including, boxing, fencing and billiards.

Today's offerings for the club's 800 or so members are not so different; the likes of yoga, darts and snooker, but as ever balanced by artistic activities such as ballet and light opera.

The building also houses the excellent Museum of Wimbledon and a gallery.

If this may seem tangential to the heritage of sport, it should be noted that much of the impetus behind such clubs as Wimbledon in the mid 19th century emanated from individuals whose concerns spanned *all* aspects of social development, moral, intellectual, cultural *and* physical.

A prime example was William Penny Brookes, a doctor in the Shropshire town of Much Wenlock.

In 1841 Brookes set up an Agricultural Reading Society, from which emerged various classes, one being the Wenlock Olympian Class, in 1850. This encouraged 'skill in athletic exercises' in tandem with 'proficiency in intellectual and industrial attainments', once again bringing to the fore Juvenal's phrase, *mens sana in corpore sano*, a healthy mind in a healthy body.

Brookes and his fellow advocates of physical culture would call up this expression repeatedly.

But there was another aspect of their movement that was also

to influence sport profoundly, and that was its emphasis on 'rational' recreation (a notion emphasised also by the founders of the Wimbledon Village Club).

Rational recreation, the antithesis of such barbaric and un-Christian 'sports' as cockfighting and bear baiting, owed its growth to the same rigours that underpinned the new community clubs. That is, officers were appointed, rules were drawn up, records were kept and memberships had to be paid for and earned.

Rational recreation equally concerned the maintenance of respectability, and as such was to redefine sport in the 19th century. Not least, as Martin Polley has shown (see *Links*), it was the annual games of the Wenlock Olympian Society that initially inspired Pierre de Coubertin to form the modern Olympic movement in 1894.

By then, the sports club, formally constituted and bound by national codes, had become the norm.

But close ties continued with village and community clubs. Some of these formed their own football and cricket sections. Some acted as a springboard for new sports clubs to form. And just as today various rugby clubs host their annual dinners at the Hurlingham, so the National Rifle Association would hold their meetings at the Wimbledon Village Club.

Another trend was for village and social clubs to lay out bowling greens, as happened at Orford House and a number of Conservative Clubs, for example at Ealing and North Enfield.

But the one activity laid on almost everywhere was billiards.

We can gain a glimpse of its importance from the archives of the **Surbiton Club**, formed by 25 local gentlemen in 1873.

That year the club hired a 'marker' (or scorer and attendant) for its billiard room, giving him an allowance of two suits per annum and 18 gallons of beer each month.

The first marker to be hired was sacked for being drunk.

In 1891 members taking snuff were requested to leave no 'nasal excretia' on the baize. The year after a boy was hired simply to clean the billiard balls. But in 1895 he had to be 'thrashed' in the cellar for disturbing players with his noise.

For the Surbiton Club's 450 or so members today, at their splendid and little altered clubhouse on **St James's Road**, opened in 1899 (*above*), life is a tad more easy going. Monday nights sees Ladies Darts, an unthinkable prospect in 1899. Tuesday is Cards Night, and on Thursday nights the Snooker League takes place. So many more balls than in a game of billiards, yet not a single boy around to clean them.

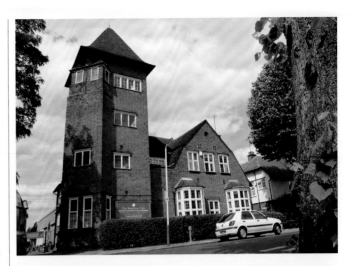

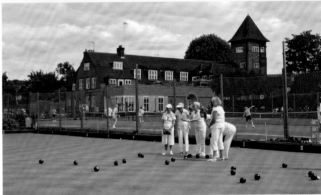

For many readers the name **John Innes** will conjure up images of bags of compost on sale at garden centres. To know something of the man himself we must go to **Merton Park SW19**. A wine merchant turned property developer, it was Innes (1829-1904) whose Merton Park Estate Company oversaw the development of the area from 1870 onwards – there is a debate as to whether it, rather than Bedford Park in Chiswick was the first prototype garden suburb – and Innes who funded the **Manor Club and Institute** on **Kingston Road**, in 1890. Next door he also endowed the Masonic Hall (now a public hall) and, across the road, the **John Innes Boys Club**.

Nearby, in the heart of the estate stood his home and its grounds. The former became the headquarters of the John Innes Horticultural Research Institute, before its relocation in 1945. The latter was opened to the public as **John Innes Park** in 1909, with a bowling green, a croquet lawn and a recreation ground alongside.

The Manor Club itself was designed by HG Quartermain, who worked extensively for Innes on the estate, and is similar in layout to Surbiton (*opposite*). It has an especially grand, high-ceilinged billiard room with original fittings from the 1890s. At the rear is a bowling green. The club also runs a veterans' football team.

Yet even with 250 or so members, yoga classes and a regular event schedule (heavy metal bands a speciality), the club craves a modern day Innes to fund the restoration of its Victorian fabric.

Across London the secretaries of similar clubs, all set up for local tradesmen and skilled artisans, reel off a litany of reasons why restoration has had to take second place to survival, in the wake of the smoking ban, of rising beer prices and business rates, rafts of new legislation and bureaucracy, the difficulties of attracting younger members and so on.

Small wonder that several long established clubs in London have succumbed to property developers.

Yet others have fought back. Having thrown open their doors to women in previous decades, they now court community groups, even nurseries. As well as the old staples of darts, cribbage, snooker, pool, table tennis, bowls and bingo, a successful club nowadays typically hosts quiz nights, curry nights and tea dances and hopes to draw packed houses for big matches on satellite television.

The **Bethnal Green Working Men's Club** has gone further still.

It rents out the upstairs hall of its Grade II listed Victorian clubhouse on Pollard Row – which once was the home of the Repton Boxing Club – to the arts and events promoters, Workers' Playtime.

In 2006 *Time Out* called the club the 'coolest joint in town'.

The relationship between older club members and young East End hipsters works well too. After all, artists and performers are working men and women too.

Bethnal Green is one of around 95 London clubs, out of some 2,000 nationwide, affiliated to the Working Men's Club and Institute Union (or CIU), an organisation founded in London in 1862 by Henry Solly, a Unitarian minister and social campaigner.

Solly was teetotal, but the hard truth is that no CIU club, then or now, can survive without the income from bar sales.

They go under different titles: Working Men's, ex-Servicemen, Railwaymen, British Legion, Trades Hall, Liberal, Labour, Conservative and Constitutional.

Alas the Streatham Automobile and Social Club has reached the end of its road, but the Done Your Bit Club in Kilburn soldiers on.

None, however, dares rest on its laurels. Back at the Manor Club, a framed noticeboard for members bears the stark title, 'Obituary'.

Too often it is in use, most poignantly of all in August 2013 when the oldest member died.

The grandson of one of the founders, the late member had kept scrapbooks archiving the entire history of the club, going back to 1891. But on his death a relative had thrown out the scrapbooks.

And so another piece of London history is lost, as the obituary board awaits its next notice...

They know all about the loss of club archives at the bowls section of the **Brentham Club** on **Meadvale Road**, **Ealing** (*see page 102*).

Opened in 1911, this Grade II listed Arts and Crafts delight was designed by George Sutcliffe for residents of the Brentham Garden Suburb, a development inspired by the writings of Ebenezer Howard and by the co-partnership principles of the campaigning Liberal journalist, GJ Holyoake.

The building housed all the usual elements of the period; a lecture hall, reading room, card room, ladies' room, billiard room (*page 149*) but no alcohol, as was also the rule at Brentham's contemporary, Hampstead Garden Suburb (whose clubhouse, similar in appearance to Brentham's, was destroyed in an air raid in 1940).

By 1914 twelve tennis courts, a croquet lawn and a nine hole pitch and putt course had been laid out at Brentham.

Other activities included French classes, a camera club and the publication of an estate magazine.

It was in *The Brenthamite* that in August 1923 a report of local schoolboy Fred Perry's first ever sporting triumph appeared, not in table tennis, his first love, not even in lawn tennis, but in a three-legged race. Perry has since been commemorated with plaques at the club, and at his family home in nearby Pitshanger Lane (*page 303*).

Later distinguished Brenthamites have included cricketers Mike Brearley and Graham Barlow, and footballer Peter Crouch.

As related by Aileen Reid (*see Links*), Brentham's days as a tenants' Co-Partnership ended in the 1930s, as did the club's temperance rule. To survive, it had also to admit members from outside the estate.

Today, around 60 per cent of the 1,100 members live outside the area, attracted to a well run club that, with sections for tennis, cricket, bowls, football, snooker, darts and bridge, appears to have come up trumps all round.

In recent years its interior has been refurbished. Now it is hoped to spruce up the exterior, and in the process convert the top floor of the tower into a library and archive room for the Brentham Society.

As experience has shown, every clubhouse should have one.

▲ There is surely no more touching evocation of the maxim *mens sana in corpore sano* than this portrayal of the philanthropist **Quintin Hogg**.

Unveiled in 1906 and listed Grade II, the statue, by George Frampton, depicts the avuncular Hogg (1845-1903), bible in hand, flanked by two youths, one carrying a book, the other a football.

A sugar merchant of great wealth, a rower, cricketer, tennis player, but above all a keen footballer, even into his fifties – one of his closest cohorts was Alfred Kinnaird – Hogg understood that sport offered young working men a path to self improvement.

But equally he insisted that physical culture had always to go hand in hand with education.

As can be seen his memorial stood in front of All Soul's Church, just north of **309-11 Regent Street**, an exhibition building originally known as The Polytechnic, which Hogg's Young Men's Christian Institute took over in 1882.

Known subsequently as the **Regent Street Polytechnic**, and now part of the **University of Westminster**, the building was adapted to house some of the finest sporting facilities in central London. First there was a full size gymnasium, opened in 1883 (now a study space called the Old Gym), then a swimming pool, opened in 1884 (now a lounge area called the Deep End). Both were improved as part of a remodelling by Frank Verity and GA Mitchell in 1910-11, to create the building we see today (also listed Grade II).

As Mark Clapson has written (*see Links*), there were often uneasy social relations between the Poly's sportier members and those more concerned with academic advancement. But what cannot be denied is just how many Poly sportsmen and women excelled, to the extent that any history of amateur sport in England cannot help but allude frequently to the the institution's many sections; for example the Polytechnic Harriers (who helped organise the athletic programme of the 1908 Olympics and established London's first Marathon), and its women who, under the encouragement of Hogg's wife Alice (also remembered on Frampton's statue), organised their own clubs from 1888 onwards.

These included, from 1907, what is now recognised as the oldest netball club in the world.

Although most of the Poly's sporting activity would take place elsewhere – at the Quintin Hogg Memorial Sports Ground in Chiswick especially (*below left and page 112*) – one reminder of the past in Regent Street's sumptuous lobby is a marble honours board listing winners of the Studd Trophy.

Named after the cricketer, Sir John Kynaston Studd, another Old Etonian and Muscular Christian who became Hogg's right hand man, the trophy was awarded to the best overall athletic performer at the Poly in any given year.

One familiar name from the 1970s is the hurdler, Alan Pascoe.

Of course this is balanced by a second honours board for the Mitchell Trophy, awarded to the Poly's best academic achievers.

A further legacy of Hogg's at Regent Street is that, much to the chagrin of students, alcohol cannot be sold in the building.

Visitors should also be forewarned that the Hogg statue seen here is, unfortunately, no longer in its original location.

Deemed an impediment to road traffic, in 1933 it was moved to its present location, 300 yards north, in the centre of Portland Place.

Meanwhile, Hogg is further commemorated by an LCC plaque at his home at 5 Cavendish Square, by the Quintin Boat Club (*page 57*), by the Quintin Kynaston School in St John's Wood (an amalgamation of two schools), and by Quintin Avenue, near Merton Park, where the Poly's first sports ground, gifted by Hogg, was in use from 1883-1900.

But of far greater import were the institutions that took a lead from Hogg, among them the Woolwich Polytechnic (established 1890, now the University of Greenwich) and the Northampton Institute (1894, now City University London).

Taking their inspiration from Regent Street, each constructed premises that combined libraries, lecture halls, classrooms and workshops with gymnasiums and swimming pools. It was the same at the **St Bride Foundation Institute**, whose Grade II listed headquarters on Bride Lane, designed by RC Murray and featured in *The Building News* of November 17 1893 (*above*), was built for print workers in Fleet Street.

More on the current uses of the St Bride's gym and pool follows on pages 139 and 177.

One sport taken seriously at St Bride was table tennis. This led to the donation of a silver trophy called the St Bride Vase, in honour of Fred Perry, one of the Institute's regulars, to mark his victory in the Men's World Championships in Budapest in 1929. No Brit has held the trophy since 1951, but here is its most recent holder, China's Zhang Jike (*left*), after his triumph in Paris in May 2013.

▲ Readers who know their London on film will recognise **Alford House** on **Aveline Street**, **Kennington**, as a location featured in Karl Reisz's trendsetting documentary of 1959, *We Are the Lambeth Boys*.

Although the film portrayed only a narrow slice of life at Alford House, it did focus on issues affecting those whom the press were starting to label as 'teenagers'; an age group that, the male of the species in particular, has been exercising the minds of social thinkers in London since at least the 1860s.

Aged between thirteen, when School Board education ceased, and 18, when they could enter the adult labour market, they were described by journalist James Greenwood in 1883 as neither boys nor men, but as 'hobbledehoys'.

Even those who had work faced long evenings with little to occupy them other than gangs, gambling games, 'Penny Gaffs' (revue-style entertainments) and cheap alcohol. In many cases they had no bed to sleep in.

One approach was to provide shelters. Of these, St Andrew's, set up in 1866 on Market Street, Westminster, evolved into a Boys' Club. Now based in a 1980s centre on Old Pye Street, it claims to be the oldest youth club in the world.

As noted elsewhere, numerous philanthropic missions were also set up by universities and colleges.

However, as Quintin Hogg and his fellow Old Etonian activist Tom Pelham recognised, bible studies went only so far. What hobbledehoys craved, like their contemporaries in the suburbs and in public and grammar schools, was

recreation. What they lacked was open space and basic equipment.

Britain's first Boys' Club to be called as such was founded in 1872 by the Rev Daniel Elsdale, amid the back streets of Kennington, off Camberwell New Road.

Later renamed the Cyprus Boys' Club, its teenage members worked as cab-washers, ostlers, street sellers and crossing sweepers.

Cyprus closed in 1914, but other clubs from those years have carried on, including a number who, in 1887, founded The Federation of London Working Boys' Clubs.

In addition to St Andrew's these include the Harrow Club (formed by Old Harrovians in 1883 and now based in a mission hall on Freston Road, Notting Dale), the Devas Club in Battersea (formed 1884 and based in a 1960s clubhouse), and Alford House.

Established on Lambeth Walk in 1884 by Frank Briant, later to become the area's Liberal MP, Alford House has never occupied a purpose-built clubhouse. Its building on Aveline Street, home to the club since 1950, was originally the Moffat Institute, opened in 1909, and an adjoining mission hall.

In fact unlike Manchester and Liverpool, where purpose-built Lads' Clubs from the late Victorian and Edwardian era still stand – the famous Salford Lads' Club amongst them – London has not a single bespoke clubhouse surviving from before the 1960s.

Several were lost in the Second World War. Since then, probably the best equipped club, the Eton Manor Club in Hackney Wick (*see page 86*), was demolished in 1967.

That said, around 400

youth organisations currently operate in London, a number of which occupy clubhouses built in response to the Albemarle Report, published in 1960.

In 1889 Tom Pelham had described some of the Boys' Clubs' rented premises as resembling 'third-class railway waiting rooms'.

In the late 1950s, reported Albemarle, they were characterised by dinginess, drabness, ugly lighting and poor furnishing.

In London the initiative was taken by the Federation of Boys' Clubs (since renamed London Youth). It launched a '20 New Clubs Scheme', with special emphasis on providing centres in recently completed high-rise estates.

One of them was the **Roehampton Youth Club** on **Holybourne Avenue** (*above*).

Designed by the GLC's Architects Department in the robust, often fortress-like style preferred for such buildings – given how boys will be boys – the £50,000 centre was co-funded by the Variety Club of Great Britain and opened by the film star and then Putney resident, Sean Connery, in June 1969.

Also from the period and only a short distance from Roehampton is

the Alton House youth centre, built in 1964 on Dilton Gardens. Like the flats around it, now forming a Conservation Area, it is a classic of its era. Yet as of 2014 it stood empty, a victim of swingeing cuts to youth services across the capital.

Alford House is similarly affected. It derives most of its income by hiring out rooms to theatre companies for rehearsals.

Where new clubs have been built they have mostly come about through deals with developers.

One example is Caius House on Holman Road, Battersea, a club founded in 1887 by Gonville and Caius College, Cambridge, and re-housed on the ground floor of a new residential block in 2014. Another is the **Crown and Manor Club** in **Hoxton**, which originated in 1903 and still gets support from Winchester College.

Its 1920s clubhouse on **Wiltshire Row**, **Hoxton**, made way for a block of flats in 2012, again with the club re-established on the ground floor (*below left*) – just another example in London of where, be it for richer or poorer, it is not so much the clubhouse, as the membership that needs to be nurtured first and foremost.

Chapter Twelve

Company sports clubs

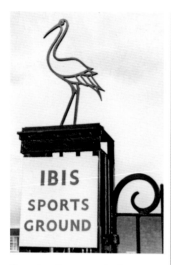

Nowadays known as the Dukes Meadows Golf and Tennis Club, the Ibis Sports Ground in Chiswick was home to the Prudential Assurance's Ibis Sports Society from 1939–91. Legend has it that the name Ibis was adopted shortly after the society formed in 1870 because at the time 'the Pru' was split into an Industrial Branch and an Ordinary Branch. Hence at sports meetings fellow workers would urge on the 'IBs' or the 'OBs', with the former prevailing. (A more likely, if prosaic, explanation is that 'ibis' was chosen by the club's cricketers because bird names were then in vogue.) Also on Duke's Meadows lies the Civil Service sports ground, where London's oldest surviving amateur football club still plays. Pictured right in 1893, 30 years earlier the Civil Service FC had been founder members of the Football Association.

When considering how mass participation sport evolved in Britain, historians tend to focus on the roles played by schools and universities, community-based clubs and the armed forces. Yet there existed a further, powerful force in the moulding of our sporting culture, right up until the late 20th century, consisting of the thousands of clubs, societies and associations formed under the aegis of companies.

In this chapter we use the term 'companies' to embrace the full spectrum of employee-based sporting entities, from factory 'works' teams playing on rented council pitches to 'business house' teams representing the world of finance, based at exclusive private sports grounds.

In the context of London's cityscape this is an important area, if only because of the surprising number of company grounds and pavilions that remain in use, albeit under different ownership.

From a sociological and historical perspective it is also worth acknowledging the huge part company sport played in the lives of so many Londoners during much of the 20th century.

To give an idea of how widespread a phenomenon this was, on a map issued in 1939 by GW Bacon & Co, showing the locations of 1,851 amateur and professional sports clubs in London, 495, or 27 per cent of the total, are identifiable as company-related clubs. No comparable data exists for today, but for sure the numbers have plummeted, and

only a handful still own grounds. Also, the majority of company clubs that do exist have had to relax their membership rules in order to recruit outsiders.

This in itself marks a significant break with the past. At all other sports clubs, membership has traditionally depended on such criteria on where you live, how much you can afford, who you know, or your talent, the school you attended or your religious or ethnic identity.

Whereas at a company sports club all that mattered was your place of work.

This was hardly a modern trend. In the 12th century, William Fitzstephen describes how Shrove Tuesday football was played by groups of workers from different crafts, each with their own ball. In the 1420s the Brewers' Company hired out its hall (or perhaps the hall's grounds) to 'ye Footballpleyers' who may also have combined according to which Guild they were apprenticed.

Company sport as it was to evolve in the modern era can be traced back to the 1860s. This was a decade in which sports such as cricket, football, rugby, athletics and rowing were becoming ever more codified and organised, partly owing to urbanisation and improved transport links and communications, but also because Victorian thinkers were

becoming obsessed with notions of masculinity and Muscular Christianity. Their urgings for greater levels of fitness were further reinforced by the threat of invasion from France, which led to the formation of volunteer brigades all over Britain.

In the midst of this barrage of hectoring and moralising, two strands of provision emerged in the workplace.

Outside London the impetus came from enlightened factory owners such as Titus Salt, who provided gymnasiums for his workers at Saltaire, and from the Quaker Cadbury family, who first allocated a sports field for male workers at Bournville in 1883. Two years later the L&NWR created a cycle and athletics track at its railway works in Wolverton.

Underpinning these efforts lay a paternalistic concern for welfare, combined with a utilitarian calculation that workers would be fitter and therefore more productive if given access to sports facilities. There was also the inherent expectation that grateful participants would develop greater loyalty both to their employers and to their fellow workers.

By contrast, in London the seeds of company sport were planted in banks and business houses, and not by the directors but by those on the shop floor, as it were, the clerks and tellers.

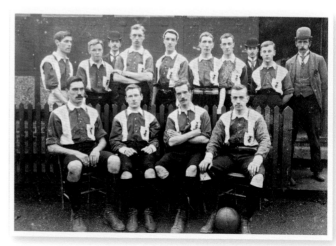

Fresh out of schools where sport had been drummed into them, these men were part of a growing breed of city workers of whom Lord Stanley spoke in 1865 at the opening of the Liverpool Gymnasium. Spending their days 'sitting in offices, often close and crowded,' these unfortunate men, Stanley warned, were prey to 'feeble constitutions and depressed energies...' caused by 'the absence of bodily or muscular exertion, combined with the pressure of what is in some sense mental occupation, though it is often mental occupation of a very mechanical kind...'

'You may say they walk to their places of business,' said Stanley. 'Well... sometimes they do, but just as often they take the omnibus to save time...' He concluded sternly, 'That is not, physically speaking, the stuff out of which one wishes the middle classes of England to be made.'

And so London's clerks and tellers embraced the cult of athleticism. Perhaps some really did so out of patriotism. But just as likely the majority were simply itching to get outside and play.

Being based in the City or central London, however, a train or bus ride away from the nearest parks and suburban grounds, and with the banks not closing until three o'clock on Saturday afternoons, organised sport was really only possible in the summer.

Thus London's earliest known bank teams were cricketers; in 1859 representing the largest joint stock bank at the time, the London & County Bank, and in 1863, the London & Westminster Bank.

From 1860 onwards clerks at the Prudential started playing cricket in Battersea Park, while the Civil Service organised its first athletics meeting at Beaufort House in west London in July 1864. That the Civil Service also had a football team in 1863 suggests that their staff had less onerous working hours on Saturdays. Certainly the number of bank teams playing football and rugby rose after 1886, once banks started closing earlier on Saturdays, at two o'clock.

As noted on the right, the first company-related club in London to lease a ground was that of the Private Banks. This however was an elite club formed by relatively well paid individuals. »

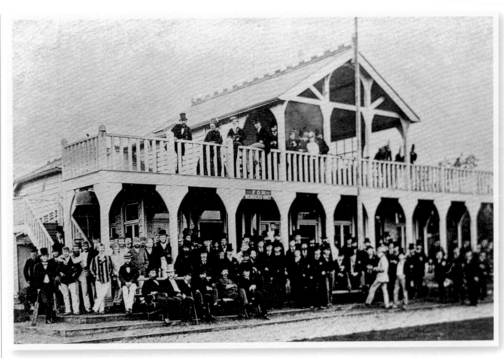

▲ Reflecting the dominance of 'gentlemen' and middle class youths in the early years of company sport in London – and the emergence also of the Indian verandah style in pavilion design – this photograph is thought to have been taken at the annual sports day of the **Private Banks Cricket and Athletic Club**, at **Catford Bridge** in June 1876.

Opened two years earlier with a match against the MCC on May 9 1874, Catford Bridge was almost certainly London's first, and possibly Britain's first sports ground to have been formally leased by a club representing business or commercial interests.

Consisting of players from the likes of Coutts, Rothschilds, Hoare, Barclays and Lloyds, a Private Banks representative team had first taken to the field in September 1866, in a cricket match at the Oval against their counterparts from the new breed of joint stock banks. As private banks were then still in the majority, their easy victory was perhaps to be expected. In 1872 it was resolved to establish a properly constituted club, which in turn led to them leasing the Catford Bridge ground from the Forster family estate.

By the end of the century the tables had turned, off the field at least, so that joint stock banks now outnumbered private houses by four to one. But the Private Banks Sports Club, as it became known, remained strong, and in 1907 its

members set up a limited company in order to finance the £21,000 purchase of the freehold and the improvement of the pavilion.

They played on after the First World War too, despite the now total dominance of the so-called Big Five joint stock banks, amongst whom were former affiliates such as Barclays and Lloyds, both of whom set up their own sports clubs and substantial grounds (in the case of Lloyds, one stop down the line from Catford Bridge at Lower Sydenham, see page 132).

Apart from its club use, as noted by cricket historian Howard Milton (see Links), for a brief period Catford Bridge was in contention to become the London home of Kent County Cricket Club. But despite playing 38 matches there between 1875 and 1921, unlike Middlesex at Lord's, or Surrey at the Oval, Kent's players and supporters never took to their metropolitan surrounds, preferring Canterbury.

Nor did it help that until a new station at Catford was opened in 1892, rail services to Catford Bridge were notoriously poor, or that proximity to the River Ravensbourne meant that the pitch was occasionally waterlogged.

Indeed we would know a good deal more about the ground's early history and that of the Private Banks club had not two floods destroyed the archives shortly after the current pavilion was opened in 1961. The building's

designers, incidentally, were Richard Sudell and DT Waters, whose *Sports Buildings and Playing Fields*, published by Batsford in 1957, was a seminal reference work of the period.

On the credit side, however, owing to its riverside location and sporting usage, the site later became designated as Metropolitan Open Land, thereby thwarting attempts to develop it.

But if the ground was destined to survive, the Private Banks Sports Club was not. Apart from the factors that, as discussed elsewhere, threatened all company sports clubs in the late 20th century, there were simply not enough private banks left. Instead, in its final years club members were listed as representing, *inter alia*, the Royal Bank of Scotland (RBS), four banks from Australia and New Zealand, and only one of the original affiliates, Coutts & Co.

Finally in 1999 Catford Bridge's lease was taken over by the five-a-side football company Powerleague. They were then superceded in 2012 by St Dunstan's College, an independent school based nearby.

Under the original lease, teams from the RBS are still able to use the facilities free of charge, with the added bonus that St Dunstan's have invested further in renovating the pavilion and restoring the pitches to a standard commensurate with this ground's undoubted historic pedigree.

▲ The badge of **West Ham United** is a reminder that their nickname 'the Hammers' comes not from their location but from their origins as the works team of the **Thames Ironworks** shipbuilding company.

The company's philanthropic managing director Arnold Hills (1857–1927), an accomplished Old Harrovian footballer and athlete, and noted campaigner for vegetarianism and temperance, formed a football team for his workers in 1895. Two years later he invested £20,000 on the creation of the **Memorial Ground**, so called because its opening coincided with Queen Victoria's Diamond Jubilee.

Complete with a steeply banked cement cycle track for cycling (see page 319), a cinder athletics track, tennis courts, an open air swimming pool (opened in 1898) and banking reportedly capable of accommodating 133,000 spectators (a gross exaggeration on

Hills' part), the ground was perhaps the most ambitious of all the multi-purpose sports grounds built in London during the 1890s (only one of which survives, at Herne Hill).

Hills hoped that the ground would bring kudos to his company and one day stage an FA Cup Final. But the public thought otherwise.

This was partly because the cycling boom was about to end, partly because of the ground's out of the way location, and partly because the football pitch was too far from the terracing (owing to the tracks). But it was also because, to Hills' dismay, the football team started fielding outside professionals, and therefore staff at the Ironworks no longer felt so involved. Local fans, meanwhile, remained loyal to existing teams.

To rescue the situation in 1900 Thames Ironworks FC formed a separate professional entity, West Ham United.

Even then gates remained poor, until after four more seasons the Hammers (or 'Irons' as they were also known) moved to the more accessible and compact Boleyn Ground in 1904 (page 251).

After that the Memorial Ground continued to offer a programme of cycling, amateur football and, on one occasion, a boxing match. But it was a losing battle, and after the Thames Ironworks closed its shipbuilding yards in 1912 – by which time Hills had become severely disabled – the Memorial Ground became **Memorial Park**, with all traces of its stand and tracks being cleared by the 1970s.

A modern gateway on **Springfield Road** (left) marks the site of the original main entrance, next to which are two robust pavilions by Saville Jones architects, opened in 2009 to serve new pitches funded by the Football Foundation. North of this are pitches and the clubhouse of two rugby clubs, East London and the King's Cross Steelers.

》 Otherwise, for the best part of 40 years other bank and business house teams rented pitches in parks or at existing private clubs.

The next great leap forward took place in 1899, when for the first time the directors of four London banks decided to invest directly in sports grounds for their staff. London & Westminster purchased ten acres for a ground on Stanford Road, Norbury, while three banks combined to buy a similar expanse in Lower Sydenham (see page 132).

The Bank of England was more hesitant. As reported in the history of the Bank's sports club (see Links), in the early 1900s the Court of Directors at Threadneedle Street regarded a staff sports club as 'not only a thing incompatible with a Business House, but also a positive menace to its well-being'. Such a club would divert a man's interest from his paid work, and in any case, it was surely the case that 'men would not wish to meet in the evening those with whom he had worked during the day.'

Once again it was pressure from below, led by one brave individual in the Private Drawing Office, that forced a change of heart. The result was the purchase, for nearly £18,000, of 18.5 acres at Priory Lane, Roehampton, where 'The House', as the sports club became known, opened in 1908 and where it remains to this day.

The Bank of England story is instructive in other respects.

For example, whereas in the majority of sectors membership of company sports clubs was open to staff at all levels, in the world of finance, while clerical and senior staff at the Bank of England gathered at Roehampton, non-clerical workers at the bank's printing press formed their own club in 1919. Originally based at Wembley, the Britannia club moved in 1930 to Walthamstow, and in the 1950s to Loughton, Essex, until finally it closed in 2005. The ground is now run by The Football Academy.

Meanwhile, in 1921, messengers at the Bank of England hooked up with non-clerical staff from three other banks to create what became known as the 'Forbanks Club' (sic) in Beckenham. As it happened in 1925 they were joined by their counterparts from Lloyds, but the name Forbanks was kept until the club was finally wound up in 1988.

Returning to the story of 'The House', it is related how, in 1907, after a ballot of Bank of England clerical staff, the site in Roehampton was preferred to one in Chingford, even though the former required a 50 minute journey via Waterloo and Barnes, followed by a 15 minute walk.

In other words, after completing their Saturday morning duties bank workers were prepared for the extra expense and time taken to reach Roehampton, and for a potentially long journey home afterwards. (In fact once Roehampton opened in 1908 the bank laid on 'conveyances' to ferry staff from Barnes to the ground. But only if they arrived on either the 1.45 or 2.27 trains, and even then at a cost of 3d per person.)

In opting for this seemingly rural, out of the way location for their new club the Bank of England staff were not alone.

Most of the banks and business house sports clubs were sited in what were then outer parts of south west or south east London. Was this because the majority of bank workers also lived in south London, where accommodation was more plentiful and affordable? Or was it simply that land there was cheaper?

Possibly both. Of the major banks, only Barclays laid out a ground north of the river, at Ealing in 1921. Yet this was to supplement their existing ground at Norbury, bought originally in 1911.

Of course being based in the City, banks and business houses had no choice but to venture out into the suburbs. In other sectors, however, companies were able to lay on grounds much closer to their premises, and in some instances on their actual doorstep.

Thus in 1900 the Great Western Railway laid out their first sports ground on land they already owned (for the care of the company's horses), alongside Castle Bar Park station in West Ealing. (Today the ground is owned by Trailfinders Sports Club.) Similarly, the Great Eastern Railway opened their ground on railway land at Stratford in 1921. Named Thornton Field after the company's American manager, the site was eventually redeveloped as sidings during the 1940s, and more recently absorbed within the Queen Elizabeth Olympic Park.

On Duke's Meadows, the Chiswick Polish Company bought sufficient land for their new factory in 1923 to lay out a sports ground immediately next door. The biscuit makers McVitie & Price did the same at their factory in Waxlow Road, Harlesden, but then in the late 20th century used this land for factory expansion.

In the brewing industry, Watneys opened their sports club in 1919 next to their Mortlake Brewery, on Williams Lane. Ind Coope had extensive sports grounds next to their brewery in Romford (now a Sainsbury's hypermarket), while the Guinness sports ground, overlooked by the company's brewery in Park Royal, was deemed good enough to host the preliminary rounds of the 1948 Olympic hockey tournament. The site is now the offices of Diageo.

In the retail sector, Debenhams bought a ground at Eastcote in 1914 (below right). Selfridges followed suit in 1925, creating a pavilion at Woodcock Hill, Kenton (now a community centre called Kenton Hall) and sharing their ground (now the Tenterden Sports Ground) with several other clubs, including that of the booksellers and stationers WH Smith.

Close by, off Preston Road, the shoe retailers Lilley & Skinner owned a ground, while in 1927 the Oxford Street department store Bourne & Hollingsworth created a full size swimming pool in the basement of their female staff quarters in Warwickshire House, Gower Street.

In the manufacturing sector, during the 1920s the match makers Bryant & May occupied the football ground at Brisbane Road that would later become the home of Leyton Orient (page 252). The company also ran a bowls club in Bow, and in 1924 established a country club for staff on West Grove, Woodford Bridge (sold in 1958 and now Ray Park).

This 1920s trend continued throughout the next decade, so that, as noted earlier, by the time the 1939 Bacon map appeared, more than a quarter of all London sports clubs were company related. In fact the truer proportion may be nearer to 30 per cent, as a cross check with Post Office directories suggests at least ten other company clubs were missed off the Bacon map. »

▲ Overlooked by the two surviving gasholders of the Bell Green gasworks, the **Livesey Memorial Hall** on **Perry Hill SE6,** is dedicated to the memory of **Sir George Livesey** (1834–1908), one of south London's most influential engineers and industrialists.

Designed by a fellow gas engineer, SY Shoubridge, and financed by the South Suburban Gas Company, of which Livesey had been chairman, the building was opened in 1911 as a bespoke working men's club, with a billiard room, reading room, concert hall and bowling green. Listed Grade II, it also has a splendid listed war memorial by Sydney March.

Most eye catching of all, decorated with green floral stems and framed by Burmantoft terracotta, is the faience panel over its entrance, a reminder that amid the smoke and stench of a gasworks – one that continued to operate until 1969 – urban man's affinity with nature burned bright.

Company-built social clubs of this ilk, once common, are becoming ever rarer, and for the current, independent management who continue to run it for the benefit of local working people, the challenge of making an historic building respond to modern tastes is not easy, as the now overgrown bowling green poignantly attests.

And yet this building's roots run deep. To some historians Livesey was an enlightened moderniser who had no formal education, started work at 14, and who in later life pioneered profit-sharing schemes and worker representation. He also brought affordable gas supplies to millions of poorer households.

To others Livesey was a ruthless capitalist who broke a union-led strike in 1889 and acted philanthropically thereafter only to salve his Christian conscience. In 1890 he endowed Camberwell's first library, at 682 Old Kent Road. His largesse also helped fund the creation of Telegraph Hill Park.

As of 2013, the library, which from 1974–2008 served as the Livesey Museum for Children, was awaiting new tenants. His statue, last seen outside the library, was in storage, while other Livesey-related landmarks, such as the East Greenwich Gasworks (now the site of The O2 Arena, which is said to be haunted by Livesey's ghost), have all but disappeared.

All the more reason therefore to cherish this gem of a working men's club, as a lasting memorial to an important, if divisive historical figure, and a reminder of how London's industrial wealth fed also into its social and recreational health.

On Field End Road, Eastcote, this is the Cavendish Pavilion, built in 1914 for staff at Debenhams department stores, which by the mid 1920s included Marshall & Snelgrove on Oxford Street and Harvey Nichols in Knightsbridge. The adjoining Cavendish sports ground was taken over by Ruislip and Northwood Council in 1948, while the pavilion is now a privately run wedding venue.

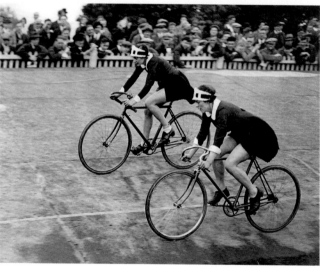

▲ In addition to the weekly round of company sport, one highlight of the year for many employees, and customers, was the annual sports day. Above, to the obvious approval of the mainly male spectators, two 'nippies' (as waitresses from the **J Lyons** chain of Corner Houses were known) take to the track at **Herne Hill** during the company's annual sports day in June 1930, kitted out in their familiar cuffs, collars and hats. At the same venue in September 1931, the Bushel Basket race (*top*) formed a popular part of the annual sports day of the **Borough Market and South London Fruiterers' Sports Association**.

Such gatherings not only helped to boost workers' morale. Having celebrities on hand to give out the prizes, and staging novelty races for charity also helped to yield favourable press coverage.

» Of the 495 company clubs identified on the Bacon map, the largest number (100) were attached to general manufacturing concerns, such as electronics, paper, packaging and furniture.

The second largest category of clubs (88) represented government departments, local authorities and public services, such as the police and fire brigade.

A further 60 represented banks and business houses. Power companies comprised a further 35 clubs, followed by 34 from the transport sector, including the recently formed London Passenger Transport Board, which alone ran clubs in 17 separate locations.

Also well represented were food and drink manufacturers (31 clubs), plus 29 associated with printing, newspapers and photographic products.

Yet 1939 was by no means the high point. Evidence suggests that company sport in London continued to develop and expand after the Second World War.

Undoubtedly one factor in this was the steady reduction in working hours, so that more teams were now able to play fixtures, for example on Wednesday afternoons as well as on Saturdays, and increasingly on Sundays too.

The fact that female employees were gaining new freedoms in the workplace was also reflected in membership numbers, and in the expansion of company-based netball leagues.

But most of all, in a period when the British people were being told by Prime Minister Harold Macmillan that they had 'never had it so good', company sport thrived because business generally was in rude health, and employment levels at their highest since before the First World War.

At the Kodak factory in Harrow, for example, from amongst a record total of over 6,000 workers during the 1950s, 25 cricket teams were active in the company's inter-departmental league.

In football, by 1957 29 teams were competing in the three divisions of the London Banks League, while the London Insurance Offices League had grown to sustain five divisions (up from three in 1948).

In most sectors the grounds acquired before the war proved sufficient to cope with this increased demand. The Ford Motor Company was thus rare in laying out two completely new grounds during the 1950s, at Rush Green, Romford, and Newbury Park, to replace an earlier ground next to its Dagenham plant.

But as post war restrictions on building materials eased, the late 1950s did see the beginnings of a spurt in pavilion construction.

Glaxo, the baby food and pharmaceutical company, built a well appointed sports and social club on Oldfield Lane, Greenford (sold to Ealing Borough Council in 2009). New pavilions were built in 1958 by North Thames Gas at Acton (now the headquarters of Wasps RFC), in 1963 by Hoover on Sudbury Avenue, Wembley (now housing on Conifer Way), and in 1965 by Associated Portland Cement (Blue Circle) on Crown Lane, Bromley (now Trinity Village residential development).

Most ambitious of all were Barclays, who in 1969 spent nearly £300,000 on a substantial new pavilion at their ground on Hanger Lane, Ealing. Designed by Peter Ednie & Partners to cater for the bank's 22 sports sections (which at the time fielded twelve football teams, six hockey teams and five rugby teams), the pavilion featured courts for the newest sporting craze, squash, and a small open air swimming pool.

Over at Roehampton the Bank of England went further by building an indoor pool. By the late 1970s the Bank's staff reached an all time high of nearly 8,000.

Such was the calibre of facilities at Roehampton that England's footballers trained there during the 1966 World Cup. True it was ideally secluded. But it was also said that no professional club in London could match it for quality.

It was the same at the Watneys ground, Mortlake, where at the opening of the new pavilion in 1960 it was reported that six full time groundsmen were employed, one of whom had formerly been the head groundsman at the Oval.

Also on the staff was a full time club secretary, the former Surrey cricketer Bob Gregory, an assistant, and a full time steward and stewardess. Yet membership of the club, which reached an all time high of 2,300 during that period, still cost Watneys' staff only threepence per week.

A further measure of how cosseted club life could be is a report from the Watneys staff magazine that in one particular year 46 tickets had been received for the FA Cup Final. Yet mild annoyance was expressed because the club had applied for 86.

Truly this was a golden era, and of course it could not be sustained.

In 1967, the sale to Ealing Borough Council of the J Lyons ground in Sudbury – a ground that, along with the Guinness ground at Park Royal, had staged hockey matches in the 1948 Olympics – hinted at what was to follow. (On the site today is a David Lloyd club and a housing estate, whose streets are named after such Olympians as Lillian Board and Mary Peters.) The sale had not simply been a reflection of the declining fortunes of J Lyons as a company. The inescapable truth was that social habits were changing just as key industries were themselves going through radical change.

Hardest hit of all were those clubs in the banking and business house sectors. Company mergers, the relocation of offices to outside London, automation and computerisation from the 1980s onwards, resulted in the laying off or early retirement of thousands of male clerical staff who had formed the backbone of their sports clubs since the late 19th century.

If these individuals were replaced, more often than not it was by younger female staff, most of whom were not interested in sport or who simply did not have the time at weekends.

There was a certain historical irony in this turnaround. For as bank staff of the post war generation admit, it was largely the quality of sporting provision that had kept them in banking in the first place. For the most part their work had been routine and dull, if safe, while for the majority there were no realistic chances of promotion. Instead, they lived for the weekend and for the joys of the sports club, its camaraderie, its spirit of competition, and indeed its undoubted perks.

Today only two banks still own and run their own sports grounds in London, the HSBC (*see page 135*) and the Bank of England. But even the latter's sports club has had to change its constitution in order to admit family, friends and local residents as members.

As club membership has fallen, so too has the scale of competition. In football, the London Banks FA (formed 1900), and the London Insurance FA (1908), were obliged to merge as the London Finance FA in 1994, running six divisions. By 2005 numbers had continued to fall so drastically that it was decided to close the league and disperse the remaining clubs amongst the Amateur Football Combination.

In the meantime, the once ultra-modern facilities Barclays boasted at Ealing were mothballed in 2000, as were the Watney bowling greens at Mortlake, where many an international match had been staged since the 1960s.

It was a similar story at the BBC's ground at Motspur Park. Opened in 1929 and sold in 2005, it too awaits a future use – a use that is limited by its designation as Metropolitan Open Land.

On which note we return to our earlier point. All over London are sports grounds that were originally laid out by companies, that have either changed hands since or now lie unused; grounds that readers may well pass every day, or have played on or attended on an annual sports day.

Collectively they form a sizeable tranche of the city's overall stock of open space. How big is not known, but an estimate of ten per cent may not be far off.

For that reason, company sport deserves much greater research than has been accorded to date.

But there is another imperative. As previous *Played in Britain* studies have emphasised, much of what constitutes sporting heritage may be deemed 'intangible heritage'.

Company sport is the perfect example of this.

Firstly the experiences of those who recall its heyday should be recorded in order to complete our picture of 20th century London. For many, the company sports club was their main social hub, in some cases where they met their spouses, and where they lived out their sporting lives.

Secondly, could there be lessons from company sport as it was once organised that might help policy advisors of the present day to achieve the golden grail of greater participation?

As stated earlier, company sport has not died out entirely. It may surprise some to learn that there is an annual event called the UK Corporate Games, and that this has been staged several times in London since 1992, most recently at Brunel University in 2009.

Admittedly these games are more focused on participation and inclusion, as may be deduced from the new breed of company staff working under such titles as Health and Wellbeing managers and Leisure Benefits officers.

They may not have the resources to buy or run sports grounds or run weekly leagues. But their essential goal has barely altered.

As the Prudential said of its Ibis Sports Society, before it was wound up in 1991, here was an association that allowed 'the clerk and the principal, the actuarial trainee and the sub-manager, to meet on common ground'.

The language may seem outdated, but not the sentiment. Thus we may ask that while company sport in London has a fine heritage, could it, in one form or another, have a fine future too?

Throughout the 1950s and 1960s lunchtime crowds of office workers, mainly male, would gather in Lincoln's Inn Fields to watch their female counterparts compete in various inter-departmental and business house netball leagues. For the men the attractions were obvious, as indeed they were for press photographers based in nearby Fleet Street. But netball was more than just a photo opportunity. For young women averse to hockey, company netball offered an ideal way to maintain a sporting life beyond school or university, and to achieve recognition at county and even international level.

Once a key figure in London athletics, Charles Herbert was a civil servant at the Treasury. He first came to prominence as captain of the Civil Service Rugby Club, founder members of the Rugby Union in 1871 (just as their soccer counterparts had been founders of the Football Association eight years earlier). In 1883 Herbert was appointed secretary of the all-powerful Amateur Athletic Association, in which capacity he overcame his initial misgivings about Pierre de Coubertin's Olympic plans to become a founding member of the IOC in 1894. His experience of overseeing AAA meetings then led him to a lead role at the first modern Games at Athens in 1896. Alas his involvement ended in 1905 after he fell down the stairs of a London bus, sustaining severe head injuries. He died in 1925.

▼ Opened on February 26 1926 by King George V, and still in use today, the **Civil Service Sports Ground** forms part of one of west London's most treasured green lungs, **Duke's Meadows, Chiswick** (see map on page 46).

Cupped by the Thames as it loops between Barnes and Kew, the Meadow's low lying pastures and orchards had survived two major threats from developers, before, in 1923, Chiswick Urban District Council made the bold decision to spend £150,000 on buying up its 200 acres or more from the Duke of Devonshire.

At a time when several outer London authorities were busy buying up large tracts of farmland for future housing and amenity needs, Chiswick's aim was to preserve the bulk of Duke's Meadows for sport and recreation, while recouping as much as possible from gravel extraction and from limited industrial and housing developments.

First to arrive, in 1925, was the **Chiswick Polish Company** (makers of Cherry Blossom shoe polish), whose new landmark factory with its prominent clocktower had alongside it a ten acre sports ground laid out for the use of the company's **Masonian Athletic Club**. (The company had been co-founded by **Dan Mason**, after whom the western part of the riverside drive at Duke's Meadows has since been named.)

Since the factory's closure in the 1980s, the site has been covered by houses on Staveley Gardens, while on the Masonian sports ground stands the private **Riverside Health & Racquets Club**. However the **Masonian Bowling Club** survives as an independent entity, based at a former Council green on the eastern side of the Meadows.

Just south of the Chiswick Polish site, as noted earlier, the **Prudential** opened its **Ibis Sports Ground** on the Meadows' southern edge in 1939.

But the largest expanse of all, extending to 30 acres, was that leased to the **Civil Service**.

Since staging their inaugural athletics meeting in 1864 (see page 306), members of various Civil Service teams had played at a number of London grounds. The rugby club, for example, had been happily based at the Richmond Athletic ground since 1893. But they were persuaded to move in with all the other Civil Service teams at Duke's Meadows and in front of the King provided the curtain raiser seen below with a match against the Royal Navy.

Earlier that day the King's son, the Duke of York, cut the ribbon to open a riverside promenade and playground, and a bandstand which to the present day forms a familiar backdrop to the closing stages of the Boat Race.

Other sports provided for Civil Service staff at Duke's Meadows were football, hockey, tennis, rowing and netball, followed in later years by bowls and squash.

To appreciate how busy the ground was at its peak, the Bacon Map of 1939 lists 37 government departments fielding teams there, from the Admiralty and Air Ministry to the Unemployment Assistance Board and the Valuation Office. And Duke's Meadows was only one of eight Civil Service grounds and 20 regional associations around the country, all self-financed by subscriptions and the issue of shares in a holding company.

At Duke's Meadows, to cater for demand a new pavilion and extended changing rooms were built on the site of the original pavilion in 1969 (see page 107). But after the number of civil servants reached a post war high of nearly 750,000 nationwide in 1977, numbers fell steadily, while the proportion of female staff – who have traditionally been less well represented in team sports – rose to a third of the total by 1996.

Hence with its use declining and cuts being required, the Civil Service relinquished its lease at Duke's Meadows in 2009.

Various Civil Service and other private teams still play there, nevertheless. But since 2010 the ground has been managed by King's House Enterprises, a company set up by a Richmond school whose pupils had played at Duke's Meadows for many years.

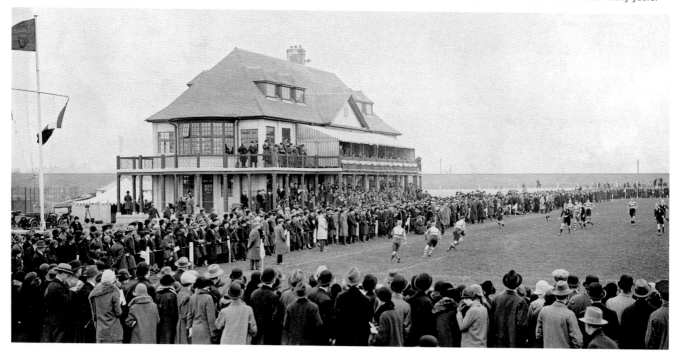

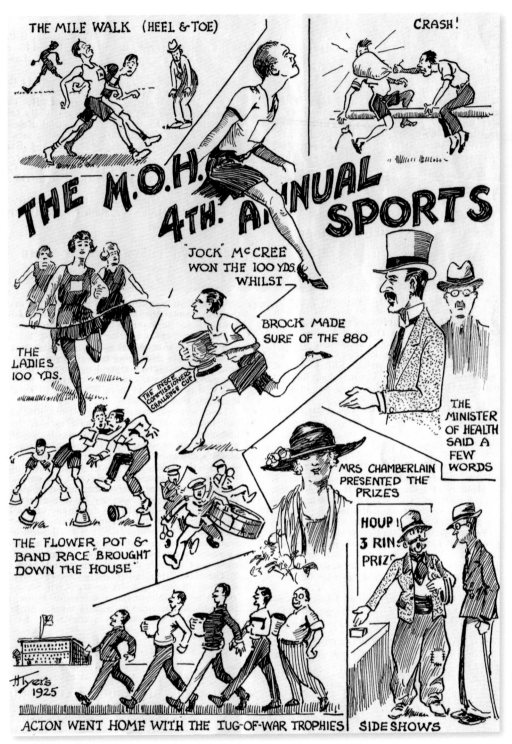

▲ Company magazines such as this one issued by the **Osram lightbulb company** in August 1954, offer a wonderful window into the sporting and recreational lives of working Londoners. Providing as they did a vital link between personnel in different departments, often based at different sites – Osram had factories in Brook Green and Wembley – they published match reports, fixtures and often, as in the *Civil Service Sports Magazine* of August 1925 (*left*), light-hearted accounts of sports days.

In these and other staff magazines such as *Ariel* (for the BBC), *The Old Lady* (Bank of England), and *The Spread Eagle* (Barclays), a tone is set which reveals much about company life. Nicknames are rife. Gentle fun is poked at players suffering mishaps (particularly whilst on tour). The support of directors is always dutifully noted, along with any laughter-inducing quip made at award ceremonies.

Team sports tended to dominate these reports. But as seen on the May 1919 front page of *Air-Co Rag*, the magazine of the **Aircraft Manufacturing Company**, based on The Hyde, Hendon, other popular activities included amateur dramatics, chess and rambling.

Not that this was ever enough. A year later Airco was bankrupt.

▶ This map shows the unusually high number of sports grounds, and of company grounds in particular, clustered in the Kent part of south east London that extends from **Catford** in the borough of Lewisham down to **Beckenham** in Bromley.

As may be seen, the area's topography is characterised by the rivers **Pool** and **Ravensbourne**, which meet just below Catford Bridge and flow north to Deptford Creek and the River Thames.

Note also how railway lines follow the paths of each river. Parallel with the Pool runs what was originally the Mid Kent Line of the **South Eastern Railway**, opened in 1857, with stations at **Catford Bridge** and **Lower Sydenham**.

Immediately west of Catford Bridge lies **Catford Station**, on the Catford Loop of what was originally the **London, Chatham and Dover Railway**, opened in 1892.

As in so many other parts of London, these lines exposed vast swathes of agricultural and private estate land to development. And yet large tracts still resisted the 'march of bricks and mortar'.

Firstly, this was because much of the land flanking the Pool River was considered flood plain.

Secondly, rail access to the City and central London, via Victoria, Blackfriars and Charing Cross, made the area attractive to a range of companies; sixteen grounds were at one time or another owned by banks or business houses, plus a further seven represented other sectors, including gas supply and shipping.

This process began in 1874 when, as noted earlier, the **Private Banks Sports Club** leased the ground at Catford Bridge (9).

Remarkably, the majority of these grounds remain in use for sport or as open spaces, although only two (19 and 20), remain in bank ownership, in both cases that of the **HSBC**.

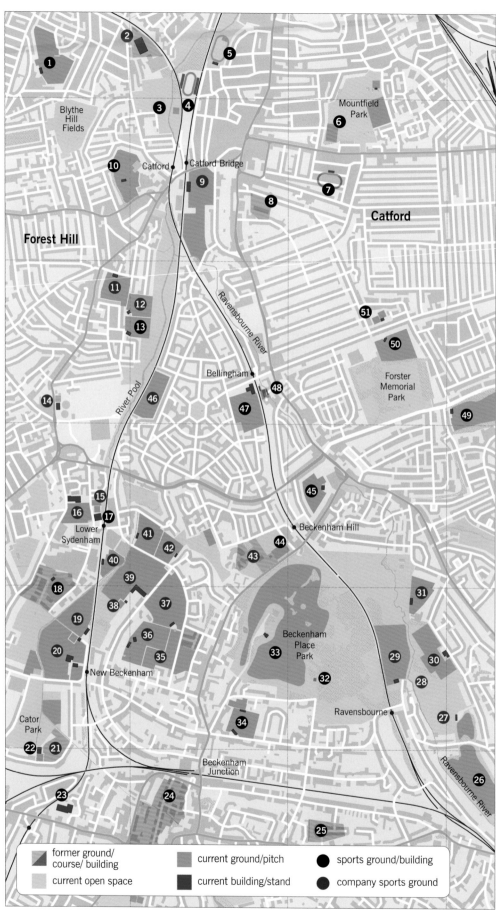

Contains Ordnance Survey data © Crown copyright and database right (2014)

Note: the dates below relate to the period in which clubs or organisations were in occupation of the ground or location, *not* to their foundation dates (although is some instances these are the same). Where dates are unknown estimates from map data appear.
Key: Bacon: marked on 1939 GW Bacon map (*see page 124*);
BC: Bowls Club; **CC:** Cricket Club; **FC:** Football Club; **GC:** Golf Club; **HC:** Hockey Club; **ILEA:** Inner London Education Authority; **LC:** Leisure Centre; **PF:** Playing Fields; **SC:** Sports Club; **SG:** Sports Ground

1. **Guy's Hospital Athletic SG** Brockley Rise (1893-)
2. former **PF** (c.1914) inc **Southern R'way** (Bacon), **Crofton School/ Crofton LC** (1974-2005), now **Prendergast Ladywell Fields College** Manwood Rd
3. **Ladywell BC** Bournville Rd (1903-)
4. site of **Catford Greyhound Stadium** (1932-2003)
5. **Ladywell Arena** athletics track (1937-)
6. site of **The Mount, Charlton Athletic** (1923-24)
7. site of **Catford Cycle and Athletic Ground** (1895-1900), now Sportsbank Rd
8. former **Catford CC** Penerley Rd (1890-1981), pavilion now **Catford Cricket & SC** and nursery, ground now **Rushey Green Primary School**
9. former **Private Banks SG**, Catford Bridge (1874-1999), **Powerleague** (1999-2012), now **Jubilee Ground, St Dunstan's College** (2012-)
10. **St Dunstan's College SG** Stanstead Rd (1888-)
11. **African Banks SG** (c.1914), **CUACO SG** (Bacon), **ILEA** (c.1950s-), now **Elm Lane PF** and **Elms Youth Club**
12. **City of London School SG** (1904-24), **Phoenix Insurance SG** (Bacon), now **Rutland Walk Sports & Social Club**
13. former **Forest Hill CC** Rubens St (1882-1980), now **Blackheath HC** (1952-) and **Catford & Cyphers CC** (1981-)
14. **Tudor Livesey Club** Perry Hill (1911-)
15. **Britannic House BC** (1910-) Westerley Crescent
16. former **Lensbury & Britannic House (BP) SG** (c.1933-94), now **The Bridge LC** (1994-), Kangley Bridge Road

17. **Lewisham Indoor BC** (1999-) Westerley Crescent
18. **Sydenham Sports Club** (1875-) Cricket Lane
19. former **Hong Kong & Shanghai Bank SG** (1913-), pavilion now nursery, ground merged with **HSBC** see 20 below
20. former **Midland Bank**, now **HSBC** SG Lennard Rd (1920-)
21. former **Cyphers CC** (1890-1985)/**Sedgwicks Insurance/ King's Hall Country Club** King's Hall Rd, now residential
22. **Cyphers Indoor BC** (1933-) King's Hall Rd
23. site of **Beckenham Baths** (b.1901), redeveloped as **The Spa at Beckenham** (1999-)
24. site of **Rectory Field**, Church Avenue, **Beckenham Town FC** (1880s)
25. site of **Albemarle Lawn Tennis Club** (c.1895-1930), now The Mead/St Christopher's School
26. **Beckenham Ladies GC** (1894-1922), **Shortlands GC** (1922-)
27. former **'AB' SG** (Bacon), now **Warren Ave Playing Fields**
28. former **Times Newspaper SG** (Bacon), now open space
29. former **Thos Cook SG** (Bacon), now **Lewisham Borough SG**
30. former **Oxo SG** (1921-95) Calmont Rd, now **Millwall FC training ground**
31. former **Spartan SG** (Bacon), Old Bromley Rd, now **Ten-Em-Bee Sports Dev Centre**, formed by **Metal Box Co** (1975-)

32. former **Foxgrove GC** clubhouse (1907-27), now **The Foxgrove Club**, course now 33 below
33. **Beckenham Place Park GC** (1927-)/**Braeside GC** (1947-)
34. **Beckenham Cricket, Tennis, Squash & Hockey Club** (1866-) Foxgrove Rd
35. former **Furness Withy SG** (post war), **Lloyds SG** (c.1960s-) Brackley Rd, now part of **Kent CCC** (1999-) see 37 below
36. former **Catford Wanderers SC** (1912-20), **General Steam Navigation Co/Gray Dawes Atlas Assurance** (Bacon), **CUACO SG** (c.1970s-), Copers Cope Rd, now **Crystal Palace FC training ground** (2001-)
37. former **Lloyds Bank** (1922-99) Worsley Bridge Rd, now **Kent County CC** (2002-)
38. former **Three Banks/National Provincial/Nat West BC**, now **RBS BC** (1899-)
39. former **Three Banks/National Provincial/NatWest/RBS SG** (1899-1999), Copers Cope Rd, now **Goals/Gambado Play Centre/Fitness First**
40. former **Yokohama Specie Bank** (c.1930-39), **Dylon SG** (post war), **Footsie SC**, Worsley Bridge Rd, currently open space
41. former **Cornhill Insurance/ De Beers/Amalgamated Press SG** (Bacon), Worsley Bridge Rd, now **Sydenham High School Girls Day School Trust SG** (2001-)

42. **South Suburban Gas SG** (Bacon), Worsley Bridge Rd, now **CEGAS SG**
43. former **Forbanks SG** (1921-88) Beckenham Hill Rd, now **Sedgehill School/Brethren Meeting House**
44. former **Old Dunstonians RFC** (1922-59) Beckenham Hill Rd, now **Sedgehill School PF**
45. **Catford Wanderers SC** (1920-) Beckenham Hill Rd
46. former **London Passenger Transport Board (Bellingham) SG** (1933-48), Firhill Rd, now **Firhill PF, Lewisham Sports Consortium** (2004-)
47. former **Merchant Taylors' School SG** (1900-32) Randlesdown Rd, **London Federation of Boys' Clubs' SG** (Bacon), now **Bellingham LC and SG** (2004-)
48. site of **Bellingham Open Air Pool** (1922-80) now Orford Rd flats
49. **Whitefoot Lane PF**
50. **Prendergast-Hilly Fields College PF** (1934-)
51. **Bellingham Bowling Club** Bellingham Road (1912-)

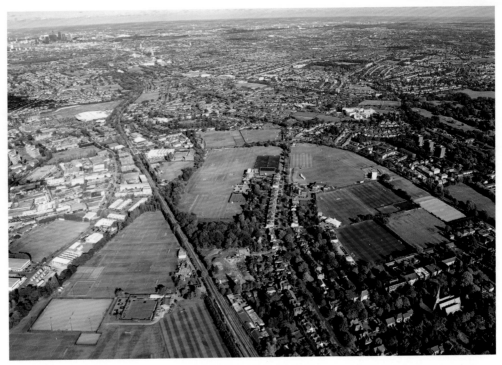

Viewed from the south, with the railway line running north from New Beckenham up to Catford Bridge, this 2011 photograph shows part of the area depicted on the map opposite. Lower left is the HSBC ground (19 and 20 on map). The free-standing white building seen centre right is the pavilion of Kent CCC (36)

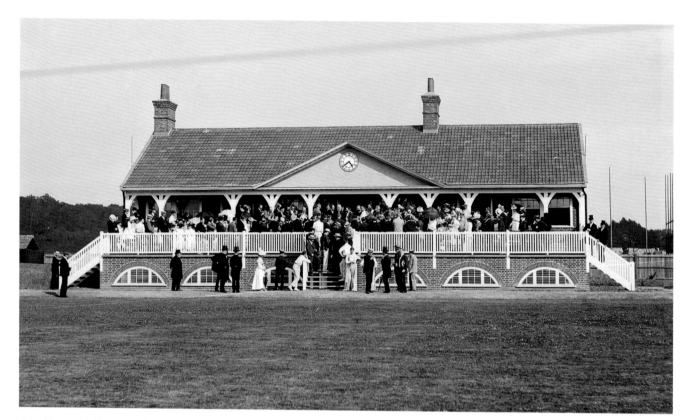

Amid a contrasting array of boaters and bonnets, top hats and tails, Lord Harlech (under the clock) declares open the **Three Banks Sports Ground**, **Lower Sydenham**, on July 8 1899. Its name derived from the fact that the London Joint Stock Bank, the National Provincial Bank of England and the Union & Smith's Bank had combined to buy the 10.5 acre farmland site for £12,000. Rather like the banks themselves, who at the time were merging and changing names with confusing regularity, the Three Banks ground absorbed the neighbouring New Beckenham Cricket Club in 1911, then a further area to the north in 1918. This resulted in a 22 acre complex under the eventual control of one bank, known as the National Provincial from 1924 until its merger with the National Westminster in 1970.

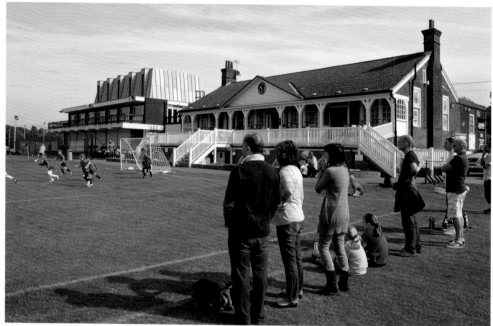

The names have changed, the players have grown younger, but the **Three Banks** pavilion on **Copers Cope Road** appears hardly to have changed, externally at least.

Since the ground was purchased in 2000 – by the former hockey Olympian and squash player Mike Corby – the pavilion has been renovated by the five-a-side football company **Goals**. The adjoining groundsman's house (out of view) also survives from 1899. To the left can be seen a pavilion with gymnasium and squash courts, built by National Provincial in 1968, now operated by **Fitness First**. To the rear, also from the late 1960s, is a sports hall, leased to the children's soft play company, **Gambado**.

Despite the change in ownership four former bank clubs remain, all now run independently: **Nat West CC** (formed as London & Westminster in 1863), **Royal Bank of Scotland RFC** (formed 1886 as the London & Westminster Bank FC), **RBS BC** (formed 1899, also originally by London & Westminster) and **NatWest FC** (formed 1969).

Note that in addition to the Private Banks and Three Banks grounds, a Forbanks ground was opened in 1922 nearby (43 on the map), for non-clerical staff at four other London banks.

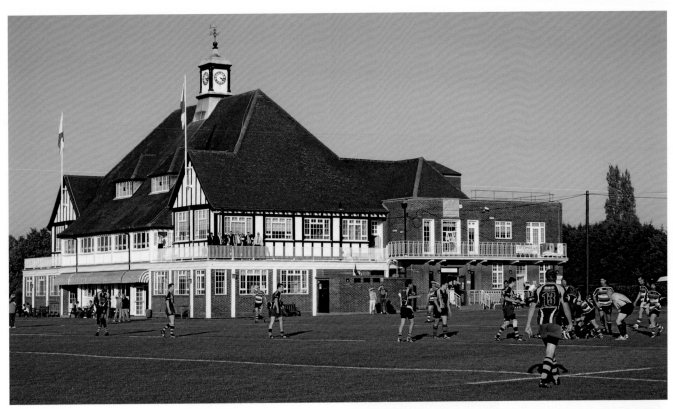

▲ 'Come on City!' sounds the cry as the **HSBC rugby XV** (in the red, white and black) get ready to ruck at the bank's ground on **Lennard Road**, Beckenham, in 2011.

Why City? Because of the three clubs that, over the years, have come together as the result of mergers and takeovers to form the current HSBC club, one was that of the London, City and Midland Bank, formed a century earlier in 1911. Why the 'City' part of its title should have persisted as a nickname, however, remains a mystery.

As for the **HSBC** ground itself, it too is the product of mergers and takeovers. Once part of the Cator estate, the southern section, served by the imposing pavilion seen here, was laid out in 1920 by the bank that was known, from 1923 onwards, as the **Midland**.

Further land purchases followed in 1922 and 1928, while much of the pavilion, one of the largest in the capital, dates from post war reconstruction carried out by architects Whinney, Son and Austen Hall, after a V2 rocket caused major damage in January 1945.

Meanwhile the northern part of the HSBC ground was owned originally by the **Hong Kong & Shanghai Bank**, whose sports club, first noted in 1887, had moved to Beckenham by 1900. One of

their players, fresh out of Dulwich College, was PG Wodehouse, briefly a staff member at the bank's headquarters in Lombard Street.

From the dates on its two gables, it would appear that the club pavilion *(right)* was opened in 1913, and extended in 1924.

When, by an extraordinary coincidence the Hong Kong & Shanghai Bank took over the Midland in 1990, it was joked that this was merely for the convenience of the two sports clubs.

Certainly since the fence came down – allowing the smaller pavilion to become a nursery – it has resulted in a formidable complex covering 29 acres and hosting not only rugby but football, cricket, hockey, bowls, tennis, squash, badminton and netball.

Few modern grounds of any ilk still host such a diverse range of sports. But then also noteworthy is that this is one of only two grounds in London still owned and operated directly by and for the staff of a bank (the Bank of England ground at Roehampton being the other).

It appears to be appreciated.

Every July some 4–5,000 HSBC workers and their families converge on Beckenham for the annual sports day.

Such fun! And what tales to tell in the office come Monday morning.

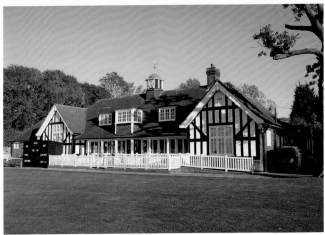

The clocktower and weathervane now seen on a block of flats built in a corner of Kent CCC's ground on Copers Cope Road, Beckenham *(left)*, formerly capped the pavilion of the site's previous owners, Lloyds Bank, while the black horse symbol itself derives from Barnett, Hoare & Co., a bank whose staff formed a Black Horse Cricket Club as early as 1861, before being absorbed by Lloyds in 1884.

▷ It was not until the 1930s that most architects finally cast off the shackles of Tudorbethan orthodoxy that had characterised so much of Victorian and Edwardian pavilion architecture. But when they did it was rarely with the aplomb shown by the **Prudential Assurance's** in-house architect, FSM Green, designer of his company's **Ibis Sports Society clubhouse** in **Duke's Meadows, Chiswick**.

Opened in June 1939 a short distance from the Civil Service sports ground, the understated Art Deco brick and concrete clubhouse (clearly influenced by the Dutch architect Willem Dudok) featured a central hall leading onto a verandah, above which was a balcony (ideal for presentations) and, interspersed with flagpoles, four moulded panels bearing the words *Ibis Bene Impiger Studiis* (roughly meaning Ibis, health, energy and zeal).

Stair towers on either side with narrow slotted steel framed windows were capped on one side by a clock and on the other by a cricket scoreboard.

Since the ground was sold by the Prudential in 1991 the clubhouse has become the hub of the **Dukes Meadows Golf and Tennis Club**, and though considerably modernised retains many original features.

In 2007 it also welcomed back the **Ibis Football Club**, formed by Prudential staff in 1913 and now run as an independent organisation. Also outliving the original company club is the Ibis Rifle Club, based in Bisley, while nearby in Chiswick, Ibis Lane recalls the Ibis Rowing Club.

Another cluster of former company pavilions is on **Windsor Avenue, New Malden**, the finest of which is the **Pearl Assurance clubhouse** (*right*).

Opened in 1934 it has been owned by King's College London since 1999 and is used by a number of university and community clubs.

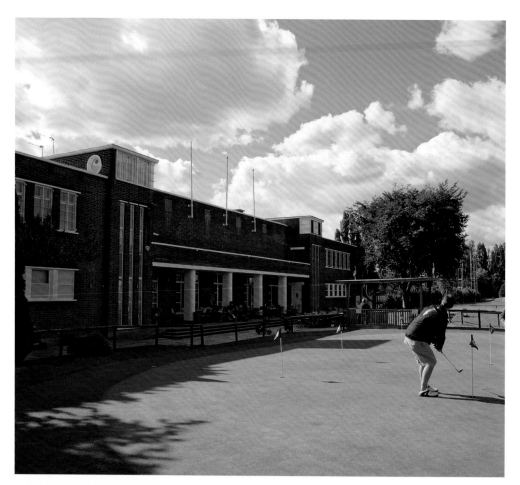

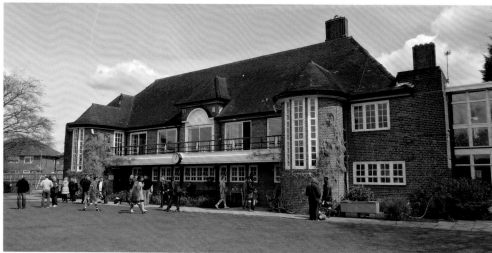

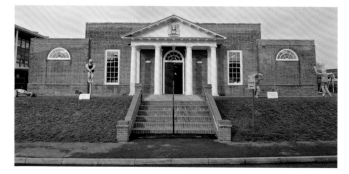

Dating from 1923 and designed by Sir Edwin Cooper in the classical style characteristic of inter war institutional buildings, the Grade II listed former pavilion of the Port of London Authority's sports ground on The Drive, Ilford (*right*), has, since its closure in 1990, found new life as the administration block of Cranbook Lane Primary School, opened on a corner of the sports ground site in 2007.

▲ In sporting terms, at least, the Metropolitan Police have London surrounded. This is **Imber Court, East Molesey**, the largest and oldest of four sports grounds run by the **Metropolitan Police Athletic Association** (the other three being at Chigwell in Essex, Hayes in Kent and Bushey in Hertfordshire).

London's police have been active on the sporting scene since the 1860s, originally at station or divisional level. At the 1908 Olympics they won medals in the tug of war, boxing and wrestling, since when members of the MPAA and the City of London Police have regularly represented Great Britain at Olympics level.

Covering 90 acres on the banks of the River Ember, Imber Court – the difference in spelling was apparently a transcription error – was purchased in 1920 for the training of police horses (including the likes of Billy, hero of the 1923 Wembley Cup Final). It then opened as a sports ground in 1929.

Although MPAA membership is restricted, Imber Court is used by a variety of clubs and organisations.

Also frequently visited by the public are its riverside rugby ground and its 3,000 capacity football ground, which hosts the Isthmian League matches of the Metropolitan Police FC. They are, of course, nicknamed The Blues.

Workers at the Ford car company, Dagenham, where production started in 1931, formed their first sports clubs in 1934. Two company grounds remain from the 1950s; at Rush Green, Romford (now used by Grays Athletic FC and West Ham United's Reserves) and on Aldborough Road South, Newbury Park, where the Sports and Social Club (*left and above left*) dates from 1960.

Chapter Thirteen

Gymnasiums and drill halls

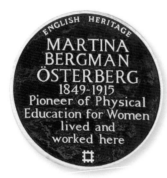

Two factors stand out in the story of British gymnastics; that the pioneers were mostly from continental Europe, and that women were actively involved in its development. Described as a 'handsome, well-built, imperious woman', Madame Österberg arrived from Sweden at the invitation of the London School Board in 1881, and in 1885 set up the Hampstead Physical Training College at 1 Broadhurst Gardens NW6, where the plaque above was placed in 1999. It was in this large terraced house that middle class girls trained to become physical education teachers under the Swedish 'Ling System', which became standard in schools in 1909. The house is also where the first trials of netball took place in Britain (men's basketball having arrived from the USA in 1892). Österberg moved the college to Dartford Heath in 1895, where netball evolved further before its codification in 1901. Another legacy was that one of Österberg's students, Mary Tait, designed the 'gym-slip', thereby allowing girls far greater freedom of movement.

Modern Londoners, it would seem, are in thrall to the gymnasium. According to the Leisure Database Company, currently one in eight of us has membership of a gym, health club or fitness centre.

How many actually attend their chosen gym is another matter, but there must be a fair few because the number of outlets in the UK has been rising steadily since 2007, to over 6,000 by 2014.

Of these, the majority are housed within leisure centres (including several inside former swimming pools, *see page 172*), or are integrated within residential or retail developments, or hotels.

That is, they do not stand alone as an identifiable building type (as for example that other creation of the Greeks, the stadium).

This has not always been the case, however, for there remain in London at least five purpose built gymnasiums dating from prior to 1914. None is still in use as a gym, but there also exists a number of other historic buildings that, although designed for different purposes, are now enjoying a second life as gyms (drill halls being the closest in design terms).

As an identifiable discipline, gymnastics arrived in London in the wake of the Napoleonic Wars, bearing a distinctly foreign accent.

Its early proponents fell into two camps; firstly, the approach fostered in Germany by Johann Guts Muths and Friedrich Jahn in the late 18th and early 19th century, which saw gymnastics as a means of military training,

with an emphasis on apparatus and developing upper body strength, and secondly, the Swedish approach, propounded by Pehr Ling, based on movement, climbing, vaulting and so on.

London's first experience of the German school came courtesy of a Swiss instructor, Peter Clias, who set up a gymnasium at 26 St James's Street in 1823. Pamphlets extolled its benefits for both the mind and the body. It was around this time that the expression *mens sana in corpore sano* started to gain in currency.

Captain Clias was followed by Dr Karl Voelker – a gymnasiarch had to have a title – who created at least three outdoor gymnasiums based on Jahn's prototype in Berlin. The first was opposite St Marylebone Church, handy for the new residents of Regent's Park, the second in Finsbury Square and the third, as seen on the inside front cover, amid the fields of Pentonville, in 1826.

Within a year Voelker had signed up 900 members and was drawing admiring crowds to displays. At Finsbury Square he advertised 'Special Classes for Ladies, Schools Welcome'.

Gymnastics attracted interest from on high, too. In 1848 what might be considered the first government funded recreational facility in London opened at the foot of Primrose Hill. Promoted by the Chief Commissioner of Her Majesty's Woods and Forests, this was the outdoor gymnasium depicted in the *Illustrated London News* of April 29 1848 (*below*).

Amazingly, there is still an outdoor gymnasium on the very same spot today, on Prince Albert Road. We, however, would call it a children's playground.

Most indoor gymnasiums up to the mid 19th century were, as now, created inside larger buildings, such as at Exeter Hall, on the Strand. However one stand alone indoor gymnasium has survived, built by a military college in Croydon in 1851 (*see opposite*).

Its provenance is significant, for it was in that decade that concerns over the fitness of British troops in India and the Crimea led to a wave of construction in the 1860s, spearheaded by a Scottish fencing teacher, Archibald MacLaren.

A real polymath, a friend to William Morris and Edward Burne Jones, MacLaren (c.1819-84) worked with architect William Wilkinson to design Oxford University's first gymnasium (now offices), opened in January 1859. This was just months before Uppingham became the first school to unveil its own gym.

What followed placed gymnasiums at the very heart of establishment life; at schools, universities, the Army, Navy and, by 1914, a whole range of clubs and institutions, from the social elite down to the poor of the East End.

Edwardian Londoners, especially the young, may not all have been in thrall to the gymnasium, but thanks to Archie MacLaren and his disciples, 'gym' was now very much part of the syllabus. Far from being foreign, it was now British to the core.

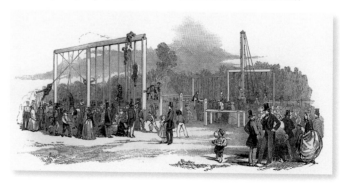

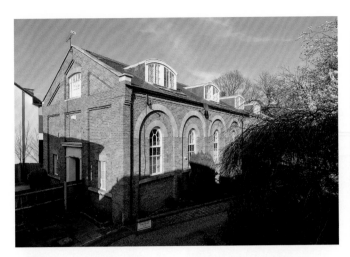

▲ Hemmed in amongst back gardens in the **Addiscombe** area of **Croydon** and accessed only from **Havelock Road**, this is **Havelock Hall**, the former gymnasium of the **Addiscombe Military Academy**. Built in 1851 at a cost of £1,562, its architect unknown, it is the earliest surviving purpose-built indoor gymnasium in Britain.

One reason why so little fuss has been made of the building – apart from it having been listed Grade II in 1987 – is that it ceased to serve as a gymnasium after only a decade's use, in 1861.

This was owing to the fact that the **East India Company**, which set up the college in 1809, had its powers taken away by the British government shortly after the Indian Rebellion of 1857.

Unwanted by the Regular Army, the college and its grounds (including a rackets and fives court and an open air swimming pool, the 'Coldstream') were sold for housing, with five of the new roads being named after leading figures in Indian affairs. One was Major General Sir Henry Havelock, who is also commemorated by a statue in Trafalgar Square.

Yet the gymnasium survived, to be used in later years as a church and as a warehouse, before its conversion into flats in the 1990s.

Another reason for its lack of acclaim is that its construction predated the wave of gymnasiums that from 1859 onwards sprang up under the influence of Archibald MacLaren.

Measuring 100′ x 36′ the Addiscombe gym had a similar footprint to MacLaren's, which varied from 80′ x 40′ (as at Preston Barracks) up to 150′ x 40′ (as at Aldershot).

But its roof was much lower, whereas the typical MacLaren gymnasium had higher walls and, in its centre, an octagonal or square roof lantern from which climbing ropes were suspended from a height of up to 65′.

Apart from the kitting out of the gymnasium – MacLaren being an advocate of the German system – his priorities were for adequate natural ventilation, open fireplaces to ensure warmth, but not heat, and the use throughout of cushioned flooring, usually a mix of dirt, rubber and sawdust (sometimes covered by canvas).

MacLaren also advocated the provision of public galleries, it being remarkable, as he wrote in his seminal work on physical education (see *Links*), how 'the presence of visitors serves to stimulate the learners to energetic action, and at the same time to assist in preserving the proper decorum...'

After working on his first two gymnasiums, for Oxford University and Radley College, MacLaren was tasked by the Army to set up a school for physical instructors at Aldershot, where he oversaw the first military gymnasium in 1862.

Over the next decade up to 60 similar gymnasiums were built for the Army and Navy, as far afield as Gibraltar and Malta, and in the London area at the barracks in St John's Wood, Woolwich, Chelsea and Hounslow.

None of these survive, but seven do outside the capital, including at Sandhurst; Brompton, Kent and Gosport (all listed). And, just as importantly, MacLaren's programme of training found its way into the educational system, leaving a legacy that extended far beyond bricks and mortar.

▲ From *The Tatler* in April 1902, 'Young Fleet Street newspaper clerks profitably employ their luncheon hours' at the **St Bride Foundation Institute** on **Bride Lane**, a Grade II listed building opened in 1893 for the benefit of print workers and still in active use today.

Note that only one woman is present, playing the piano.

As it happens this was not the Institute's gymnasium but its swimming pool, which like many pools was boarded over in winter.

As for the St Bride gymnasium itself, this achieved fame in the 1950s as the **Spur Gym**, set up by Britain's first national weightlifting coach, Al Murray, who did much

to restore the gym in general as a place that white collar workers might wish to attend.

An ex-army PT instructor from Fife, the charismatic Murray (1916-98) drew an eclectic crowd to St Bride's; weightlifters, swimmers, athletes, actors (Sir Laurence Olivier included) and cab drivers.

He also pioneered the use of weights to speed the rehabilitation of heart attack victims.

St Bride's gym continues to host classes today, but in its new guise as the Print Workshop. The pool, meanwhile, has become the **Bridewell Theatre** (see page 177), which remains a favourite bolt-hole, come the 'luncheon hour'.

Seen in 1904, the gymnasium of the Skinners' Company's School for Girls, on Northfield Road, Stamford Hill (built to the designs of W Campbell-Jones in 1893 and Grade II listed) was typical of the facilities provided at schools in middle class areas. In the centre the retractable beam post allowed horizontal bars to be raised or lowered for different exercises. Note also the 'window ladder' (for climbing), the 'buck' (for vaulting), the hanging ropes and viewing gallery. One of the girls, fifth from the left, wears one of the new gym-slips. By this time Swedish methods had become the norm in schools, not least because they cost less to equip. Since the Skinners' Academy relocated in 2010 the Stamford Hill building has been taken over by a primary school.

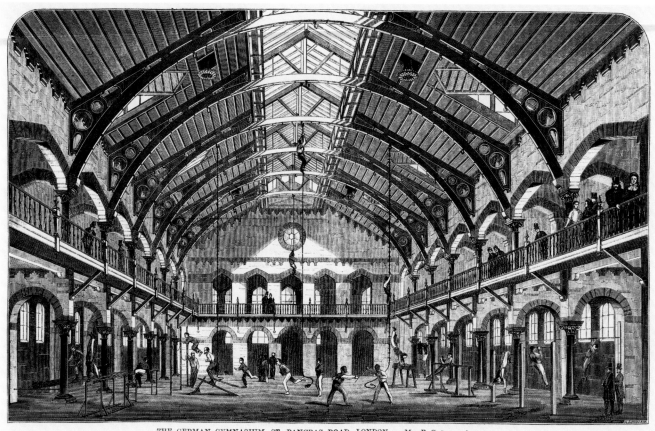

THE GERMAN GYMNASIUM, ST. PANCRAS ROAD, LONDON.——Mr. E. Grüning, Architect.

▲ From *The Builder* of May 19 1866 this is the newly completed *turnhalle*, or gymnasium of the **Deutsche Turnverein**, the **German Gymnastic Society** (GGS), at the time by far the most sophisticated facility of its kind yet seen in the capital, and still a major presence next to St Pancras Station today.

Formed in 1861, the GGS was one of several societies set up by German residents in London, of which there were around 30,000 and rising in the 1860s, more than any other single group of immigrants (the most celebrated of whom was of course Prince Albert, until his death in 1861).

Initially the GGS met in venues in the Islington and King's Cross

areas, before taking out a lease on the St Pancras site – hardly a salubrious spot but handy for members, many of whom lived in north London – in 1863.

The architect was Edward Gruning. Born in Stoke Newington and later to design the German Hospital, Dalston (now flats), Gruning had only just started in practice, and apparently offered the GGS his services for free.

He did it proud too, eclipsing MacLaren's more utilitarian Army gymnasiums of the period, albeit with a much greater budget, eventually totalling £8,500.

Measuring 120′ x 80′, with a top beam 57′ high, the main hall seen here was described as large enough

to allow for up to 300 individuals to exercise at the same time, while at least a thousand spectators could gather on the first floor galleries.

This they did in August 1866, when the GGS hosted the third day of the National Olympian Games, a landmark in the story of the modern Olympics (covered by Martin Polley in an earlier *Played in Britain* title, *see Links*).

Key to these Games and to the GGS was Ernst Ravenstein, a cartographer who was forever organising events – cycling at Crystal Palace for example – often in conjunction with other

gymnasiarchs around the country, including John Hulley in Liverpool (whose own gymnasium, opened in November 1865, but no longer extant, was arguably superior).

One feature of the German Gymnasium that still stands out is its roof structure, formed on laminated timber arches. Two train sheds at nearby King's Cross had similar roofs, neither of which survived owing to poor ventilation.

That said, given its location flanked by two major railway terminals, how pure the air was inside the gymnasium, in the age of steam, can only be imagined.

Looking towards the same end wall as above, but in 2010, the insertion of a mezzanine floor by the GNR, who took over the building in 1914, at least allows a closer appreciation of Gruning's laminated timber roof, still with the original hooks in place for ropes. Only one other roof of this type survives in London, at The Space, a former church in Westferry Road (b.1859).

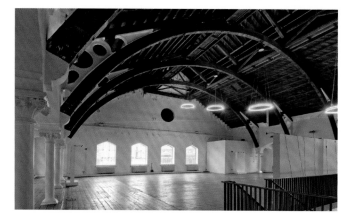

▶ Hard to believe now but the door in the centre of the terrace seen here in 1998, at **26 St Pancras Road**, was until recently the original main entrance to the **German Gymnasium**.

Indeed for those who never ventured around the rear of the building – and few did unless on railway business (or other business, for which the area was once notorious) – the only hint of the gymnasium's existence was a sign reading 'Turnhalle' above the door.

Those who did seek entrance were a varied crowd, mostly middle class office workers. Although Germans formed the majority, membership lists for the first full year, 1865-66, show that over 200 were English, 89 were Scottish, Welsh or Irish, 30 were French and the rest were divided between at least 14 other nationalities, including Swedes.

For German members this was not only a gym. It was also a community centre, with concerts, classes and a library, housed in a block between the front terrace and the main gymnasium.

Other sports staged were fencing and boxing.

The gymnasium formed also a hub for sporting governance.

Organisations whose founding meetings took place there include the Amateur Swimming Association (in 1869) and the Amateur Gymnastic Association (1888).

During the same period teams representing the GGS turned out in swimming, athletics, cycling and rugby. The rugby club eventually changed its name to North Middlesex RFC, for the same reason that the Coburg Hotel became the Connaught and the Saxe Coburgs became the Windsors.

Anti-German sentiment made the GGS increasingly vulnerable, until war broke out in 1914 (as did anti-German riots), and the organisation was disbanded.

Ironically, the building was then badly damaged by German bombs in an air raid in July 1917.

For the rest of the century the premises were used as offices, mainly by the Great Northern Railway who, in 1927, installed the mezzanine floor we see today.

By the time of the gymnasium's listing in 1976 it presented a sorry sight. But then came the new Millennium and with it, exposure of a rather more welcome nature.

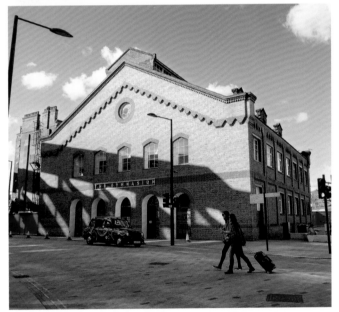

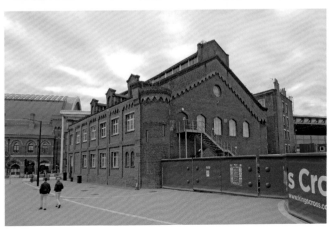

◀ From hidden gem to jewel in the crown – this is how the **German Gymnasium** appeared from almost the same spot in 2013, midway through the massive King's Cross regeneration programme led by the developers Argent (but note, the lamp post is not the same as the one above).

In order to open up the station approaches it was found necessary to demolish the terrace and front 30m of the building, none of which was of architectural interest.

The main hall is still more or less intact, however, as seen opposite, apart from the mezzanine floor.

A section of this floor might be removed before the building re-opens in its next guise, in 2015.

There are some who hoped that as part of the legacy of the 2012 Olympics that its use would in some way relate to sport.

Some even dared to suggest it become a gymnasium.

Instead it is to be a restaurant.

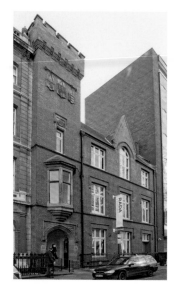

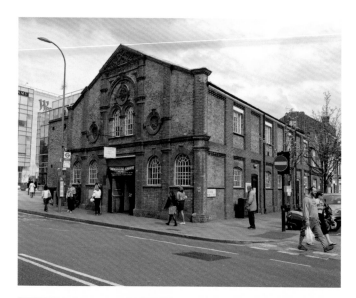

▲ Running parallel with the growth of gymnasiums in Britain came a movement which, from the 1860s onwards resulted in the provision of buildings that each contained a large hall dedicated to physical training; the equivalent of a gym, and of similar proportions, but without its equipment.

The **drill hall**, of which just over a thousand examples are extant in Britain, mainly from the period 1880-1914, emerged as a distinct building type primarily in response to fears of a French invasion.

As detailed by Mike Osborne (*see Links*), these fears resulted in the creation of a network of volunteer militias, starting with the formation of the National Rifle Association on Wimbledon Common, in 1859.

Funded by patriotic individuals and subscriptions, the drill hall was, as its name suggests, intended first and foremost as a place where civilians – upper working class and lower middle class men eventually forming the majority – could practise drill and learn to handle firearms.

Thus the key components of each building were its main drill hall, its rifle range and armoury.

Military-style drill, it should be noted, was also often the only form of physical education most working class schools laid on for their pupils before Swedish gymnastics and other sports were catered for in the early 1900s.

Had drill alone been on offer it is unlikely the volunteer movement would have thrived. Recruits had also to be lured by the attraction of a uniform and a rank, and by the prospect of regimental honours in football, rugby and cricket. In the 1860s the grounds of the South Middlesex Rifle Volunteers in Brompton formed an important venue for athletics (*page 306*).

Many a drill hall had a billiard room too, for example that of the **Bloomsbury Rifles** (*above left*), a regiment formed in 1859 by Thomas Hughes, author of *Tom Brown's School Days*. Located on **Chenies Street**, and completed in 1883, its architect, Samuel Knight, was a captain in the regiment.

Today the Grade II listed building serves as a theatre, run by the Royal Academy of Dramatic Art.

Similarly on nearby Dukes Road, the drill hall of the 20th Middlesex Artists' Rifle Volunteers, dating from 1888 and also now a theatre (The Place), was designed by Robert Edis, an architect who interestingly combined his expertise in the decorative arts with being the regiment's commanding officer.

In both cases, the buildings' layouts resemble those of public baths; that is with a front block (housing offices, a staff flat and mess rooms), behind which the actual drill hall, hardly more than a large, top-lit shed, was secreted.

This layout can also be found at the drill hall of the **2nd City of London Rifle Volunteers**, built in 1887 and designed by Alfred J Hopkins. There, a gateway at **57a Farringdon Road** (*below*) leads to the hall at the rear, now the offices of a design company.

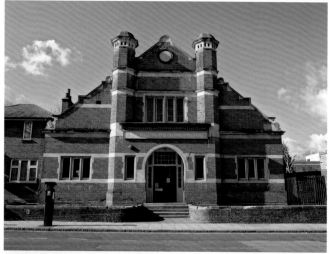

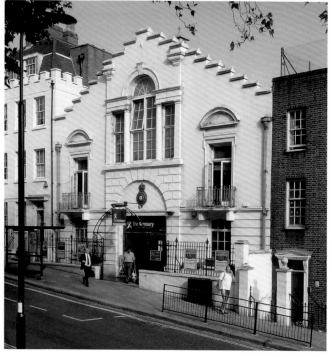

◄ The three drill halls shown opposite adhere to a simple plan, whereby the building consists solely of the hall structure, its end elevation facing the street, with ancillary rooms inserted at both the front and rear.

Each was built around the period of the second Boer War (1899-1902), a conflict in which volunteer units were, for the first time, involved in front line action. The days of civilians playing at soldiers had come to an end.

This more serious purpose was repeated when war broke out again in 1914. For many a Londoner, the drill halls seen here marked their first steps on the long march to the trenches.

In that sense drill halls may appear to have only a tangential connection with sport. But in peace time drill halls were equally seen as gentlemen's clubs, and even as forerunners of today's leisure centres, in that as well as providing a space for drill and shooting practice, they also offered physical training and a place where local groups such as the Boys' Brigade and Scouts would meet for events and celebrations.

Their saving grace has therefore, in many cases, been their utility rather than their architectural quality, and most of all the flexibility of their main halls.

On **Bulwer Street**, next to the Westfield shopping centre (*opposite top*), the former drill hall of the **1st City of London Volunteer Artillery** (opened in 1898 and designed by architect William Shearburn) is now known as the **Shepherd's Bush Village Hall**.

Saved from developers by the Wigoder Family Foundation in 2012, its main tenant is the West London School of Dance.

Looking much like a swimming bath, the **Enfield Drill Hall** on **Old Park Avenue** (*opposite centre*), was built in 1901, funded mainly by Colonel Sir Henry Bowles of Forty Hall, for the **Enfield Town Company** of the **First Volunteer Battalion** of the **Middlesex Regiment**.

Nowadays the hall is leased by the **Drill Hall Sports Club** for badminton, archery and by a ukelele band, while the basement shooting range hosts the **27th/30th Middlesex (1944) Rifle Club**.

One of several rifle clubs formed by members of the Home Guard during the Second World War, the

club is one of the few still to use a range located in a former drill hall (appropriately enough given the hall's proximity to the former Royal Small Arms Factory, home of the Lee Enfield rifle).

Meanwhile **The Armoury** on **Pond Street, Hampstead** (*opposite bottom*), with its distinctive, crow stepped gable, was opened in 1905 by the Prince of Wales for the **First Cadet Battalion** of the **Royal Fusiliers (City of London Regiment)**, whose Honorary Colonel and chief benefactor was Sir Henry Harben, chairman of the Prudential (but also remembered for campaigning to add both Parliament Hill Fields and the Golders Hill estate to Hampstead Heath).

Since 1992 The Armoury has been run by the **Jubilee Hall Trust** as a public gym, a use which is less common for former drill halls than might be expected. The Trust has also converted a former market hall in Covent Garden into a gym.

Other pre-1914 examples are the drill hall of the Volunteer Rifle Corps on East Street, Bromley (b.1872), now a pub; the drill hall of the Electrical Engineers on Regency Street SW1, now flats; the drill hall of the 6th Battalion East Surrey Regiment on Park Lane, Richmond, now a Royal Mail sorting office, and the former drill hall of the 5th Middlesex Volunteers on Whitefriars Avenue, Wealdstone, now a Sri Lankan Community Centre.

▼ This is the main hall of **Napier House**, on **Baring Road**, **Grove Park**, a typical example of the 20 or so **Territorial Army**, or **TA Centres** built in Greater London during the late 1930s, as once again the nation geared itself for war.

Mostly built in a stripped Moderne style, in plain brick, these centres were on a much larger scale than pre-1914 drill halls. This was because, from 1920 onwards the TA took on a more active role in manning field artillery and armoured units, and was given further responsibility for anti-aircraft defences.

Also, the War Office started to provide clear specifications for architects to follow, hence the similarities between the centres.

J Hatchard-Smith & Son, for example, designed those at Ewell, Clapham and Kingston (all extant), and East Ham.

Napier House was opened in January 1939 by Major Sir Frank Henry Bowater, Lord Mayor of London and a First World War veteran. Today the centre is home to two units, the **265 (Home Counties) Battery** and the **106 Regiment** of the **Royal Artillery.**

It also houses artefacts relating to the football team of one of the regiments' predecessors, the **1st Surrey Rifles**. Founded in 1859 and from 1864 based at a drill hall on Flodden Road, Camberwell, the club competed

in the first FA Cup in 1872. One of its number, William Maynard, was at 19 years old the youngest member of the first ever England team, facing Scotland in 1872.

Apart from its ongoing military role, Napier House, in common with all 46 of the TA properties across London, is available to hire for meetings, conferences and the like, through the auspices of the Reserve Forces' and Cadets' Association.

Ball games are in general not tolerated, because of potential collateral damage. But badminton is, and most of the halls are in regular use for physical training.

In that sense, the TA may be described as one of London's largest operators of sports halls.

Among the grandest of these is that of the London Scottish Regiment on Horseferry Road.

Rebuilt in 1988, it features a double decker gallery surmounted by an iron and glass lantern roof, originally designed by John McVicar Anderson (a member of the regiment) for an earlier drill hall built in Buckingham Gate in 1886.

On display in the gallery are sporting artefacts associated with London Scottish, best known today in both golf and rugby circles.

Meanwhile two 1930s drill halls no longer owned by the Territorials are at 701-703 Tottenham High Road, now a sports centre, and on Prospect Road, Woodford Green, now an evangelical church.

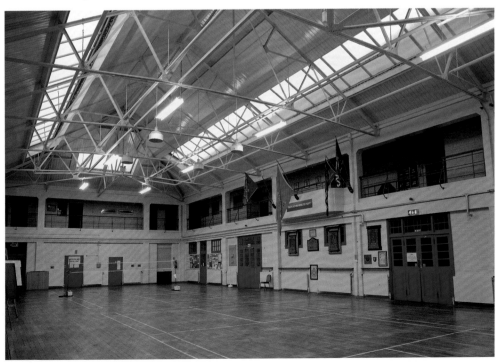

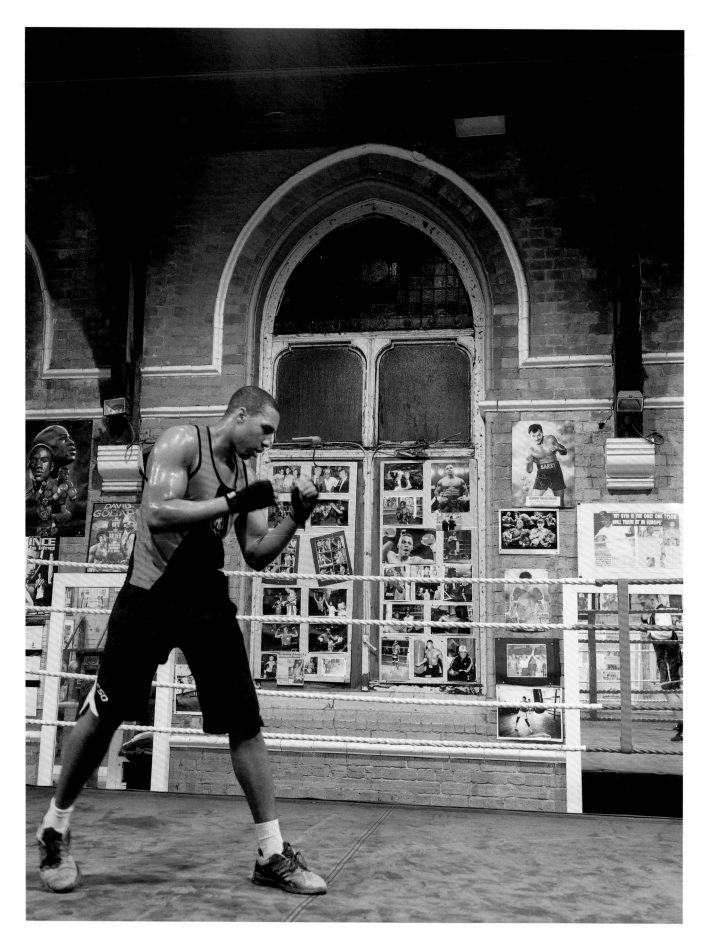

◄ Unless you were at school or in the armed forces, for the majority of 20th century Londoners, at least until the aerobics craze arrived from across the Atlantic in the 1970s, the 'gymnasium' was most strongly associated with **boxing**.

Boxing gyms were traditionally set up in the back rooms or basements of pubs. However in recent years at least three London clubs have found homes in rather more prominent surrounds.

Originally set up in 1974 by the Ghanaian Isola Akay, the **All Star Boxing Gym** is based at the former **Queen's Park Meeting Hall** on **Harrow Road**.

Designed by Rowland Plumbe for the Artisans, Labourers and General Dwellings Company, and opened in 1884, the Grade II listed hall was the social centre of the Queen's Park estate, birthplace of Queen's Park Rangers FC (*see page 244*).

It may be imagined that such clubs serve mainly local needs. But boxers travel for miles for the right club. Seen opposite, Ryan Charles, who also represents St Lucia, is from Edmonton. Similarly, the 400 or so members of the **Repton Boxing Club**, aged from 8-34, come from all over London and the south to work out, some of them three times a week, at their gym on **Cheshire Street**, **Bethnal Green** (*top right*).

Opened in 1899, the Grade II listed building was originally a public wash house, and has housed the club since 1978. Adjoining it, the slipper bath section is now flats.

Repton are actually older than the building, having been formed in 1884 as a mission for under privileged boys by Repton School in Derbyshire.

Based previously in the Victoria Park area, they are one of Britain's leading clubs, including among their alumni Maurice Hope, Darren Barker and Audley Harrison, as well as the actor Ray Winstone and two other once noted locals, the Kray twins. Frank Bruno is a patron.

Photos of these and other visitors line the walls, along with posters urging members not to spit, and to remember, 'No cuts, no glory!'

Also based in a Grade II listed former public baths, on **Wells Way**, **Camberwell** (*far right*), is the **Lynn Boxing Club**, founded in 1892 – a decade before their present building opened – and based from 1952-81 at Manor Place Baths.

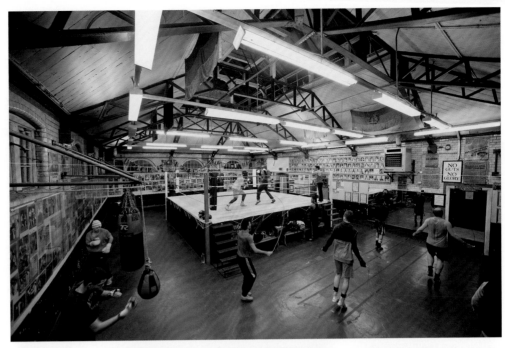

◄ Nowadays the use of sport and recreation to stimulate urban regeneration is widely accepted. So too is the adaptive re-use of historic buildings. An early example of both trends is the **John Orwell Sports Centre**, on **Tench Street, Wapping**.

A former dockyard workshop, the gymnasium was originally converted by Shepheard Epstein Hunter in 1980, and won a string of awards for its galvanising effect on what was then a community in decline.

Also making a comeback is the outdoor gymnasium. Seen on the left in **Lismore Circus**, **Gospel Oak**, is one of eight created for Camden Council by the Great Outdoor Gym Company in 2009.

Chapter Fourteen

Billiard halls

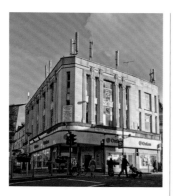

Seeing the reluctance of British men to shop for clothes, Montague Burton (1885-1952), a Jewish immigrant from Lithuania, set up a chain of outlets designed to make them feel more at ease. Corner sites with plenty of glazing were preferred so that passers-by could see shoppers inside. Another was to rent out upper floors as billiard halls, thereby offering a place for customers to wait whilst their 30 shilling suits were adjusted. Some 600 Burton's were built, most between the wars to the design of company architect, N Martin. But only three in London still have billiard tables, the former branch on Walthamstow High Street (*above*), built in 1931 and home to the Embassy Snooker Club, plus former branches in Barnet and Enfield. Below, the sign survives at the former Burton's on London Road, Morden, built in 1936.

Writing in 1801, Joseph Strutt believed that the rules of billiards were 'so generally known' as to need no further description.

By then, billiards had been around for at least 300 years.

Shakespeare had his Cleopatra bid her lady in waiting, 'Let us to billiards', while in 1674 Charles Cotton wrote that 'few towns of note' did not have 'a publick Billiard-Table'.

But while throughout the Georgian period billiard tables would become common in taverns and gentlemen's clubs, and as an accompaniment to real tennis courts – the court in James Street being but one example (*see page 275*) – it was only in the late Victorian period that billiard halls emerged as a specific building type.

The man generally accredited with bringing billiards into the modern era was John Thurston.

Thurston set up as a furniture maker in 1799, before deciding to specialise in the making of billiard tables in *c.*1814.

As Arthur Taylor has written in *Played at the Pub* (*see Links*), it was at his premises on Catherine Street, off the Strand, that Thurston built the first slate-bed tables in 1827 (which made the balls run more smoothly), and produced the first rubber cushions, in 1835. Because these were prone to cracking in the cold, in 1845 he used recently invented vulcanised rubber instead.

Thurston kept meticulous records, so that we know he supplied numerous London pubs; for example The Cock and Magpie, Drury Lane in 1818, the Angel,

Islington in 1821 and the Bull Inn, Whitechapel in 1829.

But his most influential customer was Queen Victoria.

Having played billiards as a princess, soon after her accession she took delivery of a Thurston table at Windsor, followed by a second at Buckingham Palace.

John Thurston died in 1850, but his company gained a further seal of honour when in 1892 a Thurston table was chosen by the Billiards Association (itself formed in 1885) as the standard for all competitions. This standard was for a table of 12' x 6', dimensions that remain in force to this day.

Other prominent London suppliers were Burroughes & Watts (whose swish showrooms were in Soho Square), and FG Peradon, the leading maker of cues, based in Willesden Green.

Theirs was a cut throat world in which top professionals were signed up to endorse products, while sales reps toured the country, trying to outdo their rivals. Pubs, clubs, hotels, even hospitals bought tables. Battersea Borough Council did too, installing them in their baths at Latchmere Road and Plough Road during the winter.

This boom peaked between 1890 and 1914; a period that, as will be shown, was characterised by the emergence of purpose-built billiard halls. Most of these halls offered 15-20 tables, although one of Thurston's competitors, JW Jelks of Holloway Road, opened a 30 table hall on Eden Grove in 1922, which is thought to have been the largest.

By 1937, in inner London alone, 132 billiard halls were listed in the Post Office Directory.

However, although still referred to by name as billiard halls, it was also in the 1930s that a cuckoo appeared in the nest.

Invented by bored British Army officers in India in 1875, 'snooker' – that being the slang for rookies at the Royal Military Academy in Woolwich – was originally seen as a novelty, put on to entertain audiences during intervals in billiard matches. But now it was snooker that the public wanted to watch, and, more importantly, wanted to play. Thus the billiard hall became the snooker hall.

Not that hall operators were complaining.

Since then snooker has experienced a further boost from the BBC's decision to showcase colour television in the 1970s with the programme *Pot Black*.

Not enough, it is true, to stem widespread closures of snooker halls, only 30 or so of which now operate in London. Even then, many depend not on snooker but on pool, a game played on smaller tables and imported from Australia, initially, in the 1970s.

But if the billiard hall's heyday has passed, the heritage of billiards and snooker is at least safe, courtesy, fittingly, of the company that took over Thurston.

Together with various historians, this company now maintains the excellent Snooker Heritage website (*see Links*), which tells the story in much greater detail than is possible here.

Designed by local architect ES Prior in 1889 and now a small house, this Grade II listed billiard room is all that remains of Bermuda House, a once substantial mansion on Mount Park Road, Harrow (the rest of which was demolished in 1975). For Victorian and Edwardian men of means, a billiard room was *de rigueur*, the equivalent today of a gym or a games room.

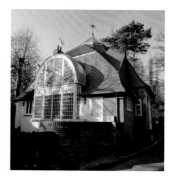

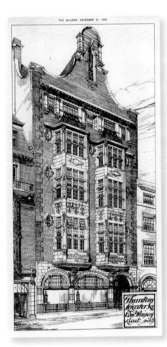

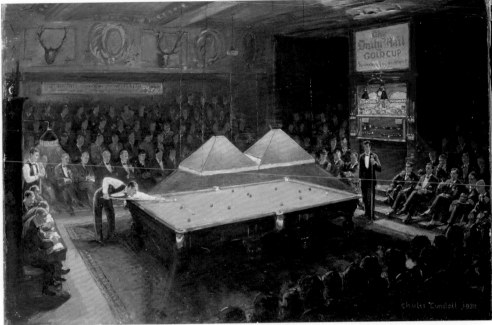

▲ As featured in *The Builder* in November 1903, this was **Thurston Hall** – later referred to as **Leicester Square Hall** – the newly opened headquarters of the world's oldest billiard table makers, **Thurston & Co.**, on the west side of the square (where number 48 now stands).

Designed by Wimperis & East, the building was rivalled only by the headquarters of Thurston's main rivals, Burroughes & Watts, opened at 19 Soho Square the year before.

In both buildings there were extensive showrooms with billiard rooms kitted out in varying decors, such as Georgian, Art Nouveau or Baronial-style, complete with all the fixtures and fittings a man could possibly desire (scoreboards, cue racks, lights and so on).

But the real draw for enthusiasts were the companies' 'match halls', where top professionals of the day did battle in such competitions as the News of the World Handicap or, as portrayed above by **Charles Cundall**, the **Daily Mail Gold Cup** of 1937.

Cundall displayed the picture at the Royal Academy in 1938 and painted several other sporting scenes of the period, Lord's and Stamford Bridge included.

Another picture of Thurston Hall was painted in words, by JB Priestley in 1932 (*see Links*).

Describing the 220 seat room as 'small, snug, companionable' he noted how few women were present, and how most of the men were smoking pipes.

Lighting up his own he went on, 'After a few minutes the world of daylight and buses and three o'clock winners receded, faded, vanished. I felt as if we were all sitting at ease somewhere on the bottom of the Pacific.'

By chance, the two players Priestley watched that afternoon – 'both demi-gods... in this tiny world of bright-green cloth and white and crimson spheres' – were the same pair later depicted by Cundall.

Head down at the table is **Tom Newman**, who lived in Tufnell Park and was known for his prominent

chin and geniality. Behind stands **Joe Davis**, who had taken over his mantle as World Champion. From Derbyshire, Davis dominated every aspect of the game, on and off the baize. In January 1955 he recorded the first officially endorsed 147 snooker break at Leicester Square, a week before the match hall closed (because the Automobile Association, based next door, had upped the rent).

Thurston's showrooms and offices had by then relocated to their works at 33 Cheyne Walk, the Leicester Square building having been damaged in an air raid in 1940 (leaving Davis to take over the match hall after the war). Then as business stuttered during the post war years Thurston moved to Primrose Hill in 1964, then to Camden High Street and Brecknock Road, until in 1990 they were taken over by EA Clare Ltd, based in Liverpool.

Burroughes and Watts' Soho Square headquarters had also closed by then, in 1969.

Other than tables and sundry accessories in various London clubs (*see below*), Thurston's last outlet in London was a shop in Edgware, closed in 2008. However artefacts from the company's past form part of the **Norman Clare Collection** in Liverpool (*see Links*), where Cundall's painting may also be seen, and which forms the basis of the aforementioned snooker heritage website.

There exists one further legacy of the Leicester Square match hall.

Viewers of the BBC's *Pot Black* programme will recall commentator 'Whispering' Ted Lowe. In 1946 Lowe had been the hall's general manager when the BBC's usual commentator turned up one night, worse for wear. Asked to fill in, a nervous Lowe kept his voice down for fear of irritating Joe Davis, who was playing that night and was also by then owner of the hall.

The BBC loved Lowe's hushed tones, as did audiences, thereby establishing the style echoed by snooker commentators ever since.

What is thought to be the oldest billiards table in the world is aptly enough to be found at the oldest gentlemen's club. Thurston originally supplied a table, their first with a slate bed, to White's of St James's Street in 1826. That table was then replaced by the current one in October 1834, at a cost of £110. This plate was fixed at some point during the post war years following a routine refit.

▲ London's breweries positively threw themselves onto the billiards bandwagon in the 1890s, creating an architectural legacy that, long after the game dropped out of fashion, shines on in Victorian and Edwardian gin palaces to this day.

Determined to prove, to the public and to local magistrates that pubs could offer more than just beer and skittles, the breweries invested heavily, in some instances devoting up to 40 per cent of a pub's floor space to the game. As *The Licensed Victualler* reported in 1900, around the same time as the **Crown and Greyhound** opened in **Dulwich Village** (*above*), 'One can scarcely imagine any properly furnished hotel or modern public house without its billiard room'.

At both the Grade II listed **Boleyn Tavern**, **Barking Road** (*right*), designed for the Cannon Brewery by WG Shoebridge and HW Rising, opened in 1900, and the Grade II* **Salisbury Hotel**, **Green Lanes** (*below right*), built by John Cathles Hill and opened in 1899, painted glass roof lights were designed to shed light onto billiard tables below.

The effect was stunning. But alas what billiard players preferred were dark rooms with lights slung low over the table. Added to which affordable overhead electric lighting became available in around 1913.

Some pubs appear to have done well from billiards. But the majority found they could never recoup their initial outlay with a game so few people could play at any one time.

Pubs also lost out to the new generation of billiard halls which offered longer opening hours.

Which is why there are no billiard tables in London pubs any more, or at best, as at the Boleyn, a pool table, somewhat dwarfed by its magnificent surrounds.

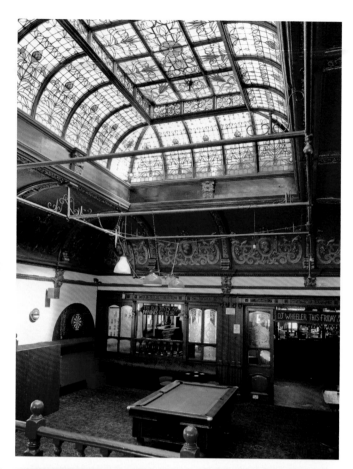

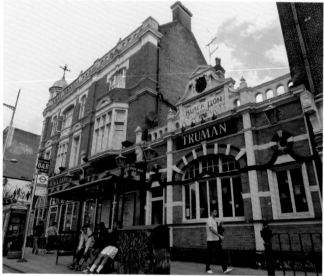

While some London pubs had billiard rooms integrated within their main structure, at several, including the Grade II* listed Black Lion on Kilburn High Road (*above*) – rebuilt in 1898 to designs by RA Lewcock – distinct single storey extensions were added. Here too the original painted glass skylights survive, only now they lighten up the pub's dining area (a common use for former billiard rooms).

'Probably the most famous snooker club in the world' says a sign over the door of the **Romford Snooker Club** on **Arcade Place**.

For it was here, on table number 13, that the owner of the club first spotted a shy lad from Plumstead potting balls with unusual aplomb.

The owner? Barry Hearn, an accountant who had grown up on a Dagenham council estate and had bought the club in 1974, having noted the popularity of the BBC's *Pot Black* series.

The teenager? Steve Davis.

While Davis went on to become England's greatest snooker talent since Joe Davis, Hearn, who became his manager in 1976, set about promoting three of London's most cherished indoor sports, starting with snooker, followed soon after by boxing and darts.

Hearn named his growing empire Matchroom Sports, literally after the match room he had set up at Romford in 1982, east London's answer to Thurston Hall.

The club itself had been opened in 1933 by the **Lucania Temperance Billiard Hall Company**, originally a Welsh company that had taken its name from a Royal

Mail ship, the Lucania, which had been broken up in Swansea in 1909. After purchasing all the ship's interior furnishings and fittings the directors made sure to place at least one bit of the Lucania in each of its billiard halls.

By 1937 there were 27 of them within Greater London alone, Romford included, more than any other single operator in the capital. Another twelve followed post war, by which time the label 'temperance' had been dropped.

Unlike its main rival, of whom more overleaf, Lucania did not build its own halls but rented space instead. At least two of its clubs were above Burton's, at Streatham and Lewisham, but the majority were located on the first floor of shopping parades.

As such Lucania bequeathed no actual architectural legacy, even if at least ten of those parades remain extant.

As for Hearn, he sold Lucania on to another chain, Rileys, in 1982, before finally relinquishing Romford in 1989. Six years later he bought Leyton Orient Football Club and renamed its ground the Matchroom Stadium.

The Romford club has retained its hallowed place in the snooker world all the same, and remains typical of its genre. A single door in an otherwise anonymous parade of shops leads up a flight of stairs, through a swing door and instantly into a magical, hushed world of glowing baize and furrowed brows.

As an old sign by the bar has it, 'The Lucania Lad – happy as the game is long!'

Probably the best preserved Arts and Crafts billiard room in London is that of the Brentham Club, on Meadvale Road in Ealing. Located within the Grade II listed clubhouse, designed by GL Sutcliffe and opened for residents of the surrounding garden estate in 1911 (*see page 121*), the room has two tables overlooked by a series of alcoves, each with bench seats and panelled screens.

▲ The **Temperance Billiard Hall Company** (TBHC) had fewer outlets in London than Lucania – 22 have been identified between 1907-39 – yet the company left a much finer architectural legacy, as seen on these pages, starting on **Fulham High Street** (*above and right*).

Listed Grade II, the building, one of nine TBHC halls to have survived in the capital (albeit none functioning as billiard or snooker halls), is now ironically a pub. Even more ironically it is called The Temperance.

Whether the directors who set up the TBHC in Manchester in 1906 were primarily motivated by their support for temperance or were simply capitalising on the billiards boom is impossible to say. But certainly they meant business.

To attract white collar commuters they selected high street locations close to railway stations.

In-house architect **Norman Evans** made sure, moreover, that while the halls looked playful from the outside, mixing Arts and Crafts architectural features with Art Nouveau decorative tilework and stained glass, inside they were set up to satisfy serious players.

That meant side lit, rather than top lit rooms, using either dormer windows or north facing skylights, and plenty of tables. Sixteen was a typical number, as shown on the plans for Fulham (*above right*).

Crucially the TBHC also courted leading amateurs, banned gambling and, according to one contemporary report, charged up to a third less than pubs or licensed premises.

Evans's earliest halls for the TBHC were in Lancashire and Cheshire, seven of which survive (including one in Bury that uniquely still functions as a snooker club).

Sent south in 1909, one of his first in London was the hall on **Clapham High Street** (*right*). Now an architects' office, it features a barrel roof formed on concrete arches, rather than the more usual pitched roof supported on steel trusses, as at Fulham.

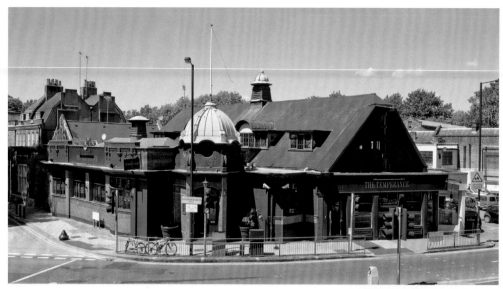

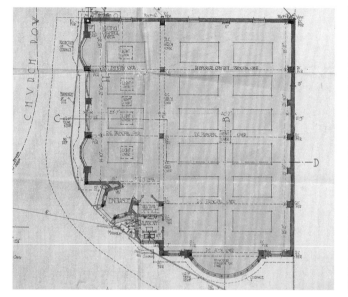

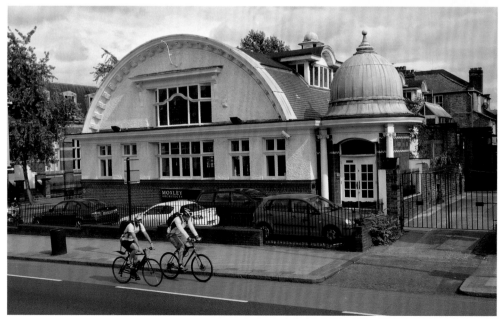

▲ Once you have seen a couple of TBHC halls you will soon learn how to spot the others. Above is the hall on **Wandsworth Road**, also by **Norman Evans** dating from *c.*1909. Originally this served as the TBHC's London headquarters, but at the time of writing is due to be replaced by a hotel on the site, retaining only the front range as its entrance.

Also empty and awaiting its fate is the TBHC on **Lewisham High Street** (*top middle*), again by Evans *c.*1909. Listed Grade II, this is one of several examples where provision was made for shops at the front, leading through a central entrance to a simpler pitched roof billiard hall, visible from Courthill Road, at the rear.

After designing some 17 halls (at an average cost of around £3,175), Evans left the TBHC in *c.*1910 to be replaced by south London architect **TR Somerford**, whose more studied approach is best seen at the TBHC hall on **King's Road** (*above right*).

Completed in *c.*1914 and now Grade II listed, this also has shops at the front – now combined into a single retail unit utilising the hall area behind – but with an adjoining garage, entered from Flood Street.

Somerford's other surviving TBHC hall, dated *c.*1914, is on **Coldharbour Lane, Brixton** (*above right*), now split into individual shops and offices. (Somerford also had a hand in designing the Brixton Academy, originally the Astoria, around the corner).

Finally, only the entrance of the TBHC on **Battersea Rise** has survived (*right*). Built in 1922 to the designs of George Spencer and Wildman architects, it closed for billiards in 1937 and after the rear was demolished in 1995 the remodelled entrance now forms part of a pub called The Goat.

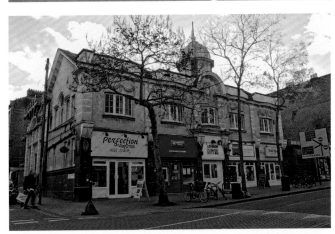

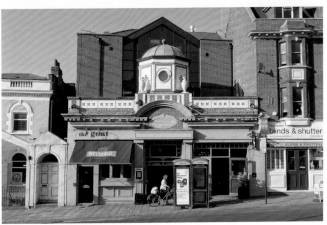

▲ That so many TBHC halls have lived on since they ceased to host billiards is testament not only to the quality of their construction but also to their adaptability as spaces.

As can be found in a list of all former TBHC halls on the *Played in Britain* website, apart from pubs and shops, two in the Manchester area have become restaurants.

Back in London, another one, on the corner of Streatham High Road and Broadlands Avenue, stripped of all its original features, is now a supermarket

Although few who go there realise it, another former TBHC from the period 1909-14 can be seen at **Highbury Corner** (*above*).

Converted into a cinema after the company sold it in the 1930s, it has since become best known as a music venue, formerly the Town & Country 2, currently The Garage.

Not all TBHC halls were purpose built. A sign over the door of 249a Mare Street in Hackney reveals that within this anonymous block there was also a Temperance Billiard Hall.

And not all temperance billiard halls were built or run by the TBHC.

Below is one such survivor, on **High Street, Ilford**. Built in 1925 and designed by JA Dartnall, it is now a Christian community centre.

Chapter Fifteen

Skateparks

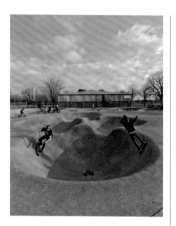

'Carving' in the 'Moguls' – Harrow Skatepark on Christchurch Avenue is a rare survivor. Opened in the midst of a skateboarding boom in 1978, originally under the name 'Solid Surf', Harrow was one of several Californian-style skateparks designed by Adrian Rolt and the company G-Force, using 'shotcrete', a concrete mix sprayed at high pressure to create surfaces that are both contoured and durable. In addition to the 'Moguls' – four interconnected crater-like bowls – Harrow's other original features are its Pool, Snake Run, Half Pipe, Peanut and Slalom, which runs into a double-lobed bowl known as 'the bollocks'. There was also a steeply sided Performance Bowl, but that was filled in during the 1980s on safety grounds. It turned out to be a small price to pay however, because, having survived various closure threats, Harrow is now widely revered. As such, is it time to consider skateparks as part of London's sporting heritage?

For a building, structure or designed landscape to be eligible for listing, it must generally be at least 30 years old.

So if we apply the same rule to which sports may be considered from a heritage perspective, skateboarding most certainly does come into the reckoning. Just.

Having emerged in California during the 1950s, when it was known as 'sidewalk surfing' or 'surf-skating', skateboarding crossed the Atlantic at around the same time as the Beach Boys.

Certainly it was in vogue by 1965 when the *Daily Mirror* hailed it as Britain's latest American fad (following in the wake of the hula hoop and tenpin bowling).

Within two years the fad had faded, but by the mid 1970s skateboarding was back, this time to stay, quite literally with a new set of wheels (moulded from polyurethane), following which in 1977 it was accorded official recognition by the Sports Council.

Not that this was a sport whose adherents were prone to engage with committees or governing bodies. Or form clubs.

London's early skateboarders were all street based, seeking out paved expanses, ramps and ledges wherever they could find them in the built environment. But as in the USA, where skateboarding had grown into an industry, it was not long before both local authorities and businesses in Britain sought to build bespoke 'parks' where skaters might be accommodated safely, and perhaps profitably, apart from the general public.

Thus there evolved two strands. Just as some runners and cyclists prefer the open road to the track, so some skateboarders stayed loyal to the streets while others happily embraced the new generation of purpose-built skateparks.

Or they did a bit of each. Or, in London, from the mid 1970s they gravitated towards an unexpected middle ground which presented itself on the South Bank.

Half street, half skatepark, unofficial and yet officially tolerated (for the most part), the undercroft of the Queen Elizabeth Hall – what planners nowadays call a 'found space' – offered exactly the varied terrain that street skateboarders crave, serendipitously if unwittingly provided by the GLC's Architects Department, under Leslie Martin.

Compared with most street locations, the South Bank undercroft, completed in 1967 and first skated on in the 1970s (one source claims 1973), had several advantages for skateboarders.

As seen below it was almost completely sheltered under its concrete canopy. Also, although theoretically pedestrians can wander through, skateboarders here faced little conflict with other user groups. But perhaps best of all, opening out as it did onto the riverside walk, the undercroft was perfectly positioned to act as a showcase for this new form of physical culture. Skateboarding, and the graffiti artists who followed in their wake, offered a youthful, clattering, ballsy alternative to the refined high art

above their heads; the very essence of what waves of copywriters have since taken to label as 'vibrant'.

Many readers will be aware that in May 2013 the Southbank Centre announced plans to convert the undercroft into retail units, as part of the £120 million 'Festival Wing' redevelopment, and that in response, a campaign called Long Live the South Bank was launched to prevent the skateboarders from being evicted.

At the time of going to press the outcome of this dispute was unknown, although in July 2013 the campaigners did manage to get the undercroft designated as an 'Asset of Community Value' under the Localism Act of 2011.

An attempt to have it also recognised as a 'Town and Village Green' under the 2006 Commons Act stalled, however, as did an attempt to get the undercroft listed (because, in June 2012, the Southbank Centre gained from the government a Certificate of Immunity, meaning that none of the structures could be listed for five years.)

Stirred nevertheless by the passion of the protesters, the Southbank Centre pledged to provide a replacement skatepark a hundred yards or so away, under Hungerford Bridge.

In most circumstances the offer of a £1 million, architect-designed skatepark would be welcomed.

But for the campaigners the offer was derided as a sop; a gilded cage in exchange for a treasured squat, steeped in 40 years of tradition.

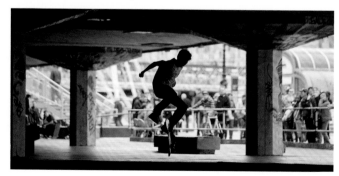

In return, critics pointed out that by claiming 'ownership' of the undercroft the skateboarders were acting counter to the footloose spirit of the early pioneers, with their continual quest for new terrains.

Whatever happens at the South Bank, skateboarding will never leave the streets entirely. If anything, newer sports such as roller blading and parkour (*see page 99*) have paved the way, as it were, for even greater recognition of street based activities.

But what of purpose-built skateparks? London's first was a commercial venture called Skate City, on Abbotts Lane, off Tooley Street, opened in August 1977.

Others included Rolling Thunder, a floodlit facility inside the former Brentford Market, and Mad Dog Bowl, set up inside a former cinema on Old Kent Road. All these early ventures soon went out of business, however, for a variety of reasons, and since the 1980s most skateparks have been provided by the public sector. Harrow's Solid Surf was unusual in that after going bust when the first boom died out, it was taken over by the local council.

Since then the situation has stabilised, so that, as of 2013, including the South Bank, there were 75 skateparks in use across the capital, the majority being local authority installations in parks or open spaces. Many are of the modular type, whereby instead of permanent concrete features, each section is formed from timber or steel, so that the layout is flexible and more easily updated. One example is Bay Sixty6 under Westway (*page 99*).

Being a relatively young sport, skateboarding, as commentators such as Iain Borden have noted (*see* Links), lacks a definitive history.

But there is a wealth of online material, and of oral testimonies from older skateboarders who recall the early years. These lead to the conclusion that, South Bank apart, there are five skateparks in London that have been in existence for 30 years or more. Three of them, however – in Meanwhile Gardens (Westbourne Park), in Kennington Park and Stockwell – have all been remodelled.

Which of the originals leaves us with Harrow, and the pick of them all, Rom Skatepark in Hornchurch.

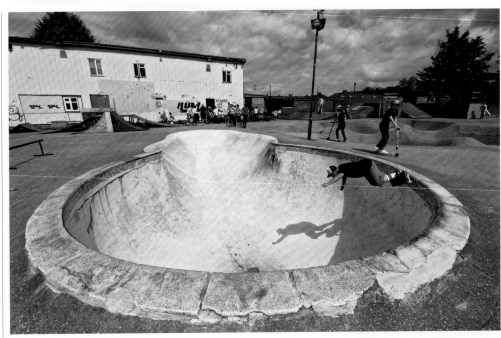

▲ Just as every golf course in the world constitutes a small patch of Scotland, so every skatepark offers a hint of sun-baked California.

This is the **Classic Pool** at **Rom Skatepark** on **Upper Rainham Road**, **Hornchurch,** London's oldest commercial skatepark, opened in August 1978 and designed by the same team, Adrian Rolt and G-Force, responsible for Harrow.

A feature that was to become standard in concrete skateparks, the Classic Pool was based on a feature known as the Soul Bowl, built just twelve months earlier at a park called Skateboard Heaven in Spring Valley, San Diego. The Soul Bowl itself was modelled on a typical backyard 'keyhole' swimming pool, in which early skateboarders often used to skate during the winter months after the pools had been drained (and when their owners were not around to catch them).

Its origins explain why the upper rims of many skatepark 'pools' are lined with blue tiles.

Also standard is the coping around the rim, designed to provide an edge on which to 'kick turn', as seen above.

Rom Skatepark's Classic Pool is one of seven original shotcrete features still in use on the site, the others being the Moguls, Slalom Run, Snake Run, Four Leaf Clover, Half Pipe (*above right*) and the Performance Bowl (*below right*).

It will be noticed that in both images on the right the boys are not on skateboards but on BMX bikes.

Although regarded as interlopers when they first turned up in the 1980s, BMX riders have come to be welcomed by skateparks, particularly commercially run ones like Rom Skatepark, whose fortunes have fluctuated greatly in line with skateboarding's popularity.

To an outsider Rom Skatepark may appear to be little more than a concrete playground. Certainly its ancillary facilities are basic. Nor can its surroundings be described as scenic.

Yet there can be no denying that Rom Skatepark is an important survivor, full of original features from arguably the most formative period in the development of skateparks.

Moreover, apart from Harrow only one other British skatepark from this period survives intact, at Livingston, Scotland, laid out in 1981.

It is for this reason that in 2013 Rom Skatepark was put forward for listing as part of the *Played in London* study. At the time of going to press the proposal was still under consideration. Would it, for example, be evaluated as a building, or as a designed landscape? And can skateboarding be considered of sufficient importance in the overall landscape of English sport?

To find out the outcome of these deliberations, the *Played in Britain* website promises to be first with the news. In the meantime, we now turn our attention to pools of a different ilk, hoping that some of that Californian sun will follow us along the way.

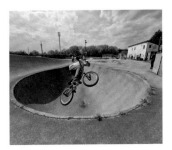

Chapter Sixteen

Outdoor swimming pools

Founded in 1864 London's oldest swimming club is the Serpentine SC, whose badge this is from the inter war period, when a certain Captain Colbridge from the US Army paid a visit. As Colbridge was to report in the *American Swimmer* of October 1923, here was a club where social rank counted for nothing. 'The elderly gentleman on your right, with the stooped shoulders, keeps a sweet shop in Maida Vale, the one next to him is a tobacconist in High Holborn. The man on your left is a major in the army. Over the way is a waiter from the Trocadero Restaurant. Down a bit you see the physician to the Queen. Here is a haberdasher's clerk from Marylebone Road...' While London's indoor pools maintained a strict regime of first and second class bathing, the great outdoors presented no such barriers. As Sir Josiah Stamp, Governor of the Bank of England, declared as he opened the open air baths in Morecambe in 1936, 'When we get down to swimming, we get down to democracy.'

Survey after survey confirms swimming's status as the nation's favourite 'participation sport'. Four out of five of us know how to do it. One in ten of us does it at least once a week, and most of us know someone who does it daily (and who appears to have boundless energy as a result).

But however often, or far one swims, whether it be for fitness or for fun, there are essentially only two breeds of swimmer; those who prefer the comfort of an indoor pool, and those for whom a roof is an abomination against nature.

Dr Robert Ellis Dudgeon fell into the latter camp.

'Every town which aspires to be considered at all perfect in its sanitary arrangements should possess ample swimming baths of pure water in the open air,' wrote the good doctor in 1870 (*see Links*).

Whereas, he complained, most of London's indoor pools at that time – built as a result of the 1846 Baths and Wash Houses Act – were 'close, stuffy and foetid'; too small for proper swimming and too shallow for diving.

Dudgeon would have heartily approved of what followed in the first half of the 20th century, when London became, in the words of Herbert Morrison of the LCC, a 'city of lidos'. There were 67 in 1939. But then in the latter part of the century came a reversal, so that today London has fewer public places for outdoor swimming – 15 in total – than the equivalent area had in 1914, when there were 24 (officially), and when the population was one million fewer.

To which the swimmers of Birmingham and Merseyside would respond, 'Lucky London!' Between them these metropolitan areas had 16 outdoor pools in the 1930s. Now they have none.

Should it matter whether people swim indoors or outdoors, as long as they can swim somewhere?

After all, there are currently around 200 public indoor pools spread around the capital, and 500 if private pools are included.

But from a heritage perspective there can be no doubt. Indoor and outdoor swimming may be two sides of the same coin, but each has its own story to tell, socially, culturally and architecturally.

Of course prior to the mid 19th century anyone who did swim in Britain swam outdoors.

For which there were plenty of opportunities in London.

Even in addition to the great tidal river flowing through the city, from Brentford to Romford, from Kilburn to Snaresbrook, London and its environs were awash with rivers, streams, lakes and ponds. And that was before the Industrial Revolution brought in its wake further temptation in the form of docks, canals and reservoirs.

Whether many people actually knew how to swim before the 19th century we cannot be sure; men of valour and of means perhaps, women probably not. In 1615 the Master of the Revels, Sir George Buck, noted that London had its share of swimming instructors, while in the Restoration period Charles II often took early morning dips in the Thames.

It was also in the late 17th century that indoor pools started to be built, for example in Long Acre and Newgate Street. Known as *bagnios* (Italian for baths) they, however, were more like plunge pools, good for a soak but not for a swim. They also had a dubious reputation for other activities.

But then, given that it inevitably entailed the exposure of flesh, any form of bathing risked the wrath of the church, plus, if indulged in outdoors, fines from a magistrate.

Swimming could be dangerous too, which is one reason why the Royal Humane Society (RHS) formed in London in 1774. The previous year, it was stated, 123 people had drowned in the city.

A new message was emerging. Learning to swim could save one's life, and that of others. Plus, as certain medical men were by now advocating, cold water did wonders for the constitution.

It was precisely within this context that the capital's first known purpose built outdoor pool was opened to the public in 1743, by William Kemp, a jeweller.

In the 1603 edition of John Stow's *Survey of London* the site chosen by Kemp (*below*), had been described as the 'Perillous Pond', owing to the number of youths who had drowned in it. Yet having bathed there many times himself, curing in the process 'a violent pain of the head', Kemp decided to make it safe for 'publick benefit' by reshaping it into a rectangular pool, 170' x 50', reducing its depth and lining it with gravel.

Covering such an expanse was,

Running between Old Street and City Road, Bath Street (*right*) recalls the location of London's first purpose built outdoor facility, the Peerless Pool, in use from 1743-1868. The site is now covered by St Luke's housing estate, bordered to the north by Peerless Street. Off this, Baldwin Street marks the location of the Peerless Pool's fish and boating pond, built over in the 1830s.

at the time, unthinkable. Instead, to ensure privacy he surrounded the pool with walls and trees, built dressing rooms, and to meet the fashion for cold plunge pools, added a small indoor bath. Also on site was a library, a bowling green and a second pond for fishing, skating and model boating.

In a stroke of marketing genius, Kemp rebranded the former pond as the 'Peerless Pool'.

Along with several of the outdoor pools and lidos cited in this chapter, more on the Peerless Pool can be found in another publication in the *Played in Britain* series, *Liquid Assets* (*see Links*).

Suffice it to say here that like most 'subscription baths' of the period, the Peerless Pool, costing one guinea for a year, or one shilling per visit, was affordable only to gentlemen (the idea that women might wish to swim was barely acknowledged.)

As for anyone else wanting a safe dip, there was the Serpentine.

In truth, when the lake had been created in Hyde Park in the 1730s at the behest of George II's wife, Caroline of Ansbach – by diverting the Westbourne between Bayswater and Knight's Bridge – its purpose had been decorative.

Yet over the next 150 years the Serpentine, along with the Thames, became one of the focal points of swimming in England.

And, like the river, it was free.

To spare the blushes of any women passing through Hyde Park, swimming was permitted only between 5-8.00am, and then for an hour or so after sunset. To guard against drownings, the RHS provided a boatman and a 'receiving house' on the lakeside.

It is from the records of the RHS that we learn the full measure of the Serpentine's popularity.

For example on warm summer mornings in both 1842 and 1843, the Society counted 8,000 men and boys in the lake before 8.00am, while over the period 1844-59 there was an average of over 260,000 bathers per year.

All were male, of course. Most, furthermore, swam naked, and almost certainly came from households with no baths. In other words, the Serpentine was one vast public bath, without any form of water filtration or circulation.

Over at Victoria Park in Hackney similar scenes were to unfold.

There, in 1846, a lake intended for boating had immediately been colonised by bathers, prompting the hurried creation of a separate bathing lake, 300' long. But even this proved insufficient, especially after swimming experienced a surge in popularity in the 1870s.

Responsible for this surge was Captain Matthew Webb, the first man to swim the Channel, and a cult hero whose powers had been nurtured in the increasingly competitive environment of English swimming.

In London the first officially recorded swimming races had taken place on the Serpentine in August 1837, organised by a body grandly titled the National Swimming Society (NSS). This had been set up by John Strachan, who, like Thomas Lord in the world of cricket, combined being a wine merchant with promoting 'wager races'. As *Bell's Life* reported from the Serpentine, 'much money was lost and won by gentlemen...'

The following year a further series of races drew estimated crowds of 20,000, despite their taking place between 6-7.00am.

In fairness, the NSS did more than attract gamblers. According to *The Times* in September 1838, 2,000 individuals had received lessons from NSS instructors in three locations, the Serpentine, Surrey Canal and on the Thames at Cremorne House.

Although the NSS proved shortlived, London continued to provide the focus of early attempts to organise swimming as a sport.

At the Serpentine alone races were staged by the London Swimming Club (formed 1859), the German Gymnastic Society (1861), and the Serpentine SC (1864). Then in 1869 London clubs met at the German Gymnasium to form the Associated Metropolitan Swimming Clubs (which in 1886 became the national governing body, the Amateur Swimming Association, now known as British Swimming). One of the Association's first acts was to organise one mile and ten mile championships on the Thames.

But then came Captain Webb's triumph in August 1875, and suddenly, every boy aspired to be the nation's next aquatic hero.

Girls gained role models too. Only weeks after Webb made the headlines, fourteen year »

▲ There are 29 ponds dotted around **Hampstead Heath** – seen here from the north, with the lido at **Parliament Hill Fields** at the very top – three of which provide a real sense of how Londoners used to swim, before the days of tiled pools and chlorinated water.

As Caitlin Davies writes (*see Links*), for all their Arcadian charm, most of the Heath ponds were man-made in the 18th century, to serve as reservoirs. The earliest of these to have been used for swimming is the **Mixed Pond**, on the right of the photograph, obscured by trees. This may well have been the bathing pond referred to by William Blake in *Jerusalem*, written in 1804.

While the Mixed Pond became a popular resort for Cockney day trippers, **Highgate Men's Pond**, opened in 1893 (second from the top on the left) attracted a more purposeful crowd. It was here that Christmas Day swims were organised by the Highgate Life-Buoys, a club formed by life savers in 1903, and where, inspired

by Swedish divers, Britain's first national diving competitions were held from a 33' board (*below*).

In 1926 a third pond, known as the **Kenwood Ladies Bathing Pond** was set aside. Seen above to the right of the bowling green, this is thought to be the only women-only facility of its kind in Europe.

Apart from the Heath and the Serpentine, from 1890-1939 the LCC operated swimming lakes at Brockwell Park, Clapham Common, Plumstead and Victoria Park. Further out, other ponds, lakes and reservoirs used for swimming were at Syon Park, Ruislip, the Welsh Harp, Valentine's Park, South Norwood and Wimbledon Common.

All survive, as stretches of water. But only on the Serpentine and the Heath does swimming continue, and only because, over the years their regulars have fought hard to make that happen.

They have hidden depths and a sub-culture all of their own, these open water swimmers. But they also have history on their side.

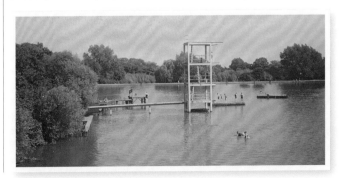

Come rain or shine, ice or fog, hardly a Saturday or Wednesday morning goes by without the **Serpentine SC** staging one race or another in the lake at Hyde Park.

All distances are measured in yards, most races are handicaps (to give everyone a chance), and wet suits are expressly forbidden.

Seen here is the line up for a race in 1925, won by Albert Greenburg, a solicitor who swam in the Serpentine every morning before breakfasting at the Lyons Corner House in Marble Arch and then cycling to his office in Kilburn.

The club has always been full of such individuals, hale and hearty, some well into their 80s. Eccentrics too, such as **Mario McClarnon** (*right*), a signalman at Clapham Junction and a bagpiper, seen in 1987 leading out members before the club's **Christmas Day 100 Yard Race**, an event first staged in 1864 and much loved by foreign TV crews seeking out wacky Brits.

From *c.*1908-33 the prize for this event was donated by JM Barrie and was called accordingly the **Peter Pan Cup**. (Second and third prizes were donated by Bovril.)

After Barrie's death Albert Greenburg, who was by now Greenbury, took over the prize giving, a role his children maintain to this very day (2013 being the race's 150th anniversary).

In the early years the club's only changing facility was a bench under an elm tree. So when the **Lido Pavilion** (seen in the background) was built in 1930, there were fears the club's spartan ethos might be compromised.

Not a chance. Even today, when half of the membership is female, changing facilities remain minimal.

Certain events do have a dress code however. In 'All Clothes' races entrants must swim fully clothed, another tradition that goes back to the early years, when life saving was high on the club's agenda.

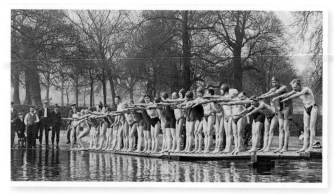

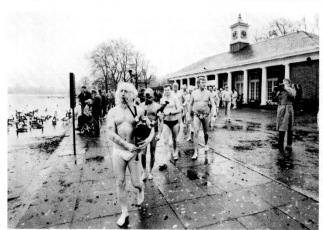

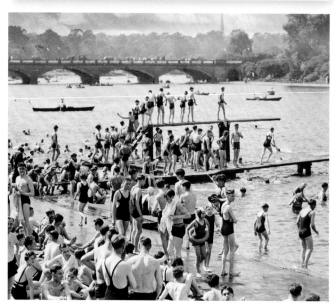

When the socialist MP, George Lansbury (1859-1940), undertook a reappraisal of London parks in his role as First Commissioner of Works in Ramsay MacDonald's Labour government, *The Times* accused him of turning Hyde Park into Coney Island. His crime? To set aside a portion of the Serpentine for daytime use as a lido, in 1930, and worse, to allow mixed bathing. It was an

instant success, as seen above in 1937, with the Serpentine Bridge (b.1828) – the boundary between Hyde Park and Kensington Gardens – in the distance. To honour Lansbury's role, this plaque (*left*), by H Wilson Parker, was unveiled on the wall of the Lido Pavilion by Clement Attlee in 1953. The Lido remains open to the public, from May to August, although the pavilion is now a café and bar.

» old Agnes Beckwith, the daughter of professional swimmer and showman 'Professor' Fred Beckwith, swam four miles from London Bridge to Greenwich in petticoats, pantaloons and stockings. Days later, Emily Parker, the sister of professional swimmer Harry Parker, swam ten miles from London Bridge to North Woolwich Gardens.

This pair's efforts were to be placed in sharp focus three years later when the pleasure steamer Princess Alice sank near Woolwich with the loss of 640 lives. Of 350 women on board it was said that only one knew how to swim.

London's swimming lakes and pools were now busier than ever.

According to the RHS, the annual total of bathers at the Serpentine rose to over 350,000, while at Victoria Park, the LCC noted that on one morning alone, an estimated 25,000 men and boys had entered the lake. An even larger lake had to be provided, while the old one was reserved solely for women, a first in Britain.

Yet in 1887 the *Pall Mall Gazette* lamented that the capital was still 'notoriously behind most of the large provincial towns' in terms of swimming. Even in vestries where baths had been built, many children could not afford even the halfpenny or penny charged for second or third class pools.

The answer in several parts of the capital was to use unemployed labour to build basic outdoor pools, to which entry was free. As noted opposite, these in turn were gradually superceded by the more advanced lidos of the inter war boom period, when London truly did become a 'city of lidos'.

So why did so many of these lidos then close in the 1980s?

One reason is that more people could afford to travel abroad, meaning that unheated pre war lidos no longer held their appeal. A further factor was that in the 1970s the GLC devolved its responsibility for former LCC lidos to local authorities, who were at the time more concerned with providing indoor facilities.

As investment dried up, so the lidos deteriorated, and user numbers dropped accordingly.

Bit by bit, outdoor swimmers became marginalised; written off as health fanatics, or, like the members of the Brockwell

Icicles, who swam in all weathers, portrayed as the epitome of English eccentricity.

Yet perceptions have changed.

No doubt milder winters and hotter summers have played a part in boosting the number of outdoor regulars. Another factor has been the increasing presence of women – as noted opposite they now form half the membership at the Serpentine – and of individuals from cities overseas where outdoor swimming is the norm.

Inspired by the writings of Roger Deakin, there has also grown a trend for 'wild' swimming. For its adherents, even lidos have come to be seen as overly sanitised.

Finally there is the growth of a new sporting discipline, one that sprang up in California in 1974.

'Triathlon' (a mix of swimming, running and cycling) made its debut at the Olympics in 2000, and at the 2012 Games was staged in and around London's oldest swimming arena, the Serpentine.

The men's event, won by Britain's Alistair Brownlee, drew an estimated crowd of 160,000.

A year later a further 100,000 flocked to Hyde Park over the five days of the 2013 World Triathlon, in which 7,300 competitors from 85 countries participated.

Not since the 19th century had the Serpentine seen such crowds.

There has been a revival of racing in the Thames too. Until recently the last major race, contested between Kew and Westminster from 1877-1939, had been the 'Lords and Commons', sponsored by the Houses of Parliament. Today there are two annual races; on a 2.2 mile course from Hampton Court to Kingston, held since 2010, and at Corney Reach, Chiswick, held since 2002.

In 2008 a GLA report into the shortage of swimming pools in the capital suggested that one way to make up the numbers was to bring back into use old lidos and bathing ponds. This has happened at two such lidos, London Fields and Uxbridge, both featured later.

Next up, in 2013 the West Reservoir at Stoke Newington was also made available for swimming, with Ruislip Reservoir expected to follow in 2014.

Like Peter Pan himself, it would seem, the appeal of London's open waters shows no sign of fading.

It is, after all, only natural.

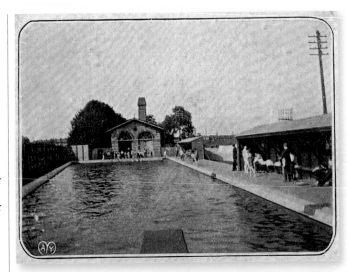

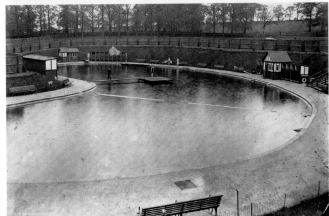

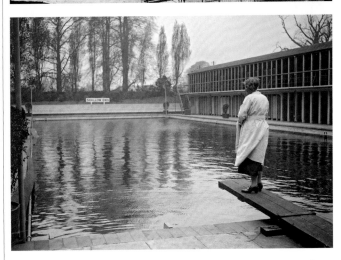

▲ Although often associated with the 1930s, purpose-built outdoor pools started to appear in the early 18th century. Outside London, ten built prior to 1914 remain open, Lymington in Hampshire (b.1833), being the oldest. Meanwhile in London, of the ten built from 1875-1913, just one survives, at Tooting Bec (b.1906), of which more later.

Pools of this era are interesting because they provide a bridge between the swimming lakes of the 19th century and the more advanced lidos of the 1930s. Here are three that did not survive.

At the top, seen in 1926, is the pool in **Alexandra Park**, opened 1875 and rebuilt in 1908 as one of the attractions at Alexandra Palace.

In common with all pre-1914 open air pools, it suffered from appalling water quality, despite the fact that it was fed from the adjoining reservoir (still extant), which itself was linked to the nearby New River.

As one correspondent to the *North Middlesex Chronicle* complained in July 1878, the water was so dirty he thought he had entered a duck pond by mistake.

But it was not only private pools that suffered. At Tooting Bec the LCC were criticised for not controlling the rats, and for not clamping down on men spitting.

It was the same at **Gladstone Park**, **Willesden** (*left centre*), where in 1903 the Council Engineer Oliver Claude Robson designed a peanut-shaped pool based on the Ducker at Harrow School – a free-form design that would regain popularity for leisure pools in the 1990s.

Here the issue of water quality surfaced in 1927 when it took a policeman 20 minutes to find the body of a boy drowned in just six feet of water. 'It was absolutely black,' said the boy's father.

In response to the same problem, that same year the LCC installed filters and aerator fountains at three of their own pools, Highbury Fields, Southwark Park and Peckham Rye.

Instead of the old system of 'fill and empty' every once in a while, like a bath, the water was now circulated and refreshed continually every five or six hours.

Like many pools of its vintage, Alexandra Park was beyond modernisation, and closed in the late 1920s. Since then the site, which adjoined the park's racecourse as it skirted the reservoir in the south east corner of the park, has become covered by trees.

Gladstone Park's pool had a makeover in 1935, and survived until 1978. Similarly, the pool on **Edensor Road**, **Chiswick** – built by unemployed labour in 1910, and seen here in 1928 (*left*) – was redeveloped in 1931 according to the new water standards set down by the Ministry of Health.

Note the two storey changing rooms, a feature rare in Britain but common in France. But then another common feature in France was that before entering any pool bathers were obliged to pass through a shower. Only in the 1930s was this patently sensible practice introduced in Britain.

There is still a pool on the Edensor Road site. It is, however, an indoor facility, the outdoor pool having closed in 1980.

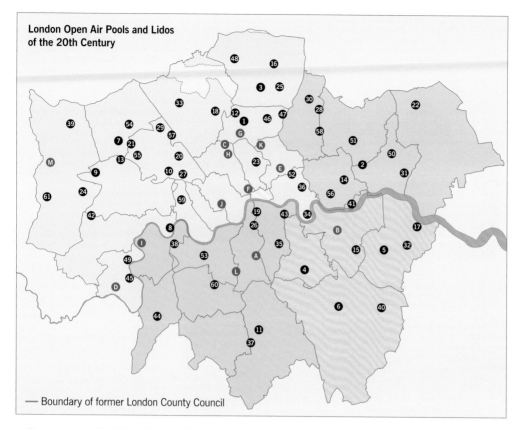

London Open Air Pools and Lidos of the 20th Century

— Boundary of former London County Council

▲ Shown here are the 75 local authority and privately run open air pools that were open to the public within the boundaries of modern London, during the 20th century.

The peak came in 1939, when 67 outdoor pools were open.

This number then fell steadily from 1970 onwards, with 28 closing during the 1980s alone.

The locations in green denote facilities in public use as of 2013. Note that there are three sites on Hampstead Heath (C).

Outdoor pools open only to members of private clubs (eg the Hurlingham Club) or to residents (eg Ealing Village) are not listed.

Defunct pools (but not swimming lakes) are identified in black, listed under the name most commonly used, to which, if not called 'lido' was usually appended the words 'Open Air Baths' or 'Open Air Pool'.

Note that this map and location list supercedes those reproduced in 2005 in *Liquid Assets*, an earlier publication in the *Played in Britain* series (see Links).

Key:
* denotes Grade II listed
† denotes facility built by private interests (ie. not local authority)
‡ denotes replaced swimming lake in same park

Outdoor facilities in use (2013):

A. **Brockwell Lido**‡* (1937)
B. **Charlton Lido & Lifestyle Club** Hornfair Park (1939)
C. **Hampstead Heath: Mixed Pond** (c.1800), **Men's Pond** (1893), **Ladies Pond** (1926)
D. **Hampton Open Air Pool** (1922)
E. **London Fields Lido** (1932-88, reopened 2006)
F. **Oasis** Endell St WC2 (1946)
G. **Park Road Pools** N8 (1929)
H. **Parliament Hill Fields Lido*** (1938)
I. **Pools on the Park*** Richmond (1962)
J. **Serpentine Lido** Hyde Park (as lake c.1733, as lido 1931)
K. **Stoke Newington West Reservoir** (for swimming, 2013)
L. **Tooting Bec Lido** (1906)
M. **Uxbridge Lido*** (1935-98, reopened as Hillingdon Sports & Leisure Complex 2010)

Defunct facilities:

1. **Alexandra Park**† (1875-c.1926) wooded over
2. **Barking Park** (1931-88) pool infilled, buildings/ fountains extant, now Splash Park
3. **Barrowell Green** N21 (1913-79) now refuse and recycling centre
4. **Bellingham** Bromley Rd SE6

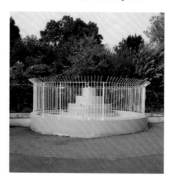

(1922-80) now Orford Rd flats
5. **Bexley, Danson Park** (1936-80) grassed over
6. **Bromley/Southlands Lido** Baths Rd (1925–80; 1983-c.1987 now leisure centre
7. **Charles Crescent Lido** Harrow (1923-81) now housing
8. **Chiswick /Edensor Road** (1910-80) now indoor pool
9. **Compton/Walford Centre** Bengarth Rd UB5 (1970-2004) now West London Academy
10. **Craven Park Lido** NW10 (1935-39, bombed in WW2) now housing on Gifford Rd
11. **Croydon Central Baths** Scarbrook Rd, adjoining 1866 indoor pool (1909-1950s)
12. **Durnsford Rd Lido** N11 (1934-89) now garden centre
13. **Ealing Northern Sports Centre**† Greenford Rd, Sudbury Hill

ex J Lyons & Co sportsground (1935-67) now leisure centre with small open air pool
14. **East Ham Open Air Baths** Central Park (1901-23), now tennis courts & bowling green
15. **Eltham Park Lido** Glenesk Rd (1924-90) grassed over
16. **Enfield Lido** Southbury Rd (1932-91), now leisure centre
17. **Erith** Stonewood Rd (1907-67) now car park
18. **Finchley Lido** High Road (1932-93) now leisure centre with small open air pool
19. **Geraldine Mary Harmsworth Lido** St George's Rd, SE1 (1938 –c.1980s) children only, grassed over
20. **Gladstone Park** Willesden (1903-c.1978) grassed over
21. **Harrow School, The Ducker**† (1866, in community use also c.1900-85) now overgrown
22. **Havering Court**† Chase Cross (1936-39) now nursing home
23. **Highbury Fields Lido** (1923–82) now indoor pool
24. **Hillingdon/Blue Pool**† Uxbridge Rd (1933-38) now bingo hall (ex Savoy Cinema)
25. **Houndsfield Lido** Edmonton (1927-80) now Water Ln housing
26. **Kennington Park Lido** (1931-88) now tennis courts
27. **King Edward VII Recreation Gd** Donnington Rd, Willesden (1911-1987) now open space next to Willesden Sports Centre
28. **Kingfisher Pool**† Highams Pk Woodford Green (1934-73) now County Hotel
29. **Kingsbury Lido** Roe Green Pk (1939-88) now sports courts
30. **Larkswood** New Rd, Chingford (1936-87) now leisure centre
31. **Leys** Old Dagenham Park (1939-80) now Ridgewell Close
32. **Martens Grove** Bexleyheath DA7 (1939-84) grassed over
33. **Mill Hill Lido** Daws Lane NW7 (1935-80) buildings extant, was garden centre, now school
34. **Millwall Recreation Ground** E14 (1925-39) grassed over
35. **Peckham Rye Park** (1923-87) grassed over
36. **Poplar** Violet Rd E3 (1924-36) now vehicle depot
37. **Purley Way Lido** CR0 (1935-79) now garden centre, diving board*/buildings extant
38. **Roehampton**† Priory Ln SW15 (1934-66) now Woking Close
39. **Ruislip Lido**† Reservoir Road (1936–c.1992), re-introduction of swimming planned 2014

40. **St Mary Cray/Blue Lagoon**† Lagoon Road BR5 (1933-39) now industrial estate
41. **Silvertown** Royal Victoria Gdns (1922-48) grassed over
42. **Southall** Florence Rd UB2 (1913-82) grassed over
43. **Southwark Park Lido** (1923-89) now childrens' play area, fountain extant (*opposite*)
44. **Surbiton Lagoon** Raeburn Ave KT5 (1934-79) grassed over between Stirling Wk/Meldone Cl
45. **Teddington Lido** Vicarage Rd TW11 (1931-75) now indoor pool and leisure centre
46. **Tottenham Lido** Lordship Lane N17 (1937-85) now flats
47. **Tottenham Marsh** fed from River Lea, next to Stonebridge Lock (1905-c.1937) now grassed over and parking
48. **Trent Park**† Bramley Rd N14 (c.1920s-2012) site awaiting development
49. **Twickenham** The Embankment (1936-81) now Diamond Jubilee Gardens (2011), pool infilled, diving board extant
50. **Valence Park Lido** Becontree (1931-71) grassed over
51. **Valentine's Park**‡ Ilford Cranford Lake (1899-1924)/ Valentine's Park Lido (1924-94) grassed over
52. **Victoria Park Lido**‡ Grove Rd (1936–89) now car park
53. **Wandsworth** King George's Park (1938-93) on site of existing swimming lake, now recreation centre, Mapleton Rd, lido buildings extant
54. **Wealdstone** Christchurch Ave HA3 (1934-97) now health centre
55. **Wembley** Vale Farm (1932-79) now leisure centre
56. **West Ham/Beckton Lido** Canning Town Recreation Gd E16 (1937-87 on site of earlier pool 1900-33) grassed over
57. **West Hendon Lido** Goldsmith Ave NW9 (1922-80) now Gadsbury Close
58. **Whipps Cross Lido** off Snaresbrook Rd E11 (1932-82 on site of Hollow Ponds Bathing Pool (1905-32) now woods
59. **White City/Hammersmith Lido** Wormholt Pk, Bloemfontein Rd W12 (1923-80) now care centre
60. **Wimbledon** Wandle Park Colliers Wood SW19 (1913-33) grassed over
61. **Yiewsley** Otterfield Rd UB7 (1934-76, indoor pool on site 1976-2010)

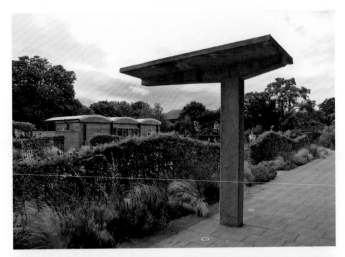

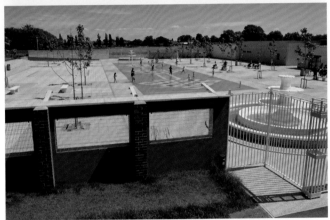

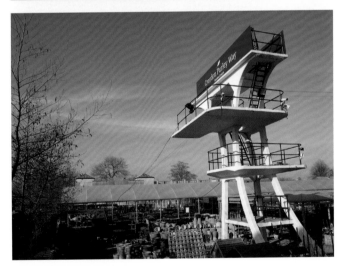

When opened with a diving display by two US Olympic gold medallists in 1935, Purley Way Lido was the closest London came to emulating the showpiece Art Deco lidos of seaside resorts such as Morecambe, Weston-super-Mare and New Brighton. Built opposite London's first airport, and designed by the Croydon Borough Engineer CE Boast, the lido exuded modernity. Its 200' long pool was electrically heated, with underwater lighting, and there was this three stage concrete diving board. After the lido closed in 1979 the site was converted into a garden centre (as were Durnsford Road in Bounds Green and Mill Hill). The entrance building survives but is much altered. The diving board, one of only a handful surviving from the 1930s, was listed Grade II in 2013.

◀ Although over 50 local authority outdoor pools were closed during the 20th century, the sites on which they were built have mostly remained within the public realm; redeveloped either as indoor leisure centres or for outdoor sporting use, or simply grassed over.

In seven locations, however, as indicated in the list opposite, certain structures have survived, for example the **aerator fountain** from **Southwark Park Lido** (*opposite*).

On this page is the central core of a post war diving board (*top left*) on the site of **Twickenham Open Air Baths**, built opposite Eel Pie Island in 1935 (see *map on page 74*).

Following its closure in 1981 the site, left derelict for over 20 years, was subject to a succession of commercial development proposals, until in 2010, the Twickenham Riverside Terrace Group succeeded in gaining support from Richmond Borough Council for gardens and a play area on the site (which, as campaigners pointed out, had been purchased by Twickenham Council in 1924 with an £11,000 loan from the Ministry of Health, 'for the purpose of providing public walks and pleasure grounds').

Finally re-opened in 2011 as the **Diamond Jubilee Gardens**, in addition to the diving board, the outline of the pool can still be seen, framed by paving stones.

Also derelict for over 20 years was the open air pool in **Barking Park**, another 1930s facility grant aided by the Ministry of Health and built using unemployed labour.

In use from 1931-88, its two fountains, entrance block and sections of its perimeter walls have been restored as part of a £7 million refurbishment of the park, half funded by the Heritage Lottery Fund. Rather than reinstate swimming, however, the pool (*centre*) has been infilled and fitted with fountains, to create a **Splash Park**, opened in 2012.

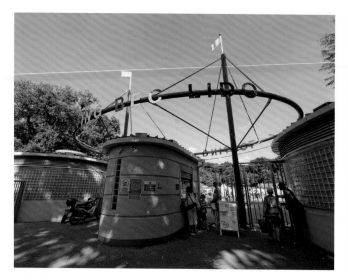

▲ **Tooting Bec Lido** is London's oldest and largest outdoor pool, and as such offers a unique overview of how this building type has evolved.

Known originally as **Tooting Bec Bathing Lake** it was jointly funded in 1906 by the Central Unemployed Body for London and Wandsworth Borough Council, but run by the LCC, on whose land it was built on **Tooting Bec Common**.

Entry was via a brick arched block at the south end, inserted into an embankment formed by the excavations (*top right*).

Because bathing was segregated – women were admitted only on Tuesdays – and was free of charge, facilities were minimal. Open fronted shelters lined the sides, while the tank was refilled only when the water became too dirty. As Janet Smith writes (*see Links*), the first time this change of water was recorded was in 1908, after nearly two years use.

Not until 1931 was a filtration plant and aerator fountain installed. Also introduced was charging, and mixed bathing, the latter requiring the addition of cubicles with doors, since painted in a distinctive range of colours (*right*). In 1936 a café was built (*centre right*).

Thus the bathing lake evolved into a lido, in both form and name.

More recently, between 1999-2002 Wandsworth have upgraded the tank and café, and at the north end built a paddling pool and new entrance block, designed by WM Architects (*above*). This block, as is the modern practice, gives direct access to the shallow end.

At the south, or deep end, the construction of a range of new indoor facilities, by David Gibson Architects, is expected in 2015.

In this block will be an office for the **South London Swimming Club**.

Formed just after the pool opened in 1906, SLSC members make up 40 per cent of the average annual attendance of around 71,500, and have played a crucial role in ensuring that, along with the current operators, DC Leisure, the lido remains open 365 days a year, Christmas Day included, even if that means breaking the ice.

In January 2006 the club hosted the first UK Cold Water Swimming Championships.

Given that heating such a vast pool would be prohibitively expensive, it is just as well, that, to adapt a phrase, some in south London really do like it cold.

The first thing that strikes new visitors to Tooting Bec Lido is its size. Holding one million gallons and taking a week to refill, the pool is 300 feet long (91m, almost twice the length of an Olympic pool) x 100 feet wide (34.5m, wider than a standard 25m pool is long). A maximum of 1,400 swimmers can be in the water at any one time, with up to 6,000 entering during the course of a day.

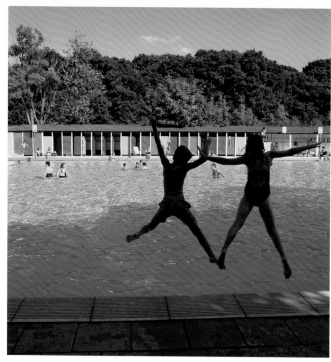

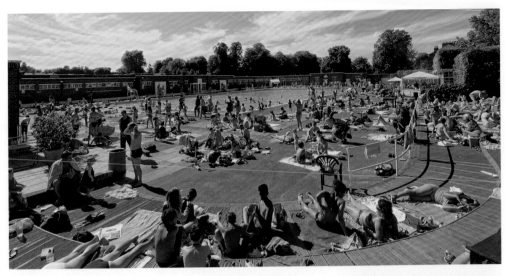

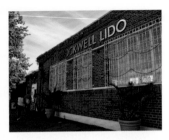

▲ Although the pool at **Brockwell Park** did not bear the name **lido** when it opened in 1937, the term was by then in common usage. Derived from the **Lido de Venezia**, a fashionable Italian bathing resort celebrated in novels and gossip columns, 'lido' had begun to appear in the British press in relation to outdoor pools in the 1920s.

One early informal reference was in Southport in 1928. George Lansbury used the term 'All British Lido' in a speech in 1929, while the mixed bathing facility he opened at the Serpentine in 1930 was often referred to as 'Lansbury's Lido'.

In a different context, in late 1920s London there was a Lido Club in Newman Street, Lido Cinemas in Islington and Golders Green, and a shade of 'lido blue' popular in ladies fashion.

As the 1930s wore on, reports increasingly described new open air pools as 'lidos'. Then in 1936 Ruislip Lido was officially opened under that name by the Grand Union Canal Company, followed in June 1937 by Tottenham Lido.

That same month the LCC's Parks and Open Space Committee recommended that the Council follow suit with its own pools.

Not everyone approved. A month later the Conservative representative for Chelsea, Miss Catherine Fulford, expressed regret that an English term could not be found instead.

As for the most common query, being an Italian word, lido should be pronounced 'lee-doh'. But when in London, rather than Rome, 'lie-doh' appears to have won the day.

▲ **Brockwell Lido** is, together with Tooting Bec, one of four surviving outdoor pools that was either built, funded or managed by the LCC from 1906-39.

During that period the Council was actively involved in the building of fourteen such pools, to which individual borough councils within the boundaries of the LCC chipped in with a further five, thereby fulfilling the promise of the LCC's Labour leader, Herbert Morrison, in March 1937, that London would become 'a city of lidos'.

Truly, never before nor since in Britain have so many publicly funded outdoor pools been created in such a short time (and had war not intervened there would have been three more LCC lidos at Battersea Park, Ladywell Park and Clissold Park, plus a fourth planned by Paddington Borough Council).

Brockwell Lido was built to supercede a lake used for swimming on the west side of Brockwell Park since 1894. Opened in July 1937 and listed Grade II in 2003, it was designed by Harry Rowbotham and TL Smithson, who as architects for the LCC were also responsible for dozens of shelters, cafés and pavilions in London parks.

Adopting the same stripped Modernist style employed at Kennington Park, London Fields and Victoria Park, the lido was essentially, as now, a rectangular brick compound with two curved corners facing the park. Within this were provided the four elements deemed to constitute the ideal lido: that is a pool large enough to host galas and water polo matches under ASA rules, a café, sunbathing terraces and spectator area.

As told by Peter Bradley in his engaging history (see Links), the lido has since been through a number of phases. From 1947-68 it was part of a network of lidos hosting the County of London Swimming Championships (echoed beyond its walls by similar events held for tennis and bowls).

When it was hot, the queues extended up to the bowling green and beyond and each visitor was issued with a coloured disk and told to leave when their session ended.

When it was cold, the lido made crushing losses.

In common with all other London lidos, Brockwell suffered badly after the GLC, the successor body to the LCC, transferred the running of lidos to the local authorities in 1971, in this case Lambeth. As maintenance levels dropped, so did attendances.

The lowest point was from 1990-94, when the lido remained closed and served as an alternative arts venue. Two former employees then won the contract to re-open it, and together with a newly formed Brockwell Lido Users Group and the Friends of Brockwell Park, launched a revival that continues to this day.

A vital part of this process was the lido's £2.5 million refurbishment and the extension of its southern flank by architects PTEa, funded by the Heritage Lottery Fund and the lido's current management team, Fusion Lifestyle, a not-for-profit organisation set up by former Lambeth and Southwark staff.

And where for many years a Mr Fry used to serve Bovril and buttered rolls by the poolside, there is now an award winning Lido Café (*right*) serving craft beers, sourdough and salads.

▶ By the time this photograph was taken in 2005, **London Fields Lido** had been closed for 17 long years.

Opened in 1932, this was the second outdoor pool, after Kennington Park, to emerge from the LCC's drawing board, and was a neighbour of a similar LCC lido, that of Victoria Park, dating from 1936.

All three were victims of local government cuts. Kennington was cleared for tennis courts in 1988, Victoria Park for a car park the year after. But London Fields was left derelict, and as long as there was a building, there was hope amongst the members of the **London Fields User Group** (whose 18 year battle has been fully chronicled on their website).

Campaign meetings were held, councillors confronted, consultants consulted and dense undergrowth cleared. At one point protesters even stood in front of bulldozers to prevent the lido's demolition.

But while they could not stop squatters turning the place into a rave venue, they did eventually triumph – no easy task at a time when Hackney Council was also facing campaigners from Haggerston indoor pool (*see page 175*), plus £25 million worth of cost overruns incurred at the Clissold Leisure Centre.

By comparison, the £2.5 million spent on the lido was a bargain.

Overseen by S+P Architects and completed in October 2006, the refurbishment created a deck level pool with disabled access (which until the Aquatics Centre opened at Stratford was the only 50m length pool in north east London).

Critically, the water is kept at a constant 25 degrees; hence the steam rising while snow lies on the surrounding parkland (*centre right*).

Run by GLL, attendances at London Fields have nearly doubled since 2007, topping 198,000 by 2012-13. Worth getting a head of steam up, for certain.

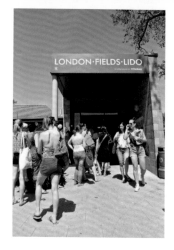

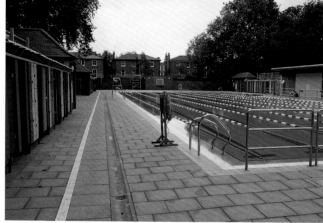

▶ On a corner of Hampstead Heath, at Gospel Oak, the Grade II listed **Parliament Hill Fields Lido** is, in architectural terms, the finest and best preserved of the 1930s pools designed and built by the LCC.

Opened in 1938 it was also the most expensive, costing £34,000 (compared with £26,150 spent at Brockwell Park the previous year). Partly this was a question of scale. With a pool measuring 200 x 90 feet and extensive sun bathing terraces at two ends, even today when tighter controls are in place, Parliament Hill Fields can accommodate 500 in the water at any one time, within a total capacity of 3,000.

The lido is also a showcase for the skills of Rowbotham and Smithson, with every elevation and detail studiously articulated, yet still using basic materials in accordance with the LCC's utilitarian ethos.

Compared with its counterparts Parliament Hill Fields has enjoyed a charmed life. Whereas every other inner London lido found itself closed at one time or another in order to save money, here the doors have never shut, other than to allow for its most recent major overhaul, in 2004-05.

For while all the other LCC lidos were transferred to the control of cash-strapped local boroughs, Parliament Hill Fields passed first to the London Residuary Body (set up after the abolition of the GLC in 1986), then to its current owners, the City of London Corporation, who have maintained it to a high standard, and been rewarded accordingly with attendances in recent years averaging 64,000.

These numbers could no doubt rise if, as at London Fields, the water was heated. But owing to the large size of the tank and the fact that it needed regular patching to prevent leaks, in 2004 the Corporation took the bold decision to insert a stainless steel tank that reduced the overall volume of water by one third and cut maintenance costs.

Some regulars were at first alarmed by this, as they had been by the loss of the diving boards, and the introduction of charges for early morning dips. Yet clearly the lido has lost none of its lure as an urban beach. Queues such as this one in August 2013 appear as redolent of the 1930s as does the very fabric of this wonderful civic treasure.

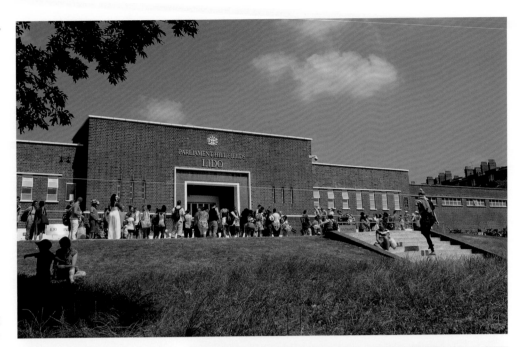

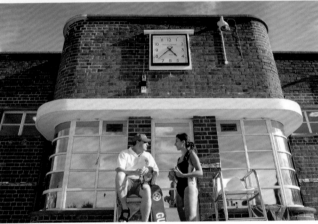

While the entrance block at Parliament Hill Fields is distinctly angular, each internal elevation features a subtly curved central bay; notably the café (*above left*) and the lido office (*above*). The Corporation has also restored or replicated various original features, including the square main clock, the aerator fountain (not shown) and the signage above the main entrance (*top*).

▲ The latest London outdoor pool to receive a makeover is **Charlton Lido** in **Hornfair Park**. Also by Rowbotham and Smithson, this was the last of the LCC lidos, having opened in May 1939, shortly before the war. Compared with its predecessors the detailing is plain, although its corner fountains, as seen here, are unusual, and its separate children's pool echoed trends in indoor pools at the time.

Following lengthy spells of closure since 1990, a £5 million revamp by new operators GLL in 2011-13 came as a huge relief to campaigners, only for their joy to be tempered by plans to rename it the **Royal Greenwich Lido**.

But, as was proven at the local football club, the people of Charlton do not give up their identity easily. The **Charlton Lido and Lifestyle Club** it is then.

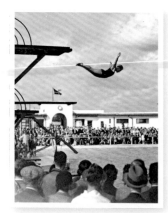

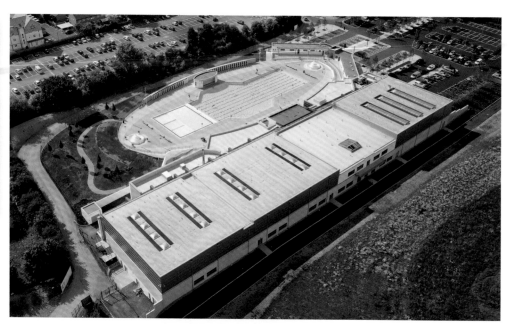

▶ While the LCC persisted with brick compounds and rectangular pools, local authorities in outer London, with only one lido to plan for, could afford larger sites and a more adventurous approach. One such example was **Uxbridge Lido**, opened in 1935 with a display of diving by **Miss Katinka 'Bobby' Larsen** (*above*), and seen here after its refurbishment in 2010.

Designed and built by the firm of George Percy Trentham, Uxbridge had the second longest pool in Greater London, at 220´ long, with a deeper, wider centre section for diving and water polo.

Following its closure by Hillingdon Council in 1984, two community groups had spells running the lido, until in 1998 it appeared to have closed for good and was left to rot for over a decade. But as at London Fields, that was not the end.

A campaign led by swimmer Duncan Goodhew, a petition to Downing Street, and the fact that the lido was listed in 1998 (*see right*), led to Hillingdon reviving the lido as part of a £31 million development, co-funded by the London Development Agency, Sport England and the Heritage Lottery Fund.

Designed by FaulknerBrowns and run by Fusion Lifestyle, the **Hillingdon Sports and Leisure Complex**, as it is now known, features a sports hall and indoor 25m pool alongside the lido, the end of which is now separated to form a children's pool, fed by heated water from the indoor pool.

In its heyday Uxbridge drew up to 300,000 visitors a year. In 2012-13, over 350,000 used the facilities, indoor and out.

Could this formula be repeated elsewhere? Actually, it already has, as seen opposite.

One unusual aspect of Uxbridge is that rather than being listed as a single entry, each structural element was listed separately in 1998: namely the entrance block (*above centre*), the two aerator fountains (*above*), the actual pool and the grandstand (*left*), with its rooftop viewing area for galas, water polo and diving displays, such as the one that opened the lido in 1935.

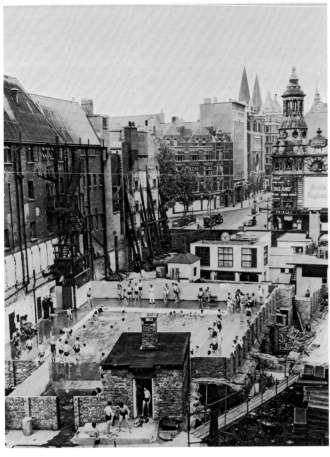

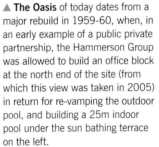

▲ Since the 1930s, only three public outdoor pools have been built in London. The latest of these, opened in Northolt in 1974 at the Compton Centre, closed in 2004, while the oldest, **The Oasis** in **Holborn**, was, ironically, originally planned as an indoor pool.

Here it is in July 1946, just after its opening. Top right is the Princes Theatre, nowadays known as the Shaftesbury.

The Oasis site has enjoyed a long association with bathing. From c.1728-1851 there was a plunge pool or *bagnio* known as Queen Anne's Bath, fed by a natural spring. In 1853 two vestries built on the site one of London's earliest public baths and wash-house. This was rebuilt in the 1890s, and was in the process of being rebuilt again when war broke out in 1939.

For the next six years the half finished and exposed main pool served as a static water tank for the fire brigade, until come peacetime, with no funds or resources to complete the works, Holborn Borough Council made the best of what they had by opening the site as a makeshift outdoor facility.

A wartime Decontamination Centre served as changing rooms. Sun terraces were created amid the muddle of half finished and bomb damaged buildings. But for all its austerity, as the 1950s wore on, with good reason Londoners started to call it 'The Oasis'.

▲ **The Oasis** of today dates from a major rebuild in 1959-60, when, in an early example of a public private partnership, the Hammerson Group was allowed to build an office block at the north end of the site (from which this view was taken in 2005) in return for re-vamping the outdoor pool, and building a 25m indoor pool under the sun bathing terrace on the left.

Opened in 1960, the latter was Britain's first metric pool. The Oasis was also the first modern complex to link indoor and outdoor pools on the same site. Initially the outdoor pool opened only in the summer, but when repairs to the indoor pool led to its temporary closure in winter 1986-87, the heated outdoor pool was kept open, and proved such an attraction that it has remained open all year round since the 1990s.

It seems such a sensible idea, yet only three other councils tried it out.

Willesden added an indoor pool next to an existing outdoor one in 1966, but closed the latter in 1987.

More successfully, in 1974 Haringey added an indoor pool at Park Road Lido, while in 1966 **Richmond** purpose-built the **Pools on the Park** (*below left*). Designed by Leslie Gooday this fine complex has since become one of three post war London pools to have been listed (in 1996).

For the other pair, we too must now head indoors...

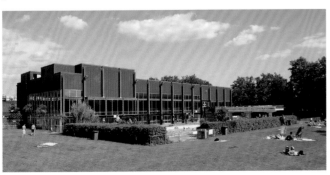

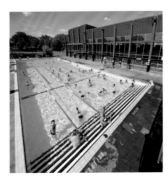

Chapter Seventeen

Indoor swimming pools

London has more functioning public baths and indoor pools that date from prior to 1939 than any other city in the world, there being 18 in the public realm and five in the private sector (one of which is at Buckingham Palace). Then there are 26 former baths buildings of the same vintage that now serve other functions. One is Hornsey Road Baths, Islington. In use from 1892–1991, its pools have been demolished but the gatehouse and laundry have been converted into an arts centre. On the side wall, its neon sign is said to be the sole survivor of twelve similar signs commissioned at various London baths in the 1930s. Before the First World War Hornsey Road clocked up 300,000 users in a year. Only two other baths in Britain were busier, both not far away, as will be revealed.

Of all the building types featured in *Played in London*, the issues that affect indoor swimming pools, and more specifically public indoor pools, are arguably the most complex, in terms of their design, functionality, management and funding.

Unarguably, they also affect the greatest number of Londoners.

That is because more people in the capital, and in Britain as a whole, go swimming regularly than play any other participatory sport, football included.

Also, swimming forms part of the national curriculum.

Patently not all swimmers care whether their pool is historic or modern, provided that it is clean, affordable, accessible and large enough (although its depth is also an issue if one dives or plays water polo).

Nevertheless, it has been evident since the 1970s, when London witnessed its first campaigns to save historic baths – on Silchester Road, North Kensington and North End Road, Fulham – that an appreciable number of swimmers feel a strong sense of ownership and affection towards what are now termed 'heritage pools'.

Heritage pools not only look different to their modern counterparts. They sound different. They are lit differently. Some would say they even smell different. And because swimmers interact with pools not as visitors but as 'users', they become, both literally and metaphorically, immersed in the historicity of their surrounds.

So what is the current status of heritage pools in London?

As of 2013, excluding those in private homes, there are thought to be around 525 indoor pools in the capital, the vast majority built since 1980. Of these, 210 or so are run commercially, while some 120 are in private clubs, in the educational sector or in residential developments.

The remainder, serving the bulk of the population, are in the public sector, totalling 193 indoor pools at 103 sites (although by 2016 this figure should have risen by an extra 14 pools, currently in development at seven further sites).

Of the 103 currently active sites, 18 have pools or buildings that date from prior to 1939 (ten of which are listed). A further 20 sites have pools from the period 1945-70 (including three that are listed).

So evenly spread across the years are London's historic pools that, with the exception of the 1940s, when no pools were built, it would be possible to swim in at least one public pool dating from each decade from the 1890s up to the present day; starting at either Dulwich or Camberwell (both 1892) and finishing up at the Clapham Leisure Centre, or even the Aquatics Centre in Stratford (both 2012).

Now there is a challenge for a charity swimathon!

From this it would appear that the capital is well endowed with heritage pools, which it is if compared with other British cities (although Edinburgh has the highest proportion per capita,

with seven dating from 1970 or earlier). Indeed, as stated on the left, no other city in the world has more historic pools than London.

True, none can quite match the Edwardian splendour of Manchester's Victoria Baths (1906), or Birmingham's Moseley Road Baths (1907), both listed Grade II*. On the other hand, whereas the Victoria Baths have been closed for swimming since 1993, and the future of swimming at Moseley Road is now under threat, Londoners can at least take comfort from the fact that between 2000-13, largely owing to pressure from user groups and conservationists, local councils and their partners (the new breed of not-for-profit leisure operators) spent at least £90m on refurbishing thirteen baths that date from before 1939.

Yet for every pool saved, campaigners and conservationists can also point to sacrifices exacted in the process; of surplus pools being demolished or converted into gyms, of Turkish baths turned into exclusive spas, of entrance blocks turned into flats, or parts of sites sold off for development.

There have been outright losses too. Again between 2000-13, eight pre-1939 public baths in London were closed or demolished. This followed the loss of six during the 1990s, eight during the 1980s, and seven during the 1970s.

As mapped on page 170, several of those baths have been adapted for other uses, as at Hornsey Road (*see left*). Indeed this adaptability is one of the strengths of historic

Atherton Leisure Centre (*right*), opened as West Ham Baths in 1934, closed in 2011. Other pools closed since 2000 include Haggerston and Acton (both 1904), Streatham (1928), Ilford (1931), Clapham Manor (1932) and Eltham Hill (1939), plus eight from the 1960s. Most are being replaced, but the toll indicates how London's stock of older pools is rapidly draining away.

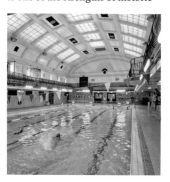

baths. Whether listed or not, being solidly built and having legions of committed supporters has proved crucial in determining their fate.

One notable exception was the aforementioned Silchester Road.

Despite being Grade II listed and garnering the support of no less a trio than Sir Nikolaus Pevsner, Sir John Betjeman and Sir Osbert Lancaster, the baths, built in 1888 and designed by Thomas Verity, were controversially demolished in 1985. Campaigners had hoped at least to save them as some form of community centre.

But for swimmers, preserving historic baths for other uses is not the issue. For them, every inch of water lost and not replaced represents a defeat.

The irony of this is that when the instigators of public baths first started to gather support in the mid 19th century, swimming was not on their agenda at all. At a time when only the very rich had access to bathrooms, and there was no such thing as a domestic washing machine, their concern was public health and cleanliness, not sport or recreation.

So how did swimming pools enter into the equation?

A more detailed account of the process can be found in *Great Lengths*, an earlier book in the *Played in Britain* series (*see Links*).

Great Lengths also contains case studies of several of the buildings featured in this chapter.

But the basics are as follows.

London's earliest indoor pools were all commercial enterprises, starting with tepid plunge pools, housed in *bagnios* (meaning baths in Italian), in the late 17th century, and with small cold baths, built for their supposed medicinal benefits. The 'Roman Bath' in Strand Lane, is a surviving example of the latter type, in central London.

The capital's first indoor baths to be advertised specifically for swimming was in Lemon (now Leman) Street, Whitechapel, in May 1742. Like all baths built over the next century this was priced at levels only gentlemen could afford; typically one shilling to swim and two shillings for an individual hot bath.

Owing to the costs and technical challenges of enclosing and heating large expanses of water, the size of early indoor pools was modest. The one at Lemon Street,

for example, measured just 43' in length, compared with the 170' long, open air Peerless Pool, completed the year after (*page 154*).

As for women, although most baths operators did allocate them specific times, only one thought fit to provide a pool for women's use alone. Measuring just 30' x 14' – compared with the adjoining men's pool of 66' x 21' – this was at the Royal York Baths, located within the central section of York Terrace East (*below*), built on the edge of Regent's Park in 1820.

The building's exterior remains unchanged but the pool areas, closed in *c.*1914, now form part of the Royal Academy of Music.

Indoor pool design took a giant leap forward in the early 1840s.

On Ashley Crescent (now Shepherdess Walk), just north of the Peerless Pool, the first class Metropolitan Baths measured an impressive 110' x 48', while alongside, with its own entrance on Wenlock Road, the second class Wenlock Bath was even larger at 180' x 30'. In fact not until the Empire Pool was built at Wembley in 1934 (*page 72*) would London have a larger pool.

Meanwhile the National Baths on Little Queen Street, Holborn, had a T-shaped first class pool, 135' long and 70' at its widest, with a viewing gallery at one end.

On July 18 1843, six years after London's first known swimming races on the Serpentine, the National staged what was possibly the world's first indoor swimming races, organised by the National Swimming Society.

In addition to first and second class pools, both the National and Metropolitan Baths had suites of individual baths, known as 'slipper baths'. The National also had a wash house, or laundry.

In that sense they offered a template for the public baths that would follow. Except that they

were both beyond the pockets of those who plainly needed their services most.

Britain at this time had only one publicly-funded baths. Built in Liverpool in 1829, it too, however, was aimed specifically at a middle and upper class clientele.

As for Britain's burgeoning working class population, as Edwin Chadwick attested in his *Inquiry into the Sanitary Conditions of the Labouring Population of Great Britain* in 1842, a lethal cocktail of damp, filth, bad air, poor water and overcrowding had produced 'an adult population short-lived, improvident, reckless, and intemperate, and with habitual avidity for sensual gratifications.'

The poor, commented one contributor to Chadwick's report, wore their dirt 'like a great coat'.

But what could be done? In Liverpool the solution, prompted by a local housewife, was for the Corporation to build the country's first municipal baths (that is, offering slipper baths, not a pool) and wash house, in 1842. But in London, with its fragmented system of local vestries rather than one single municipality, a different approach was needed.

Hence in October 1844, unaware of what had been achieved in Liverpool, the Bishop of London and the Governor of the Bank of England, William Cotton, called a meeting at the Mansion House to form the 'Committee for Erecting and Promoting the Establishment of Baths and Wash Houses for the Labouring Classes'.

Cotton's priority, and that of the 230 businessmen, philanthropists and churchmen who pledged support, was to build 'model baths' in poor neighbourhoods.

In the end only one such model building was completed, in Whitechapel (*see right*). However a parallel effort, led by another committee member, Sir Henry »

▲ On **Old Castle Street**, in **Whitechapel**, this brick arcade, lintel and date stone are the sole remnants from the first purpose-built 'model baths' designed by Price Prichard Baly in 1846, although it opened a year late in 1847 after its foundations sank into an old cesspool. The building then suffered a fire and did not re-open until 1851, and ended up costing £30,000, nearly triple the original estimate. Even then it failed, and had to be rebuilt, after which its replacement enjoyed a long life before finally closing in 1989.

In its second incarnation the Whitechapel Baths did include facilities for swimming. But a number of London baths did not, especially in areas where the local vestry could only afford to provide slipper baths and a wash house.

Among surviving examples, each listed Grade II, those on Cheshire Street, Bethnal Green (1899), and Wells Way, Camberwell (1902) now host boxing clubs (*see page 145*), while on **Flask Walk**, **Hampstead** (*below*), the **Wells and Campden Baths and Wash House** (1888), funded by a charity, is now housing.

» Dukinfield, the vicar of St Martin-in-the-Fields – a parish then riven with poverty – did achieve its goal.

This was to promote the Baths and Wash Houses Act, passed in Parliament in August 1846.

It was this single piece of legislation that would lead to the network of public baths in Britain that we know today. And yet it did not mention swimming once.

Rather, it was an act that empowered local authorities, should they wish, to borrow or raise money in order to construct public baths offering three levels of service, at prices affordable to the 'labouring classes'.

First and foremost was the provision of wash houses, for the laundering of clothes and linen.

Second was the provision of slipper baths, costing no more than one penny for a cold bath, and twopence for a warm one (clean towel included).

Thirdly, recognising that even one penny would be too expensive for some, the Act allowed for the provision of 'open bathing places'.

By 'open' the Act did not mean, as some historians have stated, 'open air'. Rather it meant bathing places, indoor or outdoor, 'where several persons bathe in the same water'. In effect, a communal bath.

Given that filtration and circulation systems would not be introduced until the early 1900s, and that 'open' baths rarely had their water changed more than once a week, the quality of the water can readily be imagined.

Take up of the 1846 Act was slow at first, so that by 1870, as reported by Dr Dudgeon (see Links), there were still only twelve public baths in the capital. But crucially, between them they had 19 baths deemed suitable for swimming.

How was this? Because the 'open baths', for all their murkiness, had proved

surprisingly popular for swimming. And because the income derived from them helped to subsidise the loss making slipper baths and wash houses, local baths commissioners started to consider building more of them.

In other words, the 1846 Act had been a law with unintended consequences.

That said, from a swimmer's perspective Dudgeon was highly critical of this first generation of public pools. Most he described as being too small, too gloomy, and too shallow. In only two, where the maximum depth reached six feet, could 'a middle-sized man get out of his depth, which is a great charm to the practised swimmer.'

In addition, the only baths of an appreciable length were private ones, such as Lambeth Baths (of which more below) and the Metropolitan and Wenlock Baths.

(The National closed in 1855, unable to compete with public baths built on nearby Endell Street in 1853. Holborn Underground station was later built on the site.)

Yet by the end of the 1870s the prospects looked quite different.

Firstly, as noted in the previous chapter, thanks to the celebrity of Captain Webb, conqueror of the Channel in 1875, more people than ever now wanted to learn to swim.

Secondly, because it took years for architects and engineers to overcome the manifold technical challenges presented by large scale baths, with their mixture of hot and cold water and wet and dry atmospheres, virtually all the early public baths were outdated within a decade or so. By the 1870s, the designs were beginning to improve, and crucially, had first class facilities that were attractive to the middle classes.

In this respect Lambeth Baths, opened in 1853 on Westminster Bridge Road and funded by a mix of private capital and charitable

donations, proved to be one of the most influential models of all.

Designed by AH Ashpitel and John Whichcord, Lambeth had first and second class pools measuring 122' and 133' respectively, and as a result became the capital's new hub of competitive swimming.

(Its rival, the Metropolitan Baths did stay in business, nevertheless, until c.1905. A play area on Sturt Street now occupies the site.)

One other factor in Lambeth's success was its company secretary, George Cape, who made sure to schedule in a series of crowd pleasing events. In 1861, for example, Lambeth became the first baths in Britain to admit women as spectators to one of its 'water fêtes', or galas. In 1879 Captain Webb competed in a six day marathon at the baths, an event in which the young Agnes Beckwith also appeared. (Her father Fred, the 'Professor', was 'swimming master' at Lambeth.)

In short, Lambeth demonstrated both the potential of large scale pools, and the popularity of swimming as a spectator sport.

It is also believed to have been the first baths where ropes were used to separate lanes.

Another example set by Lambeth was that in order to save on heating bills during the winter, it emptied both its pools and hired out the space for sports and events. One image from 1868 shows cricket nets set up. Another from 1881 shows a gymnasium and running track in use.

It was partly to enable public baths to follow Lambeth's example that in 1878 the 1846 Act was amended. From then on, local authorities would be permitted to close their pools for up to five months a year, between November and March. The only proviso was that they could not then hire out the pool halls for

music or dancing. Only 'healthful recreation' would be permitted.

Thus public baths took their first steps on the road to becoming what we now call 'leisure centres'; that is, buildings designed to house both wet and dry sports.

Also in 1878 municipalities were allowed to increase their charges to a maximum of 8d for first class pools. This was still less than private operators were charging, but combined with the concession for winter closures the 1878 amendments encouraged more vestries to take the plunge.

From a total of 14 public baths in 1879, with 25 pools between them, by 1914 London's total had shot up to 45 sites with 104 pools. Moreover, 19 of those pools were for women (albeit they were all still smaller than the men's).

If taking in outer London areas also – that is, the area covered by modern day London – the total by 1914 was 68 sites and 138 pools.

By then a further change to the legislation, in 1896, extended the activities permitted in baths during the winter to allow for music and dancing, provided a licence could be obtained from the LCC. This explains why at baths built in London after 1896, separate entrances and lobby areas were created to meet the licensing requirements. At Kentish Town the words 'Public Hall' can still be seen over the doors. Other baths, such as Seymour Place, also still have in place the proscenium arches and stages built for winter performances.

How baths evolved otherwise forms the theme of the rest of this chapter, starting with London's oldest baths, dating from 1892.

At that time designers had to cater for a myriad of distinctions; first class and second class, male and female, swimmers this way, slipper baths the other, wash house at the side. Plus of course waiting rooms, boiler rooms and staff rooms.

Along with libraries, schools, hospitals and parks, public baths now formed one of the cornerstones of civilised urban existence.

In that sense they transcend sporting heritage.

And yet had it not been for the popularity of swimming, it is doubtful that any of them would have survived to the present day.

Once public baths emerged in the 19th century, private pools struggled to compete. But this did not deter EH Blunt from investing £11,000 in building the Stanley Hall and Marble Baths on Junction Road, Tufnell Park. Opened in April 1885, there was a 60´ pool on the ground floor, with a public hall upstairs. In 1909 the pool was converted into a cinema. Today the building is a music venue.

▲ Dating from between the wars, this is a blazer badge of the **Otter Swimming Club**, formed at Marylebone Baths in 1869.

The date is significant, because of 117 swimming clubs currently active in the capital, only the Serpentine SC, formed in 1864, is older (*page 156*). Also, 1869 was the year in which representatives of various London clubs, Otter included, met at the German Gymnasium to form the body that would eventually become the Amateur Swimming Association (now known as British Swimming).

Two other important aquatic bodies formed in London were the Amateur Diving Association, in 1901 and, in 1908 during the Olympics, at the Manchester Hotel on Aldersgate Street, the International Amateur Swimming Federation. Better known as the Fédération Internationale de Natation Amateur (FINA), its first secretary was George Hearn, from Weston-super-Mare.

In common with most swimming clubs, Otter runs its competitions on a handicap basis, to encourage swimmers of all abilities. To reflect this its most important artefact is the George Rope 'Average' Trophy, awarded annually since 1911 to the member with the highest cumulative total of place points.

Currently with around 375 members, the Otters were based for years at the Chelsea Manor Baths, but nowadays divide their activities between six pools, so difficult has it become for clubs to book 'water time' in the capital.

Also of note are the **Halliwick Penguins SC**, based at the Southgate Leisure Centre. Formed in 1951, Halliwick was the first ASA affiliated club to cater for swimmers with disabilities.

Similarly, formed in 1961 at the Seymour Baths in Marylebone, the **Seymour Synchro Swim School** was Britain's first affiliated club to take up synchronised swimming. Its founder was Dawn Zajac, a trapeze artist who had learnt about this new form at the Hollywood Athletic Club in Los Angeles.

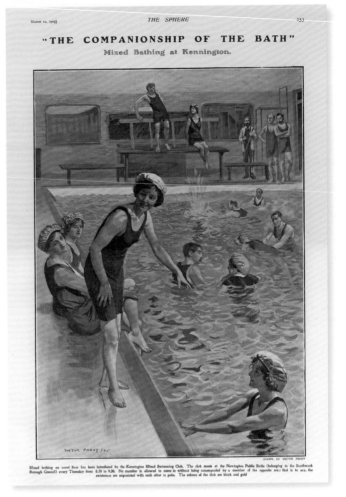

MARCH 11, 1905] THE SPHERE 253

"THE COMPANIONSHIP OF THE BATH"
Mixed Bathing at Kennington.

Mixed bathing on novel lines has been introduced by the Kennington Mixed Swimming Club. The club meets at the Newington Public Baths (belonging to the Southwark Borough Council) every Thursday from 8.30 to 9.30. No member is allowed to come in without being accompanied by a member of the opposite sex; that is to say, the swimmers are acquainted with each other in pairs. The colours of the club are black and gold.

▲ After Bexhill became Britain's first seaside resort to permit mixed bathing, in 1901, the first public baths to follow suit was **Manor Place in Walworth**, as featured here in *The Sphere* in March 1905.

Sessions were limited to one hour a week, and only members of the Kennington Mixed Swimming Club could gain entry. Unaccompanied males were excluded.

By 1914 mixed sessions had caught on at Silchester Road and Kentish Town, where the rules were specific. Bathers had to wear dark costumes with drawers underneath. Males and females had to enter and leave the water on their respective sides of the pool and proceed directly to their cubicles (the doors of which were shielded behind curtains). Once dressed they had to 'leave the building without delay'.

In the 1920s mixed bathing was adopted at the Chiswick open air pool in Duke's Meadows, and by the 1930s was routine at all lidos.

Even so, only after World War Two did mixed sessions become the norm in public baths, while more recently, single sex sessions have returned in some areas of London at the request of members of the Muslim community.

Another
INTER - CLUB - COMPETITION
(under A.S.A. Laws)
PENGUIN - OTTER - PLAISTOW

SUTTON.

FFRENCH-WILLIAMS.

BELL.

The Three most prominent Clubs in the South of England.
PENGUIN — Holders of the Hudson Memorial Trophy
OTTER — Team Swimming Champions of England
PLAISTOW — Water Polo Champions of England

DOVE.

MITCHELL.

TEMME.

PEARMAN.

The programme consists of a triangular contest between the A and B teams of the three clubs, and will include :—

SUMMERS.

PASCOE.

INDIVIDUAL RACES OVER THE THREE STYLES.
TEAM RACE OF 10 A SIDE.
MEDLEY RACES.

MILTON.

C. T. DEANE

WATER POLO.

Supported by :

Thrilling display of difficult dives by the Highgate Diving Club's aspirants for Olympic Honours.

FORDHAM.

WAGSTAFF.

Exhibition by England's foremost Lady Divers.

MARTIN.

BEVERIDGE.

FRIDAY, 13th. March 1936.
7.45 p.m. for 8.15 p.m.

RAY.

LARSEN.

MARSHALL ST. BATHS, W.1.

MATHER.

Admission (including tax) :
Numbered & Reserved 2/- Unreserved 1/6d. Rover 1/-

LOVELY.

Obtainable from :
L. PICKERING, 9, Blackburn Road, N.W.6.
H. M. WAGSTAFF, "Blandings" Highwood Hill, N.W.7.
W. B. LOVELY, 66, Woodlands Avenue, Wanstead, E.11.
Westminster Public Baths, Marshall Street, W.1.

O'CONNOR.

Inter-club meetings such as this (*left*) were great earners for local councils, and typically ended with water polo, a sport invented in the 1870s to add zest to galas. Formed in 1889, the London Water Polo League is thought to be the oldest in the world. Among its current members are West London Penguin SC, whose team in 1926 (*right*), based at Lime Grove, were national champions.

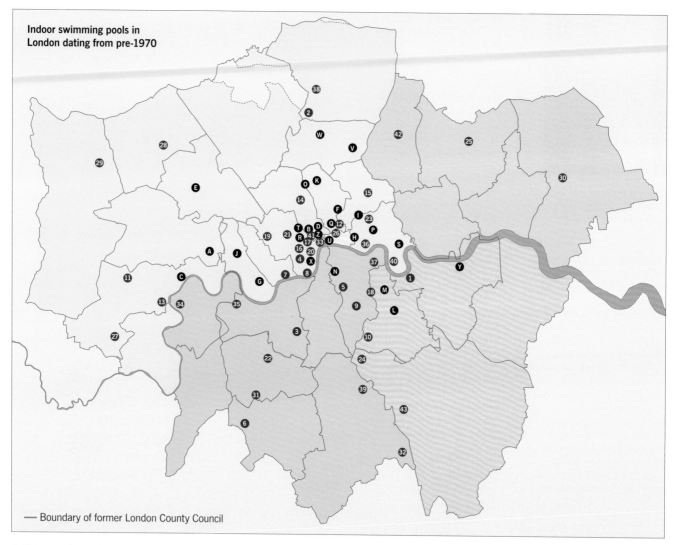

Indoor swimming pools in London dating from pre-1970

— Boundary of former London County Council

▲ This map shows the location of **indoor swimming pools** that were built within the boundaries of modern London prior to 1970 and were extant as of 2013.

In **blue** are pools still in use; from both the public and private sector prior to 1939, and in the public sector only from 1945-70.

In **black** are pre-1939 pools from all sectors (public, private and educational) where all or part of the structures are extant.

School pools are not included.

* denotes Grade II listed
** denotes Grade II* listed
† denotes facility built by private interests/educational institutions (ie not local authority)
§ denotes listed on Heritage at Risk register as of 2013

Public baths and indoor pools built prior to 1939, in use as of 2013:

1. **Arches Leisure Centre** Trafalgar Rd SE10 (1928)
2. **Arnos Pool*** Bowes Rd N11 (1939)
3. **Balham Leisure Centre** Elmfield Rd SW17 (1915)
4. **Buckingham Palace†** SW1 (1938)
5. **Camberwell Leisure Centre*** Artichoke Place SE5 (1892)
6. **Cheam Leisure Centre** Malden Rd SM3 (1938)
7. **Chelsea Sports Centre*** Chelsea Manor St SW3 (1907)
8. **Dolphin Square†** Chichester St SW1 (1937)
9. **Dulwich Leisure Centre*** Crystal Palace Rd SE22 (1892 with 2010 entrance)
10. **Forest Hill Pools** Dartmouth Rd SE23 (1885 entrance with 2012 pools)
11. **Heston Pool** New Heston Rd TW5 (1938)

12. **Ironmonger Row Baths*** Norman St EC1 (1931-38 with 2010-12 renovations) *(below)*
13. **Isleworth Leisure Centre** Twickenham Rd TW7 (1939 with 2010-11 renovations)
14. **Kentish Town Sports Centre*** Prince of Wales Rd NW5 (1901 with 2008-10 renovations)
15. **King's Hall Leisure Centre*** Lower Clapton Rd E5 (1896 with 1990 renovations)
16. **Lansdowne Club†** Fitzmaurice Place W1 (1935)

17. **Marshall Street Leisure Centre*** Marshall St W1 (1931 with 2010 renovations)
18. **Pioneer Health Centre†**** St Mary's Rd SE15 (1935)
19. **Porchester Centre*** Queensway W2 (1925)
20. **Royal Automobile Club†**** Pall Mall SW1 (1911)
21. **Seymour Leisure Centre*** Seymour Place W1 (1937)
22. **Wimbledon Leisure Centre** Latimer Rd SW19 (1901)
23. **York Hall Leisure Centre*** Old Ford Road E2 (1929, with second pool, 1967, not listed)

Pools 1945–70, in use as of 2013:

24. **Crystal Palace National Sports Centre**** SE19 (1964)
25. **Fulwell Cross Leisure Centre** High St, Barkingside IG6 (1968)
26. **Golden Lane Leisure Centre*** Fann St EC1 (1962)
27. **Hanworth Air Park Leisure Centre** Feltham TW13 (1964)

28. **Harrow Leisure Centre** Christchurch Ave HA3 (1967)
29. **Highgrove Pool & Fitness Centre** Eastcote Rd, Ruislip HA4 (1964)
30. **Hornchurch Sports Centre** Harrow Lodge Pk RM11 (1957)
31. **Morden Park Pools** London Rd SM4 (1968)
32. **New Addington Leisure Centre** Central Parade CR0 (1963)
33. **Oasis Sports Centre** Endell St WC2 (outdoor pool 1946, indoor pool 1960)
34. **Pools on the Park*** Twickenham Rd TW9 (1966)
35. **Putney Leisure Centre** Dryburgh Rd SW15 (1968)
36. **St George's Leisure Centre** Shadwell E1 (1969)
37. **Seven Islands Leisure Centre** Lower Rd SE16 (1965)
38. **Southgate Leisure Centre** Winchmore Hill Rd N14 (1965)
39. **South Norwood Leisure Centre** Portland Rd SE25 (1969)
40. **Tiller Leisure Centre** Tiller Rd E14 (1966)
41. **University of London Union**† Malet St WC1 (1952)
42. **Waltham Forest Pool** Chingford Rd E17 (1962)
43. **West Wickham Leisure Centre** Station Rd BR4 (1967)

Pre 1939 baths and pools no longer in use but with significant structural elements extant:

A. **Acton Baths** Salisbury Rd W3 (1904-2011) chimney* retained within new leisure centre (*below right*)
B. **Bourne & Hollingsworth Ladies Hostel**† Gower St WC1 (1927-74) then 52 Club for UCLH staff (1974-2011) future of pool pending
C. **Brentford Baths***§ Clifden Rd TW8 (1896-1990) part residential
D. **Coram Community Campus**† Mecklenburgh Square WC1 (1900) now offices
E. **Empire Pool**†* Empire Way HA9 (1934-48) in use as Wembley Arena
F. **Essex Road Baths** Tibberton Square N1 (1895-1984) section of ironwork extant on Tibby Place Park (*above right*)
G. **Fulham Baths*** North End Rd SW6 (1902-81) entrance block and rear sections extant, now dance studios
H. **Goulston Street** E1 (1878-39) bombed WW2, Old Castle St

frontage extant, housed Womens' Library (2002-13), future pending
I. **Haggerston Baths***§ Whiston Rd E2 (1904-2000) now boarded up, future pending
J. **Hammersmith Baths** Lime Grove W12 (1907-c.1980s) front block now residential
K. **Hornsey Road Baths** N7 (1892-1991) front block, laundry, chimney and neon sign extant, now arts centre, nursery & residential (*right*)
L. **Ladywell Baths***§ Ladywell Rd SE13 (1885-c.1965) later gym, pending conversion to community centre
M. **Laurie Grove Baths*** SE14 (1898-1991) now art studios for Goldsmiths College
N. **Manor Place Baths*** Walworth SE17 (1895-1978) front block now Buddhist centre, pool hall was recycling centre, pending redevelopment 2014
O. **Marble Baths** at **Stanley Hall** Junction Rd N19 (1885-c.1905)
P. **Mile End Road Baths** Whitechapel E1 (1932-81) front block extant, now health centre
Q. **Northampton Institute**†* St John St EC1 (1896-1995) now 'The Pool' law library, City University London
R. **Polytechnic**† Regent St W1 (1910-c.1982) now lounge at University of Westminster
S. **Poplar Baths***§ East India Dock Rd E14 (1934-88) re-opening pending
T. **Royal York Baths** part of York Terrace East* NW1 (1820-c.1914) now part of Royal Academy of Music
U. **St Bride Institute***† Bride Lane EC4 (1893-1994) now Bridewell Theatre
V. **Tottenham Baths*** Town Hall Approach N15 (1905-98) front block now arts centre, chimney extant (*above right*)
W. **Western Road Baths** Wood Green N22 (1911-97) now The Decorium function suite
X. **Westminster Baths** SW1 Great Smith St (1893-c.1970s) now Abbey Centre/Wash House Café
Y. **Woolwich Baths** Bathway SE18 (1894-c.1982) now University of Greenwich performing arts centre
Z. **YWCA Baths** Great Russell St WC1 (1932-2001) now part of Bloomsbury Hotel

▲ As was once the case with floodlights at football grounds, the chimneys of public baths often stood sentinel above the rooftops.

At **Hornsey Road** (K on map), where the swimming pools closed in 1991, a year short of the baths' centenary, the restored but now merely decorative chimney finds itself artfully encased within the glazed atrium of **Tiltman Place** (*top left*), a residential development named after the baths' architect, AH Tiltman.

Similarly the Edwardian chimney of **Tottenham Baths** (V) now looks down on the **Bernie Grant Arts Centre** (*top right*), built on the site in 2007.

As at Hornsey, the baths' former entrance block has been retained as part of the arts centre.

Another chimney preserved is that of **Acton Baths** on Salisbury Road (A). Opened in 1904, the baths were demolished in 2012, but the unusual, Grade II listed chimney (*below left*) – a square, tapering design with terracotta detailing at its crown – will be incorporated within a new leisure centre due to open on the site in 2014.

Back in Islington, another former baths building designed by AH Tiltman was on **Essex Road** (F), backing onto Tibberton Square.

After its closure in 1984, sections of the ironwork, thought to have been from the ladies' pool and wash house, were re-erected in a park created on the site.

Known as **Tibby Place** (*above*), it is bordered by Laundry Lane.

▶ The oldest baths building in London which still serves the needs of a functioning swimming pool – actually two pools, both of them modern – is the entrance block of **Forest Hill Baths**, now **Forest Hill Pools**, in **Lewisham**, designed by H Wilson, Son & Thomas Aldwinckle, and opened in 1885.

One sign of affluence in the area was that at neither these baths, nor at those on nearby Ladywell Road, were wash houses provided.

When Forest Hill Baths were closed owing to structural defects in 2006 campaigners feared that the whole building would be lost, especially after it was turned down for listing. However, as has often been the case, the entrance block remained comparatively robust.

Added to this, the baths form part of an historic townscape on **Dartmouth Road**, including Louise House (an 'Industrial Home' for disadvantaged girls), Holy Trinity Church School and Forest Hill Library. To maintain the integrity of this group and retain swimming on the site, a modern, two pool leisure centre was therefore erected, as seen here, both at the rear and to the side of the entrance block.

Costing £10 million and opened in 2012, the architects were Roberts Limbrick, who had earlier revamped another Aldwinckle design, that of Kentish Town Baths (*page 174*), and whose work at Allianz Park is featured elsewhere.

As for **Ladywell Baths**, designed by the same architects as Forest Hill and also opened in 1885, they were built next to the local parish hall and church (*below right*), thereby prompting one reporter to describe the set up as 'cleanliness next to godliness'.

After closing for swimming in 1965 the building served as a gym, but then lay derelict until restoration of the building as a community hub was started by the Ladywell Tower Trust in 2012.

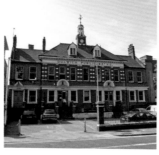

▲ While only the entrance block at Forest Hill survives, two miles to the north, **Dulwich Baths** on **East Dulwich Road** has London's oldest functioning indoor pool... oldest, that is, by a matter of weeks.

Opened in June 1892, Dulwich was one of a pair of baths designed by Henry Spalding and Alfred Cross for the Vestry of Camberwell.

Camberwell Baths, in **Artichoke Place** (*opposite*), also still in use, followed in October 1892.

The Vestry had been advised to choose sites located on main roads; for ease of access, to create a commanding presence and to enhance the baths' viability when hired out as a public hall in winter.

But even in the late 19th century such sites were hard to find, let alone afford, which is why at both Dulwich and Camberwell the sites eventually chosen were long, narrow and hemmed in on both sides.

Behind each grand entrance block, first and second class pools were built, one behind the other, with facilities such as slipper baths tucked into the remaining nooks and crannies.

So tight was the site at Dulwich that there was literally only a few inches between one corner of the second class pool and the rear boundary wall.

Lack of space also meant that the ground floor level was raised

a few feet, to allow for boilers and an establishment laundry to be installed in the basement.

This was to have implications for the baths' recent refurbishment.

In 1990 the building was saved from closure after pressure by local campaigners. In 1993 it was listed Grade II (as was Camberwell).

In 2002 the centre's new operators, Fusion Lifestyle, injected new life by ripping out a 1970s suspended ceiling to reveal the original timber hammerbeam roof over the main pool, which was now a gym (*above centre*). Fusion also converted the former ladies slipper bath area into a crèche.

But when a further £6.1 million phase of works drawn up by architects Watkins Gray was carried in 2009-11, in order to provide step free access, a new entrance had to be provided at the rear of the site, on **Crystal Palace Road** (*above*), leaving the grand old entrance somewhat high and dry.

Used mainly for offices and meeting rooms, the block also houses a men's slipper baths section, kept intact for posterity, and one of only two of its kind left in the capital (the other being at Ironmonger Row, designed by Alfred Cross's son, Kenneth).

Parish Hall, and Baths, Ladywell.

▶ If space is at a premium at Dulwich, it is even tighter a mile north at **Artichoke Place**, where the restored façade of Spalding and Cross's Grade II listed **Camberwell Baths** masks a warren of facilities crammed into interlinking blocks.

Even more so than at Dulwich, the baths appeared doomed at one point, especially after Southwark opened the flagship £12 million Pulse Leisure Centre in Peckham in 1999, barely a mile away. But Camberwell users refused to give up, until in 2007 Southwark agreed to a partial makeover that would at least extend the life of the Victorian baths by a further decade or so.

Completed between 2010-13 and costing over £5 million, as at Dulwich the work was overseen by Watkins Gray architects.

The set up at Camberwell is the opposite of Dulwich; that is, the pool retained for swimming (*right centre*) is the former first class, rather than the second class pool. As seen, a boom divides the original tank into a 25m standard pool, with a smaller learner pool alongside.

As may also be seen, the timber hammerbeam roof at Camberwell is identical to the one at Dulwich.

Behind this pool, the former second class pool is now the Jubilee Sports Hall (whose renovation was funded by £490,000 from the Olympic Legacy Fund), while across the corridor is a dance studio whose original roof structure, once part of the wash house, has been exposed and restored.

Further to the rear, another redundant area has been converted into the Camberwell Youth Centre.

North of the river, meanwhile, behind-the-scenes changes effected in the 1990s have extended the life of another hardy survivor.

As at Dulwich and Camberwell, at the **Kings Hall Leisure Centre**, (originally **Hackney Baths**), the listed Portland stone frontage, on **Lower Clapton Road** (*below*)

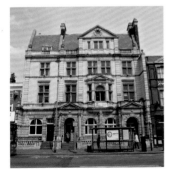

presents a relatively compact and unaltered street frontage, behind which lies a complex of assorted buildings from different periods, filling almost an entire block.

Designed by Edward Harnor and Frederick Pinches and opened in 1897, Hackney had three pools, one of which remains in use, the other two having been converted to dry sports. The smaller of these, the former ladies pool (because ladies' pools usually were smaller), retains its timber hammerbeam roof.

In other parts of the complex now taken up with changing rooms, gyms and studios, there were originally 73 slipper baths for men, 33 for women, and 24 vapour baths. Other London baths were larger, yet Hackney, the only baths in the borough at the time, was the busiest in Britain.

In the year 1913-14, 380,740 users were recorded, 51 per cent of whom swam in the pools.

From the same era, **Wimbledon Baths** has also undergone internal restructuring, while at the same time managing to look almost entirely original from the street; in this case, a quiet residential street, **Latimer Road** (*below right*).

Opened with a single pool and slipper baths in 1901, a second pool was added in 1929, along with sea brine baths, solarium baths 'a boon to the business man and woman who cannot take proper exercise', and pine baths 'especially beneficial after vigorous exercises and games'.

Also provided was a club room and a 25 yard rifle range for local sea cadet and air training corps.

In the 1960s, a learner pool and café were added, and, as was the fashion, false ceilings added over the 1901 pool.

Since then, Merton Council and the centre's operators GLL have undertaken two further modernisations. These have included the conversion of the 1929 pool into a gym (but leaving the original roof and balconies extant), and, in 2013, the creation of a spa; the modern equivalent of those treatments so extolled in 1929.

No doubt in each of the cases shown here, it could be argued that modern leisure centres might have proved more cost effective. Yet equally each shows just how flexible, and also, how robust the original buildings have proved to be over more than a century of use.

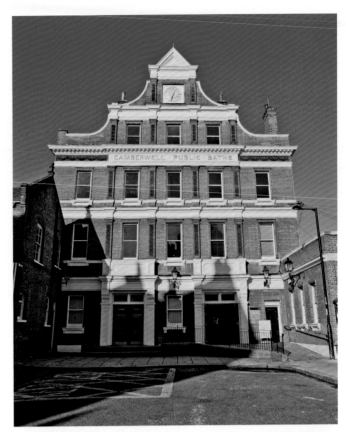

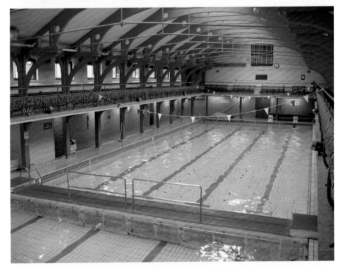

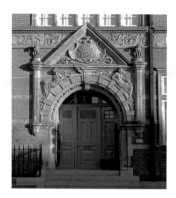

▶ Glowing in the aftermath of a £25.3 million refurbishment, completed in 2010, is the largest, and finest of London's surviving Victorian water palaces, the Grade II listed **St Pancras Baths** on **Prince of Wales Road**, now known as the **Kentish Town Sports Centre**.

The centre stands as a beacon for all those conservationists, and indeed swimmers around Britain who believe that, like the wonderfully restored St Pancras railway station a mile and half to the south, facilities of this age can still provide a public service.

Of course it helps that, in its hour of need, Kentish Town gathered some influential friends, including various celebrities and the then Culture Secretary Tessa Jowell.

That its future also became a hotly contested local election issue in 2006, when Camden's Liberal Democrats made its full restoration a key part of their winning manifesto – was also crucial.

As was the fact that Camden was able to claw back some of the costs by converting the two upper floors of the entrance block into flats and by clearing a plot behind the baths to make room for town houses.

No question, had a decision on the baths' restoration been delayed only by a year or so, once the credit crunch started to bite, the scheme might never have gone through.

But it did, and the figures tell their own tale. In 1913-14 Kentish Town was Britain's second busiest baths with 315,513 users, including 170,329 swimmers in its four pools.

Since its refurbishment, in 2012-13 Kentish Town attracted an astonishing 417,149 visitors overall, including 272,000 swimmers to its three pools – this despite the presence a mile and a half away of Swiss Cottage Leisure Centre, rebuilt by Camden a few years earlier at a cost of £27 million.

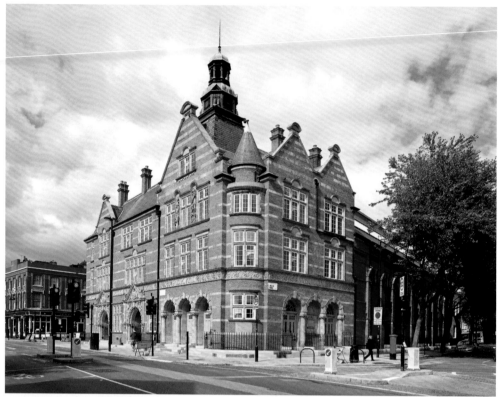

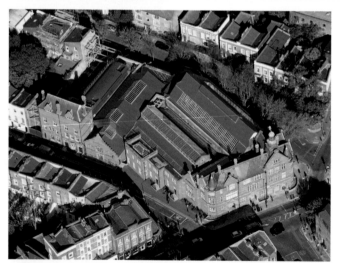

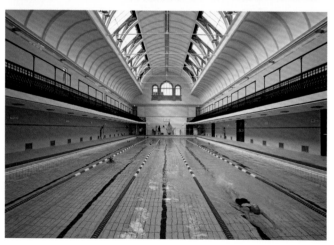

◀ Designed on an awkward site by Thomas Aldwinckle and opened in 1901, **St Pancras Baths** originally consisted of four pools (two for men, two for women), 129 slipper baths and a wash house. As late as the 1970s it required 23 staff simply to maintain the building.

Three of its pools still function, the largest being the **Willes Pool** (*below left*), named after Willes Road, with which it runs parallel. This, the best preserved internal feature after wholesale changes effected in the 1960s, has a distinct roof structure whose trefoil profile – hidden for 40 years by a suspended ceiling – was designed by Aldwinckle to lessen the echo so common in Victorian pools.

The second class Grafton Pool, meanwhile, has a new suspended ceiling, with a gym and studio on the mezzanine floor created above.

Unusually for London, although it was common in other cities, the water for the pools is drawn from one of the baths' original 140m deep bore holes. Even better, using modern heat exchange technology, cool air from the bore hole is now used both to cool parts of the building and to heat the water, thereby saving energy costs.

Another St Pancras example of 19th and 21st century technology combining for the public good.

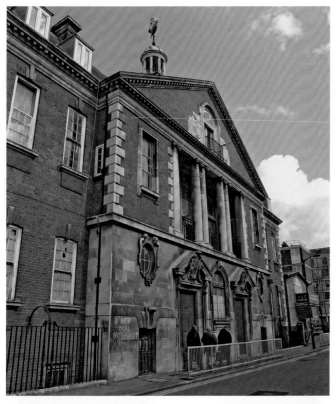

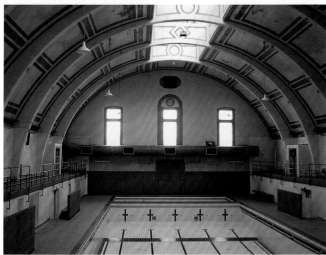

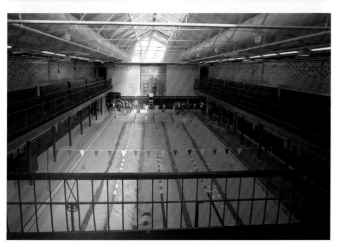

◄ Compared with Camden, swimmers in Hackney have endured rather choppier waters in recent decades. London Fields Lido, it will be recalled, was closed for 18 years before returning to action against all the odds in 2006 (see page 162).

Fourteen months later Clissold Leisure Centre opened eight years behind schedule after its costs had rocketed from £7 million to £45 million. Over in Newham, meanwhile, Hackney swimmers could hardly fail to notice that the cost of the Olympic Aquatics Centre had also shot up, to £280 million.

And all the while in the midst of this, boarded up since February 2000, lies **Haggerston Baths**.

Seen here from **Whiston Road** (although the northern elevation on Laburnum Street is also richly detailed), Haggerston was opened by Shoreditch Council in 1904, with a single pool, 91 slipper baths and a wash house. At the time it was said that fewer than one in 20 local homes had access to a bath, while half a mile away, still in Shoreditch, Hoxton Baths on Pitfield Street was the fifth busiest baths in Britain.

Miraculously, Haggerston Baths survived the Blitz, despite houses on either side of it being flattened. Hoxton Baths did not, and now all that remains are two sections of white tiled party walls; of the former second class pool, backing onto the Passmore Edwards Library (now the Courtyard Theatre) on Bowling Green Walk, and of the first class pool, backing onto the former Shoreditch Electricity Generating Station (now used by Circus Space), on Coronet Street.

The latter building, incidentally, generated electricity by incinerating refuse (or 'dust' as it was called), and enabled Hoxton to become one of the first baths in Britain to be powered by electricity.

Hoxton Baths was important in architectural terms too. Opened in 1899 and designed by Henry Spalding and Alfred Cross, it incorporated several design ideas that marked the transition from the Victorian baths of the 1890s to the more progressive ones of the Edwardian period.

So five years later, when it came to Haggerston, Shoreditch entrusted the task solely to Alfred Cross.

In 1906 Cross laid out the ideas he introduced at Haggerston in his seminal work, *Public Baths and Wash Houses (see Links)*

One was to create 'amphitheatre seating' at pool level, with changing cubicles behind the rear, upper level of the seats. This was to create a more intimate atmosphere at galas and winter events (boxing being the favourite).

Another innovation, copied from Hoxton, was for the pool roof to be arched and plastered, with recessed skylights, thereby softening the ambient light and lessening the echo that plagued baths with exposed steelwork. Cross also trialled the use of non-slip rubber surfaces.

Not all his ideas succeeded. The poolside seats, for example, were removed in 1964, to create the pool surrounds as seen left (in 2003).

But the building's other qualities, and Cross's status were enough for Haggerston to be listed in 1988.

After it was closed in 2000 a campaign to re-open it started immediately, until after ten years of community action and hard graft, in 2010 it appeared as if renovation works were about to begin. A grant of £5.1 million had been secured towards overall costs of £21 million. Architects had been appointed.

But then came the credit crunch.

At the time of going to press, the Haggerston Pool Community Trust was dusting itself down for renewed action, all too aware that elsewhere in London a number of other historic baths had indeed re-opened their doors, but, as will become apparent overleaf, not for swimming.

Just off King's Road on Chelsea Manor Street, the main pool (*left*) of the Grade II listed Chelsea Sports Centre (*right*), received a £700,000 revamp in 2008. When opened in 1907 the baths had two pools (one now a sports hall), two sections holding 90 slipper baths (one now a gym) and no wash house. It cost £33,000 to build, compared with the £60,000 spent on Haggerston in 1904.

◀ It will be of scant consolation to campaigners in Haggerston, or indeed their counterparts elsewhere in Britain (including Newcastle, Manchester, Birmingham, Glasgow and Aberdeen) that a number of former baths buildings in the capital have gained a new lease of life that does not involve swimming.

Opened in 1894, **Woolwich Baths** was taken over after its closure in 1982 by Thames Polytechnic – founded in 1890 as the Woolwich Polytechnic, and now the **University of Greenwich** – to house their student union. It has since been converted into the university's **Centre for Performing Arts**, known as **'The Old Baths'**.

Designed by the ubiquitous Woolwich architect HH Church, its main frontage on **Bathway** (*top left*) is little altered apart from the restyled main entrance, which features etched windows, possibly from the 1930s (*above right*).

Opened in 1893 on **Great Smith Street**, the **Westminster Baths and Wash House** (*left*) is now the **Abbey Conference Centre**, while the adjoining Westminster Public Library, built as part of the same complex and by the same architect, FJ Smith, is an Indian restaurant.

A plaque by the entrance recalls that baths had originally been built on the site in 1851, two of the local vestries having jointly adopted the 1846 Act only months after it was passed.

Owing to its position close to the centre of government, and to its enterprising superintendent, Charles Newman, Westminster was one of the most fashionable and best kept baths for swimming and aquatic entertainments, especially water polo. Hanging ferns added style. Splash curtains protected spectators. Water sprays cooled the air, and in the pool, a great favourite with swimmers was a water chute, an idea Newman borrowed, he said, from a diving show at Olympia.

An indication that not all its users were affluent was the provision of a second class pool, 63 slipper baths and a wash house, said to have been popular with local flower girls.

Both Westminster's pools were demolished in the 1970s, although skylights from other sections can be seen if visiting the Wash House Café inside the Abbey Centre.

One of Britain's earliest pool campaigns was fought over **Fulham Baths** on **North End Road**. Built in 1902 and now Grade II listed, the baths were occupied by protestors for thirteen months in 1979-80.

Its entrance block (*left*), a

glorious mish-mash of pseudo-classical forms, by E Deighton Pearson, is now home to the **Dance Attic Studios**. Most of the baths structures behind have been demolished, but a section of tiled wall survives at the rear, where there is now housing on St John's Close.

All over Britain a number of former baths have been converted into churches or faith centres.

On **Manor Place** in Southwark, the Grade II listed front block of **Newington Baths**, built in 1895 and closed in 1978, is currently a Buddhist Centre (*above*).

The gates to Laurie Grove Baths in New Cross (left and right), in use from 1897–1991 and now part of Goldsmiths College, show how men and women were channelled into seemingly identical sections. Yet men were allocated four times more hours of swimming. In the 1950s and '60s the gala pool, now studios, doubled in the winter as a club for the area's growing Afro-Caribbean community.

▲ Opened in 1893 primarily for the benefit of print workers in and around Fleet Street, the **St Bride Foundation Institute** on **Bride Lane** was among several educational and social institutions built by charitable organisations during the late 19th and early 20th centuries to include within their plans a swimming pool.

Measuring 75' x 27', it was until Golden Lane opened in 1962 (*see page 184*) the only affordable pool for workers or residents within the City (the nearest otherwise being at St George-in-the-East, in Wapping, or Endell Street, Holborn).

Designed by RC Murray and listed Grade II, the Institute building – a 'hidden gem' if ever there was, tucked between office blocks on New Bridge Street and St Bride's Church – also provided eight slipper baths and a laundry, much needed for workers in the notoriously grimy print industry.

On upper floors there was a gymnasium, classrooms, a print museum and two libraries, one of which housed, and still houses, the unique William Blades collection.

In sporting circles the Institute became known between the wars for table tennis (Fred Perry played there). In the late 1950s its Spur Gym was well known amongst weight lifters (*see page 139*).

But while the building and most of its social and educational facilities have remained in use, in 1994 the pool was converted into the **Bridewell Theatre**.

Happily the original iron columns and balcony railings of the pool gallery remain in view, and in the adjoining bar can be seen the drying racks from the laundry.

However, as seen top right there occurred in January 2011 a rare chance to see parts of the original pool tank briefly exposed.

This was courtesy of the **Offstage Theatre** company, which took splendid advantage of the setting for its staging of *Amphibians*, a play examining the life of elite swimmers, written, appropriately enough, by Steve Waters.

◀ From the same period and sector, the **Northampton Institute** on **St John Street, Clerkenwell** – now **City University London** – was opened in 1896 for 'the promotion of the industrial skill, general knowledge, health and well-being of young men and women belonging to the poorer classes.'

Designed by EW Mountford and now listed Grade II, the Institute housed a pool and gymnasium in a single storey range on the north eastern side of the triangular site.

In 1908 the pool was used by swimmers training for the Olympics at White City, while the Great Hall, now a lecture theatre, staged the actual Olympic boxing tournament, held on a single day.

War time damage saw the gym demolished and the pool re-roofed, as seen here in the 1960s.

Since its closure in 1995, the space has been converted into **The Pool**, a library for law students in which the former cubicles are used to store reference materials (*left*).

▲ **York Hall Leisure Centre** on **Old Ford Road**, **Bethnal Green** – named as such because it was opened in 1929 by the Duke of York – is one of just three public baths in London surviving from the 1920s; a decade of strikes, hardship and of shortages in the building industry, and yet one in which baths became ever more sophisticated, and much less bound by the rigid distinctions of class and gender that had previously dictated their design.

In fact when Greenwich Baths (now the Arches Leisure Centre) opened in 1928 it would prove to be one of the last in Britain to have

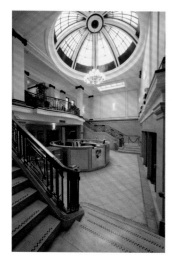

its pools specifically labelled as first class, second class and ladies.

One practical reason for abandoning these distinctions was that purification systems were now sufficiently advanced to render as obsolete any differentiation between first and second class pools on the basis of water quality.

Reflecting these new standards was the **Paddington Central Baths**, now the **Porchester Centre**, on **Queensway** (*right*). Opened with two pools in 1925, its motto was 'every day is clean water day'.

Having clean water in both pools at all times, moreover, allowed much greater flexibility; for example women were no longer confined to smaller 'ladies pools', while those same smaller pools could now be used more for children.

Another trend, seen at both York Hall and Paddington was to provide Turkish baths.

London already had dozens of private Turkish baths, dating from the 1860s onwards. They could also be found at public baths in the provinces (the best surviving examples being in Manchester, Harrogate and Dunfermline). But to provide them in working class districts such as Bethnal Green and Paddington represented a real progression in the capital.

Relatively lavish they were too, as was reflected in the lobbies at both **York Hall** (*left*) and the **Porchester Centre** (*right*), where the finishes, fixtures and fittings would have hardly seemed out of place at private clubs.

At both establishments the Turkish baths appealed to a diverse crowd; cab drivers, boxers, gay men and at York Hall, members of the Jewish community and, reputedly, of the underworld too.

In both cases the facilities still exist, expensively revamped and rebranded in recent years as 'spas' by their current operator, GLL.

But what of swimming? At the Grade II listed Porchester Centre, designed by Harold Shepherd, both the original pools, unusually, remain in use, the larger of the two (*above right*) having retained its original form, minus only the poolside cubicles, removed in 1986.

Also unchanged is the adjoining Porchester Hall, a stately public hall whose exterior Pevsner dismissed as 'flabby Beaux-Arts Baroque'.

One of its uses is for boxing, which takes us back to York Hall.

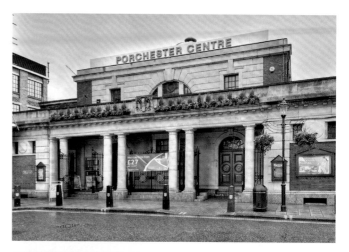

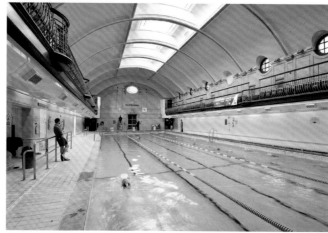

Designed by Bethnal Green's borough engineer AE Derby, York Hall also opened with two pools.

The smaller one was rebuilt in 1967, while also during the 1960s the wash house was replaced by a modern laundromat, incorporated within a high rise council block, Mayfield House, designed by Wakeford, Jerram and Harris, linked to the baths and still extant on Cambridge Heath Road.

The main pool at York Hall, meanwhile, has remained boarded over since 1950 and is best known for boxing (*see page 23*).

So much so that when demolition of York Hall was on the cards in 2004 the East End resounded with protests, sufficient to persuade Tower Hamlets and, once again GLL, to invest £4.5m in a much heralded refurbishment.

In 2008 the Duke of York's nephew, the Duke of Kent did the honours by re-opening the centre, which just left one final accolade.

This followed in 2013 when the building was listed Grade II, thereby granting York Hall equal billing with its Paddington contemporary.

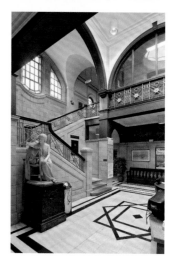

So often when celebrating our heritage it is the aquatic splendours of the Victorian and Edwardian eras that come to the fore. This pair provides evidence that, their 'flabby' exteriors notwithstanding, the baths of the 1920s were also beacons of advanced technology and enlightened social attitudes.

Sport for all, as it were, but with a bit of pampering and pummelling thrown in for good measure.

▶ Hemmed in between shops, offices, flats and a car park, and within hailing distance of Carnaby Street, the **Marshall Street Leisure Centre** in **Soho** is another historic baths whose survival is owing to a combination of statutory protection (it was listed Grade II in 1982) and public protest, and whose revival has come about courtesy of an enabling residential development.

Marshall Street is historic on several counts. Firstly, baths have operated on this site longer than any other in London. Opened in 1852 with 120 slipper baths, a wash house and a small plunge pool, the original building was designed by the country's first baths specialist, Price Prichard Baly, and as was par for the course with early baths, served for around 40 years.

Messrs Spalding and Cross were then called in to oversee its modernisation in the mid 1890s.

Their efforts lasted a similar period before being demolished to make way for the present building, completed in 1931.

Once again Alfred Cross was involved – it would be his last commission before his death in 1932 – but this time in partnership with his son, Kenneth Cross.

Two new pools were built, 100' and 70' in length, hidden behind the narrow front block (*above right*), which also housed slipper baths, offices for Westminster's Rates Department and a health clinic for mothers and children (hence

the matronly figures looking down over the clinic's separate door).

At the rear, on Dufour Place was built a depot for Westminster's Highways Department, housing street cleaning vehicles and staff.

As well as serving local residents, market traders, shop workers and sundry Soho night owls, Marshall Street's gala pool, with its seating for 500 or so spectators, became one of London's prime venues for international and inter-club competitions, water polo matches and diving displays (including by the Highgate Diving Club and, in 1948, by Johnny Weissmuller).

Some swimmers complained that the shallow end was too shallow, at three feet, and that the design of both end rails and scum troughs made fast turns difficult. One called the water 'heavy as lead'.

Yet in the 1950s a number of records were broken here.

Predictably there was uproar when Westminster Council closed the centre in 1997 and a developer announced plans to incorporate the main pool within a private club.

Ten years of lobbying by the Friends of Marshall Street Baths ensued. Local businesses formed a regeneration consortium, and between them and Westminster a rescue deal finally emerged. By replacing the smaller pool at the rear with a gym and building 52 flats, some within the front block, the centre could be reborn at no cost to the public purse.

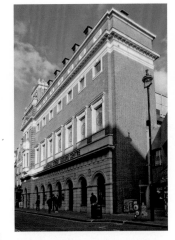

Completed in 2010 and costing £25m, of which £11m was spent on the leisure elements (designed by Finch Forman architects), the centre now offers a gym, fitness studio and a spa, and in common with the Porchester Centre, is run by GLL.

But the 100' main pool steals the show (*below*). Its poolside seats and teak cubicles have been removed, as has the 5m diving board. The creamy white Sicilian marble pool lining and green Swedish marble detailing has been magnificently restored, as has the trademark Cross designed reinforced concrete vaulted roof and skylights.

One term to describe the pool is 'Roman Renaissance'. But in a part of London where theatre and style go hand in hand, 'classic' will serve just as well.

Alfred Cross was a great advocate of durable materials, and of generating civic pride through quality design. Here at Marshall Street, Walter Gilbert's fountain, depicting a merman and dolphins, occupies a niche at one end of the marble lined pool (*above*), while in the lobby (*centre*) the mahogany kiosk provides a polished welcome. Even in the stairwells there is quality at every turn (*top*).

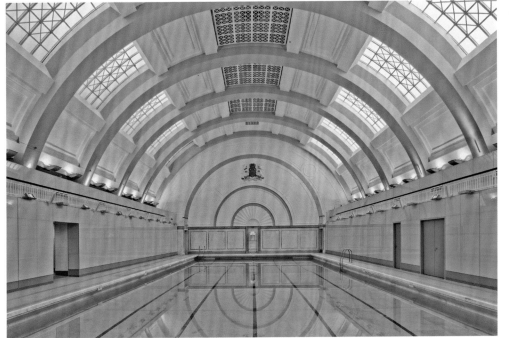

▶ Looking across **St Luke's Gardens** towards **Norman Street**, this is **Ironmonger Row Baths** following its £16.5 million refit by Tim Ronalds Architects, completed in late 2012. And if the red brick and Portland stone detailing look familiar that is because this is yet another building from the drawing board of Messrs Cross & Son.

Today the baths fall within the boundaries of Islington. But before 1965 the local authority was Finsbury, the last London borough to adopt the 1846 Act, and the slowest to implement it.

One factor in this was a lack of funds. Another was the proximity of baths in neighbouring boroughs. In fact, counting the open air Peerless Pool, whose site lay 100 yards away, no fewer than 14 public and private baths operated within a mile of Ironmonger Row between 1743-1939, the highest concentration recorded in Britain.

Ironmonger Row's first phase, on the east side of the gardens, with the water tank visible at roof level, opened in 1931 and consisted of a laundry and 82 slipper baths, at a time when only four per cent of local households had baths.

The second phase, designed solely by Kenneth Cross and completed in 1938, consisted of the central linking block, in which there were Turkish baths in the basement (now rebranded as a spa), and on the left, a swimming pool. This was adjoined by a children's pool, with a café above, looking down on the main pool.

Before the recent refurbishment the link block was a web of stairs and corridors. Now it forms a modern atrium (*below left*) with a new main entrance, accessed from Norman Street. Above this is a stone panel added in 2012.

As can be seen, this may be a modern leisure centre in terms of its facilities, but happily it remains 'Ironmonger Row Baths' in name.

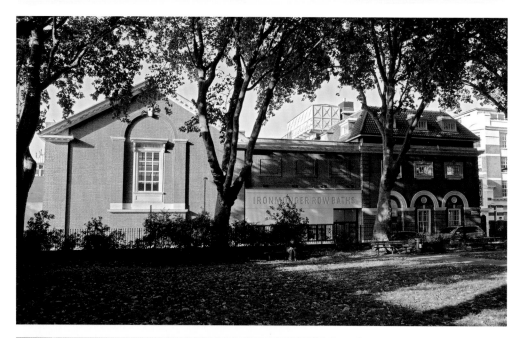

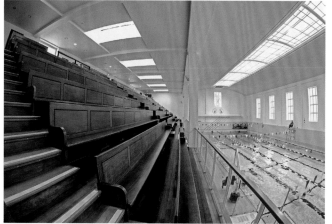

◀ The main pool at **Ironmonger Row** differed from earlier pools by concentrating its seating – stylishly crafted in teak – on one side, high above the water. This, a form that became common at post war pools, was partly to allow space for changing rooms underneath, now that poolside cubicles were ruled out on grounds of hygiene (so that bathers had to go through showers and footbaths before swimming).

Also, the pool tank was built to a depth of twelve feet at one end, so that it could host competition diving (for which higher seating was ideal). As a result, the Highgate Diving Club made Ironmonger Row its regular Friday night club headquarters until the late 1960s.

No diving boards today, alas. But other original features have been kept. Seen here (*left*) is one of the clocks that told users of the slipper baths how long they had left to soak.

Also preserved is the towel chute linking the floors containing the slipper baths with the ground floor laundry, together with the towel attendant's wooden kiosk on the first floor landing (*left*). One of the slipper baths, used by the public as recently as 1986, has also been preserved in its cubicle.

Supplementing these original features are information panels dotted around the building, displaying archive material and the memories of regular users. Some are displayed in the laundry, still in use and believed to be the last of its kind at a public baths in London.

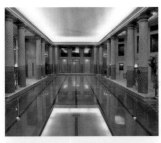

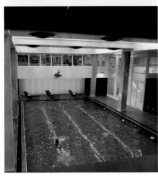

▲ Here are four small but perfectly formed pools from the first half of the 20th century, each secreted within a larger building (and whose presence cannot therefore be discerned from the outside), and each restricted to club members or residents of the building in question.

The most sumptuous of the four lies in the basement of the Grade II* listed **Royal Automobile Club** on **Pall Mall** (*top*).

Opened in 1911, the club was designed by Charles Mewès, whom the *RIBA Journal* considered an 'intellectual Frenchman' of 'the best type', and AJ Davis, a Mayfair architect and *bon viveur*.

One of the pair's earlier works had been the Ritz Hotel.

The 86' RAC pool has been described variously as Roman, Pompeiian or Egyptian in style.

After its opening Mewès and Davis were asked to repeat the design for three transatlantic liners.

Along with its adjoining Turkish baths the pool has been beautifully restored in recent years by architects Mackenzie Wheeler.

Discretion prevents the RAC revealing who swims there now, but past regulars have included Herbert Asquith and Winston Churchill.

More popular still with politicians is the pool at **Dolphin Square** in **Pimlico** (*above*). When completed on the banks of the Thames by developer Richard Costain in 1938, Dolphin Square was the largest block of flats in Europe, a veritable 'mini-city' of 3,000 residents, many of them MPs, in 1,310

flats, with access to their own shopping arcade, squash courts, tennis courts and a croquet lawn.

Designed by Gordon Jeeves with input from engineer Oscar Faber, the actual flats – now forming a Conservation Area in their own right – are built in a monumental, Neo-Georgian style.

Yet the 60' pool hidden within the building's core is distinctly Art Deco, in its proportions if no longer in its decor, although as can just be seen, an original dolphin sculpture by John Skeaping looks down on the water from the end gallery.

Also modernised, in 2004, but retaining its 1930s colour scheme and lighting, is the 80' pool at the **Lansdowne Club** on **Fitzmaurice Place** in **Mayfair** (*right*).

The Grade II* building in which this exuberant, mirrored pool sits was built originally for Lord Bute in 1763, to designs by Robert Adam. As an English Heritage plaque states, from 1921-29 the house was occupied by Gordon Selfridge.

However its use as a private members' club dates from 1935, when the interior was remodelled by architect Charles Fox and the basement pool installed and fitted out by contractors White Allom, in a style described as 'Arte Moderne'.

Unusually, membership of the club was from the outset open to women on equal terms, a fact which appears to be reflected in the pool's softer tones and styling.

As can be seen, the pool is framed by a gallery with curved corners, from which at one end elegant stairs, a diving board and a water chute used to lead down to the water. In the ceiling above the pool was a glass bottomed fish tank, lit up at night.

Also fitted, as was once common in small private pools, were rings suspended on ropes, from which members would swing across the water, from ring to ring. Apparently quite a few attempted this feat after a few glasses of bubbly, causing quite a splash in their evening suits and ball gowns.

What larks! But no longer. The rings, water chute and diving board were removed on safety grounds. On the other hand, one tradition has survived, that of inter-club races against other private clubs with pools, including the Hurlingham (*see page 118*) and the RAC.

On these occasions, we are told, swimwear is the required attire.

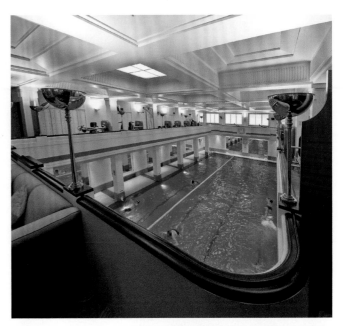

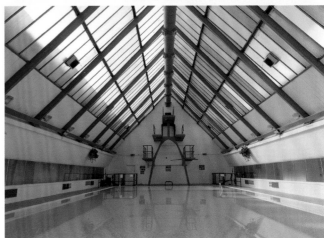

▲ When opened in 1935 this delightful 75' pool with horseshoe diving board formed the focal point of the celebrated yet controversial **Pioneer Health Centre** on **St Mary's Road, Peckham** (*right*). Designed by Sir Owen Williams shortly after he completed the Empire Pool (*see page 72*), the centre was commissioned by two doctors, George Scott Williamson and Innes Pearse, to demonstrate the then radical notion that exercise and a healthy diet could reduce disease.

Families paid a small fee for access to the centre's facilities, but in return had their lifestyles and health monitored by doctors.

Unable to secure funding as part of the new NHS, the centre closed in 1950, since when it has been listed Grade II* and converted into flats, known as **Frobisher Place**.

However viewing during Open House weekends is possible, and

is highly recommended, for this is one of the most important buildings of the 20th century in London.

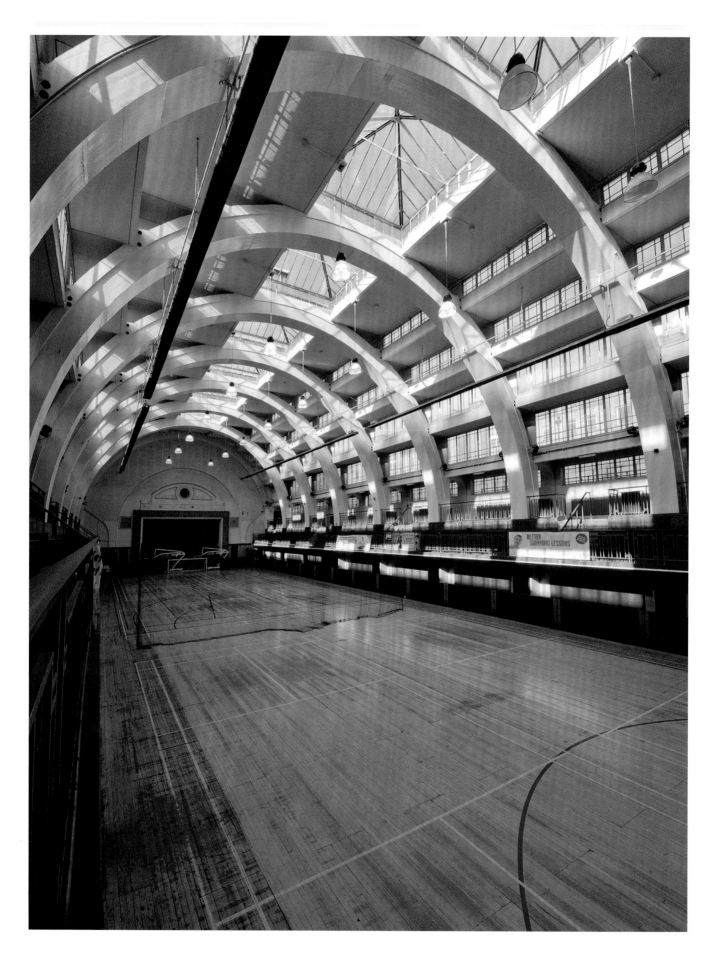

◀ Although boarded over and used solely for dry sports since the mid 1980s, the former main pool hall at the Grade II listed **Seymour Leisure Centre** in **Marylebone** – opened in 1937 and designed (yet again) by Kenneth Cross – has lost nothing of its power to impress.

Not that anyone would know that this lofty space even existed when viewing the building from street level. No doubt advised by planners at the Borough of St Marylebone that the baths should blend in unobtrusively with its residential surrounds, Cross encased this vaulting concrete, steel and glass structure within one of his standard brick and Portland stone exteriors.

Only from high up in one of the neighbouring blocks of flats is the concealment exposed (*top right*).

That Cross was otherwise adept at working in a modern idiom had been shown a year earlier when, in conjunction with Cecil Sutton he designed the Super Swimming Stadium in Morecambe, the most expensive open air pool ever built in Britain, and one unashamedly Modernist in every detail.

And in every other respect, Seymour Baths was cutting edge.

Its services and plant were all powered by electricity (rather than coal). Changing rooms were located away from the poolside, and instead of leaving their clothes in a cubicle, swimmers placed them in wire baskets, stored at a central point. They then had to pass through 'cleansing rooms' featuring showers and footbaths.

As noted earlier, these seemingly obvious means of maintaining hygiene and water purity had been borrowed from the Continent. The same is true of the roof structure used to span the main pool at Seymour Place.

Its origins can be traced back to the previous decade, in Paris.

In 1921-23, the pioneering engineer Eugène Freyssinet had built two towering airship hangars at Orly, using a series of parabolic reinforced concrete arches (all, alas, destroyed during the Second World War). Then in 1924 architect Louis Bonnier adapted the form, using rounder concrete arches to span the new swimming pool in Butte aux Cailles, a surburb of Paris.

The pool is still in use today.

Nearer to home, a similar roof structure may be seen at the Royal Horticultural Society's exhibition hall in Victoria, opened in 1928, while as featured in *Great Lengths* (*see Links*), similar roofs also survive at Smethwick Baths in the West Midlands (b.1933), and at Upper Mounts Baths in Northampton (b.1936).

Both these baths are listed Grade II, as is the one other baths with the same roof structure, namely **Poplar Baths** on **East India Road**, whose main pool is shown here (*below right*) shortly after its opening in 1934.

Note the proscenium arch at the far, deep end, and that of Seymour Place (*left*), reflecting the pools' use for dances and performances when boarded over in wintertime.

Kenneth Cross's father Alfred was rather dismissive of the work of borough engineers. But in the case of Poplar, borough engineer Harley Heckford could hardly be faulted. The design may have been derivative, but it was elegantly done, and as user figures of around 275,000 per annum showed, exceptionally popular too.

But whereas at Seymour Place swimming continued after the 1980s in the building's second pool, at Poplar the whole building was closed as a cost cutting measure in 1988 and the pool hall used thereafter as a training centre for construction workers.

On the days it has been opened to the public since, for Open House weekend or during an art installation in 2012, the scale of damage to the actual pool tank has been all too apparent.

Not that this ever deterred local campaigners. Just as their counterparts at Marshall Street and London Fields had to wage ongoing battles over extended periods, 25 years and several false starts passed before Tower Hamlets was finally able to confirm, in March 2013, that a rescue package for Poplar Baths had been agreed.

Led by property developers Guildmore, the £36 million scheme will see the main pool brought back into use, albeit as a dry sports hall, and the original lobby area restored, while a new 25m pool will be built in an adjoining block.

An upgraded youth centre and 60 council flats also form part of the scheme, drawn up by Pringle Richards Sharratt Architects, who recently modernised three other pools in Hounslow, including Isleworth, built in 1939.

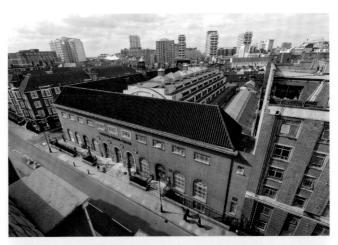

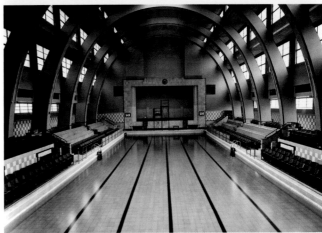

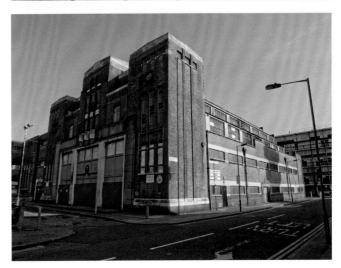

Seen from East India Dock Road, with its stripped, almost brutal brick exterior – again concealing a more curvaceous inner core – Poplar Baths has long been an acquired taste. Some locals called it Poplar Gaol. But in common with the likes of Tate Modern and Battersea Power Station, it has never been without friends, and all being well, its time will come again.

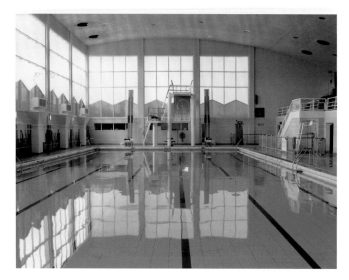

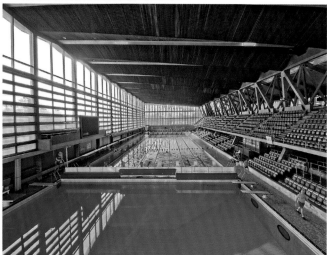

▲ The **Hornchurch Sports Centre** in the Borough of **Havering** does not immediately catch the eye. And yet it occupies a niche unique in post war architecture, being one of only two public pools to have been built in Britain during the years 1945-60, a period when homes, hospitals, schools and factories took priority. (The other was the Empire Pool, Cardiff, built in 1958 but demolished in 1998.)

Opened in 1956, in design terms Hornchurch was similar in layout to pre war baths such as Ironmonger Row. But with its solid roof and extensive glazing it also offered a taste of what was to follow. Lighter, larger, with no class or gender distinctions, more public pools, 197 in total, were built in Britain during the 1960s than in any other decade since 1846.

Most were located in areas not yet served with pools, which in the Greater London area meant the outer suburbs and new towns, such as Harlow and Stevenage.

Another common feature, as urged in the 1960 Wolfenden Report, was the provision of large tiers of seating, in the expectation that galas and water polo would regain their popularity. They did not.

Nor did it help that because of the post war restrictions on building, the emerging generation of architects had no experience of pool design. All that glazing, for example, led to problems with glare and condensation. The sheer size of the new pool halls also led to high levels of energy consumption.

Yet the desire of designers to break with convention also resulted in some exceptional architectural statements, the largest and most prominent survivor of which is the Grade II* **National Sports Centre** at **Crystal Palace** (top right).

Opened in 1964, this would be the main focal point of English swimming until Ponds Forge opened in Sheffield in 1990. Before the Aquatics Centre was built in Stratford for 2012 it was also the only Olympic sized pool in London.

Under its magnificent roof, lined with teak slats to absorb echo, the main 50m pool sits between a training pool and a diving pool.

In another part of the centre is a 25m pool, added in 1975.

As noted in Chapter 4, combining as it does wet and dry sports under the same roof, with only a tier of seats and an open concourse dividing them, the NSC has ongoing problems with ventilation, temperature control and acoustics. Most recently in 2007 it required some £5m worth of running repairs to ensure it would stay open until at least 2012.

Long term the plan is to build a new pool on an adjoining site, and convert the original pool hall into a second dry sports area. But for now it remains in use, and busy, and as breathtaking as ever as it celebrates its half century.

▲ Proving that lessons from Peckham's Pioneer Health Centre had been learnt, the 20m pool in the heart of the Grade II **Golden Lane Estate**, the only public pool in the City, is slotted in among high and low rise flats along with a gym, dance studio and courts for tennis and netball. Designed by Chamberlin Powell and Bon in 1962, the centre has recently enjoyed a £2.3m refit by architects Cartwright Pickard.

Also Grade II, the **Pools on the Park**, designed by Leslie Gooday and originally opened in 1966 as **Richmond Baths** (above centre), consists of two indoor pools and one outdoors (see page 165), grouped around a central walkway and set within a walled enclosure in the **Old Deer Park**. Yet for all the seemingly affluent location, it still contained 24 slipper baths, possibly the last to be built in the capital.

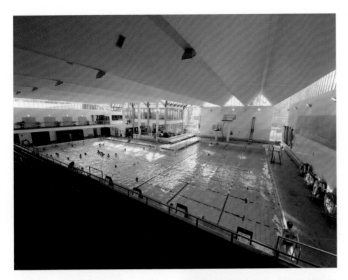

▲ Pool designers in the 1960s were full of ideas, not all of them viable.

Creating a separate diving pool, for example, as at the **National Sports Centre** at **Crystal Palace** (*above*) was all well and good at a national training facility. This was, after all, London's only 10m board until the Aquatics Centre opened in Stratford in March 2014.

But it was and still is costly to run and, with all that glazing, it has never been ideal for spectators.

Elsewhere, to accommodate diving and lane swimming safely in the same pool T-shaped designs were tried at Coventry and Leeds. But the most practical solution was the L-shaped pool, pioneered at the **Putney Leisure Centre** on **Dryburgh Road** (*top*).

Opened in 1968 and designed by Powell and Moya (architects of the 1951 Skylon), Putney is, as of 2014, one of only eleven public pools in the capital with functioning diving boards. According to the Great Britain Diving Federation, at least 85 London pools have had diving boards removed on health and safety grounds since 1977.

Among those that remain in 1960s pools are the boards at Waltham Forest, Fulwell Cross, York Hall and **Morden Park** in **Merton**.

Designed by George Lowe and Partners and opened in 1967,

Morden Park (*above*) also houses possibly the last pool in Britain built to Imperial dimensions, its main pool being 110' in length.

As noted earlier, Britain's first metric pool was at the Oasis, built in 1960 (although, bizarrely, diving boards had been built to metric standards since the 1930s).

The ASA had adopted 110' as its standard short course length on the basis that three lengths were the nearest to 100m, the minimum distance in international swimming. Except that 330' was actually 23" longer than 100m.

Under pressure, in 1967 the ASA thus adopted the nearest metric equivalent, that is 33.3m (of which York Hall was the first example).

This period of confusion explains why so many reports during the 1960s and '70s stated that this or that pool had been built inches too long or too short. They were not. It was the decision makers who fell short, caught between tradition and the rest of the modern world.

But in any case the matter was soon to be settled, because in 1976 the Sports Council decreed that from thenceforward, the internationally accepted dimensions of 25m and 50m would be applied.

This was 68 years after the international governing body, FINA, had been formed... in London.

▶ To conclude, which, if any of the capital's late 20th century pools or leisure centres might themselves merit protection in the future?

When the **Brixton Recreation Centre** opened in 1984, nine years late, one journal described it as riddled with faults and plagued by 'shoddy workmanship'. Its costs having escalated from an estimated £2.75m to £26m, it represented 'atrocious value for money'.

Yet in 2006 when 'the Rec' was threatened with closure, Brixtonians defended it to the hilt. If indeed it was an expensive folly, with its second floor swimming pool looking out over passing trains and its sports hall on the fifth floor, it was their folly, used by around 60,000 people per month.

So could this citadel of sport be another example of the axiom that we should never judge a building until it is at least 30 years old?

Which leads us to a second question. Whereas, as we have seen, several Victorian and Edwardian baths have gone on to enjoy a second lease of life in different guises, so far not a single post war pool or leisure centre has been preserved after its useful life has ended.

Is this because they are now such specialised buildings that, rather like modern stadiums, no other after-use is feasible?

If so, will our swimming heritage recede ever further into the past, to those pools of the 1960s, at Crystal Palace, Richmond and beyond, thereby adding even greater significance to the likes of Dulwich and Camberwell, still going strong, 121 years after they opened, and counting.

Fortunately, swimming offers every member of the public a chance to formulate a response to these questions based on first hand experience. After all, we may never get to play at Wembley, but we can all get to swim in the Olympic pool.

Or take a train to Brixton and watch the swimmers go by.

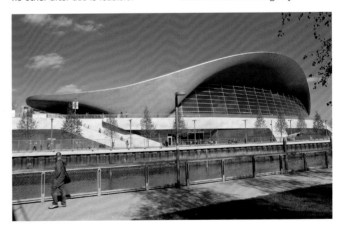

Re-opened in all its post-Olympic glory in March 2014, the £269 million Aquatics Centre takes over from Crystal Palace as the focus of competitive swimming in London. Designed by Zaha Hadid and S+P Architects, the centre has two 50m pools, a 25m diving pool, 2,500 seats, and already the look of a classic. Anyone can swim there, and everyone should, if only to see what all the fuss was about.

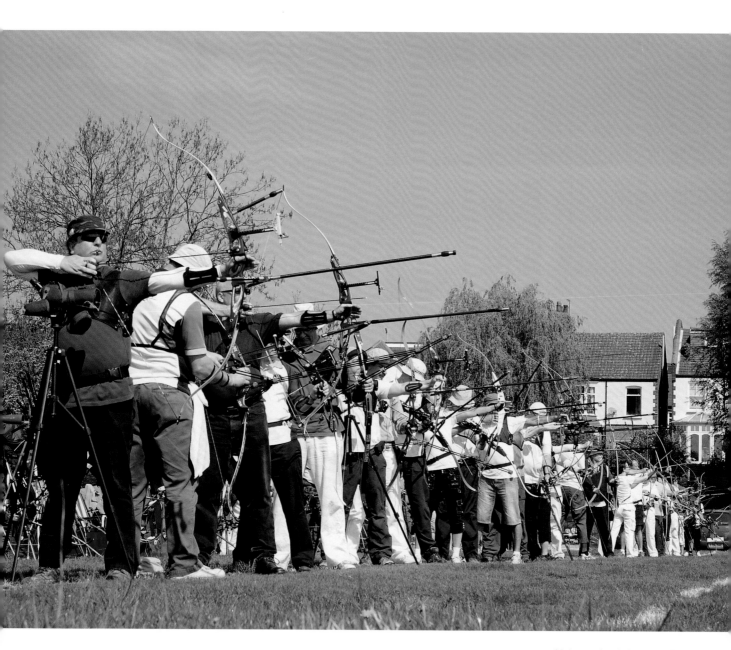

Lining up for their annual Good Friday shoot in 2011, the Aquarius Archery Club was originally formed as a lawn tennis club in 1923 by the Metropolitan Water Board and is based on a covered reservoir in Fortis Green. Two other former MWB clubs still active in London are the Aquarius Golf Club, also based on a covered reservoir, in Honor Oak (*page 220*), and the Aquarius Sailing Club in Hampton.

SPORTS

This section of the book looks at the heritage issues affecting seventeen selected sports. As may be noted from the list on the right, they represent only a fraction of the sports played in London as of 2014, each being chosen on the basis that they meet at least two of the three following criteria.

Firstly, their roots in the capital were established prior to 1914; secondly they may be considered a part of mainstream British sport, and thirdly, historic buildings or sportscapes specifically created for them remain in active use.

The odd one out in the selection is speedway, a sport not seen in London since 2005, which found its way to Britain only in the 1920s, and which has left few tangible traces in the capital.

Such was speedway's popularity in the mid 20th century, however, at times on par even with football, that its demise, at least in London, offers a reminder of how transient sporting trends can be.

Among other sports no longer played in London, quoits might also be considered an unexpected casualty, given its popularity in riverside pubs before the 1940s. (For more on quoits, readers are directed to an earlier book in this series, *Played at the Pub*).

Returning to the modern day list, some readers might have expected our selection to include boxing, hockey or croquet. All were indeed contenders, but lost out ultimately because each is now staged predominantly in buildings or on grounds originally designed for other sports and activities.

Ice sports have also been omitted owing to the fact that only one rink operating prior to 1939 survives, on Queensway.

From a cultural perspective it should be noted that eight of London's current sports are directly identified with other parts of the British Isles: golf, rugby league, camogie, curling, Gaelic football, hurling, shinty and wrestling (from the Lake District and Cornwall).

Meanwhile nearly a quarter of the sports listed have been introduced from further afield; from the USA, American football, first seen here in 1910, basketball, volleyball and tenpin bowling, and from the Indian sub-continent, polo, in the 1870s, and kabbadi, first recorded in Britain in the 1960s.

Speedway and quoits apart, which sports are *not* played in London? Unsurprisingly, other than those for which London is patently unsuited – surfing for example – very few indeed.

Among them are horse racing (albeit staged not far away, at Kempton Park, Sandown and Windsor), harness racing, or trotting (Wolverhampton being the nearest centre), bat and trap (concentrated in Kent), and stoolball, still firmly rooted in Sussex, five hundred years or so after it was first recorded.

Still, there is one sport that remains absolutely exclusive to London. Dreamt up in 1907 by soldiers based on Clapham Common and still contested there every Tuesday night in summer, rugby netball has yet to spread beyond SW4. But, give it time...

Played in London

This list sets out the 107 sports or categories of sport currently played in London at an organised level. Not included are fitness activities such as aerobics and bodybuilding, mind sports such as bridge, poker and chess, and sports organised by London-based clubs but played beyond the capital's boundaries, such as air racing and kite surfing. Note, not all the following activities are recognised by Sport England.

American Football	Fencing	Racketball
Angling	Fives (Eton and Rugby)	Rackets
Archery	Floorball / Unihockey	Real Tennis
Association Football	Flying Disc / Ultimate	Rifle Shooting
Athletics	Futsal / Five-a-side football	Roller Hockey
Australian Rules Football	Gaelic Football	Roller Skating
Autocross	Goalball	Rounders
Badminton	Go Karting	Rowing
Baseball	Golf	Rugby League
Basketball	Greyhound Racing	Rugby Netball
Baton Twirling	Gymnastics	Rugby Union
Bicycle Polo	Handball	Sailing
Billiards	Hockey	Shinty
BMX Racing	Hurling	Skateboarding
Boccia	Ice Hockey	Skiing
Bowls	Ice Skating	Skittles
Boxing	Inline Speed Skating	Snooker
Broomball	Kabbadi	Softball
Camogie	Korfball	Squash
Canoeing	Lacrosse	Stock Car Racing
Clay Pigeon Shooting	Lawn Tennis	Sub Aqua Diving
Climbing	Martial Arts (inc. Aikido,	Swimming
Cricket	Judo, Karate, Kendo)	Synchronised Swimming
Croquet	Model Aircraft Flying	Table Tennis
Cross Country Running	Model Yacht Sailing	Tenpin Bowling
Curling	Modern Pentathlon	Trampolining
Cycle Racing	Motor Cycling	Triathlon
Cycle Speedway	Netball	Tug of War
Darts	Octopush	Volleyball
Disc Golf	Parkour	Wakeboarding
Diving	Petanque (Boules)	Water Polo
Dodgeball	Pigeon Racing	Water Skiing
Dragon Boat Racing	Polo	Weight/Power Lifting
Equestrian Sports (Show	Pool	Windsurfing
Jumping, Dressage)	Powerboating	Wrestling

Chapter Eighteen

Bowls

Georgian gentlemen enjoy a game of bowls, as depicted in one of a range of copper panels created by FT Callcott for the Grade II* listed Black Lion on Kilburn High Road, at the time of its reconstruction in 1898. Since the 16th century and the apocryphal tale of how Sir Francis Drake coolly continued with his game on Plymouth Hoe as the Spanish Armada approached, bowls has occupied a special niche in the nation's imagination. That no records exist of there ever having been a bowling green at the Black Lion matters little. Almost certainly bowls was played somewhere in the area, as it was all over London. Even by 1800 former greens in Clerkenwell and Hoxton had been commemorated by street names, to be followed by later examples in Putney Heath, Southwark, Woolwich and (*below right*), Kennington.

Bowls leads the way in this section of the book because it has been part of everyday life in London since at least the time of Shakespeare and, in certain respects, compared with sports of a similar vintage, has changed relatively little since.

Then, as now, bowls, shaped (or originally weighted) to give them a 'bias', so that they roll in a curved trajectory, are aimed at a smaller bowl, a 'jack'. The bowl closest to the jack scores a point.

As is often said, here is a game so simple that it takes just seconds to learn, but a lifetime to perfect.

Whether or not the Bard played is unknown, though the many references to bowls and bias in his works suggest that he was certainly familiar with its pleasures, and its frustrations.

As was Charles II. It was under his auspices that in 1670 the first known laws were drawn up (long before the first known laws of golf and cricket appeared, both in 1744). Most would be familiar to bowlers today, especially Rule 20, which stated 'keep your temper'.

Another convention, repeated by Randle Holme in 1688, warned that 'noe high heeles' should be worn on a bowling green.

We know that women did play at this time, Mrs Pepys among them, but this rule was firmly aimed at men. We also know that 17th century greenkeepers were highly skilled. Philibert de Grammont, a French visitor to Charles II's court, described one green as being 'almost as smooth and level as the cloth of a billiard table'.

Also worth noting is that bowling greens were the first sportscapes in London, in the modern sense (that is, other than tilting grounds and deer parks), to have been specifically identified on maps; for example in 1692 at Croydon and on Rocque's map of 1746, at Lamb's Conduit Fields, Southwark and Mile End.

Further references exist not only to bowling greens but also to bowling 'alleys', for example at Whitehall Palace (*see page* 15).

When associated with palaces or great houses 'alleys' were often narrow lawns (the equivalent of a single 'rink' on a modern green).

Elsewhere the term referred to what we would call skittle alleys, mostly pub alleys, where gambling and drinking were rife; hence a ban on their operation in 1541.

But then bowls had been subject to repeated restrictions since 1363 because, in common with other 'unlawful games', it was said to distract men from archery practice. Not that the bans had much effect. They certainly did not deter the English sea captains playing in 1588.

As at Plymouth Hoe there were no doubt many patches of open ground in London where bowls was played, but which were not specifically set aside as greens. In 1679 John Locke described how 'several persons of quality' could be seen 'bowling two or three times a week all the summer' in 'Marebone and Putney'. Also cited, in 1647, was Paddington Green.

Croydon's bowlers, as recorded in 1749, played on a patch of

common at the rear of the Three Tuns Inn, on Surrey Street.

Indeed throughout the 18th century pubs and tea gardens would become the main providers of greens. Islington had at least three, at Dobney's, at the Belvidere and the White Conduit House.

Yet by 1801 Joseph Strutt believed bowling to have fallen out of favour in the capital.

If so – and Strutt cannot always be trusted since he rarely left his patch in Bloomsbury – there can be no doubt as to who was responsible for its revival.

Once again, as so often in sporting history, it was the Scots.

So successfully did the Scots modernise and make the game newly respectable – that is, free from the taint of gambling and of excess – that despite bowls since being described often as 'quintessentially English', the form played in London today is in effect the Scottish game.

This process started in 1849, when the rules were redrafted in Glasgow and dozens of clubs started to form, culminating in 1892 in the formation of the world's first governing body, the Scottish Bowling Association.

The Scots also made advances in green construction, so that level greens were now no longer the domain of the wealthy alone.

All over Britain 'sea washed' turf from the Moray or Solway Firths or Cumberland became *de rigueur* for aspiring clubs.

A Glasgow firm, Thomas Taylor, still in business, also perfected the art of producing matched sets

of hardwood bowls made from lignum vitae, each with a reliable, measurable degree of bias.

The Scottish revival led to British bowling splitting into four distinct camps.

In London, where clubs started forming during the second half of the 19th century, eight clubs combined with others in Reading and Southampton in 1895 to form the London and Southern Counties Bowling Association. This was followed in 1903 by the formation, also in London, of the English Bowling Association (EBA), which, as would happen across most of the south east, adopted the SBA rules. Subsequently known as 'flat green' or 'lawn' bowling, under these rules the green is divided into 'rinks', or lanes, up to six per green, with games taking place simultaneously in each rink.

In Lancashire, Yorkshire, north Wales and parts of the Midlands a different code held sway. Called 'crown green', in this the green rises in the centre, and games take place any which way, so that players need always to be mindful of other games taking place at the same time.

Meanwhile, in parts of the north east and East Anglia a third form became established, known as Federation bowling, similar to the EBA but with subtle differences.

Finally, there remained 20 or so clubs dotted around England, for example at Chesterfield, Lewes and Barnes (right), who carried on playing what is sometimes called Olde English or Elizabethan bowls, on greens that are neither flat nor have a crown but have idiosyncracies all of their own.

That London adopted the 'Scotch Game' is mostly attributed to WG Grace, who, as his cricket career wound down discovered bowls offered an ideal means of carrying on his sporting life. Thus soon after moving to Crystal Palace in 1899 (*see page 211*) he converted a tennis court into a green, which in turn led to his promotion of the EBA four years later. Twenty five clubs joined. By 1922 there were nearly six hundred.

No question Grace's celebrity helped to popularise the game. But other factors were equally at play.

The provision of bowling greens in public parks, starting in 1891 at Battersea Park, made bowls affordable to working men, so »

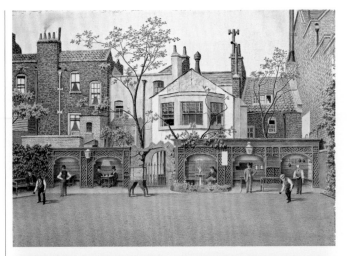

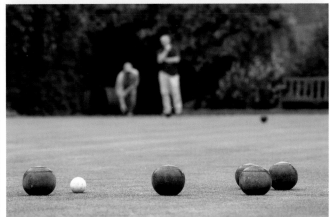

▲ Bowling greens at pubs were once common. In Georgian London amongst the best known were those at the Yorkshire Stingo on Marylebone Road and the Green Man in Blackheath. But by the second half of the 20th century, as the income from bowling decreased – partly because serious bowlers preferred private clubs where they could exercise greater control – most pub greens were sold off or converted into car parks. Inner London's last pub green – depicted in watercolour in 1902 (*top*), it is thought by **Walter Greaves** – was at the **Six Bells**, **King's Road** (now a restaurant), and was converted into a beer garden in 1969.

Since then the loss of pub greens has scarcely abated, so that barely 300 or so still function in Britain overall, only one of which survives in the capital.

And quite a survivor it is too. Tucked behind the **Sun Inn** on **Church Road**, the green of the **Barnes Bowling Club** (*centre and bottom*) is believed to have been in use since c.1805, and possibly since the pub opened, in c.1775.

Bowling in the area goes back even further, however, for a bowling green was recorded across the road, where the Barnes Green Day Centre now stands next to Barnes pond, in 1693.

Not clear is when the Barnes club actually formed. A modern sign on the gate gives the date as 1725, but alas no evidence for this date has since been found.

What is for certain is that no other London green is older and that Barnes is also the only green in the capital not to conform to the requirements of flat green bowls, as laid down by the EBA from 1903 onwards.

Firstly, the green is rectangular, not square, and is neither flat nor has a crown, but slopes down a few inches from each of its longer sides.

Secondly, while in flat green each bowler plays with four bowls (invariably made from synthetic materials), each with a bias typically rated as '3', at Barnes the bowlers each play with two old fashioned 'woods' (some of which may well date back to the 19th century) whose bias measures nearer 12–13. This extra bias means that the bowls travel almost in a semi-circular path.

Also, rather than playing in rinks, games are played from corner to corner (as appears to be the method depicted at the Six Bells).

Barnes is unconventional in other ways too. There is no dress code. Recent members have included the poet Roger McGough and singers Alan Price and Roger Chapman, while in 2013 both the club captain and secretary were female.

Of course the big question is that, given the pressures facing pubs, can Barnes continue to keep alive its historic version of the game? For while the Sun Inn itself is listed Grade II, the green enjoys no such protection other than being eligible for designation as an Asset of Community Value.

Hopefully this will be enough in the short term. But long term, here lies a hugely significant patch of turf, and one that needs to be protected as such, whatever mechanism is used.

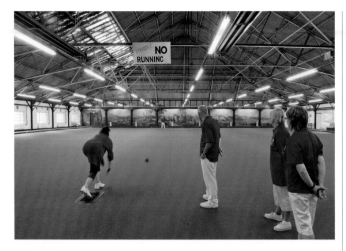

▲ Indoor bowling facilities consist mostly of windowless sheds with clear span roofs. But that does not mean they are without interest.

When opened in 1935, the six rink indoor hall at the **Paddington Sports Club**, **Castellain Road** (*top*) was said to be the largest of its kind in Britain, and while its playing surface is now made from modern polypropylene, its structure remains unchanged. For an aerial view *see page 295*.

Also of note is a mural at the far end of the hall, depicting mountain scenes and castles, painted by Edward W Holland in 1948.

Apparently there was a similar mural at the **Temple Bowling Club** on **Sunset Road, Herne Hill**, where the clubhouse (*above*), by Leslie H Kemp & Tasker in 1933, has three indoor rinks on its upper floor, overlooking two outdoor greens.

Other pre-war indoor facilities are at Cyphers BC, Kings Hall Road, Beckenham (b.1933), at Croydon BC, Nottingham Road (1937), and at the Crystal Palace Indoor BC on Anerley Road (also 1937).

In fact it was this last named club that pioneered the indoor game when formed in 1905, once again with WG Grace to the fore, and to which the unusual concentration of indoor clubs in south London

– matched in Britain only by Glasgow – can surely be attributed.

Playing initially on mats inside the main gallery of the Crystal Palace, and later inside the Australian Pavilion, the club moved out after the fire and in 1937 built its current headquarters on Anerley Road in just ten weeks. As the club history notes, 'This spoke volumes for the British workman.'

In contrast is the cavernous **Brixton Recreation Centre**, which opened in 1984 after years of delays and cost overruns (*see page 185*), and where indoor bowls is played on the ground floor in entirely different surrounds (*below*).

that in 1901 six clubs combined to form the London Parks Bowling Association.

The presence in London of so many Scots also helped. In fact when Grace organised the first home internationals at Crystal Palace in 1903, Scots were in a majority on both the English and Welsh teams participating.

A further factor was the EBA's stringent imposition of standards. This meant no gambling, strict amateurism, no cash prizes, and all players to wear whites (whereas crown green bowlers were rather more relaxed in all these respects).

In other words, bowls joined the roster of sports deemed by polite society to be 'respectable'.

The game enjoyed two other advantages. Firstly, as Grace had demonstrated, it offered sporting fellows a chance to remain active once they reached a certain age. For tennis and cricket clubs, such as Heathfield (formed in Wandsworth in 1875) and Bounds Green (1887), having a bowling green meant they could retain members long into their dotage.

Secondly, the compact size of bowling greens meant that, like tennis courts, one or two could be readily accommodated within existing grounds, or slotted into those patches of land left in the centre of suburban housing developments, behind back gardens or in awkward corners.

Bowling's 20th century boom continued unabated until the 1970s. Starting with the National Westminster Bank in 1899, business houses embraced the game, as did factory-based clubs, London Transport, the railways, the Post Office, the Civil Service and local council staff clubs.

Between 1900-39 hundreds of private clubs formed, with ladies sections proliferating from the 1930s onwards. During the same decade London also became the focus for indoor bowling (*see left*).

London took centre stage in terms of governance and major tournaments too. Many a national championship was held at the Paddington Sports Club, where the EBA offices were based, or at Mortlake (home of the Watney's sports club), while Wimbledon Park's public greens hosted the championships of the English Women's Bowling Association (EWBA) from 1935-75.

Those were the glory years for London's bowlers, but from the 1970s onwards decline was to set in. Symptomatic of this was the EBA's relocation to Worthing in 1974, and the EWBA's to Leamington Spa, in 1976.

In 2008 the two bodies merged under the new name of Bowls England, now based in Leamington Spa.

The statistics alone are sobering. At its peak in the 1960s the Middlesex Bowling Association had some 240 clubs in membership. By 2009 that total had halved, of which 107 clubs were from within the boundaries of London.

At the time of writing in late 2013, that total had dropped to 87.

One of the chief factors has been the loss of so many parks greens, closed in order to save costs or because demand has dropped to uneconomic levels. For most local authorities bowls has become the most expensive sport to provide for, per head, with membership of parks clubs dropping to the region of 10-30 members, yet each green costing in the region of £10,000 a year to maintain.

Elsewhere, the fall off has been less dramatic, but even so, in the Kent part of London, eight clubs closed in the period 2009-13, a total mirrored in Essex. Surrey's London total fell by 12 clubs, to a total of 50 in 2013. This left 267 bowling clubs in London overall, a figure expected to fall steadily over the next decade.

And yet despite this decline, according to Sport England figures more people played bowls in 2012-13 than played cricket or rugby, making it the ninth most popular participation sport, with an estimated 400,000 players in Britain overall.

Nevertheless, the trend remains downward, and the pressures on London clubs show no sign of abating. As membership numbers decline and running costs rise, there exists a very real danger of this most historic of sports slipping away in the capital, barely noticed.

'Old men's marbles', so the reckoning goes, has no place in the modern age.

Which of course is exactly what people said in the early 19th century, before the Scots and Dr Grace came along.

▲ Public bowling greens started to appear in Scotland from 1858, but one of the first in London was at **Battersea Park**, in 1891. At the time of writing the resident club there was down to ten members.

Over at **Parliament Hill Fields**, meanwhile (*top right*), the resident club, formed in 1938 and also struggling for members, have been obliged to share their green with the Hampstead Heath Croquet Club.

Elsewhere, three greens in Lammas Park, Ealing, laid out in 1907, were handed over to croquet players in 2010. At Canbury Gardens, Kingston, where one of Britain's first ladies clubs formed in 1910, the green is now a play area, with its pavilion serving as a community centre.

Is this trend irreversible?

Certainly some private clubs such as North London (*page 105*) and Heathfield are thriving. Some, such as Croydon and Temple, have outdoor and indoor facilities and so can remain open all year round.

Visit London's busiest parks greens (such as Hyde Park, *page 4*) and the bowlers are most likely to be young, but from South Africa, Australia or New Zealand, countries where 'barefoot bowling' is a popular social activity.

Even more diverse is the scene at **Finsbury Square** (*right*). The green, laid out in 1962 on the roof of the first car park to be built under a London square, was once dominated by workers from the nearby Whitbread brewery. Now it is mostly frequented by office workers of all nationalities, often with a drop of Sauvignon to hand from the neighbouring wine bar.

Traditionalists baulk at such behaviour, but even Bowls England acknowledges that by relaxing

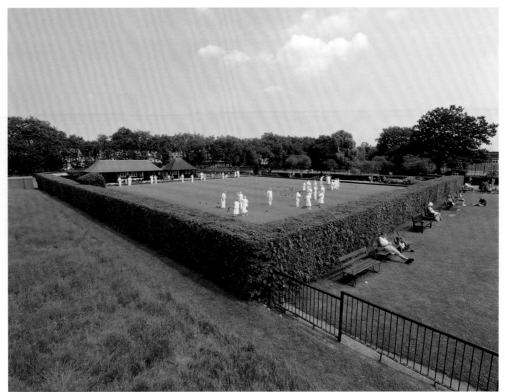

dress codes and making greens more welcoming, numbers can rise. Councils also recognise that, as in golf, many now prefer to 'pay and play' rather than commit to a club.

Clearly these are complex issues. How to revivify an historic game without sacrificing its finer points, one of many challenges that *Played in Britain* author Hugh Hornby will be addressing in his national study, *Bowled Over*, in 2015.

For their part, bowlers argue that bowls' importance extends way beyond issues of sport or heritage.

Fresh air. Companionship. Moderate exercise followed by a handshake and a drink. These, they contend, are timeless qualities which, in an age when the population is growing ever older, and open space becomes ever more precious, cannot and should not be left to the rub of the green.

Chapter Nineteen

Archery

'Fast!' and 'Loose!' is the cry at the Artillery Garden, Finsbury, the oldest venue for archery in the world, where every year an organisation called the Fraternity of St George 1509 brings together archers keen to keep alive the use of traditional longbows, not for re-enactment purposes but for sport. Unlike in target archery the Fraternity archers shoot, as did their Tudor precursors, at 'marks' (a series of shields on posts), the idea being to get one's arrow as 'close to the mark' as possible. But for all its hi-tech bows and carbon arrows, there is one element of modern target archery that does connect directly with history. As seen at the Aquarius Archery Club in East Finchley (*below right*), the standard target consists of a roundel known as 'the Prince's Colours'. This dates back to the 1790s and was named after the Prince of Wales, whose patronage of archery did much to increase its popularity.

Anyone who jests that 'nostalgia ain't what it used to be' should consider the sport of archery.

As a weapon, the longbow's last decisive role on these islands was at Flodden Field in 1513. That was just two years after Henry VIII had decreed that for the defence of the realm all men under the age of 60 had to desist from 'unlawful games' and attend archery practice at their local butts instead.

(Incidentally, although some places in London bear the name 'butts', as in The Butts in Brentford and Newington Butts, it is thought that these derive from the medieval term for a strip of land or ridge where two fields abut.)

Henry VIII's statute of 1511 was just one of a succession of decrees making archery practice obligatory for able bodied males going back to 1363. One can therefore readily imagine the social divide between those who took to the butts with gusto and boasted of their prowess in the tavern afterwards, and those who shirked their duty, or were simply hopeless with the bow.

For the latter, the emergence of the musket and the subsequent decision, in 1595, to stop the recruitment of archers into the military, must have been a relief.

But for the nation's bowyers and fletchers, it spelt ruin. In London, within 30 years only four bowyers were left in business.

For the nation's archers, on the other hand, the crack of pistol shots at the butts galvanised them into forming what, in modern parlance might well be described as a preservation society.

By focusing on archery's merits as a manly discipline, and by using pageantry to reinforce its place in popular culture (invoking Cressy and Agincourt along the way, with a dash of Robin Hood added for good measure), a relatively small band of enthusiasts saved archery from becoming the province only of antiquarians and military historians, thereby, ultimately, paving its way to becoming the Olympic sport of today.

Archery is thus not only one of our oldest organised sports – the 'Scorton Arrow' in Yorkshire, which dates back to 1673, is the oldest continuously staged competition in Britain – but it may also have been the first to have been consciously reinvented in the context of national heritage.

Looking the part was to become a crucial aspect of archery in this, its new phase. In 1676 'gentlemen archers' wearing 'hats turned up at the outside, tied with large knots of green ribbon' were described gushingly by William Wood (*see opposite*) as 'a most heroic rarity'.

From an instrument of death wielded by horny-handed archers to a noble pastime for city gents, this was quite some rebrand.

Although gatherings took place in various locations around London – Hyde Park, Tothill Fields and Hampton Court included – archery in the capital was until the 1790s mostly centred upon Finsbury Fields.

Extending north from Moorgate, the Fields, originally fenland, had been used for sport since at least the time of William

Fitzstephen in the 12th century, and in 1498 had been designated by the Mayor of London as a practice area for archers. It was during this period, in the 1550s, that a stray arrow famously pierced the hat of Dame Alice Owen, out walking in the fields, causing her in later life to mark her good fortune by founding an eponymous school, originally in Islington, now in Potters Bar.

If anything, Finsbury Fields became even more hazardous after 1590 when the new generation of sporting archers set up a series of marks, or targets, almost like a golf course (*see overleaf*). However, creeping encroachment gradually reduced the extent of these marks, during which time in 1641, in a corner of the Fields, the Honourable Artillery Company established their New Artillery Garden, where they have remained ever since, and where in 1652 a few HAC members and others set up the Society of Finsbury Archers.

It was this body that, come the Restoration, under the leadership of William Wood and with the support of Charles II, would establish archery's credentials as a respectable pursuit.

The Finsbury Archers eventually disbanded in around 1757, while another longstanding tradition, that of a competition for a silver arrow, held at Harrow School since 1684, was also discontinued, in 1772. However, it was not long before a new champion arrived in 1781, in the unlikely form of Sir Ashton Lever of Alkrington Hall, Middleton, in Lancashire.

Described as the 'father of modern target archery' Lever (1729-88) had arrived in London in 1774 in order to put his considerable natural history collection on permanent display in Leicester House (on the north side of Leicester Square). For a while the hippopotamus in his Holophusicon, as Lever called his museum, was the talk of the town.

Lever's right hand man Thomas Waring, meanwhile, took up archery to ease a chest complaint – too many hours bent over a ledger – and ended up becoming a leading authority on the sport.

Not to be outdone, Lever took it up too, and at Leicester House in 1781 formed The Toxophilite Society (from the Greek *toxon* for bow). The few remaining Finsbury Archers joined up, and for the next three years the Society met at the Highbury Barn, before switching to the Artillery Garden in 1784.

As always, a strict dress code was in force, namely a single breasted green coat, with a buff 'Kersymere' waistcoat, hessian boots and 'hat turned up over the right eye, with a black feather'.

Always one for dressing up, the Prince of Wales signed on as patron, after which membership shot up to 165, allowing the now 'Royal Toxophilite Society' to secure its own ground off Gower Street, where Torrington Square is today. (Their counterparts in Wales, the Royal British Bowmen, formed in 1787, despite their name were the first sporting society in Britain to admit women.)

From all over the country, Societies of Archers, Bowmen and Woodmen, feathers in caps, converged on the RTS ground, and on Blackheath and Dulwich Common, where a series of grand meetings took place before the Napoleonic Wars. There were regular shoots at Lord's too, before in 1821 the RTS relocated to a ground behind the Crown Tavern in Bayswater. (Lancaster Gate station was later built on the site, although the Archery Tavern on nearby Bathurst Street lived on until 2007, and is now a restaurant.)

But it was their next move that really established the RTS's standing; a six acre plot in the midst of the new Regent's Park, on which they built a pavilion called Archers' Hall, opened in the presence of William IV in 1834.

During the ensuing period the RTS played a leading role in establishing the first governing body, the Grand National Archery Society, in 1861 (since renamed Archery GB). With societies setting up all over (including the Woodmen of Hornsey and the Cantelowe Archers, in Camden Square), and with pubs laying out archery grounds (the Abbey Tavern in St John's Wood for example), a wave of archery emporiums opened up in London, eight in the Oxford Street area alone.

One reason for this boom was that archery had, by this time, become the first sport to be publicly embraced by women, that is, before croquet in the 1850s and lawn tennis in the 1870s.

Archery remained nevertheless the province of the upper and middle classes. So much so that the RTS's presence in Regent's Park became increasingly resented, until finally they were evicted in 1922. As chronicled by Peter Gerrie (*see* Links), the Reform Union described the RTS at the time as an 'antiquated society' pursuing a 'childish sport'.

No trace remains of Archers' Hall, which lay close to York Bridge. But a skating pavilion built within the RTS grounds in *c.*1869 survives, now serving the adjoining tennis courts (*page 103*).

From Regent's Park the RTS set up anew in St George's Fields, on Bayswater Road (now flats), before they decamped to Burnham, just outside London, in 1967.

But they left behind a strong legacy. In 1914, there were around 70 archery clubs across Britain. Today there are over 1,100, of which around 20 are in London, all mostly geared up for target archery. Of these the oldest is the Richmond AC, formed at the Old Deer Park in 1873, followed by the London Archers, formed in the 1930s and in the summer based on Perks Field in Kensington Palace Gardens.

The others all formed from the 1950s onwards.

Not all their members shoot with modern recurve bows however. As will be noted later, the longbow is now back in fashion, if not yet at the Olympics, certainly at the Artillery Garden, and perhaps even in a field near you.

A feather in the cap of sporting heritage, if ever there was.

▶ An archer on the side of **Longbow House**, **Chiswell Street** (b.1955), marks the spot on which 400 years earlier the so-called 'Copperplate Map' of *c.*1555 (London's first ever street map), depicted one of several groups of longbowmen in action in and around 'Fynnesburie Field' and Spitalfields. Off Chiswell Street, in Grub Street, bowyers, fletchers and bow-string makers were clustered, at least until the demise of archery led, according to John Stow in 1598, to former bowmen idling away their time in 'bowling-alleys and ordinary dicing-houses'.

Behind Longbow House lies the HAC's **Artillery Garden**, where in 1676 **William Wood**, Marshal of the **Finsbury Archers**, proudly donned the breastplate seen below.

One of Britain's oldest pieces of sporting silverware, measuring 37cm tall by 30cm wide, the **Braganza Shield** was commissioned by the Finsbury Archers in honour of **Catherine of Braganza**, the Portugese princess who is said to have introduced tea drinking to the English (for which three cheers), and who, like her husband, Charles II, was a great supporter of archery.

Legend has it that **Wood,** whose book of 1682, *The Bowman's Glory, or Archery Revived,* is an invaluable source for historians, was knighted on the spot by Charles in 1681 after a particularly fine display

with the bow at Hampton Court.

At Wood's burial at **St James, Clerkenwell** in 1691, three flights of whistling arrows were shot across his grave. And when St James was rebuilt in 1788-92, members of the recently formed **Toxophilite Society**, who took possession of the Braganza Shield after the Finsbury Archers disbanded, erected the memorial to Wood we see inside the church today, with its elegaic lament, 'Few were his equalls, and this Noble Art has suffer'd now in the most tender part'.

As for the Braganza Shield, in 1929 the Toxophilites handed it over to the **Victoria and Albert Museum**, where it can be seen to this day.

▶ As mapped somewhat sketchily in 1594, these are the **Finsbury Marks**, a network of posts and shields set up by archers, surely one of the most remarkable sportscapes ever seen.

There would appear to be 185 (or at most 190 if other named features also had marks). Some can be readily located, for example **Bunhill** in the south and **Rosemary Branch** in the north (marked as *Ros Brach*), close to the site of the present day pub of that name by the Regent's Canal, the line of which today appears to follow the curving path of the marks running from Rosemary Branch south westwards towards the **Stone by the Pond**, possibly in the region of the Angel.

Overall it would appear that the marks extended a mile and a half north-south, almost as far as the modern day Balls Pond Road, and a mile or so from west to east, from Islington Green to Haggerston.

Competing in small groups, the object was to shoot from one mark to another, with the one shooting the closest getting to choose which mark to go for next. Distances varied from 200-400 yards.

Some marks were named after individuals (such as **Baines his Needle** and **Parkes his Pleasure**), some after places (such as **Perelous Pond**, *see page 154*), and some after historical figures (including **Julius Caesar**, **Ro Hood** and **Friertuck**). Others appear to be named after sponsors, or were purely jocular, as in the case of **Martinsmonkie** and **Maydenblush**.

A later map of 1628 indicated that 158 marks were still in use, of which 80 had kept the same name.

By 1737 only 21 remained (again several with new names), until in 1786 upkeep of the marks ended.

Since then various attempts have been made to pinpoint more closely where the marks lay. Perhaps with modern mapping techniques a renewed effort would reveal more.

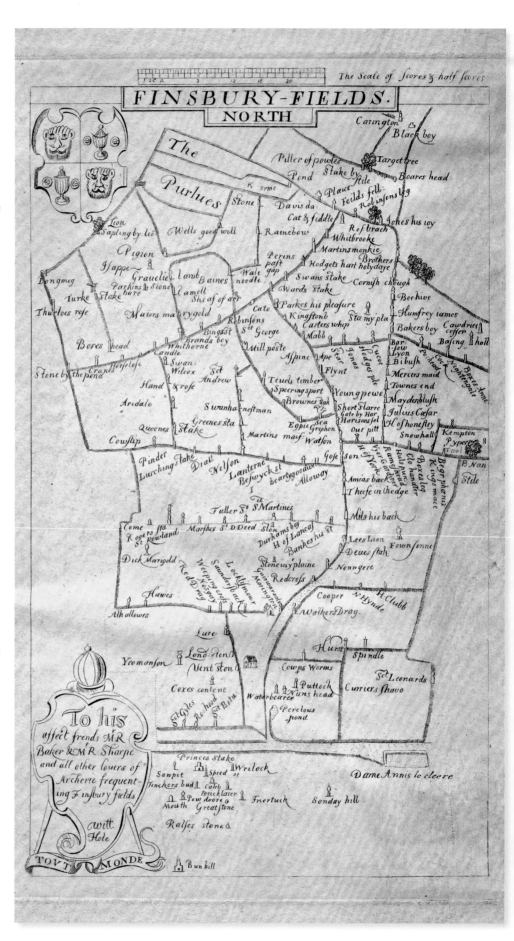

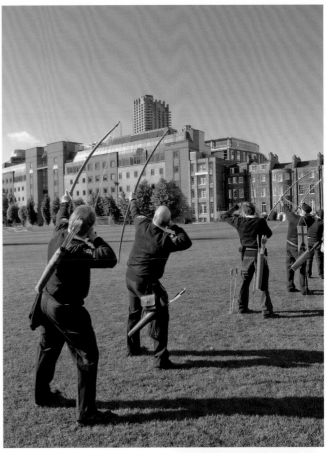

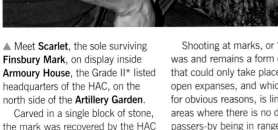

▲ Meet **Scarlet**, the sole surviving **Finsbury Mark**, on display inside **Armoury House**, the Grade II* listed headquarters of the HAC, on the north side of the **Artillery Garden**.

Carved in a single block of stone, the mark was recovered by the HAC in 1881 after it was found forming part of a bridge, on New North Road, spanning the Regent's Canal (another snippet of archery history bound up with the Prince of Wales).

Scarlet, it transpired, was one of the later marks, placed by the HAC some time between 1628, when a fourth, revised map appeared, and 1737, when the fifth and final map was produced.

Scarlet's whereabouts had been revealed in a book of 1858, *A Perambulation of Islington* (see *Links*) in which mention of another surviving mark was made. Called Whitehall, this had stood close to the site of the present day Britannia Leisure Centre, and bore the initials AC (meaning Archers' Company) and the date 1683.

From this, and using the 1737 map, we can deduce that Scarlet's original position had been close to the canal bridge, in the midst of what is now Shoreditch Park.

Shooting at marks, or 'roving' was and remains a form of archery that could only take place in large open expanses, and which today, for obvious reasons, is limited to areas where there is no danger of passers-by being in range (as was Dame Alice Owen's experience).

Hence in London the **Artillery Garden** (*above right*) is an ideal choice, for practical as well as for historic reasons.

But the extraordinary aspect of archery is that archers with longbows can equally be seen competing at most London clubs where only target archery is practised. And, what is more, they compete alongside other archers using all the most up-to-date equipment, sights, stabilisers and all, as seen at the Aquarius AC (*page 186*).

This is the equivalent of tennis players turning up on court with wooden rackets strung with catgut, or of cyclists on Penny Farthings lining up at the velodrome.

They are easy to spot, the traditional archers, with their slender yew bows, their arrows made from ash with turkey feather fletches, leather

quivers (*right*) and old style brushes (*below*), used to wipe arrowheads clean after retrieval.

Many will be members of the British Long-Bow Society (formed in 1951), and will have sourced equipment from members of the Craft Guild of Traditional Bowyers and Fletchers, who might also be members of the Worshipful Company of Bowyers, or even the Society of Archer Antiquaries.

In short, there appear to be plenty of 21st century toxophilites willing to keep alive a form of sport that in the end takes us right back to the basics. A bit of wood, a bit of string, an arrowhead, a steady arm and a keen eye.

The 'Noble Art' whistles on.

Chapter Twenty

Cricket

It is appropriate, if coincidental, that the oldest known cricket ball in the world and the oldest known bat are held by the museums of the MCC at Lord's and of Surrey County Cricket Club at the Oval, the two great and contrasting powerhouses of the London game. The ball, its red dye faded but its design instantly familiar, dates from 1820 and was swatted around Lord's over a three day period by William Ward, a director of the Bank of England, for his record innings of 278. Ward loved Lord's so much he paid £5,000 to save it from developers five years later. In 1845 he would also play a role in the securing of a lease for cricket at the Oval. Much less is known about the 1729 bat of John Chitty of Knaphill in Surrey (*below right*) other than it is typical of the period, being more like a hockey stick. This was because bowlers then delivered the ball underarm and along the ground. The bat as we know it today, with its spliced handle, willow blade and shoulders, evolved between 1771 and the 1880s.

There are sports older than cricket, such as football, real tennis, bowls, golf and archery. But there are none that have been organised and codified to the same degree as cricket, for as long.

Nor, surely, are there any whose history has been so assiduously researched and recorded by such a multitude of writers, statisticians and collectors.

This holds true in several parts of England. But the sheer volume of material – in the MCC's museum and library at Lord's alone – combined with the considerable number of historic clubs still active, makes London an unrivalled centre of cricketing heritage.

That is not to say that London was a cradle of the game. The earliest reference to cricket in England is of it being played by schoolboys in Guildford, in 1598. But it had clearly reached the capital by the Restoration, for there are references to games on Richmond Green in 1666, on Mitcham Green in 1685, and on Clapham Common in 1700, when a notice in the *Post Boy* newspaper announced that 'ten gentlemen aside' were to play on Easter Monday for a stake of £10 a head.

Remarkably, as detailed later, cricket is still played on all three of those open spaces. Not so on other public fields since lost to development, such as Walworth Common (where cricket and football were subject to licence in 1705), Lamb's Conduit Fields (where All London played Mitcham in 1707, now the site of the Brunswick Centre), and most

famously White Conduit Fields in Islington. According to the *Saturday Post* in 1718 it was there that a game between 'gamesters' from London and Kent resulted in a court case after it was alleged that the visitors absconded once it became clear they would lose the match, and therefore their stake.

In 1725 we find the earliest reference to cricket at an enclosed ground, that of the Honourable Artillery Company in Finsbury (*see opposite*). At the same venue in 1747 took place one of the earliest women's matches, between teams from Charlton and Sussex.

London cricketers were at the fore when it came to drawing up laws for the game, starting at the Artillery Ground (or Garden) in 1744. These laws were then refined in 1755 at the Star and Garter, a Pall Mall tavern whose regulars formed the exclusive White Conduit Club, named after the aforementioned ground in Islington. (Also formed at the Star and Garter was the Jockey Club, in 1750).

As London's golfers were also to discover, playing a potentially hazardous game on public land was bound to provoke hostility. So it was that the White Conduit Club's 'Lordling Cricketters,' as *The Times* called them in 1785, commissioned one of their number to find a private ground.

His name, coincidentally, was Thomas Lord. Hence in 1787 the first Lord's ground opened, with its patrons establishing a new entity that same year, the Marylebone Cricket Club. The MCC in turn took upon itself the role of guardian of

the laws of the game in 1788.

(White Conduit Fields, meanwhile, disappeared under bricks and mortar, with the tavern on the site replaced in the 1840s by the White Conduit House pub, now a restaurant, on the corner of Barnsbury Road and Dewey Road.)

From this period onwards, cricket was to achieve ever greater importance at all levels of London society. The annual Eton v. Harrow match, for example, first staged at Lord's in 1805, became one of the high points of the 'Season'. Still played today, it is considered the longest running fixture in cricket.

Lord Byron, who played for Harrow in that 1805 match, wrote of how afterwards he and his teammates got 'very drunk' and 'kicked up a row' at the Haymarket Theatre. But public schoolboys were hardly unusual in this respect. All over London cricket clubs and grounds were established at and adjacent to public houses, whose licensees acted both as promoters and bookmakers. One such ground was by the Spotted Dog in Forest Gate, where cricket was first recorded in 1844. Today it is one of six enclosed sports grounds in London that are over 150 years old, and although it is now used only for football (by Clapton FC), all five of the other grounds on that list still stage cricket (*see page 27*).

Similarly, of the 46 London sports clubs whose origins date back 150 years or more (*see page 18*), 27 are cricket clubs. They represent, moreover, many of the villages and market towns that may be said to have maintained

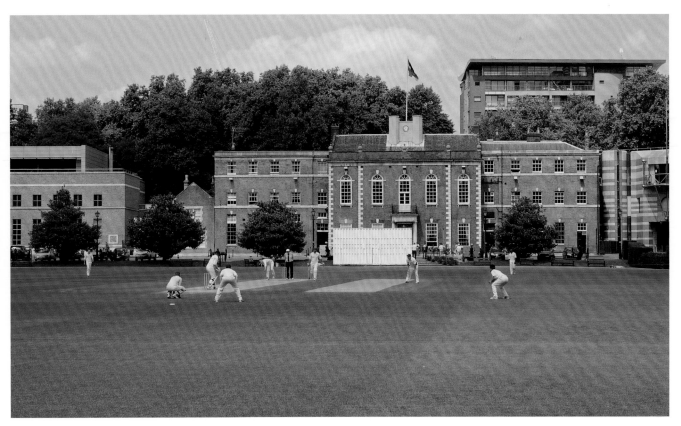

their identities long after being absorbed by the Metropolis; the likes of Hampstead, Putney, Bromley and Walthamstow.

Cricket was the first team sport to be accommodated in public parks. As noted in Chapter 12, clerks at the Prudential started playing at Battersea Park in 1860, two years after its opening. By 1905 there were 450 cricket pitches in London parks, but over 1,500 teams applying to use them.

Working class youths and men formed the mainstay of these teams, excluded as they were from private membership clubs and the old boy network. Trades and professions were also well represented, among them actors, as may be seen by studying the small ads at the back of *The Stage*.

Cricket was to play a pivotal role in the wider evolution of London sport. Both Lord's and the Oval started out as genuine multisport venues, as did the grounds at Beckenham, Dulwich and Richmond. Moreover dozens of clubs that today play football, rugby and hockey were started by cricketers. Even the nomenclature of cricket, exemplified by Victorian clubs such as Mitcham Wanderers, Islington Albion and Richmond Town, was borrowed by football.

Thus there was a Sutton United CC 30 years before the FC of that name formed in 1898.

Cricket clubs similarly extended their facilities to cater for tennis, bowls and squash. In the case of lawn tennis, the MCC took a lead role in drawing up rules for the infant game in 1875.

London's cricketing heritage is further enriched by the fact that, whereas all other English cities are identified with only one county, the capital is divided between four.

Although teams representing Surrey and Kent had first played each other in 1709, the modern county clubs date from 1845 and 1870 respectively. For its part Middlesex formed in 1859.

These three counties were among eight to form the first County Championship in 1888, while Essex, where cricket was first recorded in 1732, formed a county club in 1876 and joined the Championship in 1895.

London is further unique in that two of the county clubs, Middlesex and Surrey, are actually based in the city, both at grounds that stage Test Matches. The contrast between these two power centres, between the refined airs of St John's Wood and the bustle of Kennington, forms the basis of one of London's

most celebrated sporting rivalries.

At the level below, where there are 93 London clubs operating in four main county leagues (not to mention the hundreds more who remain unaffiliated), a multi-layered social and historical mix can be found. In Osterley, the Indian Gymkhana Club formed in 1916. Post war, West Indian clubs brought new life to the scene. Even today Asian teams are forming every year, while Kiwis and Aussies, once a mainstay in the 1990s, now find themselves outnumbered by South Africans.

So it is that, aided by a modernisation programme carried out by the England and Wales Cricket Board from 1997 onwards, the game in London appears to be in rude health, with some clubs fielding six or seven teams every weekend and having waiting lists for junior members.

Of course not all in the garden is rosy. Some historic clubs have suffered from lack of facilities, or have had to amalgamate in order to survive. But as this all too brief chapter seeks to show, cricket's strength has always been its ability to change with the times, while paying due regard to its heritage.

In that sense it is a capital sport, through and through.

▲ Hidden away between Bunhill Row and City Road, the pristine ground of the **Honourable Artillery Company (HAC),** known either as the **Artillery Ground** or **Artillery Garden**, is London's oldest enclosed sports venue, having staged cricket since at least 1725, and archery since 1652 (*see pages 192 & 195*).

Before Lord's took over its mantle in 1787, estimated crowds of 10,000 were common at the ground, some paying 6d for entry. The stakes were high too, once reaching 500 guineas, as a result of which one disputed match in 1775 is said to have ended in a riot.

Appalled, the HAC barred cricket until finally it relented, subject to strict conditions, in 1846. Rugby, football and, until recently, hockey have also found a home there.

But it is on summer evenings, when the hubbub of the city has ebbed, or at weekends, when an eerie calm prevails, that the Artillery Ground is at its most magical, as members of the HAC's own cricket club, formed in 1860, entertain teams representing business houses, old boys organisations and charities; unbeknown to the outside world other than to those passers-by who might catch a glimpse of its greensward through gaps in the buildings, and marvel.

▶ Legend has it that after the opening of the cricket ground on **Chislehurst Common** in July 1822, seen here in 2010, the notoriously haughty MCC player Lord Frederick Beauclerk described it as 'pretty good for a goose common'. And so it should have been, for Viscount Sydney had spent £191 on having the eight acre site 'grubbed, burnt, levelled and sowed with grass'.

But if in this instance the landowner was indulgent towards cricketers – who unlike commoners had no actual rights – this was not always the case. For the game's rise in popularity coincided exactly with the huge changes wrought upon the landscape by the spate of Enclosure Acts introduced during the late 18th and early 19th centuries.

The tenants of Chislehurst Common, **West Kent CC**, had themselves formed in 1812 on a part of Bromley Common called Princes Plain, until an Enclosure Act of 1821 forced them to depart.

What was to make Chislehurst an exception, and perhaps even unique, is that in the Act of 1888 which appointed Conservators to manage the Common for public benefit, specific clauses were included to allow West Kent CC to play on the ground as long as they maintained it in good order, and to allow other clubs to use it when not required by West Kent.

One of those other clubs was Chislehurst CC, formed in 1876, with whom the older club eventually merged to form the current incumbents, and guardians, **Chislehurst and West Kent CC**, in 1980.

In addition to its parliamentary protection, Chislehurst is celebrated as the venue where the exiled Emperor Napoleon III, who lived in nearby Camden Place during the 1870s (*see page 218*) watched cricket. Also noteworthy is the ground's rustic timber pavilion, thought to date from the 1890s.

▲ Roll up to **Richmond Green** on a Tuesday or Thursday evening in summer, or a Saturday afternoon, and there is a fair chance of catching a match involving teams from either **The Cricketers** or **The Prince's Head**.

In theory you can get as close to the action as you like, even cut across the pitch, which is marked out with white flags and warning signs (*above right*). You may even see the occasional shopper or dog walker doing just that, sometimes oblivious, sometimes simply to save time. Otherwise, a bench on the boundary is as good a place as any to contemplate the fact that history is firmly on the side of the cricketers.

For although the green has shrunk over the centuries – before the arrival of the railway in the 1840s it extended as far as the Old Deer Park to the north – cricket has been played on or somewhere near this patch for around 350 years.

We know this because in a letter to his wife on May 29 1666, Sir Robert Paston mentions that he has just met one of the king's attendants 'who says he saw your son very well engaged in a game of cricquett on Richmond Green.'

More reports follow in the 18th century, including one of a match in 1731, Richmond v. Sussex, which has a special place in history as the first cricket match for which any reports of team scores have been found. It was also the occasion of a riot in which angry punters tore the shirts off the Sussex players' backs in protest at the match ending before a result had been reached, apparently because the opposition had arrived late.

Such behaviour clearly did not put off one local publican, who by 1770 had renamed his pub the Crickett Players. The current Cricketers, dating from the 1840s, stands on the same site.

That the Green is now used by pub teams only is no surprise. Owned by the Crown Estate, it has always retained public access.

Local teams wishing to play to a higher standard have therefore historically moved to grounds where the pitches are more protected and where admission can be charged.

Thus **Richmond CC** set up at the Old Deer Park in 1862 while on an adjacent site in 1886 **Richmond Town CC** helped establish the Richmond Athletic Ground, now best known as a rugby venue (*see page 263*).

▶ Showing cricketers young and old on the **Lower Green** at **Mitcham**, this photograph, so rich in detail, dates from 1869 and is one of the earliest images known of the game.

Certainly its location is instantly recognisable. In the background is the White House, a distinctive late 18th century house with a bowed porch added *c*.1826. Listed Grade II, it can clearly be seen in the modern photograph below right.

What has changed the most – apart obviously from the posing styles of the players, their garb, and the fact that the open space is now officially called the **Cricket Green** – is that the road in the foreground is now more defined, busier and, unusually, separates Mitcham CC's pavilion (*centre right*) from the pitch.

Before this pavilion was built in 1904, Mitcham's players changed on the north side of the green at the Cricketers Inn, which was bombed during the Second World War and rebuilt in 1958. Next door to the pavilion, another pub, formerly the King's Head, was an important coaching inn on the London Road (now the A217), leading to Epsom and Brighton. It has since been named after the former Surrey and Mitcham player Burn Bullock, who was the pub's landlord from 1941–55.

Bullock and others were alas powerless to prevent the pavilion catching fire during an air raid, an incident that caused the club's earliest records to be destroyed.

This was a huge loss for the club, and for historians, because although Mitcham claims to be the oldest cricket club in the world, it can offer no firm evidence.

The earliest written reference is of a Mitcham team challenging an All London team at Lamb's Conduit Field in 1707. This is followed by a report of a match on Mitcham Green between Mitcham and Ewell in 1731. There is also a famous tale of how Lord Nelson stopped by on his way to Portsmouth before the Battle of Trafalgar and gave a shilling to cricketer John Bowyer, 'to drink to the confusion of the French'.

But frustratingly there are no records to indicate when the present day club was formed. Also frustrating is that while several histories mention a print entitled 'Crickette on Ye Olde Meecham Green' and dated 1685, no such

print has ever been found, nor anything like it from that period.

What is beyond doubt is that the Cricket Green as a ground has a pedigree that is over 300 years old, one that is overlooked by a charming array of historic buildings and forms the focal point of a Conservation Area.

Other 18th century cricket grounds in the public realm that are still used for cricket or general recreation include Moulsey Hurst where cricket is first recorded in 1723, later to became Hurst Park; Blackheath (1730), Duppas Hill, Croydon (1731, but possibly 1707), Woodford Green (1735) and Kew Green (1737).

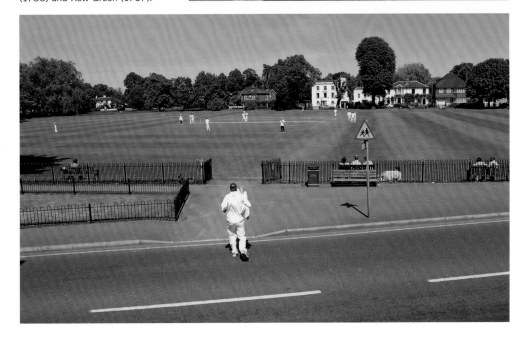

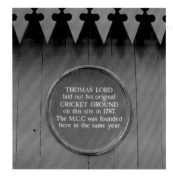

▲ On the rear of a shelter within the gardens of **Dorset Square NW1** this plaque records the location of the first **Lord's cricket ground**, in use from 1787–1810.

Naming sports grounds after their proprietors was common in Georgian Britain (as it was also for gentlemen's clubs, such as Boodle's and Brooks's). There was Hall's in Camberwell, Prince's in Knightsbridge and Emerson's in Ealing.

Born in Thirsk but brought up in Diss, **Thomas Lord** (1755–1832) was, by various accounts, either a charmer or a calculating social climber. At a time when aristocratic cricketers hired professionals to do the strenuous work of bowling, as noted earlier he found work with the White Conduit Club in Islington. Lord was a capable cricketer, but it was as a go-getting factotum that he won the trust of the club's leading lights, Lord Winchilsea and George Lennox (later to be the fourth Duke of Richmond).

Keen to find a private ground nearer to town this pair set Lord on the trail, in return for which they indemnified him against any losses.

Thus was created the first Lord's on seven acres of the Portman Estate known as Dorset Fields, just north of the New Road (later Marylebone Road). In 1787 this was on the very edge of the city. By 1808, with two years left on the lease, a hike in the rent persuaded Lord that the future lay elsewhere.

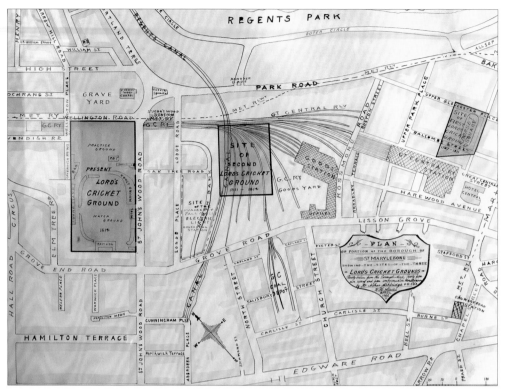

▲ Showing the location of the **three Lord's grounds**, this map, displayed in the MCC museum, was drawn in 1902 by **William Slatter**, one of eight members of the Slatter family to have worked at Lord's. His father had been the groundsman, while William rose to become Clerk of Works. Slatter's memoirs, collected in 1914 (see *Links*), provide a uniquely intimate record of the ground in its first hundred years.

The **first Lord's** is marked on the right (east of Marylebone Station, which had opened in 1899).

The **second Lord's** lay within the Eyre estate, at a place called North Bank. At the request of MCC members Lord transferred all the turf from the original ground to the new site, 700 yards to the north west. But the ground was never popular. Perhaps its aspect was unfavourable. Perhaps members objected to the fact that work was about to start nearby on the first phase of Regent's Park.

Whatever, despite the ground officially opening in May 1811 – although it had been in use for two previous years by St John's Wood CC – the MCC played no matches there until 1813, and even then on only three occasions.

By that time, however, no doubt to Lord's relief, the ground's fate had been taken out of his hands. As part of plans laid down by John

Nash, mastermind also of Regent's Park, the ground was slated to make way for the Regent's Canal.

Although a shortlived venue, the site of the second Lord's is marked by more plaques than any other former sports ground in Britain.

The first is on the corner of Lisson Grove and Lilestone Street, the second is on the west side of Park Road, by a set of footsteps leading down to the Regent's Canal, and the third (*below*) can be seen from the canal footpath.

Having only recently signed an 80 year lease for this second site, in 1813 Lord managed to negotiate compensation worth £4,000 from the Eyre Estate in order for the canal scheme to proceed.

The Estate also found for him a new site, a short distance to

the north, at £100 per annum. Apparently the site had been used to dump spoil excavated for the construction of the Maida Hill tunnel of the Regent's Canal.

Once again Lord arranged for the turf from the second ground, which had of course originated at the first, to be relaid at the third.

The opening event at the new ground was not a match but a reception to mark the consecration of St John's Chapel, which had also just been completed across Wellington Road (and where Mrs Lord would soon be laid to rest).

The first match followed on June 22 1814, MCC v. Hertfordshire.

Thomas Lord, meanwhile, had become a pillar of the community.

He had married well, in 1793, and after ending his playing career in 1802 supplied wine to a range of well connected clients, the royal family included. In 1807 he became a member of the Vestry in the parish of St Marylebone.

Yet he also managed to alienate various MCC players by refusing to pay £20, as he had promised, to the first batsman to hit a ball out of Lord's.

But it was in 1825, now aged 70, that he created the biggest stir of all by announcing that, with the consent of the Eyre Estate, most of Lord's number three was to be redeveloped for housing.

▶ Almost a century on from that bombshell, and all is not only well but the ground still bears the name of Thomas Lord, which suggests that either the MCC were a forgiving lot or that Lord was not all bad.

Even so, no-one could complain had the name been changed to Ward's, for it was the gentleman cricketer and Bank of England director William Ward who was so outraged by Lord's declaration in 1825 that he wrote out a cheque for £5,000 on the spot (the equivalent of several million today), thereby taking on the lease himself and allowing Lord to retire comfortably to Hampshire.

Ward's first challenge came a few days later when fire destroyed the pavilion, and with it – another loss for historians – all the MCC's early records. Ten years later Ward then passed on the lease to James Dark.

Like Lord, Dark was a former professional cricketer made good. Born on the Edgware Road, he transformed Lord's into a multisport hive of activity. In 1837 he offered not only cricket but trap ball, quoits, archery, bowls, lawn billiards, skittles, even football. A gravel running path featured what was described in 1842 as the best 200 yard sprint track in London. Dark also added bespoke facilities for real tennis, rackets and billiards.

As well he might, for the irony was that the MCC played relatively few games there. In fact once the Kennington Oval opened in 1845 there was a real danger that Lord's would be completely eclipsed. The pedestrian (or athletics) fraternity were soon to take their events elsewhere because Dark would not let them charge gate money, whilst the atmosphere at cricket matches was quite unlike that of later years. One spectator in 1849 complained that 'betting on the

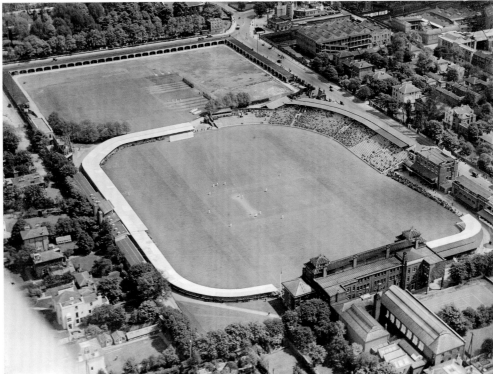

game is quoted as unblushingly as if Lord's were a racecourse'.

Another recalled the ground presenting 'rather a dreary scene'.

Worst of all was the pitch, described as notoriously poor, being heavy clay, badly drained and littered with pebbles.

Dark nevertheless saved Lord's. In 1860 the new owner of the Eyre Estate offered to buy up the lease so that housing could be built. Dark refused, and in 1864 accepted an offer from the MCC instead, for the lease and all the fixtures and fittings, for £12,500.

Finally the club became master of its own destiny by purchasing the freehold in 1866 for £18,333, with assistance from amateur cricketer William Nicholson MP, whose fortune had been made in gin.

With the freehold and a full time secretary now in place, Lord's started its path to becoming the elite venue seen above in 1921.

The first **Grand Stand** (on the left) went up in 1867, as did the **Tavern** on the opposite side.

In 1877 the ground hosted its first Middlesex match, followed in 1884 by its first Test, against Australia. (The Oval's first Test had been four years earlier.)

Then to celebrate the MCC's centenary in 1887, the club paid £18,500 for an extra 3.5 acres on its east side (seen at the top). As this site had previously been Henderson's Nursery, purveyors of fine tulips and pineapples, the pitch which took its place was called the **Nursery**; apt given that it was to become a training ground.

(It was through a tunnel under the far end of the new Nursery pitch that Sir Edward Watkin's railway was routed in 1891, as noted on page 21.)

Three of the buildings seen above remain standing.

In the foreground is the **Pavilion**, completed in 1890, again with the aid of William Nicholson, hence its early nickname, 'the Gin Palace'.

Behind it can be seen a **lawn tennis court**, now forming the **Harris Garden**, and two other buildings dating from 1900; the indoor **real tennis court**, which replaced Dark's original and is still in use today, and to its left the smaller **rackets court**. In 1953 this was converted into the **Imperial Cricket Memorial Gallery**.

It is yet another measure of the importance of Lord's that this facility is now recognised as the oldest sports museum in the world.

Most visitors to the Museum at Lord's head straight for the Ashes, symbolically represented by a tiny pottery urn (far left). This was presented to the English captain in Melbourne in 1883, a year after *Sporting Times* had mourned the 'death' of English cricket caused by Australia's win at the Oval in 1882. The MCC collection around which the museum is based was itself started in 1864.

▶ In the 1950s Nikolaus Pevsner described **Lord's** as 'a jumble without aesthetic aspirations, quite unthinkable in a country like Sweden or Holland'. A jumble? No question. Therein lies one of the joys of British cricket grounds. But without aesthetic aspirations?

That said, had architect Thomas Verity got his way the Lord's **Pavilion** would have been constructed largely in stone. We must therefore be grateful that a strike by masons necessitated the use of brick and terracotta instead, thus lending the building its wonderfully rich, warm hue.

And that an £8m refurbishment in 2004-05 restored so much of its original splendour and finery.

When it opened in 1890 *Baily's Magazine* aptly described the building as the 'lawcourt of cricket', appearing as if it were 'meant to stand forever'. It dominated the ground as surely as the MCC ruled over the game.

It also invited generations of batsmen to attempt lofting a ball over its roof. So far only one, Albert Trott, has succeeded. That was back in July 1899. (Needless to add the bat with which he achieved this feat is in the MCC museum.)

At the heart of the Pavilion is the **Long Room**. Extending for 93 feet between the corner towers, lined with portraits and bathed in light from the windows looking out over the pitch, this exclusive area echoes both the form and function played in medieval country houses by the long gallery.

As Duff Hart-Davies has also noted in his architectural history of Lord's (*see Links*), the generous scale and detail of its doorways, windows and circulation areas equally reflect Verity's experience as a designer of numerous West End theatres and restaurants.

It embodies the same rigid social distinctions too. This, after all, was a building that until 1962

Gilbert Bayes' Grade II listed Portland stone bas-relief, depicting thirteen sportsmen and women, has been a popular meeting point since its unveiling on the corner of Wellington Road and St John's Wood Road in 1934. Between the figures are Henry Newboult's epic words, 'Play Up, Play Up and Play the Game'. Look closer and there is a dedication, not to the MCC but to the Borough of St Marylebone.

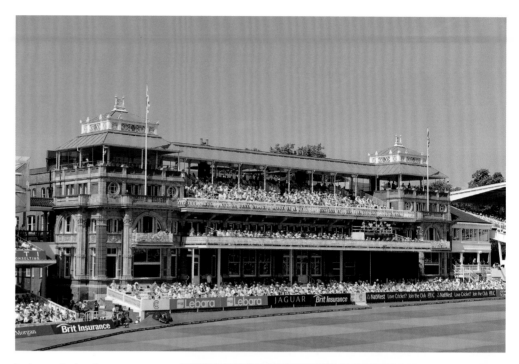

had separate dressing rooms and entrances onto the pitch for amateur and professional players, and to which women were denied entry as members until 1999.

As seen above and in the 2011 aerial view (*right*), the Pavilion – currently the only cricket building to be listed Grade II* – does not quite dominate as before, being hemmed in by the **Allen Stand** (built 1935) to its east side and the **Warner Stand** (1958), to its west.

Less apparent is that the pitch slopes, by around 6' 6", from the Warner Stand down to the Tavern Stand in the south east corner.

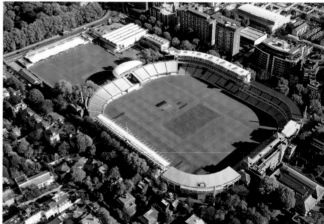

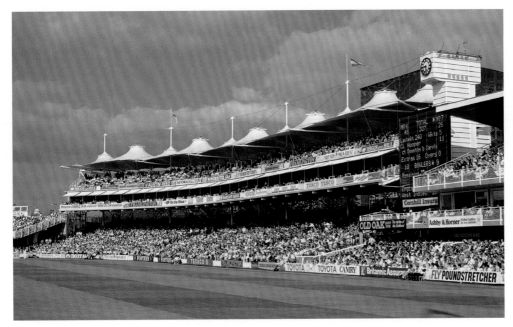

▲ One remarkable aspect of Lord's is the level to which the MCC, so often castigated for its conservatism in other matters, has in recent years shown itself to be a patron of modern architecture.

This trend commenced in 1987 with the new **Mound Stand** (*above*) designed by Michael Hopkins & Partners and engineers Ove Arup.

This has a two-tiered upper level shaded by a PVC coated, tent-like fabric canopy, sitting over an arched colonnade, modelled on that of the original Mound Stand (designed in 1898 by Frank Verity, son of Thomas). Coincidentally the arches were built using London stock bricks recycled from a former tent manufactory in Camberwell, dating from 1857.

From pitchside the structures blend seamlessly together.

From St John's Wood Road (*above right*) the contrast of old and new is pure delight.

In contrast, an unashamedly modern, white steel framework characterises the **Grandstand** (*right*). Designed by Nicholas Grimshaw, again with Ove Arup as engineers, and opened in 1998, this replaced a 1920s stand justly considered one of the worst ever built in Britain. Its architect Herbert Baker did however leave two rather more cherished legacies; the **Father Time weathervane** (*see page 338*), and the **Grace Gates** (*page 210*).

Boldest of all is the glass fronted **Media Centre** (*top right*). Designed by Future Systems and opened in 1999, its aluminium semi-monocoque structure was conceived in a boatyard. Almost as radically it spans a gap between the **Compton** and **Edrich Stands** that had been regarded as sacrosanct because it enabled members in the pavilion to see through to the trees beyond the Nursery End.

Having crossed that particular Rubicon, as the ground approached its bicentenary in 2014 the MCC considered an even more radical proposal, known as the 'Vision for Lord's'. To be financed by building flats along the Wellington Road side of the Nursery, estimated to be worth £100 million, this vision and the way it was progressed provoked an almighty rift among members.

At its core, nevertheless, lay legitimate concerns. For while its international counterparts such as the Melbourne Cricket Ground (opened 1853) and Eden Gardens in Calcutta (1864) hold 100,000 and 90,000 respectively, Lord's holds just 29,300; this to cater for a club that has 23,000 full and associate members, and a waiting list of 10,500, which could take 23 years to clear.

And that is before allowance is made for the 8,000 members of the MCC's tenants, Middlesex CCC, who come second in the pecking order for big match tickets, after which comes... the general public.

In 2011 the 'Vision' fell at the last hurdle, accompanied by a statement that the 'preservation of Lord's as a cricket ground was more important than a windfall of cash'.

In its place a new ten year masterplan has been drawn up. More cautious in some respects, more extensive in others, its final costs may be in the region of £200 million, yet it will increase the capacity by only 2,700, to 32,000.

Another London case, therefore, of 'watch this (confined) space', while at the same confirming this author's dictum that the difference between a 'stadium' and a 'ground' is that while the former may one day be completed, the latter is *always* a work in progress.

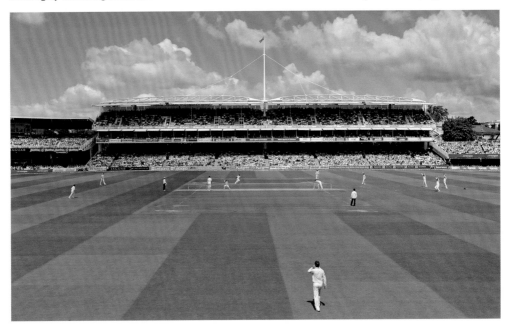

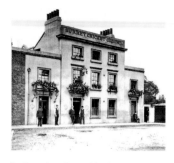

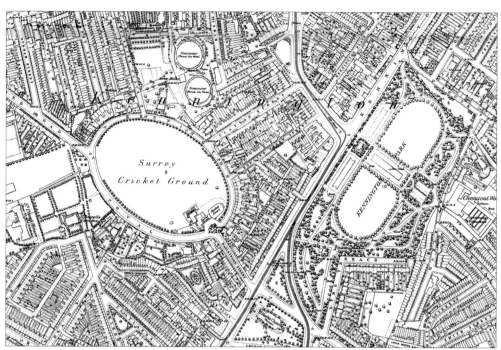

▶ So to London cricket's other great work in progress. Some 40 cricket grounds around the world bear the name **Oval** – in the West Indies, South Africa, New Zealand and Australia – all in homage to this, the original, in SE11.

Yet the name **Kennington Oval** actually predates the ground, having been coined to denote the road that encloses the site, laid out in 1790 in advance of a housing scheme.

Its promoters ran out of funds, and so the fields in the centre became a nursery, later a market garden. A revised set of plans for semi-detached villas and a road through the middle then failed in 1841, while according to papers held by the site's owners, the Duchy of Cornwall, the market garden fell into 'a most ruinous condition... the effluvium arising from decayed vegetables' having become 'a nuisance and a source of ill-health'.

The Duchy was therefore happy to lease the Oval to **Montpelier Cricket Club**. About to lose their own Bee Hive ground in Walworth to development, Montpelier raised £300 to lay a pitch, using 10,000 turves cut from Tooting Common.

Inaugurated on May 13 1845, the Oval can claim to be the fifth oldest enclosed sports ground in London (*see page 27*).

Three months after its opening match, members of Montpelier and other local clubs met at the Horns Tavern (now the site of a Job Centre Plus on Kennington Park Road) to form **Surrey County Cricket Club**.

But even with two clubs now in residence the rent proved hard to meet, and in 1851, with Montpelier seeking to raise funds by staging foot races and poultry shows, the Duchy resolved to hand the Oval over to builders, once and for all. Surrey even identified an alternative site, in Brixton, until no less a figure than Albert, the Prince Consort, stepped in to save the day, in his capacity both as regent to the young Duke of Cornwall and as a new convert to cricket.

Consequently Surrey took over the lease from Montpelier in 1855, and have retained it ever since.

As shown by the 1871 map above, the Oval's distinct character was evident from its earliest years.

Within the ground there were no stands, just a pavilion, built in 1858, and the adjoining **Surrey Tavern** (*top left*), occupying an existing house. To the immediate east of this was a rackets court.

To the north lay the **Phoenix Gas Works**. Familiar to cricket fans all over the world as a backdrop to games, its first gasholder was in place by 1850. By 1880 there were five, the largest of which, seen on the right, in around 1910, still dominates the ground.

South of the gasworks, **Bowling Green Street** was now lined by tenements, while **Kennington Common**, where cricket had been played since at least 1724, had been transformed into **Kennington Park** in 1854.

Even so, a chemical works bordered the park on one side.

Given these most urban (and noxious) of surrounds – and this was before Marmite opened a factory nearby in 1927 – Surrey's attachment to the Oval might seem unlikely, especially as Kennington ceased to be part of Surrey when the County of London was created in 1889.

So why did they not follow Kent and Essex, who abandoned their own Metropolitan grounds, at Catford (in 1921), and Leyton (in 1933) for, say, the calmer environs of Sutton or Guildford?

No doubt the opening of the Oval Underground station in 1890 improved the ground's business case. But just as importantly, by then the Oval had forged for itself a place in sporting history.

As noted on page 225, under Surrey secretary Charles Alcock, who was also the first secretary of the Football Association, from 1872–92 the Oval in effect served

as England's first national sports ground. In 1880 it staged England's first ever home Test match (four years before Lord's staged a Test). Some 20,000 spectators paid a shilling entrance, twice the normal price, on each of the first two days, many of them watching from banks raised around the perimeter by soil excavated from the culverting of the River Effra. The follow up Oval Test in 1882 was the match which gave rise to the Ashes tradition.

Meanwhile the Oval became the home of the FA Cup Final, and of numerous football and rugby internationals. By 1886 Surrey's profit from staging football alone exceeded £1,000.

But as football grew ever more popular, so too did Surrey's expenses rise, as did the number of complaints from cricketers about the quality of the pitch.

In September 1895 a vote of Surrey members was taken, as follows: for the continuance of football, 453; against, 1,095.

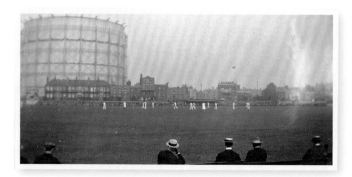

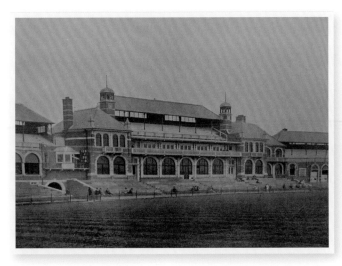

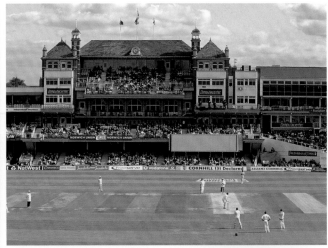

▲ Over the years the **Oval** has never quite been able to shake off comparisons with its counterpart in St John's Wood. Thus while Lord's has been described as the High Church of cricket, the Oval is the Low Church. And that if Lord's represents the London of Thackeray, the Oval is that of Dickens.

One wit commented that the essential difference was that at Lord's members are required to wear jackets and ties at all times, whereas at the Oval they are merely asked not to remove their shirts.

This is not just a case of reverse snobbery, however. The two grounds are entirely different in character, but this is not only due to their locations or clientele. Also pertinent is that whereas the MCC own Lord's, Surrey have only ever been tenants (albeit of the Duchy of Cornwall), and as a result have been far less able to raise the funds necessary to develop the ground.

If it therefore seems unfair to call the Oval 'ugly as sin', as did one cricket writer, at the same time, for sure, it is no beauty.

During negotiations for a new lease in the 1890s the Duchy told Surrey to invest at least £12,000 in a **new pavilion**. Playing safe, the club hired Thomas Muirhead

to repeat almost exactly the design he had recently completed for Lancashire CCC at Old Trafford.

With a substantial new **Surrey Tavern** behind the pavilion and stands on both flanks – as pictured above in 1902 – the final bill came to £38,000. This meant that further developments were limited to low key, piecemeal additions, such as, in the 1920s, a cover at the Vauxhall End, which in time came to resemble a football ground more than a Test match venue. In fact the ground did continue to stage occasional football matches, as well as hockey and lacrosse.

The Oval then suffered terribly during the Second World War when it was converted into a Prisoner of War camp that, in the end, was never used but ruined the pitch.

It took a public appeal to restore it, and other areas damaged by bombs. But despite Surrey then going on to win seven County Championships on the trot during the 1950s, in front of packed crowds, both the south and north sides remained uncovered and basic.

Not that schoolmasters able to watch from the rooftop of **Archbishop Tenison's School** (*below*) ever complained.

Except that as Surrey's finances continued to deteriorate, real fears grew that an inner city ground of this size was no longer sustainable. In desperation, in 1968 Surrey became the first county to sell perimeter advertising. They were then hit with huge bills when the 1985 Bradford fire resulted in more stringent safety standards.

Finally crisis point was reached in 1988, resulting in the launch of a campaign, 'Save the Oval'.

As may be seen on a wall inside the main entrance, among those supporters of the campaign whose names are embossed on bricks were the unlikely mix of the MCC, Jeffrey Archer, Mick Jagger and Surrey stalwarts Stuart Surridge and the Bedser twins, Alec and Eric. (Alec, the first bowler ever knighted, in 1996, later bequeathed his archive to the Oval Museum.)

Surrey also became the first major club in Britain to sell their ground naming rights. Nowadays such deals are routine. But when the Oval became the **Fosters Oval** in 1989 it was a watershed.

The Oval of today very much reflects this new era of sponsorship and corporate hospitality. Still the Duchy was refusing to sell the freehold, but at least Surrey could now raise the capital to plan ahead.

And up, as far as Muirhead's Pavilion was concerned. As seen above, in 2000, the upper tier roof and corner turrets might appear the same, but during 1993-95 they were raised by the insertion of three additional storeys. An extra tier of seats was also built in front of the lower level.

Matters were even more complex at the rear of the pavilion, until in 2013, all was revealed...

These artefacts – a plaque mounted outside the pavilion and a ceramic jug from the 1920s, on display in the Oval Museum – were gifted by Surrey's neighbours, Royal Doulton, whose factory in Black Prince Road added to the general fug around the ground until its closure in 1956.

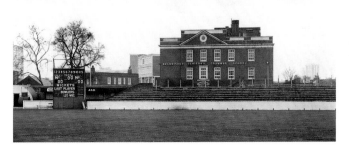

Inside the main gate at the Oval, this red brick bas-relief from the early 1990s, by sculptor Walter Ritchie, a former apprentice of Eric Gill, depicts the Yorkshire and England batsman Sir Len Hutton, whose innings of 364 v. Australia in 1938 has never been surpassed at the ground. In the panel below, a radial diagram shows how, over 13 hours at the crease spread across three days, Hutton amassed his record total, shot by shot, and without scoring a single six. Hutton died in 1990, but in his last years had been a prominent supporter of the 'Save the Oval' appeal.

▲ Coming full circle – between 1897 and 2008 the façade of the **Oval Pavilion** was almost entirely hidden behind the **Surrey Tavern** (not the Tavern seen on page 204 but a larger, late Victorian gin palace designed by Thomas Muirhead, subsequently replaced in 1968 by an unsympathetic modern tavern and banqueting suite).

Surrey had intended that the Tavern's demolition and the creation of a courtyard in front of the pavilion – a space that the ground's orientation had always craved – was to have been accompanied by the construction of a new 2,000 seat stand incorporating a 168 bed hotel, in the adjoining eastern corner of the ground.

The hotel plans were turned down on safety grounds, owing to the proximity of the gasholders. But the creation of the courtyard went ahead, and with it a much needed refurbishment of the newly exposed Pavilion frontage.

Completed at a cost of £2 million in 2013 and designed by ADAM Architecture, not surprisingly the works reflect the tastes of Surrey's landlord. A new classical portico flanked by steps leading to

At its rear, facing Kennington Oval itself – the road, not the ground – the OCS Stand is framed by a 600 foot 'living screen' consisting of clematis, wisteria, honeysuckle and ivy which, as the years go by, will soften its impact considerably, not only for visitors to the ground but also for the many residents whose flats overlook the site (and whose views into the ground were blocked by its construction).

a balcony forms the main focus. In a break from the classical orders, the capitals are based on the Prince of Wales feathers, while above the pediment are mounted two stone urns, based on the design of the famous **Ashes urn** (*see page 201*). The Ashes tradition, it will be recalled, originated after England's loss to the Australians at the Oval in 1882.

Another couple of urns adorn the gateposts of the newly restored and repositioned **Hobbs Gates**, seen here in the foreground.

Now centre stage, the gates were originally located to one side of the Tavern, and were designed by Louis de Soissons in 1934 to honour the Surrey and England batsman Jack Hobbs on the occasion of his retirement. (A blue plaque to Hobbs appears on page 212).

But if on this side of the Oval the accent is on solid Victorian red brick, classical stonework and iron railings, on the opposite side of the ground, approached from Harleyford Road, a quite different design ethic prevails.

In place of the hodgepodge of stands and hospitality boxes that once filled the Vauxhall End, all is now orderly, unified and elegant in the form of the sweeping steel and concrete **OCS Stand.**

Viewed below from the Pavilion in 2013, with the **St George Wharf Tower**, Britain's tallest residential building, dominating the skyline towards Vauxhall, the £25 million stand was based on an original concept design by HOK Sport Architects and completed in 2005 by the Millersport practice.

Rising to four tiers in its centre – from which spectacular views of the London skyline may be had from its rooftop bars – it is, rather surprisingly, the first major stand to have embraced and celebrated the ground's oval form.

It also, vitally, raised the Oval's capacity from 19,000 to 23,000, thereby ensuring that not only would Surrey be able to maintain some of the conference and corporate capacity lost by the demolition of the Surrey Tavern, but also that, at a time when its rivals were modernising impressively, the Oval would retain its all important status as a Test venue.

The addition of retractable floodlights has in addition enabled Surrey to stage lucrative quickfire evening games in the T20 series.

In this respect the fact that the nearest bit of Surrey lies nine miles south, in Worcester Park, pales into insignificance against the ground's proximity to central London.

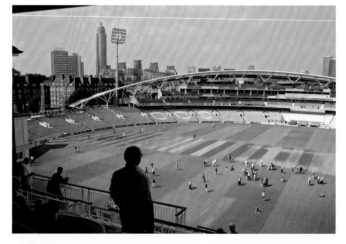

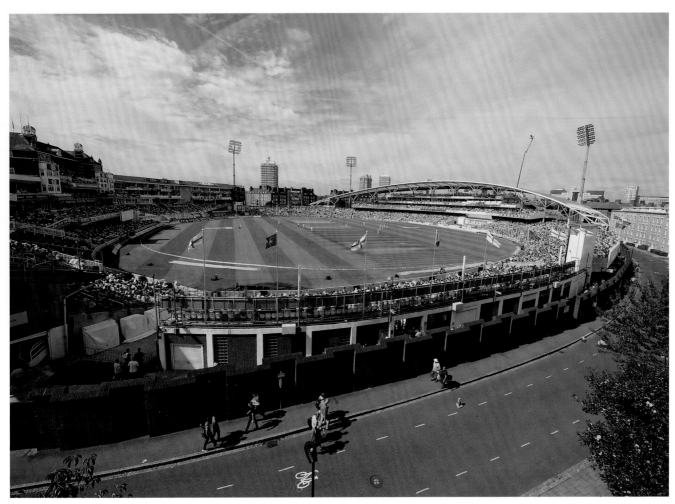

▲ Taken during a Test match v. India in 2011, this view illustrates two unique characteristics of the **Kia Oval**, as it is currently called.

Firstly, its expanse of turf measures 170m x 150m, larger than any cricket ground in Britain, in the centre of which ground staff can choose between 43 wickets, laid side by side. This is one reason why, in the old days, the Oval was known as 'the bowler's graveyard'.

The second characteristic is that, in addition to the Duchy of Cornwall and the former prime minister Sir John Major, Surrey has a host of friends in high places. And while they may not contribute to the club's coffers, their often colourful, occasionally raucous presence has long provided a quirky diversion during longueurs in play.

One of their viewpoints, this one included, is **Lohmann House**, one of several blocks of council flats surrounding the ground, all named after cricketers.

On the far, south west side of the ground, similarly unhindered views were possible until the 1990s, and

not only from the upper deck of a passing bus. (If you were lucky the driver would dally long enough to be able to check the scoreboard.)

Best of all were the windows of flats in **Stoddart House**, or, as noted earlier, the rooftop of **Archbishop Tenison's School**. But since the erection of the **Bedser Stand** in 1991 (by the floodlight mast on the left), and the advent of big screens, such viewpoints are now much more restricted.

It is the same down on street level, where finding an elevated ledge, scaling a lamp post or even climbing the walls – once a rite of passage for south London schoolboys – is now all but impossible. Next to Lohmann House, another lost vantage point was the roof of the 1930s **Cricketers** pub, on which the bold and boozy would perch with pride (or in its later days, Fosters).

The pub closed in 2007, but that still leaves the oldest vantage point of them all.

Oval Mansions (*above right*) was built in the 1880s, presumably for

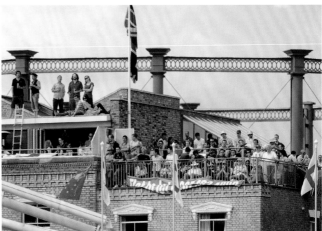

workers at the adjacent gasworks, who no doubt did not lack for friends on the occasion of all those early Test matches, Cup Finals and internationals. In that sense it could be said that the building forms one of the oldest grandstands in town.

Nowadays its flats sell for over half a million pounds. That, however, does include access to the communal terrace.

Drinks, we are told, are extra.

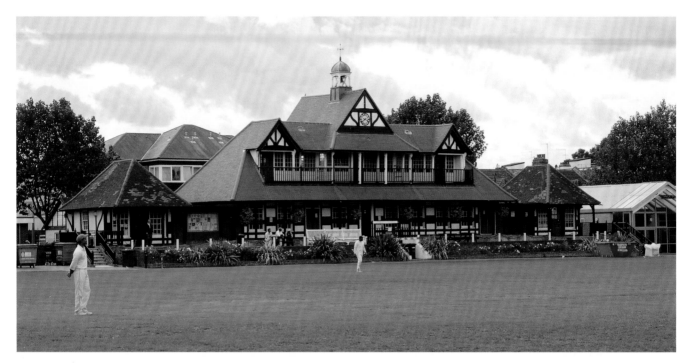

▲ While Middlesex and Surrey have stayed put, **Essex County Cricket Club** spent 48 years in the capital before departing in 1933. Behind them they left this fine Grade II listed pavilion and a ground, little known but with an eventful history.

Located on **Crawley Road E10,** the **Leyton County Cricket Ground** was originally called the Lyttleton Ground, having been laid out in 1883 by Lord Lyttleton, scion of a noted cricketing family. Initially it was leased by the Insurance Cricket and Athletics Club, until in 1885 the captain of Essex CCC, Charles Green, decided that his club would gain more support in Leyton than in Brentwood, where it had played since its formation in 1876.

Green was a local, the son of a wealthy shipbuilder in Hoe Street, Walthamstow, and later to become the managing director of the Orient Steam Navigation Company, which is said to have inspired the title of another Leyton sports club in 1888 (*see page 252*).

The Lyttleton Ground soon showed its potential. Essex hosted the first visit of an Indian team, in 1885, followed by the Australians the year after. Clearly ambitious, Essex then paid £12,000 for the freehold and, with Lyttleton's help, raised a further £3,500 to build the pavilion seen here, opened in 1886. Its architect was Richard Creed, whose later design for Lord's was to be rejected in favour of Thomas Verity's.

For a period it looked as if here was a venue with real prospects. In 1894, the year that Essex achieved first class county status, a railway station, now called Leyton Midland, opened nearby.

The ground was also well used during the winter, including a Football League match, Arsenal v. Leicester in March 1895, when the Gunners' own ground was closed because of crowd trouble.

In 1896 an estimated 12,000 packed the ground for another visit by the Australians.

But as Kent were to find at Catford, a growing catchment area was no guarantee of support, and in 1921 Essex had to rescue their finances by selling the ground's freehold to the newly formed Army Sport Control Board.

They stayed on at the ground however, always hopeful of buying it back, and it was during this uncertain period that two historic events took place. In May 1927 the BBC experimented with their first ever radio broadcast of a cricket match, during an Essex game v. New Zealand, while in June 1932 Leyton witnessed a first wicket partnership that would go into the record books (*see below*).

But still Essex could not afford to buy back the ground and in 1933 they left for what was to become a peripatetic existence until finally settling at Chelmsford in 1966.

The Leyton ground meanwhile was sold to the Metropolitan Police, who in turn sold it to the local education authorities in 1938.

In time its concrete terracing, a small grandstand and the now famous scoreboard were removed and it reverted to being an anonymous, suburban ground, of which there are so many in London (some also with good tales attached and yet equally unknown).

But then Essex returned; initially in 1957 for just two matches a year, later for an annual cricket week, for which crowds of 2–3,000 were common, until finally, the construction of a sports hall in one corner and the ground's greater use by schools finally rendered it unsuited to first class games. The last Essex match, v. Glamorgan, was in 1977.

From then on the pavilion went into steady decline until, having been listed Grade II in 1999, it was sensitively restored with lottery funding. Today the building serves as a youth and community centre, while the pitch is used by various teams, among them **Leyton County CC**.

Fans gather by the scoreboard at Leyton having cheered a first innings partnership that, at 555, had beaten the existing record by one run, and demonstrated why commentators often used the expression 'as good as a Leyton wicket' as a benchmark for quality. The innings was amassed by the Yorkshire pair of Percy Holmes and Herbert Sutcliffe. But as Stephen Chalke relates in his entertaining

account of the day (*see Links*), the scorers inside the rickety box had by this point discovered that the actual score had been 554, and had only agreed to leave it at 555 after a deal of browbeating, as the Essex captain finally admitted in 1978. The scoreboard has long since gone, but this part of the ground and the houses behind are still recognisable, backing onto Brewster Road.

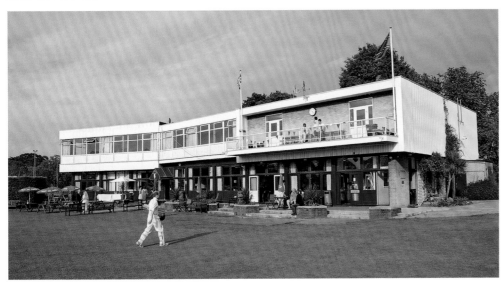

◄ Unlike football, where even in the lower reaches of the semi-pro game grounds are enclosed and entrance fees charged, in cricket, step down one level from the first class county game and pretty much every ground is open and accessible to the public, if not always easy to spot, hidden as they so often are behind hedges or tucked between gaps in the houses.

Ealing Cricket Club, on **Corfton Road**, was formed in 1871 by the Rev ES Carter, along with four other members of the clergy. The club president was the local MP, and the vice president a captain in the army. The club's pavilion (*top*), an appealing blend of vernacular styles and materials, opened in 1900 and is locally listed.

Ealing is one of 30 clubs in the Middlesex County Cricket League, every single one of which is based in London. By contrast, of the 59 clubs forming its equivalent, the Surrey Championship, only 28 have London addresses.

One is **Malden Wanderers CC**, formed in 1879, whose attractive Art and Crafts pavilion (*left*) on **Cambridge Avenue**, New Malden, dates from 1928. At its core is a main hall with a lofty ceiling, intended, as the opening brochure stated, for badminton and dances for up to 110 people 'in absolute comfort'. It was designed by the Malden captain, Jimmy Walker. Four years later the club secretary embezzled £1,000 from club funds, forcing a corner of the ground to be sold for housing.

Formed in 1862, **Richmond CC** shares the **Old Deer Park** ground (*page 262*) with five other sports: tennis, bowls, archery, squash and rugby. The club is unusual in two other respects.

Firstly, its pavilion (*left*) is a rare example, in London sport at least, of a postwar design of note. Opened in 1969 its architects were Frank Saunders & Partners.

Secondly, although located in Surrey, Richmond play in the Middlesex League, a reflection of the fact that Richmond upon Thames is the only London borough that straddles two counties and the River Thames (*page 25*).

Meanwhile to the east, 22 of the 63 clubs in the senior Kent league are based in London, as are 13 of the 40 in Essex. This brings a total of 93 clubs playing senior League cricket in the capital.

▲ Even readers who know nothing of cricket may well recognise the beard, or at least be familiar with the initials of its doughty owner.

Created in 1999 by Australian sculptor **Louis Laumen** and taking pride of place in the Coronation Gardens at **Lord's**, this modern statue of **Dr William Gilbert Grace** (1848–1915) is yet one more reminder that, as the centenary of his death approaches, the cult of WG shows little sign of fading.

Here was a player so prodigiously talented – scoring some 54,896 first class runs and taking 2,876 wickets over a period of 44 years – that one reporter called him 'a freak of nature'. Famously signs went up outside grounds saying that if Grace were playing the entrance fee would be 6d, if not, 3d.

Grace has been credited with inventing modern batting, saving the MCC from its inward looking torpor and transforming cricket from a marginal plaything of gamblers to a national and international sport.

He has had six biographers and had his life and career picked over in countless books, articles and academic papers. He has also had more memorials and commemorations in London than any other sportsman; this for a player who, born in Gloucestershire, lived in the capital only in the last 17 years of his life. But then he was already a national treasure as a teenager, having appeared at both the Oval and Lord's in 1864, and in 1866, at the age of 18 – this just one of dozens of feats that cricket fans can still reel off today – scoring 224 not out at the Oval before being given a few hours off to compete at the National Olympian Games at Crystal Palace where he won the 440 yards hurdles (*see page 64*).

Best known of his memorials are the **Grace Gates** (*above*), forming the main entrance to Lord's on St John's Wood Road. Unveiled in 1923, with Portland stone piers and ornate ironwork, the gates were designed by architect Herbert Baker and listed Grade II in 1996.

During his lifetime it was said that WG was the most famous Englishman in the world, apart only from William Gladstone. He was certainly the highest profile sports celebrity the nation had ever known, even if he was notoriously prickly, was acutely uncomfortable as a public speaker, and for a doctor was said to have had dubious standards of personal hygiene.

In his defence, one contemporary described Grace as just 'a great big schoolboy'.

Unsurprisingly the largest collection of artefacts relating to WG is held by the MCC Museum at Lord's. This was the cap he wore as captain of the England team that toured Australia in 1891–92. The S stands for Lord Sheffield, who financed the tour, including covering WG's fee of £3,000 and the cost of hiring a locum for his practice in Bristol. The bust (*right*) was sculpted by WH Tyler in 1888. Neville Cardus wrote that it was only when he saw two workmen remove this bust from the Long Room at Lord's, in early September 1939, that he knew war really was on its way. Like several anecdotes told by Cardus, this may not have been true, as is also the case with numerous tales about WG himself. They continue to be circulated, and enjoyed, nevertheless.

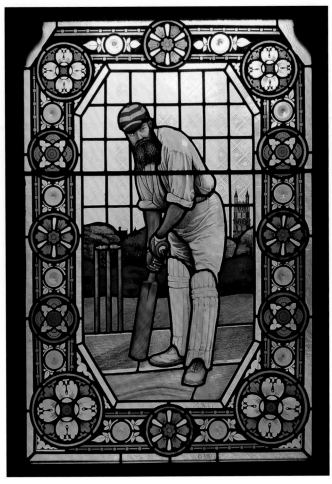

▲ **WG Grace** had just enrolled as a medical student in Bristol at the time the **Champion** pub in **Wells Street W1** opened in 1868. This stained glass window was, however, a much later addition, being one of eleven panels, each representing a different champion, created for the pub by Ann Sotheran in the 1990s.

Rather like Henry VIII the received image we have of Grace is that of him as an older, stockier man, rather than the tall, lean figure of his youth. By the time he retired from the England team at the age of 50 he weighed nearly 18 stone.

He nevertheless played on for the London County Club at Crystal

Palace for another nine years, and in the meantime carved for himself a second sporting career in **bowls**.

Indeed it could be said that he did as much to popularise the game of bowls as he had done for cricket, resulting in the game's first ever international taking place at **Crystal Palace** in July 1903, where the photograph, below left, was taken.

Without doubt WG never made much money from bowls, if any. But then he did not need to, having already grown rich from what the *Wisden* cricket almanac described as his 'breathtakingly grasping' attitude. This venality, widely recorded, as was his often blatant gamesmanship, may explain why WG was never knighted.

But it also serves to expose the hypocrisy of the cricketing establishment, not least that Grace always played for the Gentlemen (that is the amateurs), rather than for the Players (the professionals) in their annual encounter at Lord's.

As *Wisden* conceded 'Nice customs curtsey to great kings'.

And they did not come any greater than Grace.

▶ Just as Elizabeth I appears to have slept in almost every Tudor bed in England, it is hard to find a cricket ground or bowling green where WG did not play. On the other hand, he truly was in great demand.

As a cricketer he was a regular visitor to London from the age of 16. As a part time medical student, after eleven years of study, he finally qualified at St Bartholomew's Hospital in 1879.

He was then in practice in Bristol and playing for Gloucestershire until 1898 when he and his family moved to **Lawrie Park Road** in Sydenham. The house was demolished in 1963 but a plaque on a block of flats (*top*) marks the spot, as do two neighbouring developments, Doctors Close and Cricketers Walk.

Grace had been invited to the capital to spearhead a new enterprise called the London County Cricket Club, an attempt by the Crystal Palace Company to attract more visitors. The cricket ground was in the same part of the park where Grace had won his hurdles medal in 1866.

The move to Sydenham was accompanied by sorrow, caused by the death of WG's daughter Bessie, and by an unseemly row of his own doing with his former friends at Gloucestershire.

After the Crystal Palace venture failed in 1908 the Grace family moved again, to **Mottingham Lane SE9,** where a blue LCC plaque on what is now a care home (*above right*) is displayed, and where WG finished his playing days with Eltham CC. His last appearance at the crease was in July 1914, when he scored 69 not out. He died the following year and was buried at Beckenham Cemetery, Elmers End, where a pub bearing his name stands in Witham Road.

Amongst other associated sites, **Gracefield Gardens** (*above right*) marks where Streatham CC played from 1882–1914. It was named as such purely because Grace had played on the ground occasionally.

Grace House meanwhile (*above*) is one of several council housing blocks overlooking the Oval. Ironically another is Lohmann House, named after a Surrey player who once refused to play for England in protest against amateurs such as Grace supposedly getting more in expenses than the £10 fee he was due as a professional.

Any photograph, programme, cheque or scrap of paper bearing the great man's signature is highly treasured. This one is from a signed copy of his autobiography, held in Surrey's library at the Oval.

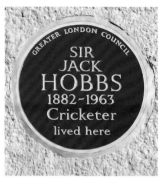

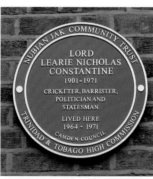

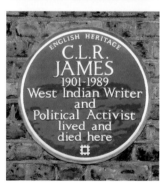

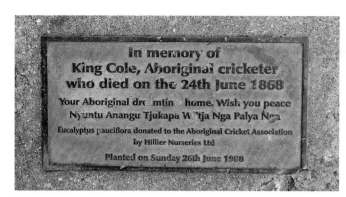

◄ Another Surrey cricketer who dared to speak out against rampant 'shamateurism' was **Bobby Abel** (1857–1936). Born in Rotherhithe, Abel's batting skills were spotted while playing club cricket in his early 20s in **Southwark Park** (where this plaque may be seen on the side of the Café Gallery). Such a relatively late blossoming was not uncommon, for few working class boys at board schools had access to the game, let alone coaching.

But Abel made up for it over a 23 year career at the Oval, which would have lasted longer had his eyesight not deteriorated.

As short as WG was tall, Abel was hugely popular, unorthodox in style, modest in demeanour. Off the field he fathered eleven children, ran a sports shop, and eventually lost his sight completely. His final years were spent in the family home in Handforth Road, just around the corner from the Oval.

Also of humble birth, but from Cambridge, **Sir Jack Hobbs** (1882–1963) followed Abel into the Surrey team in 1905 and scored freely over the next three decades. In 1953 he became the first professional cricketer to be knighted, a reflection not only of his talent but also, in the new Elizabethan age, of the changing status of professional cricketers.

We have already noted the gates named after Hobbs at the Oval. The GLC plaque seen here is at his house in **Englewood Road, Clapham**. To modern eyes, especially those unfamiliar with London property prices, the house may appear modest for a star who did well from various commercial endorsements and from his sports outfitters at 59 Fleet Street, images of which can be seen on the British Pathé website. The shop is still recognisable today.

But both the house and shop remind us that even the highest paid professionals of Hobbs' era remained relatively rooted in their communities, whether it was travelling to the Oval on the bus or serving, apparently always affably, behind the counter of his shop.

Cricket in the West Indies and the Afro-Caribbean community in London as a whole both owe a great deal to the Trinidad born **Lord Learie Constantine** (1901–71), whose final years were spent, as the plaque records, at **Kendal Court** on **Shoot Up Hill, Cricklewood**.

After making a name for himself in West Indian cricket, Constantine spent nine years playing for Nelson in the highly competitive Lancashire League, during which time he was one of Britain's highest paid sportsmen. In the 1930s and '40s he became one of the first black sportsmen to engage actively in race relations. He also worked as a broadcaster and as a barrister. Knighted in 1962, he then served with the Sports Council, was a governor of the BBC and, in 1969, became the first black peer in the House of Lords.

During his years in Nelson Constantine took in as a lodger his fellow Trinidadian, **CLR James**. Whilst James helped Constantine write his first book on cricket, Constantine helped James gain work as a cricket correspondent for the *Manchester Guardian*.

Their friendship was also to have long term consequences for the West Indian independence movement. As James wrote in his classic 1963 memoir, *Beyond a Boundary*, the two men 'unearthed the politician in each other'.

James' plaque can be seen in **Railton Road, Brixton**, where as an octogenarian he lived in a book-filled flat from 1981–89, courted by a stream of admirers.

A devoted admirer of WG Grace and avid scholar of cricket history, James might well have known the story of **King Cole**, or **Bripumyarrimin** to give him his real name, one of a party of Aboriginal cricketers who in 1868 became the first Australians to tour England. Wherever they went the 'Blacks', as they were known in the press, were greeted with a mixture of curiosity, casual racism but also respect, especially once they started winning matches.

King Cole, a nickname given to him by the tour's white organisers – others in the team included Tiger,

Redcap, Twopenny and Dick-a-Dick – did well in the opening match at the Oval, where in front of estimated crowds of 7–8,000 he took two catches and scored 14.

Alas, however, a few weeks later he succumbed to tuberculosis and was buried in a pauper's grave in Victoria Park Cemetery, Mile End. In 1894 this was turned into **Meath Gardens** (*see page 82*) where the plaque above was placed next to a eucalyptus tree donated by the Aboriginal Cricket Association in 1988.

Rather grander is the now restored tombstone in **Brompton Cemetery** (*below*) of **John Wisden**, whose business was based near Leicester Square (*see opposite*).

But surely grandest of all is the Grade II listed tomb at Highgate Cemetery of the professional William Lillywhite (1792–1854), who pioneered roundarm bowling in the 1820s and set up a sports outfitters in Islington. His sons then expanded the business to become the London emporium we know today at Piccadilly Circus.

Finally, one other plaque of note is at the home of the one-time Gloucestershire teammate of WG Grace, Gilbert Jessop (1874–1955), at Sunnydale Gardens NW7.

Sadly now obscured behind a porch, this marks Jessop's time in London between the wars as a journalist, author and secretary of Edgware Golf Club.

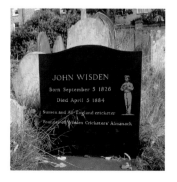

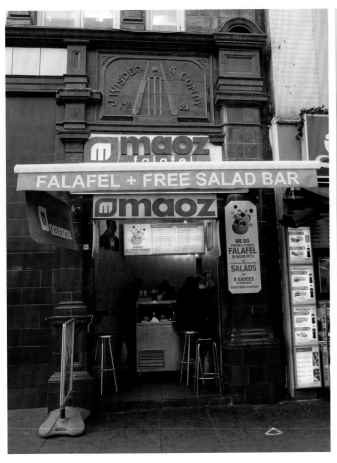

▲ If there is one Victorian cricketer everyone has heard of, apart from WG, it is **John Wisden**. Just as *Hansard* and *Whitaker* have entered the language, the name Wisden is synonymous with cricketing facts and figures. And unnoticed by most pedestrians strolling down **Cranbourn Street WC2**, the offices where the *Wisden Cricketers' Almanack* was produced from 1906–28 was at number 21.

The doorway may have become a fast food outlet, but above it there is no mistaking the identity of the former occupants, or that this was originally part of the adjoining Leicester Square Underground Station. Not least its maroon glazed faience identifies it as the work of the architect Leslie Green, many of whose stations from the same period, finished in the same materials, are still in use.

Leicester Square is, however, believed to be the only example of a business enterprise having its name incorporated within the station's fabric, perhaps because Wisden had already been established on the site since 1872.

The company's founder, Brighton born John Wisden (1826–84),

enjoyed an illustrious career as an all-rounder for Sussex and various touring teams, supplemented by a sideline in cricketing clothing and gear that he started in Leamington in 1850.

Five years later in London he opened a 'cricket and cigar shop' in Coventry Street, which he renamed John Wisden & Co in 1870. The shop and office on Cranbourn Street followed in 1872 and, rebuilt in 1906, was linked to a showroom at the back, at 17-18 Great Newport Street.

At its peak Wisden exported goods all over the world, with factories at various times in West Ham, East Sheen and Holloway. But while this part of the business ceased trading in the 1940s, his eponymous almanack lived on.

Launched in 1864, it was at the time one of several. Lillywhite's produced a similar publication. But *Wisden* went from strength to strength, even after the founder's death, and today there are thousands of collectors desperate to complete their collections, with some well preserved early editions fetching around £35–40,000 each at auction.

▶ There is a sports ground at the end of **Wicket Road** in **Perivale**. But why, in the late 20th century when developers built houses on this new cul-de-sac, did they choose a cricket name rather than one associated with, say, football, rugby or hockey, all of which are also played on the ground?

The developers were not alone in this bias, as any London street directory will confirm. When we conjure up images of England and of suburbia we lean towards cricket more than any other sport, even though in the last century football has completely outstripped the game in terms of profile and participation levels. Some surveys suggest that there may be ten times the number of active footballers in this country than cricketers.

Yet in Greater London, records show there to have been at least 28 pubs incorporating the word **Cricketers** in their title since the early 18th century – such as the one at **Kennington Oval** (*right*) – yet not one featuring the words 'football' or 'footballers'; this despite the historic links between football and alcohol being just as close as they have been with cricket.

That cricket is a summer game no doubt helps.

But just as important, as the pub sign makes clear, is that cricket is a game rooted in the countryside. Consider, the wicket (a small gate) consists of stumps (or cut down trees) and a bail (the top bar of a sheep gate).

Some historians further contend that the word cricket itself derives from a shepherd's crook.

Thus cricket still has the power to evoke a sense of *rus in urbe*, even when no cricket has been played in the vicinity at all, such as at **Cricketers Walk**, a new development next to WG Grace's former home in **Sydenham**.

Our three other examples all have genuine links however.

Cricketfield Road was named as such in 1864 because at the time it faced Hackney Downs, a cricketing spot before other team games caught on later in the century.

The **Cricket Green** at **Mitcham**, in use since the 18th century, has already been noted, while **Cricket Lane** in **Beckenham** leads to the Sydenham Sports Club, laid out in 1875 (*see page 133*).

By contrast, only one road has football in its title (*page 222*).

Chapter Twenty One

Golf

Of all the sports once played on Blackheath, 'goff' endured the longest, having been a presence on its windswept heights for over 300 years. Hence when the London County Council renamed several roads in the area in 1933 – ten years after the Royal Blackheath Golf Club had finally moved on, to Eltham – what had been known as Windmill Road became Goffers Road. Since 1843 this same road had intersected the Blackheath course's seventh and final hole, which offered the further hazard of an old gravel pit in front of the green. But then that was all part of Blackheath's historic appeal for golfers, seen below right in 1893. As Bernard Darwin (the grandson of Charles) wrote in 1910, '... as we hack our ball along with a driving mashie out of a hard and flinty lie, narrowly avoiding the slaughter of a passing pedestrian, we feel that we are on hallowed ground...'

Among the waves of tourists who every year head for these shores chiefly to play golf – according to VisitBritain 262,000 of them from the USA, Ireland, France, Germany and Spain in 2008 alone – it is unlikely that many, if any, include a London course on their itinerary.

Maybe just outside the capital the magnificent Wentworth course in Surrey, or Sunningdale in Berkshire, or one of the courses in Sandwich, Kent, take their fancy. But not a single course in London has ever hosted one of the so-called 'majors' in international golf, and unlike in many other sports, London has played only a small role in the evolution of the game and its governance.

Golf is, after all, a Scottish game (albeit with Dutch antecedents), first recorded in 1457, when James II of Scotland decreed that 'ye fute-ball and ye golf be utterly cryit dune, and nocht usit'.

But longevity is only part of Scotland's claim on the game.

Whether in Florida or Fukuoka, on the Fylde or in Finchley, on heathland or common, moor or meadow, in essence every golf course in the world is a conscious attempt to recreate the features that characterise the grassy, sandy, undulating links of Fife, on the east coast of Scotland.

No other sport is so closely allied to so specific a landscape.

But if the spiritual home of golf is St Andrews, where the Royal and Ancient Golf Club formed in 1754, that is not to say that golf is of only remote interest in London,

or that its heritage is marginal. On the contrary. Ever since James VI, the son of Mary Queen of Scots, herself a keen golfer, ascended to the English throne in 1603, there has been a Scottish presence in London. And wherever there have been Scots, there has been golf.

Two references confirm that golf had adherents in 17th century London. In 1659, the keeper of Tuttle (or Tothill) Fields, Westminster, complained of horsemen preventing the gentry from playing 'at bowls, goffe and stowball'. Published in 1671, a book called *Westminster Drollery* contains a Thomas Shadwell song redolent of the Restoration period, celebrating frolicks, seduction and 'innocent sports', golf included.

Then there is the oft quoted account by the Rev Dr Alexander Carlyle of how, on a trip south in 1758, he was travelling through Kensington en route to play golf at Moulsey (or Molesey) Hurst when his party was spotted by Coldstream Guards.

'On seeing our clubs, they gave us three cheers in honour of a diversion peculiar to Scotland.'

After the game, in which only Scots participated, the party crossed the Thames to the villa of the actor David Garrick, where Carlyle delighted his host by striking a ball through an archway in the garden.

That garden and Garrick's villa can still be seen, on Hampton Court Road. But so too can Carlyle's golf club, in the museum of the Royal Blackheath Golf Club (*see opposite*).

Known in its early years as the Honourable Company of Goffers at Blackheath, this club was, until the formation of the North Devon Golf Club in 1864, the only golf club south of the border.

As to when it first came into being, that is one of the great debates of golfing history.

On one hand the Honourable Company of Edinburgh Golfers, formed in 1744, lays claim to being the oldest surviving golf club in the world (as opposed to course).

However, from at least 1831 onwards Blackheath claimed to have been 'instituted in 1608'. As such it celebrated its 400th anniversary in 2008, even though, by then, it was accepted by the club's own historians that there was no actual evidence of any club or society having been formed in that year, or of golf being played on Blackheath on a regular basis.

All that could be deduced was that the newly crowned King James and his Scottish entourage were often to be found at nearby Greenwich Palace during this period, and that his son Henry played golf on Blackheath before his premature death in 1612.

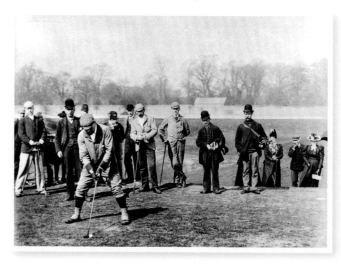

A group of individuals playing occasional games is, however, a rather different matter from a formally constituted club.

In the *Edinburgh Almanac* of 1830 it was stated cautiously that Blackheath had been 'established prior to 1745'. But again, no-one has discovered why this date was cited, other than the fact that, as Neil Scaife has reported in his sumptuous history of the club (*see Links*), Blackheath have in their possession a brass button and a seal, each of which bears the club's crest and the date 1745. Yet as Scaife adds, the button was made by a Gerrard Street firm some time between 1805 and 1840, and the seal was purchased in 1829.

A further confusion is that the earliest record of a club captain being appointed is 1766, while the club's earliest documentation is a cash book from 1787.

Important though these details are, more interesting are Blackheath's social roots. That first captain, we learn, Alexander Duncan from Craigton, also served at various times as captain of both the Edinburgh Company and the Royal and Ancient Golf Club in St Andrews, suggesting that there were close ties between all the golfing societies of this period.

Blackheath's history also reveals that the majority of these players were not only Scottish and wealthy. They were also freemasons and inveterate gamblers, for whom golf, it would appear, was hardly more than an aperitif before the serious business of wining and dining (when at Blackheath, usually at the Green Man).

Golf then was quite different to the game we know today. For a start the balls, leather cased and stuffed with feathers, were difficult to loft into the air for long distances. Until the 1860s there were no designed courses.

By today's standards Blackheath's rough, treeless expanses, scarred by gravel pits and criss-crossed by public roads and paths might not appear immediately suited. But it had other attractions, not least that golfers were largely left to their own devices and the ground was at least well drained, if flinty.

But as the 19th century wore on, other factors started to weigh against Blackheath. Firstly the area became busier with traffic

and pedestrians so that golfers had to wear red coats and hire forecaddies to carry red flags. Complaints from local residents continued nevertheless. Secondly, as games such as cricket, hockey and then rugby and football grew more popular, the golfers found themselves competing for space.

Meanwhile golf itself was changing. Having been a five hole course originally, in 1843 Blackheath was reconfigured to seven. But by the 1870s, prompted by the rules evolving at St Andrews, 18 hole courses were starting to become more popular. Partly this was owing to the introduction of more aerodynamic, mass produced *gutta percha* balls, which added extra zip to the game and made it more affordable to the middle classes.

Thus golf in London entered a new phase in 1865, when the city's second club was set up by London Scottish volunteer riflemen on Wimbledon Common. A third club, also formed by Scots, then appeared on Clapham Common in 1874, followed by a fourth (a breakaway from London Scottish) in 1882 and a fifth, the Royal Artillery Golf Club on Woolwich Common in 1885. An attempt to establish golf on Peckham Rye was less successful, before two more clubs, the Royal Epping Forest Golf Club, and Tooting Bec, were formed in 1888.

By that year there were 57 courses in England, all located on coastal links or on public inland commons or heaths.

But that too was about to change, and dramatically so. By 1914 the total in England had rocketed to around a thousand courses, of which at least 90 had sprung up since 1890 within the boundaries of what is today modern London.

These new courses differed from those that preceded them in two respects. Firstly, the majority were laid out either on private land, or on public land that was now designated solely for the use of golf. A similar process was at work in horse racing, resulting in the first enclosed 'park' course at Sandown in 1875.

Secondly, although Scots were still prominent, there were now growing numbers of Englishmen playing the game and, in some cases, lavishing large sums on it, either by converting their own private estates, or by underwriting new membership clubs. Among them, as noted by historian Richard Holt (*see Links*), was the hotelier, Frederick Gordon, who thought nothing of building a railway line to access his Stanmore estate, and then laid out a golf course for the amusement of his friends, family and guests. He was joined there by Thomas Blackwell (of Crosse & Blackwell fame). »

▲ Although not officially conferred until 1901, **Blackheath Golf Club** had used the title 'Royal' since 1849. It was therefore apt that when the club finally left Blackheath in 1923 they should relocate to **Eltham Lodge** (where Eltham Golf Club had formed in 1891).

Listed Grade I, the Lodge was built by Hugh May in the 1660s as a retreat for Sir John Shaw, who had been granted the estate as a reward for his financial support for the exiled Charles II. To this day the club leases the Lodge and grounds from the Crown Estate.

While the club rooms are lined with portraits and golfing landscapes, the club museum is a cornucopia of historic artefacts, including the medal seen here, thought to be the oldest in golf.

Dated 1789 it was commissioned by the self-styled **Knuckle Club**, in effect a masonic dining club formed by Blackheath members wishing to play golf during the winter.

Other treasures include the aforementioned brass button and seal dated 1745, a silver putter from 1766, and an 1875 Calcutta Cup, from the same source as rugby union's cup of 1879.

Eltham Lodge can be visited during Open House weekends, while visits to the museum may be made by arrangement with the club. Other than St Andrews, there is no finer place to learn about golf in Britain before the 20th century.

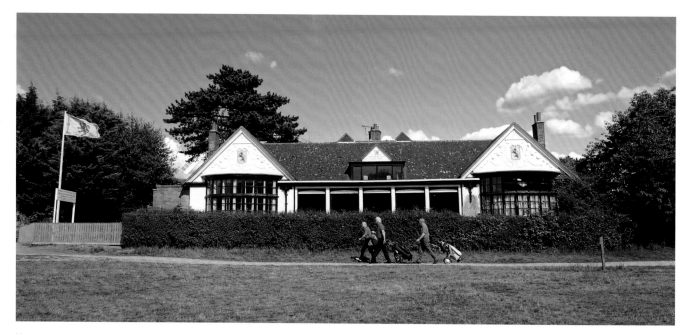

>> Whole swathes of Middlesex and Surrey were now being pegged out and re-landscaped by a new generation of golf course designers, all intent on providing challenging and yet also playable courses (for novices had to be encouraged), preferably as close as possible to a railway station.

They were aided by further advances in golf equipment, most notably rubber core balls, introduced in 1898 and even cheaper and swifter than their *gutta percha* predecessors.

Middle class women were already taking up the game by this time, at North Devon in 1868, at Wimbledon in 1872 and at Sutton in 1894. Now the working classes wanted to join in.

Taking advantage of this several clubs set up 'artisan' sections, whereby working men could play during restricted periods in return for manual labour on the course. Royal Blackheath still have some 40 members in this category.

Further access was provided by philanthropic developers such as

Albert Toley (*see page 34*), whose land speculations led to affordable clubs being set up at Ilford in 1907 and Brent Valley in 1909.

Inevitably there were casualties. Of the 90 golf courses laid out between 1890–1914, 38 would not survive. Most, particularly after 1918, succumbed to housing developments. Some simply failed to attract enough members and were turned into parks. At Honor Oak in 1896, the laying out of a golf course on One Tree Hill, a favourite open space, provoked an angry demonstration attended by an estimated 15,000 crowd. After sustained unrest and lobbying, the LCC finally bought the site and restored public access in 1904.

But on the whole, on the eve of the First World War golf appeared to have colonised London and the Home Counties exactly as *Punch* magazine had predicted in a cartoon of the 1880s entitled 'the Golf Stream'.

By 1909 *Sporting Life* was able to report, 'London is fast becoming the hub of the golfing universe...'

▲ Members of the capital's second oldest golf club, **London Scottish**, return to their clubhouse after a round on **Wimbledon Common**, where the club has played since its first season in 1865, and where by order of the Common Conservators red tops have been obligatory since 1892, so as to warn the public that a game was in progress. This followed the practice at **Blackheath**, portrayed in an 1881 painting by Heywood Hardy (*below left*) and remains the rule also at Chingford Golf Course in Epping Forest.

London Scottish's founders were members of the London Scottish Rifle Volunteers, who discovered the Common's rugged charms after it became the rallying point for the National Rifle Association. Leading the LSRV was Lord Elcho, who ruled over the golf club with a rod of iron. He also charged civilians a membership fee four times greater than that required from Volunteers.

Despite this, the number of civilian members kept rising, as did opposition to Elcho, resulting in a breakaway club forming in 1881 under the prominent Scottish golfer and wine merchant, Henry Lamb.

Granted royal status in 1882 this new entity, the **Royal Wimbledon Golf Club**, shared the Common until, in 1907, it decided to create its own private course on adjacent farmland, south of Camp Road (where it remains to this day).

Meanwhile a ladies golf club formed on the Common in 1872 and played on a separate nine hole course until 1915,

when it moved over to share with the Royal Wimbledon.

A fourth club formed in the vicinity in 1908. Consisting mainly of local shopkeepers and businessmen, the Wimbledon Town Golf Club (renamed in 1928 **Wimbledon Common Golf Club**) was permitted to share the Common course with London Scottish – provided they wore red, naturally (*below*) – a relationship which continues today.

Their clubhouse, opened in 1912, is on Camp Road, while the London Scottish clubhouse, seen above, designed by HO Crewell, dates from 1897 and is a short distance from the windmill where the club was originally based.

Every May the season opens with the London Scottish captain driving off the first tee, accompanied by a bagpiper. Whoever retrieves the ball wins a bottle of whisky. The members, who still include volunteers from the London Scottish Regiment, then retreat to the clubhouse for a supper of haggis, neeps and tatties.

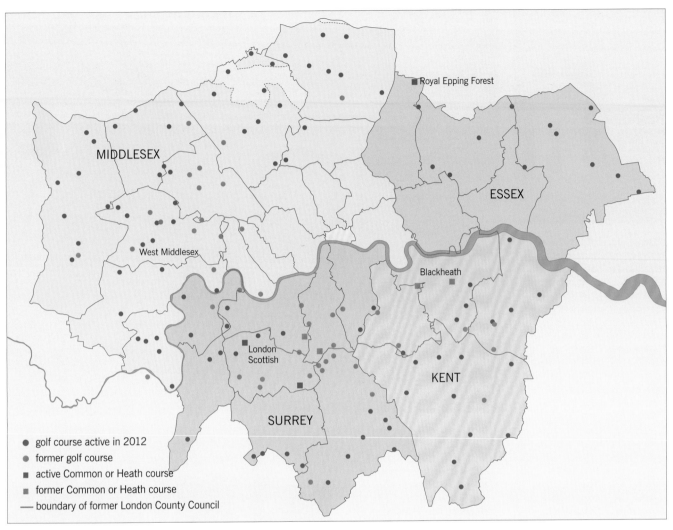

Royal Epping Forest

MIDDLESEX

ESSEX

West Middlesex

Blackheath

London
Scottish

KENT

SURREY

● golf course active in 2012
◉ former golf course
■ active Common or Heath course
■ former Common or Heath course
— boundary of former London County Council

▲ Given the intensity of urbanisation since the 'Golf Stream' began in the 1890s, it is striking that, excluding driving ranges and pitch and putt courses, there are now **108 golf courses** in London. They vary in size greatly: 29 have nine holes, ranging in total yardage between 898 at Barnet Copthall to 5,878 at Woodford; 68 have 18 holes, mostly in the 6–6,500 yard range, and eleven feature 27–45 holes.

More remarkably, if combined, these 108 courses would amount to almost exactly the same area

as that of the London Borough of Greenwich, or three per cent of the total land mass of the capital.

If one wanted to play every hole in London it would require a trek of no less than 301 miles, or the equivalent of Blackheath to Kelso.

Identified above are the locations of all 108 courses, plus the names of the earliest clubs to have formed in each of the four counties.

Of the 108, 55 courses opened between 1890–1918, 20 between 1919–39, and a further 19 during the period 1973–96.

Sixteen of the courses fall into the category of municipal (although several more lie on publicly owned land that is leased to private clubs).

Note how only four courses, all south of the river, survive within the former LCC boundaries: Dulwich & Sydenham Hill (formed 1894), Roehampton (1904), Aquarius (1912) and the 'pay and play' Central London Golf Centre, Wandsworth (opened 1989).

The map also shows how few courses lie within Metropolitan Essex, and how 44 of the 50 or

so courses lost to development (excluding the likes of Blackheath and Clapham Common, which remain as open spaces) were in Surrey and Middlesex. For example, it was once said that courses lined the route from Shepherd's Bush to Harrow. But at least six in that belt were commandeered to build homes 'fit for heroes' after 1918. These included **Acton**, where the streets laid out on the former course all have golfing names, such as The Fairway, The Green and Mashie Road (below).

London Borough of Ealing
MASHIE ROAD W3

Designed by JS Brockleby in 1914, these Arts and Crafts homes on Maycross Avenue, Morden (far left), formed the clubhouse of Merton Park Golf Club until the course was bought for housing in 1933. Another reminder of this course is Links Avenue, nearby. The design of golf clubhouses often echoed domestic homes so that in the event of a club's demise they would still be saleable.

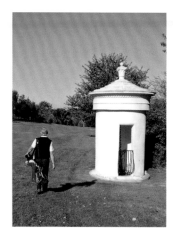

▲ Golf is often criticised for its impact on the environment. But the game has also been instrumental in the preservation of numerous historic buildings, as illustrated by three cases from the 1890s.

In 1890 a builder called William Willett purchased **Camden Place, Chislehurst,** an 18th century mansion remodelled by architect George Dance. During the 1870s the exiled Emperor Napoleon III and his wife Eugenie lived there.

Willett planned to construct up to 300 houses within Camden Place's 124 acre park until eminent local residents persuaded him to build only on the edges and allow a golf course to be laid out instead. This opened in 1894, with Camden Place serving as the clubhouse for the newly formed **Chislehurst Golf Club**.

Seen above on part of the course is an 18th century ornamental well which features on the club's badge, and (*above right*) one of the club's elegant lounges. The house was listed Grade II* in 1954.

As noted earlier, the Royal Blackheath Golf Club occupies Eltham Lodge, a Grade I listed building originally converted into a clubhouse in 1891. That same year **Richmond Golf Club** formed and took over another mansion that would subsequently be Grade I listed; **Sudbrook Park** (*centre right*), designed by James Gibb in 1726.

In total thirteen London golf clubs have clubhouses or outbuildings that are listed. Yet tellingly not one of these was purpose built for golf (although London Scottish's clubhouse, seen on page 216, has been listed locally by Merton).

Needless to add, ownership of listed buildings on the grand scale seen at Chislehurst, Richmond and Eltham is a double edged sword.

Such buildings may be ideal for hosting lucrative events, but their fabric is costly to maintain.

This balance is even harder to achieve in the public sector.

The 18 hole course at **Beckenham Place Park** (*below right*), for example, is said to be the most played upon public course in Europe. In its centre stands **Beckenham Place Mansion,** also listed Grade II*, built for John Cator in 1773. This and the surrounding park was taken over by the LCC in 1927 and since then by Lewisham.

But only a small part of the house is set aside for golfers, the rest having been boarded up in the 1990s. As a result it is on English Heritage's Heritage at Risk Register, and as of 2013 was still awaiting a decision on its future.

Again, however, the popularity of golf in the park could prove a factor in finding a viable solution.

Meanwhile eight other London courses have listed structures or scheduled monuments within their boundaries, such as gate lodges and ice houses. Coombe Wood has a unique 16th century Gallows Tamkin (part of the water supply for Hampton Court), while golfers at Sudbury may encounter both a Roman stone boundary marker and a medieval moated site.

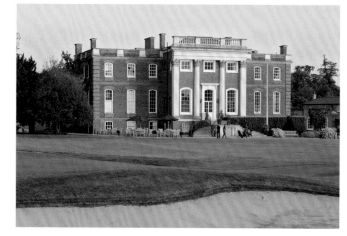

▲ There is hardly a club where **Harry Colt** worked that does not celebrate that fact, such is the high regard for this Highgate born solicitor (1869-1951) who gave up the law to try his hand at course design. Over 300 courses in 24 countries were shaped by his acute eye and flair for natural contours, twelve of them in London, plus the likes of Stoke Park, Wentworth and Sunningdale in the Home Counties. There is even a Colt Association, dedicated to celebrating his legacy, and a Colt Cup contested by players representing clubs where his designs were carried out.

▲ As well as being the guardians of historic buildings, a number of golf clubs are to be found within historic landscapes. In England, of the 1,620 or so sites currently on the **Register of Parks and Gardens of Special Historic Interest,** 95 contain a nine or 18 hole course.

Ten of these are in London, namely Sidcup Golf Club (formed 1891), Royal Mid-Surrey (1892), Hampton Court Palace (1895), Wimbledon Park (1898), Sundridge Park (1901), Richmond Park (1924), Addington Palace (1930), Harrow School (1978) and Central London (1989). The tenth, seen here from the west, with the North Circular Road in the distance, is the course of **Wanstead Golf Club**.

Formed in 1893, its clubhouse occupies late 18th century, Grade II listed stables. However it is the setting that is of greater interest.

Having formed part of the royal hunting forest of Epping, the site was enclosed as a deer park in the 16th century. Subsequent owners undertook a series of landscaping works, using water features fed by the River Roding to particularly scenic effect. Humphrey Repton, who oversaw one phase of these works in the period 1813-18, called Wanstead Park 'one of the most magnificent places in this country'.

But not for long. Mounting debts led to Wanstead House's demolition in 1824, while the park was let for grazing and much of the woodland felled to pay off creditors.

After decades of decline, in 1882 the Corporation of London bought the eastern part of the estate and re-opened it as Wanstead Park.

The remainder, retained by Lord Cowley, was then sold for housing and, in the central area, leased to the new golf club.

The course at Wanstead is also significant in that its original nine holes were designed by **Tom Dunn** (*below*), one of the most influential golfers of the late 19th century.

Born in Blackheath, where his father was the golf professional, Dunn (1850-1902) worked on at least 21 courses in London, including Wimbledon Common, during which time he and his family lived in the Windmill Cottage.

Dunn was an exponent of the 'penal school' of design. This was characterised by regularly shaped, steep bunkers placed in such a way as to penalise less skilled players.

But as golf became more popular and, as stated earlier, technology advanced – those rubber core balls introduced in 1898 made it easier to hit longer shots, for example, while improved earth moving equipment allowed designers more scope – Dunn's work was soon superceded.

Newly emerging 'golf architects' such as James Braid, JH Taylor and Harry Colt focused more on strategic designs that would challenge the best, yet also be enjoyable for golf's growing number of middle class, recreational players.

So successfully, and with such classic beauty did these early 20th century designers succeed, that golf historians are now asking whether certain courses might themselves be categorised as historic landscapes, worthy of conservation in their own right.

Colt's contemporary, **Harry Vardon**, a gardener's son from Jersey, also took up course design, after winning a record six Open championships between 1896 and 1914. Tuberculosis stymied that run of success, but Vardon continued to teach (his trademark overlapping grip became standard amongst professionals), helped in the design of fourteen golf courses and wrote several best selling books on golf.

At the South Herts Golf Club where he was appointed the professional in 1902 – hence this plaque on his house around the corner in Totteridge Lane – there is a bronze statuette of Vardon, by Henry Pegram, and a Vardon Open tournament held annually. On the morning of this, the South Herts captain lays a wreath on Vardon's grave at nearby St Andrews Church.

LONDON BOROUGH OF BARNET

HARRY VARDON

PROFESSIONAL GOLFER

BORN MAY 9th 1870

LIVED IN THIS HOUSE

• FROM 1903 UNTIL •

HE DIED IN 1937

▶ On a clear day, members at the **Aquarius Golf Club** in **Honor Oak** like to joke, they can check the time by peering over to Big Ben, such is the course's proximity to central London. But that is only part of this unusual club's appeal.

If the course as seen here (with The 02 Arena just visible on the right), appears a little flat, that is because it sits on top of what was, when completed in 1909, Europe's largest covered reservoir. Holding 55 million gallons, the reservoir remains in use today, still sourcing water via an Italianate pumping station at the northern end of the nine hole course.

The name Aquarius derives from the staff association of the **Metropolitan Water Board**, which initially laid out football and hockey pitches on the reservoir. But it was the golf club formed in 1912 that proved most popular, being cheap to join, one of the first clubs to allow play on Sunday, and to grant (almost) equal rights for women. Even today the club stands out for being run entirely by volunteers.

That players have to watch out for the array of inspection covers, and the looming presence of the Grade II listed valve house (on the left); that there is also a fair drop down to the lower holes at the pumping station end, is just par for the course, as it were.

Certainly it was challenging enough for an Alleyn's School pupil called Henry Cotton to hone his precocious skills there in the early 1920s before he turned professional, aged 16, and went on to conquer the golfing world.

As for the Aquarius staff association, it went on to lay out tennis courts on the reservoir at East Finchley – now home to the Aquarius Archery Club (*see page 186*) – while at the former MWB works at Hampton, the Aquarius Sailing Club has remained happily afloat since 1948.

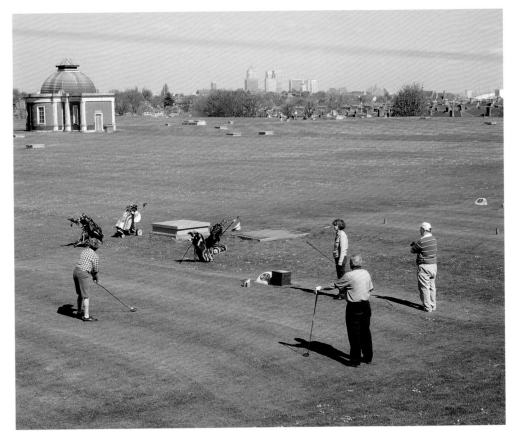

◀ When the newly formed **Prince's Club** gained permission from the Conservators of **Mitcham Common** to play golf there in 1891, its founders and friends, who included the likes of AJ Balfour, Herbert Asquith and Lord Cecil, were much attracted by the fact that the course was as well connected as they were, lying immediately next to Mitcham Junction station.

Those born on the other side of the tracks were however less happy that such a large part of the Common should be monopolised by this elite, and although there was a step forward in 1907 when the **Mitcham Village Golf Club**, formed entirely by local artisans, won the right to play on the course at specified times, not until 1924 was unfettered access finally granted.

Appropriately, as the Prince's Club withdrew to their other course at Sandwich, the now public course at Mitcham Common was ceremonially opened by the Labour Prime Minister and keen golfer, Ramsay MacDonald.

Mitcham Village were then joined by the newly formed **Mitcham Golf Club**, on an 18 hole course which, physically as well as socially, has straddled both sides of the track ever since.

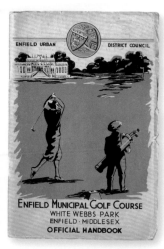

ENFIELD MUNICIPAL GOLF COURSE
WHITE WEBBS PARK
ENFIELD · MIDDLESEX
OFFICIAL HANDBOOK

▲ **Whitewebbs Park** in **Enfield** is one of sixteen local authority golf courses currently operating in London. It was opened in 1932, around the same time that the golf architect Alister MacKenzie wrote that, in his view, the provision of municipal golf courses had deterred many a working man in Britain from espousing Bolshevism.

Although hardly an argument that carried much weight, it is true that the creation of public courses after the First World War did play a major role in introducing to the game thousands of Londoners for whom membership of a private club was out of the question, both financially and socially.

Typical of the sort of *hauteur* that prevailed at this time was an incident recounted in the history of Dulwich and Sydenham Hill Golf Club (*see Links*). In 1919 the club's professional was censured for allowing his brother to use the members' lavatory, considered then to be 'a serious transgression'.

Money and class were not the only obstacles. For much of the 20th century, so long were the waiting lists at most clubs that their committees could pick and choose who they admitted. That meant that many refused or restricted access to women. Others, notoriously, if

never officially, refused membership to Jews and other ethnic minorities.

It is nevertheless simplistic to bracket golfers of any period since the 1920s according only to social, ethnic or class divisions. Or gender (for there were, and remain, golf clubs for women who prefer to remain separate).

When **Stanmore Golf Club** (*below left*) formed in 1893 it sought to offer 'a social meeting ground, where the hard worked man of business may lay aside his everyday worries and anxieties; and friends meet in healthful rivalry and enjoyment'.

Yet by the late 1930s this solidly middle class club was in such dire financial straits that it was saved only when Middlesex County Council purchased the course and leased it back to them.

The Council did this not because it was pro-golf; more that it wished to ensure that the open space on which Stanmore's course lies was not eaten away by development on the fringes. To borrow, once again that phrase from John Betjeman's *Metroland*, the planners' goal was '...to keep alive our lost Elysium'.

It was owing to this same policy – of proactively buying up sports grounds and large tracts of farmland between c.1925 and 1952 – that resulted in nine of London's sixteen municipal golf courses today being located within the former boundaries of Middlesex; four being in Hillingdon, three in Ealing and two in Enfield (including Whitewebbs Park).

Since that period three trends have emerged to alter the character of golf in London.

Firstly, during the economic boom of the late 20th century a new generation of 'golf centres' appeared, offering not just a course but driving ranges, fitness centres and other facilities designed to attract a family audience.

Secondly, this trend coincided with the emergence of a new breed of golfer, one less likely to join a club and, particularly since the recession, more likely to 'pay and play' wherever good deals could be found.

Thirdly, traditional membership clubs have been hit by changing social patterns. As recently as the 1990s clubhouses were invariably packed at weekends with members, their families and friends eating and drinking until the small hours.

Now as increasing numbers of golfers barely tarry after a round, clubs have been forced to make up for the loss of income by hiring out their clubhouses for events, and by encouraging outsiders to come along and 'pay and play'.

This shift in golfing patterns has consequences not only for the character of the sport, but also for the management of golf's land assets. Potentially it means that more membership clubs could be forced to hand over the running of their course, or even to sell it to an outside management company. Or, if planning restrictions allow, to sell up to developers.

Or, if the land is required to remain as open space, local authorities will have to take on the cost of guardianship.

Golf faces other challenges too. As noted earlier, the sport has in recent years come under pressure for its use of pesticides, its water consumption, and, in some instances, of its occupation of open space in otherwise built up areas.

All these social, environmental and management issues mean that, with three per cent of the capital's land mass being occupied by golf courses, this is one sport whose future touches all Londoners.

After a round on Chingford Golf Course – laid out on part of Epping Forest by the Corporation of London in 1886 – a retired London cabbie, a retired printer and a schoolteacher compare notes outside the Chingford Golf Club. Based in a former grocer's shop on Station Road, the club formed in 1923 because the Royal Epping Forest Golf Club, with whom they now share the course, would not admit tradesmen. The course is also shared with the Chingford Ladies Golf Club, formed in 1925, and with the public, who 'pay and play' for £10-25 per round. Since the 1990s both mens' clubs have seen their membership fall. As 'pay and play' becomes more popular, it is golf clubs who may struggle to stay the course.

Chapter Twenty Two

Football

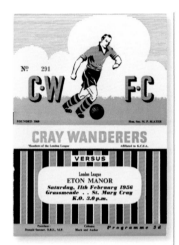

Formed in the village of St Mary Cray (now within the borough of Bromley), Cray Wanderers are aptly named, having played at ten locations. Their current billet is Bromley FC's Hayes Lane, four miles west of St Mary Cray. But the club have a rather more special claim to fame. Formed in 1860, they are the oldest club within the modern boundaries of London to have adopted and to have continued to play Association football. Only two other clubs are older. Both in Yorkshire, Sheffield FC formed in 1857, Hallam FC followed in 1860. Back in the London area, the Old Harrovians claim to have formed in 1859, but were in abeyance from 1931–63, while the Civil Service first fielded a team in 1863 (see page 124), when they were founder members of the Football Association. By comparison, the capital's oldest senior professional club, Fulham, did not form until 1879.

According to some aficionados London is hardly a football town at all, lacking the intensity and sense of identity manifested by fans in cities such as Manchester, Liverpool and Newcastle.

There is a further sense that while professional football and the Football League evolved in the north west and the Midlands during the 1880s, London is forever identified as the home of the governing body, the Football Association (FA), the creation of a coterie of amateurs in 1863.

One tale from the 1920s neatly captures this divide. A blazered gentleman, apparently well known at the Stock Exchange, was seen boarding the FA's coach after an England international match.

'Who does he represent?' asked someone on the coach. 'The public schools,' replied another.

The same enquirer then turned to Charlie Sutcliffe, a Lancastrian official of the Football League, and asked, 'So who do we represent?'

Said Sutcliffe *sotto voce*, 'The public houses'.

But while there can be no doubt that the north-south divide remains an abiding feature of English football, with particular resentment felt because of Wembley's monopoly of showcase games, the notion that Londoners are somehow not serious about football does not stand up to scrutiny. At grass roots level the London Football Association, whose jurisdiction extends to a 12 mile radius of Charing Cross, is one of the FA's largest regional affiliates, with around 1,000 clubs

in membership. The neighbouring and, in some cases, overlapping Essex County FA, ranks similarly highly in national terms.

Moreover, while most European capitals manage to sustain only a small number of professional clubs – Madrid has three, Rome two, Paris one – between 1921-91 there were always eleven or twelve London clubs in the Football League. From 2011-13 this rose to an unprecedented fourteen, divided between the Football League and Premier League.

In world football, only one other city has more senior clubs, and that is Buenos Aires.

London's footballing depth is not merely attributable to its size. Both Rio de Janeiro and Sao Paulo in football-mad Brazil have larger populations, yet sustain fewer senior clubs. Rather, it reflects, as is so often the case when analysing sport in London, the concentration of wealth in the capital.

At the top end of the scale, with regular sell out crowds of 60,000, Arsenal – the first London club to have turned professional, in 1891 – are patently attractive to investors and sponsors, worldwide.

Less so at the opposite pole, where clubs such as Barnet and Dagenham & Redbridge attract gates of 2-3,000 and would hardly consider themselves wealthy. Yet both have succeeded in gaining membership of the Football League during a period when a string of once proven clubs from such northern centres as Grimsby, Lincoln, Barrow and Stockport have all lost their places.

If London's relative economic strength is one factor, let us also consider, as we will later, the extraordinary emergence of AFC Wimbledon, a club run by and for its supporters since 2002 and promoted to the League in 2011.

In AFC Wimbledon's story, surely, lies evidence that football culture is ingrained in London no less than in any of the other so-called 'hotbeds' of the game.

Not that this need be a surprise. After all, football has been played in the capital for over 800 years.

As noted in Chapter 1, William Fitzstephen's brief account of London life, written in c.1174, offers the earliest known description of an organised ball game anywhere in Britain.

The original Latin text has been re-interpreted many times since, but even allowing for some licence, the basics are clear. On Shrove Tuesday schoolboys would enjoy cockfighting in the morning, before gathering in the fields – most likely Smithfield, or the 'smooth field' where horses were bought and sold every Friday – to 'play at the ball'.

Each school, wrote Fitzstephen, had its own ball, while the 'ancient and wealthy citizens' came on horseback 'to see the sport of the young men', and to take pleasure 'in beholding their agility'.

This brief description may not seem much, but it accords absolutely with what we know about Shrove Tuesday football in later centuries, and indeed finds echoes in the nine Shrovetide games still played in Britain today

Football Lane leads to the pitches of Harrow School, in use since the mid 19th century. But many a village and town had an area set aside for the game before then. A 1780 map of Wimbledon, for example, shows 'Homefield', an area previously referred to as 'Football Close' (close meaning an enclosed place). To this day fans still speak of their club's ground as 'home'.

FOOTBALL LANE

and described for *Played in Britain* by Hugh Hornby (*see Links*).

From Fitzstephen until the 17th century references to ball games in London, and Britain as a whole, are predominantly in the form of banning orders; the practice being cited variously as dangerous, antisocial or a distraction from archery practice.

It was in one such edict, issued by the Mayor of London, Nicholas de Farndon, in 1314, that the word 'foot-ball' is first recorded in the English language.

Intended to maintain law and order in the City at a time when the English army under Edward II was marching north to subdue the Scots – a march that culminated in defeat at Bannockburn – the edict proclaimed that 'whereas there is great uproar in the City through certain tumults arising from the striking of great foot-balls in the fields of the public, from which many evils perchance may arise... we do command and do forbid, on the King's behalf, upon pain of imprisonment, that such game shall not be practised henceforth within the City.'

That over 30 more banning orders would be issued over the next 350 years suggests that football was not easily suppressed.

Indeed there is evidence that the game had friends as well as enemies. In a list of *c.*1422 of the 'Crafftes and Fraternites' that hired Brewers' Hall (on the site of the current hall in Aldermanbury Square), 'ye footballplayers' paid twice, the total being 20d.

Whether this was for gatherings inside the hall, or for playing in its grounds, is not known.

A few streets to the south, on Suffolk Lane, in 1581 the first headmaster of Merchant Taylors' School, Richard Mulcaster, not only endorsed 'footeball' as part of a boy's education, he also described a form of game that is recognisable today; played between teams with a set number of players, adopting set positions and with a referee officiating.

Other sources describe similar forms of organised football, confirming that the game was not confined to the streets or to Shrove Tuesday. Nevertheless, it is the more vivid mob games that continued to draw the most attention. For example in his poem of 1716 on *The Art of Walking the*

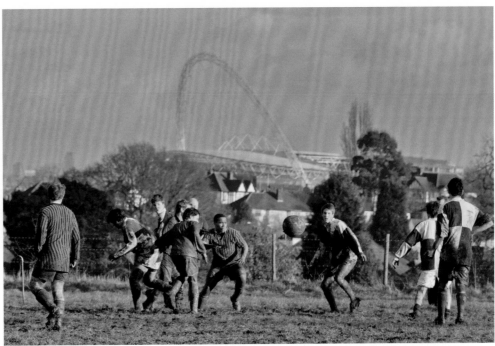

Streets in London, John Gay writes of encountering 'the Furies of the Football War' while passing through Covent Garden.

He sees the apprentice 'quit his Shop to join the Crew'. He sees the crowds following 'the flying game' and watches as the ball 'skims the street' then 'soars on high' before a 'dextrous glazier', clearly spotting the chance of some extra trade, sends the ball hurtling against a penthouse window.

A French traveller, César de Saussure, described a similar game in 1728. 'The populace has other amusements and very rude ones, such as throwing dead dogs and cats and mud at passers-by on certain festival days.

'Another amusement which is very inconvenient to passers-by is football. For this game a leather ball filled with air is used, and is kicked about with the feet. In cold weather you sometimes see a score of rascals in the streets kicking at a ball, and they will break panes of glass and smash the windows of coaches, and also knock you down without the slightest compunction; on the contrary, they will roar with laughter.'

Shrove Tuesday was equally known as 'football day', as cited in a letter of 1815 from a man signing himself NS, reproduced in William Hone's *Everyday Book.*

'Having some business which called me to Kingston-upon-Thames... I got upon the Hampton-court coach... We had not gone above four miles, when the coachman exclaimed to one of the passengers, 'It's Foot-ball day'. Not understanding the term, I questioned him what he meant by it; his answer was, that I would see what he meant where I was going.

'Upon entering Teddington, I was not a little amused to see all the inhabitants securing the glass of all their front windows from the ground to the roof, some by placing hurdles before them, and some by nailing laths across the frames.

'At Twickenham, Bushy, and Hampton-wick they were all engaged in the same way: having to stop a few hours at Hampton-wick and Kingston, I had an opportunity of seeing the whole of the custom, which is, to carry a foot-ball from door to door and beg money. At about 12 o'clock the ball is turned loose, and those who can, kick it... I observed some persons of respectability following the ball: the game lasts about four hours, when the parties retire to the public-houses, and spend the money they before collected in refreshments...

'I understand the corporation of Kingston attempted to put a stop to this practice, but the judges confirmed the right of the game, and it now legally continues, to the no small annoyance of some of the inhabitants, besides the expense and trouble they are put to in securing all their windows.' »

Arch rivals – measuring a third larger than a standard football and weighing nearly twice as much, the stuffed leather ball used for Harrow School's unique brand of 'footer' is a reminder that until Association rules started to dominate, 'football' was a generic term, encompassing a wide range of games in which both kicking and handling were permitted. Nowhere in the world has this diversity remained as evident as in London, where, in addition to Association football (or 'soccer') one can play or watch both rugby football codes (Union and League), plus their cousins Gaelic football, American football (or 'gridiron') and Australian Rules football. Add the Harrow game – which can be viewed during the spring term by turning off the High Street into Football Lane (*opposite*) – plus two other unique forms of football played just outside the capital, at Eton College, and this totals nine distinct footballing codes.

>> But if Shrove Tuesday football was the best known form of the game, there were regular matches too. As noted by historian Adrian Harvey (*see Links*), during the late 18th century men hailing from Westmoreland and Cumberland formed The Gymnastic Society in London. Wrestling was their main sport, contested at the Belvidere in Islington, a tavern later famous for rackets (*see page 287*). But they also played football on Kennington Common, otherwise known as a venue for cricket, public meetings and hangings (and now part of Kennington Park).

One 22-a-side match between the two factions of The Gymnastic Society in 1789 was played for a stake of 1,000 guineas.

After the Society's last game, in 1796, according to *The Sporting Magazine* in 1800, football dropped out of fashion. Certainly that was the view of Joseph Strutt (*see Links*). Writing in 1801 from his house in Hatton Garden, Strutt described football as 'formerly much in vogue among the common people' but now 'little practised'.

In fact it was still being played, in a variety of different and quirky ways at various London schools; at Westminster's newly created playing fields in Vincent Square, for example (*see pages 1 and 21*), and on the Green and in the cloisters at Charterhouse (*right*). By this time the Wall Game at Eton was also established.

But outside the schools, by the 1820s football had become enough of a curiosity for one JRP to write to William Hone, editor of the *Everyday Book*, with a description of how every Sunday, near Copenhagen Fields in Islington, weather willing, a group of Irishmen played football from three o'clock until dusk. Again, this was no mob game, but one played with 'the parties chosen' and the field boundaries fixed.

Perhaps in Kennington and Islington lie the seeds of that perception that Londoners *per se* were not especially keen on the game, and that it was incomers who kept it alive.

Certainly, as Harvey and others have stated, football's renewed popularity in Victorian Britain was more pronounced in the industrial north and Midlands. Of a total of 93 teams mentioned in *Bell's Life* and other newspapers during the period 1830-59, only eight were in the London area. One of them, however, was significant, and may be considered as the capital's first recognisable football club.

Surrey FC was formed at The Oval in 1849 by Lambeth born William Denison (1801-56), a well known writer on cricket and honorary secretary of Surrey County Cricket Club, itself formed four years earlier.

Membership was limited to gentlemen from four cricket clubs, while the form of football to be played was clearly based on reports of the games played over half a century earlier by The Gymnastic Society. Reproduced in *Bell's Life* in 1849, these Surrey FC rules are considered by Harvey to have been the first ever printed outside the confines of public schools.

Little more is known of Surrey FC. But by the end of the following decade, several new London teams had appeared; at Blackheath (1858), Forest, in Snaresbrook (1859), Crystal Palace and Richmond (both 1861), Barnes (1862) and the Civil Service (1863).

Each, however, played to a different set of rules, as did the public schools. In fact when an Old Etonian suggested in *The Times* on October 5 1863 that a universal code should be agreed, the public schools more or less rejected the idea. As seen below, however, representatives of the London clubs did not.

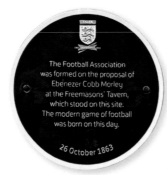

The Football Association was formed on the proposal of Ebénezer Cobb Morley at the Freemasons' Tavern, which stood on this site. The modern game of football was born on this day.

26 October 1863

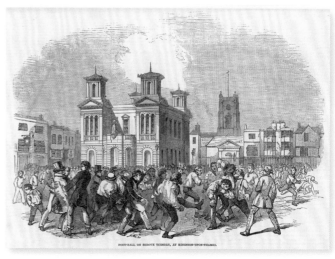

FOOT-BALL ON SHROVE TUESDAY, AT KINGSTON-UPON-THAMES.

▲ **'Football Day'** in the **Market Place** at **Kingston-upon-Thames**, as depicted in the *Illustrated London News* in February 1846, at a time when the authorities in Surrey and across Britain were becoming increasingly intolerant of sporting activities in public places.

Kingston's game was last played in the Market Place in 1867, after which only one annual match survived in Surrey, in Dorking, where it too was banned, in 1897.

As Hugh Hornby has written, play at Kingston was between residents living either north or south of The Castle Inn in the Market Place (now a branch of Next). Their respective goals were Kingston Bridge (over the Thames) and Clattern Bridge (over Hogsmill River), both still extant.

Should you ever be in Kingston, it is well worth standing on the very spot from which this scene was drawn, with the Guildhall, now called **Market House**, still dominating the Market Place, and with **All Saints Church** visible in the distance, exactly as in 1846.

The locations of other known Shrovetide games in the London area are shown on the map on page 226.

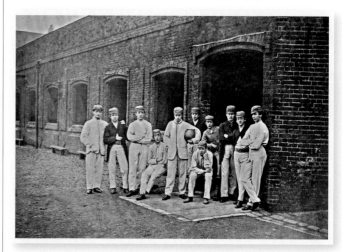

▲ Another historic site of football interest that can still be visited is the **Cloisters** at **Charterhouse**, seen here in 1863. Seventy yards long, nine feet wide and with a vaulted roof, the cloisters were built in 1571 so that the Duke of Norfolk could walk to his tennis court under cover. The boisterous nature of 'football' played by Charterhouse boys within its confines can well be imagined. Teams were six to nine boys per side. Doors at each end served as goals, while if the ball exited through one of the openings, the first player to leap out and 'touch' it won the right to throw it back in. Holding the ball is **Bertram Hartshorne**, who that same year attended the inaugural meeting of the FA on his 19th birthday.

The last game in the cloisters took place in 1872, shortly before the school relocated to Godalming.

▶ In October 2013 the **Football Association** (FA) unveiled the plaque seen opposite on the site of the **Freemasons' Tavern**, on **Great Queen Street, Holborn**.

The Tavern – despite its name a suite of private dining rooms attached to Freemasons' Hall – was where the FA held its first meeting on October 26 1863.

As that meeting was taking place work had already started on rebuilding the Tavern. Hence the façade seen today, now part of the **Grand Connaught Rooms**, is not as it would have appeared in 1863.

Note also that the Freemasons Arms pub in nearby Long Acre is a separate entity with no connection.

That it took 150 years for the FA to commemorate its own founding is no surprise to most historians.

For all the game's wealth, only recently have the football authorities engaged in their own history, and then, critics would argue, only because they have been persuaded of the commercial value of heritage.

Equally, it should be added, there is no plaque to commemorate the founding of the Football League at Anderton's Hotel, on what is now 164 Fleet Street, in 1888.

The story of what occurred at that first FA meeting is well told elsewhere. Suffice it to say that all twelve clubs and schools represented were from London; that one of them, Blackheath, decided in the end not to join (see page 261), that Charterhouse, after hearing Bertram Hartshorne's report, opted to hold fire (they eventually joined in 1868), and that there was certainly little expectation that one day Association, or 'soccer' rules would evolve to become standard around Britain, let alone the world.

Indeed for its first few years there was no certainty that the organisation would survive at all.

That it did, as stated on the plaque, was owing to men such as **Ebenezer Morley** (1831-1924).

Born in Hull, like many of football's pioneers Morley was a genuine all rounder. A solicitor and founder of Barnes FC, Morley became the FA's first secretary and drafted its first set of rules.

He was also a member of the **London Rowing Club** (page 49), in whose boathouse his portrait hangs (top right). His house, at **26 The Terrace**, still stands in Barnes, while nearby is the **White Hart** pub, where he and other rowers would

regularly meet. Also nearby was **Limes Field**, where in December 1863 a trial of the first FA rules took place in a match, Barnes v. Richmond (see map on page 46). **First Avenue** and **Second Avenue** now occupy the site.

After refining the rules, a further trial match was held in January 1864 between teams captained by Morley and Charles Alcock at **Battersea Park**, almost certainly on the cricket pitch where the athletics track is now situated (page 311).

Battersea Park was again the scene when, in March 1866 – a month after Morley and Charles Dickens Jnr had officiated at an athletics meeting at Beaufort House (page 306) – Morley scored the opening goal in the first ever representative match played under FA rules, London v. Sheffield.

Until the 150th anniversary celebrations Morley's name was all but forgotten. There is no plaque to him in Barnes, while his modest grave (second top right) makes no mention of his role in football.

It lies in **Barnes Old Cemetery**, a cemetery (page 119) within Barnes Common that is no longer enclosed and which, as a result, had become completely overgrown until recently cleared. Certainly few if any of the footballers playing on the adjoining pitches have any idea of how close lie the remains of such an important figure in the game's history.

Also cleared of overgrowth is the grave of the aforementioned **Charles Alcock** (1842-1907), at **West Norwood Cemetery**.

Born in Sunderland but raised in Chingford and educated at Harrow, Alcock combined his work as a journalist with acting as secretary to both the FA and to Surrey CCC. It was at his suggestion, at a meeting in the offices of a weekly

newspaper, *The Sportsman*, in **Boy Court, Ludgate Hill**, in 1871 (roughly where Limeburner Lane now lies), that the FA Challenge Cup was instigated as a knock out competition, based on the Cock House championship at Harrow.

Alcock went on to captain The Wanderers to victory in the first Cup Final, played in 1872 at **The Oval**, the home, of course, to Surrey.

A copy of that trophy was added to Alcock's tombstone (*below right*) when it was re-dedicated in 1999, courtesy of the FA, in conjunction with the Friends of West Norwood Cemetery, Surrey CCC and English Heritage.

If the trophy looks unfamiliar, that is because the present FA Cup is actually the third different design to have been used since 1871.

The first FA Cup trophy was stolen in 1895. The second, made in 1896, was withdrawn in 1910 after Manchester United had made a copy without permission. The original trophy was then presented in 1911 to Arthur Kinnaird, the President of the FA, to honour his 21 years in the role.

Known more formally as **Lord Kinnaird of Inchture**, Kinnaird (1847-1923) was a familiar figure in football circles. With his auburn beard and, in his youth, his hard tackling style, he played in a record nine FA Cup Finals, winning five. With Alcock he was instrumental in persuading the FA, however reluctantly, to sanction professionalism in football in 1885.

As outlined in Andy Mitchell's biography (see Links), outside football Kinnaird was a founder member of the British Olympic Association, a director of Barclays Bank and was active in the Regents Street Polytechnic. He also helped purchase the Quintin Hogg Memorial Sportsground in Chiswick (page 47), opened in 1910.

That a road near to that ground was named after Kinnaird in 1928 is, however, unrelated. Rather it was because Kinnaird's property company, Kinnaird Park Estates, bought land in the area in 1928. (There is another Kinnaird Avenue within the company's other estate, in Bromley.)

From 1918-34 the chairman of Kinnaird Park Estates, incidentally, was another key figure in the story of London football, a man whose name will become familiar in this chapter, Henry Norris.

England's first football captain, Cuthbert Ottaway (1850-78) played in three Cup finals, opened the batting with WG Grace and won Blues at Oxford in five different sports, a record never beaten. But it took two fans, Paul McKay (*above, left*) and Michael Southwick, to revisit Ottaway's short life, and to lead efforts to restore his grave at Paddington Old Cemetery, in 2013.

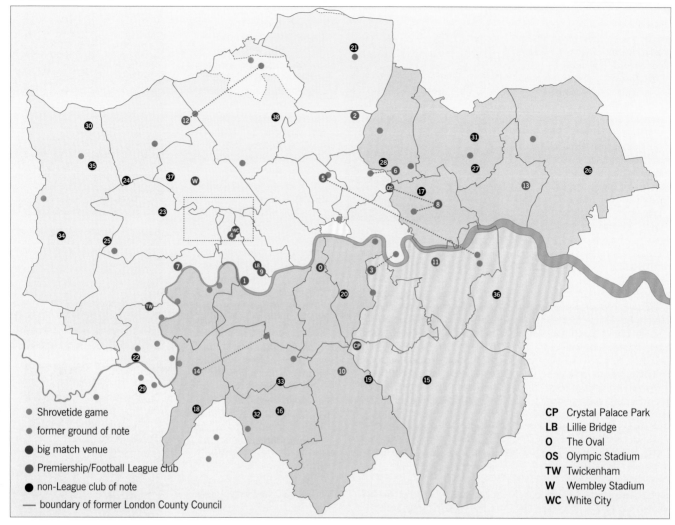

- Shrovetide game
- former ground of note
- big match venue
- Premiership/Football League club
- non-League club of note
- — boundary of former London County Council

CP	Crystal Palace Park
LB	Lillie Bridge
O	The Oval
OS	Olympic Stadium
TW	Twickenham
W	Wembley Stadium
WC	White City

This map shows the location of London's highest ranking and longest established football clubs playing at enclosed grounds, as of 2012–13. Green dotted lines show the movements of clubs that have relocated significant distances. Marked as 'former grounds' are those locations where substantial grounds have been vacated, plus the grounds of significant clubs that no longer exist. The many moves of Queen's Park Rangers (4), within the dotted area, are mapped separately on page 244.

▲ It could be argued that the **football map of London** is in itself an expression of sporting heritage – a manifestation of history, of local rivalries and of local identities.

But it is a map that invites caution when it comes to analysis. For although every fan instinctively retains a mental map of London football and of where his or her club's heartland is located, defining the extent of the club's overall catchment area has, in recent years, become increasingly difficult.

This blurring has partly resulted from the biggest clubs, **Arsenal**, **Chelsea** and **Tottenham**, widening their spheres of influence in recent years. It is also a result of people's greater mobility within the capital.

Identifiable divisions nevertheless persist. For example the A10 road remains for many the nominal boundary between **Arsenal** (5) and **Tottenham** (2). The Lea Valley still more or less divides Tottenham's heartland from that of **West Ham** (8), which is why the latter's

move to **Stratford** (OS) in 2016 represents such a significant shift.

But there have been many such moves. In 1937 **Clapton Orient** (6) moved from the Middlesex side of the Lea to Leyton, in Essex. In 1910 **Millwall** (3) crossed the Thames from the Isle of Dogs to New Cross.

None of these moves, however, was as momentous as that of **Arsenal** in 1913, from Plumstead to Islington, a distance of 9.5 miles, further than any English club has moved, other than Wimbledon's controversial relocation to Milton Keynes in 2003 – not shown on the map – of which more later.

Arsenal's move not only had an impact on Spurs and Orient, it also created a vacuum, eventually filled by **Charlton** (11). Yet even today there remain strong pockets of support for Arsenal in Kent.

Chelsea (9), meanwhile, are known to have a following in south west London, south of the river. Is this because no professional club ever established roots in that area

before the arrival in Kingston in 2002 of **AFC Wimbledon** (14)? And could it be that the tradition of **Shrove Tuesday football** in that part of Middlesex and Surrey in the 18th and 19th centuries, based more on handling than kicking, led towards the unusual preponderance of rugby clubs in the area, and therefore to the choice of **Twickenham** (TW) as the national home of rugby?

As for the existence of only six senior clubs within the boundaries of the former LCC (marked in red), that can largely be explained by high land values rendering ground ownership problematic. But it does not explain why three of those six clubs, Fulham, Chelsea and QPR, are to be found within a single borough, that of Hammersmith and Fulham, or why 20 of London's 32 boroughs have no senior clubs at all within their boundaries.

In short, what this map suggests is that the geographical spread of clubs, although influenced by history, might otherwise be random.

Premiership and Football League clubs as of season 2012-13, in order of formation date

Key: f. club formed
CC cricket club/AC athletic club
o. current ground opened
(*capacity*) in 2012-13
• future ground plans

1. **Fulham** f.1879 for boys at St Andrew's Church, Greyhound Rd (*extant*) **Craven Cottage SW6** o.1896 (*25,700*) • to be expanded to 30,000 after 2014
2. **Tottenham Hotspur** f.1882 by schoolboy members of Hotspur CC **White Hart Lane N17** o.1899 (*36,240*) • to be replaced by new stadium (*56,250*) on existing site
3. **Millwall** f.1885 by workers at Morton's factory, Westferry Rd, Isle of Dogs (*dem*) **New Den SE16** o.1993 (*20,146*)
4. **Queen's Park Rangers** f. summer 1886 by players of St Jude's Institute (*extant*) and Christ Church Rangers **Loftus Road W12** o.1904 by Shepherd's Bush FC, used by QPR since 1917 (*18,439*) • relocating to new stadium on Old Oak Common (*40,000*) in 2018
5. **Arsenal** f.Dec 1886 by workers at Royal Arsenal, Woolwich **Emirates Stadium N5** o.2006 (*60,432*)
6. **Leyton Orient** f.1888 as Clapton Orient by players of Eagle CC **Matchroom Stadium, Brisbane Rd E10** o.1905 by Leyton FC, used by Orient since 1937 (*9,271*)
7. **Brentford** f.1889 by members of Brentford Rowing Club **Griffin Park TW8** o.1904 (*12,763*) • to be replaced in 2016 by new stadium (*15-20,000*) on Lionel Rd TW8
8. **West Ham United** f.1895 by workers at Thames Ironworks shipbuilders, Canning Town **Boleyn Ground, Upton Park E13** o.1904 (*35,016*) • relocating to Olympic Stadium (*54,000*) in 2016
9. **Chelsea** f.March 1905 by HA Mears **Stamford Bridge SW6** o.1877 by London Athletic Club, used by Chelsea since 1905 (*41,798*) • club seeking to relocate
10. **Crystal Palace** f.March 1905 by management of Crystal Palace Company **Selhurst Park SE25** o.1924 (*26,309*)
11. **Charlton Athletic** f. June 1905 by local teenagers. **The Valley SE7** o.1919 (*27,111*) but club played at Catford 1923-24, C. Palace 1985-91, West Ham 1991-92
12. **Barnet** f.1912 by merger of Barnet Alston and Barnet (also given as 1888 and 1919) **Underhill EN5** o.1907 by Barnet Alston (*6,023*) • relocated to **The Hive** Camrose Ave HA8 (*5,000*) 2013
13. **Dagenham & Redbridge** f.1992 by merger of Dagenham (f.1949 and Redbridge Forest (f.1979) **London Borough of Barking & Dagenham Stadium, Victoria Road RM10** o.1920 by Sterling Athletic, used by Dagenham FC since 1955 (*6,078*)
14. **AFC Wimbledon** f.2002 by supporters of Wimbledon FC (f.1912, relocated to Milton Keynes in 2003) *share with* **Kingstonian** f.1885 **Cherry Red Records Stadium, Kingsmeadow, Norbiton KT1** o.1989 by Kingstonian (*4,850*) • AFCW planning to relocate to Borough of Merton

Non-League clubs with enclosed grounds and of historic interest (in alphabetical order)

15. **Bromley** f.1893 **Hayes Lane** o.1938 (*5,000*) *share with* Cray Wanderers f. 1860
16. **Carshalton Athletic** f.1905 **War Memorial Ground, Colston Ave SM5** o.1921 (*5,000*)
17. **Clapton** f.1877 **Spotted Dog, Upton Lane E7** o. as cricket ground *c.*1844, used by Clapton since 1888 (*c.2,000*)
18. **Corinthian Casuals** f.1939 by merger of The Corinthian FC (f.1882) & The Casuals (f.1883) **King George's Field KT6** (*2,700*)
19. **Croydon** f.1953 **Croydon Sports Arena SE25** o.1953 (*8,000*) *share with* **Croydon Harriers AC** f.1920
20. **Dulwich Hamlet** f.1893 **Champion Hill SE22** o.1992, on site used since 1931 (*3,000*)
21. **Enfield Town** f.2001 **Queen Elizabeth Stadium, Donkey Lane EN1** o.1953 (*2,000*)
22. **Hampton & Richmond Borough** f.1921 **The Beveree TW12** o.1949 (*3,500*)
23. **Hanwell Town** f.1925 by supporters of Newcastle Utd. **Reynolds Field, Perivale UB6** o.1981 (*c.1,500*)
24. **Harrow Borough** f.1933 **Earlsmead HA2** o.1934 (*3,070*)
25. **Hayes and Yeading United** f.2007 by merger of Hayes (f.1909) and Yeading (f.1960) **Beaconsfield Road UB4** o.2013 (*5,000*)
26. **AFC Hornchurch** f.2005 **Hornchurch Stadium RM14** o.1952 for Upminster FC and athletics (*3,500*)
27. **Ilford** f.1987 but original club f.1881 **Cricklefield Stadium IG1** o.1923 (*3,500*) *share with* **Ilford AC** f.1923
28. **Leyton** f.1868 **Hare & Hounds Ground, Lea Bridge Road E10** • current status uncertain
29. **Metropolitan Police** f.1919 **Imber Court KT8** o.1920 (*3,000*)
30. **Northwood** f.1926 **Northwood Park HA6** o.1978 (*3,075*)
31. **Redbridge** f.1958 as Ford United **Oakside Stadium IG6** o.1957 by Barkingside (*3,000*) *share with* **Barkingside** f.1889
32. **Sutton United** f.1898 **Gander Green Lane SM1** o.1919 (*7,032*)
33. **Tooting & Mitcham** f.1932 by merger of Tooting (f.1887) and Mitcham (f.1912) **Imperial Fields SM4** o.2002 (*3,500*)
34. **Uxbridge** f.1871 **Honeycroft UB7** o.1978 (*3,770*)
35. **Wealdstone** f.1899 **Grosvenor Vale HA4** o.1947 by Ruislip Manor, used by Wealdstone since 2008 (*2,640*)
36. **Welling United** f.1963 **Park View Road DA16** o.1925 by Bexley Utd, used by Welling since 1977 (*4,000*) *share with* **Erith & Belvedere** f.1922
37. **Wembley** f.1946 **Vale Farm HA0** o.1928 (*2,450*) *share with* **Hendon** f.1908
38. **Wingate & Finchley** f.1991 by merger of Wingate (f.1946) and Finchley (f.1874) **Abrahams Stadium, Summers Lane N12** o.1931 (*3,500*) (*see page 111*)

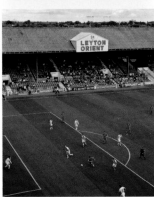

Living in the city – Charlton (*top*) exist mainly because Arsenal left the area in 1913. Leyton Orient (*centre*) were once based in Clapton, while in 2013 Barnet had to move to neighbouring Harrow, partly owing to access limitations at Underhill (*above*).

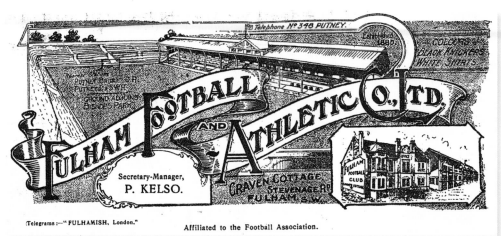

▲ London's oldest senior football club is **Fulham**, formed as a boys' club by the Rev James Cardwell at **St Andrew's Church** on **Greyhound Road**. But was it formed in 1880, as clearly the club believed when its main stand was built in 1905?

Or was it 1879, as a former player, Henry Shrimpton, insisted in a booklet he penned in 1950 but that remained largely unknown until 1969? (Shrimpton had captained Fulham in their first ever match at Craven Cottage in 1896 and went on to become the club secretary.)

Today 1879 is the officially endorsed date. But the discrepancy, albeit a minor one, highlights two issues pertinent to football.

Firstly, in its early years, the historical narrative of Association football was written mainly by administrators, former players or sports writers, and was passed down from generation to generation, more or less unchallenged. Owing to a surge of interest in social and cultural history, since the 1980s these narratives have been revisited and often found wanting. As a result, we now know far more about football's past than ever before.

Secondly, at club level, much of the important task of revision has been undertaken not by academics but by fans, driven by their genuine thirst for knowledge.

'Football without fans', it was once said, 'is nothing'. Football history without the efforts of fans would be similarly lacking.

▲ Nowadays much of the day to day running of **Fulham** takes place at the club's training ground in south west London, **Motspur Park**, itself a sports ground of historic interest (*see page 113*).

But when any football fan thinks of Fulham, they think immediately of **Craven Cottage**.

How best to describe this unique ground? How about 'Fulhamish', as the club's telegraphic address was listed on this rare, surviving letterhead from 1915 (from the collection of the late Dennis Turner, a widely respected fan/historian).

The original Craven Cottage had been a rustic lodge, built by Baron Craven in 1780 but destroyed by a fire in 1888. It took the west London building contractors Mears & Co two years to prepare the site before Fulham were able to play their first match there in 1896.

Lying close to the start of the Boat Race course, on the opposite bank of the river were the **Barn Elms** fields where Ebenezer Morley had once played.

As outlined in Chapters 9 and 10, Craven Cottage is the only senior English football ground with listed structures; the **Stevenage Road grandstand** and its adjoining **pavilion**, both designed in 1905 by **Archibald Leitch** and both Grade II.

Both can be seen below, in the foreground, with Bishop's Park on the left and the Thames beyond.

This setting is, in itself, enough to place Fulham apart. Quite literally, in fact. No-one today would build a stadium in such a location, with such poor public transport links.

So the fact that, over a century later Fulham are still there, *and* competing at a high level, is something of a miracle. Or if not a miracle, certainly quite 'Fulhamish'.

From 1903-08 the club chairman was Henry Norris. It was his property company, Allen & Norris, based at 190 Fulham Palace Road (still an estate agent today), that built many of the houses that surround Craven Cottage.

In 1904 Gus Mears, the building contractor, offered Fulham the tenancy of the larger, more accessible Stamford Bridge (*see right*). Norris, however, wanted to be the master of his own house.

For five other London clubs the consequences of Norris' stance were to prove immense, as will become apparent. But for Fulham, the die was cast. Because of its prime location, from 1977–97 there were repeated attempts to sell Craven Cottage and relocate the club or merge it with QPR or Chelsea.

On one occasion, in May 1992, a crowd of 8,671, the highest that season (an indication of how low Fulham's fortunes had fallen), turned up at what was expected to be the last ever match at the ground.

There was further alarm in 2002 when home matches were switched to QPR's ground, whilst Fulham once again considered whether to sell up and move on.

To huge relief – but only, it has to be said, after concerted lobbying by the fans, combined with the club's failure to find an alternative – Craven Cottage was upgraded and re-opened two years later.

Seen below, as part of that upgrade, covered stands were erected at each end. There are now also advanced plans to build a new Riverside Stand, thereby raising the capacity from 25,700 to 30,000.

If built, the proposed stand design will allow the Thames path to continue between Bishop's Park and Hammersmith for the first time, a welcome development. But for sailing clubs on the opposite bank, the possibility that the stand's taller structure might affect wind patterns remains a point of contention.

As, until 2013, did a statue on the riverside concourse of the ground. Unveiled by the club's then owner, the Egyptian Mohamed Al Fayed, it depicted the late singer Michael Jackson, hardly a figure identified with football. But then one of the treasures of the original Craven Cottage had been an exotic Egyptian Hall, so the chairman's indulgence was hardly unique.

Indeed it could be described as perfectly 'Fulhamish' – typifying that almost parallel state of unreality which, in London's crowded football market, could well be the club's greatest asset of all.

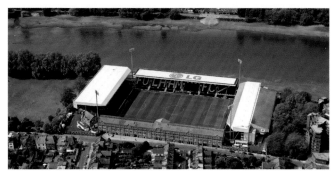

▶ There are essentially two types of professional football club; those that from little acorns do grow, like Fulham, forming the vast majority, and those few that were set up from scratch, as limited companies, usually in order to utilise a pre-existing ground.

Two London clubs fit the latter bill, both formed in March 1905.

One was Crystal Palace, the other was **Chelsea**. And as depicted in the club's museum at **Stamford Bridge**, this was the famous incident that sparked it off.

As outlined in Chapter 28, Stamford Bridge had been laid out for athletics in 1877, with a small stand and pavilion, and was leased by the **London Athletic Club** (LAC).

By around 1900, however, it was clear that athletics was no longer a paying proposition, and also that the cycling boom was over.

Football, already now firmly established in the north and Midlands, was the next big thing.

Tottenham had laid out their new ground in 1899. Henry Norris was making waves down by the river. Elsewhere, Griffin Park and Upton Park had opened in September 1904, followed seven weeks later by Loftus Road.

But not one of these grounds had the potential of Stamford Bridge. Here was a site of eleven acres (nearly twice the area of Craven Cottage), with two railway stations close by and within easy reach of central London.

Aware of this, and after years of waiting for the LAC's lease to expire, in September 1904 two brothers, Gus and Joe Mears – of the same Hammersmith-based building firm that had laid out Craven Cottage in 1896 – finally managed to get hold of the freehold.

Stamford Bridge, they felt sure, would offer a perfect alternative to Crystal Palace as a home for internationals and the Cup Final.

Gus Mears assumed, moreover, that Fulham, the senior club in the district who, after all, were at the time only renting Craven Cottage, would leap at the chance to play there. So when Henry Norris turned him down, and then no other partners came forward, reluctantly Mears resolved to sell the site to the Great Western Railway, who wanted it for a coal and goods yard.

But first he felt duty bound to tell his friend, Fred Parker, a member of the LAC who shared Mears' dream.

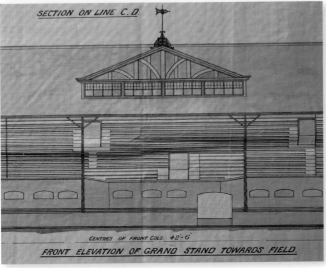

SECTION ON LINE C. D.

CENTRES OF FRONT COLS 42'-0"

FRONT ELEVATION OF GRAND STAND TOWARDS FIELD.

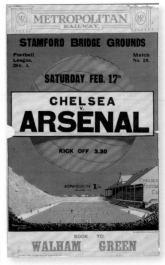

▲ **Stamford Bridge** was never quite as compact or as vertiginous as in this poster from 1923. Nor did it ever 'stagger humanity', as one local newspaper had promised.

But Messrs Mears and Parker had been right. Londoners flocked to the new Stamford Bridge.

Chelsea's match v. Manchester United in April 1906 drew 67,000, the largest crowd yet seen for a League match in London, even if, as another less than impressed local reporter put it, the club was no more connected with the borough of Chelsea 'than with Timbuctoo'.

But 'The Bridge' was very well connected. In addition to Walham Green (renamed Fulham Broadway in 1953) there was, at least until 1940, a second station just south of Fulham Road, on the West London Extension Railway.

In other words, Fulham hardly stood a chance, which may explain why in 1910 Henry Norris lost interest and took over Arsenal.

The bon viveur Gus Mears, meanwhile, whose catch phrase had apparently been 'Don't worry!' died at the age of just 37 in 1912. His one other sporting contribution had been to act as a steward at the 1908 Olympics.

As Parker later recalled in a letter, Mears called him over to 'The Bridge' one Sunday in late 1904. While the two men strolled, mulling over their disappointment, suddenly Mears' dog leapt up and bit Parker on the leg, drawing blood.

Instead of showing concern, Mears merely shook his head.

'Scotch terrier,' he muttered. 'Always bites before he speaks.'

Despite his pain Parker could not help but laugh. He told Mears that he was the 'coolest fish' he had ever met.

Mears thought about this for a moment and then, out of the blue, declared that he had changed his mind. He said that Parker had reacted so well to the dog bite, and made so little fuss, that perhaps his judgment on the stadium scheme was to be trusted after all.

In the words of Alexander Pope, 'What mighty contests rise from trivial things!'

Within days Mears and Parker were in Glasgow to meet Archibald Leitch and see Ibrox, Celtic and Hampden Parks, the world's three largest football stadiums, all recently built. On February 23 Leitch submitted his first plans for Stamford Bridge to the LCC.

One was for the main stand, as seen above, with a form of roof gable that would soon become familiar to fans all over London.

Three weeks later, on March 14 1905, Chelsea FC was launched at the **Rising Sun** pub, across the road from Stamford Bridge.

The pub is still there today, renamed **The Butcher's Hook**.

As for Henry Norris, desperate not to be outwitted by Gus Mears, in January 1905 he secured a 99 year lease for Craven Cottage, and then hired the nearest football ground designer he could find..

Which is why, if you want to see how the plan reproduced above looked when it was built at Stamford Bridge, turn to the feature on the stand at Fulham (*page 109*). Leitch used almost the same plans for both clubs, and saw both stands open the following September.

▲ **The Shed** at **the Bridge**, the Shelf at the Lane. The Palace, the Valley, the Cottage and the Den.

The Hammers, the Gunners, the Daggers and the Dons, the Blues, the Spurs, the Lions and Bees. Not forgetting the Os and the Hoops (or Rs if you must).

The 'thes' of London football have a poetry and a rhythm all of their own, as familiar to fans as any character in a soap opera or station on a Harry Beck map.

There are the old names, now seldom heard: the Pensioners, the Lillywhites, the Cottagers. But the Addicks have made a comeback and the Vampires have never gone away. (They are still in Crouch End).

Not so the Nest, the North Bank, Cold Blow Lane and now Underhill. And what of Champion Hill and the Spotted Dog?

Two of the latest 'thes' to have entered the football lexicon have proved maddening to traditionalists.

Division One is now 'the Premiership', while the old Second Division is 'the Championship'.

Of course you knew that Queen's Park Rangers never did play in Queen's Park, or that Millwall left Millwall long ago, and that just as Clapham Junction is actually in Battersea, Chelsea are really based in Walham Green.

And have you noticed what all these clubs have in common?

Not one of them has the word 'London' anywhere in their names. Odd that. But perfect sense.

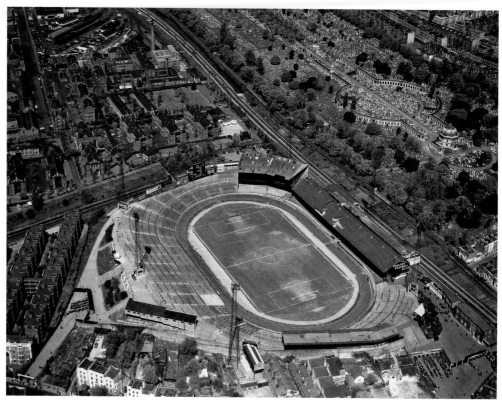

▲ By the time this view was taken in 1960, apart from six towering floodlight pylons erected three years earlier, **Stamford Bridge**, with too few seats, too little cover and a dog track, appeared an unsightly mess.

How had this come about?

As hoped by Gus Mears, in 1920 the Bridge did succeed the Palace as the venue for the Cup Final. But this was only until Wembley was ready in 1923. Thereafter, what development did take place was ill-judged and poorly executed.

This was not down to Chelsea. They were merely tenants of the ground company, as the **Stamford Gate** entrance on **Fulham Road** made clear in the 1950s (*right*).

Indeed, following the death of Gus Mears in 1912, his brother Joe came to treat the Bridge first and foremost as a cash cow.

In 1922 the Football League had to complain about the pitch after it had staged 65 athletics meetings and baseball matches during the summer. At other times it had also staged rugby.

In one sense this diverse event schedule was admirable, just what London sport needed. But the profits were never ploughed back into the infrastructure.

Then in 1928 the introduction of speedway racing messed up the running track that the Bridge's

eminent groundsman, Charles Perry (*see page 308*), had once tended so proudly, forcing athletics to relocate to White City in 1932.

(The Bridge had by that time been an athletics venue for 54 years, longer than any other major London venue, before or since.)

Joe Mears then dropped speedway and set up a greyhound racing operation instead.

As noted in Chapter 30, dog racing proved so lucrative that the interests of Chelsea now took a back seat. Thus in 1935 when an oddly angled cover was erected at the rear of the south terrace (*seen above in the foreground*) it was designed primarily to shelter bookmakers, not football fans. That we remember it still is

mainly because in 1966 it was aptly renamed **The Shed** at the suggestion of a Chelsea fan.

Similarly, as also seen above, in 1939 the Leitch company designed an ill-conceived double decker stand in the north east corner. Had the ground company been more concerned about football fans, any new stand should have been built on the west side, where there was still no cover at all.

As it transpired, the 1960s turned out to be Chelsea's most successful decade to date. The Blues were swinging. The Bridge became almost an extension of King's Road. But then the party was over and in its place a modern day Battle of Stamford Bridge was about to commence.

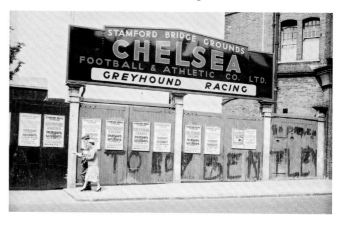

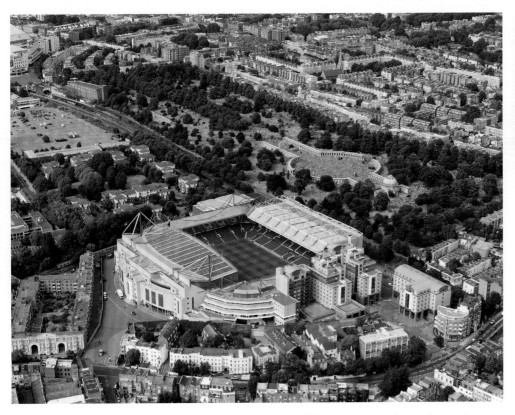

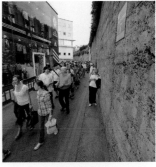

▲ On one side, the glazed frontage of the **Chelsea Megastore**. On the other, a 25 feet high concrete wall separating **Stamford Bridge** from the properties behind, amongst them a cluster of Italianate artists' studios, the essence of old Chelsea.

Crudely shuttered, and all the better for it, the wall that divides these two worlds, just visible also on the aerial view (*left*), was built in 1905 as the retaining wall of the **Shed End**, and is the only surviving element of Gus Mears' Bridge.

Today the Shed End is a two tiered, all-seated stand backing onto a four star hotel.

Since Roman Abramovich bought Chelsea in 2003, paid off its debts and started to pump money into the team, he has found two things that, so far, money cannot buy.

Firstly, as a result of the property wrangles of the 1980s, the land on which Stamford Bridge sits was transferred to a separate entity called the **Chelsea Pitch Owners** (CPO). This was set up by Ken Bates in 1993 to ensure that the club could never be forcibly evicted.

But with virtually every match now a 42,000 sell out, and with no room to expand, the club has started to look elsewhere. Both Earls Court and Battersea have been considered, reportedly White City and Imperial Wharf also, all without success.

For all the chairman's wealth, finding a 20 acre site in west London where a new stadium might gain planning permission has, so far at least (as of March 2014) proved impossible.

But even if a site can be found, the club must still obtain a 75 per cent vote in favour of the move from amongst the CPO shareholders.

Heritage protection takes many forms. But in all of sport there is nothing quite like that of the CPO's hold over Stamford Bridge.

Another case of 'watch this space'... quite literally.

▲ Can a global brand that is owned by a Russian oligarch, which consistently fields teams with only one or two Englishmen, and whose stadium has only one element that predates the 1970s, still be said to be in touch with its heritage?

Visiting the **Chelsea** museum, opened on the club's centenary in 2005, the answer would seem to be firmly in the affirmative.

In fact as long term fans argue, in order to appreciate Chelsea's position today, riches and all, it is more imperative than ever to understand the past. Even if it is an extraordinarily complex tale.

Chelsea's woes began in the 1970s when Leitch's grandstand was replaced by a colossal three tier stand seating 11,500 (this was

after greyhound racing ceased in 1968). Designed by Darbourne & Darke, the critics loved it. But on a practical level the stand, seen above backing onto Brompton Cemetery, was flawed, expensive, and plunged Chelsea into debt.

Worse, after a new chairman, the acerbic controversialist Ken Bates, took over the ailing club in 1981, the ground's freehold, up to then controlled by the Mears family, fell into the hands of property developers. At one point Chelsea's gates dropped to under 7,000.

Years of conflict ensued, made bloodier when the same property developers purchased Fulham in 1986, followed by QPR in 1987.

That all three clubs remain on their grounds today is owing

to various factors: the resolve of councillors at the Borough of Hammersmith and Fulham; Bates' doggedness in the courts; massive, co-ordinated opposition from amongst the fans, and finally, but crucially, the collapse of the property market in the early 1990s.

Even as the dust settled, Bates set in train his long cherished redevelopment of the Bridge under a masterplan entitled the **Chelsea Village**. Completed during the period 1993-2001, this comprised the North, or **Matthew Harding Stand** (named after a benefactor), designed by HOK Sport, and the **South** and **West Stands**, both by KSS Architects. All three feature column-free roofs held up by space-saving catenary arches, a revolutionary design conceived by engineer Stephen Morley, whose other credits include Wembley and the Centre Court at Wimbledon.

Almost as radical at the time – it has since become commonplace at stadiums – was Bates' provision for two hotels behind the south, or **Shed End Stand**, seen in the foreground (*above*) and also from **Fulham Road** (*left*, taken from almost the same viewpoint as the 1950s photograph seen opposite).

And to think, all this because Fred Parker kept his cool under assault from a Scotch terrier.

ARCHIBALD LEITCH, M.I.Mech.E.

The well-known Football Ground Expert.
Engineer for the reconstruction of the Spurs' Ground.

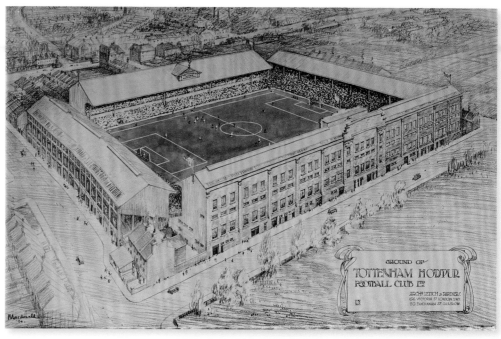

GROUND OF
TOTTENHAM HOTSPUR
FOOTBALL CLUB LTD

ARCH⁰ LEITCH & PARTNERS
56 VICTORIA ST LONDON SW1
80 DUCHMAN ST GLASGOW

▲ **Tottenham Hotspur** were the fifth London club to hire engineer **Archibald Leitch** (1865-1939), pictured here in their 1908 club handbook. A specialist in factory design, Leitch's first football commission had been to design Ibrox Park for Rangers, the club he supported in Glasgow, in 1899.

His career nearly ended at Ibrox too, when in April 1902 a section of timber terracing collapsed, killing 25. Mortified, Archie set about designing a safer terrace, combining solid banking with steel crush barriers, a system first implemented at Stamford Bridge and Craven Cottage in 1905.

Other than Fulham and Chelsea, Leitch worked for eight other London clients: Woolwich Arsenal (first in 1904), QPR, via their landlords, the GWR (1907), Tottenham (1908-34), Millwall (1910), Arsenal (1913), Crystal Palace (1924), Twickenham (1924-32), West Ham greyhound stadium (1928) and Romford FC (c.1937).

From 1899-1955 the company had offices in Victoria Street, while Leitch himself settled in London in 1915, living first in Barnes, then Southgate, before retiring to Cockfosters and becoming a regular at White Hart Lane.

Leitch's biography is part of the *Played in Britain* series (see *Links*).

▲ Of all London's grounds in the 20th century, none bore the stamp of Archie Leitch more than **White Hart Lane**. All four stands were his firm's work, as shown on this sketch publicising the design of the last of them, the **East Stand** (in the foreground), completed in 1934.

This was how the ground was configured when its highest gate of 75,038 was recorded in 1938.

Even though by that time Spurs were the only London club to have covered stands on all sides, 'the Lane' never had quite the style of 1930s Highbury or the scale of Stamford Bridge.

Instead, here was a functional ground run by a conservative club defined by its location. To the east, the Marshes, the River Lea, the border with Essex. To the west, forming the spine of Tottenham, the High Road, following the line of the old Roman Ermine Street from Bishopsgate up to York.

As indicated in Chapter 6, until the late 19th century Tottenham had been a largely rural area, with market gardens and an emerging middle class. Now it was crammed with 20th century terraces, flats, factories and warehouses.

Moreover, until the Victoria Line opened in 1968, the closest tube was nearly two miles away at Turnpike Lane. Hence to help people find the Spurs ground it became known after the nearest railway station, White Hart Lane.

But even this, and a second station to the east, Northumberland Park, had limitations. Both were served by lines running only north to south, from Liverpool Street up to Enfield. To a certain extent this axis defined Spurs' catchment area.

In fact it is possible to cast an even narrower net and trace the club's entire history to within a few streets of White Hart Lane.

It began in 1880 when boys from Tottenham Grammar School and St John's Presbyterian School (both since closed) formed a cricket club. They chose the name Hotspur CC owing to the area's links with the Earl of Northumberland's family, one of whose scions had been Henry Percy, or 'Harry Hotspur'.

Adopting football in 1882, the young Spurs soon turned for advice to John Ripsher, whose bible classes many of the boys attended at All Hallow's Church (still extant on Church Lane).

With Ripsher's help they were able to establish themselves on Tottenham Marshes, store their goalposts at Northumberland Park station, and get themselves organised. This in turn led to them renting their first enclosed ground in 1888, a field off Northumberland Park itself.

His protégés having earned their spurs, as it were, Ripsher stood down in 1894 (he later died a pauper), and in 1895 Spurs adopted professionalism, the third London club to do so after Woolwich Arsenal and Millwall.

Needless to add, they too would soon be clients of Leitch.

After a late start, this football business was really starting to catch on in the capital.

As Archie Leitch once said, 'where two may stand only one may sit'. Hence a ground that once held 75,000 has, since its redevelopment as an all-seater in the 1990s, held only 36,284. Of Leitch's work, only the core and rear wall of the East Stand survives. Given that Spurs have 21,000 on a waiting list for season tickets, their desire to start afresh can be no surprise.

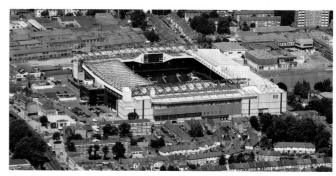

▲ Flanking the entrance to **White Hart Lane** on either side of **Bill Nicholson Way**, the buildings above could be said to embody opposing forces in the history of **Tottenham Hotspur**; God and Mammon, or at least bible classes and beer glasses.

On the right is the former **Red House Coffee Palace**, built in c.1878-80 to offer working men an alternative to the demon drink.

It was financed by a solicitor and Baptist teetotaller, Joshua Pedley, who also founded the **Tottenham & Edmonton Dispensary** which, in 1910, was rehoused in the building next door to the Red House (*on the far right*).

Pedley was also responsible for saving Bruce Castle, now the home of Haringey's local studies archive and therefore the repository of much of Spurs' history.

Another connection? One of the clerks in Pedley's office was Bobby Buckle, Spurs' first captain.

As noted opposite, Buckle and his team mates had relied heavily on another devout Christian, John Ripsher, for moral and material support, and not least for finding them rooms in which to meet; first at the YMCA on the High Road, then in Dorset Villas on Northumberland Park. Ripsher had to look again in 1886 when the vicar of All Hallows caught the youths playing cards.

It was at that point that a room was secured at the Red House, where the club would meet for the next five years, until 1891.

On the left, above, facing the Red House, is the former **White Hart Inn**, latterly called **Valentino's** before its closure in 2013.

In an earlier incarnation the pub had at its rear a bowling green and meadow, until a new landlord, George Beckwith, converted the meadow into a nursery and market garden. After his death in 1898, Charrington, the brewers, decided to sell most of the site for housing, while hiring a new landlord, William Gilboy, to run the White Hart.

Gilboy had another idea though. Having run a pub next to Millwall's ground on the Isle of Dogs he put Charrington in touch with Spurs, whose nearby ground on Northumberland Park was struggling to cope. (One match in April 1899, v. Woolwich Arsenal, had drawn 14,000 spectators.)

By September the new ground had been laid out, and such were the profits accrued from Spurs' growing number of thirsty fans that Charrington completely rebuilt the White Hart as we see it here (although a block of urinals placed in the middle of what is now Bill Nicholson Way have long gone).

Even after purchasing the site of the ground from the brewery in 1905 Spurs continued to give the ground's address as 750 High Road, the same as the White Hart.

Until, that is, in 1921 when they purchased number 748, the Red House, turning it into their new offices and a boardroom.

Only in 1982 when the new

West Stand was built (*seen in the background*) would the Red House cease to be the club's administrative hub. But the building still belongs to Spurs and to this very day 748 High Road remains their address.

Until recently one of the distinguishing features of the Red House was a clock, erected in 1934 and surmounted by a cockerel, the symbol adopted by the club in the early 1900s (because fighting cocks always wore spurs). That cockerel is currently in store, but inside the main entrance can be seen an even finer, and older example.

Shown on the right, this magnificent copper piece, 2.6m tall, weatherbeaten but proud, was created in 1909 by a former Spurs player, WJ Scott, and supplied at a cost of £35 by Fred Braby & Co. of Euston Road, manufacturers of metal products. (The firm also supplied corrugated iron pavilions to sports clubs.)

Until 1957 the cockerel perched on the gable of Leitch's West Stand.

It was then transferred to the East Stand, before being retired indoors in 1989. Two fibreglass copies are now mounted on the stand roofs in its place.

Legend had it that inside the ball were treasures from the club's early years. Instead, only a soggy 1909 handbook was found. But no matter. The cockerel on its ball remains a potent symbol, and one that is sure to take pride of place when the next chapter of the Spurs' story begins, only a few yards away.

Unveiled in 1983, this bust of Bill Nicholson OBE (1919–2004), the most successful manager in Spurs' history, is displayed in the Bill Nicholson Suite at White Hart Lane. To reach the suite visitors will have passed by the Red House, where his office was from 1958–74, and walked along Bill Nicholson Way (*left*). On Northumberland Park, around the corner, there is the Bill Nicholson pub, formerly the Northumberland Arms, behind which lay Spurs' ground from 1888–99. Nicholson himself, a gruff Yorkshireman, would have been bemused by all this. He lived a short walk from White Hart Lane in a modest family home on Creighton Road, with his allotment at the rear, and other than on match days did his utmost to shun attention.

▶ First seen in April 2013, this dramatic digital rendition was, as of March 2014, the latest of a series of impressions released by **Tottenham Hotspur** to show how a new 56,250 seat stadium at **White Hart Lane** might look if and when all the necessary planning hurdles might be overcome.

(Note those signs of the time on the roofs, preparing the way for the sale of the stadium's naming rights, *vide* Arsenal's Emirates Stadium and The O2 Arena).

In this particular image, however, it was not only the proposed stadium design that caught the eye, but its relationship with the older buildings on either side, seen facing onto **Tottenham High Road**.

In the 1720s when Daniel Defoe took a trip along the High Road he described it as 'one continu'd street' in which most buildings belonged 'to the middle sort of mankind, grown wealthy by trade'.

Nearly two centuries later and contrary to what many Londoners might imagine from their own passing impressions of the High Road – or from news reports in the aftermath of the Tottenham riots of August 2011 – there are still numerous buildings in the vicinity that merit Defoe's description; that is of being 'fine in their degree'.

In fact, between Lordship Lane and Northumberland Park, on the same side of the High Road as the football ground, there are no fewer than ten buildings listed locally by Haringey Council (including the **Tottenham & Edmonton Dispensary** and the **Red House),** plus a further seven listed Grade II (including **Warmington House** at number 744, a Georgian town house that was for many years occupied by the Spurs Supporters' Club).

These historic buildings may be seen clustered in the south western corner (*or lower right*) of the view above.

Meanwhile in the north west corner (*left*) lies a handsome terrace of four buildings listed Grade II*.

At the end of this terrace (by the steps leading to the proposed stadium's upper concourse) **Dial House** dates back to 1691.

These houses, or ones like them, wrote Defoe, were occupied by men 'who still taste of London', many of whom were 'immensely rich'.

Men of wealth still do congregate in Tottenham. According to a BBC survey in 2012, Spurs fans pay the highest average prices for season tickets in the Premier League. And yet fewer than a quarter of them live within even a ten mile radius of 'the Lane'.

Analysis of several other Premier League clubs reveals this same disconnect: lavish stadiums set amidst deprived inner city areas.

Spurs' response is to point out the work done by the Tottenham Hotspur Charitable Foundation, which runs a range of programmes in Haringey and three other London boroughs, and overseas; the sort of philanthropy of which Joshua Pedley would surely have approved.

But if charity begins at home, recent relationships on the home front have not all been easy.

When in 2008 Spurs declared that rather than seek a move they would redevelop White Hart Lane there was widespread relief. After 125 years in the neighbourhood, most locals agreed that Spurs were a heritage asset in their own right.

But when the first set of stadium plans were published, the historic buildings in the south western

corner of the site, the Red House included, were missing, their place taken by an open plaza.

SAVE Britain's Heritage and English Heritage were among several parties to object to the plans, their concern being not only for the buildings but for the maintenance of the High Road's historic linear frontage.

Thus after lengthy negotiations new plans were drawn, and finally approved along the lines seen above. True, one listed building would have to be sacrificed. This was the Grade II Fletcher House, at number 774. But otherwise, with the Red House saved and destined to be restored by Spurs as a coffee house, and the remaining historic buildings due to complement the sleek modernity of the stadium, it seemed that all parties were satisfied.

The **Northumberland Development Project**, as the £400 million scheme was now called, represented a victory for heritage, good design and for the planning process.

Except that almost immediately, in October 2010, out of the blue Spurs announced that they now wished to be considered as tenants of the new Olympic Stadium, five and half miles east from Tottenham.

It took at least a year for the ramifications of that proposal to be settled and for Spurs to finally re-commit to Tottenham, mollified by the pledge of £27 million worth of public investment into the immediate area, jointly funded by Haringey and the GLA.

So it was that once again work restarted on the masterplan, work that continues as this book goes to press. But the basics, as broadly illustrated above, should remain along the following lines.

The existing ground sits on the southern half of the site, on the right. The northern half, on the left, was taken up by houses, warehouses and small businesses (one of which, ironically owned by a Spurs fan, was refusing to move at the time of going to press).

Most of the northern site was cleared by 2013 when work began on a superstore, the idea being that above the store, club offices and hospitality areas would link to the new stadium via a walkway.

The new stadium itself is to be centred some 110m north west of the current one, thereby releasing land for up to 200 flats, new headquarters for Spurs' charitable foundation and a club museum.

In the main English football clubs are happy to fly the flag of heritage when it suits them, whereas planners have no such latitude. Club owners, players and managers, and even stadium architects may come and go, but it is the people of Tottenham who must live with the consequences.

Hence they await a final scheme, expected for completion in 2017 or thereabouts, that will hopefully honour the integrity of Defoe's 'continu'd street' and will continue to 'taste of London', old and new.

But it has been a long road so far, going back to 2008, and there is still a long road ahead.

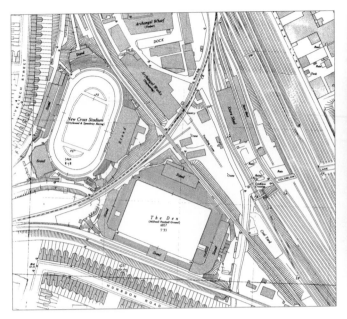

▲ Professional football at the start of the 20th century was no more a place for sentiment than it is today. Nor was land for a football ground easy to find, or afford, at least not in heavily populated parts of London.

That is why in 1908-09 the directors of **Millwall** looked long and hard before choosing the site above, shown as it appeared on an Ordnance Survey map of 1950.

The most controversial aspect of this site was that it was on the *south* side of the Thames, whereas Millwall, self evidently, were a club from the Isle of Dogs.

They had been formed in 1885 by tinsmiths, several of whom were Scottish, working at JT Morton & Co, makers of canned and bottled foodstuffs on Westferry Road (where now stands a block of flats called Cascades). In 1893 the Dockers, as Millwall were dubbed, became the capital's second professional club after Woolwich Arsenal.

Four different grounds on the island were rented before the directors reluctantly concluded that the area was not sufficiently populous, and the local transport infrastructure not developed enough to sustain a professional outfit.

So it was that Millwall crossed the river to New Cross; a distance of only one and a half miles, but into another world, all the same.

Almost inevitably their chosen advisor was Archie Leitch, who was at the time working on another, rather larger football ground, that of Manchester United at Old Trafford.

Millwall's new site, a former rhubarb and cabbage patch, triangular in shape, hemmed in by three railway lines and with only one road, Cold Blow Lane, offering direct access, did not appear to promise much. It took months to build up the terraces, and when finally ready, in October 1910, Lord Kinnaird, by that time aged 63, had to be literally manhandled over a wall to get him through the throng and into the ground to perform the opening ceremony.

As Millwall were now being called 'the Lions', the ground was named **The Den**. And how well it lived up to that name.

Approached through cobbled streets and under railway arches, The Den was ugly and intimidating. No other British ground was closed more often owing to hooliganism.

Yet The Den was also wonderfully eccentric, more so after the **New Cross Greyhound and Speedway Stadium** (the 'Frying Pan'), as seen above, opened on an adjoining site in 1934 (see *page 334*). Nowhere in London were two such venues so close, and yet so self-contained.

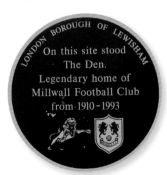

▲ With its four, almost identical stands seating 20,146 the new(ish) home of **Millwall** is a no-nonsense football enclosure, the sort that Archie Leitch would have absolutely endorsed. But then it was designed by the Glasgow based Miller Partnership, who in the late 20th century had almost as many new grounds to their name as Leitch.

It was also the first all-seater stadium to have been purpose built in the aftermath of the 1990 Taylor Report, and the first in London to occupy a site that had once been covered by housing (although since slum clearances in the 1960s it had been an open space called Senegal Fields).

But what to call this new venue? When opened in 1993 it was named **The New London Stadium** by an American management company which promised to make it into an all-purpose events venue. Clearly they did not know the area or the refrain of Millwall fans, 'No-one likes us, and we don't care.'

After the company's withdrawal a year later, the stadium became known instead as **The New Den**.

Since Millwall vacated The Den in 1993 dozens of British grounds have been similarly redeveloped, many with new roads named after former players or with footballing themes. The Den, by contrast, is covered by John Williams Close, named after a Lewisham council worker who was killed on duty one evening. This plaque on Cold Blow Lane is therefore the only marker of the club's 83 year presence.

Two decades later, it is now known simply as **The Den**.

In some respects little has changed. While the club does sterling work in the community, its fans still occasionally attract the wrong sort of headlines. The stadium itself, located 700 yards north of the old one, is also hemmed in by railway lines.

But rather as White Hart Lane is now being revamped to help regenerate the Tottenham area, The Den now finds itself at the centre of plans with a similar intent.

Known as the **Surrey Canal Renewal** scheme, this envisages creating a new residential district based around enhanced sporting facilities at The Den, a new sports centre with basketball arena, and a new station on Surrey Canal Road.

The developers also propose to turn the site of the dog track, now a barren expanse called Bridge House Meadows, into a community park.

While funds are being raised to implement this scheme the area's sporting heritage is of course being trumpeted. Some people, it would seem, do like Millwall after all.

▲ Name, corporate colours, logo – whether selling fizzy drinks or fast food, these are among the elements on which brand recognition is built.

Then in football there is the most powerful element of all, the story.

Above is the cover of an *Evening Standard* album from the 1950s. This was offered to readers wishing to save a series of cartoon strips on the history of **Arsenal**, written by their correspondent Bernard Joy, a former amateur player who wrote the first comprehensive history of the club, *Forward Arsenal*, in 1952.

Since then the bookshelves have filled up with more histories of Arsenal than of any other London club, with a particular emphasis in recent years, because of the centenary of the club's momentous move to Islington in 1913. As mentioned earlier, largely owing to the efforts of enquiring fans, we now know far more about this period than ever before.

But important though this new knowledge undoubtedly is, there are other reasons to focus on Arsenal in detail. (There is, assuredly, no bias on behalf of the author.) It is because, firstly, so much of the Arsenal story can be told through historic sites and buildings; secondly because the club has played such a major role in the shaping of London football, and thirdly because, as a club, as a brand, Arsenal have embraced the notion of heritage with such gusto.

Added to which, whether one loves or loathes the Gunners, theirs really is quite a story.

▲ Two London clubs derive their names from buildings. Crystal Palace is only a memory, but much of the **Royal Arsenal** at **Woolwich** still stands – part museum, part residential – and it was here that the story of **Arsenal FC** began.

Built in 1717-20 (its design has been attributed to Vanbrugh or Hawksmoor), with its sundial added in 1764, this is the Grade II* arched entrance to **Dial Square**, now serving as a bar and restaurant.

As commemorated by a small plinth on the green facing the arch, it was in the Dial Square section of the 'Great Pile' (as the ordnance factory was known) where in 1886 workers formed a football team.

Taking the lead was a Scot, David Danskin, who had become frustrated that the only other clubs in the locality, such as Blackheath (*see page 260*) preferred rugby. Two of the other workers were former Nottingham Forest players, forced south to find work, and it was owing to their contacts that the team adopted Forest's colours of cherry red and white (later adjusted to scarlet and white).

Royal Arsenal FC were not a works team in the sense understood in Chapter 12. But it was very much a workers' club, at a time when the Arsenal was the largest armaments factory in the world. Further support came from soldiers

stationed at the nearby Woolwich Barracks and the Royal Military Academy. So although the area was on the outer edge of London, it was a vital hub of the British Empire.

This helps to explain why, of all the London clubs at the time, it was Royal Arsenal who were the first to adopt professionalism, in 1891. That professional teams from the north were also trying to poach their best players was a further factor.

But it was a brave step all the same. South of Birmingham only one other professional club existed (Luton Town), while senior figures at the London FA, seeking to emulate their counterparts in rowing and athletics, were determined to ostracise any club or player who flouted amateurism.

Fortunately most of London's other clubs rejected this line and were happy to play Royal Arsenal. But, as professionals, the club needed regular competition and so in 1893 they took the even bolder step of applying to join the Football League, with all the travelling north and expense that that entailed.

Popular members they became too. Northern clubs embraced the idea of an annual trip to London, and liked even more Arsenal's loyal band of travelling supporters, who apparently often brought with them an impressive array of fireworks for post match revelries.

Residents on the south side of Hector Street in Plumstead SE18, are used to strangers peering into their back gardens. For as seen above, and as highlighted in red on the 1916 OS map (*right*), between Mineral Street and St Paul's Church (now St Patrick's) there are seven houses whose gardens contain remnants of terracing that once lined the southern touchline of the Invicta Athletic Ground. This

was where Royal Arsenal played from 1890–93 until the landlord upped the annual rent to £350 (at a time when the average paid by clubs outside London was £100). Unwilling to pay more, Arsenal subsequently developed the Manor Ground, also shown on the map (*and opposite*), while housing went up on the Invicta ground in 1897. The surviving terraces are thought to be unique in British football.

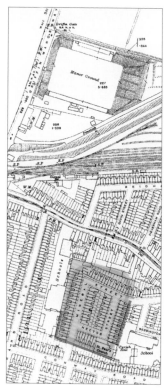

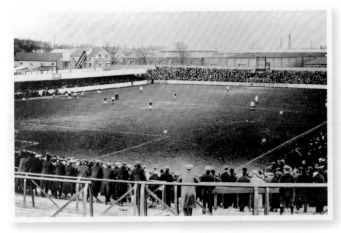

▲ It's that man again. In the foreground, the unmistakeable form of patented **Leitch crush barriers**, seen from the east terrace of the **Manor Ground**, **Plumstead**.

The image was taken between 1906-13 from the north east corner of the ground, as shown at the top of the OS map opposite.

The Manor Ground appears twice in the Arsenal story. During their first full season, as Royal Arsenal, they had played on **Plumstead Common** – the nearby **Star Inn** where the players changed is still extant – before renting a field on **Plumstead Marshes** in 1887. As this suffered from waterlogging they moved to the adjoining **Manor Field** for seasons 1888-90.

They returned in 1893, having spent £3,900 on its freehold (rather than pay the inflated rent at the Invicta Ground), and it was there that they made their debut in the Football League, now under the name of **Woolwich Arsenal**.

This was because when the club formed a limited liability company in 1893 the use of the word 'royal' in their title was forbidden.

Leitch's involvement started in June 1904, soon after Arsenal won promotion to Division One, and only weeks after he had started working for Henry Norris at Craven Cottage.

Arsenal were not a wealthy club, however, and so Leitch's works were initially confined to improving the existing stands and building up the east terrace, to create an overall estimated capacity of 35,000.

Apart from the need to increase capacity, another reason for raising the east terrace was that behind it, as shown on the OS map, ran the **Southern Outfall Sewer**.

Laid in the 1860s as part of the Metropolitan Board of Works new drainage network for London,

the pipe was later covered by an embankment which offered a clear view into the Manor Ground. At least now with a tall bank of their own, Arsenal could block much, if not all of that view from outside.

Certainly the new terrace was a local landmark. But it was also destined to enter footballing history.

As noted earlier, this part of London was full of military men, and so when one of them saw fans gathering on the top of the newly raised east terrace, according to the *Woolwich Gazette* of August 26 1904, this is what he exclaimed:

'Look at 'em on the Spion Kop.'

Meaning 'look out' in Afrikaans, **Spion Kop** was the name of a hill in South Africa where four years earlier 243 British troops had been killed in a botched operation.

And so began the tradition of calling a large football terrace a 'Spion Kop', or 'Kop' for short. Two years later the name was similarly adopted for Liverpool's new terrace at Anfield (a terrace designed also by Leitch), and before long the name became almost generic.

It was not until the summer of 1906 that the Leitch barriers seen above were installed on Arsenal's Kop, but that would be his last work at Plumstead. Only recently have Arsenal historians discovered that his firm's bill remained unpaid for four years as the club's finances steadily worsened.

There were several reasons for this decline. Between 1905-08 Clapton Orient, Chelsea, Fulham and Spurs all joined Arsenal in the Football League. That long trek out to Plumstead on a notoriously slow line now seemed much less attractive to the capital's floating football fans. Allied to this was the gradual downturn of the Woolwich economy, culminating

in the transfer of torpedo production to Scotland in 1910.

By that year Woolwich Arsenal were so mired in debt that they were only able to carry on courtesy of a bailout by, of all people, Henry Norris of Fulham.

Why Norris did this, and what happened next has been picked over endlessly by historians.

First he tried to merge Arsenal with Fulham. Then he tried to move Arsenal to Craven Cottage. To some, he was an asset stripper, to others a saviour. But what he was, above all, was a man of action.

In March 1913 Norris invited the press to the Connaught Rooms in Great Queen Street and announced that he was relocating Arsenal to a site north of the river, in Islington.

The following month a meagre 3,000 saw Arsenal's final match at the Manor Ground, by which time the club was doomed to relegation.

A year later, the outbreak of war nearly scuppered Norris's Islington gamble. Ironically, it also resulted in the Royal Arsenal taking on more workers than ever before. Indeed the Manor Ground was built over in 1915 as part of that expansion.

Above is a 2011 view of the site, not from the Spion Kop – that was levelled long ago – but from the ridge of the Southern Outfall Sewer, now a footpath called **The Ridgeway**. Down below **Nathan Way** runs parallel to it. The round tank on the right more or less marks the spot from which the archive photo top left was taken.

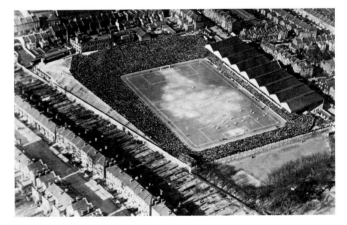

Bankrolled by Norris, designed by Leitch, Arsenal's new ground in leafy Highbury met with fierce opposition in 1913; from local residents who called it 'a vulgar project', from Spurs and Clapton Orient, and from fans in Woolwich. By moving Arsenal Norris changed forever the football dynamic in London. But a bit of Plumstead did live on. The terrace on the left, that too was called the Spion Kop.

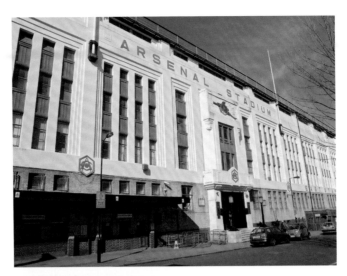

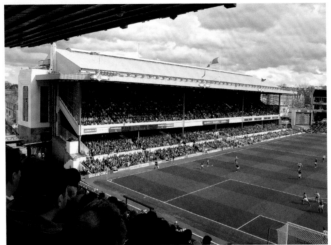

▲ Archie Leitch may have laid out the original Highbury in 1913, but the form of the stadium as it was to be celebrated in later years was the work of **Claude Waterlow Ferrier** (*above*) and **William Binnie**.

The partners' first drawings for Highbury are dated 1928, by which time Arsenal were a changed club. Sir Henry Norris (knighted for his war efforts) had departed under a cloud in 1927, suspended by the FA for financial irregularities. Taking his place as chairman was the patrician Sir Samuel Hill-Wood MP, an old Etonian with a country estate and a fortune derived from cotton.

As for Ferrier, an urbane, well travelled Londoner, his portfolio included the National Institute for the Blind, the Army and Navy Club and a string of smart hotels, shops and restaurants. Binnie, a Scot, had previously been with the Imperial War Graves Commission.

Tragically Ferrier would not see the partners' masterplan completed. He died after a road accident in July 1935, aged 57, leaving as his best known work Arsenal's **West Stand**, completed in 1932.

It was in one of its lounges that this bust was displayed until the stadium's closure in 2006.

Put bluntly, architects like Ferrier and Binnie did not usually work for clients like football clubs. But Arsenal, clearly, they were different.

◀ Viewed from **Avenell Road** seventy years after its opening in 1936, Arsenal's **East Stand** was, at £120,000, Britain's costliest stand.

It was also the most refined and forward looking; a building that stood proudly in an age of Odeons and lidos, speedway aces and Tote boards.

Facing it, built on the Spion Kop, the West Stand – a mirror image from pitch-side though different at its rear, where it backed onto housing – had also been lavishly finished, at a cost of £50,000 in 1932.

The previous year, under manager Herbert Chapman, the Gunners had became the first club south of Birmingham to win the League title. They then went on to win it three times in a row between 1933-35, and again in 1938. Arsenal were, as a result, England's best supported club of the decade, with average gates of 37-46,000.

But wealth and honours were only part of the equation.

Binnie had worked in New York. Ferrier was an ardent Francophile. Art Deco was all the rage. No doubt it was at their prompting and that of the chairman that Highbury took on the trappings of the West End, cocktail bars included.

Every detail counted. As seen on the **East Stand** in 2006 (*left*), the otherwise plain pitched roofs of both stands were masked by a cantilevered awning, with streamlined glazing at each end.

On these awnings, on the East Stand façade, even on the fascia of the **North Bank** roof, added in 1935 (*left*), were AFC monograms, said to have been designed by Chapman. There were padded seats, and heated lounges. There were lucky horseshoes in the aisles of the **West Stand** upper tier and moulded concrete flourishes along both stands' balcony walls (*left*).

There was even a lift.

The 1930s ended with Highbury becoming a star in its own right, with the release of a film, *The Arsenal Stadium Mystery*.

And although it would take years after the war for the club to claw back its expenditure during the 1930s, English football was all the better for Arsenal's daring.

As was London. No longer would the big boys from the north or Midlands have it all their own way.

After a slow start in professional football, London had arrived.

▶ When Messrs Norris and Leitch originally homed in on Highbury as a promising location it was largely owing to the proximity of **Gillespie Road** station, which had opened on the Piccadilly Line in 1906.

Its operator, the London Electric Railway Company (LER), was then privately run and for most of its early years struggled financially. It might therefore have been tempted to raise capital by selling off station names to commercial enterprises.

Gordon Selfridge, for example, lobbied for years to get Bond Street station renamed after his department store. But even though Lord Ashfield, the LER's managing director, was a personal friend, he never managed it.

And yet on November 5 1932, Gillespie Road station was officially renamed **Arsenal (Highbury Hill)**.

If we are to believe the Arsenal story, and no evidence has been found to contradict it, no money changed hands. Instead, the renaming – unique in the history of the tube system – has always been attributed to the lobbying skills and persistence of Herbert Chapman. It is further stated that Chapman had had the idea on his very first visit to Highbury, in December 1913, when he was manager of Leeds City.

Certainly timing was a factor. Eight months after the renaming, in July 1933, the LER was transferred into public ownership, after which any such change – that is, one likely to benefit a specific company – would have been unthinkable.

A remarkable coup, therefore, not least considering the costs it incurred. To change the name of a tube station today, according to Transport for London, would cost in the region of £1-2 million.

For history's sake, replica tiling on the Arsenal station platforms still spells out the name Gillespie Road. But the suffix Highbury Hill has not been used since around 1960.

On which note, walking up **Highbury Hill** you come across another eye-catching legacy from the 1930s. This is the former entrance to the **West Stand** (*above right*), completed in 1932.

Clearly Ferrier and Binnie were still toying with their use of graphics at this stage. But what a bold, and at the time no doubt provocative intervention on a street otherwise lined with Victorian houses.

The vulgar project, it appeared, had at last acquired some style.

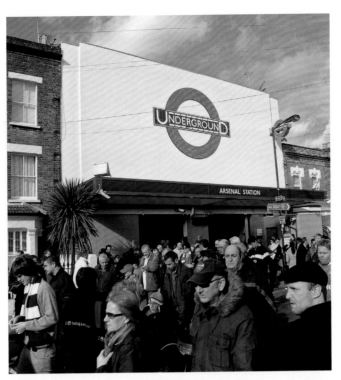

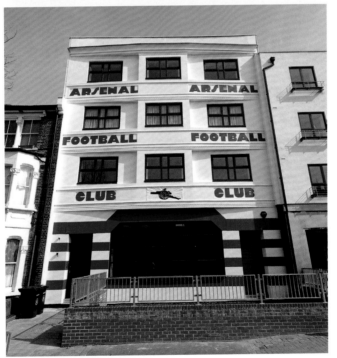

▲ Yorkshireman **Herbert Chapman** (whose bust this is, by **Jacob Epstein**) was appointed by Sir Henry Norris as Arsenal's new manager in 1925, having won two League titles and the FA Cup with Huddersfield Town.

At Arsenal he did the same.

'Go and entertain!' That was what he told his players before each game. But Chapman also ensured they were well drilled and felt fully involved in team tactics.

His sudden death at the age of 55, from pneumonia, in January 1934, was a huge blow to Arsenal and to English football generally.

Apart from getting the tube station renamed, among the many innovations credited to Chapman are the numbering of players' shirts, the use of rubber studs, the installation of a large clock in the ground, the use of white balls and the changing of Arsenal's red shirts so that, uniquely, their sleeves were now white.

Whether or not these ideas were Chapman's alone, all were first rate. He was also an advocate of floodlights, which Arsenal installed for training purposes in 1936.

That same year the Epstein bust was placed reverentially in a niche in the new East Stand, where it remains to this day. There are also replicas at the new Emirates Stadium and at Huddersfield Town.

Dedicated in 2005, this plaque marks the suburban house at 6 Haslemere Avenue, Hendon, where Herbert Chapman died in 1934. Six months later Sir Henry Norris died too, aged 69. No plaques for him though. He was buried in East Sheen Cemetery where, by chance, Archie Leitch was also laid to rest, in 1939. Their graves lie just over 100 yards apart, the same length as a football pitch.

▲ In the 1990s the **Arsenal** story took another leap forward. On the pitch, the arrival of French manager Arsène Wenger heralded a return to the glory days of the 1930s, while off it appeared this, the **North Bank Stand** in 1993.

Undoubtedly it was the finest stand of the post-Taylor decade, and as such is featured elsewhere (*see page 115*). And yet it had been in use for only four years before Arsenal, having been warned by their neighbours that any expansion plans would be firmly resisted, started looking for an alternative site. Overall the stand served for just 13 seasons – four more than the Spion Kop at Plumstead – before being levelled.

As ever, it was down to numbers. At its peak Highbury held 73,295 in 1935. After 1996 that total fell to 38,500, all seated. Manchester United, by comparison, had 68,210 seats, a total that would eventually go up to 75,000. And while in 1989 Arsenal had squeezed 53 executive boxes into a clumsy development at the Clock End – one that suggested the club had abandoned all their architectural principles – United had 180.

Finding a site for a major new stadium in north London was never likely to be easy, but this being the Arsenal story they found one in 1999, virtually under their nose.

The leaving of a much loved ground is nevertheless a tough call, as 38 other British football clubs have found since 1990.

Not one of them left behind a ground like Highbury though.

◄ From a photographic exhibition by **Simone Novotny** (*see Links*), a resident in the converted **West Stand** looks out over the gardens where for 93 years **Arsenal** made their pitch.

Welcome to **Highbury Square**.

Normally, when a football club vacates its ground all the structures are cleared. But the East Stand had been listed Grade II in 1997, while its opposite number was listed locally by Islington Borough Council.

The idea to convert both 1930s stands into flats and create a square seems obvious now that it has been done. But when proposed initially by architects Allies and Morrison nothing of this sort had ever been attempted at a sports stadium.

Highbury's last match was on May 7 2006, an emotional day on which grown men did indeed cry.

Over the next three years the North Bank Stand and Clock End were demolished. A 450 space car park was created under the pitch, which was then re-landscaped by Christopher Bradley-Hole.

In total, 725 flats were created; 69 of them in the 'affordable' category, the rest going on sale from £250,000 up to £1.1 million.

Happily, the structural grid on which both 1930s stands had been planned proved ideal for conversion into flats. The use of extensive glazing also helped to preserve their visual identity as stands.

Added to which those buying into the East Stand – for which Arsenal stakeholders were given priority – were to have the added pleasure of entering via the famed **Marble Hall** (*left*), where Herbert Chapman's bust still greets one and all.

Public access to the square is confined during certain hours to a path along the former southern touchline. Fuller access is however available on Open House weekend.

In its final seasons the ground was often dubbed 'the Highbury Library', owing to its perceived loss of atmosphere. Now, what residents say they like most about Highbury Square is its tranquility.

One section contains a **memorial garden** (*left*) to the 500 or so fans whose ashes had been scattered on the pitch over the years.

Naturally those Arsenal fans who number amongst the new residents revel in its history. One has formed a Highbury Square football team.

Just a shame they have to go somewhere else to find a pitch.

▶ From the centre spot of **Highbury**, seen here in 2010 following its reincarnation as **Highbury Square** (*top right*), to the centre spot of the **Emirates Stadium**, in **Ashburton Grove**, is a distance of just 480m.

But what a price was paid – a reported £390 million – and what an effort was required to achieve this shortest of hops.

After rejecting 14 other sites in the capital, it took Arsenal and their professional team of HOK Sport (architects), Buro Happold (engineers), Sir Robert McAlpine (contractors), plus 28 other firms of planning, property and technical consultants, six years to gain all the permissions and complete the 60,000 capacity stadium, before its opening on July 22 2006.

Building the stadium was only part of this particular Arsenal story, however. A waste and recycling plant had to be cleared and a replacement built, at Arsenal's expense, on a nearby site on Lough Road. Over 60 businesses had to be compensated and relocated. Some 2,600 new flats and homes were built, split between four sites.

By the time Highbury Square was complete in 2009, Arsenal had spent almost a decade acting as the largest commercial and residential developer in the borough.

In theory they might have saved themselves a good deal of effort and expense had they parked their new stadium on a sea of tarmac somewhere out on the M25, as would have been the preferred option in the USA and large parts of Europe.

Instead of which they opted for a site that bore striking similarities to that of Millwall's Den, back in 1910, needing two substantial footbridges to provide access, and a massive podium to raise the stadium above the web of railways, tube lines, sewers and other services lacing its 25 acres.

Here then is a stadium cheek by jowl with its residential neighbours, handy for public transport and within easy walking distance of local pubs and kebab shops.

How traditional can you get?

And yet how radical too, for by creating pedestrian routes linking east with west, by opening out new public spaces and placing artworks in prime locations (*right*), Arsenal have regenerated an entire quarter.

Welcome to Gunnersville, London N5.

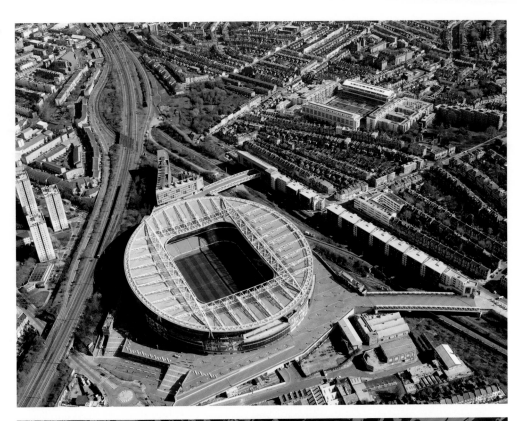

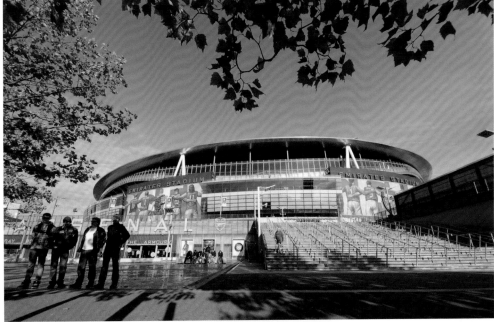

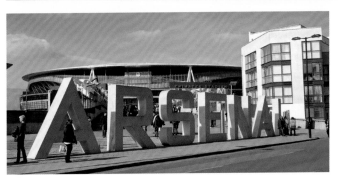

▲ Cockney winger **Danny Clapton** worked as a porter at Billingsgate Market before joining Arsenal in 1953. Soon he became the favourite of a boy on the Clock End, also named Danny, the son of Belgian refugees from the Nazis.

Thirty years on and after making his fortune in diamonds, Danny Fiszman joined Arsenal's board and together with Ken Friar, himself a fixture in the club offices since 1950, and managing director Keith Edelman, took on the responsibility of overseeing the move from Highbury.

Moving into a new house is seldom straightforward, and not all fans were happy with what they found at the **Emirates Stadium**.

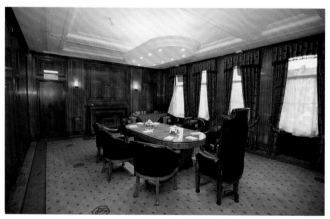

The boardroom at Highbury may now be someone's living room, but Arsenal took with them the fixtures and fittings and recreated the room at their new offices on Drayton Park. The club's main shareholders are nowadays American, Russian and Iranian, but the chairman's seat remains occupied by an Old Etonian, 'Chips' Keswick having taken over from Peter Hill-Wood (Samuel's grandson), in 2013.

Firstly, the name. Even though it is nowadays common for 'naming rights' to be sold – in London the first had been the Fosters Oval, in 1989 – there was a belief that a club with the traditions and ethos of Arsenal, whether real or perceived, would be above such a deal (as the MCC have been at Lord's).

Nor did it help that until 2005 Emirates had sponsored Chelsea.

Some fans therefore insisted on referring to the new stadium as **Ashburton Grove**, even though the road of that name had been swallowed up by the development and no longer existed.

There were further concerns that despite Arsenal now having 22,000 more seats at their disposal, within four years of the move ticket prices rose to become the highest, or amongst the highest in the Premier League (depending on which criteria were applied).

This hike was compounded by three observations.

Firstly, that the atmosphere in the Emirates Stadium was as muted as it had been inside the 'Highbury Library', if not more so.

Secondly, that this atmosphere was partly a consequence of the stadium having been designed, as a seamless bowl; that is, without identifiable sections such as the old North Bank, where younger, more vocal crowds could congregate.

Particular attention was focused on the occupants of the 7,000 Club Seats, forming the stadium's mid tier, whom, it was noticed, were often late back to their seats after half time. Was this not proof that such spectators, dubbed by the press as 'the prawn sandwich brigade' (a term coined in 2000 to describe corporate guests at Manchester United), could never be considered true supporters?

Thirdly, it was remarked that while official attendances were invariably announced as around 60,000 or more – the actual capacity is 60,362– hundreds of seats often remained empty. This was because Arsenal included in their calculations every seat sold, whether occupied or not.

The weary cynicism that this practice engendered, together with the other concerns relating to pricing and atmosphere, are by no means confined to Arsenal.

Yet nor, so far at least, have they resulted in any loss of support.

On the contrary. In the later years at Highbury Arsenal had a waiting list of over 30,000 for season tickets. Yet instead of that figure plummeting when the new stadium opened, by March 2012 the reported figure had actually risen to over 40,000, suggesting that the new stadium had in fact increased interest levels, and that there were still plenty of people out there who could afford to attend.

Clearly within the pages of the Arsenal story there were echoes in this disconnect between what one sector of the club's support felt – that is, disenfranchised, left behind – and how the club sought to progress. In 1910 Arsenal had been perceived as a working man's club, but had needed rescuing by a money man, Henry Norris. In 1913, thousands of fans in south east London had been disenfranchised by the club's move to Highbury, only for thousands more in north London to adopt Arsenal thereafter.

And so yet again history reminds us that football fans will always be torn between a desire for their club to succeed, and the possible price that success will exact.

But if that is one conundrum that no football club has so far proved able to solve, there has at least been one complaint that Arsenal have managed to address.

That was the unease expressed by many fans that for all its architectural excellence – which was at least widely acknowledged – the new stadium simply did not feel like 'home'.

Thus in 2009 commenced the **'Arsenalisation'** of the Emirates Stadium, as the club described it. Or, as others might put it, the reconnection of the club with its heritage.

One step was the commissioning of various statues to be sited on the outer concourse; of Herbert Chapman, Thierry Henry, **Tony Adams** (*above*) and, in 2014, of Dennis Bergkamp. Another was to display banners celebrating other Arsenal legends, Danny Clapton among them (*top left*).

This was followed by the naming of the north footbridge after Ken Friar, and the south after Danny Fiszman.

Alas neither Danny was around to witness the commemorations.

Danny Clapton was running a pub in Hackney when he died, aged 51, in 1986, while his one time admirer, Danny Fiszman, passed away the day before the bridge naming ceremony, aged 66.

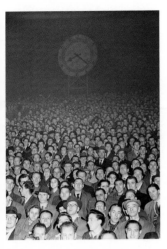

▲ The **Arsenalisation** of the **Emirates Stadium** has taken several forms. Take, for example, the distinctive **clock** at **Highbury**, seen above during one of Arsenal's pioneering floodlit matches in 1951.

Regarded at the time of its installation in the early 1930s as a genuine innovation, Herbert Chapman has been credited with the idea. But the design was almost certainly by either Ferrier, Binnie, or one of their staff.

Either way, the clock became an iconic symbol, and as such when the club moved in 2006 the clock went with them and was installed on the outside of the south east corner of the Emirates Stadium.

Yet still fans yearned to see the familiar clock face inside the stadium, and so in 2010 a replica made by the clockmakers Smith of Derby was erected over the roof of the south end (*below*), which was itself then renamed the **Clock End**.

A striking piece of sporting heritage, it must be said.

At the same time, again at the request of fans, the opposite end of the stadium was also renamed the North Bank.

Meanwhile, an earlier stage in the Arsenalisation process saw eight huge banners depicting 32 Arsenal 'greats' hung around the

stadium's exterior, as seen (*right*), from the public space known as **Armoury Square**. Also in the square two cast iron cannons brought over from the **Woolwich Arsenal** provide their own perfect photo opportunity.

But perhaps the most compelling exhibit is the '**Spirit of Highbury**'.

Unveiled in 2009, this is an assembled team group showing all 482 players who played for Arsenal's first team during the 93 years at Highbury, plus their fourteen managers (*below right*).

Set against the backdrop of the East Stand and shifting subtly from black and white to colour during the 1960s, the image was sponsored by Nike, created by the advertising agency Wieden & Kennedy, and researched by club historian Fred Ollier. Remarkably, photographs of all but four of the 482 players were found.

Together with all the other banners and displays The Spirit of Highbury has transformed the outer concourse of the Emirates – an area open to the public at all times – into the equivalent of an outdoor museum.

There is a conventional indoor **Arsenal Museum** too, based on a collection originally exhibited at Highbury in 1993, when it became London's third sports museum, after Lord's and Wimbledon.

On average around 120,000 people a year visit the museum and take the stadium tour, for which audio guides are now available in nine languages, Mandarin being the latest addition.

Gunnersville, it would seem, is now very much on the tourist map.

As for the Arsenal story, no doubt as a result of the move to Ashburton Grove, followed in 2013 by the centenary of Highbury, there has been an extraordinary outpouring of historical material (*see Links*). This includes works by Jon Spurling and Brian Glanville, by Sally Davis (whose detailed chronicle of the life of Sir Henry Norris is available online), and by the Arsenal Independent Supporters' Association's History Society, formed in 2009 to revisit all aspects of the club's history, both in print and online.

Even the fans themselves are now claiming their place in history.

The Arsenal Supporters Club magazine, *Gunflash*, first issued in 1949, is considered the oldest publication of its kind in Britain.

A supporter stops in Armoury Square (*left*) to read some of the dedications inscribed onto 10,500 granite paving stones, contributed by fans paying from £50–£595 each. More inscribed stones lie by the North Bank, costing up to £999. All profits from the paving stones, the club is careful to add, go towards the Arsenalisation of the stadium. And there are acres of concourse still to pave.

Inevitably fan-based histories are prey to partisanship, just as the club's own version is subject to studious corporate vetting. But combine all the outlets, and all the means of dissemination, and what emerges might well be described as a frenzy of heritage. Or even as the Arsenalisation of Arsenal.

It is at any rate a model from which any sports club could learn, whatever their story.

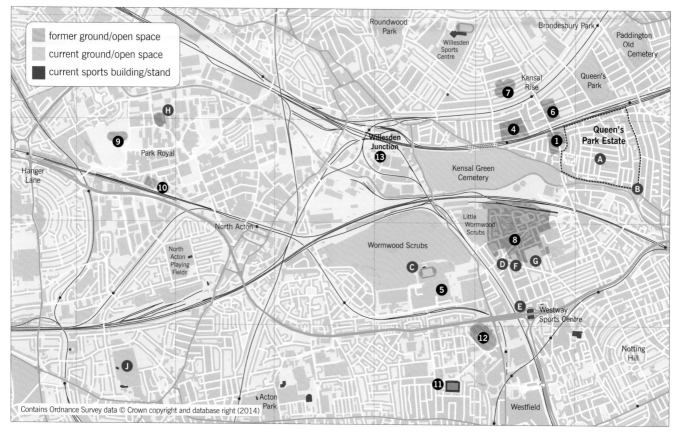

legend:
- former ground/open space
- current ground/open space
- current sports building/stand

Contains Ordnance Survey data © Crown copyright and database right (2014)

▲ Having looked at the issues raised by Arsenal's various moves, we now turn to a club that has moved more than any other senior British football club. Since forming in 1886 **Queen's Park Rangers** have moved 15 times and had twelve grounds, almost equalling that other, once nomadic rugby club, Harlequins (*see page 270*).

Rangers' ranging can mostly be explained by the pressures that London clubs have typically had to face, from landlords, developers and local interest groups. But Rangers were also to suffer from genuine bad luck and poor timing.

Their story equally highlights how commercial interests built and hired out sports grounds in the late 19th and early 20th centuries, purely as speculative ventures.

Rangers can claim one other rare attribute. The housing estate in which they were born – its boundaries shown above – survives as a distinct entity. Built between 1874-87 on land purchased from All Souls College, Oxford, by the philanthropic **Artisans', Labourers' and General Dwellings Company**, the **Queen's Park Estate** consisted of some 2,000 terraced homes, many still intact.

In common with the company's other estates, Shaftesbury Park (Battersea) and Noel Park (Wood Green), no pubs were permitted, while tenants were selected only from 'the most quiet and provident portion of the industrial classes'.

The area's first football team, formed in 1882, was **Christ Church Rangers**. Based in the adjoining

College Park Estate, they played on a field near Willesden Junction, one of their opponents being another church-based team, St Andrew's, later to become Fulham.

Youths living on the Queen's Park Estate, meanwhile, formed a team in 1885 at the **St Jude's Institute** (*below*), where the vicar Sidney Bott had created a gymnasium.

St Jude's first match took place at Roundwood Park. Then in early 1886 they played Christ Church Rangers, following which a merger was suggested. The name **Queen's Park Rangers** was chosen to appease both parties and because most of the players lived on the estate.

Thus contrary to surmise, the club had no links with the actual park, **Queen's Park**, which opened

a year later in November 1887.

In the absence of detailed reports or club minutes, not all Rangers' early grounds can be located, but from research by various historians (*see Links*), the following sequence emerges:

1886–88: Rangers' first ground was **Welford's Field** (**1**) behind a pub, The Case is Altered, on Harrow Road (not extant). Owned by J Welford's dairy (whose former premises can still be seen on Shirland Road), and rented for £8 a year, the field was where Wellington and Pember Roads now meet.

1888–90: somewhere in **Brondesbury**, Rangers' second ground (**2**, *not marked*) had also been used by **London Scottish RFC**. To afford the £20 a year rent Rangers started charging for admission, but when the pitch kept getting waterlogged had to switch some home matches to Barn Elms.

1890–91: Home Farm, Kensal Green (**3**, *not marked*) could have been any one of a number of fields in the vicinity.

1890–91: Kensal Rise Green (**4**) lay where houses on Burrows Road and Mortimer Road were later built.

1891–92: outside the club's original catchment area, the site

In the Queen's Park Estate, on the corner of Ilbert Street and Fourth Avenue (A on the map) stands the St Jude's Institute (*right*). It was there that, as a plaque recalls, Queen's Park Rangers formed in 1886. The Institute had opened two years earlier and would serve as the club's headquarters until at least 1898. On Harrow Road, the Estate's former Meeting Hall (B) is now a boxing club (*see page 144*).

of the **Gun Club** on **Wormwood Scrubs** (**5**), is still used for sport, backing onto the **Linford Christie Stadium** (**C**) (*see page 311*).

1892–96: it was at the **Kilburn Cricket Ground** (**6**) where Rangers started to develop a real following. One match in October 1895 drew a gate of 3,000. Kempe and Keslake Roads now occupy the site.

1896–1901: the grandly titled **National Athletic Ground** (**7**) was a speculative development built to capitalise on the boom in cycle racing. Opened in 1890 with a 1,000 seat grandstand (*see page 316*), by late 1895 its promoters had gone bust, allowing Rangers, who had already played there in local cup finals, to negotiate a ten year lease with the estate owners, All Souls College, Oxford, at £100 per annum, rising to £150.

As gates rose to 8,000, the club considered buying the ground. But after turning professional in 1898 and joining the Southern League, their mounting debts led All Souls to terminate the lease in 1901.

1901–02: Rangers' next stop (**8**) lay within fields north of **St Quintin Avenue**. With not even a pavilion at first, the Rangers players had to change in the **North Pole** pub (**D**), (now a supermarket), while visiting teams changed in the **Latimer Arms** (**E**), a 600 yard walk away on the corner of Latimer and Walmer Roads (now flats, next to Westway). Despite the lack of facilities, 12,000 attended Spurs' visit in December 1901, to the annoyance of local residents, who petitioned for the club's eviction.

Two areas of open space on St Quintin Avenue survive: the **West London Bowling Club**, formed in 1903 on Highlever Road (**F**) and **Kensington Memorial Park** (**G**).

1902–04: homeless, with most of their players departed, Rangers' eighth move in fourteen years took them back to **Kensal Rise** (**7**). All Souls now demanded £240 a year. But, at the end of their first season back Rangers managed a £600 profit, and in October 1903 drew a record 15,000 v. Southampton. All Souls' response was to demand £400 a year for a further lease. Rangers' offer of £300 was turned down, and so yet another move beckoned.

The Kensal Rise ground was later rented to a minor club, until it was sold for housing, on Leigh and Whitmore Gardens in c.1920.

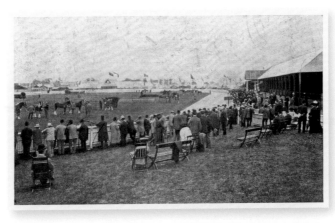

▲ According to one writer, when **Queen's Park Rangers** made their ninth move, in 1904, 99 out of every 100 of their regular fans asked, 'Where is Park Royal?'

And yet had history taken a different turn, the name **Park Royal**, rather than Wembley, might have been famous around the football world today.

Seen above, the Park Royal in question was the showground of the **Royal Agricultural Society** (**9**). Bought and developed by the RAS in 1902 at a cost of £68,000, the 100 acre ground was intended as a permanent home for the Society's annual show.

But the first two shows there both made losses, and by 1904 the cash-strapped RAS was only too glad to rent out the central Horse Ring to Rangers.

A fine ground it made too, with two stands offering cover for 5,000, and banking said to hold 35,000.

That capacity was never tested. Even so, despite its remoteness, special trains laid on from Paddington and other stations by the Great Western Railway resulted in average crowds of 12-15,000.

There was even a suggestion that, with the RAS keen to sell, Park Royal would make a perfect site for a new national football stadium to replace Crystal Palace.

After all it was served by three stations (on the GWR, L&NWR and Metropolitan lines), by adjoining sidings (so that on match days extra trains could be laid on), and had plenty of room for expansion, with the nearest buildings, Willesden Infirmary and Twyford Abbey, then a nursing home, lying nearly half a mile distant.

Thanks to the RAS, who named it Park Royal when the Prince of Wales opened the 1903 show, it also had a wonderful name.

But the FA was not then in the

business of stadium development (and would not be until the 1990s). Moreover, having been completely upstaged by developments at White City, where the Franco-British Exhibition and Olympic Games were due to take place, the RAS was desperate for a quick sale.

So it was that Park Royal became London's largest industrial park, best known from 1935-2005 as the home of the **Guinness Brewery**, and nowadays a business park. (The Horse Ring was located at the west end of **Cumberland Avenue**).

But if it seemed that one great opportunity had been lost, the GWR had other ideas.

Located just south of the RAS grounds, between Coronation Road and the GWR's Park Royal station, QPR's next **Park Royal** home (**10** and *below left*), although still out of town, was their best yet.

But once again, fate was to prove unkind. After just eight seasons, during which time QPR won the Southern League twice, in February 1915 the ground was commandeered by the army, and for the eleventh time in 34 years Rangers were homeless.

What is more, by the end of the war they had found another home, so that Park Royal – briefly one of the most advanced stadiums in London – was now surplus to requirements.

Apparently it remained in use by a minor club called **Park Royal FC** until, in the 1930s, the site was swallowed up by light industrial units on what is now called **Johnsons Way**.

There would however be one more **Park Royal Stadium** (**H**).

Opened on **Abbey Road** in 1931 this one staged greyhound racing and, from 1935-36 the rugby league matches of **Acton & Willesden** (*page 273*). The stadium eventually closed in 1969 and the site is now a hire centre.

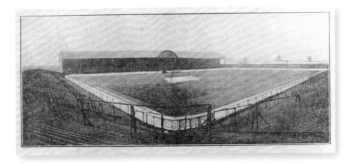

Until recently little was known about QPR's second Park Royal ground (10), other than that it was rented from the GWR and located on Coronation Road. But then Rangers historian Martin Percival discovered an article in a 1907 GWR magazine that made it clear that rather than being a company ground, or a purely speculative venture, the ground was designed specifically for QPR in the hope

of maintaining the weekend rail traffic the club had built up at the RAS grounds since 1904. Able to hold 45,000, with seats for 4,250, the ground was Archibald Leitch's fourth commission in London, and was a clone of his design for Middlesbrough in 1903. Opened in November 1907 by Lord Kinnaird in front of a 16,000 crowd, it took just 21 weeks to build, but lasted only eight years as a senior venue.

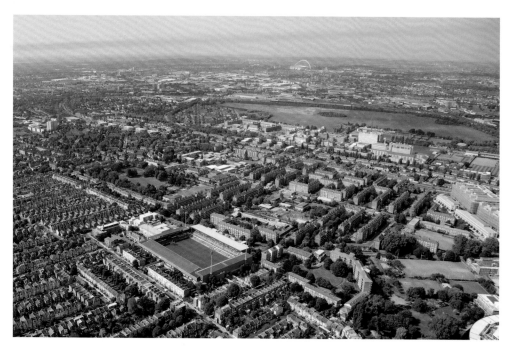

White City was then a hive of innovation, with newly installed floodlight pylons and much admired tracks for greyhound racing and athletics. But with the pitch appearing remote and the stands, with their estimated 80,000 capacity, too large, the stadium lacked atmosphere.

So QPR returned to Loftus Road in 1933, and in 1948 bought its freehold and 39 of the surrounding houses.

Yet still it was not quite right, and in 1962-63 Rangers tried White City a second time, and again reached the same conclusion. Too big, no atmosphere.

The Loftus Road we see today is the result of a rebuild carried out between 1968-81, during which time the club reached the First Division. While several other clubs had bankrupted themselves by building lavish, architect-designed stands (Chelsea included), Rangers' stands, designed by Michael Newberry, were applauded for their functionalism and affordability.

Similarly utilitarian was British football's first artificial pitch, laid at Loftus Road in 1981 and deeply controversial, before its removal seven years later.

From 1996-2002 Rangers pioneered the idea of sharing with a rugby club, **Wasps RFC**, with whom they also shared a training ground at **Twyford Avenue**, (J on the preceding map), now owned solely by Wasps (*see page 261*).

Since then QPR have come under various different owners, the latest being Malaysian businessman, Tony Hernandes. Almost needless to add, in 2013 Hernandes announced what many fans had been expecting for a long time; that QPR would be on the move again, to a site at **Old Oak Common** (**13**).

Fortunately, in Malaysia the number 13 is not unlucky. But for all the club's restless history, the leaving of the Loft will not be easy.

Box like and boxed in, Loftus Road has no airs or graces, is painfully cramped and has no room to expand. It also illustrates the effect of the 1990 ban on terracing. Whereas its record gate was 35,353, in 1974, in all-seater mode it holds 18,439, which in 2012 made it the smallest ground in the Premier League. And yet for many fans the ground embodies the club's unpretentious image.

▲ Viewed from the south east in 2006, **QPR's** twelfth home ground has its main entrance on **South Africa Road**, but is better known as **Loftus Road** (**11**).

Loftus Road is the street lined with Victorian terraced homes whose back gardens can be seen nudging up against the blue-clad rear of the **'The Loft'**, the stand seen above, nearest the camera (*and below right, at the far end*).

This naming of the parts might seem minor, but in the hearts and minds of fans, it is anything but. And nor is the ground's location.

Almost the entire history of QPR has been played out in this corner of west and north west London, from Shepherd's Bush in the foreground to Park Royal in the distance, and even, in 1967 when the club won its only major honour, **Wembley Stadium**, whose arch can be seen on the horizon.

In the lower right hand corner is the curve of the BBC's former **TV Centre**, and above it, the BBC's **Media Village**, built on the site of

the 1908 Olympic Stadium, itself better known as **White City** (**12**).

Loftus Road was actually opened by an amateur club, **Shepherd's Bush**, in October 1904, but having lain vacant since war erupted in 1914 proved handy for Rangers when they set up home there in 1917. Sections of the steelwork from Park Royal's stand were re-used to build a small main stand on the south, or Ellerslie Road side.

Opposite, beyond a rough track that would later become South Africa Road, loomed the rear of one of the exhibition halls left over from

the 1908 Franco-British Exhibition; until, that is, much of the exhibition grounds were built over by a council housing estate (in the centre of the aerial view) in 1936.

But even back in 1904 two sides of the ground were hemmed in by housing, and this, combined with a troublesome pitch, persuaded QPR's directors to move, yet again, in 1931, to the adjoining **White City** stadium.

At first this bold step seemed justified. One Cup tie, v. Leeds, drew Rangers' largest ever home crowd of over 41,000, in 1932.

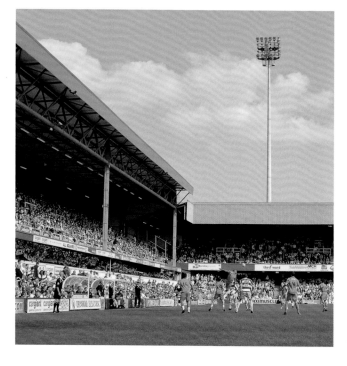

▶ As we saw in the case of White Hart Lane and Charrington the brewers, one of the drivers of early professional football was the **beer trade**. Watching and playing the game has always been a thirsty business, and for breweries, a profitable one, a relationship that in London goes back to the 1420s at Brewers' Hall (*see page 223*).

This synergy is especially evident at **Brentford**, where **Griffin Park** was laid out on an orchard leased from Fuller Smith & Turner, whose Griffin Brewery, home of London Pride, was, and remains in nearby Chiswick.

Opened in September 1904 (seven weeks before Loftus Road, three miles away), Griffin Park – seen here from the east in 2006 – is renowned for being the only football ground in Britain to have a pub on each corner.

No doubt over the years football supporters, home and away, have helped to sustain this quartet.

But in common with most of the terraced houses that also surround the ground, all four of the pubs actually predate Brentford's arrival.

Seen on the right, on the corner of Brook Road South and Braemar Road, with the floodlights of Griffin Park above the rooftops, is **The Griffin**, dating from c.1886.

It was in this pub that in 1889 the first Brentford players, many of them from the local rowing club on the Thames, changed before their matches on a nearby field. (Unusual colours they wore too, as revealed far right.)

Further up Brook Road, on its corner with New Road, stands **The Royal Oak**, which claims to date back to 1787 (although the building is late Victorian).

The other pair of pubs are on Ealing Road, behind the east end of the ground (nearest the camera on the aerial view). There is **The New Inn**, on the corner of New Road and **The Princess Royal**, on the corner of Braemar Road, both thought to date back to the 1850s.

Griffin Park's other unusual asset is that, lying as it does under the flight path to Heathrow, it is able to earn considerable fees from hiring out its stand roofs for advertising.

But despite these assets, and the ground's genuinely homely charms, in common with QPR, Brentford have been restless for years, constrained by their surroundings – their current capacity is 12,763

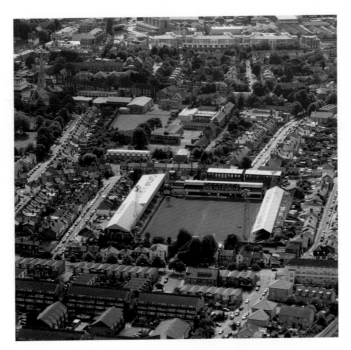

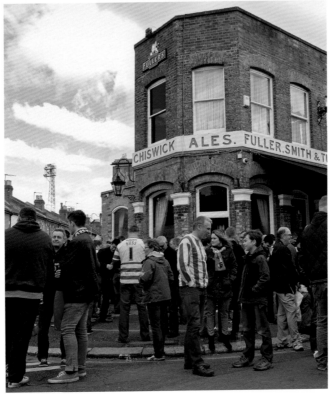

TOMMY LAWTON
Brentford and England

▲ **Brentford** have long been known for their red and white stripes, as sported by **Tommy Lawton** in a 1953 edition of *Charles Buchan's Football Monthly*. But when the first Brentford players emerged from The Griffin in 1889 they wore pink, claret and light blue hoops. These gave way to claret and light blue stripes, followed by blue and yellow stripes in 1903. Only in 1925 was the present strip adopted.

Elsewhere, Tottenham have at various times flirted with light blue and white as opposed to their usual dark blue and white, and at the time of writing are playing in all white. QPR's blue and white hoops were green and white before 1925. Crystal Palace started out in claret and light blue because their first secretary came from Aston Villa. Their current scarlet and royal blue kit dates from 1973. Millwall switched from the dark blue of Scotland to royal blue in 1936, while Orient went from red to blue and back again between 1893 and 1967.

Does it matter? In June 2012 there was a hue and cry when the new owners of Cardiff City, the 'Bluebirds', changed the strip to red, on the grounds that red is lucky.

A year later City were celebrating promotion to the Premier League for the first time in their history.

– and by their desire to extend the club's Community Sports Trust, the winner of numerous awards since being set up in 1987.

The Bees are therefore planning to move into a new 20,000 capacity stadium on Lionel Road, near Kew Bridge, a mile to the west, in 2016. Griffin Park will then be sold for housing.

How the four pubs will fare once that happens is anyone's guess,

but experience suggests that some Bees fans will stay loyal to their time honoured pre-match routines.

Elsewhere, two other pubs with historic footballing connections are the **Butcher's Hook**, Fulham Road (originally called the Rising Sun), where **Chelsea** formed in March 1905, and the **Foresters Arms** (now The Antelope) on Mitcham Road, where **Tooting and Mitcham** were formed in April 1932.

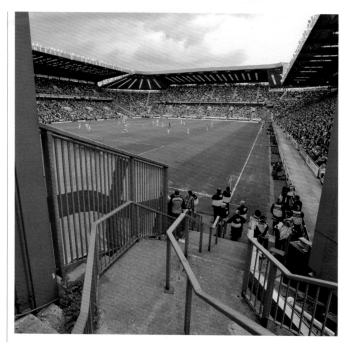

▲ 'Which match shall I go to this afternoon?' That was a question thousands of Londoners used to ask on those Saturdays when their own team was playing out of town.

Posters such as this, issued by **LCC Tramways** in 1932, make it clear that London's floating fans were there to be courted. Even today on most weekends there are 10–20 games in the capital across the game's top eight divisions, drawing up to 180,000 spectators in total, depending on the fixtures.

That said, never was there a night like **February 6 2007**.

Uniquely in the history of world football, London staged four internationals that night, not one of which involved England. There were 60,000 at the Emirates Stadium for Brazil v. Portugal, plus an aggregate 24,500 for Australia v. Denmark at Loftus Road, South Korea v. Greece at Craven Cottage, and Ghana v. Nigeria at Griffin Park. The total television audience worldwide was over 400 million.

Capital sport indeed.

None of which, of course, would be possible without the rail network. Like the brewing industry, the rail companies loved football. The GWR's deal with QPR at Park Royal has already been noted. Millwall's Den was similarly laid out on railway land, as was Lillie Bridge and numerous greyhound tracks.

Rail companies profited further, as did the Post Office, from the distribution of pools coupons, which in the 1930s were said to have been delivered weekly to six out of every ten British households.

But the railways' biggest pay day came on Saturdays, until the motorway era at least, as players, officials and supporters crisscrossed the nation in their tens of thousands on scheduled services or on football 'specials'.

It was with the latter in mind that in 1936 the **London & North Eastern Railway** named 25 of their new B17 locomotives after football clubs – including Arsenal, Tottenham and West Ham – intending that fans would travel to away games on trains hauled by their very own loco. That proved logistically impossible in the end, but the trains nevertheless yielded some excellent publicity.

When eventually the locos were scrapped between 1958-60 all 25 clubs were offered one of the brass nameplates. While some of these have since ended up in private hands, all three London clubs still have theirs.

The **West Ham** plate, seen below in the 1980s at **Upton Park**, is currently in storage, as is that of Tottenham. Arsenal's plate is displayed in the Marble Hall at Highbury Square.

One of the perks offered by the LNER was that the train driver of a football special was allowed free entry to the match. As one later recalled, this led to a stream of fans dressing up as train drivers, each trying to blag their way in.

▲ Formed in 1905 by teenagers living on East Street SE7 (now Eastmoor Street, leading to the Thames Barrier), **Charlton Athletic** described themselves as successors to Woolwich Arsenal when applying to join the Football League in 1921.

They also claimed that **The Valley** (seen above in 2010), a former chalkpit opened in 1919, two miles west of the old Arsenal ground, had the potential to hold 150,000. That Charlton station was on the same slow line which had supposedly held back Arsenal's prospects was not mentioned.

Charlton did get elected, but for a while it appeared that this corner of Kentish London was indeed cursed.

Heavily in debt to their building contractors, Humphreys, Charlton panicked and tried to build an alternative ground in Catford (see page 133), before returning to The Valley even more indebted, in 1924. Humphreys in effect then kept the club afloat until in 1931 they introduced Charlton to the Gliksten brothers from Hackney.

Albert and Stanley Gliksten owned one of the largest timber yards in Europe, on Carpenters Road, Stratford, a few doors down from the builders' yards of WJ Cearns, the chairman of West Ham (now part of the Queen Elizabeth Olympic Park).

With the Gliikstens' backing, manager Jimmy Seed guided Charlton to Division One in 1936, and for the six seasons either side of the war 'the Addicks' ranked amongst the ten best supported clubs in the League. One Cup tie in 1938 saw a record 75,000 pack into The Valley.

In London club football only Stamford Bridge was larger.

Heady days indeed, especially as this period coincided with Brentford also playing in the First Division, while Spurs, West Ham and Fulham were all in the Second.

The trouble was that for all their timber, the Gliikstens seemed less bothered with bricks and mortar. Thus as Charlton slipped down the divisions and crowds declined

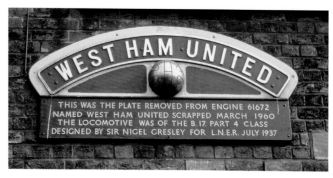

From a vast bowl holding nearly 80,000 to its present capacity of 27,111, The Valley (*right*) is unrecognisable from how it was before Charlton's epic return in 1992. Only the Jimmy Seed Stand, built in 1980, on the left, survives from that time. The other stands date from 1993–2002. From 1938–71, on the north side of Woolwich Road (top left), stood Charlton Greyhound Stadium.

accordingly – in 1956 Jimmy Seed blamed this on a 'lack of partisanship in the district' – The Valley, with its two vast open terraces and one small 2,500 seat stand, built by Humphreys in 1922, became a crumbling anachronism.

What followed in the 1980s was as complex as anything that plagued the likes of Fulham and Chelsea in terms of boardroom upheaval and disputes over ground ownership. But in SE7 it had a rather more serious outcome.

In 1985 Charlton's directors took the hugely unpopular decision to leave The Valley and groundshare with the club's south London rivals, Crystal Palace (see right).

Cruelly, this exile coincided with Charlton returning to the top flight.

The story of how the club made its way back to The Valley, seven long years later, was enough to fill a book. And a great read it made too (see Links), told by Rick Everitt, one of the campaign leaders.

At one point in 1990 fans formed a Valley Party and stood in 60 of the 62 wards in Greenwich Borough Council. They polled nearly 11 per cent of the vote.

Point made and with certain wealthy supporters now digging deep, the fans set about clearing the weeds so that The Valley could reopen in 1992, albeit with a capacity of only 8,337.

Since then, many more millions have been invested. Directors have come and gone, the team has gone up and gone down. At the time of writing it is on the up, with average gates of around 20,000, double what they were before the 1990s.

Not only has The Valley been turned into a bright and welcoming enclosure, but the club has also emerged as a beacon of social action. In 2013 it was voted Coca-Cola Community Club of the Year.

People power, then, is the *leitmotif* of Charlton's history.

But why Addicks? In their early years it is said an East Street fishmonger, 'Ikey' Brown, would twirl a haddock above his head at home games. Another version has it that he rewarded the players with fish and chips. Either way, by 1909 Charlton were being called The Addicks in the local press.

Twice the club has tried to change this, first to the Robins, and then to the Valiants. But the tradition would not fade away and the Addicks they remain.

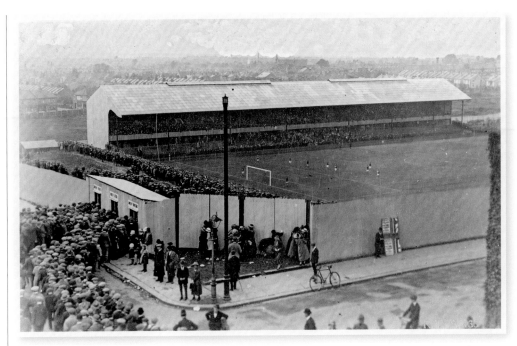

▲ A single policeman keeps order by the Holmesdale Road turnstiles of **Selhurst Park**, Archie Leitch's next London football ground, on its opening day in 1924.

As on several previous commissions, Leitch worked with the contractors Humphreys. And, as was by now his custom, he assured the press that here was a ground large enough to host Cup Finals. But at that stage only the lower banking had been terraced and the stand was a basic version of those built for Chelsea, Fulham and Spurs, 15-20 years earlier.

For despite their name, **Crystal Palace** were not a wealthy club.

Yet they had played before on a ground that hosted Cup Finals.

The first Crystal Palace FC had been formed by staff at the exhibition grounds in Upper Sydenham in 1861. Two years later they had been founder members of the FA, before disbanding. Then in 1895 the Crystal Palace company laid out a vast bowl stadium which did indeed become the new Cup

Final venue (see page 66), but was otherwise relatively under-used. Hence in 1905 the current Crystal Palace club was formed, as Chelsea had been, in order to bring business to a pre-existing ground.

As it transpired 'the Glaziers' played there only ten years before the stadium was commandeered for the war effort. Palace then played briefly at Herne Hill (page 320), followed by The Nest, a ground opposite Selhurst Station.

Selhurst Park appeared full of promise. Here was a 15 acre site in an increasingly populated area served by three stations and with the nearest professional clubs, Millwall and Charlton, being six and eight miles away respectively.

And yet in 1925 Palace were relegated to the Third Division, and it took another 30 years for the banking to be fully terraced.

Palace did finally make it to the First Division in 1969, when a second stand was built. Ten years later a record 51,482 squeezed in, only for the capacity to fall soon

after when land to the south was sold for housing and a supermarket in order to bail the club out.

As first Charlton (from 1985-91) and then Wimbledon (1991-2003) shared the ground and therefore the outgoings, two more stands went up in the 1990s.

Below left in 2013, seen from the same corner as above, is the **Holmesdale Road Stand** with its unusual, curving cantilevered roof.

So all four sides were now developed, albeit each with their own quirks. In other words, a classic British mishmash, now able to accommodate just over 26,000.

At least twice, in 1991 and 2011, 'the Eagles' (as the Glaziers were rebranded in 1973), talked of moving back to Crystal Palace and redeveloping the athletics stadium (page 68). But wherever they play in the area, there remains one great mystery.

London's population south of the river is 2.9 million, more than Manchester and Liverpool combined. Palace's fanbase stretches even further south, beyond the M25 towards Crawley.

On paper Crystal Palace should be the Arsenal of the south. Instead of which they have only occasionally sparkled and occupy a ground that is less than regal.

Is it something in the air? Are south Londoners less passionate?

There are many unexplained stories in London football. But the plot at the Palace, surely, is the most baffling of all.

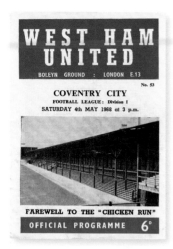

WEST HAM
UNITED
BOLEYN GROUND : LONDON E.13
No. 53

COVENTRY CITY
FOOTBALL LEAGUE : Division I
SATURDAY 4th MAY 1968 at 3 p.m.

FAREWELL TO THE "CHICKEN RUN"
OFFICIAL PROGRAMME 6D

▲ Even in the heyday of football's working class terrace culture, the **Chicken Run** was in a league of its own. Forming the east side of the **Boleyn Ground**, it measured 15 feet from front to back, with a narrow passage behind housing urinals. The actual terracing consisted of timber planks built over a void into which fag ends and litter would be discarded, topped by a tin roof held up by 19 columns.

No place for the faint hearted, the Chicken Run was home to some of east London's mouthiest football cognoscenti. They bounced on its timbers, hammered on its fencing. And should the winger of a visiting team dare to make a run down that touchline, they were sure to pass on the benefit of their wisdom.

Terraces like this had once been common... in the Edwardian era. In fact, had the ever vigilant LCC been the licensing authority the Chicken Run would have been condemned years earlier. Instead, the ground fell within the more indulgent jurisdiction of (confusingly) the Borough of East Ham. In 1965 this and its neighbouring borough of West Ham merged to form Newham, which was then absorbed into Greater London. Three years later, as seen above, the chickens finally came home to roost.

▶ August 1937 and as was their annual custom, the players and directors of **West Ham** pose in front of the **Boleyn Castle**, the building on Green Street from which their ground takes its name (although it is equally known as **Upton Park**, the name of both the district and the nearest tube station).

The 'Hammers', or equally the 'Irons' (nicknames which may be traced back to the club's origins at the Thames Ironworks shipbuilding company in 1895) moved to Green Street in 1904. This was after they had moved out of the grandiose Memorial Ground, which, with its cycling and running tracks (*see pages 126 and 319*) had proved less popular than its backer, Arnold Hills, had hoped.

As readers will be aware, in 2016 West Ham will leave the Boleyn Ground, which they own – having paid the Roman Catholic Archdiocese of Westminster a bargain £30,000 for its freehold in 1959 – for the Olympic Stadium, which of course has an athletics track and which they will rent.

Throughout this chapter we have touched on how certain elements of London's football heritage have withstood change, and how others have fallen by the wayside. Inevitably, all eyes will now focus on east London. How will West Ham's move affect the balance of power in the capital, and how will it alter the character of the club?

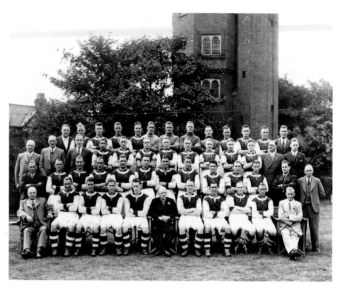

Patently we can only speculate. But because the lessons from Arsenal's move are still fresh in the mind, there can be no doubt that heritage will play a key role in helping Hammers fans face the immense transition that lies ahead.

And the Boleyn Ground?

Unlike at Highbury, no buildings of any merit are being left behind. The stadium will be levelled. But the Boleyn name itself will certainly not fade, even if its associations are bound up almost entirely in what historians call 'invented tradition'.

For in truth, the Boleyn Castle was never a castle. True, the octagonal redbrick structure was topped by a crenellated parapet.

But the tower itself was more likely an ornamental conceit, constructed originally in the mid 16th century, possibly as one of a pair, in the gardens of Green Street House.

Local tradition had it that Henry VIII courted Anne Boleyn in the tower, or that she was imprisoned there when his ardour cooled. But there is no evidence for either tale, and the tower almost certainly dates from after her execution in 1536.

But no matter. Local tradition is not to be dismissed lightly, and even if the football ground's days are numbered, there will still be a Boleyn Road, a Castle Street, a Tudor Road, several businesses on Barking Road that rejoice in the name Boleyn and, most famously of all, the Boleyn Tavern, the favoured gin palace of Hammers fans (and possessor of a celebrated billiard room, *see page 148*).

What is to be regretted is that neither West Ham nor the Archdiocese did anything to save the Boleyn Castle itself, or Green Street House, from demolition in 1955. Nor is there anything to mark the tower's location, which was where spaces numbered 42-50 lie in the club's car park.

Otherwise, a cartoonish castle bearing no resemblance to the original forms part of the club's crest, while two giant renditions of this pastiche flank the ground's main entrance (*opposite*).

So perhaps the Hammers' departure might pave the way for a more considered, 21st century Boleyn Castle to rise up, and herald the next chapter in this historic site's evolution.

Unlike their team mates, when this group of West Ham players gathered at Cassaterri's Café on Barking Road (since demolished), it was to discuss tactics. Known as 'The Academy', they were led by Malcolm Allison, seen here at a reunion in the 1960s, in the centre. Two evenings a week they were allowed to coach schoolboys, one of whom was Bobby Moore. All seven players went on to

become managers, with Allison, Dave Sexton (second left) and John Bond (third from right) proving the most successful. Ever since West Ham have embraced the tag 'Academy of Football'. But while the list of graduates is long and impressive, most ended up being sold to ease the club's finances. Moving to Stratford, it is hoped, will enable the Academy to hang on to more of its own.

▲ Although two and a half miles from Green Street, the **Olympic Stadium** still lies within the Borough of Newham and also, significantly, within the boundaries of the old County Borough of West Ham.

As backers of the move are keen to stress, the Hammers are therefore not only staying within their manor, on the Essex side of the River Lea, but arguably going back closer to their roots.

Taken in 2010, this view of the stadium in mid construction is from the **Greenway**, a path that runs along the top of the Northern Outfall Sewer. Just over a mile eastwards on the path, past West Ham station, lies Hermit Road, where Thames Ironworks played in 1895, and Memorial Park, the Hammers' home from 1897-1904.

In that respect West Ham's relocation might be regarded as hardly more than a local affair; just another football club moving on, an experience that 17 others in the top two divisions have been through since 1993.

As such, West Ham face a familiar set of issues. For example, which fixtures and fittings from the Boleyn Ground will go with them?

Top of the list will be the John Lyall Gates on Green Street. (Ilford born Lyall served as player, coach and manager at West Ham from 1955-89.) Also to be packed into the removal van, surely, will be the contents of the club's museum. This was a £4 million venture opened in 2002, but then mothballed when the club was sold to an Icelandic businessman in 2006 (a sale that meant for the first time since 1906 there were no members of either the Hills or the Cearns families on the board).

As of early 2014 the current owners – David Gold, who grew up on Green Street, and David Sullivan, Cardiff born but raised in Hornchurch – have stated there are no plans for a new club museum at Stratford, which is to be regretted (as is the decision of the British Olympic Association to renege on their promise of an Olympic-related museum).

But, at the very least, the original museum collection needs to be kept intact, and in the club's hands.

Then there is the sensitive issue of what to do with the fans' **memorial garden** by the John Lyall Gates (*above right*).

In February 2014 this question was settled when it was announced that after 2016 the ground is to be replaced by a 'village', laid out, as at Highbury, with 700 flats set out around a garden where the pitch now lies. Within this will be a memorial garden, centred around a newly commissioned statue of Bobby Moore. As seen on page 256, this will be the third of the great man.

Other, intangible aspects of the club's heritage are more easily transferred. The ends of the Olympic Stadium are to be named after Bobby Moore and Sir Trevor Brooking, as is currently the case at the Boleyn Ground.

But what of West Ham the club? The once family-run club with its roots in working class east London?

Its owners insist that the move from a ground holding 35,000 to

one holding 54,000 will enable more fans to attend matches at lower prices. They argue that the availability of the Olympic Stadium, and the fact that the Government, the Mayor, the LLDC and Newham were all desperate for them to move there (and are backing this up with public funding) offered a once in a lifetime opportunity; that instead of the Hammers' dreams fading and dying, as expressed in the club's anthemic 'Bubbles' song, the move represents West Ham's best chance to challenge for honours.

Whether they are proved right or not, theirs is a gamble – as bold as it is controversial – that will change the landscape of London football to a degree unprecedented since Chelsea's arrival in 1905 and the relocation of Arsenal in 1913.

This, in short, is history in the making.

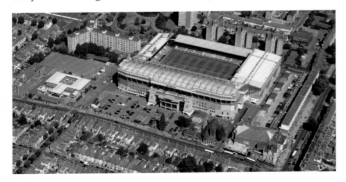

Furthest from the camera (*right*), the oldest structure at the Boleyn Ground is the East Stand, built in 1968 to replace the Chicken Run by the firm of WJ Cearns (who sits in the centre of the team group opposite). When West Ham move to Stratford, where coincidentally WJ Cearns were based, they will leave behind the Church of Our Lady of Compassion (b.1911), to the right of the main entrance, and the Boleyn Tavern (b.1900) on the corner of Green Street (bottom right). The late lamented Boleyn Castle stood where the club's car park now lies, a short distance from the mock castle on the left side of the main entrance. Who knows, perhaps one day West Ham will replace the castle on their crest with a symbol of their new neighbouring tower at Stratford, the ArcelorMittal Orbit.

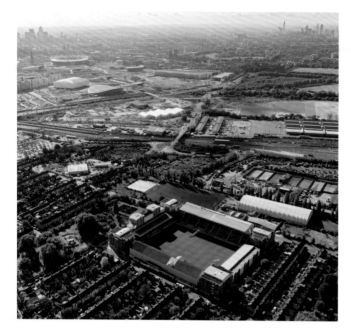

▲ While history may be in the making at the **Olympic Stadium,** viewed here in 2011 (top left), there are fears that West Ham's move will precipitate the breaking of their neighbours, **Leyton Orient.**

Orient's **Matchroom Stadium** (in the foreground), also known as **Brisbane Road,** lies a mile and a half north of the Olympic Stadium. For the ground's wider context and a map, see page 82. But in the narrower context of professional football, the basic facts are these.

With average gates of 4-5,000 and a capacity of 9,271, Orient are minnows compared with West Ham. But that was not always the case. Formed in Lower Clapton by members of a cricket club (itself formed by students at Homerton College in 1881), the club adopted the name Orient in 1888 at the suggestion of one of the players, who worked at the Orient Steam Navigation Company.

In 1905 Orient joined the Football League, in the same year as Chelsea, 14 years before the Hammers, and by the 1920s

had a substantial ground on Millfields Road that once held over 37,000. Ousted by a greyhound racing syndicate in 1930 they moved a short distance to the Lea Bridge speedway track (*page 87*) before finally settling at Brisbane Road in 1937.

Since then, apart from a purple patch in the early 1960s – when they had one season in the First Division and drew a record 34,345 for a Cup tie against West Ham – Orient have frequently battled against the odds. Indeed the reason that the ground holds comparatively few today is because both ends were shrunk in 2003 to make room for apartment blocks, a deal that brought in over £7 million.

When London bid for the 2012 Games, Orient's chairman, the east London snooker, boxing and darts impresario, Barry Hearn, put in a bid for 'the Os' to play at the proposed stadium. When this failed he applied to share it with West Ham. He also sought through the courts to prove that both the Premier League and

Football League had broken their own regulations by allowing West Ham onto the patch of another club. He also tried to gain support for a new Orient stadium on the Eton Manor site.

All without success.

Further salt was added to Orient's wounds when in 2013 West Ham announced plans to distribute 100,000 free tickets per season for their matches at the Olympic Stadium.

Hearn responded, 'Orient won't go under overnight, but we'll slowly slip away with an ageing audience.'

History, alas, would rather back up his gloomy prediction.

Seen above is the **Hare and Hounds** ground of Orient's erstwhile neighbours, **Leyton FC,** a mile north on **Lea Bridge Road.**

Formed in 1868, and therefore one of London's oldest clubs, Leyton played there from 1901-04.

They then turned professional, joined the Southern League (where they competed with the likes of West Ham and Spurs) and in 1905 created a new ground.

Laid out on council owned land, Leyton called this new ground **Osborne Road,** but it was a step too far and in 1912 the club reverted to amateur status and moved on. Osborne Road was then taken over as a works ground by the matchmakers Bryant & May, before Leyton returned in 1929 and emerged as one of the top amateur clubs of the period.

In fact they had just played in their fifth Amateur Cup Final when they were evicted by the council... to make way for the Orient.

Or rather, **Clapton Orient** as they were then known. Only in 1946 did they rename themselves Leyton Orient.

Osborne Road, meanwhile, was renamed Brisbane Road.

Alas poor Leyton. Rendered homeless by their more powerful neighbours, they eventually returned to the Hare and Hounds, went through several incarnations, until finally in 2011 they disbanded.

And Leyton have by no means been alone. Look further east and the casualty list mounts...

From the Hare and Hounds (*above right*) to the Spotted Dog (*right*). Orient left Clapton and headed east in 1930. Upper Clapton Rugby Club did the same in 1933. But the first local club to cross the River Lea was Clapton FC. Formed in Hackney in 1877, they moved to the Spotted Dog ground on Upton Lane in 1888, and have remained there since. Named after the adjoining pub (*see page 8*),

the ground has been staging sport since at least 1844 and is the fifth oldest in London (*page 26*). But for how much longer? Although 'The Tons' won the Amateur Cup five times and once drew regular crowds of 4,000, nowadays a three figure crowd is considered welcome. The Spotted Dog pub itself, a Grade II listed building, has also fallen on hard times and has been boarded up since 2004.

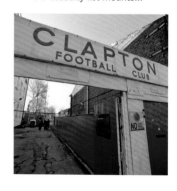

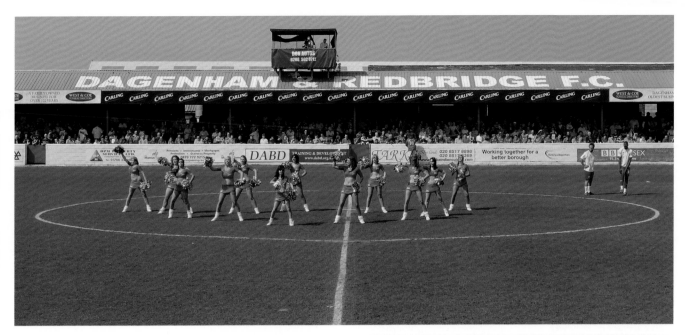

The Only Way is Essex – pre match entertainment courtesy of **The Daggerettes** at **Victoria Road**, home of **Dagenham and Redbridge**.

Though convoluted, the Daggers' story is instructive, for it encapsulates a trend that has dominated east London football since the 1970s; that is, the steady reduction of amateur and semi-professional clubs, with numerous, once prominent names either fading, disappearing or merging.

Leyton and Clapton have by no means struggled alone.

Dagenham formed in 1949 and in 1955 took over Victoria Road from **Briggs Sport** (the works team of a car body manufacturer that later merged with **Ford Sports** to form **Ford United** at a ground in Rush Green. Ford's other sports ground features on page 137.)

Meanwhile, three much older Essex clubs were about to feel the pinch. **Ilford**, formed in 1881, sold their ground in **Lynn Road** (where two games in the 1948 Olympics had been staged), in 1979, and merged with Leytonstone. Flats on **Dellow Close**, named after an Ilford player, now occupy the site.

Leytonstone, formed in 1886, played on **Granleigh Road**, a compact three-sided ground which once held 10,500 for a Cup tie in 1951. It too became housing.

The hybrid **Leytonstone/ Ilford** then moved in and merged with **Walthamstow Avenue**.

Formed in 1900 and one of the top amateur clubs of the 1950s, Avenue were based at

east London's best non-League ground, **Green Pond Road**, which had also hosted an Olympic match in 1948 and where the record gate had been 12,400 in 1938. Its 940 seat main stand (*right*) was completed in 1939.

Green Pond Road remained in use until 1989 – housing, not surprisingly, now occupies the site – before the Leytonstone/Ilford/ Walthamstow club rebranded itself as **Redbridge Forest** and moved in with Dagenham at Victoria Road.

Finally, and perhaps inevitably, Dagenham and Redbridge Forest merged in 1992, but this time with great success, because in 2007 the club achieved League status.

The ends, it would seem, had therefore justified the means. At last, this part of metropolitan Essex had a senior club, with a now smart, if modest ground holding just over 6,000. Moreover, several of the leading figures in the club had been part of the long journey; the Daggers chairman, Dave Andrews, for example, had played for Walthamstow Avenue, while the manager, John Still, had played in the last ever Amateur Cup Final in 1974, and had previously managed Leytonstone and Redbridge Forest.

One measure of the Daggers' achievement is the story of another amateur club that dared to dream. Formed in 1929, **Romford** invested heavily in climbing to the top and between 1960 and 1972, in the days before automatic promotion, applied for membership of the Football League ten times.

Part of their sales pitch was the image of **Brooklands** above. Drawn originally in c.1937, with floodlights added later, in 1964, it had been the last ground scheme designed by the company of Archibald Leitch.

At the League's 1967 elections Romford won as many votes as Wigan Athletic. But it was not enough and by 1977 Romford were in such debt that Brooklands had to be sold for housing.

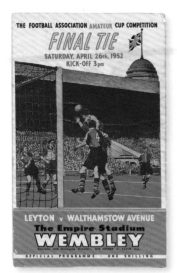

To reach the 1952 Amateur Cup Final at Wembley, Walthamstow Avenue did not have to travel far. En route they met Hounslow, Southall, Tilbury, Wimbledon and Walton & Hersham, before beating fellow east Londoners Leyton in front of a capacity 100,000 crowd. In the Avenue team was Essex and England cricketer Trevor Bailey (*see page 93*). Bailey would also play in an epic match the year after when Avenue held Manchester United to a 1–1 draw at Old Trafford in the FA Cup. Match programmes such as the one above, worth £10-£20 today, form part of a thriving trade amongst collectors, for whom outlets like the one at Dagenham (*below*) represent pure heaven, and for the historian, a rich source of material.

▶ It was not only at Wembley that fans turned out in their thousands to watch the exploits of London's amateurs. Pictured in 1951, this is the ground of **Dulwich Hamlet**, its address, coincidentally but surely inspirationally, **Champion Hill**.

Four times Hamlet have been champions of the **Isthmian League** (now Ryman League), a competition formed specifically for London amateur clubs in 1905, and four times winners of the Amateur Cup.

In fact such were the playing strengths of London's amateur clubs that in the 71 seasons that the Cup was contested, from 1894 to 1974, London clubs won it 32 times, and only on 28 occasions did neither finalist come from within the boundaries of modern day London.

Only the north east, represented by such clubs as Bishop Auckland and Crook Town, could match this concentration of talent.

Champion Hill, as seen here, was built in 1931, and although it was never Hamlet's intention to turn professional – as did the likes of Leyton (briefly), Wimbledon (*below*) and Barnet in later years – the ground would not have been out of place in the lower divisions of the Football League. The main stand had seats for 2,400, while the all time record was 20,500, when Champion Hill hosted the 1933 Amateur Cup Final, Kingstonian v. Stockton. (Wembley only took over as the Final venue in 1949.)

Hamlet's average gates during the 1930s were in the region

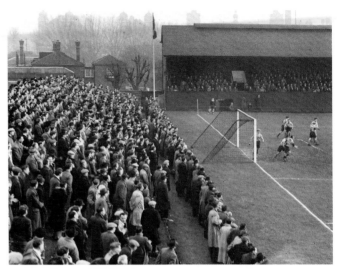

of 7-8,000, comparable with those, for example, of Clapton Orient in the Football League. But this popularity did not last.

For Dulwich and other amateurs such as Clapton and Leyton, the decline started during the 1960s. Until then many talented players preferred to remain amateur whilst holding down steady jobs, mainly because professionals were subject to a maximum wage (until 1961), could be transferred at their club's whim, and because it was in any case a precarious occupation.

One resolute amateur was Hamlet hero **Edgar Kail** (*page 90*).

At the same time, it was no secret that some top amateurs were handsomely rewarded under the counter. In fact it was because of this 'shamateurism' that in 1974 the

FA dropped the distinction between amateurs and professionals.

Faced with mounting overheads, ground upkeep also now became a major headache.

Fortunately for Dulwich, financed by the building of a supermarket next door, Champion Hill was completely rebuilt in 1991 to a more appropriate 3,000 capacity.

In 2002 rivals Tooting & Mitcham were similarly able to move from their once impressive Sandy Lane, which in its pomp held 17,500, to the more compact Imperial Fields, holding 3,500.

Not that downsizing has proved any guarantee. Nowadays attracting barely a few hundred spectators, most of London's once eminent amateur clubs face pressure simply to survive at all.

▲ In 1964, on the back of eight Isthmian League titles and victory in the Amateur Cup, **Wimbledon** decided to turn professional.

What followed was then unprecedented. In 1977 the Dons became London's 12th Football League club. Just nine seasons later they made it into the First Division. In 1988 they won the FA Cup.

This meteoric rise meant leaving their modest Plough Lane ground

to share with Crystal Palace while a new site was sought in Wimbledon. But when that failed after numerous sites were ruled out... a bombshell.

In 2002 Wimbledon's directors sought and received permission from the FA to relocate the club to Milton Keynes and to rename it the 'MK Dons'. Back in London, irate fans immediately formed a new club, **AFC Wimbledon** (AFC standing for A Fan's Club).

Playing in Kingston, amazingly this new club then emulated its forerunners by rising up to achieve Football League status in 2011.

In late 2012 the two clubs, AFC Wimbledon and MK Dons finally met, in the FA Cup. This (*above*) was how the fans made their point.

Truly, here is a tale that encompasses everything anyone need know about the role of place, and of heritage, in football culture.

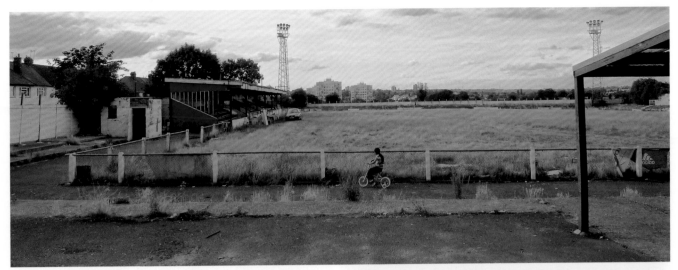

▲ Forming a corner of Clitterhouse Playing Fields, on high ground overlooking Brent Cross, **Claremont Road** was, from 1926-2008, the home of another once eminent amateur club, **Hendon** (formed as Christchurch FC in 1908 and known later as Hampstead Town, then as Golders Green FC).

Although never grand – the ground's record gate was 9,000 in 1952 – Claremont Road's proximity to the North Circular made it ideal for amateur internationals, as a base for Arsenal's third team (in the post war period), as a training ground for foreign teams visiting London, and for film companies looking for a football-related location.

The ground was also a familiar landmark, owing to its distinctive floodlights, erected in 1962 and switched on for a friendly against the then mighty Wolverhampton Wanderers; an indication of how much clout London's amateur clubs had at that time.

This clout did not extend to the tenure of the ground, however.

In the 1920s Clitterhouse Playing Fields, previously a dairy farm, had formed one of a series of extensive land purchases carried out by Middlesex County Council (a policy that was to provide a particular boost to golf, see Chapter 21). The County Council then transferred the land to Hendon Urban District Council, requiring them to sign a covenant, reserving the playing fields for public recreation in perpetuity.

Yet as Hendon FC's fortunes waned in the late 20th century, and as the area became subject to various development proposals, Hendon UDC's successor body,

Barnet Borough Council, saw fit to have the covenant annulled, paving the way for housing on the Claremont Road site.

Hendon played their last game there in September 2008, but instead of the builders moving in, as seen above in 2011, vandals and squatters took possession.

As of mid 2013 the site was still a desolate ruin, the floodights still eerily in place.

As for Hendon, following the example of AFC Wimbledon, the fans set up a trust to run the club and arranged a groundshare with **Wembley**, at **Vale Farm**, over four miles away. When this deal expired Hendon moved again, in 2013, to share with **Harrow Borough**.

To paraphrase Oscar Wilde, for the Borough of Barnet to have lost one historic club was unfortunate. But then in 2013 **Barnet FC** itself also moved out of the borough.

Barnet is another amateur club that took the plunge by turning professional, in 1965. Its ground, **Underhill** (above right) first used for football in 1907, was well named. Tucked away amid a housing estate, with a cricket ground at one end, it was celebrated for its pronounced slope.

While the Bees were an aspiring Southern League club, this quirk was tolerated. But when ticket tout Stan Flashman started bankrolling Barnet in 1985 and six years later promotion to the Football League was won, followed by promotion again in 1993, Underhill's slope became a liability, as did its lack of capacity and access. Flashman's lack of accounting also nearly earned the club expulsion from the League.

He departed in 1993, and when the Bees lost their League place in 2001 most observers assumed the adventure was over.

But they were wrong. Under a dynamic new chairman the Bees regained League status in 2005, and ploughed at least £4m into Underhill so that it would meet the League's required basic standards, including a minimum capacity of 6,000. The Bees even bought the cricket club, as well as several neighbouring houses in an attempt to improve access.

But the club also never stopped looking for a new site, somewhere in Barnet. In 1995 it was hoped that this new home might be the Copthall Athletics Stadium. Instead of which Saracens Rugby Club were appproved as Copthall's new tenants in 2012 (see page 265).

Running out of options, in

2013 the Bees relocated to a temporary stadium built at their training ground, **The Hive**, in neighbouring Harrow.

For fans of other Middlesex clubs, Hendon and Barnet's struggles were familiar. The Hive, for example, had originally been intended for **Wealdstone**, whose own **Lower Mead** ground had been sold to a supermarket in 1991.

Close to The Hive, the **White Lion Ground** of **Edgware Town**, near Burnt Oak, was, in 2013, in the same state as Claremont Road, despite having been sold for housing in 2007. Similarly, **Western Road**, once the home of **Southall**, lay unused for four years before being finally built over in 1996.

In Middlesex, it would seem, no football ground, no covenant, no club can ever be taken for granted.

The only constant is change.

▲ Conveying his trademark expression of inscrutability, this bust of **Sir Alf Ramsey**, unveiled in 2009, looks out over the players' tunnel at **Wembley Stadium**.

Ramsey (1920-99) is of course remembered for masterminding England's World Cup campaign in 1966, a triumph that continues to wield a powerful hold on the nation, as much for the fact that it has never been repeated as for the feat itself. The memory resonates at Wembley in particular, but also in London as a whole.

For despite his carefully clipped tones, Ramsey was a Dagenham boy who made his name with Tottenham in the post war years. One of his World Cup winning XI was west Londoner George Cohen, who played for Fulham,

while, as commemorated in 2003 on the corner of **Green Street** and **Barking Road** (*right*), three played for West Ham.

From left to right they were **Martin Peters**, who hailed from nearby Plaistow, **Geoff Hurst**, brought up in Chelmsford (and knighted in 1998), and the captain, **Bobby Moore**, from Barking. (The fourth player in this iconic group, caught on camera after the 1966 Final, was Ray Wilson of Everton.)

When West Ham leave the Boleyn Ground in 2016 the bronze quartet will be resited outside the Olympic Stadium.

Moore, who died from cancer in 1993 at the age of 51 and was the only footballer to have had a memorial service at Westminster Abbey, is commemorated in a number of other ways.

Somewhat prosaically, a slip road off the North Circular in N10 and an Indian restaurant in Wembley bear the great man's name, while at West Ham there is a Bobby Moore stand, a bust and a plaque. At **Wembley** there is a bridge, a VIP lounge and a second sculpture (*below right*), unveiled in 2007, with his England team mates on the plinth below.

This and the other two works on the page are by Philip Jackson.

A mannequin of German goalie Hans Tilkowski gropes skywards in the reception area for stadium tours at Wembley (*above*), where above the ticket desk is displayed the now slightly sagging crossbar against which Geoff Hurst's shot rebounded for England's hotly disputed third goal on that epic afternoon in 1966. How often it is that the simplest of artefacts carries the greatest meaning.

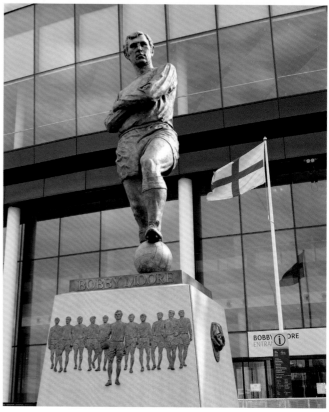

▶ Until 1990 sports-related statues were extremely rare in Britain. By 2013, according to the Sporting Statues Project (*see Links*), there were over 160, 70 of which portray footballers or football managers.

In addition to those at the Emirates Stadium, Wembley and at Upton Park, at **Stamford Bridge** (*right*) is another Philip Jackson sculpture, of the **Chelsea** striker **Peter Osgood** (1947-2006).

Born in Windsor and dubbed 'The King of Stamford Bridge', Osgood made his debut in 1964 at the age of 17 and over the next decade scored 150 goals. His power and prowess, matched by his flamboyance, made Ossie a 1960s cult hero on the Kings Road.

Accordingly, in addition to his statue, unveiled in 2010, his ashes were buried under the centre spot at the Shed End of the Bridge.

Redheaded goalkeeper **Sam Bartram** (1914-81), from South Shields, played over 600 games during his 22 years at **Charlton Athletic**, a period that coincided with the Addicks' best ever run in the 1930s and '40s. Loved for his showmanship and his loyalty, Bartram's statue, by Anthony Hawken (*right*) was placed outside **The Valley** on the club's centenary in 2005. Around the corner there is a Sam Bartram Close.

Another one club stalwart was **Johnny Haynes** (1934-2005) of Fulham, whose statue by Douglas Jennings (*right*) was erected outside the stand at **Craven Cottage** which now also bears his name, in 2008.

A gifted midfielder who played over 650 games for his club and for England, Haynes famously became the first British player to earn £100 a week, in 1961.

Finally, in Brooklyn Avenue, Loughton, there is a plaque to **Ron Greenwood** (*below right*).

Born in Lancashire but raised in Alperton, Greenwood was on the ground staff at Wembley Stadium in the 1930s, played for Brentford, Chelsea and Fulham, coached at Arsenal, before in 1961 he began a memorable 13 years as manager of West Ham. In fact it was Greenwood who, in the spirit of the West Ham Academy, nurtured the skills of Messrs Moore, Peters and Hurst. He ended his career with five years as the manager of England.

'Football is a simple game,' Greenwood once remarked. 'The hard part is making it look simple.'

▲ We conclude with the **Old Parmiterians' Ninth XI**, posing proudly in 2010. Should the name be unfamiliar, OPFC were formed by old boys of Parmiter's School, Bethnal Green, in 1898, and are based at the **Douglas Eyre Sports Centre, Walthamstow**.

OPFC happens to be the largest club in membership of the largest adult football league in Britain.

Perhaps best to read that again.

For one could spend a lifetime immersed in the upper levels of London football and know little or nothing about OPFC or the thousand or more clubs playing week in and week out on Hackney Marshes, Wormwood Scrubs or any of the other 2,900 full size and junior grass football pitches dotted around the capital (as calculated by Sport England's Active Places database in 2013).

Each weekend OPFC field 14 teams, eleven of them in the **Amateur Football Combination** (AFC), plus three teams of veterans.

No-one gets expenses. In fact every player pays to play; £5 per match for boys, £10 for adults.

In common with many of the clubs originally set up by old boys, by banks or by business houses, and who now play in the AFC, or in the Arthurian League, or in the venerable Arthur Dunn Cup, inaugurated in 1903, OPFC are today open to all comers, Parmiter's School having left Bethnal Green for Hertfordshire in 1977.

As for the AFC, as of 2014 this consists of 91 member clubs, whose combined roster of over 9,000 registered players turn out for 306 teams each weekend, spread across 29 divisions.

In Britain (and possibly in Europe) only the Sheffield & District Junior Sunday League consists of a greater number of teams.

From this one might assume that all is well with grass roots football in London. But not at all.

The AFA has lost over 40 teams in recent years, while in 2013 the London FA (a separate body) had 959 affiliated clubs, compared with around 1,600 a decade previously.

Club secretaries cite the rising costs of pitch hire, kit and travel. Sponsorship has dried up. Plus there are now commercial five-a-side centres that offer floodlit, artificial pitches (therefore no postponements), and one hour time slots, perfect for weekday evening kickabouts.

Just as 'pay and play' has altered golfing habits, so too do these centres challenge the traditional model of an 11-a-side game played for 90 minutes on a full size pitch.

Much is written about the threat to football's soul from Russian oligarchs, Arab sheikhs, digital TV and spiralling ticket costs. But the challenges facing Old Parmiterians and their ilk on the playing fields of London are as germane to the future of football as those that affect the likes of Arsenal or Chelsea, or even Orient or Barnet.

For a simple game, it really is remarkably complicated.

Chapter Twenty Three

Rugby

For most visitors to the 1851 Great Exhibition, this 'educational appliance' on stand no. 187 – that of leathermaker William Gilbert – would have been their first glimpse of a rugby ball. Gilbert had been supplying balls to Rugby School since the 1820s. What has never been ascertained is whether it was the boys who requested the egg shape because it better suited their evolving game based on carrying the ball and place kicking, or whether they adapted their game to the ball, shaped as it was because Gilbert used pigs' bladders, said to be more resilient. (Rubber bladders were not introduced until 1862.) By 1851 two schools in London had taken up rugby football: St Paul's, who still play the game, and the Royal Naval School, whose playing fields survive in front of the school's original building, now part of Goldsmiths College in New Cross. As for the 1851 exhibition ball, it remains on display, at the William Webb Ellis Museum, based in Gilbert's former workshop in Rugby. 'Gilbert' balls are still the game's preferred brand, having been manufactured by Grays of Cambridge since 2002.

Usually when thinking of heritage we bring to mind notions of continuity. But when it comes to rugby, the game's rival codes, rugby union and rugby league, have both been subject to such major change over the last two decades that it is possible to offer here only an interim report.

In some respects rugby's heritage has been swept aside, to borrow a phrase famous in the game (*see opposite*), with 'a fine disregard' for the past. In others, it has proved surprisingly resilient.

Rugby's revolution kicked off in August 1995 when, after a century of espousing amateurism, the governing body of world rugby union finally dropped its ban on the payment of players.

The Football Association, it will be recalled, sanctioned professionalism in 1885. Its counterparts in cricket granted equal rights to professionals only in 1962, tennis in 1968, while in athletics, professionals were barred from the Olympics until 1986.

In rugby, clubs in the north of England first raised the issue of payments in the 1890s, urging the game's London-based governing body, the Rugby Football Union (RFU), formed in 1871, if not to sanction full professionalism then at least to allow players to be compensated for wages lost whilst playing for their clubs.

Dominated by ex-public school, middle and upper class men who could afford to play for fun, the RFU would allow no such thing.

So it was that in 1895 'the Great Schism' took place, as 22 clubs from Lancashire, Yorkshire and Cheshire broke away to form the Northern Union (later renamed the Rugby Football League).

Rugby was not alone in arguing over monetary matters. But only rugby and one other sport, bowls (*see Chapter 18*), split so decisively that separate codes would emerge.

During the years that followed rugby union's change of heart in 1995, speculation was rife that union and league might come back together. But this is sport we are talking about, and during rugby's 'Hundred Years War' the consolidation of separate power bases (union in London, league in Leeds), and the evolution of different rules (such as union teams fielding fifteen players, league teams thirteen) meant that neither side was prepared to yield.

That said, there have been some adjustments that only a decade earlier would have been deemed unthinkable, even heretical.

Most notably, players now switch codes with equanimity. In the past, any union player caught playing rugby league, even if only as an amateur, was banned for life.

As for rugby league (the less powerful of the two codes) by far its most significant response to the new era was, in 1996, to switch its traditional season of August-May (which ran parallel with football and rugby union) to one running from March-September.

From Warrington to Hull, it was as if Christmas were being swapped with Easter.

In a similar vein, in 2009 Saracens, one of London's oldest rugby union clubs, played a 'home' match at Wembley Stadium. Said one shocked diehard, this was tantamount to Waitrose products going on sale at Tesco.

Yet the experiment proved so popular that Saracens have returned to Wembley several times since, reaching a climax in March 2012 when their match against another London rugby institution, Harlequins, drew 83,761, a world record for a club game.

Until the mid 1990s, it should be added, Saracens had been playing in front of barely 1,500 or so spectators at a homely ground in Southgate with one tiny stand.

So where did all these extra fans come from? The fact is, many of them were already sold on the game, but in the past had turned out *en masse* only for international matches at Twickenham.

Whereas in club rugby, apart from local cups and representative matches, the RFU banned any quest for points under a league system, arguing that it would sully the amateur spirit. Most inter-club matches were in effect friendlies; hard fought, but essentially an end in themselves.

That all changed in 1987 when a league system was finally sanctioned by the RFU, after which crowds at club matches started to rise, a major factor in preparing the ground for professionalism (as was the need to put an end to years of creeping 'shamateurism').

As a result of this more regular, competitive fare, rugby union has since become the third most popular spectator sport in England

Rowland Hill, and gentlemen all, thanks for your efforts to 'keep up the ball'
Out of the Moneygrub's sordid slime! 'Professionalism' and 'Broken Time'
Wanted the touch of a vigorous hand, to keep the Amateur Football Band
From the greedy clutch of the spirit of trade, and speculation, alas! Arrayed
In spoil-sport fashion against true sport, on turf and river, in course and court.
Keep it up, gentlemen! Let not the shame
Of money-greed mar one more grand English game!

Punch magazine applauds the RFU's defence of amateurism in its edition of September 28 1895. The ban on professionalism was finally lifted in 1995, two days before the 100th anniversary of rugby's 'Great Schism'.

and Wales. In season 2011-12, just under three million paid to watch the game. Although still modest compared with 33 million for football and six million for horse racing, this still represented a steep rise from a relatively low base.

No question, the RFU's previous stance on amateurism did, over the years, nurture an admirable culture of sportsmanship, exemplified by the fact that while in soccer players frequently challenge referees' decisions, their counterparts in rugby always (or at least nearly always) show complete respect, to the point even of calling the referee 'sir'. As Oscar Wilde put it (with apologies to readers tired of the quotation), football is a game for gentlemen played by hooligans, while rugby is the other way round.

However rugby's amateur ethos also meant that its clubs catered much more for their playing members than for their spectators.

The consequences of this have been especially felt in London. For come the rise in demand post 1995, most of the capital's grounds proved unable to cope.

As will become apparent, with the exception of Blackheath and Richmond, most of London's most prominent rugby clubs took years to find established homes, and even then, most were rented.

Indeed rugby rather took pride in its ability to thrive in testing circumstances. Pitches in the middle of nowhere, muddy turf, cold baths; all were part of the game's laddish allure. If particularly organised a club might have a small stand. Otherwise, a clubhouse with a bar fulfilled most of their needs.

It still does at the lower levels of the game, which in London currently amounts to around 90 clubs playing in regional leagues.

But at the national level, the pressure to have grounds that meet newly imposed minimum standards has led to an exodus.

In season 2012-13, five of the twelve clubs in the Premier League were originally from London. Yet only two still played in the capital, of which only Harlequins owned its own ground. Saracens, the other, rents Copthall Stadium from Barnet Council, while the remaining three all play at football grounds beyond the M25; Wasps at High Wycombe, London Irish at Reading and London Welsh at Oxford.

While these departures are to be lamented, other breaks with rugby's traditions have, at least in some quarters, been welcomed.

For example, for all its once ingrained sexism, rugby has opened its doors to female players.

Rugby players' and fans' reputation for boozing, hell raising and politically incorrect behaviour in general, has also, gradually, been tempered. Yet one thing that remains unchanged is that, however tanked up, rugby fans still do not need to be segregated, or policed in a way that is routine in football.

In terms of how rugby union regards its own heritage, there is no doubt that 1995 constitutes a sort of 'year zero' for the new owners and investors now active in the game. In that respect, recent work by Tony Collins on rugby's cultural history offers an important counter (see Links).

In addition, the World Rugby Museum at Twickenham remains unsurpassed as a resource.

London is, furthermore, as Dick Tyson has shown (see Links), home to numerous historic clubs. Of the 46 London sports clubs that were 150 years old or older as of 2014, four play rugby: Richmond (who formed in 1861 but adopted rugby a year later), Blackheath (1862), Civil Service (1863, the same year its members also formed an Association club), and St George's Hospital Medical School (1863).

Another twelve will reach the 150 mark in the next decade, including Guy's Hospital and Harlequins (1866), Wasps (1867) and Ealing (1871). This is a greater number of survivals than in football.

How well and in what form these and other London clubs will survive in the new era is, however, another matter altogether. For if there is one great fear amongst traditionalists, it is not that rugby will die – in many ways both league and union are more popular than ever – but that in order to maintain their upward momentum, they will increasingly have to adopt the survival methods more associated with professional football.

For rugby, a game that has so often sought to occupy the moral high ground, that alone would represent the most egregious break with heritage of all.

WILLIAM WEBB ELLIS
Rector 1843-1855 who at Rugby School in 1823 with a fine disregard for the rules of football as played in his time first took the ball in his arms and ran

▲ **William Webb Ellis** (1806-72) devoted his life to the Anglican church. He loved his mother, never married and was no friend of Rome.

At best, before he died (in the south of France), Webb Ellis might have hoped that a series of sermons delivered at St George's Chapel in Albemarle Street, and other essays published between 1832-53, would cause him to be remembered.

One of his sermons during the Crimean War was reported in the *Illustrated London News* in 1854.

Or that he would be remembered in the Essex village of Magdalen Laver, where, as rector he raised an endowment of £999 to build the local primary school in 1862 (now housing on School Lane).

Instead of which, as the plaque at another of his former churches, **St Clement Danes** in the **Strand** makes clear (*above*), William Webb Ellis will be forever remembered for a single act he is said to have performed when he was just 17.

As numerous historians have made clear, whether or not Webb Ellis committed this act is not the issue. We will never know. All that can be confirmed is that carrying the ball and running with it – the one element that most distinguished Rugby's game from other football variants at the time – clearly, if gradually, did become accepted at the school during the 1830s, and was definitely sanctioned when the rules were first committed to paper, in 1845.

Rather more important is the question of how Webb Ellis came to be identified and how this information was then used.

Webb Ellis had been dead for four years when a letter in *The Standard* in 1876 prompted an Old Rugbeian and antiquarian, Matthew Bloxam, to ask his contemporaries if anyone could recall how running with the ball had first caught on.

Subsequently, in a letter to the school journal, *The Meteor*, in 1880, Bloxam cited Webb Ellis as the practice's orginator. Bloxam did not reveal who was the source of this claim, but the school archivist Jennifer Macrory (*see Links*) suggests that it was probably Bloxam's younger brother, John, who had been a contemporary of Webb Ellis.

Matthew Bloxam died in 1888. But then in 1895, clearly anxious to remind the world of Rugby's role in the creation of the game, and, crucially, at a time when, as noted opposite, the northern clubs were challenging the authority of the RFU, the Old Rugbeian Society decided to conduct a fuller enquiry.

By then even fewer former pupils from the 1820s were alive. But the final report, in 1897, soberly concluded that Webb Ellis, 'in all probability' was the pioneer, as a result of which in 1900 the school erected a plaque that credited Webb Ellis with having shown 'a fine disregard for the rules of football as played in his time'. (In other words, he had cheated.)

And so, based on the evidence of one, unnamed source, speaking over fifty years after the event, William Webb Ellis has named after him a trophy (the Rugby World Cup, no less), an office building at Twickenham Stadium, a pub in **Twickenham** (*left*), a museum in Rugby and a sheaf of articles and academic papers analysing the man and the myth.

To rephrase the old adage, how readily we show 'a fine disregard' for the truth in the interests of a good story. And how often heritage and history are not one and the same.

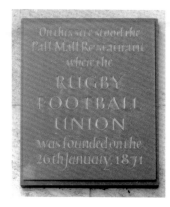

▲ Easily missed on the front of **Oceanic House** at **1 Cockspur Street SW1** – built in 1903 for the White Star Line, owners of the *Titanic* – this plaque is a reminder that, when formed at the Pall Mall Restaurant which stood on this site in 1871, the **Rugby Football Union** was essentially an all-London affair, as the Football Association had been just over seven years earlier.

Of the 21 clubs who attended the inaugural meeting, only one was from outside the capital, Wellington College. Rugby School, oddly enough, did not join until 1890.

Two of the 21 clubs, Civil Service and Clapham Rovers, played both Association and Rugby rules. In fact Rovers later won the FA Cup in 1880.

The Civil Service club is also one of the eight London founding members that still play rugby.

Of these, two represent teaching hospitals; Guy's (whose sporting section formed in 1843 but whose earliest recorded rugby match was in 1866) and King's College (founded 1869).

The others were Wimbledon (1865), St Paul's School, and the best known trio, Blackheath, Richmond and Harlequins.

Legend has it that there could have been 23 founder clubs had the chaps from Wasps (1867) and Ealing (1871) not gone to the wrong place at the wrong time.

Rival fans in rugby have no need for segregation. On the contrary, drinking together is encouraged, as here in 2010 at the Rectory Field, where a third of Blackheath's income derives from members and social events. The big difference today is that women, more or less excluded from clubhouses until the 1960s, are now welcome, both as fans and as players. Meanwhile, much less in evidence are the 'spoils of war'. At Blackheath, as at many a club, the clubhouse doubles as an informal museum. But whereas amongst the displays of trophies, shirts and portraits there would in the past often be items 'borrowed' from rival clubs, or street signs liberated during club tours and the like, nowadays such tomfoolery is much less evident. Which is not to say that it no longer takes place...

◀ Before Twickenham opened in 1909, international and showpiece rugby matches in the capital were staged originally at The Oval, and from 1881-1909 predominantly at the grounds of Blackheath and Richmond; both still in use and, reflecting the two clubs' historic status, both featuring substantial pavilions built around 1886.

Richmond's pavilion is listed Grade II and features overleaf.

Seen here in 1938 is the pavilion of **Blackheath FC** at **Rectory Field**.

Blackheath were one of at least eight clubs to have started out playing on Blackheath itself, until growing crowds forced them to rent a private field on Old Dover Road in 1877. Rectory Field, laid out in the grounds of Charlton Rectory, opened six years later in 1883.

Morden Cricket Club, who themselves had been suffering from overcrowding on the Heath, then asked Blackheath if they could share Rectory Field. This resulted in July 1885 in the formation of the **Blackheath Cricket, Football and Lawn Tennis Company**, which negotiated a 21 year lease of the ground and used its capital of £5,000 for the construction of the pavilion. (Having bought the freehold in 1921, the company still operates today, as does its three sporting sections.)

Since the 1960s the pavilion's central roof lantern has been removed, as has the first floor viewing balcony. Extensions have been added to both the front and sides. But the core is still just about recognisable, and if no great architectural treasure, certainly the building has proved its durability, and is packed with memorabilia (relating not only to Blackheath but also to the **Barbarians**, a touring club formed by Blackheath player William Percy Carpmael in 1890).

Visiting Rectory Field today, with its single entrance off Charlton Road and its leafy surrounds, it is hard to imagine how an estimated 18,000 packed the ground for England v. Scotland in 1901.

On the other hand, there were originally two entrances and more space behind the south touchline, where in 1923 a comparatively large timber stand was built, seating 2,000, with a paddock, or terrace for 6,000 in front.

In this guise Rectory Field hosted an annual pre-Wimbledon tennis tournament and a number

of Kent County cricket matches, thus making up, as far as London cricket fans were concerned, for Kent's departure from Catford Bridge in 1921 (*see page 204*).

But after suffering war time damage the wooden stand had to come down in the late 1960s. A further loss was the enforced sale of car parking space behind the stand in the eary 1970s in order for the neighbouring Bluecoat School to expand. This made it impossible to host county cricket games, a real blow to all parties at Blackheath. But at least the proceeds of the sale helped fund the 600 seat **Peter Piper Stand** (*opposite centre*), built on what had been the paddock of the old stand.

Rectory Field aside, Blackheath FC hold an important place in the wider story of London rugby.

Firstly, they are the capital's oldest 'open' rugby club, having started out in 1858 as the team of the Blackheath Proprietary School, before becoming 'open' – in the sense of admitting players other than pupils or old boys – in 1862.

Only one other 'open' club is thought to be older, Liverpool St Helens, founded in 1857.

A plaque marking the location of the Proprietary School may be seen on the front of Selwyn Court, a 1930s block of flats in Blackheath Village.

Secondly, in 1864 Blackheath played a pivotal role in rugby history when, having become founder members of the Football Association in October 1863, they decided three months later to withdraw over a ruling that 'hacking' (that is, kicking one's opponent's shins), be outlawed.

As Adrian Harvey has written (*see Links*), Blackheath's dispute with the FA was never just about that one rule. Besides which there were several other like-minded London clubs quite content to carry on as they were, playing

to rugby rules. One of them was Richmond, whom Blackheath played under rugby rules for the first time in January 1864, a few weeks after the split with the FA.

As these two clubs have carried on playing each other annually, this fixture is now regarded as the oldest in club rugby.

(Note however that both retain the suffix FC, rather than RFC.)

Blackheath and Richmond also have in common their decision to follow the likes of Harlequins and Saracens by creating two separate arms, professional and amateur, in 1996, but then subsequently to reverse that decision.

Backed by former player Frank McCarthy (known affectionately as 'Frank the Bank'), Blackheath tried their best to compete as professionals. But after McCarthy's death in 1999, and the failure of a share issue, Blackheath's members voted in January 2000 to revert to the original model of a unified club, living within its means.

For most members this *volte-face* was a huge relief. And yet as long as there are other clubs prepared to pay generous match fees and expenses, clubs like Blackheath, for all their history, will struggle to hang on to their best players.

That said, in 2013 Blackheath were drawing average crowds of 800 and had 1,300 members, juniors and women included. In fact it was Blackheath's women who, in the spirit of the club's founders, helped organise the first ever women's England v. Scotland international, in 1992.

It was played on Blackheath, naturally, opposite the **Princess of Wales pub** on **Montpelier Row**, where as a plaque records (*below left*), the first men's international had been planned in 1871, and where several clubs used to meet.

It is another corner of Blackheath well worth visiting for its array of sporting memorabilia.

▲ While Blackheath and Richmond have stayed put, four clubs formed in the Hampstead area have had to travel far and wide to find homes.

They are Harlequins, Saracens, Rosslyn Park and **Wasps**, whose badge, as seen on this club cap – supplied by athletic outfitter **George Lewin & Co** of Crooked Lane – has barely changed since 1873.

Formed in 1867 in Primrose Hill by old boys of Merchant Taylors' and by students at University College Hospital, Wasps have had at least 14 home grounds. For sure, as in most sports, the march of bricks and mortar has been a factor in this. But in common with many rugby clubs, Wasps' early wanderings were equally a consequence of them being more interested in playing, and in the social side of rugby, than in the provision of spectator facilities.

As such they often lived a largely hand to mouth existence, funded by members' subscriptions, modest gate receipts and regular handouts from benefactors.

Blackheath and Richmond avoided this by combining with other sports clubs to form a holding company that could then develop their respective grounds. But they were the exceptions.

That Wasps and other clubs were able to survive repeated moves says much about their collective spirit. It reflects also the mobility, and by implication the wealth, of their players and supporters, able to undertake long treks across the city on a regular basis.

Wasps' first grounds were near Hampstead Heath and off Finchley Road. In 1872 they headed west to Lillie Bridge, then to Beaufort House in 1876 (*see page 306*). During the 1880s they were based at the Half Moon ground in Putney.

From there they moved north to Chiswick in 1892, south to Balham in 1894, then west, courtesy of Albert Toley (*page 34*) in 1895 to Wormwood Scrubs, followed by Horn Lane, Acton, in 1907.

Finally, with assistance from the RFU, in 1923 Wasps settled at Vale Farm, Sudbury, where they built an 800 seat stand in 1953, a smart pavilion in 1963, created three highly praised pitches, issued a regular magazine (*The Buzz*, of course) and remained seemingly content until... 1995. That year again.

Clearly the club could not play as professionals at Sudbury. It was a rugby ground, not a stadium.

Instead, Chris Wright of the Chrysalis group, bought Wasps and that other once itinerant club, Queen's Park Rangers, so that both could share Loftus Road. Sudbury was then sold for housing – Wasps' clubhouse is now a Hindu community centre, backing onto Hastings Close – while the former North Thames Gas Board ground on Twyford Avenue, Acton (*page 246*), was bought for both clubs to share for training.

There were successes. Wasps were the first champions of the professional era in 1997 and won the prestigious Heineken Cup in 2004 and 2007. But as a business the venture went spectacularly wrong, leaving a mountain of debt.

From the wreckage, Twyford Avenue has survived, now in the care of Wasps FC, the club's amateur outfit. But after emerging from receivership, London Wasps, the professional club, now play at ground number fourteen, that of Wycombe Wanderers FC, 22 miles to the west. After 73 settled years at Sudbury, for the Wasps faithful, it was back on the road.

▲ Ever since Scottish 'goffers' gathered on Blackheath in the 17th century (*see Chapter 21*), sport has acted as a magnet for the capital's ex-pat communities. In rugby, **London Scottish** – whose matches at the **Richmond Athletic Ground** are always accompanied by kilted pipers – were the first of the 'Exiles' to form, in 1878.

They were followed by London Welsh (1885), London Irish (1898), London New Zealand (1926), London French (1959), London Cornish (1962), London Japanese (1979), London Nigerian (1991), London South Africa (2005) and London Italian (2007).

For all these clubs, inevitably there remains the issue of how 'open' they can be without losing their identity. London Scottish, for example, who are members of both the RFU and the Scottish Rugby Union, and who have provided more Scottish internationals than any other club, have an entirely Scottish directorate, with Scottish companies acting as sponsors. But when it comes to the first team they have had to set a realistic minimum of one third of the squad being Scottish, or having Scottish links.

It seems to have worked. After a calamitous collapse in the early years of professionalism the Exiles have fought their way back to the second tier of the national league – encouraged all the way by Ralph, one of their pipers, who just happens to hail from Chicago.

▲ Overlooked by William Chambers' splendid pagoda in Kew Gardens, the **Old Deer Park** has, as its name suggests, been hosting 'sport' for some time; since the 15th century in fact, when this verdant expanse on the banks of the Thames was enclosed as hunting grounds by Henry VI. Two centuries on James I enlarged the park to its current extent of some 363 acres; a now Grade I listed landscape that, in addition to the Kew Observatory, encompasses five current sporting facilities, shown on the map below.

Until the railway cleft the two areas apart in 1848, the Old Deer Park bordered another historic place of sport, **Richmond Green** (**A**).

This is where cricket has been played since at least 1666 (*page 198*) and where **Richmond FC** started off in 1861, formed by military students who had no idea that only cricket and bowls were legally permitted on the green.

They were allowed to play on nevertheless until, in time, they faced the same problems that bedevilled teams on Blackheath; that is, crowd incursions and

opposition from local residents.

Richmond Cricket Club, formed in 1862, were in the same boat but, having good local connections, in 1865 they were able to negotiate from the Crown Estate the lease of what has since become known as the **Old Deer Park Sports Ground** (**B**).

Rugby was first staged there in 1866, which gives this corner of the park a claim to be the oldest ground in club rugby, although strictly it was not until 1872 that **Richmond FC** became formal co-tenants with the cricket club.

These two were joined by clubs for archery and tennis (1873), hockey (1874), bowls (1922) and squash (1969). In November 1878 the ground also staged London's first floodlit rugby match, although it was not a success.

As it transpired Richmond FC did not stay for long. In 1889 they moved to a second ground formed within the park, the **Richmond Athletic Ground** (**C**), or **RAG** (*see opposite*).

In the meantime, 217 acres around the Observatory were laid

out for the **Royal Mid-Surrey Golf Club** (**D**) in 1892 – *The Spectator* called this a 'very deplorable blemish' on the park – while six years later Richmond Borough Council laid out the **Old Deer Park Recreation Ground** (**E**). A corner of this ground was then developed in 1966 as the **Pools on the Park** complex (**F**).

Returning to rugby and the Old Deer Park ground (**B**), **London Scottish** played there in 1893-94 before they too moved to the RAG. Next came two clubs, **Old Merchant Taylors'** (until 1922) and **Rosslyn Park**, who in 1957 made way for **London Welsh**.

After 36, frequently muddy years at Herne Hill (*page 320*), London Welsh were thrilled with their new surrounds, and raised £7,500 towards the 760 seat stand seen above. Opened in September 1957, from 1966-73 the stand and pagoda formed the backdrop to a golden era. Often London Welsh fielded 14 internationals at a time, and when Cardiff visited in 1972 the crowd exceeded 10,000.

Nowadays life in the Old Deer Park ground is somewhat quieter, London Welsh's first XV having moved out to Oxford in 2012.

Yet with the club's offices and amateurs still based there, and with five other sports firmly ensconced – only the hockey club have chosen to leave – the Old Deer Park remains one of the few Victorian grounds in London to have maintained a genuine multi-sport profile, while retaining much of its Arcadian charm.

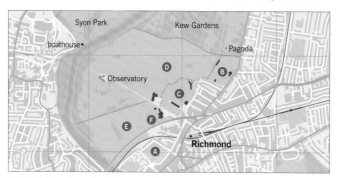

Contains Ordnance Survey data © Crown copyright and database right (2014)

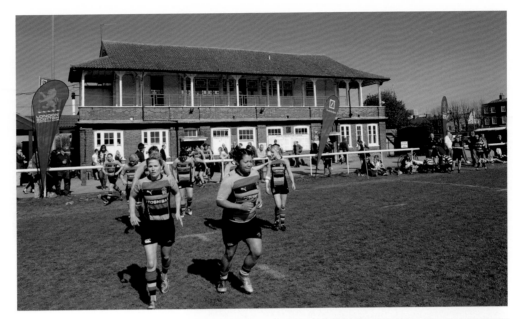

▶ **Richmond Ladies' Second XV** step out to face the T-Birds of Thurrock at the **Richmond Athletic Ground** (RAG) in 2012, wearing colours adopted by the club in 1867 after a player saw Belgian soldiers on parade in London.

In common with their old rivals Blackheath, Richmond have, since their near disastrous brush with professionalism in the late 1990s, managed to bounce back thanks to the generosity of their members.

True, the RAG, with its current capacity of 5,000, could not host matches in the Premiership, should that need arise. Nor are the Crown Estate or Richmond Borough Council ever likely to sanction a stadium on the site. But with seven pitches on its 26 acre expanse, the RAG is indisputably one of London's busiest rugby centres.

Between them resident clubs **Richmond FC** and **London Scottish** run 16 adult men's and women's teams, plus a similar number for juniors and minis (aged 6-12).

Rugby is, however, very much the cuckoo in this particular nest.

As noted opposite, **Richmond CC** decamped from **Richmond Green** to the **Old Deer Park** in 1865. But other clubs played on there, one of them being **Richmond Town CC**, composed mainly of tradesmen.

By the 1880s they too wanted to move on. Apart from mounting problems with crowds, in 1880 a boy was killed by a cricket ball, the second such fatality on the Green.

The obvious move was to follow Richmond CC to the Old Deer Park. But because the rent there was high, in 1885 two of the Town CC members joined up with Edwin Ash of Richmond FC to launch the **Richmond Town Cricket Ground & Athletic Association Ltd.**

This company was then able to provide the Crown Estate with the necessary guarantees for the lease of nine acres of the park.

As at Blackheath, the company invested its capital in laying out a ground and constructing both an 800 seat timber grandstand and a brick pavilion. Still in use and listed Grade II in 1997, the pavilion faces on its south side the reserve pitch (*as seen top right*), and on its north side has another balcony topped by an ornate gable, facing the main pitch (*above right*).

Growing to over 20 acres by 1896, the RAG emerged as one of London's most prominent grounds.

Richmond FC moved there in 1889. In 1893 it hosted an England v. Scotland football international, followed in 1894 by the first ever FA Amateur Cup Final. Also in 1894 London Scottish moved in, so that in the period before Twickenham opened in 1909 the RAG overtook Blackheath as London's preferred international rugby venue.

Other sports included cycling, athletics, bowls, hockey and tennis. These were supplemented by dog shows, flower shows, and from 1892-1967 by the **Royal Richmond Horse Show**, which at its peak was very much part of the London season.

But cricket? Alas for Richmond Town CC they, the originators of the ground scheme, were eased out in 1958, never to return. They later moved to Sunbury and have since been renamed Kempton CC.

One of the factors in this rugby takeover had been the need to raise £30,000 for a new stand, after the old timber one burnt down during the 1957 Horse Show.

Seating 960 and designed by Manning & Clamp architects and Jenkins & Potter engineers, the stand (*right*) features a rare example, in Britain at least, of a cantilevered roof, barely 11cm thick, created purely in reinforced concrete (*see Chapter 10*).

Together with both the 1957 stand (*opposite*) and 1969 pavilion at the Old Deer Park ground (*page 209*), and the 1966 Pools on the Park (*page 165*), the RAG stand makes this corner a real draw for lovers of post war architecture.

In the RAG clubhouse (*right*) a memorial lists the 260 members of Richmond and London Scottish who gave their lives in two world wars. It was the sacrifice made by so many rugby players during 1914-18 that set off the 'rush to rugby', a 1920s trend that saw numerous public schools, Harrow included, drop soccer in favour of what was now seen as the more manly and patriotic oval ball game.

▲ Staying in south west London's 'rugby belt', a couple of miles along the road from Richmond is the ground of **Rosslyn Park** on **Priory Lane**, Roehampton.

Barnes lies to the north, while immediately behind the ground to the south is the exclusive Roehampton Club (offering golf, tennis, squash, croquet and an indoor pool). This adjoins the ultra modern National Tennis Centre (*see page 302*) and the sumptuous Bank of England Sports Club.

Rosslyn Park's home ground, in contrast, is about as basic as a ground can be whilst still charging for admission (from its single turnstile).

The main stand (*top right*), dating from 1957, is a rickety, intimate 350 seat structure clad in corrugated iron, while across the pitch is a low, narrow shelter (*above*). The single storey brick clubhouse behind one goal is, to put it politely, functional.

Not that this, nor the rumbling of traffic on the adjoining South Circular, nor the overhead roar of planes *en route* to Heathrow, need be a deterrent.

On the contrary, should any Londoner wish to sample the ambience, not to mention the beer and chips of a traditional rugby club, one apparently untainted by the gold rush of the late 1990s, and yet still remain competitive at a national level – no mean feat in the current climate – Priory Lane is absolutely *the* place to go.

Distinct in their hooped red and white shirts, 'Park' were formed in the Rosslyn Hill area of Hampstead in 1879. Storing their goalposts at the White Horse pub (still extant), their first pitch was near South End Green, where a club member called Lionel Roberts recorded their matches in a precise, and precious handwritten journal that remains proudly in the club's possession.

(That the club has an archive *and* archivist is, in itself, noteworthy.)

Subsequently Park moved to Gospel Oak, then to Gunnersbury Lane, Acton. It was from there that in 1892, partly at the behest of the rugby-loving Pierre de Coubertin, founder of the modern Olympics, Park travelled to Paris to become the first English club (rugby or football) to play on the Continent.

From this encounter Park treasure an exquisite item of silverware presented by the French; a piece featured in an earlier book in the *Played in Britain* series, *The British Olympics (see Links)*.

As noted earlier, in 1894 Park settled at the Old Deer Park.

During their time there, in 1939 the club organised the first Schools Sevens Tournament, an event that has since grown to become the largest of its kind in the world, involving over 7,000 boys and girls on various pitches, not on Priory Lane but around Wimbledon.

The reason for this is that Priory Lane lacks one important asset, and that is space.

When in 1957 Park first became tenants of the Roehampton Club – which since its own formation in 1902 had used this part of their grounds for polo and tennis – they rather assumed that there would be room for two pitches (that being the

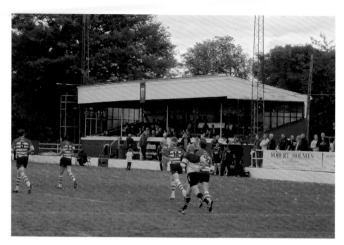

minimum most rugby clubs need to operate their various XVs). But soon after moving, Wandsworth Borough Council compulsorily purchased the western end of the site for housing.

This housing, on Woking Close, also swallowed up the far end of the site, on the corner of Priory Lane, which since 1934 had been occupied by the Roehampton Open Air Baths (*see page 158*).

So one pitch only it was, and has remained, which is why Park players have become wearily accustomed over the years to trekking out to sundry pitches around the Richmond area, and why, in 2013, plans were drawn up for an artificial pitch to be laid similar to that of Saracens' (*see opposite*), so that more games can be staged at Priory Lane.

Lucky **Saracens**, meanwhile, lease not one ground but two, one of which has three pitches.

Formed in 1876 in Primrose Hill, Sarries had eleven grounds before renting **Bramley Road** from Southgate Borough Council in 1945, originally on condition that they charged entry for no more than six matches per season.

Seen above is their stand, built in 1951. In 1971 it witnessed a crowd of 5,000, but more typically gates rarely exceeded four figures.

Yet as we have noted, in 2012 Saracens played Harlequins at Wembley, a football stadium no less, in front of 83,761, a record for any club rugby match ever played.

Rosslyn Park and Saracens were once all but equals. But then someone moved the goalposts.

Purchased as grazing land for the GWR's workhorses, then converted into the company's sports ground in 1900, this 18 acre site on Vallis Way W13 (*right*), was taken over by Trailfinders in 1997, and since 1999 has been the home of Ealing. Formed in 1871, Ealing attract gates of 4–600 yet, like Rosslyn Park, remain competitive at a national level. Unlike 'Park', having two pitches does help though.

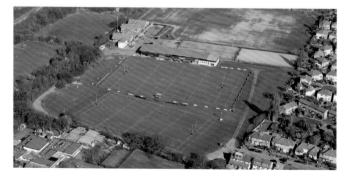

▲ May 2013, and watched by a capacity crowd of 10,000, Mako Vunipola touches down for **Saracens** in an Aviva Premiership match v. Bath at **Allianz Park** in **Mill Hill**.

Or put another way, in a league sponsored by one insurance group (British), in a stadium sponsored by another (German), a Kiwi of Tongan parentage scores for a club named after medieval Muslim warriors – a club that, no kidding, merged in 1879 with another club called the Crusaders – and that is now backed jointly by South African investors and by a British businessman, Nigel Wray, who made part of his fortune from shares in Domino's Pizza and has since amassed the nation's largest collection of sporting art and memorabilia, the Priory Collection.

But of course the story is far more layered than that.

As someone who attended Mill Hill School and used to play rugby for Old Millhillians, Wray will have known just how tough a challenge Saracens faced in gaining a foothold in this particular corner of London, surrounded as it is by playing fields and detached homes in quiet roads.

Copthall Stadium, as Allianz Park was formerly known, was, according to its regulars, including **Shaftesbury Barnet Harriers AC**, a

vital athletics facility. Or, according to its detractors, a scandalously under-used public resource.

Opened in 1964 the stadium had staged rugby before. From 1993-95 it was the home of a rugby league club, coincidentally also called the Crusaders, later renamed the Broncos (see page 273).

In 1997 Barnet FC gained consent to revamp Copthall for football, with the track resited to an adjoining area, only to be rebuffed by a government planning inspector. A decade later, Saracens, proposing to keep the track where it was, got the nod instead.

Unveiled in February 2013, their £20 million redevelopment saw the upgrade of the stadium's classic 1960s West Stand (see page 114). Both ends of the track

were covered by temporary stands, each seating 1,100, while, as seen above, a permanent 4,800 seat East Stand was built to the designs of architects Roberts Limbrick.

But most radical of all was the pitch. For not only have Saracens become the first rugby union club in the world to play competitively on an artificial surface, but come the end of the season the edges of the pitch are rolled up, the temporary stands removed, and the track brought back into use for summer athletics.

Allianz Park is the 14th ground Sarries have called home. Before Bramley Road, where their amateur forebears are still based (see opposite) they had played in Crouch End, Muswell Hill, Tufnell Park and Winchmore Hill. After

turning pro they shared briefly with Enfield FC then spent 15 years at Watford. So Mill Hill, it could be said, does represent a return of sorts to their north London roots.

Sarries have also staged recent 'home' matches at Twickenham, at Wembley and, as shown on the inside of the back cover, at the HAC ground in the City of London.

In 'growing their fanbase', Saracens have proved to be masters of marketing. But in the context of English rugby and of local authority sports provision overall, more intriguing still is the Sarries' use of the new pitch combined with the reincarnation of an athletics stadium, both of which beg the obvious question: is what we see here the future?

Or is it merely a jolly fine try?

Groundsmen look away now – far from discouraging pitch invasions Saracens positively invite fans to inspect their new 3G surface at Allianz Park. Dig down and amid the two tone 'polyethylene fibrillated yarn' can be felt tiny granules of rubber, added to absorb the impact of a flying prop forward. Verdict so far? Not a single complaint, not even from losing visitors.

▲ After their first visit to the site of the proposed new ground at **Twickenham** in 1907, the RFU's chairman, William Cail, president Charles Crane, and members of the Ground Committee repaired to the **Railway Tavern** on **London Road**, opposite Twickenham station.

If at that point they harboured any doubts, it was too late. The RFU were now the owners of a remote 10 acre site, almost a mile from the nearest station, not on any bus route, prone to flooding and rather too close for comfort to the Mogden sewage works.

After Twickenham opened in October 1909 with a match between Harlequins – who agreed to stage their first XV matches there – and Richmond, most reports focused on how difficult it was to get there. Someone sneeringly called the new ground 'Billy Williams' Cabbage Patch'.

Williams, a land agent, rugby referee, MCC cricketer and former Harlequins player had indeed put forward the site to the RFU. But it was William Cail who drove the scheme and who agreed to the site, because, as Ed Harris writes in his history of the stadium (see *Links*), it was all the RFU could afford.

And it had been an orchard, not a cabbage patch.

In time the taunt evolved into an affectionate nickname, as reflected by the fact that since the 1970s, as seen above, the Railway Tavern has traded under a new name.

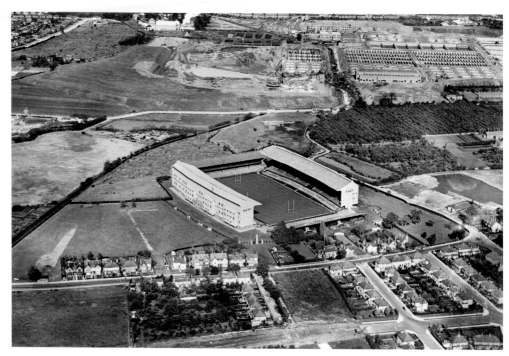

▲ As Kevin Costner's Ray Kinsella almost put it in the 1989 baseball epic, *Field of Dreams*, 'Build it and they will come'. And so they did.

For the novelist and one time Rosslyn Park player, Alec Waugh, a big match at **Twickenham** became as much a gathering of the clans as a sporting event.

Perhaps the ground's remoteness actually added to rugby union's sense of itself as a game apart, for players and aficionados only.

Seen here from the south, with the sewage works in the distance, **Twickenham** certainly still had the look of an outpost in 1935. (Just out of view to the west lies the area's other main landmark, Kneller Hall, home since 1857 to the Royal Military School of Music).

But if Twickenham was still, as earlier critics had complained, 'fearsomely remote from Piccadilly Circus', London's spread westwards had rendered the ground more accessible, by road at least. A bus service had started in 1924, while in 1933 the completion of Twickenham Bridge provided a direct road link, coincidentally, from Richmond and the Old Deer Park.

The bridge in turn paved the way for the construction of the Great Chertsey Road, or A316, a vital artery seen above in mid-construction in the foreground.

During the same period the RFU extended their land holding to 32 acres, providing enough room to park 3,000 cars.

Seen here is the ground at the end of this second phase of development. Carried out between 1925-31, this expanded the ground's original capacity of 30,000 (including 6,000 seats divided between two small stands named A and B), to 74,000 overall, including 27,500 seats.

At the far end, the two-tier North Stand had been designed and built by the now familiar double act of Archibald Leitch and Humphreys of Knightsbridge (see *previous chapter*). On its opening day in January 1925, a then world record crowd for rugby of 60,000 packed Twickenham for the visit of New Zealand.

This was followed in 1927 (the year that 'Twickers' hosted the BBC's first outside broadcast) by the completion of the East Stand (seen below in 1990), and in 1931 by its mirror image on the west. (Humphreys were again the

contractors. The extent of Leitch's involvement is unclear, despite both stands having his trademark criss-cross balcony trusses.)

Only the South Terrace, now fitted with patented Leitch barriers, remained open. Partly this was to keep the pitch ventilated, partly it was owing to the proximity of houses on Whitton Road (which remained an obstacle to stand construction until the RFU was able to buy them all in the 1970s).

But in any case, this terrace was now regarded in rugby circles as a hallowed hump, where players, past and present, would gather on international match days to pass judgement on the finer points of the action.

Built during a time of economic hardship, the £135,000 costs of Twickenham's redevelopment did not please everyone. RFU grants to rugby clubs, on which many depended, had to be suspended while the debts were paid off.

Yet the new look ground could not be described as indulgent.

All three stands were hardly more than steel-framed barns, with minimal facilities other than in the West Stand, which now housed the offices of the RFU (originally located on Surrey Street, off the Strand). Because of this Twickenham became known to those in the inner circle simply as 'HQ'.

Otherwise, here was a thoroughly manly enclosure. No frills, no fuss.

Rugby union to its core.

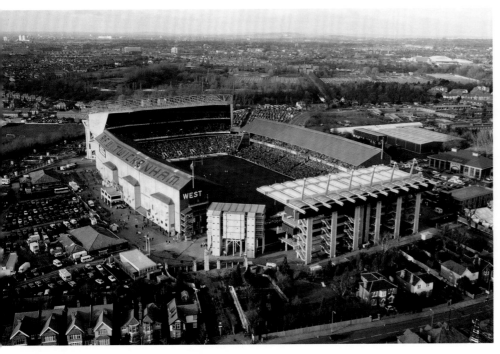

▲ Viewed from the south in 1991, this was **Twickenham** at a critical juncture in its development.

▲ Embroidered onto the **England shirt** of Harlequins player **Ronnie Poulton**, in 1914, this rose is one of many fine treasures held at the **World Rugby Museum**. Opened at **Twickenham** in 1996, the museum houses the largest rugby collection and archive in the world.

Although it would be another four years before the payment of players was sanctioned, behind the scenes, slowly but surely the RFU had been nudged into the modern era.

In 1966 an application to build a South Stand had been turned down, partly because it would have overshadowed the houses on Whitton Road. To overcome this the RFU set about buying up as many of the houses as possible.

The RFU were then hit by costly remedial measures required under the 1975 Safety of Sports Grounds Act. Forced to explore additional income streams to fund these works the RFU found themselves in untested waters, talking to hotel chains and supermarkets about joint developments on the site. At one point the RFU even considered relocating.

As it was, the men in blazers had no choice but to accept the presence of advertising hoardings for the first time. To raise further income, in 1980 the RFU registered both the 'Twickenham Rose' as it appeared on England shirts (*top right*) and the image of Hermes, as it appeared on the stadium's famous weathervane.

This more commercial approach may have dismayed the old school, but it yielded dividends when a second attempt to build a South Stand won approval in 1979.

Designed by Jan Bobrowski (engineers) and the Howard Lobb Partnership (architects), the £3.8 million stand (*seen above in the foreground*) was completed in February 1981 and was similar in form to two stands by the same design team at Cheltenham and Goodwood racecourses; that is, constructed using pre-cast concrete and cable-stayed cantilevered beams spanned by translucent, vaulted pvc roof panels (*see page 114*).

Watford FC had a smaller version built in 1986 at Vicarage Road.

Twickenham traditionalists were not amused. Some considered it a racecourse stand that looked out of place. Certainly it towered over the existing three pre war stands. But in another sense the South Stand was to prove a vital stepping stone in the RFU's learning curve.

Within the shell of the stand was space for twelve executive boxes. Having overspent on the project, the RFU were reluctant to fit these out. Besides which, all this modern corporate hospitality nonsense, that was not the rugby way at all.

Begging to differ, the designers made a proposal. They would fit out two boxes at their own expense, for their own use, after which the RFU were welcome to see them in operation and then decide.

By the end of the following year all twelve boxes had been fitted out and gleefully snapped up.

Not only that but by the mid 1980s a new broom had swept through the RFU, and with league rugby now about to show how large the audience for the game could be, if marketed properly, a new masterplan for Twickenham was commissioned.

Having decided not to continue the South Stand design further, a fresh design team was appointed in 1988, by which time the ground's licensed capacity had fallen to just 62,000. Most internationals were four to five times oversubscribed.

Drawn up by the Husband Design Group, the first phase of the masterplan was the North Stand.

This is the three tier stand seen at the far end (*above*), beyond which lay allotments that the RFU had to buy for £1.5 million in order to provide the extra car parking spaces that were now required as part of the planning consent.

Had the Husband masterplan been completed as planned, with standing on the lower tier, Twickenham's capacity could have neared 120,000. But two months before Mowlem, the contractors, started work on the North Stand in 1989, disaster struck at Hillsborough. From that point on, only seating was to be permitted.

Added to which, construction costs were now soaring.

As Twickenham hosted the 1991 World Cup Final, rugby union stood at a crossroads, caught between the past and the future.

Just like Twickenham itself.

The red rose has various associations in English history, but its choice as an emblem for the England team – made before the first international in 1871 – may be owing to the fact that it appeared also on the crest of Rugby School.

Similarly, the choice of white shirts and shorts for the England team may have been copied from Rugby, at a time when most public school teams played in white kit, because it could be boil washed without the colours running.

Poulton's rose was not standard issue. Before 1920 every player had to provide their own rose and sew it onto their shirt. (The same applied in amateur athletics.)

Poulton, alas, never wore the shirt again. A sniper's bullet felled him in the trenches in 1915.

Other treasures in the museum include, from the world's first international match in March 1871, both the oldest surviving England shirt, worn by JH Clayton, and the oldest England cap, awarded to Arthur Guillemard. (A Scottish cap from the match also survives and can be seen in *Played in Glasgow*, *see Links*). Ten of England's team that day had gone to Rugby School.

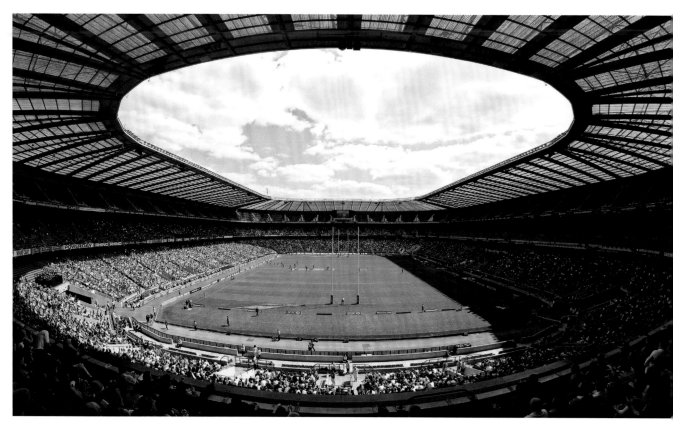

▲ The home of English rugby union, effectively the third stadium to have occupied the **Twickenham** site since 1909, is paradoxically a rather un-English sort of venue.

For a start it is relatively rare for any stadium operator in Britain to stick with the same design team over an extended period. At Twickenham, unusually, four stands were built over the 17 years from 1989-2006 by essentially the same team. Their constituent names would change. Mowlem the contractors became Carillion, while the Sheffield-based Husband Design Group were first absorbed by Mott MacDonald and later became Ward McHugh Associates.

But throughout the entire process the common denominator was architect Terry Ward.

Not only did this continuity

result in a relatively pain free process but it also helped keep costs down. Learning as they went along, planning in advance and taking advantage of falling building costs, the RFU and their team were able to complete the project for no more than £250 million – astonishing value considering that extra land had to be purchased, houses bought and demolished, four older stands and an office block demolished, and a number of other planning requirements met.

On top of which Twickenham now seats 82,000, making it London (and Britain's) second largest 'colosseum' after Wembley, and houses a host of other revenue-earning facilities. The last piece in the jigsaw in particular, the South Stand – which replaced the 1981 original after only 24 years' use –

includes a 156 room hotel, a 400 seat community arts theatre, a fitness centre, superstore and RFU offices, and forms a new public face for the stadium on Whitton Road.

As a result, from the exterior the South Stand forms an obvious departure from the earlier three. It also has corner ramps rather than the exposed stair towers that feature so prominently on the earlier stands (*as seen below*).

However, from inside (*above*), apart from the roof of the South Stand being more translucent, the bowl appears virtually seamless.

What cannot be denied is that the new Twickenham divides opinion. One architectural critic called it an 'aggressive, oversized, depressing concrete monstrosity'. The actor and rugby enthusiast Colin Welland

described it as 'without warmth, intimacy and conviviality'.

But to put its design in context, Twickenham is actually what many a large stadium designed during the 1980s looks like, be it in Germany, Italy, North or even South America. If it was a shock to English sensibilities perhaps that was because nothing else of this scale ever emerged in this country during that period.

Another critic called Twickenham 'a frightful scar on the view from (Richmond) Hill... as ugly as the great gasholder at Southall'. He asked in the local newspaper, could not 'the stark hideousness of (the) naked grey concrete' be painted, or, better still, masked by trees?

That was in 1931, however, referring to stands that, in time, came to be treasured as classics.

'Fortress Twickenham' from the north in 2011 – a lumpen monstrosity to some, heaven on earth for others. In the distance, a mere 700 yards to the south, lies the Twickenham Stoop Stadium, home of Harlequins, who were tenants of the RFU until finally striking out on their own in 1990. Nowhere in London are two such high profile stadiums in such close proximity.

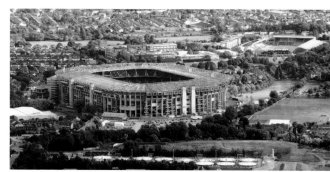

▶ Other than the admirable World Rugby Museum in the East Stand, the modern day **Twickenham** can seem disconnected from rugby's heritage. But there is one other place in which the past resonates strongly. On the west side of the stadium, high up on a Portland stone pier in the centre of the main gateway stands a **golden lion**.

Given that on an international match day fans typically consume up to 120,000 pints inside the stadium – thanks to an advanced dispensing system able to pour a pint in just under three seconds – it seems appropriate that the lion's original home was a brewery.

The Lion Brewery, built on the south bank of the Thames in 1837, just as rugby itself was evolving, was adorned with at least three lions, modelled in a material called Coade's Artificial Stone (actually a form of ceramic stoneware). When the brewery was demolished in 1948 to make way for the Royal Festival Hall the largest of the lions, on the building's river frontage, was rescued, apparently at the behest of George VI, and relocated to the entrance of Waterloo Station. It was then moved in 1966 to the southern end of Westminster Bridge, where it remains today.

The Twickenham lion, meanwhile, smaller in scale but more menacing in its expression, and thought to be one of a pair from another part of the Lion Brewery, remained in storage until the GLC presented it to the RFU to mark their centenary in 1971.

Its gilding was added at the time of the gate's reconstruction in 1996, but the pier on which it stands is older, having been erected in 1929 as part of a memorial created in honour of **Sir George Rowland Hill** (1855-1928).

A Greenwich man all his life, Hill was born in the Queen's House – his father was headmaster of the Royal Hospital School – and was 16 when the rugby club he played for, also called Queen's House, and which his brother had formed, became founder members of the RFU.

For most of his working life Hill was Record Keeper at Somerset House. In his spare time he became a much respected referee and a Conservative councillor on the LCC. He played a leading role in securing Rectory Field for his local club, Blackheath. But the reason for the memorial is that

from 1881-1904, Hill served as the RFU's Honorary Secretary.

It was during this period of office that, as cited in that *Punch* verse on page 258, Hill helped precipitate rugby's 'Great Schism' by refusing outright to countenance 'broken time' payments to players at northern clubs.

A passionate and apparently spell binding speaker, Hill inveighed time and time again against the forces of 'commercial speculation' in the game. In return he was elected President of the RFU for three years in succession. In 1926 he became the first man to be knighted for services to the game.

It says even more of the man that £6,500 was raised for his memorial at a time of economic crisis nationally and when the RFU were having to borrow heavily from the banks to build new stands.

The RFU had to go through a similar process to rebuild the stadium as we see it today, borrowing eye-watering sums while selling thousands of debentures to wealthy supporters.

In the process, almost everything that Hill stood for a century earlier was turned on its head. Players were now professional and, almost worse, for this devout Christian,

they played on Sundays.

Hill might have been only marginally less horrified that in order to help pay for Twickenham's redevelopment, the RFU actively courted other sports. In 2000 there were talks concerning the stadium's suitability to host the 2005 World Athletics Championships. And while approaches from Wimbledon FC and Fulham to play football at Twickenham were turned down, the RFU did say it would welcome Premiership clubs wanting to play occasional European ties there.

As it has transpired, however, only one other sport has been played at Twickenham in recent years. Again Sir George would not have stood for it for a moment. But in October 2000 Twickenham hosted England v. Australia, the opening match of the Rugby League World Cup. This was followed by the Rugby League Challenge Cup Final in April 2001, when Wembley was out of action.

In his *Times* obituary Hill was described as 'an amateur of amateurs'. As such, the modern Twickenham would appear entirely alien to him. Except perhaps the fine wine cellar, still to be found in the depths of the West Stand.

Some traditions never die.

Designed in 1950 by artist Kenneth Dalgleish and depicting the winged messenger, Hermes, sending a pass to an earthly team mate, this weathervane is the only bit of the old Twickenham still visible from inside the new. For years it looked down on the South Terrace, where TV cameramen routinely focused on it as part of their coverage. Today it sits on the stand roof in the south east corner.

▼ Like most newly completed stadiums **Twickenham** does its best to establish some linkage with the past by having bars and lounges named after legends of the game.

Plaques and artworks play a part too. On either side of the Rowland Hill memorial are four bronze figures of players in action (*as seen far left*) by sculptor **Gerald Laing**, while in front of the South Stand, by the same artist, is a powerfully poised 2010 work, entitled **Lineout** (*below*). A plaque at its base spells out what the RFU consider to be rugby union's core values, namely teamwork, discipline, respect and sportsmanship.

Nearby is another artwork called 'The Union Player'. Unveiled on the side of the East Stand in 1993, this was sculpted by, of all people, the one time Bermondsey heathrob, teen idol and actor, Tommy Steele.

'Core values' or 'cor blimey', each piece helps to soften Twickenham's daunting scale and hard edges. And there will be more such stadium dressing in the run up to the World Cup, due to be staged in 2015.

Should England triumph on that occasion, no doubt even more sculptures will follow. But just as importantly, HQ Mark Three will have secured its place in the nation's hearts and minds.

That is what Twickenham exists for. That is the sort of heritage that every stadium craves; to be a winning place, in every sense.

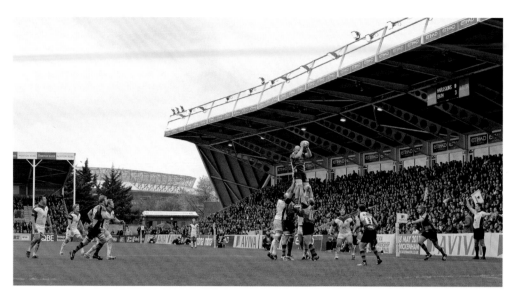

▲ With **Twickenham** looming in the background, a near capacity crowd of over 14,000 watches **Harlequins** (or, to give them their official title, **Harlequin FC**, in the singular) play Bath at **The Stoop** (or, to give it its official title, the **Twickenham Stoop Stadium**) in October 2010.

As we have noted, several rugby clubs in London have led nomadic existences, and in their early years Harlequins were no different. The Stoop is the 17th ground on which the club's first XV has played.

Yet in other respects Harlequins' story is unique, for as also noted, among those 17 grounds was Twickenham. The Stoop, moreover, is the only ground in London owned (rather then rented) by a rugby club that is large enough to host matches in the Aviva Premiership.

Its name derives not, as it might sound, from some ancient topological feature, but from **Adrian Dura Stoop** (1883-1957), Quins captain from 1906-14, secretary from 1905-14 and 1920-38, and president from 1920-49.

Stoop it was who, more than any other individual created the aura that, even over half a century after his death, still attaches to

Harlequins; an aura that for their admirers is founded upon an open playing style and old school sportsmanship, but which to their detractors is a manifestation of *hauteur* and the club's links with the rugby establishment.

What cannot be denied is that Harlequins have always lived up to their name. That is, they have seldom shrunk from the limelight.

Founded as Hampstead FC in 1866, their early matches took place at Hampstead Cricket Club's ground on Lymington Road, then at a ground named only as Finchley Road, before moving east to Highbury in 1869-70.

No longer identified with Hampstead but keen to retain their HFC monograms, the players dug out a dictionary and started reading out words starting with H.

What could have been a long session proved a doddle. With its waggish connotations, and at a time when rivals included the likes of Wasps, Mars and Flamingoes, 'harlequin' gained instant approval.

To go with their new moniker the Quins adopted a playing strip that remains arguably the most eccentric in British sport (*see opposite*).

A year later the club became founding members of the RFU.

But they signally failed to find a settled home. After leaving Highbury in 1872 Quins flitted from Tufnell Park to Belsize Road (near Swiss Cottage), followed by Putney Heath, Kensal Green, Stamford Brook, Turnham Green and Devonshire Park in Chiswick.

In 1883 they thought the ground of Chiswick Park CC might at last be the one, but this was sold to St Thomas's Hospital in 1897. The club then had two seasons at the Catford Cycle and Athletic Ground (*page 318*), followed by a further two seasons at the Wimbledon Polo Grounds.

Stoop, the son of a London-based Dutch stockbroker, arrived on the scene via Rugby and Oxford in 1902, by which time Quins were tenants of Heathfield CC on Wandsworth Common. (There is still a Heathfield Bowls Club in the area.) Wealthy enough not to need to pursue his career in the law, Stoop set about moulding Harlequins around his ideals and principles.

On the pitch he encouraged a new form of fluid, probing rugby

orchestrated by the half backs, with Stoop himself in the centre of the action. Under his tutelage, it was said, Quins played a form of rugby more akin to handball than football.

He also insisted the players cut down on their smoking, stick to beer rather than spirits, and that they play first and foremost for enjoyment, not for competition.

No doubt this was exactly the sort of attitude that persuaded the RFU in 1907 that Quins would be just the right sort of tenants for their proposed ground at Twickenham (not forgetting that Billy Williams was himself was a former Quin).

So it was that Stoop led his team out for the inaugural game at Twickenham in 1909, along with the aforementioned Ronnie Poulton. These two and other Quins players of the era would feature prominently in England's early internationals at the ground too.

For the RFU, Quins' tenancy proved crucial. It meant that the new ground was in regular use and that fans became accustomed to its location. For the Quins it was a mixed blessing. Despite the prestige of the venue (which arguably gave visiting teams a lift), and Quins' glamour as a team, they were never able to attract crowds commensurate with the ground's scale. Most matches were played against a backdrop of near empty, echoing stands.

Furthermore, there was nowhere at Twickenham where Quins could train or meet socially.

Hence in 1923 Stoop – now with an MC to his name after the Great War – and other Quins, set up a separate limited company and, for £2,125, bought a training ground on Fairfax Road in Teddington.

They raised a further £3,700 for a pavilion to be built by the two companies then busy working on the North Stand at Twickenham; who else but Messrs Leitch and Humphreys.

Adrian Stoop was one of eleven Quins to have served as president of the RFU, a record for one club. Being part of the establishment meant that they were also well connected. Thus it was often said that Quins were able to attract the best of the emerging Varsity players by arranging jobs for them in the City. (But then the same was also said of Blackheath and Richmond.) Another measure of

Harlequins' standing was that in 1951 the club was jokingly described as the third party in the House of Commons, larger even than the Liberals. Eleven MPs had played for the club, including two on the Labour benches. Among the Tories was the MP for St Marylebone, Sir Willam Wavell Wakefield, Stoop's successor as president of Harlequins and, like Stoop, a former England captain.

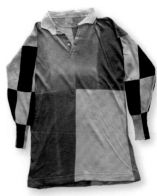

▲ Seen in 1968, this was the West Stand at **The Stoop** before it was replaced in 2005. But why a running track at a rugby ground?

After the Second World War the RFU started to limit Quins' use of Twickenham. For example no matches were allowed in October whilst the pitch was re-seeded.

So Quins took to staging more games at Fairfax Road, supplemented from 1954-60 by half a dozen or so per season in the vast bowl at White City (the best attended of which was 18,720 for the first rugby union match played under floodlights during the modern era, v. Cardiff, in October 1954).

In the spirit of the age, meanwhile, Twickenham Borough Council decided to build a municipal stadium on a former refuse dump on Craneford Way, opposite the RFU headquarters.

Designed by Borough Engineer Alfred Knolles and costing £100,000, apart from its use by local schools Harlequins were to be the main tenants, agreeing a 42 year lease for the use of the pitch and the top floor club rooms, at a reported annual rent of £2,300.

Quins unofficially opened the new venue with a veterans match in November 1963, unilaterally declaring that it was to be called the **Adrian Stoop Memorial Ground**.

A few weeks later a second club signed up as tenants, the newly formed **Twickenham Athletics Club**.

This was followed in August 1964 by an athletics meeting to mark the official opening of what the Council and local press called the **Twickenham Sports Stadium**.

However it was not long before

that same press was dubbing it a white elephant, costing ratepayers £20,000 a year to run. Criticism grew further after Twickenham was absorbed into the new borough of Richmond upon Thames in 1965.

Quins were not entirely happy either, because of the track. But the site did have room for two pitches and was handy for Twickenham, where the first XV continued to play whenever possible.

By the end of the decade a compromise presented itself.

For years the local authority had coveted Fairfax Road for school expansion. So in 1970 Quins agreed to sell their seven acres to Richmond Council for £185,000. The pavilion, no great loss, was demolished and Collis Primary School subsequently built on part of the site. (Harlequin Road now runs at the side.)

In return, Harlequins were able to negotiate a 999 year lease for the Craneford Way stadium site, which occupied 14 acres, for a bargain £90,000.

Arguably this was the best result in Quins' history, although it did not bode well for the athletics club. Clearly unwanted, they moved to Barn Elms in 1983.

But Harlequins were being squeezed out too, at least from Twickenham. Partly this was because of the stadium's growing schedule of matches. Partly it was because opening up the stadium for relatively small crowds was no longer cost effective, even though the advent of league rugby in the late 1980s did provide a welcome boost to Quins' gates.

The turning point came in

1990 as Quins played their last match at Twickenham (or so they imagined) and embarked on a £100,000 redevelopment of The Stoop, starting with the removal of the unloved track.

Come professionalism in 1996, Quins were in pole position. They had solid backing, owned their own ground and, as had been the case in 1909, a star studded team to usher in the new era.

Hence in barely a decade the **Twickenham Stoop Stadium**, as it was renamed in 2005, grew to its current all-seated capacity of 14,816, split among new four stands. Seen opposite is the East Stand, completed in 1997, and to its left, the temporary North Stand.

Quins' transition to the new era was not trouble-free. In 2005 they were relegated. Back in the top flight, during a match in 2009 one of their team was caught cheating, an incident subsequently dubbed 'Bloodgate'. Not least because of Quins' historic espousal of fair play, the scandal shook the rugby world.

Reputations were destroyed. Heads rolled. But Harlequins recovered, and in the process rekindled their relationship with Twickenham. In 2008 they had experimented by staging a home match there, just after Christmas. The 'Big Game', as it became tagged (complete with its own website) has since become an annual 82,000 sell out.

To have increased their regular support sufficiently to fill The Stoop would have been an achievement in itself. To fill Twickenham for a club match appears little short of miraculous, even if a good many in the crowd attend more for the *craic* than for the rugby.

But nor is Harlequins' fame limited to London. In 2013 there were 31 clubs around the world bearing the name Harlequins, several of them with close ties to the parent club and to each other, including six in the USA, five in Wales and others in South Africa, Kenya, Australia and New Zealand.

Quins are also closely involved with their amateur counterparts, based on Broom Road, Teddington, not far from Fairfax Road, and with the Harlequins Ladies club.

But most radical of all, in 2006 the club agreed to share The Stoop with a club also called Harlequins. What were they playing at?

Why, rugby league...

In pantomime the harlequin was celebrated for his garish, diamond-patterned outfits. Using quarters instead, Harlequins have lived up to this tradition. Adopted in 1870, the official club colours are 'light blue, magenta, chocolate, French grey, black and light green'. No other club strip, in Britain and possibly worldwide, is as multi-coloured. Seen above from the Quins' collection is one of the oldest shirts to have survived. Supplied by George Lewin, Athletic Outfitters of Crooked Lane (suppliers also of Wasps' caps, as we saw), it is thought to date from 1898. The Quins described their 2010 shirt (*below*) as marrying the 'classic Harlequin aesthetic' with 'fully sublimated, cutting edge Koolite polyester fabric' that offered 'excellent moisture-managing characteristics'.

LONDON HIGHFIELD
v
AUSTRALIA
THE AUSTRALIANS' FIRST
MATCH IN LONDON
UNDER FLOODLIGHT!

WEINGOTT

WHITE CITY STADIUM
WEDNESDAY. NOVEMBER 22nd...KICK-OFF 8% P.M
ADMISSION...RESERVED 10/-...UNRESERVED 5/- 2/6 1/6

▲ Thought to be the work of **Victor Marcus Weingott** (whose father, incidentally, was a leading maker of briar pipes on Fleet Street), this fine poster from 1933 is a reminder that **rugby league** has a heritage of its own in the capital. A heritage characterised, it has to be said, by remarkable persistence in the face of a largely indifferent populace.

After the 'Great Schism' of 1895 the Northern Union tried on several occasions to win over Londoners by staging internationals in the capital. The first, Great Britain v. New Zealand at Stamford Bridge in February 1908, drew 14,000, not bad considering England's Union XV were playing Ireland at Richmond on the same afternoon. But at Park Royal the following December only 2,000 turned up to see Australia.

Further moderately attended internationals took place at Craven Cottage in 1911, Highbury in 1921 and Herne Hill in 1922.

Rugby league, noted the London press, was quicker than union and the players more agile. But whatever its merits, the game was mostly viewed as faintly alien.

Given this ambivalence, the Leeds-based Rugby Football League (RFL), as the Northern Union was renamed in 1922, took a huge gamble in 1929 when it chose to stage the Challenge Cup Final, the highpoint of the game's calendar, at Wembley Stadium.

That there were no rugby league grounds in the north large enough to cope with demand was one factor.

That Arthur Elvin offered the RFL a good deal at Wembley helped too. Even so, requiring the fans of Wigan and Dewsbury to travel south, at a time of immense economic hardship, took some bravado.

But it did pay off. A crowd of 41,500 attended, and with only a few exceptions the Challenge Cup Final has been part of London's sporting calendar ever since.

Noting this, over at **White City**, Elvin's rival Alfred Critchley – the man who in 1927 had saved the derelict stadium by introducing greyhound racing – saw rugby league as a timely business opportunity. Saturday afternoons at White City were already given over to football, in the shape of QPR (although not for long, *see page 244*). But there were no greyhound meetings on Wednesday evenings.

All he needed were some of those new fangled floodlights being installed by the Dutch company, Philips, in Belgium and Holland.

Critchley flew over to see them in 1932, coincidentally in the company of the former Quins and England player, Wavell Wakefield, who had just become a director of the wireless company, Rediffusion.

So it was that London's first taste of floodlit action in the 20th century was a rugby league exhibition match, Wigan v. Leeds, at White City in December 1932. A crowd of 10,000 marvelled at what they saw, whitewashed balls and all.

Suitably encouraged, Critchley bought up a struggling northern club, Wigan Highfield, and entered them as **London Highfield** in the Rugby League for season 1933-34.

It was during that season that the exhibition match advertised here took place.

Australia won comfortably in front of 10,541. But was it the novelty of the lights and the Australians that drew the crowd?

Throughout the 1930s Critchley, Elvin and other businessmen tried to tempt Londoners with imported sports such as speedway, ice hockey and baseball, each with variable success. But rugby league was from just up the road, and the capital was full of northerners.

Surely it was worth a punt?

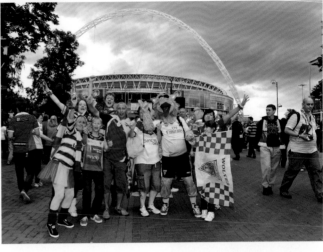

▲ November 2011 and yet another relaunch of a rugby league club, this time the **London Broncos**.

Concerning their predecessors, London Highfield lasted only a season, their average gates of barely 2,000 a real let down for Critchley.

Not that this deterred another businessman, Sydney Parkes.

As chronicled by Dave Farrar and Peter Lush (see Links), in 1935 Parkes set up not one but two clubs, each at stadiums he intended for greyhounds but for which he had yet to obtain racing licences.

Parkes targeted northerners employed at Ford's in Dagenham and set up supporters' clubs.

He was rewarded when, playing at the new Park Royal Stadium on Abbey Road (pages 244 & 327), **Acton & Willesden RLFC** started well until, as at White City, interest faded and Parkes disbanded them after one season. (He did obtain a racing licence, however, so the stadium stayed in use, until 1969.)

Streatham & Mitcham RLFC, based at Parkes' other new stadium, on Sandy Lane (opposite the ground of Tooting & Mitcham FC), fared better. But still he closed the club, in 1937, having failed to gain a racing licence, which had been his main intent all along.

Mitcham Stadium was eventually demolished in 1955, although its main stand was re-erected at Leyton Orient's Brisbane Road, where it remains in use today.

Club number four, **Fulham RLFC**, a subsidiary of the football club, emerged 43 years later in 1980.

Once again, the impetus was largely commercial, and once again things started brightly, in front of nearly 10,000 at Craven Cottage. But once again interest flagged.

However this time, instead of disbanding, Fulham RLFC lived on thanks to its dedicated fans, albeit rebranded under new owners as the **London Crusaders** in 1991.

From 1984-94 the club played at three venues, all unsuitable: the athletics stadium at Crystal Palace, the Polytechnic Stadium, Chiswick and Copthall Stadium, Mill Hill.

In 1994 they were taken over by Australians, renamed the **London Broncos** and moved to The Valley, home of Charlton Athletic, which at least had no track. It was there that in 1996 Broncos became founder members of the RFL's daring new summer time Super League.

Sceptics deemed their inclusion a sop to commercial interests. But the Broncos held their own and in 1999 reached the Challenge Cup Final. Rugby league, it appeared, had at last established a foothold in the capital, albeit an assisted one.

But not a settled one. As ownership of the club continued to change hands, the Broncos moved to, of all places, that former bastion of amateurism, The Stoop, as tenants of the Quins. In 2000 it was back to The Valley, followed from 2002-05 by Brentford's Griffin Park, then in 2006 back to The Stoop, where the Broncos were rebranded as... **Harlequins RLFC**.

They even adopted the Quins' famous quartered shirts.

For diehards on both sides of the rugby fence this was a move too far. Apart from the assault on each club's heritage, there were some fans who, although keen to support rugby league during the summer, in winter also supported the likes of Wasps or Saracens.

How could they now cheer on a team wearing Quins' colours?

On April 29 2006 The Stoop made history by becoming the first ground to stage union and league matches on the same day. In the afternoon Quins FC beat Plymouth in front of 12,301 fans whose tickets included both matches.

After a changeover of pitchside adverts, in the evening their RLFC counterparts beat Huddersfield.

But not in front of anything like 12,301 spectators. Nor did the restoration of the Broncos name in 2011 nudge gates above the 2-4,000 mark, still amongst the lowest in the Super League.

At the time of going to press the Broncos just embarked upon yet another new chapter, this time as tenants of Barnet FC, at The Hive, a new ground established in Harrow.

But at least the Broncos are no longer alone. **London Skolars** (named after their sponsors) were formed by university graduates on Hackney Marshes in 1995, and now play at the **New River Stadium, White Hart Lane** (right).

A mile or so from the Spurs' ground at the other end of 'the Lane', this dates back to 1973 and was where Seb Coe used to run for Haringey AC in the 1980s.

In 2003 the Skolars became the first amateur rugby league club since the 1920s to turn semi-pro.

As a result they now play in the game's third tier, alongside such old established northern greats as Rochdale Hornets and Oldham.

Significantly, most of their players hail from London. For whatever deals are done at the top, it is well known that the surest way to establish a sport in alien territory is to build from the grass roots. Well known, at least, to scholars of history.

Wembley in August 2012, as fans of Warrington (in the blue and yellow) and Leeds (in... blue and yellow) gather on Olympic Way before the Challenge Cup Final (above). First contested in 1897 and held at Wembley almost every year since 1929, the match differs from its counterpart, the FA Cup Final, in that it is traditionally attended by fans of all different clubs as a day of celebration. Team colours are worn proudly. Rival fans mix and mingle, and for a day or so London pubs fill with the clamour of northern accents and ribald songs. In that sense, rugby leaguers are no different from their union counterparts, brought together by beer and banter, free, on the whole, from the segregation and simmering partisanship that has so blighted football. This, surely, is the most precious component of rugby's heritage, league and union.

Chapter Twenty Four

Real tennis

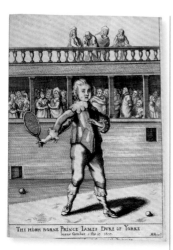

Following in the family tradition, the young Duke of York, later James II, is depicted in what is probably the Great Open 'Tennis Play' (or uncovered court) at Whitehall Palace in 1641 (*see page 15*). Being portrayed as a fit, athletic youth was an important part of establishing the Stuarts' credentials as worthy successors to the likes of Henry VII and VIII, both accomplished players. Not that this helped James' father, Charles I, who lost his head outside the Banqueting House directly opposite this court. The galleries of royal tennis courts were magnets for gamblers, but also for fawning courtiers. After one match involving James' brother, Charles II, the diarist Samuel Pepys described how every move the king made on court was 'extolled without any cause'. Even though Pepys conceded that the king played well, he wrote 'such open flattery is beastly'.

First there was the hand. Then followed the ball, the wall and later the net. By the 16th century there also appeared the racket.

Such were the basic stages in the evolution of a whole family of games to have emerged in Europe, each with their own quirks, court designs and scoring systems.

In this and the following three chapters we look at five different forms of this family of games played in modern day London: real tennis, fives, rackets, squash and lawn tennis.

Of these, real tennis is the oldest recorded, having arrived in London, almost certainly from France, by at least 1449, when it was banned from the grounds of Grocers' Hall. Known variously as 'le tenys', 'tennesse' or 'tennys', its name is thought to derive from the French 'tenez!' ('take this!'), called out by the player about to serve.

As for the name 'real tennis', this started to appear in 1867 (in *The Field*), in order to distinguish the game from its up and coming offshoot, lawn tennis.

Another name is 'royal' tennis. This is because, as we noted in Chapter 1, tennis was played by a succession of kings and princes from the reigns of Henry V to James II, at the palaces of Richmond, Westminster, Blackfriars, Hampton Court, Whitehall and St James's.

But royals and the nobility were by no means the first to play the game, as has become evident from examining the form of the actual court. The court as we have known it since the 17th century – Hampton Court being the oldest

extant example – is covered, and consists of four walls and a paved, or nowadays, concrete floor. This is because, before the invention of vulcanised rubber it was difficult to create a ball that would bounce on softer surfaces such as grass.

On three sides of the court are protrusions with sloping roofs called penthouses.

Known as a *jeu à dedans*, this form of court replaced an earlier design which had a penthouse on one side only, known as a *jeu quarré*.

Until recently tennis historians believed that the penthouse was modelled on a monastery cloister.

However research by Roger Morgan and others (*see Links*) has shown that in common with other medieval European games, particularly in Italy, tennis almost certainly originated in the streets, and that the penthouse in fact echoes the awnings of shops.

Equally striking is how many of these games, several of which survive, share the 15, 30, 45 and 60 point scoring system used in real tennis and, of course, later adopted by lawn tennis.

Records of this system go back to the early 15th century, and probably further, for barely a century later we already find scholars speculating as to its origins. The likeliest theory is that the number 60 and its quarters had special significance in medieval Europe, for example forming the basis of French coinage.

It is also known that the score 45 was already being shortened to 40 as early as 1580.

Concerning the history of the

game in London, several major studies have been conducted over the past decade or so (*see Links*), all, it should be noted, by individuals who play real tennis and have been smitten by its heritage.

As a result a series of early courts have been identified near the Haymarket (*see opposite*), plus three in Southwark: at Winchester House, at the Falcon Inn, off Tooley Street, and by Marshalsea Prison, on Borough High Street. This last one was originally a Fives Court where plays were performed during the Southwark Fair (before its suppression in 1762). It was later converted to tennis, hence the access road was renamed Tennis Court in the 19th century, then Tennis Street in 1951.

Overall, nearly 50 courts have been identified in the area now forming modern London since the 15th century. Only Bristol, with eleven courts in the same period, approaches this number.

In the late 19th and early 20th century London was also the base of Joseph Bickley, whose patented wall and floor render (of which more later) was, and remains, revered by players not only in real tennis but also in rackets and fives.

Thirteen of Britain's total of 26 real tennis courts in use today date from that Bickley era, including three of the five now operating in London. By comparison, outside Britain there are just 18 courts in total, in the United States, Australia, France and Ireland.

Yet again, it has been largely the British who have kept a once common European game alive.

Discovered in 1922 in the rafters of Westminster Hall and held since by the Museum of London, this tennis ball dates from no later than 1520, and has a leather casing stuffed with dog hair. Other fillings included moss, shredded leather and even beard clippings. From 1461–1535 the main maker of tennis balls in London was the Ironmongers' Company, based next to a court off Fenchurch Street.

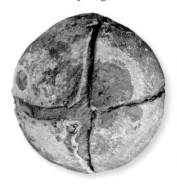

▶ Illustrated by **Thomas Shepherd** in c.1850, this is the **Royal Tennis Court** in **James Street** (renamed **Orange Street** in 1905). In the distance runs Haymarket.

This is the only one of some 30 courts known to have operated in central London between the mid 15th and the mid 19th centuries of which there is any trace left visible to the public.

(As featured on page 16, there are remnants of two 16th century courts in Whitehall, but for reasons of security these cannot be visited.)

This lack of evidence is hardly surprising. Other than the examples found in royal palaces, most of the early courts were built in timber.

It is also true that tennis was never as popular in London as it was in Paris, at least before the Revolution. There, in 1596, albeit in a city with then twice London's population, there were an estimated 250 tennis courts (some said as many as 1,100), employing some 7,000 staff and professionals, several of whom competed in England. In that sense tennis could be described as one of the first genuinely international sports.

By comparison, a list drawn up in 1615 by the Clerk of Works at Petworth House, West Sussex, identified just 14 courts in London.

Eight of these were in the City. Two were at Whitehall. The others were at Blackfriars, Essex House (off the Strand), Somerset House and Southampton House, where the site was, until the 1960s, marked by an alley called Tennis Court, now covered by the Holborn Gate office block.

All the courts on the Petworth list had closed by 1700 (although a later court built at Whitehall would survive until 1793). So had three other courts opened after 1615; one at St James's Palace and two in Lincoln's Inn Fields, both converted into theatres.

During the 18th century, in common with so many aspects of cultural life in London, the focus of tennis shifted westwards.

As chronicled by David Best and Brian Rich (see Links), the first public court in the West End, located approximately on the corner of the modern day Oxendon and Coventry Streets, had been built in c.1635, and with two bowling alleys formed part of Piccadilly House, a gaming establishment nicknamed Shaver's Hall. This

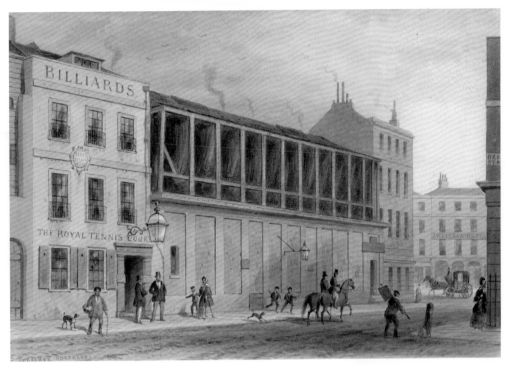

thrived until Panton Street was laid out on part of the site in the 1680s.

From c.1729–c.1800 tennis was also played at the 'Fives Court' on St Martin's Street (better known for pugilism). Its licensee from the 1740s to 1772 was Thomas Higginson, who also built tennis courts in Holborn and on Great Windmill Street, the latter in use from 1743 to c.1819, after which it too was converted into a theatre, before being turned into the Argyll Rooms (later the Trocadero Palace music hall).

Higginson was also briefly the licensee at James Street.

Two courts occupied this site. The first, immediately to the left of the entrance building seen above (where the Court Keeper lived), was built in c.1673 to replace Shaver's Hall. But in 1680 its roof collapsed, injuring several players, and by 1713, once again it became a theatre.

Its replacement, seen above on the west side of the Keeper's House and thought to date from the late 17th century, lasted longer. In fact from 1780 onwards it became the headquarters of English tennis. Frederick, Duke of York, played there regularly. In 1816 it staged the first of four matches billed as World Championships, involving English, Italian and French players (this only a year after Waterloo).

Then in 1819 a select group of army officers and dandies formed a

club and relaunched the building as the Royal Tennis Court and billiard rooms. Only when a new court opened at Lord's in 1838, followed by another at the Prince's Club in 1857 (see page 287), did the importance of James Street wane, until finally it closed in 1866.

Thereafter the court served as a warehouse before being taken over by Westminster's Cleansing Department in the 1950s. It was then replaced by a block of offices in the 1970s, as seen on the right.

It will be noticed that the **Court Keeper's house** survives, as 8 Orange Street, and that the original street plaque – once positioned on the Keeper's House (just visible above) – is now fixed to the walls of the modern offices (right).

Note that the date 1673 relates to when the street was laid out, rather than to the tennis court.

Another reminder of the area's sporting past is the **Hand and Racquet pub** on Whitcomb Street. Alas for the landlord at the time, the building we see today opened just as the court closed.

After the final match in 1866 the Earl of Warwick bought the stone floor pavings, hoping to relay them at Warwick Castle. But after over a century of play they were found to be too worn to be of use. More robust were the spectator benches. These were transported to the court at Merton College, Oxford, where they remain in use to this very day.

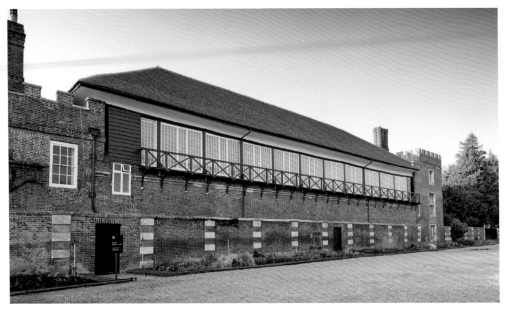

▶ All three of Britain's oldest real tennis courts may be visited by members of the public.

And what courts they are!

At Falkland Palace in Fife, Scotland, stands the oldest working court in the world, built in 1539 and still without a roof, as were all courts in the early years. At Merton College, Oxford, the court dates from 1798.

The third is this, the **Royal Tennis Court** at **Hampton Court Palace.**

For visitors to the palace there is a door to the court (seen on the left) entered from the Broadwalk, open from April to October.

Members of the resident tennis club, which formed in 1818, enter via **Tennis Court Lane** (*above*).

As may be deduced from its exterior, the building has been added to in several phases. This has given rise to a theory, put forward by David Best in his history of tennis at the palace (*see Links*) that the court may stand on the site of an earlier example – one built by Cardinal Wolsey from 1526-29 – and that a section of the outside, east wall we see here, may be a remnant of that earlier court.

What is certain is that there have been three courts at the palace.

Cardinal Wolsey's original was an 'Open Play' (or uncovered court), whose exact location was never recorded on any documents.

A second, covered tennis court was built on another part of the site (next to the Chapel) by Henry VIII, after he took over Hampton Court from Wolsey in 1529. This was virtually identical to 'Great Close Tennis Play' he built at the same time at another

of Wolsey's seized properties, Whitehall Palace, but with only one corner turret rather than four.

Henry's court remained in use until *c*.1661, after which the space was converted into lodgings. Its side walls and turret survive however, clearly visible from the palace gardens (*page 15*).

Meanwhile in 1625 the newly crowned Charles I started to build the third court – possibly on the site of Wolsey's original – forming the basis of the structure we see today.

In essence, its floor plan and west wall survive from 1625.

Both end walls, and the adjoining Keeper's House (on the right), date from 1636–37, when Charles I also added a roof for the first time.

This makes the building the second oldest functioning covered court in the world (the oldest being at Fontainebleau, built in 1601).

Charles II implemented further changes in 1660–61, for example remodelling the penthouses and *tambour* to reflect the growing preference for courts styled as *jeu à dedans* rather than *jeu quarré*.

Like most real tennis courts the

Hampton Court building has been used for other purposes periodically. For a decade Sir Christopher Wren turned it into a timber store. For two years George I, no great lover of sport, used it as a drawing room.

Since then the only major changes have been the glazing of the upper windows, supposedly to prevent the Prince of Wales (later Edward VII) from catching cold, and more recently the addition

of modern heating and lighting. For this may be one of only four purpose built sports-related structures to be listed Grade I, but it remains a working building; the oldest functioning sports building in England, no less, and one that is said to be busier than any other real tennis court in existence.

Which means that if you do pay a visit, there is a good chance of finding a game in progress.

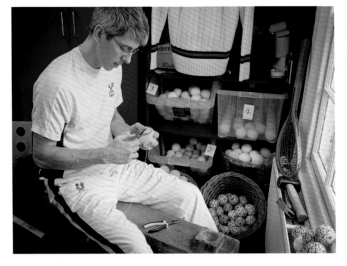

Over the years real tennis players have tried alternatives, but it would seem there really is no substitute for a ball made by hand, using methods barely altered in centuries. That is, a cork centre is wound with cloth and, after being hammered into shape, tied with twine to form the core seen on the left. Two strips of bright Melton cloth are then sewn on for the completed ball. Each one

takes 40 minutes to make from scratch or 20 if, as is common, a used core is recycled. For professionals like Nick Wood, at Hampton Court that means finishing off at least ten balls a day in order to keep up with demand. His workshop forms part of the original Keeper's House, which, restored in 1993, also contains living quarters and club facilities for the court's 500 or so members.

▶ At **Hampton Court**, as inside every real tennis court, there is an aural and visual quality quite unlike that of any other sporting enclosure.

The rackets, still wooden framed and assymetric as of old – and nowadays made solely in Britain by the family firm Grays of Cambridge – impart a distinct twang as they make contact with the ball, even though their strings are now synthetic rather than sheep gut (cat gut was apparently never used).

The balls, handmade, solid yet only around 75g each in weight, 'cut', as it is said, almost silently off the smooth walls and floor, or thud and roll echoingly against the inclines of the wooden penthouses that line three sides of the court.

Every sound seems to resonate, yet with a polite restraint. As if in thrall to this, the players too rein in their voices. The loudest call is that of the marker, if there is one, who from the sidelines calls out the score or 'marks' each chase – that is, that part of the court on which, whenever a ball is allowed to bounce a second time, plays an important part in the scoring (a part that, frankly, remains baffling to most outsiders).

As can be seen, the chases are are identified by a number painted on the side walls. Traditionally court walls are black, as too was the ceiling at Hampton Court, until painted white in 1914.

As for the floor, in order to darken the paving so that balls would be more visible, before the 1890s it was common for a coating of lampblack and oxblood to be administered. According to one former professional at Hampton Court, this process was made easier by slaughtering the beast on the floor itself.

The current, bloodless coating was applied in 1985.

Viewing a real tennis match also has its quirks. This view was taken from one of two end galleries, in this case from the north end, known as the *dedans*, where, as we will see on the next page, most spectators gather at ground level, under the **penthouse**. There is a further gallery alongside the court, on the left, either side of the net.

Typically no more than 100–120 spectators can watch a match at any one time.

Other features to note include the projection, known as the *tambour*, at the **hazard** end of the **main wall**

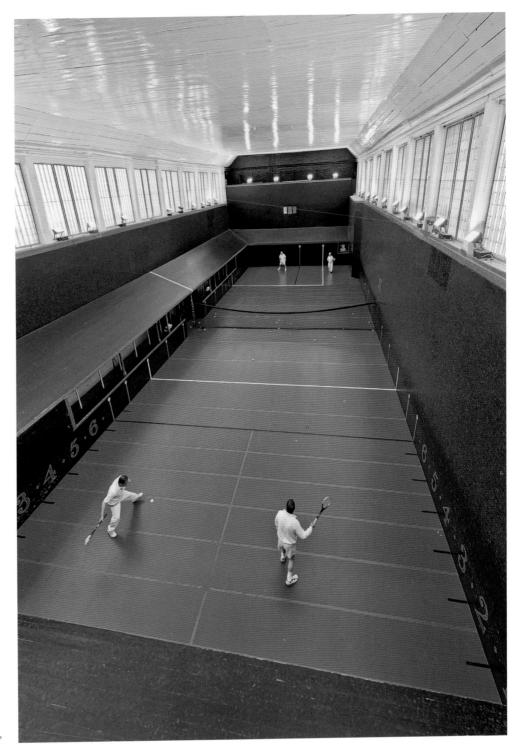

(far right) and in the **back wall**, a small opening (to the right of the player's shoulder) called the **grille**.

Each feature plays a part in the tactics and scoring of the game.

For most visiting players the court at Hampton Court seems larger than most. And it is, if only by a matter of inches. During the summer months they must also get used to the presence of visitors wandering in from the Broadwalk

and watching from the side gallery, some no doubt hoping that Prince Edward, the Earl of Wessex, a keen player, might be on court.

But only rarely do these tourists cause any disturbance, for just like any individual entering a cathedral or great house, they know instantly that here is no ordinary place of sport, but one echoing with history, and steeped, almost literally, in majesty.

▲ This unusually exuberant *œil de bœuf* window above an entrance to the rear of **62 Lillie Road,** in **West Brompton SW6**, has intrigued many a passer-by over the years.

And is that a royal crest in the decorative arch above?

The window is easily explained. From at least 1889–1919, number 62 was the home and office of **Joseph Bickley** (1835–1923).

His works were around the corner in Seagrave Road.

Just as the English aristocracy were rediscovering the pleasures of real tennis, and public schoolboys were reinventing rackets and fives, Bickley branched out from his trade in architectural mouldings to develop a patented form of 'non-sweat' wall and floor rendering.

By doing so, in the words of the *Morning Post,* Bickley 'did more... for these games than any other individual in the last fifty years.'

Even today Bickley's name is uttered with reverence, both in Britain and in the United States.

Back at number 62, there has long been a rumour that Edward VII enjoyed trysts with Lillie Langtry in the studio at the rear, hence the royal crest. More likely, it marked Bickley's status as plasterer to the Royal Household.

N° 12,696 — A.D. 1889

Date of Application, 12th Aug., 1889
Complete Specification Left, 19th Sept., 1889—Accepted, 2nd Nov., 1889

PROVISIONAL SPECIFICATION.

An Improved Composition for Covering the Walls and Floors of Tennis and Racquet Courts and Analogous Purposes.

I JOSEPH BICKLEY of 62 Lillie Road, West Brompton, in the County of Middlesex, Contractor, do hereby declare the nature of my said invention to be as follows :—

Whereas the walls and floors of Tennis and Racquet Courts as at present plastered frequently become useless for play owing to the water deposited from the atmosphere
5 running down the said walls.

Now the object of my invention is to remedy such defect by a special method of treatment hereinafter described. As the lining or covering of the walls are required to be of great strength and solidity, the materials must be specially prepared for it.

The sand or other sharp flinty grit must be freed from pieces of wood, coal
10 and such like impurities and thoroughly washed and sifted and should be dry before mixing with cement.

The Portland Cement to be used should be of the best quality and slow setting and allowed to cool or airslack.

The walls are prepared as follows :—the joints are raked out to a uniform depth of
15 a quarter of an inch and kept well wetted or douched for several days before the covering is laid on.

I next prepare a material herein after referred to as "Glue" of Portland Cement and water, made to the consistency of cream, which is laid on the wall and well "dubbed" into the wetted brickwork with a brush until the thickness of ⅛ of an inch
20 is reached. On this "glue" I lay a coating or backing composed of 1 part by measure of coarse washed flinty grit, and 1 part by measure of prepared Portland cement, and when nearly set I score horizontally and allow about 40 hours rest ; it is then sprinkled with water, slightly at first (say for 3 days) and then increasing in quantity for a week after which I lightly sprinkle for 2 days and then allow the
25 water to drain off. This treatment ensures the coating or backing "taking" the "Glue."

Another coat of "Glue" is well dubbed in and the finishing coat, which consists of 1 part of finely washed sand and 1 part of finely sifted cement, is then carefully applied and well faced.
30 After 45—50 hours interval the wall is wetted the water not being allowed to run down.

Black Paint may then be applied at a suitable time after the finishing of the cement work ; Where it is so desired the "Black Staining" may be worked into the finishing material in the following proportions viz. :—2 parts of fine cement, 1 part of finely
35 washed sand, and 1 part of Black Manganese.

By this system the objectionable "sweating" of the walls is entirely prevented while a sound, strong and hard wall is ensured.

I do not confine myself to the exact proportions named neither do I confine myself to the exact descriptions of materials as they may be very much varied to suit
40 circumstances.

Dated this 12th day of August 1889.

GEO. DOWNING,
8, Quality Court, London, W.C., Agent for Applicant.

▲ Players of **real tennis** not only love to play on a Bickley court, they also delight in remarking how old Joe took his secret formula to the grave with him. But did he?

As it transpires his methods were a matter of public record, as can be seen from this 1889 patent, which he followed up in 1909 with a slightly refined version (number 30,576). Yet when Harrow School were planning a new rackets court in 1964 and wanted to replicate the Bickley formula they found that there was a secret, of sorts.

Thanks to a report on their plans in the *Daily Express*, the school was contacted by a former Bickley plasterer, HG Harbour, then in his 80s. Perhaps because Harbour recalled having honeymooned in New York, at the company's expense, while working on a new court on Park Avenue, the Harrow team was able to source the patent from a New York public library.

What they discovered, however, was that the composition of Portland cement had altered since Bickley's day, and also, tantalisingly, that the patent did not yield quite enough information, as no doubt Joe Bickley intended.

With trial and error the Harrow court was completed. But the stories never quite abated...

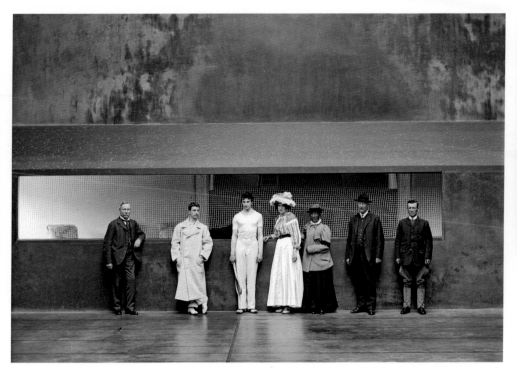

▲ There are still some 15 locations in Britain where **Bickley real tennis courts** remain in use, including the two earliest ones to have featured his 'non-sweat' formula, built at the **Queen's Club,** as seen above, in 1886-87. Queen's also has two rackets courts originally by Bickley.

▲ Framing the *dedans*, the walls and floor of the newly completed court at **Crabbet Park**, **West Sussex**, bear the deep shine and polished patina that was, and remains, the hallowed hallmark of their creator. Photographed in July 1907, **Joseph Bickley**, then aged 72, stands seemingly satisfied, if perhaps a little distant, on the left.

Bickley had by then worked on courts in at least twelve locations in Britain, plus three in the USA. Indeed it is from notes compiled in New York in the 1980s – some 20 years after the patent's rediscovery in the same city by the Harrow School researchers – that we have learnt more about his techniques. The report was compiled by a team about to restore another Bickley court, at Greentree on Long Island.

Bickley's objective, as he stated in his patent, was to provide surfaces that would not 'sweat', a frequent complaint in earlier courts, which is why so few were glazed.

At the same time, all surfaces had to be robust, especially for rackets, in which a small hard ball is struck at high velocity.

By mixing in with his cement pigments such as manganese dioxide – he referred to it as Bickley's Mineral Black – he was also able to create black walls and black, or sometimes dark red floors, without the need for bull's blood, paint or maintenance.

From the Greentree notes we learn that Bickley never worked if there was any threat of frost, and that once started, his men worked continuously, night and day. One witness recalled in 1905 seeing Bickley's men meticulously and repeatedly rubbing the surface, then applying water, on a single square patch over a 24 hour period.

Each tennis court floor consisted of six large slabs formed from cement mixed with marine sand sifted through a fine sieve, the equivalent of what today would be termed a 0.5mm mesh, as used in mining, archaeology and even *haute cuisine*.

It was further noted that the cement was always mixed by Bickley himself. So was this the moment when, unseen, he slipped in his secret potion?

Again, alas not. Analysis of cement samples carried out at Greentree confirmed the use of manganese dioxide but found no other special ingredients.

In fact, concluded the report, backing up some of the conclusions at Harrow in 1964-65, Bickley's results were produced by applying the patented formula, backed up by painstaking workmanship.

If this method was incredibly labour intensive, it was also costly. And it did not always work. The report mentions one floor failure at an unspecified American court. At Seacourt on Hayling Island in 1912 the court roof collapsed in mid-construction.

It nevertheless comes as a shock to see reports in September 1913 of Bickley, seemingly busy and in demand, filing for bankruptcy.

Clearly he managed to avoid this, because he carried on until at least 1919, when, at the age of 84, he oversaw work at Hampton Court.

But what of Crabbet Park?

Next to Bickley in the group portrait, taken by the eminent photographer Bedford Lemere, stands the young court professional, Woolwich born **Fred Covey**, who went on to win the world title four times on Bickley's court at the Prince's Club. Next to Covey stand Crabbet Park's owners, **Neville** and **Judith Lytton**.

The grandson of the author Edward Bulwer-Lytton, Neville was an artist and later a war hero, twice amateur real tennis champion and winner of a bronze medal at the 1908 Olympics. Judith, the great grand-daughter of Lord Byron, was considered the leading female player of her time. After 1917 however, she and Crabbet Park became best known for the Arabian horse stud which she, and later Covey ran until their deaths, within weeks of each other, in 1957.

The stud finally closed in the early 1970s when the M23 sliced through the park. As for the tennis court, it still stands and is listed Grade II*, but now houses the offices of a software company.

More of Bickley's work is in evidence at Lord's (1900), and Hampton Court, where in an estimate dated 1919 he wrote that if the Office of Works wished him to apply crowns in gold leaf on the court walls, as he had done at Queen's (*above*), there would be an extra cost of £29.

After his death in 1923 the company, now run by his stepson, a Mr Freeman, relocated to Battersea, first to 34 Granfield Street, then in *c.*1931 to number 50. Lacking orders from real tennis or rackets the focus had by then switched to squash and fives. Among the company's later clients were Hampstead Cricket Club, the Cumberland Tennis Club, the RAC and Whitgift School (*see page 285*).

The company was last recorded in 1940. As noted opposite, however, the last ever 'Bickley' court was built at Harrow School in 1965, for rackets.

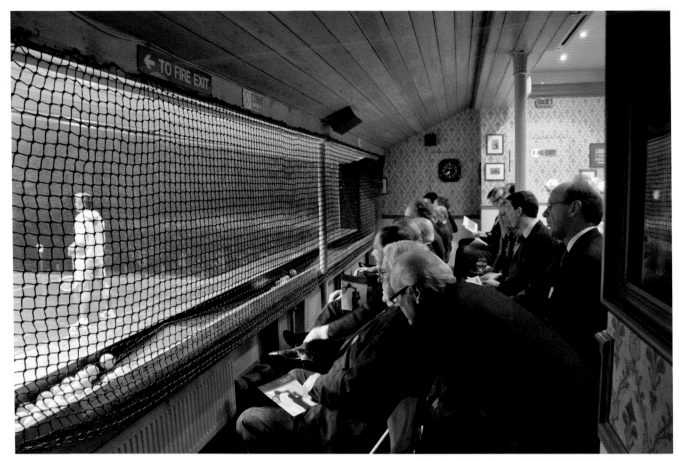

▲ If Hampton Court is the church of real tennis, the **Queen's Club** in **Palliser Road, West Kensington** is its parliament, and this, the *dedans* of the East, or **Championship Court** – one of two at Queen's – is the debating chamber.

Gathered in October 2010 are the great and the good of this venerable game, warmed by an open fire and red wine, hushed one minute, applauding the next.

No glass, only netting separates them from the players. Above their heads, more spectators perch in the upper gallery behind the penthouse, while a third group, some wrapped in blankets to keep out the evening chill, huddle in the side gallery.

There are no scoreboards, electronic or otherwise, and no sound system to relay the voice of the marker, despite the presence of a full house. That is, there are 120 spectators in total, this being the occasion of the British Open Championships.

Hardly a soul present has not played the game at one time or another, or is a stranger; this in a sport with around 3–4,000 players nationwide and just 50 or so professionals.

Founded in 1886 and best known as a lawn tennis venue (*see page 302*), the Queen's Club was, as already noted, Joseph Bickley's first major commission.

Working with architect William Marshall, he fitted out both the real tennis courts still in use today, plus two others for rackets.

Real tennis and rackets (*see Chapter 26*) are old bedfellows, Queen's being one of four clubs in Britain where both are still catered for. Since the 1940s Queen's has also been the base of the two sports' joint governing body, the **Tennis and Rackets Association**, formed in 1907.

Before Queen's, the TRA was based at the Prince's Club in Knightsbridge.

Before that, during the latter part of the 19th century, the *de facto* headquarters of real tennis were at the **Marylebone Cricket Club** at **Lord's**, where, on the site of the present day Mound Stand, the first real tennis court was built at a cost of £4,000 in 1838. Certainly it was worth the expense, for within months of it opening 150 new members signed up, amongst them, according to one writer, 'the

finest nobles of the land'. A rackets court was then added in 1844.

The real tennis court we see at Lord's today is in a different location, behind the pavilion.

Opened on the very first day of the 20th century, together with an adjoining rackets court it cost £8,110; that is, half of what was spent on the pavilion (a measure of the game's continued importance).

With its double-doored entrance and carpeted *dedans* (*below*) the court offers a curious talking point for the thousands of visitors who

pass through on guided tours of Lord's and its museum (a museum, incidentally, that is housed in the former rackets court).

Should you ever be one of those visitors, be sure to notice the tennis court's surfaces. The walls were rendered by Bickley, at £250 per wall. But the floor, unusually, is paved, as all tennis courts once were, and paved moreover with flagstones originally laid at the old court in 1866. These shiny slabs can thus be described as the oldest structural elements at Lord's.

▶ Electronic scoreboards, blue walls, players not in whites? Could this really be real tennis?

Traditionalists might say not, but for the team behind the **Middlesex University Real Tennis Club** at the university's **Hendon Campus**, this is real tennis as it must be if the game is to survive.

Designed by architects Pringle Richards Sharratt, and opened in 1999 at a cost of £1.46 million, the court was gifted by Peter Luck-Hille, a devoted player and scion of the Hille family that stood at the forefront of furniture design in post war Britain.

It is not the game's only modern court. Six centres have been built in England since 1990, a burst of construction unprecedented since the Edwardian era. One of those new courts, at the Harbour Club, Chelsea, closed in 2007. This one at Hendon, known originally as The Burroughs, struggled in its early years. But in 2009 its members took on the responsibility of running the club and of coaching students, and has set out to offer affordable rates and attract high level games.

As was Luck-Hille's intention, the court has also become a showcase for modern building techniques and materials. This includes the use of poured concrete with no expansion joints and highly polished and resilient Armourcoat plaster, combined with advanced heating, lighting and ventilation systems.

Similarly the penthouses, lined by Maranti boarding, are pitched at just over 27 degrees (a fraction steeper than the usual), thereby rewarding the server and making for a more challenging game. Meanwhile five built-in cameras record matches and assist with coaching.

Just as radically, the MURTC has put on 'Real Ten' nights in which top professionals play quick-fire matches interspersed with music, cheerleaders and prizes.

Inevitably not all of this meets with approval. Rather as some music lovers will always prefer vinyl, for some real tennis players the idiosyncrasies of older courts, their bumps and angles, their patchy light and even their draughts are highly treasured. For them Hendon is almost too perfect, or 'true', even though it achieves exactly what Bickley himself would have striven for, if only he had had the materials, and the technology.

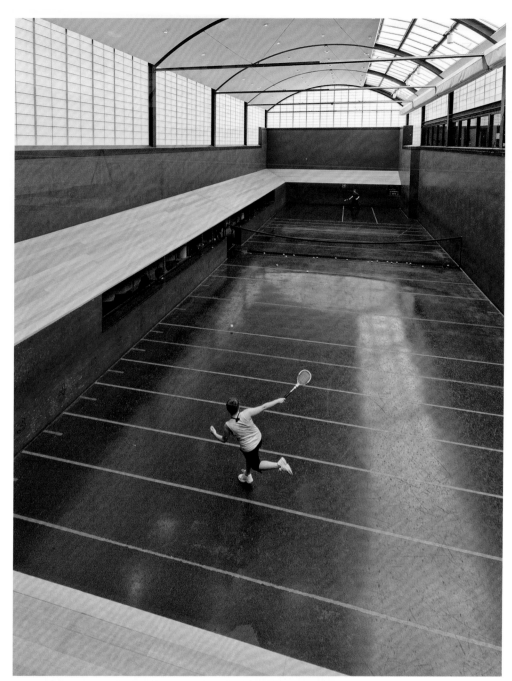

Cool in every sense, the real tennis court at Middlesex University uses translucent wall and ceiling panels to dramatic effect.

Chapter Twenty Five

Fives

In the early 19th century boys at Eton College had to attend a daily roll call in the School Yard. To fight the boredom, whilst the Masters stood on the steps of the 15th century St Mary's Chapel, reading out names, the boys did what generations of boys had done before them when confronted with an expanse of masonry. They tossed balls against it. Thus evolved a variation of the then popular game called fives. What made Eton fives unique, however, was that when, from the 1840s onwards, purpose-built courts for the game were constructed, their design was consciously modelled on the area at the foot of the Chapel steps (*above and right*), buttress, split levels and all. Several sports have architectural elements woven into their fabric. But only Eton fives can be traced back to a specific building; a Grade I listed building, moreover, that stands virtually unchanged since those first tentative games.

From around 1729 until 1825, almost exactly the same time as the boys at Eton were finessing their own version of the game, one of London's prime sporting establishments was the 'Fives Court'. Located on St Martin's Street, just around the corner from the James Street tennis court (*see page 275*) – on the site where now stands the Sainsbury Wing of the National Gallery – the venue's best known attraction was boxing. But its bread and butter, daytime trade was being hired out for the game of fives.

This was not quite the form of fives that we know today and which owes much to those young pioneers at Eton. But then as noted in the previous chapter, over the centuries dozens of similar games, of handball, or of 'hand tennis' as Strutt called fives (*see Links*), have been recorded worldwide.

The ones that most closely resemble fives share at least two attributes: first, that players compete against each other by hitting a small ball against a wall, and second, that instead of rackets or bats, hands are used, gloved or ungloved. This distinction offers the best explanation we have for the derivation of the game's name, for in pugilistic circles a hand or fist was often known colloquially as a 'bunch of fives'.

Popular in Ireland, Wales, the north east and especially the south west of England, early versions of fives were commonly played against church walls. Maybe it was a West Country lad who brought the game with him to Eton.

There is certainly plenty of evidence in that part of England to confirm its popularity, not least in the form of notches found in the stonework of several churches in Somerset. Fives also matches the description cited by Taunton Sessions in 1633, of an 'idle game used by tossing of a ball against the Chapple Wall'.

Despite the damage it caused, especially to windows, fives in this unlikely context continued well into the 18th century, until such time as purpose-built walls could be erected, often in the grounds of public houses.

A number of such 'fives walls' survive in the south west. None has been found in London. But as noted earlier, there was certainly a 'fives court' in the capital by 1729.

In their history of Eton Fives, Dale Vargas and Peter Knowles (*see Links*) cite an advertisement for this establishment in 1742, published in the *Daily Advertiser*.

Addressed 'To all Gentlemen that like the exercise of Tennis, Fives or Billiards' it advertises two establishments run by Thomas Higginson: a tennis court next to Adlam's Coffee House, near Little Turnstile, Holborn, where fives and billiards could also be played, and Fives Court on St Martin's Street 'for Fives-playing only either with Racquets, Boards or at Hand-Fives at 2d, 3d or 4d a Game'.

In 1838 Dickens likened Mr and Mrs Nickleby to those fives players who would pass the hat around after matches in order to scrape a living. In *Vanity Fair*, Thackeray describes boxing, rat-hunting and fives as amongst the fashionable pursuits of the aristocracy.

Map records show two 19th century courtyards being called Fives Court: in Whitechapel,

marked on Horwood's 1807 map, where Haydon's Walk is now, and on Lockie's 1816 map, in St Dunstan's Alley, near Tower Hill.

There is a Fives Court today, off Hayles Street SE11, which may well have been used for informal games, as it was renamed as such between 1893 and 1911, having previously been called East Court.

By far the most commonly cited reference to fives during the 19th century comes from William Hazlitt's evocative obituary of the Irish house painter and famed fives player, John Cavanagh, published in *The Examiner* on February 7 1819 (and well worth reading in full). It begins:

'It may be said that there are things of more importance than striking a ball against a wall... But the game of fives is what no one despises who has ever played at it. It is the finest exercise for the body, and the best relaxation for the mind...'

When Cavanagh played at Copenhagen House, where fives was played against a wall housing part of the kitchen chimney, wrote Hazlitt, the brickwork would resound so loudly that the cooks inside would exclaim, 'Those are the Irishman's balls'. When he played at the Fives Court in St Martin's Street the proprietor could sell out the gallery at half a crown a head, at a time when one shilling for a cricket match was deemed expensive.

By the 1830s the fives of Cavanagh and his ilk, based around gambling, high spirits and drinking, had fallen out of fashion. But, rather as happened with football around the same time, it would soon re-emerge from the public schools in a rather different guise, played in three-sided courts with specific hazards, and above all, codified.

Emerging from this period, three main types of fives are played in Britain today, each named after the school where they originated: Eton, Rugby and Winchester fives.

Only the first two are played in London, however, and of the 19 locations where courts are in use – if we include Eton within our calculations, despite it lying just outside London – only three are not situated in school grounds.

But that does not mean the game is played only by schoolchildren.

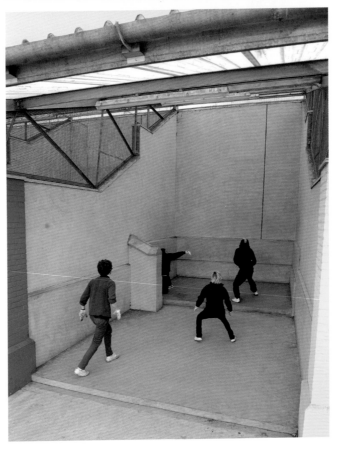

◀ London's largest concentration of **Eton fives courts** is to be found at **Highgate School**, **Hampstead Lane**.

This block of ten consists of six built back to back in 1899, plus four added in c.1913. The school has another block of eight courts built in the 1920s.

By that time most fives courts were roofed. In the grounds of **High Elms, Orpington**, the estate of the prominent banker, Sir John Lubbock – now managed as a country park by Bromley Council – stands a rare uncovered court (*left*).

This was presented by Sir John in 1860 as a gift to two of his eight sons (all Etonians), Alfred and Edgar. Alfred later played cricket for Kent – excellence at fives and cricket have often gone hand in hand, as it were – while Edgar played for the Wanderers in the first ever FA Cup final at the Oval in 1872.

Sir John would have been delighted that the court has since been listed Grade II, for it was he who introduced to Parliament the Ancient Monuments Protection Act of 1882, the very foundation stone of modern day heritage protection.

From possibly the oldest known Eton fives court to London's newest is a leap, not only across the city but also across social boundaries.

Located incongruously next to an elevated section of the West Cross Route (*left*), this is one of four courts at the **Westway Sports Centre** (*see Chapter 8*), where fives enthusiasts are seeking to shake off the game's public school image and win back some of the popular appeal it enjoyed in the 18th and early 19th centuries.

But of course you can never take the Eton out of Eton Fives.

That buttress-like protruberance inside the court – known to players as 'the pepper box' and a key feature in the rules and tactics – plus the various ledges and levels, are all modelled on the original.

▶ The appeal of **Eton Fives** is its simplicity; four players in two teams, no referees needed (not even for the top games), nor any special kit, apart from gloves. Yet players must be nimble, quick-witted and ambidextrous, and be prepared to travel to some fairly unusual locations, such as here at **Westminster School**.

Not since cockfighting and real tennis were last seen in Whitehall Palace has any sport been played quite so close to the very heart of the nation.

As eagle-eyed readers might have deduced, after blinking twice perhaps, those towers bathed in light are indeed the West towers of Westminster Abbey, and this block of three courts abuts the wall of the Abbey's South Cloister.

Yards from here, in the West Cloister, lies the grave of the 18th century pugilist Jack Broughton (see page 19) who would have known London's fives courts well.

Westminster School's first Eton fives courts were built in 1883 nearby, in Little Dean's Yard, where an earlier form of game called 'woodens' – half fives, half rackets – was played with bats.

These modern day courts, shoehorned into a tightly enclosed garden, were built between 1958–61.

Although used mainly by Westminster boys, members of outside clubs also play here during the season, including those who normally play at Westway in the shadow of a tower block.

From Eton College, via Westway to Westminster... truly that is some London journey.

All London's other Eton fives courts are at public schools; namely Highgate, as we have seen, Harrow, Mill Hill, Queen Elizabeth's (Barnet), Emanuel (Battersea) and St Olave's (Orpington).

Between all these locations and Eton there are 68 courts.

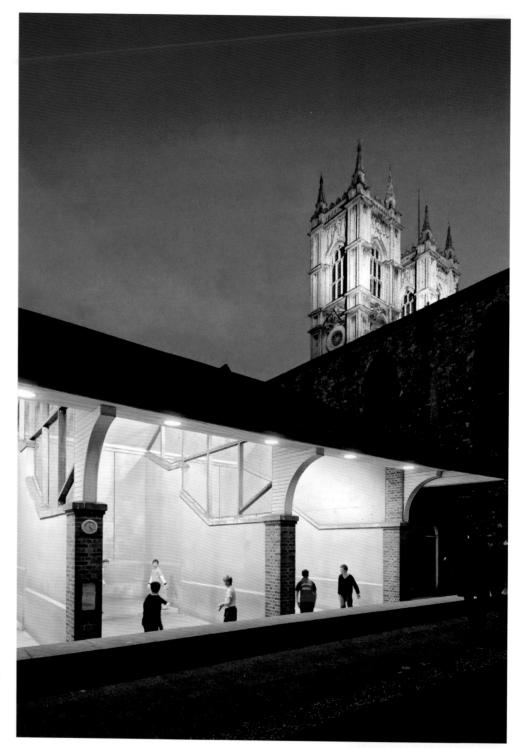

▶ Until the 1970s **fives balls** were hand made, with a cork core wrapped tightly with strips of cloth and then covered with stitched leather. Three London sports goods manufacturers were among the main suppliers: Jefferies & Malings (founded in 1852) and H Gradidge & Sons (founded in 1870) were both based in Woolwich. TH Prosser (formed in 1862) was in Holloway. As these companies died out after the Second World War, and because demand was never enough to justify mass production, a fives player called Anthony Baden-Fuller, who had just started working for Shell, began experimenting during his lunch hours. The result, in use ever since, is a composite ball of cork and rubber which lasts longer, bounces higher and has made modern day Eton fives a faster game too.

▶ While one form of fives emerged from Eton, Winchester College resolved to be different and adopt a court with a smaller buttress. Much less popular than Eton fives, this version is not played in London. But a third version is, based on courts built originally at Rugby School.

Resembling more closely the form of fives popular in the West Country in the 18th century, Rugby fives evolved during the mid 19th century. In Thomas Hughes' famous rendition of life at Rugby, *Tom Brown's School Days*, published in 1857, there is a reference to Tom having a bat for the game, as has also been noted at Westminster during the same period. In one episode Tom deems cricket to be a superior game because in cricket one must merge into the team, whereas in fives one plays for oneself.

In the 1890s Rugby fives spread to three London schools: Dulwich College, where the courts were destroyed during the Second World War, and to St Paul's and University College School, both of whom still play.

Not until a set of rules was agreed in 1930, however, was the game officially titled **Rugby fives**.

There are currently 34 Rugby fives courts in the Greater London area, at nine locations.

Two courts are at the Bank of England Sports Club, Roehampton. The others are all at schools. In addition to St Paul's and UCS they are at Merchant Taylors' (Northwood), Stoke Newington, St Dunstan's (Catford), Alleyn's (Dulwich), Shrewsbury House (Surbiton) and **Whitgift School, Croydon**, where the block of four courts seen here was built in 1934. Although since painted over, their walls and floors are lined by the now familiar 'smooth jointless non-sweat' cement render patented by Joseph Bickley (*see page 278*).

As seen at Whitgift, unlike its Eton counterpart, Rugby fives can be played as singles. There is no buttress, or change of floor level, and the court is four sided, so that the rules, pace and tactics are quite different from those of Eton.

One interpretation of this is that whereas the boys at Eton relished the complexities and subtleties of their multi-faceted courts, those at Rugby, in the tradition of Tom Brown, preferred a more action-packed, hard hitting game.

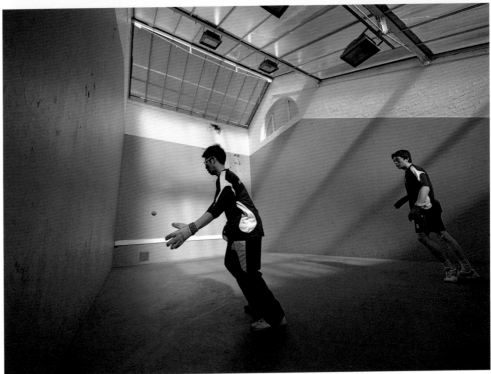

Played in a four sided court with no hazards, and with greater force than its Eton counterpart, Rugby fives is played with leather-stitched balls (*left*), made using a rubber core wound with thread. Since 2005 the UK Fives Federation has sought to promote both versions, Rugby and Eton, and to develop an even simpler 'one wall' version at various London schools and at Westway.

Chapter Twenty Six

Rackets and squash

Highly strung – that is the nature of the racket used in the game of rackets, which is why Harrow School's professional, John Eaton, has to re-string five of them a day to keep his players supplied. Note how small is the racket's head, and that the frame is made from wood. Metal frames have been tried but they tend to split more easily, such is the power and pace behind this little known but long established court sport. In his 1832 *Book of Sports* Pierce Egan wrote, 'There is no game, perhaps not even cricket, which combines so well skill with so much bustle... the racket player is always on the move; standing still is entirely out of the question; and two or three games... are calculated to do more good towards the restoration of health, and keep the frame clear from the effects of gout and rheumatism, than the whole contents of Apothecary's Hall.'

There may be only a thousand or so rackets players in the whole of Britain, and only eight rackets courts in the London area. Found in pairs, these courts are at three schools, Harrow, St Paul's and Eton, plus a fourth pair at the Queen's Club in West Kensington.

But to dismiss rackets on that basis, and to ignore its place in London's sporting heritage would be an oversight.

Firstly, rackets was invented in London, in highly unusual circumstances.

Secondly, the game is governed from London, from the Queen's Club, as noted earlier, by the Tennis and Rackets Association (real tennis, that is, not the lawn variety also played at Queen's).

Thirdly, although rackets itself may be little known, the game that it spawned has become rather more widespread, and that game is, of course, squash.

In essence rackets is a cross between tennis and fives, in that rackets, rather than hands, are used (hence its name) yet the ball is struck against a wall rather than across a net. The closest equivalent is the Basque game of *pelota*.

But if tennis and fives are games that started out in the street, not so rackets. Uniquely rackets emerged during the 18th century in the courtyards of two debtors' prisons in London.

The Fleet Prison, depicted below by Theodore Lane in c.1825, stood on the east bank of the River Fleet. In the 1730s William Hogarth sent Tom Rakewell there in his *Rake's Progress*. A century later Charles Dickens did the same with Mr Pickwick, shortly before the prison was demolished in 1846. The site is now an office block called 5 Fleet Place, on Farringdon Road.

The King's Bench Prison was in Southwark, on the site of what

is now the Scovell housing estate, between Southwark Bridge Road and Stone End Street. Tobias Smollett and John Wilkes were among the prison's inmates in the 18th century, as later would be Dickens' father, and the character based on his father, Mr Micawber.

Debtors' prisons were quite unlike the penal institutions of today. Accommodation depended on how much detainees could afford. The public came and went freely. There were gin shops and coffee houses, but also disease and overcrowding.

So organised did rackets become at 'the Bench' that in 1814 there were four courts, used not only by inmates but also by the public, and looked after by six 'racket masters', each elected to the post. In some instances the income derived was enough to earn the racket master's release.

Inevitably the game's popularity led to it spreading beyond the prison walls, to pubs and pleasure grounds. As with fives it also found its way into public schools.

The first was Harrow, where rackets was played against the walls as early as 1822. Covered courts then followed at Woolwich in 1830, Lord's in 1844 and at the Prince's Club in 1857 (*see opposite*). In 1862, William Hart-Dyke, an Old Harrovian, was crowned the first gentleman champion.

And so within a generation rackets had transcended its lowly origins to become a sport of the privileged. How it was then returned to the people in the form of squash we will come to later.

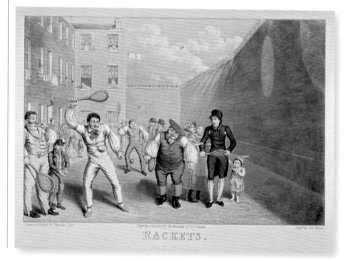

RACKETS.

'A Gentleman of the College' describes life in the Fleet Prison in 1749:

Within whose ample Oval is a Court,
Where the more active and robust resort
And glowing, exercise a manly Sport
(Strong exercise with mod'rate Food is good,
It drives in sprightful streams the circling Blood;)
While those with Rackets struck the flying Ball,
Some play at Nine Pins, Wrestlers take a Fall;
Beneath a Tent some drink, and some above
Are slily in their Chambers making Love;
Venus and Bacchus each keeps here a Shrine,
And many Vot'ries have to Love and Whine

▶ From 1820 until the 1850s London's most popular open rackets court outside prison walls was in the gardens of the **Belvidere Tavern**, on the corner of **Pentonville Road** and **Penton Street**.

The court was one of three in the area, the others being at White Conduit House (better known for its cricket), and The Eagle, on City Road. Other pubs with courts were the Oxford & Cambridge on Chalk Farm Road, the Yorkshire Stingo on Marylebone Road, the Boileau Arms on Lonsdale Road (now called the Castlenau), the White Bear, Kennington, and the Rosemary Branch, Peckham.

Pierce Egan considered that even if the company at these courts was 'not sufficiently select' they were just about tolerable for gentlemen. But equally he admired the skills of the professionals. In this respect rackets, like real tennis, has always been relaxed about professionalism, never developing the hostility that would divide such sports as lawn tennis, rowing and athletics.

At the Belvidere the leading player was initially the court's owner, Thomas Pittman. He then gave way to his younger brother John, who in turn was beaten in London's first formal staging of the national championships, also at the Belvidere, by John Lamb in 1838, in a match played for £100 a side.

The Pittmans were also known as makers of rackets, before those other familiar manufacturers such as TH Prosser, also on Pentonville Road, Jefferies of Woolwich and FH Ayres of Aldersgate took over.

Illustrated here is a doubles match in *c.*1858. But by the time the next championship was contested in London in 1860, at the Woolwich Depot of the Royal Artillery and at the Prince's Club (*right*), the game had moved indoors to courts with four walls.

The demise of open courts was regretted by many, including TH 'Harry' Gem, one of two rackets players who famously pioneered the game of lawn tennis in Birmingham. Gem considered that the old style, single walled courts, being slower and requiring greater accuracy, fostered more stylish play and a greater variety of shots.

The Belvidere Tavern was rebuilt in 1875 and today is known as the Lexington, while the gardens are now occupied by a rear wing of the Public Carriage Office.

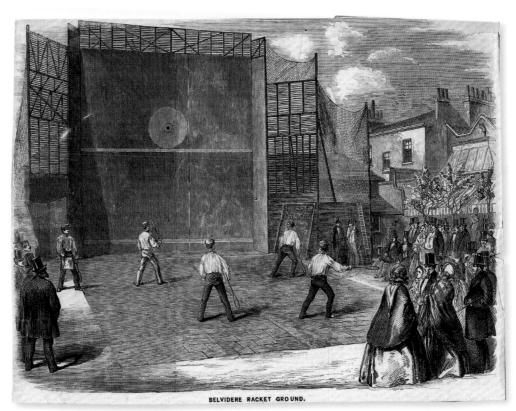

BELVIDERE RACKET GROUND.

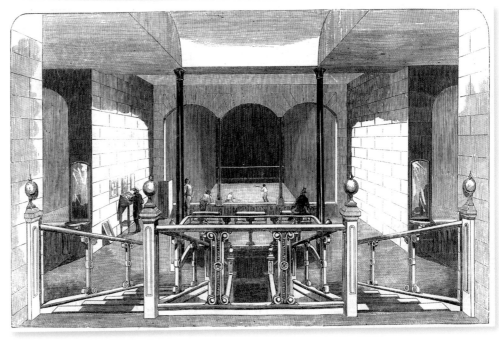

▲ A private club in an exclusive part of town, the **Prince's Club** on **Hans Place SW1**, featured here in the *London Illustrated News* in August 1857, had seven covered courts plus one for real tennis, and offered an entirely different class of rackets, in every sense of the word.

It was at Prince's that a court size of 60' x 30' with a 35' high front wall was established, and where the focus of the game switched until the site was redeveloped in 1886. After that the Queen's Club took over (*see page 280*) although a new Prince's Club opened nearby and remained in use until 1939 (*page 23*).

It will be noted that Prince's always used the spelling 'racquets'. They were not alone. Close to the Fleet Prison, off Fleet Street, in the 1720s there was a Racket Court (later covered by the *Daily Express* building). In 1799 this was styled on one map as Racquet Court, and in 1875 on another as Raquet Court.

This confusion persists today, although the majority concur with the magazine *Pastime* which, in its June 1883 launch issue declared, 'We do not, as do some sinners, spell rackets 'racquets', and for this reason – the word is not so spelled in any of the dictionaries.'

'The first sight of the flight of a **racket ball** must surprise the beginner by its swiftness'.

So wrote Edward Pleydell-Bouverie in 1890, who learnt the game on this, the older of two rackets courts at **Harrow School**.

If anything that sense of surprise and swiftness are even greater today. The fastest serve recorded in lawn tennis, as of 2012, is 164 mph. In rackets the ball has been known to reach 180 mph, and that is with a small, hard ball struck in a confined court.

The irony of this is that here is a game that was born in a place of incarceration, yet played in an open court, which, once set free, became trapped inside four walls.

As can be seen, the walls and floor of the Harrow court bear all the signs of having been rendered with Joseph Bickley's patented formula (*see page 278*). But as recorded on an exterior wall (*see below*), the court was originally built earlier, in 1864. It was then officially opened the following January and is therefore the oldest functioning rackets court in the world. Yet what happened before its construction is of equal interest.

Rackets was first played at Harrow in *c.*1822 against the walls of the School Bill Yard, an area in which boys had to contend with all manner of hazards; drainpipes, windows, chimneys and so on.

Because competition for game time was fierce, and because the hardness of the fives balls then in use made rackets an unpredictable and potentially dangerous activity, younger boys and novices took to playing in smaller yards dotted around the school, but using slower, rubber balls instead.

To distinguish between the two forms, they were nicknamed 'harder' and 'softer', the latter also being known as 'baby-racquets'.

By 1850 a more catchy name had caught on, 'squash'.

That same year Harrow's first bespoke rackets courts, both open, were built in the grounds.

Neither was ideal, however, so in 1863 a group of Old Harrovians, including the amateur champion, William Hart Dyke, got together to finance an indoor court for all year round play, just like the new ones at the Prince's Club.

Costing £1,600, the court we see here was the result of that effort.

At the same time, sufficient funds were raised to build an additional four Eton fives courts, and three other courts, reportedly designed for Rugby fives. These were not popular, however, hence boys used them for squash instead.

In a letter to *The Times* in January 1924, William Hart Dyke, by then a veteran politician, insisted that the extra courts had always been intended for squash.

But whatever, none of these 1860s courts have survived, and no other purpose-built squash courts are recorded elsewhere until the 1880s, when some were built at Elstree School.

Meanwhile, as noted earlier, all eight of London's rackets courts today are found in pairs. But it was not until 1964 that a second court was added at Harrow.

Of a standard size, that is slightly smaller than the original one next door, which was just celebrating its centenary, this new court was built using Bickley's original formula as far as was possible for the walls and floor. For years it was the only modern rackets court in Britain, until another pair was built at St Paul's School in Barnes, in 2001.

There, incidentally, they stick to the modern spelling of 'rackets'.

At Harrow, its honours board, starting in 1854, is headed 'racquets'. Yet on the next board, listing all the professionals to have worked at the school, it becomes rackets.

But the real interest of this latter board is that only nine individuals have filled this post since 1822. The one who attracts the most attention is Charlie Williams. In 1912 Williams sailed to New York for a world title match.

He did get there, but only after spending nine hours in a lifeboat after his ship, the *Titanic*, went down.

Understandably the match was called off, but Williams went on to serve at Harrow until 1922.

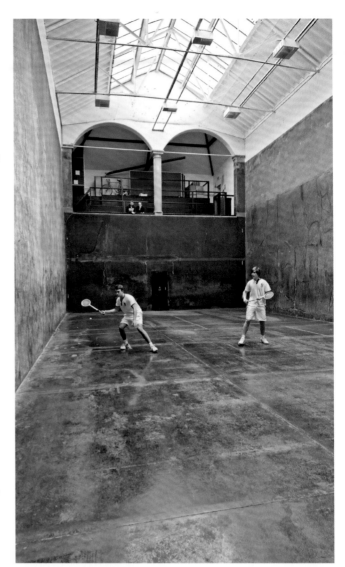

Britain's earliest suppliers of rackets balls in the 19th century were J Wilson of Roman Road, Bow, and Jefferies & Malings of Woolwich. The original Mr Maling, it is said, learnt his craft whilst an inmate at King's Bench Prison. The composition of the balls was similar to those of real tennis, using strips of cloth tightly wound with thread, but then baked and covered with smooth sheepskin.

The modern ball, introduced after experiments in the 1950s, is made in five stages; a factory supplied polyurethane core (*above left*) is machine wound with cotton, then covered with black binding tape. Two layers of white medical tape are then added before being trimmed and smoothed down. A seasoned professional can finish off around 40 an hour. In a typical game players will get through 25.

▶ Two miles west of Epping station at the end of the Central Line, and a few hundred yards north of the M25, the ruins of **Copped Hall** lie outside our study area. Yet just as we have strayed beyond the boundaries of London in the other direction to take in Eton, so there is every reason to do the same here.

A Georgian mansion remodelled by architect Charles Eames Kempe in the 1890s, Copped Hall was gutted by fire in 1917 and, after decades of neglect and uncertainty, is currently being restored by a Trust. Its extensive grounds are listed Grade II* on the Register of Historic Parks and Gardens, and are a delight. But for our purposes it is the splendid building seen here, to which visitors repair for tea and cakes after their perambulations, that merits attention.

Commissioned by EJ Wythes, who inherited Copped Hall from his grandfather, a railway and property magnate, in 1887, and who married into the aristocracy, the **Recreation House** was completed in *c.*1906 and is itself listed Grade II.

Designed also by Kempe, it is a prime example of the sort of facility then being built as adjuncts to great houses, with a rackets court forming the main space, overlooked by a viewing gallery at one end (*right*). At the opposite end, occupying three floors, are a reading room, a changing room and, in the basement, a boiler room.

When not in use for rackets, partitions could be moved and the space used for social gatherings.

One element of the Recreation House that has puzzled historians concerns its court dimensions.

As noted earlier, the standard size for rackets courts, established in the 1850s, was 60' x 30'. But not until 1907 was a governing body for the sport established (the Tennis and Rackets Association).

Consequently, the dimensions of rackets courts built in private grounds during the period 1850-1914 varied considerably.

Early courts for squash were similarly variable. At Elstree, the first school other than Harrow to play the game (because its headmaster had taught at Harrow), the courts, opened in the 1880s, were three-sided and outdoors.

Britain's first private squash court, meanwhile, built also by an Old Harrovian, Vernon Harcourt, at his house in Cherwell, Oxford,

in 1883, measured 38' x 20'. Ten years later Lord Desborough's squash court at Taplow Court was six feet shorter but 18 inches wider.

As the game spread, a number of squash players wrote to the press to state which size of court they believed was preferential, which were the better materials (timber or cement), and which type or size of ball should be used.

One correspondent to *The Times* in January 1913 declared that he knew of 12 different types of ball, and that it really was up to the individual to build a court according to the type of squash he wished to play, long or short, fast or slow.

In light of these variations architectural historians have sometimes been unsure as to whether certain courts were intended for rackets or for squash.

The Recreation House at Copped Hall is one such anomaly.

Measuring 40' 6" x 22' 11" it appears small for rackets but too long for squash, certainly longer than the standard finally laid down in 1911 of 32' x 21'.

One conclusion has therefore been that Copped Hall was designed for a hybrid form of 'mini-rackets'. Other courts of similar dimensions were at Catton Hall, Norwich (1897), Beninborough Hall, York (1901), Ickworth House, Suffolk (1909) and the Bank of England Sports Club, Roehampton (1909). But only the one at Copped Hall has remained intact.

In fact very few rackets courts of any size have survived outside the schools. Two courts built in 1874 at the Royal Naval College in Greenwich were subsequently remodelled for squash, but now serve as exhibition space. Similarly the court at Lord's, built in 1899, was converted in 1953 into what later became the MCC Museum.

Rackets did make a brief appearance at the 1908 Olympics at the Queen's Club, as did real tennis. But neither were deemed a success, and in any case by then it was patently obvious which way the tide had turned.

As one writer put it, 'rackets is essentially a game for the young', whereas, as the aforementioned correspondent to *The Times* noted in 1913, squash could be played by anyone, even an 'elderly duffer'.

He might also have mentioned that squash rackets and balls were cheaper and lasted longer.

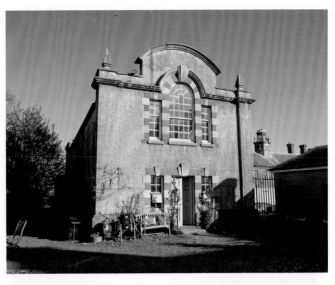

Hence, within 20 years, courts for squash completely outnumbered those for rackets.

There was even a squash court on the *Titanic*. Apparently the ship's original onboard squash instructor had dropped out at the last minute owing to illness, which is how the Harrow professional Charlie Williams secured his passage.

Considering where the game had started, it seemed only right.

THE VOGUE OF SQUASH RACKETS : A GAME FOR BOTH SEXES.

PHOTOGRAPHS BY SPORT AND GENERAL. DRAWING BY STEVEN SPURRIER, R.O.I., OUR SPECIAL ARTIST AT QUEEN'S CLUB. (COPYRIGHTED.)

INCLUDING THE WINNER, MISS S. HUNTSMAN (EXTREME RIGHT, STANDING), AND RUNNER-UP, MISS CAVE (EXTREME LEFT, SEATED): COMPETITORS IN THE LADIES' SQUASH RACKETS CHAMPIONSHIP.

FINALISTS IN THE LADIES' SQUASH RACKETS CHAMPIONSHIP: MISS S. HUNTSMAN (RIGHT), THE WINNER, AND MISS CAVE, RUNNER-UP.

THE LADY CHAMPION OF LAST YEAR : MISS JOYCE CAVE.

THE NEW LADY CHAMPION (SQUASH RACKETS): MISS. S. HUNTSMAN.

THE LADIES v. MEN SQUASH RACKETS HANDICAP : MISS S. HUNTSMAN, WHO BEAT MR. R. GORDON CANNING, IN PLAY AT QUEEN'S CLUB.

▲ 'Squash rackets has of late become highly popular as a game both for men and women,' reported the *Illustrated London News* in November 1922, in a feature on the second **Ladies Squash Rackets Championship** at the **Queen's Club**.

'And as it can be played in the winter, and takes up even less room than hard courts for lawn-tennis, it is likely to prove a great boon to the seekers of exercise in towns.'

In a decade that also brought to London Wembley Stadium, greyhound and speedway racing, the first modern lidos, darts and the Charleston, squash came of age.

In 1923 a squash committee of the Tennis and Rackets Association was formed. Standards were agreed, national competitions organised and gradually the sport started to assert its independence. Finally this led to the formation of

the Squash Rackets Association in 1928, with its London focus shared between Queen's, the Royal Automobile Club in Pall Mall and the Bath Club in Dover Street.

Hotels started installing squash courts. In the suburbs clubs were formed in St John's Wood, Dulwich (*see page 94*), Purley and Surbiton.

Four years after the death of Joseph Bickley in 1923, Bickley and Co., now based in Battersea, advertised themselves as 'tennis court specialists'. Two years later this had changed to 'squash racquet court specialists.'

But they had rivals: Humphreys of Knightsbridge (builders of many a London stadium and grandstand), Grays of Cambridge and Carters Sports Courts of Green Lanes N16.

Yet for all the hundreds of courts built between the wars, few were standalone buildings of note, and fewer still would survive.

Undoubtedly the best of these is to be found in **Hammersmith**.

Seen opposite, this exquisite Grade II listed early 1930s building, with a garage on its ground floor, was commissioned by Dick and Naomi Mitchison for the garden of their **Rivercourt House**, very much a social and artistic hub in 1930s west London.

Designed by John Macgregor with decorative bronzes by Gertrude Hermes – the seahorse on the roof for example – the court now finds itself absorbed within the grounds of **Latymer Prep School**, and serves as a drama studio for pupils at the adjoining Upper School.

Around the world today there are 50,000 squash courts and 20 million players in 185 countries. London alone has over 400 courts spread around 45 leisure centres and 94 clubs. For many of these clubs, whether set up originally for cricket, tennis or rugby, squash has become a core activity, and in many cases a lifeline, in terms of membership and revenue.

As a result, squash is no longer a novelty. One court looks exactly like another, which was precisely the point of the 1920s standardisation process.

Yet seen here in Hammersmith is a rare example of how the game could inspire great design.

Nor let us not forget that squash itself has succeeded very much by design; one more example of a worldwide sport that can truly claim to have been 'made in London'.

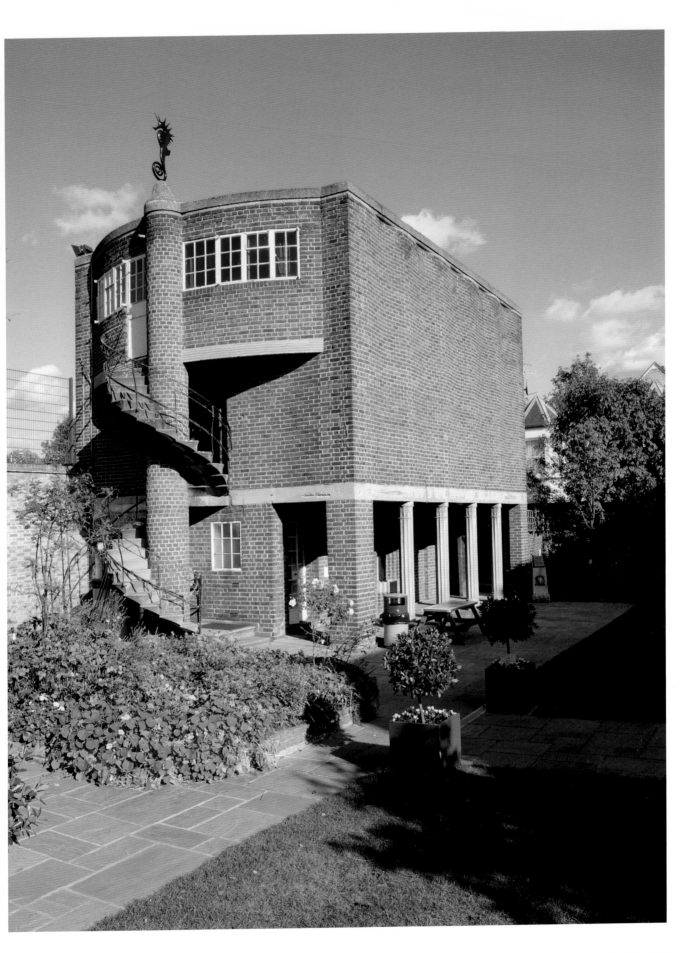

Chapter Twenty Seven

Lawn tennis

All sports have been driven to a greater or lesser extent by advances in materials and technology. But as encapsulated by this exhibit at the Wimbledon Lawn Tennis Museum, without two breakthroughs in particular, lawn tennis would never have been possible. The first was the invention of the lawn mower, by Edwin Budding of Stroud, in 1830. Before then grass had been kept in trim either by animals grazing or by skilled workers wielding scythes. The lawn mower brought neatly tended turf within reach of the middle classes. The second advance was the discovery in 1839, by the American Charles Goodyear, of a process he called 'vulcanisation'. This made rubber more stable in different temperatures, and thereby opened up a whole new world of sporting applications. By the 1850s manufacturers in Germany had perfected the mass production of air-filled rubber balls. It was then only a matter of time before a couple of real tennis or rackets players took one of these balls out onto a neatly trimmed lawn...

Of all the racket and court-based games played around the world, only lawn tennis has achieved truly mass global appeal.

It has done so, moreover, game, set and match, by virtue of design; that is, by its brilliant utilisation of space and geometry, its ready adoption of modern materials and by its quirky, time honoured scoring system, which manages to balance simplicity with jeopardy at key moments. In addition, whereas live audiences for real tennis, rackets or squash number only in their hundreds, owing to their court design, tennis can be watched by thousands.

Lawn tennis was the first game to be played at a high level by both sexes. Just as importantly lawn tennis clubs gave women and girls a competitive and social outlet beyond anything they had experienced in a sporting context, and was certainly more physical than archery or croquet.

And wherever there were women and girls, men and boys were sure to follow. Thus did lawn tennis become what historian Richard Holt has called Britain's 'first truly national game'.

As in so many sports, London was to play a pivotal role in the evolution, codification and governance of lawn tennis.

Considering its evolution, on the left we allude to the role of the lawnmower. Strictly, the first game aimed specifically at the owners of Britain's pristine new lawns was croquet whose first modern rules were published by John Jaques of Hatton Garden in 1857.

Yet just as croquet ascended to the height of fashion – the 1864 edition of the rules sold 65,000 copies – its appeal rapidly withered. Men found it too sedate, while its promoters sought to turn it from a casual party game into a serious sport. As the London Daily News recalled in June 1875, 'Croquet had the misfortune to become earnest...'

Leaving behind, it should be added, a number of croquet lawns, ripe for the next big thing.

Like croquet, which was based on much older games using mallets and hoops, lawn tennis did not suddenly materialise out of nowhere. William Hickey, for example, describes meeting regularly with his chums at the Red House, Battersea, in 1767, to play what they called 'field tennis'.

By 1793 the Sporting Magazine was claiming, 'Field tennis threatens ere long to bowl out cricket.' One of its adherents, ironically, was a founding member of the MCC, Sir Peter Burrell, of Langley Park, Beckenham.

But what was field tennis? In his 1837 book, Games and Sports, Donald Walker described 'Long' or 'Open Tennis' as a game for one to six players per side, played upon ground 'rolled and arranged' for the purpose. Frustratingly he says nothing of the type of ball used.

Whatever, it could well have been this game, based closely on real tennis, that in the 1840s was played by Lord Arthur Hervey, a regular real tennis player at James Street, in the gardens of Ickworth House, Suffolk, and by

a correspondent to The Field, who recalled playing outdoor tennis in Leyton in c.1868.

When the antecedents of lawn tennis became a hot topic in the 1870s, another correspondent to The Field was a Birmingham solicitor. Harry Gem described how in c.1859 he and Jean Pereira, a Spanish wine merchant, both rackets players, had experimented with a game using rubber balls on Pereira's lawn in Ampton Road, Edgbaston (as featured in Played in Birmingham). The pair then moved to Leamington in 1872 and set up the world's first lawn tennis club.

Gem wrote to The Field because a similar outdoor game had just been launched in London, in February 1874. Patented by Major Walter Clopton Wingfield, a Welsh army officer with friends in high places, it was titled 'Sphairistikè, or Lawn Tennis', and was available as a £6 boxed set from French & Co of 46 Churton Street SW1 (now a Vietnamese restaurant).

Each set consisted of a net, poles, pegs and a mallet, a brush to paint lines, four rackets (that is, real tennis rackets, made by Jefferies & Malings of Woolwich), a set of red India rubber balls (from Germany) and an eight page instruction booklet.

'Beware of spurious imitations,' warned Wingfield. As well he might, for although a sales ledger, now in the possession of the Lawn Tennis Museum at Wimbledon, shows that 1,050 sets were sold in the first year – several to members of royal and aristocratic families – rival tennis sets soon appeared.

After serving in India and China, Major Walter Wingfield moved to London to become a member of the royal bodyguard. He was living at 112 Belgrave Road, Pimlico, when he took out his patent for 'A New and Improved Portable Court for Playing the Ancient Game of Tennis' in February 1874. This GLC plaque, however, is at his later Pimlico address, 33 St George's Square.

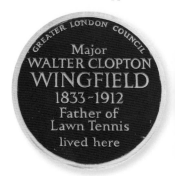

GREATER LONDON COUNCIL
Major
WALTER CLOPTON
WINGFIELD
1833–1912
Father of
Lawn Tennis
lived here

One of them was promoted by George Lambert, the real tennis professional at Lord's, where lawn tennis quickly caught on. Many years later one of his descendants claimed that Wingfield concocted the idea for lawn tennis after seeing Lambert trying it out at Hatfield House in 1866. This ties in with a story that it was the politician Arthur Balfour, a regular at Hatfield, who suggested that Wingfield's name of Sphairistikè, a cod Greek invention, would not catch on, and that 'lawn tennis' would surely be preferable.

Wingfield's box set may have launched the game, but it was members of the MCC at Lord's who drafted the first revised rules. One of the committee was the real tennis amateur, JM Heathcote, who, whilst experimenting in his back garden in Brighton, had his wife cover one of the rubber balls with flannel. They have been covered ever since.

While the MCC tinkered, other London clubs took up the game. Most notably, in 1875 the All England Croquet Club at Wimbledon tried it, and liked it so much they held their first championships, for men only, two years later, in July 1877.

This was not the game's first public airing in the capital, however. Two months earlier, on May 17 1877, there took place what The Field considered to be the first public exhibition of lawn tennis, a match between George Lambert's brothers, William and Charles, both also real tennis professionals, at the Maida Vale Roller Skating Rink on Portsdown Road, now Randolph Avenue (see page 34).

Ironically, it was played on the rink's asphalt surface, under cover. In other words, 'lawn tennis' showed itself almost immediately to be adaptable, even if it was never played on ice, as Wingfield had stated would be possible.

Alas poor Wingfield. From the MCC the business of rule making for lawn tennis passed to the All England Club. One of the first of his rules to be jettisoned was his idea of an hourglass-shaped court.

Meanwhile manufacturers such as Slazenger, newly arrived in London from Manchester, and FH Ayres of Aldersgate, started to mass produce tennis goods. Worse, the Major's three sons all died and his wife lost her mind.

In later life Wingfield developed an interest in bicycle design and founded a culinary society. But he was largely forgotten by the time he was buried at Kensal Green in 1912, and only in recent decades has his contribution been fully commemorated, at Wimbledon.

On which note, the All England Club was only one of several clubs to adopt tennis. The cricket clubs in Richmond (in 1874), and both Woodford Wells and possibly Hampstead followed suit in 1878, as did Beckenham in 1879. They were joined by archery clubs in Putney (1879) and Ealing (1882). These clubs remain active, as do Bexley (1880) and Surbiton (1881), formed specifically for tennis.

By 1882, when the first Lawn Tennis Annual was published, of 26 clubs listed nationally, twelve were in the London area. By 1914, London's total had risen to 159.

The scale of some of these early clubs was breathtaking. Founded in 1881, the Norwood Sports Club, in Woodvale Avenue SE25, had 54 courts, and in 1888 became the headquarters of the newly formed Lawn Tennis Association (later based at the Queen's Club and today at Roehampton). The original clubhouse is now the Waterside Community Centre, while a public sports ground occupies the rest of the site.

Even larger was the Brooklands Club in Blackheath Park. Opened in 1909 this had 69 courts until sold off for housing in the 1930s.

Other once prominent clubs lost to development were Prince's (closed in 1886, see page 287), and Chiswick Park LTC (closed 1946), both said to have been second in rank only to Wimbledon.

Yet overall the number of tennis clubs continued to rise, reaching a peak of 3,220 in Britain in 1938. Today the total stands at 2,700, of which, according to the LTA, 114 are in London, with around 1,000 courts. Another 1,000 or so courts also exist in London's public parks and leisure centres.

But perhaps the best way of demonstrating how lawn tennis has colonised the capital is to pick up a modern street atlas and look within the boundaries of London's 32 boroughs. Depending on the edition, typically only three pages, covering the outer extremities of the city, do not have at least one tennis court marked.

▲ Disused tennis courts with their surfaces crumbling and their nets long gone are, sadly, a common enough sight in Britain's parks. But this court is different. This almost certainly is the **oldest concrete lawn tennis court in the world**, a description which, although apparently an oxymoron, explains why it is also the only known surviving example of an **hourglass-shaped court**, as specified by **Major Wingfield** in his original box set of Sphairistikè in 1874.

Equally interesting is the court's location, in the gardens of **Down House**, the family home of **Charles Darwin**, on the outer edges of the London Borough of Bromley.

Laid in 1881, the court intrigues tennis historians on two counts.

Firstly, why concrete? We know of earlier concrete courts, for example at Charterhouse in 1875, and of early asphalt courts at Ickworth House, Suffolk, and Maida Vale (see left). But concrete, in a country house garden?

The most likely answer is that, like their father, the Darwins often espoused new ideas and methods. Son George in particular, a keen

tennis player, was what we would now call 'an early adopter'. Living in Cambridge he was among the first to ride a bicycle with pneumatic tyres and to have a telephone.

That said, family papers suggest it was Charles' wife, Emma, who did most to have the court built.

Secondly, why lay it in the shape of an hourglass, in 1881, when rectangular courts had become standard by 1877? Especially as a watercolour of Down House in 1880, by Albert Goodwin, depicts a grass court closer to the house, and this appears to be a rectangle.

This grass court, we know from letters, was much used by friends and family members during the summer, often with the elderly Charles watching from the sidelines.

Was it perhaps Emma's decision to provide an all-weather hourglass court, simply to offer a quaint alternative?

Despite close analysis of every available source, no-one has an answer. So far. All that can be added is that the placement of a clamp where the net would have been fixed (left), and the pattern of cracks, suggests that this is the original surface. (The pattern closely matches photographs of the Charterhouse court). And that from 1907–27 Down House served as a girls school, so if the court was used for tennis or netball it withstood this use remarkably well.

Readers wishing to inspect the court more closely are welcome to do so. Down House has since 1996 been managed by English Heritage, and is open to the public all year round.

▲ Lottie Dod, Dorothea Lambert Chambers, the Renshaw brothers, Suzanne Lenglen and Bill Tilden – stars from the early years of lawn tennis – all had cause to frequent this modest range of buildings.

For here, tucked away in a corner of what is now the sports ground of **Wimbledon High School**, are the former buildings of the **All England Lawn Tennis Club** (AELTC), still in use as changing rooms by the girls some 90 years after the club moved out to its current grounds on Church Road.

Located at the end of **Nursery Road** but known as **Worple Road** (the main road to the north), it was on this site that the **Wimbledon Championships** were born in 1877.

Not that this was ever the intention. Lawn tennis did not exist in any formal sense when the grandiosely titled **All England Croquet Club** formed at the Strand offices of *The Field* in July 1868. Nor did Worple Road, other than as a cart track serving an otherwise semi rural, remote spot.

Sandwiched between a dairy farm and a brick field, with the London & South Western Railway along one side, the grounds opened in May 1870, with twelve croquet lawns and a small single storey brick pavilion. Seen above with its bay window, it is thought to be the sixth oldest sports related building still in use in London (*page 101*).

As mentioned, Wingfield's tennis sets went on sale in 1874. A year later Worple Road witnessed its first tennis match. The rest is well known. In April 1877 the club was renamed the **All England Croquet *and* Lawn Tennis Club**. The following June the first Wimbledon Championships took place, and from then on the grounds developed year by year, to create the complex we see below, photographed during the final Worple Road Championships in June 1921.

Where the Centre Court was located there is now a hockey pitch,

while the buildings that survive can just be made out in the top right, or northern corner of the grounds.

Next to the pavilion stood the AELTC Secretary's Office (*also seen left*) and to its left a single storey extension housed changing rooms (fixtures and fittings from which are now on display in the Wimbledon Lawn Tennis Museum).

Behind these club buildings there had been a roller skating rink, built in the 1870s and used briefly by the AELTC for indoor tennis. This was then replaced by workshops, until eventually the flats seen in the modern photograph, known as Pavilion Court, were built on the site in 1995.

Public access to the grounds today is possible only as far as the main entrance, where stands a gate erected in 1935 to mark the 50th anniversary of that first lawn tennis match at Wimbledon.

However the site boundaries have not altered since 1921, thereby allowing us to see why the grounds and its approaches were simply unable to cope with the rising tide of public interest.

Worple Road became crammed with cars. For spectators arriving from Wimbledon Station, half a mile away, a narrow path alongside the railway (still extant) offered the most direct route, but one that could become uncomfortably congested and subject to flying smuts from passing locomotives.

Indeed the AELTC had had to erect its first scoreboard, in 1880, because no-one could hear the umpire calling out the scores whenever a train went past.

Eventually, as Alan Little's chronicle of the ground reports (*see Links*), conditions deteriorated from being 'very congested' when there were 6,000 in the grounds, to 'packed to suffocation' when numbers approached 8,000.

Suzanne Lenglen apparently hit the last ever shot at Worple Road. After that, like most former grounds of major clubs the site was expected to sell for development. Instead of which the High School stepped in, ensuring that this precious corner of tennis history has remained happily, if anonymously, in sporting use ever since.

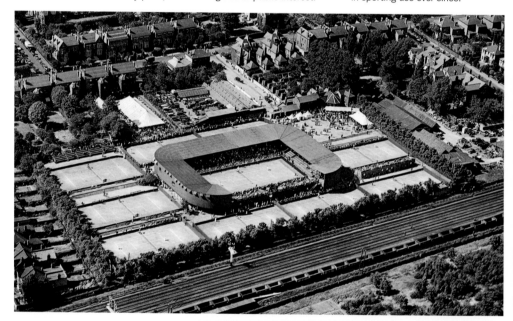

Among various artefacts to survive from Worple Road (other than the dressing room fittings) is this roller, presented to the All England club in 1872 and seen here in 1907. Notice that the pony wears leather boots to protect the turf. After 49 years at Worple Road the roller was used on the new Number One Court at Church Road from 1924–86, before being retired and put on display in the Wimbledon grounds.

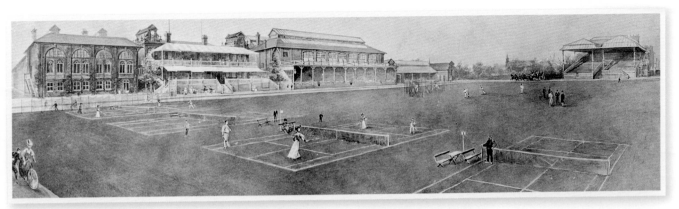

▲ After the Prince's Club in Hans Place succumbed to developers in the 1880s, an opportunity arose for a more central London club to outpoint Wimbledon both as a tournament venue and as the social focus of lawn tennis.

Thus arose the **Queen's Club** in **Palliser Road**, **West Kensington**.

Depicted here in the 1890s, Queen's offered the game from the day its doors opened in May 1887. It had room for 30 outdoor courts and was better connected than the AELTC at Worple Road in every sense; more so once Baron's Court Underground station opened on its doorstep in 1906.

Unlike the AELTC, however, lawn tennis was only one of many sports on the Queen's roster – there were 25 in the 1890s according to club secretary EB Noel – and it was only when the likes of football, rugby and athletics moved on after 1928 that lawn tennis took centre stage, as remains the case today.

For that reason we shall return to Queen's later. But for now it is worth marvelling at how such a large site has resisted developers when so many other west London clubs and grounds did not.

Rather more typical are the capital's smaller lawn tennis clubs, able to slot into tight urban spaces. Of these, perhaps the most constrained example is the **Paddington Sports Club** (*right*).

Opened in 1928 by the tennis glamour couple, Kitty and Leslie Godfree, the **Paddington Sports Club** is entered via a narrow opening between the mansion flats on **Castellain Road**, and is otherwise completely enclosed.

Yet that is partly why tennis, and indeed bowls, also played at Paddington, were so perfectly suited to Britain's burgeoning towns and cities. Each required less room than cricket or football, but added value to their surroundings by providing for residents' social and recreational needs.

In fact at Castellain Road it is thought the narrow site had been the base of an earlier tennis club since at least 1913. Before that it had possibly been used for dumping spoil from the Underground.

For its part the club's bowls section had formed in 1905 at the nearby Paddington Rec (*see page 34*). Its 1935 **indoor bowling centre**, nearest the camera, features elsewhere (*page 190*), as does the former **Maida Vale Roller Skating Rink** (*page 23*) with its prominent grey roof on **Delaware Road,** on the left, now the home of BBC Studios (and not to be confused with the aforementioned rink on Portsdown Road, now Randolph Avenue).

But if bowls and tennis were once of equal importance at the Paddington club, in recent years, as at the Queen's Club, lawn tennis has come to dominate. Largely this is owing to the concentration of young professionals in the vicinity, plus the earning power of a floodlit all-weather tennis court compared with a turf bowling green in use for only six months a year.

In that sense, lawn tennis and London were made for each other.

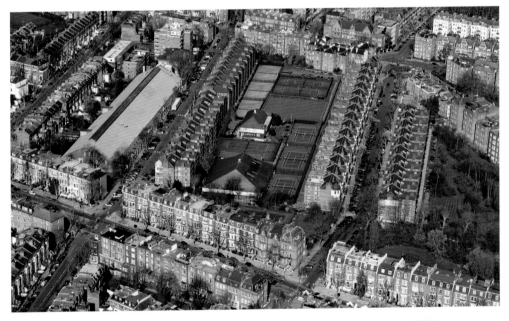

ENGLISH HERITAGE

DOROTHEA LAMBERT CHAMBERS
1878-1960
Lawn Tennis Champion
lived here
1887~1907

ENGLISH HERITAGE

KATHLEEN ('KITTY') GODFREE
née McKANE
1896~1992
Lawn Tennis Champion
lived here
1936~1992

Two themes central to the history of lawn tennis concern the role of women and the game's place in suburban life. Dorothea Lambert Chambers, winner of seven Wimbledon singles titles between 1903–14, grew up at 7 North Common Road, Ealing, where this blue plaque can be seen. Her father was a local vicar, while she was a member of the Ealing LTC, based since 1906 on Daniel Road.

Only one female Londoner has since emulated Lambert Chambers at Wimbledon. Kitty McKane, a member of the now defunct Kew LTC, won two singles titles at Wimbledon's new Church Road grounds in 1924 and 1926. Also in 1926 she and husband Leslie Godfree became the only married couple to win the Mixed Doubles. Kitty's blue plaque is at their home at 55 York Avenue, East Sheen.

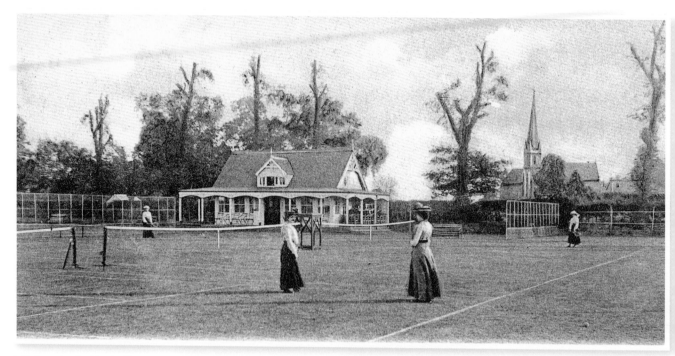

▲ Perhaps inspired by the likes of Dorothea Lambert Chambers, lady members of **Bexley Lawn Tennis Club** gather in c.1909 at the club grounds on **Parkhurst Road**. In the background, then as now, is the spire of St John the Evangelist.

Bexley are one of London's oldest and most settled lawn tennis clubs. Their potted history, if perhaps lacking glamour, is certainly typical, and is extracted here to give a flavour of how suburban clubs have developed over the years:

1880 club founded **1893** timber pavilion (*above*) erected, former rackets champion Sir William Hart-Dyke MP appointed club president **1908** minute books survive from this year onwards, annual tennis subscription set at £1 6s 0d **1914** South East & Chatham Railway arrange for 11.56pm train from Dartford to stop at Bexley and Sidcup for benefit of members travelling home after annual dance **1927** club joins Kent Lawn Tennis Association **1931** death of

Sir William Hart Dyke, aged 93 **1939** table tennis introduced **1941–46** club closes during war, grass courts cut by hand owing to petrol rationing **1945** pavilion damaged by flying bomb **1946** club re-opens, bowls section closed, croquet equipment put in store **1949** mains electricity installed **1950** club president AR Potter, a local councillor and businessman, buys site from landlords Oxford University, leases it back to club at £45 per annum with option to buy when funds permit **1951** two shale courts laid by Leicester court specialists *En Tout Cas* on the site of the bowls and croquet lawn **1953** telephone installed **1957** pavilion connected to main drains, but in absence of flushing toilets Hon Secretary must still empty Elsan toilets weekly **1960** club purchases ground from Potter family for £1,500 **1962** car park laid on site of an old court **1963** members build pavilion extension, install gas-

heated showers and flushing toilets **1964** club learns from contacts at Table Tennis Association that it could be eligible for government grants, decision made to build squash court **1965** original men's changing room, lately a refreshment room, removed to make way for third shale court, sprinkler system installed, first squash court built at cost of £3,800, rate of hire fixed at 2s per player per 40 minutes **1966** snooker table purchased **1967** second squash court built at cost of £3,000, savings of around £1,500 made by Hon Secretary acting as site foreman **1972** volunteers replace pavilion roof, bar takings exceed £5,000 for first time **1973** third squash court built at cost of £6,000 **1975** squash court hire doubles to 20p per player per 40 minutes **1976** bar takings reach £10,000 **1979** three grass courts replaced by *Tennisquick* courts, two courts now floodlit at cost of £28,000, financed by grants from Sports

Council and local authority, and by donations **1983** original shale courts replaced by *Playdek* courts **1984** club is founder member of British Racketball Association* **1989** pavilion lobby added in brick **1990** floodlighting extended **1991** last remaining three grass courts replaced by cushioned acrylic courts, pavilion and squash courts fitted with card entry system, squash courts fitted with gas heating **1993** permission granted for new brick clubhouse and other improvements **1997** £250,000 lottery grant secured **1998** completion of new clubhouse, plus two glass walled squash courts, two tennis courts resurfaced, car park extended on site of original 1893 pavilion

*Racketball, not to be confused with rackets, is a game developed by the Bexley secretary Ian Wright, in the 1960s, using shorter rackets and softer balls in a squash court. It is now played all over Britain.

Seeing how popular lawn tennis was becoming, the LCC's Parks Department started laying out grass courts in the 1890s, with Battersea Park, as ever, one of the first, photographed here by Sidney Smith in 1912. Shale and tarmac courts were introduced between the wars. By 1963 there were 2,918 tennis courts in public parks across London. Today around 1,000 are in use.

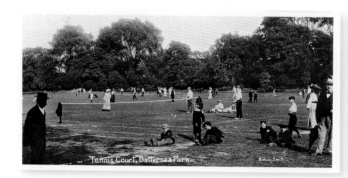

Tennis Court, Battersea Park.

▶ While the majority of London's tennis clubs, as at Bexley, have found it necessary to replace their original timber clubhouses with modern, functional, if regrettably anonymous buildings, members of **Beckenham Cricket and Tennis Club** decided in 1996 to buck the trend. The result, seen here at their archetypically leafy suburban ground in **Foxgrove Road**, is one of the best restored, and oldest functioning timber framed pavilions in London (*see page 101*). As such, it was listed Grade II in 2013.

On the opposite side of the ground sits the 1960s pavilion of the cricket club. This was formed in 1866, while the tennis section followed in 1879. Within a year ladies were admitted, in such numbers that in *c.*1896 this separate pavilion was built for their use. Later extended in 1906, it took today's Beckenham members eight years to complete the restoration.

Visiting the ground today it is hard to imagine that for one week in every June from 1886 to 1996 Foxgrove Road was the venue of a pre-Wimbledon tournament as important as its counterpart at the Queen's Club. Known as **The Kent All-Comers' Championships**, the event drew legions of top international players, among them the Brazilian **Maria Bueno**, to whom the renovated pavilion lounge (*right*) was dedicated in 2003.

Facilities at the tournament may have been relatively basic, as the aerial view from 1965 indicates (*below right*). The stands were all temporary, and the show courts were laid out on the cricket pitch.

Yet Beckenham was no sleepy backwater. In 1963 it became the world's first tennis tournament to be sponsored (by Rothmans), and five years later was the first grass tournament to be held in the new, so called Open Era, in which professionals were at last allowed to compete alongside amateurs.

But these developments were also to lead to the Beckenham tournament's demise after 1996, by which time other pre-Wimbledon events, particularly Queen's, had become major, televised affairs, slotted into an increasingly packed international calendar.

Foxgrove Road is therefore a rather quieter place of late, but with a pedigree, and a pavilion, that occupies an esteemed place in London's tennis history.

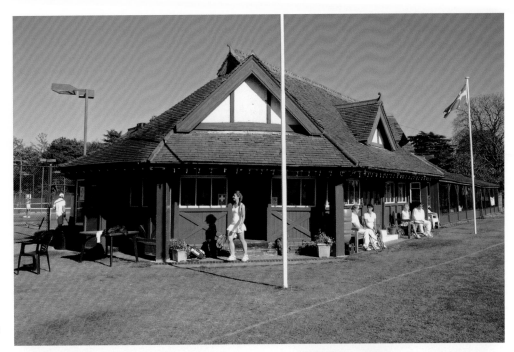

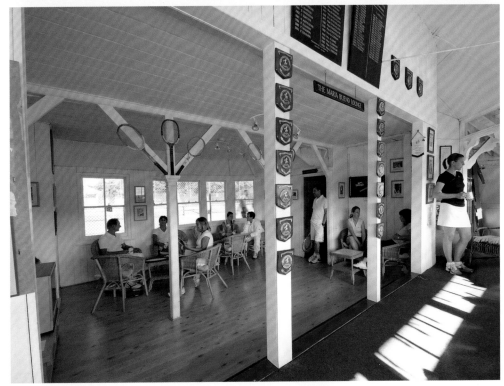

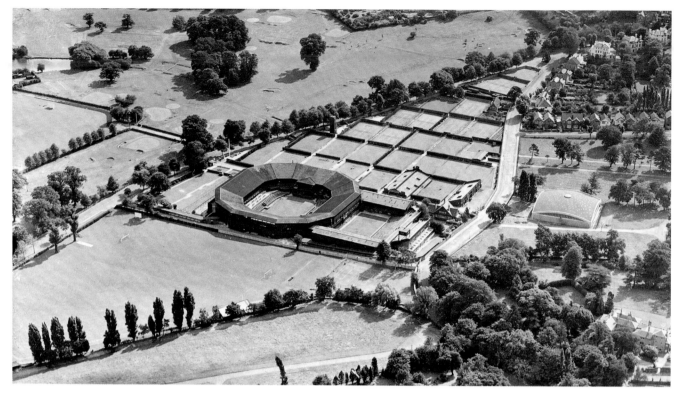

▲ Shortly before its opening in June 1922, Bernard Darwin, whose childhood had been spent at Down House, wrote in *Country Life* that the new **Wimbledon** lay 'in a wonderfully pretty and peaceful spot... with but a very few houses in sight that look down upon it from the crest of a wooded hill and do not like, very possibly, this new object in their landscape'.

Even some forty years later when this view was taken in *c*.1960, the second home of the **All England Lawn Tennis Club**, on **Church Road,** appears not to have impinged too greatly on its surrounds.

And yet... this was a 13 acre site that had once formed part of **Wimbledon Park**, an estate owned by Earl Spencer and landscaped in the late 18th century by Capability Brown. After most of the park was sold for housing in 1864 a group of local residents

combined to save as much green space as they could. In 1889, just as Wimbledon Park station was about to link the area with central London, nine acres, lying across the road from where the AELTC would later settle, were taken up by the **Wimbledon Sports Club**, whose cricket section had formed on Wimbledon Common in 1854 and who also offered lawn tennis. A portion of their ground, still in use today, can be seen above, centre left. Adjoining this, another tract of the park was saved in 1898 by the formation of the **Wimbledon Park Golf Club**, whose course can be seen at the top of the photograph.

In the top left corner is the southern tip of Capability Brown's lake. This and the remaining parkland was bought for the public by Wimbledon Borough Council in 1914 and retains the name **Wimbledon Park**.

In the lower left, running up to the AELTC's fence, was the sports ground of **John Barker & Co.**, the Kensington department store.

So a pretty and peaceful spot it was, and very possibly not all local residents were delighted when in 1921 work started in their midst on the largest reinforced concrete stadium yet seen in Britain.

Four times the size of its predecessor at Worple Road, the new **Centre Court** held 9,899 seats with standing room for 3,600; smaller than a football stadium, it is true, but until this point the largest concrete structures in sport had been individual stands, built in urban settings.

Only one other contemporary scheme was comparable, and that was the Empire Stadium, then in its planning stage at another peaceful spot, Wembley Park (*see page 72*). Designed to hold

120,000, the new stadium at Wembley would clearly be larger.

But in George Hillyard, AELTC Secretary and a former Wimbledon champion, and architect **Charles Stanley Peach** (1858–1934), the AELTC had at least two individuals who understood the geometry of stadiums better than their counterparts at Wembley. Not least each court was laid out on a north-south axis so that the sun would not shine directly in the players' eyes, as it had done at Worple Road and would do so, absurdly, at Wembley.

A one-time medical student and surveyor in the Canadian Rockies, Peach had made his name as a designer for electricity companies. His Grove Road Power Station in St John's Wood (b.1904) was a familar backdrop to Lord's until its demolition in 1972, but his delightful sub-station in Brown Hart Gardens W1 still stands, as do a number of his other London buildings, including the Central Cold Store (b.1911) on Charterhouse Street EC1.

To complete Peach's scheme the AELTC had to raise £140,000 via loans and debentures. Not since Arsenal moved to Highbury in 1913 had such a leap of faith been taken in London; for the headquarters, no less, of an amateur club who expected to use the show courts for just thirteen days a year.

To provide optimum viewing at the new Centre Court, Peach designed a twelve sided stadium and placed a farthing-sized white disc in the centre to test the sightlines. He also used shuttering to provide a textured finish to the reinforced concrete (a year before the same technique was used at Wembley). Leslie Godfree served the first ball, but only after a delay caused by rain.

THE ARCHITECTS' JOURNAL, MAY 31, 1922

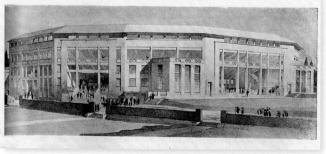

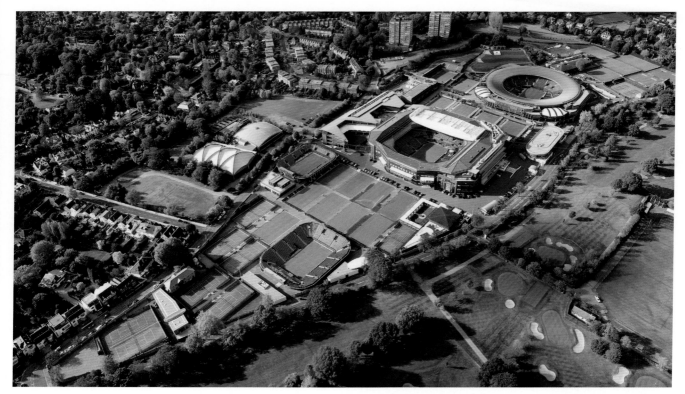

▲ Viewed in 2012 from the south east, with **Wimbledon Park Golf Club** in the foreground, the grounds of the **All England Lawn Tennis Club** have, since 1922, been like a constantly changing stage set.

Hardly a year has passed without alterations of sorts; an extra row of seats here, a gate and a scoreboard there, and, in some instances, structures going up and coming down within a matter of years.

Wimbledon is perhaps London's most complex sporting complex, yet one that somehow makes perfect sense.

It has been often said that no one in their right mind would build a venue of this scale or stature on a site so awkwardly shaped, so poorly served by main roads, so far from the nearest stations and in such a quiet residential and parkland area.

Yet it is those very characteristics that have been the making of Wimbledon's worldwide reputation.

In 1922 the Championships were attended by a total of 120,000 people. In 2009 they peaked at 511,043. The record for a single day, also in 2009, was 46,826 on June 26.

Since then the capacity has been pegged at 38,500, still greater than that of Tottenham's White Hart Lane or West Ham's Upton Park, but some way below meeting the voracious demand for tickets.

At the same time the site has had to cope with a massive rise in the corporate hospitality market and in the demands of the international media.

That it continues to meet these demands is largely the result of a redesign carried out by the Building Design Partnership (BDP) between 1994–2000. Reported to have cost £100 million (although, as ever, the AELTC is far too discreet to discuss such details), this was achieved by expanding the site to 42 acres. This now includes a total of 54 courts, 19 of them used for the Championships.

Much of the BDP masterplan involved redesigning circulation routes and enhancing public areas, their approach being informed by the notion of an English country garden. Many of their other back-of-house improvements would remain unseen and even underground.

However BDP's most visible addition, as seen above, is the new **Number One Court**, with its circular lightweight steel shell roof held gracefully in tension, column free, above a bowl seating 11,432.

One of London's most stylish arenas of the late 20th century, the court stands on the former John Barker sports ground. The AELTC bought this in 1967 and until 1981 leased it to the London New Zealand Rugby Club, who renamed the ground **Aorangi Park**.

The name lives on in **Aorangi Terrace**, a turfed picnic and 'big screen' viewing slope behind Number One Court, better known since as 'Henman Hill' or more recently 'Murray Mound'.

In place of Peach's original Number One Court, a further new facility is the E-shaped **Millennium Building**, also by BDP. This houses facilities for players, members, the

press and the ever popular ball boys and girls. North of this stands a new **Broadcast Centre** (seen with its rooftop lawn). On the Church Road side (centre right), the building with rounded corners houses offices, a shop and the **Lawn Tennis Museum**, opened in 2005.

Two older buildings have survived. Directly opposite the new Number 3 court (centre left), on the west side of Somerset Road, stands a simple concrete dome, its vault a mere three inches thick in parts. Designed by engineers CJ Pell & Partners in 1958 and covering two **indoor courts**, arguably this is one of the most important historic structures at Wimbledon. (It can also be seen on the aerial view opposite.)

The other is of course **Centre Court**, which, as a result of the expansion northwards during the 1990s really is now centre stage.

Decked in Boston ivy on the Church Road side of the grounds, behind what was Court 13 but is now the new Court Three, this was Wimbledon's reinforced concrete water tower, demolished in 2007, much to the dismay of those who found it useful as a prominent reference point. Stanley Peach designed it to hold a 2,000 gallon tank, fed by water pumped from the lake in Wimbledon Park.

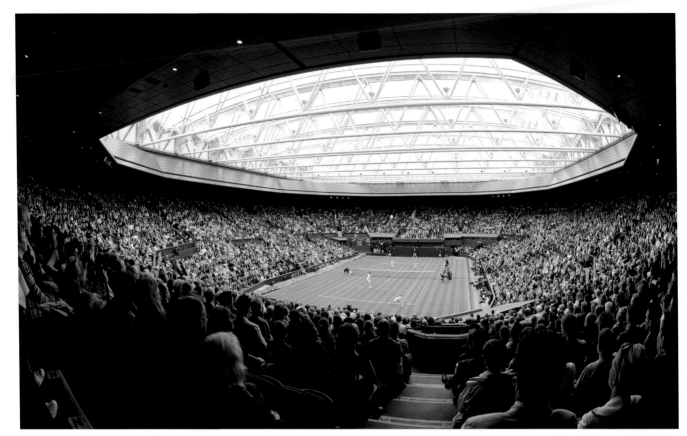

▲ It is to be expected that entering any large scale sporting arena will induce a certain frisson. But on setting foot inside **Wimbledon's Centre Court** what most people react to instantaneously, viscerally, without necessarily being able to explain why, is the grass.

Instinctively they know that were the grass to be replaced by an inorganic, synthetic surface, the space would take on an entirely different character.

Wimbledon is now the only Grand Slam tournament still played on natural grass. The French have always preferred clay. In New York they gave up turf in 1975. Melbourne followed suit in 1988.

But at Wimbledon the AELTC have remained faithful to their roots, despite the painstaking care

that is required all year round, and despite the cost of employing 16 ground staff (plus another dozen during the Championships).

Even so, just as the composition of hard courts has advanced, turf technology has moved on too.

Since 2001 Centre Court's surface has changed from a mix of four grass types to a more durable rye grass mix. Its cut has been raised from 6mm to 8mm.

Combined with advances in players' fitness and in the design of rackets and balls, this has led to a complete change in the way tennis is played at Wimbledon. Instead of the old style of 'serve and volley', players nowadays exchange blows more from the baseline. The result is that many games now take longer.

Add the fact that all but seven Championships since 1922 have been affected by rain delays, which in turn has exasperated television schedulers in over 180 countries, and it becomes clear why, in 2004, after years of debate, the AELTC announced that Centre Court was at last to have a retractable roof (even though this meant discarding a brilliantly engineered roof erected as recently as 1992).

Costing an estimated £100 million, and designed by **Populous**, with engineers **Capita Symonds**, the concertina-style roof was first used in 2009. It closes in ten minutes, but then it takes another 30 minutes or so for the airflow inside the court to be adjusted so that play can resume.

The installation of lighting also

means that play can now continue after sundown, although not later than 11.00pm in order to comply with local planning agreements.

Despite this, other than the east side of the Centre Court, which was completely rebuilt as part of the roof development, the inner core of Peach's original design remains remarkably intact. This can be seen especially in the lower concourses and, above, by tracing the angled line of the low balcony walls dividing the upper and lower tiers, still with Peach's criss cross concrete detailing.

The remodelling of the upper level, meanwhile, has allowed a further 1,200 seats to be added, taking the overall capacity up to 15,000. Not changed, however, are the 74 dark green Lloyd Loom wicker chairs that have always furnished the Royal Box.

The world of tennis does have larger venues. Flushing Meadow in New York holds over 23,000, The O2 in London 17,500.

But these are modern, multi-purpose venues with artificial surfaces. The Centre Court at Wimbledon, by contrast, remains a temple to turf, a place where we are reminded of the roots of the game; not of tennis, but of *lawn* tennis.

After nine decades of alterations the original canted outline of Stanley Peach's 1922 Centre Court can still be detected on its south side, where first floor balconies provide AELTC members with views across the southern courts. In the distance, spectators pack the Aorangi Terrace (top left) to watch live action on screen being relayed from inside Centre Court.

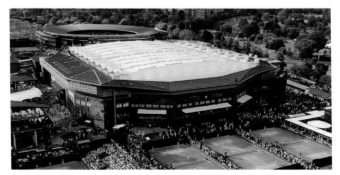

From the moment that Major Wingfield's boxed sets appeared in 1874, lawn tennis turned into a veritable battleground of the brands, with **Wimbledon** itself emerging as one of the most potent.

Consider that the highest ranked tennis tournaments today, the Grand Slams, are the US Open (first contested in 1881, a mere seven years after Wingfield's sets went on sale), the French Open (1891) and the Australian Open (1905).

Yet in this country our Grand Slam is not the British Open, nor even the English Open. Rather, it is the 'Wimbledon Championships'.

Wembley apart, surely no other London suburb enjoys such renown.

Understandably the AELTC does its best to capitalise. So from its annual statistical roundup of the Championships – always an illuminating read – we learn that in addition to sales of strawberries and cream (142,000 portions in 2012) and the distribution of bananas to players (12,000), the best selling items were Wimbledon branded towels (25,000) and mini tennis ball key rings (15,000).

We think of the modern era as being especially commercial, but in lawn tennis it was ever thus, almost from the off, as manufacturers fought each other over patents and copyright, and bargained with clubs

and tournament organisers for the right to become official suppliers.

Wimbledon's first suppliers of balls were Jefferies of Woolwich, followed in 1880 by **FH Ayres** of **Aldersgate**, who also erected temporary grandstands at Worple Road in exchange for fifty per cent of the ticket revenue. Ayres were still active in 1930 when the branded balls above were issued.

By that stage, however, they had lost their status as sole suppliers to the tournament to Slazenger, who took over in 1902 and have held the position ever since, absorbing Ayres along the way in 1940.

Another brand inextricably linked with Wimbledon is Robinsons Barley Water, who signed up in 1934.

Then there were suppliers of clothing, shoes, nets, gut and line markers, plus builders of courts and makers of lawn mowers. Under the tennis section of a London trades directory from 1915 no fewer than 41 companies were listed.

Most intense of all was the rivalry between racket manufacturers. Until lawn tennis arrived, London's various firms, such as **Prosser** of **Pentonville Road** (*above right*), had served a relatively small number of real tennis and rackets players from modest workshops. Now, as new firms and improved manufacturing processes emerged, the key to

success was to gain endorsements from top players. Below is an example. Dating from c.1895 this is a **Slazenger EGM**, made, according to the company, 'from the directions and adjustments' of the well known player from Kent, Ernest G Meers.

Adverts for the racket insisted that Meers derived no 'pecuniary benefit' from this association, a likely story but a common one at a time when shamateurism was rife.

The racket seen here, used and signed by Wimbledon champion RF Doherty (who was actually Wimbledon born) is one of literally hundreds of historic rackets held in the collection of the **Lawn Tennis Museum** at **Wimbledon**, where all the other artefacts on this page are also held.

Opened in 1977 and rehoused in its current building in 2005 the museum is an absolute treasure trove of branded items, quirky products, posters, paintings and tennis fashion, offering a brilliant exposition of the game's history.

Some 70–80,000 visitors pass through its doors every year, while during the Championships it is reckoned that at least 60,000 ticket holders are from overseas.

Once again, it would seem, those inventive Victorians knew a thing or two when it came to combining business and pleasure.

The Wimbledon Lawn Tennis Museum has possibly the largest collection of tennis-related artefacts in the world, but there are many collectors out there also, willing to pay high prices, particularly for items associated with star players. Fred Perry's racket from the 1934 Wimbledon Championships, for example, sold at Christies in 1997 for £23,000. But acquisition is only part of the process. The exchange of knowledge is also highly valued. In Britain this led in 1988 to the formation of the Tennis Collectors Society, whose newsletters, edited and compiled by Gerald Gurney and Bob Everitt have provided a mine of information for historians. Another unique resource is the Kenneth Mitchell Library at Wimbledon. Opened in 1977, the library's oldest book on tennis is by Antonio Scaino, an Italian priest. It was published in Venice in 1555. Apart from early rule books, almanacks and periodicals, one of the library's strengths is its collection of tennis-related fiction, such as the novel below. Published by Methuen in 1930 it bore the name of the tennis champion, Bill Tilden, whose own story was itself a 20th century American epic.

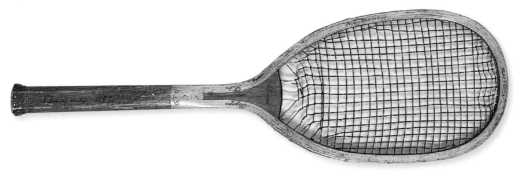

▶ There are older clubs in London where lawn tennis is played, the likes of Hurlingham (*see page 118*), the Cumberland in Hampstead (formed 1880), the Connaught in Chingford (1885) and Blackheath (1885). Yet once again we are drawn back to the **Queen's Club** in **Palliser Road**, for two reasons.

Firstly, seen here in 2012, Queen's is important as the venue of London's only surviving pre-Wimbledon tournament on grass.

Held in June and for men only (the women's equivalent takes place in Birmingham), the seven day event, originally sponsored by Stella Artois, now Aegon, is the direct descendant of the **London Grass Court Championships**.

First staged by the London Athletic Club at Stamford Bridge in 1884, they moved to Queen's in 1890, and today draw around 50,000 spectators during the week, with the **Centre Court**, holding just under 6,500, sitting on mainly temporary stands in front the clubhouse.

The event itself is rather less formal than Wimbledon. But then Queen's as a club is different too, and not only because of its thoroughly urban setting. Because membership of the AELTC is limited to 375 Full and Life Members, plus a few hundred honorary and temporary members, it is exceptionally difficult to join (even assuming one is deemed eligible).

Queen's, by contrast, currently has over 4,100 members across its four main sports, lawn tennis, real tennis, squash and rackets, with a profile that reflects its west London catchment area, celebrity, multi-national and all.

No question it remains the preserve of the wealthy. New members aged 28 or over are, for example, required to buy one share in the club, valued in 2012 at £12,000. But then this is a club that had to raise £35 million in

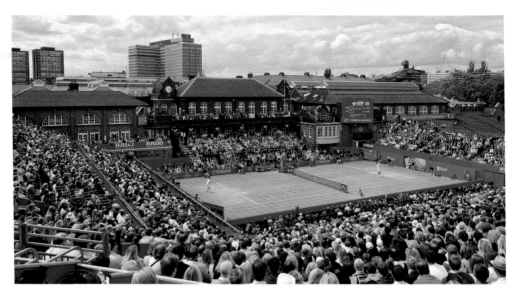

2007 in order to buy back the lease from the Lawn Tennis Association.

It is a complex tale. But in brief, headquartered at Queen's since 1959, having bailed out the club with loans six years earlier, the LTA decided in the late 1990s to leave West Kensington. This was in order to create a national centre for developing young talent, something they felt was not viable at Queen's, especially on a site officially designated as a private open space. This designation restricted their ability to build more indoor facilities, though it at least ensured that no other party could come in and redevelop the site completely.

So it was that, albeit after a protracted legal battle, the LTA departed for Roehampton in 2007 (*see below*), leaving Queen's to plan a more independent future.

The second reason for returning to Queen's is that, as mentioned earlier, the majority of historic buildings at London's other tennis clubs have been replaced. Not so at Queen's, where remarkably, most of the original buildings erected in 1887–88 still stand.

In the image above, the lantern windows of the club's two real

tennis courts (*see page 280*) lie to the right of the clubhouse. Just visible, directly behind the clubhouse's clocktower, are the roofs of the club's two oldest indoor lawn tennis courts.

Indoor lawn tennis had started in earnest in London in 1885 at the Hyde Park LTC, which despite its name was in Porchester Square (where Porchester Hall now stands).

But the focus soon shifted to Queen's, where the interconnected **East and West Courts** opened in

April 1888. Two types of wooden flooring were tried before a third, using American white wood, stained green, passed muster.

Seen below during the **1947 British Covered Court Championships** – the player top left is the French star **Jean Borotra** – it was in these courts that the indoor tournament of the 1908 Olympic Games took place.

Apart from new court surfaces, lighting and paintwork, the scene is otherwise exactly the same today.

Opened by the LTA in 2007, the National Tennis Centre in Roehampton is sited within part of the Bank of England sports ground, where can also be found the offices of the International Tennis Federation. Formed in 1913, the ITF dropped 'lawn' from its title in 1977. Despite only four of the 22 courts at Roehampton being grass, the LTA has firmly resisted calls to follow suit.

▶ The unveiling of a **blue plaque** is always a poignant occasion. To be gathered around the front door of the subject's house, to put into context their everyday life, adds greatly to our understanding of the individual. It can also distinguish an otherwise unremarkable house.

Except that in this instance, **223 Pitshanger Lane, Ealing**, is special in its own right, having been built in 1906 in **Brentham Garden Suburb**, the first such suburb to have been built on 'co-partnership' principles.

It was in the garden of this house and against the garage door that young **Fred Perry**, our cover boy, honed his tennis skills in the 1920s. Inside, in the kitchen, he also practised table tennis so assiduously that in 1929 he won the world title in Budapest.

Much of his youth was equally spent at the **Brentham Club**, just around the corner (*page 121*), where the green plaque (*below right*) is on display.

Perry, of course, went on to win the singles title at Wimbledon in 1934, 1935 and 1936, no doubt helped by training alongside the equally dominant Arsenal team of the era. To earn his keep he commuted daily from Ealing into town to his job at the Co-operative Wholesale Society and later to the sports goods manufacturers, Spalding, based at Putney Wharf.

After his third Wimbledon title Perry turned professional, moved to the USA and set up the eponymous sportswear company that remains an international brand today.

Surprising though it may seem, that Perry is today honoured at **Wimbledon** – by a set of gates on Somerset Road, and by this statue by **David Wynne** (*right*), unveiled in 1984 – would have been unthinkable during his career.

Perry was a northerner with working class roots. Born in Stockport (where there is another plaque, on Carrington Road), his father was a left wing activist in the Co-operative Party. To compound matters, Fred was unashamedly competitive, thereby alienating the amateur hierarchy who, notoriously, snubbed Perry after his first Wimbledon title. Only in the 1950s would this rift be healed, so that when eventually he died in 1995, Perry's ashes were buried under the statue, with everyone's blessing.

Clearly, both parties had had much to learn from each other.

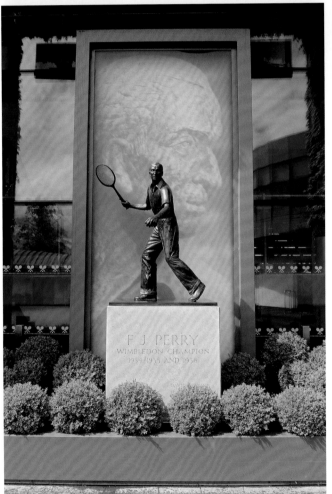

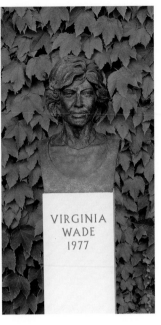

VIRGINIA WADE 1977

Finally, and unavoidably, one of the thorniest issues in modern day lawn tennis is that, despite the AELTC consistently directing profits of £25-30m a year from the Wimbledon fortnight into the development of young British talent, via the Lawn Tennis Association, the nation has seen so few homegrown talents prosper in their own backyard.

No one needs reminding that 77 years elapsed between Fred Perry's last victory in the men's singles at Wimbledon in 1936 and Andy Murray's long awaited victory in 2013.

But at least British women have fared better, as commemorated, some would say belatedly, outside the Centre Court at Wimbledon in 2004.

Sculpted in bronze by Ian Rank-Broadley are busts of Britain's five women's title holders since 1919.

They are Kitty Godfree (1924 and 1926), Dorothy Little (1934 and 1937), Angela Mortimer (1961), Ann Jones (1969) and Virginia Wade (1977, *above*).

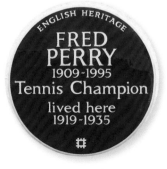

FRED PERRY
1909-1995
Tennis Champion
lived here
1919-1935

FRED PERRY
1909 - 1995
Tennis Champion
played here
1919-1935

Chapter Twenty Eight

Athletics

'As long as there have been men on earth it may safely be asserted that there have been running matches,' wrote Montague Shearman, a London barrister, sprinter, athletics historian and administrator in 1887 (see Links). The same might also be said of those other athletic disciplines, walking, jumping and throwing, he added. All come as naturally to man as weeping or laughing. But in design terms it is running that has always set the space. At ancient Olympia the stadium was built around a straight track, one stade in length (c.192m). From this Greek unit of measurement the Latin word stadium is derived. In modern athletic stadiums, it is around the fixity of a 400 metre running track that all field events and spectator accommodation must be configured. In this chapter, the first of four focusing on track-based sports, we look at London's role in establishing this model, and how it came about that a modern Olympic Games is closer in form and content to a typical Victorian athletics meeting than to any of its classical precursors.

When Pierre de Coubertin started to lobby for a revival of the Olympic Games in the early 1890s, it was largely as a result of what he had seen and experienced during several trips to England.

The Frenchman had been particularly struck by his visit in 1890 to the Shropshire town of Much Wenlock, where an annual Olympian festival had been held since 1850. Yet ironically, with its eccentric mix of sporting and intellectual contests, Much Wenlock was, by 1890, miles away, metaphorically as well as literally, from the mainstream athletic culture of the day. Instead, a much truer version of what Coubertin's modern Olympics were going to look like could be found at running grounds in almost every major English city; Birmingham, Manchester, Liverpool, Newcastle and Sheffield included, or in the capital, where at least 50 venues are recorded as having staged athletics during the second half of the 19th century.

At these, mostly long lost grounds, in the likes of Battersea, Bow and West Brompton, the event programmes were based on centuries of precedent, consisting then, as in the 12th century (as recorded by William Fitzstephen), of various forms of running, jumping and throwing.

In fact the only athletic events at the 2012 Olympics that Londoners from before 1800 might not have recognised would have been the relay (a race first staged at Stamford Bridge by the Ranelagh Harriers in 1895), the steeplechase

(introduced at Rugby School in 1837), the discus (because the English preferred to throw iron quoits), the javelin (which replaced long thin iron bars) and the hurdles, a variation of sheep fence jumping, popularised in the 1840s. Interestingly, hurdles for male athletes remain the same height today, at 3'6" (106.7cms), as recorded at Lord's in 1843.

Another event that might raise a quizzical eyebrow would be the pole vault. For centuries 'pole leaping' had been primarily a means of crossing streams or ditches. Henry VIII famously tried it and ended up submerged in mud. So until it was adapted for competition in the early 19th century, length, rather than height, counted the most.

Londoners in the 17th and 18th centuries were accustomed to seeing men about town carrying poles. Such was the standard issue for 'running footmen', employed by the nobility to run ahead of their coaches, often across country.

To provide some 'sport' (that is, betting), footmen were also sent out to race. Of many examples, one 30 mile race from Clerkenwell to St Albans in 1618 was said by the epistolarian John Chamberlain to have won the Duke of Buckingham £3,000 in bets and drawn huge crowds, despite the weather being 'sour and foul'.

In 1660 Samuel Pepys witnessed two footmen run three laps of Hyde Park, quite possibly along a route similar to that followed by triathlon competitors at the 2012 Olympics.

London's first known experience of pole vaulting for height, as is the modern way, came at one of Dr Voelker's gymnasiums in the 1820s (see page 138). By then, running footmen had been rendered surplus to requirements, largely owing to road improvements and the faster speeds of horse drawn coaches.

On Charles Street, Mayfair, a pub by the name of The Only Running Footman recalls the last of their kind, thought to have been employed by the 4th Duke of Queensberry, who died in 1810.

In their place stepped a new breed of professional athlete. Known as 'pedestrians', initially these were men (but occasionally women) who walked against the clock. Most celebrated of all was Captain Barclay. In 1809 he walked 1,000 miles in 1,000 hours for 1,000 guineas at Newmarket. Barclay was followed in 1815, three months after Waterloo, by 51 year old George Wilson from Newcastle, who undertook a 100 guinea challenge to walk 1,000 miles in 20 days on Blackheath.

So large were the crowds of gawpers and gamblers drawn there that on the 16th day, with 751 miles completed, Wilson was arrested and the mob dispersed.

Over the next 30 years such interventions became routine.

Ever more nervous of crowds, especially after Peterloo in 1819, local authorities used every power they could muster, such as various Turnpike Acts and the 1835 Highways Act, to stop races on public roads or in public spaces.

This best selling 1852 lithograph depicts a celebrated ten mile race at one of London's earliest bespoke running tracks, circling the cricket pitch at Copenhagen Fields, Islington. The 'Old Cope' measured 586 yards, or three laps to a mile. Only one female appears present, on the far right. Almost certainly she was a wife or relation of one of the contestants, since they were all running shirtless.

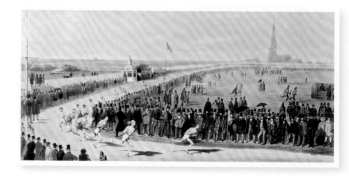

Thus pedestrianism shifted gradually to private grounds.

There had been at least two such venues in London in the 18th century. According to John Goulstone (*see Links*) in the 1720s the pleasure garden at Belsize House, Hampstead, charged 3d admission for foot races. In the 1740s it cost 2d to see races at the Artillery Ground in Finsbury.

But it was not until the 1830s that the country's first bespoke tracks were laid, in each case at cricket grounds. Possibly the earliest was at Hyde Park, Sheffield, in 1836, followed in London by Lord's, where a narrow path with a gravel surface circled the pitch in 1837. Other tracks of the period were merely roped off on turf.

Pedestrianism, whether walking or running, had by this time come under the control of a coterie of publicans, mostly ex-pedestrians. In 1843 they fell out with Lord's over gate money, so the focus in London switched to the Bee Hive cricket ground in Walworth. This sufficed only for three years before the ground was sold for housing.

Copenhagen Fields' track (*see opposite*) also closed after only three years. In its place was built the Metropolitan Cattle Market in 1855, now the site of Caledonian Park. Other shortlived tracks were at the Royal Oak, Barking (1851-54), the earliest London venue known to have a cinder track surface, and at the Flora Tea Gardens, Bayswater (1849-53). This had a 240 yard gravel track, but was closed after four pedestrians were accused of 'roping', that is, rigging a race by failing to run at their best.

Such scandals continued to blight pedestrianism, so that for a couple of years the only track in the south of England was at the New Surrey Pedestrian Grounds, opened in 1853 on Garratt Lane, Wandsworth. It was there that the capital's first 440 yard track was laid out in 1859. But again, as noted by Kevin Kelly (*see Links*), it too soon closed, in 1864, after complaints from 'puritanical neighbours' in new houses nearby.

Still more promoters tried their hand. Between 1856-62 at least 15 tracks opened in London.

For each one, the challenge was the same. Could professional athletics ever be respectable and, moreover, could it ever be viable?

▲ In the absence of any standards, early running grounds came in all shapes and sizes, none odder than the narrow, pear-shaped and notoriously uneven 260 yard cinder track of the **Metropolitan Running Ground** at **Hackney Wick**, pictured here in the *Illustrated Sporting News* of April 26 1862.

Laid out in the grounds of the **White Lion** pub by landlord James Baum, the track is shown looking south towards **Wick Lane** (now **Wick Road**), from the embankment of the **North London Railway**.

This embankment was terraced to form a viewing slope and led to the adjacent **Victoria Park Station**.

As chronicled by Warren Roe (*see Links*), between 1857 and 1875 Hackney Wick hosted some of the most famous 'peds' of the day, including Charlie Westhall, the 'London Clipper'; Sam Barker, 'the Billingsgate Boy' and the American Indian 'Deerfoot'. On occasions crowds of 8-10,000 were reported.

After 1875 Bartripp Street was built on the site, while Victoria Park Station closed in 1943. Bartripp Street was then cleared in the late 1960s to make way for the East Cross Route. But the embankment can still be seen from Wick Road, as can the White Lion (rebuilt in the 1930s and as of 2012 boarded up).

Such was the popularity of pedestrianism that 'the Wick' was one of six Victorian running grounds within a mile radius of today's Olympic Stadium (*see page 82*).

Of the others, the largest was the **Prince of Wales Olympia Running Ground**, or **Bow Running Grounds**, depicted on its opening day in March 1863 (*above right*), also by the *Illustrated Sporting News*.

Located next to the White Swan on **Devons Road** (demolished in the 1920s), according to *Bell's Life*

Bow was able to hold 50,000, a typical exaggeration, and was best known for its proximity to noxious factories. Despite this in April 1864 it staged the inaugural meeting of the **Mincing Lane Athletic Club**, the first athletics club in the capital (although several already existed in the provinces).

Formed by merchant traders working in the City – Mincing Lane is off Fenchurch Street – in 1866 the club renamed itself the **London Athletic Club** (LAC) and relocated to leafier Brompton, west London, where, as we shall show, another cluster of running grounds existed.

The use of pedestrian grounds by gentlemen amateurs was at the time common, despite most of them being keen to disassociate themselves from what Walter Rye of the LAC called 'the loathsomeness' of 'roping and betting'. Yet even Rye, who in later life was an antiquary, recognised the value, the heritage even of these grounds, as evinced in his lament below.

As for 'stinking' Bow, it outlived all its east London rivals, being last mentioned in reports in 1908. Appropriately or not, a tall brick sewer ventilation shaft now marks the spot, on Violet Road.

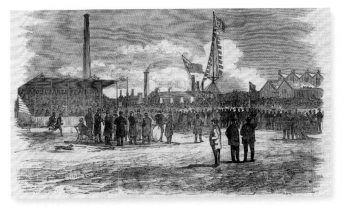

from '**The Champion Sports – A Prophecy**' by Walter Rye, 1868 (published in *Rubbish and Nonsense* 1887)

A broken paling, a grass grown pathway,
A dressing room ravaged, a grand stand gone,
I saw in a dream, and I knew it was Brompton,
And for a lost running ground cried out forlorn.

Ah, woe on the spread of bricks and mortar;
We soon shall have never a training place left.
The 'Old Cope' has vanished, and Garrett Lane's built on,
And now, beloved Brompton, of you we are bereft.

There's no place to run at, for Bow is too stinking,
A mile round the 'Wick' is seven laps and a bit.
No more may we hope to produce a good runner,
How the deuces can a Londoner hope to get fit?

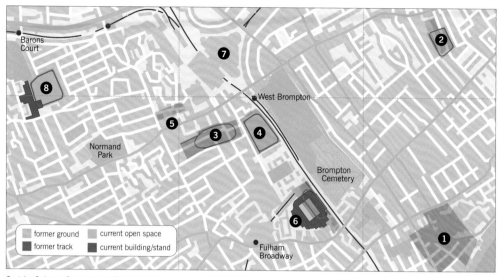

Contains Ordnance Survey data © Crown copyright and database right (2014)

Legend:
- former ground
- former track
- current open space
- current building/stand

▲ Walter Rye need not have feared, for pedestrianism was about to enter a new era, and especially in **west London**, where seven grounds operated during the 19th century.

In fact it was in this corner of Hammersmith and Fulham that the character of modern athletics was ultimately determined, with profound consequences for the sport, nationally and internationally.

But first, two other venues marked above need to be noted.

Baron de Berenger's **Stadium**, or **British National Arena** at Cremorne (**1**), where athletics formed part of a spectrum of 'manly exercises' from 1831-43 is today commemorated by Stadium Street.

Meanwhile the **Queen's Club** (**8**), opened in 1887 and nowadays best known for tennis (*page 302*), staged inter-Varsity athletic meetings from 1888-1928.

As for the other venues, during the 1840s and '50s the exploits of England's 'peds' created a real stir, not least amongst middle class youths, many of whom were destined for desk jobs and who, in the words of Montague Shearman, craved 'violent exercise'.

The army recognised the benefits too. In 1849 the Royal Military Academy held its first athletics meeting at Woolwich. This was followed by students at Oxford in 1850, at Kensington School in 1852 and at Harrow a year later.

Westminster and Charterhouse caught the athletics bug in 1861.

Perhaps sensing an opportunity, in May 1860 former 'ped' John Roberts opened a track at the **West London cricket ground** on **Thistle Grove**, **Brompton** (**2**).

This ground's significance is that it was one of the first where middle class athletes gathered, starting with members of the West London Rowing Club in 1861. Two years later at the ground, Walter Chinnery, a stockbroker and middle distance runner, was among a group who decided to form London's first athletic club, the **Mincing Lane AC**.

But despite Roberts laying on a cinder track, a bowling green and three rackets courts, neither Chinnery's club nor any other chose Thistle Grove as their base and in 1868 the ground was sold for housing on what is now Roland Gardens.

From the *Illustrated London News* of April 1867 a view of the first inter-Varsity athletics meeting held in the capital, at Beaufort House. Putting the stone, or weight, as shot putting was then called, was recorded as a trial of strength in Arthurian legends and was especially popular at Highland Games, at which the weight of 16lbs, still the standard today, was set in the 1830s.

The next stop for London's growing amateur fraternity was a field used as a rifle range at the rear of **Beaufort House** (**3**), headquarters of the **South Middlesex Rifle Volunteers** on **North End Road**.

The oval track laid in the grounds was in use for only five years, from 1864-69, before this site too was sold for housing, on Sedlescombe and Racton Roads.

But during those five years Beaufort House formed the setting for several important developments, starting with the first annual sports of the **Civil Service** in 1864.

Organising the programme that day was Charles Herbert, an official at the Treasury, and stickler for detail, as well he needed to be. The programme featured the 100 yards, hurdles, quarter-mile, half-mile, one mile, three mile walk, high jump, broad jump, pole leaping, throwing a cricket ball, throwing the hammer, hopping and a consolation race.

Such a broad range of disciplines had been a hallmark of rural sports

for centuries. But what Herbert brought to the table, as did Rye, Chinnery and their contemporaries at Oxford and Cambridge, was greater standardisation and more accurate measurement, timing and record keeping.

Over the next two decades these men would argue repeatedly amongst themselves as to who might be considered an amateur, and whether being a gentleman was important. But they all agreed that for athletics to become established on a national basis, there had to be governance.

Beaufort House was the setting for the first attempt at establishing such a governing body.

It came in the form of the **Amateur Athletic Club** (AAC), set up in early 1866 with an Old Etonian and Cambridge all rounder, John Chambers, at its head.

As Peter Lovesey has pointed out (*see Links*), that the AAC formed at that particular moment was almost certainly in response to attempts by another group to organise national championships. Called the **National Olympian Association** (NOA), this had been set up in late 1865 by representatives from Liverpool, Manchester, Much Wenlock and Shrewsbury. None was part of the Varsity set, while their most noted London member, Ernst Ravenstein, was the president of the German Gymnastic Society and therefore beyond the pale as far as the West Brompton elite was concerned.

For this elite, wrote Lovesey, 'the prospect of athletics (being) controlled from anywhere but London was unthinkable'.

Despite having no powers the AAC therefore threatened to ban any athlete who took part in the NOA's inaugural games at **Crystal Palace** in the summer of 1866.

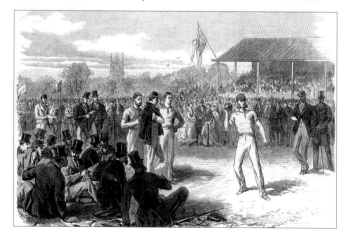

The threat failed, the games went ahead and drew a 10,000 crowd to its athletics day. But the NOA lacked the clout to build on its gains and it was the AAC, whose own hastily convened championships took place at Beaufort House in March 1866, that prevailed.

For this dominance to continue, however, it was vital for the AAC to have better facilities. This became especially apparent during its 1868 championships when, in the 440 yards, a runner collided with a sheep that strayed onto the track (an indication of how rural the area still was). The sheep sustained a broken leg, but the athlete, Edward Colbeck, carried on and ended up establishing a new world record.

For Chambers and the AAC the future lay next door, literally.

There, with its entrance handily next to West Brompton station, was **Lillie Bridge cricket ground (4)**.

Laid out in the early 1860s, the ground was prepared for athletics with an almost rectangular cinder track of 586 yards (three laps to a mile), and re-opened by the AAC in March 1869.

For a description, Wilkie Collins' 1870 novel *Man and Wife* cannot be bettered. Although critical of the burgeoning cult of athleticism, Collins described vividly the scene at Lillie Bridge, with its 'broad smooth path, composed of finely-sifted ashes and sand', its 'vast enclosure' and 'amphitheatrical wooden stands'.

Like Berenger at Cremorne, James Dark at Lord's, and Surrey CCC at the Oval, Chambers hoped to turn Lillie Bridge into a national sporting arena.

For a few years this seemed entirely possible. In 1871 it staged a cycling championship on a 400 yard track laid with red brick dust

inside the cinder running track. That same year the infield was hired by Middlesex County Cricket Club. In March 1873 Lillie Bridge even hosted the Football Association's second ever Cup Final, Wanderers v. Oxford University.

Tellingly, however, neither Middlesex nor the FA chose to return, forcing Chambers to rely increasingly, and uncomfortably, on income from the events of the **London Athletic Club** (LAC). This was the former Mincing Lane club, several of whose members, such as Walter Rye, openly despised Chambers. Chambers' own AAC had, meanwhile, petered out under his brusque leadership.

Lillie Bridge's appeal was hardly enhanced in 1876 when a smallpox hospital was built at the southern end, forcing Chambers to erect a tall screen.

There was another distraction to the north. Only a few hundred yards away, on North End Road, yet another pedestrian ground had opened up, also in 1869.

Run by Messrs Fox and Broad, the **Star Running Grounds (5)** offered the standard pedestrian fare of handicaps, sprints and mile races, and clearly had its devotees. *Sporting Life* described it as 'always a favourite resort'. From *Bell's Life* we learn that it had a 380 yard track made from crushed brick.

Now as the expression goes, two is company, three is a crowd. But in April 1877, incredibly, a third running ground appeared on the scene, just south of Lillie Bridge.

Stamford Bridge (6) came into being because LAC members, who now, scandalously, included tradesmen, tired of Chambers' demands. And although after 1905 it would become better known as the home of **Chelsea Football Club**,

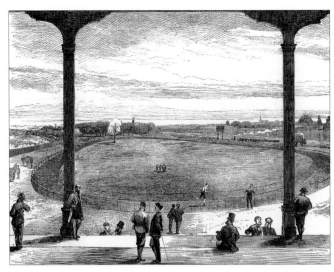

Stamford Bridge (*above*) staged athletics for 54 years in total, until 1931, longer than any other major London venue, before or since.

Of its neighbours, the Star closed in 1879 when railway sidings were built there. Flats on Thaxton Road now occupy the site.

As for Lillie Bridge, Chambers, once the arch amateur, was increasingly forced to stage professional races and crowd pleasers, such as balloon ascents, in order to pay the bills.

The ground's last great track event came in August 1886 when an estimated 20,000 saw Walter George break the world record for the mile, a record which stood for 29 years.

Thirteen months later came the end, in riotous fashion, as seen below. But even this was only another phase in the extraordinary tale of west London's recreational life. In the same year that Lillie Bridge closed, just to the north there opened the **Earls Court exhibition grounds (7)**, followed further north, up the West London Railway in 1886, by the National Agricultural Hall (later renamed **Olympia**) in 1896, and further still, by **White City** in 1908.

The charred remains of Lillie Bridge as seen in the *Illustrated London News,* following the riot of September 19 1887, in which one man died and several police and firemen were injured after two heavily backed sprinters failed to race, both apparently having been bribed to lose. Refused a refund and seeing the bookmakers making a hasty exit, the crowds torched the stands and looted the pavilion.

Laid out on a market garden and orchard, Stamford Bridge, depicted here in *The Illustrated Sporting and Dramatic News*, opened on April 28 1877 in front of a 6,000 crowd. With its 440 yard cinder track, laid by former 'ped' Bob Rogers, it was possibly the first venue in London (or at least the first for which we have images) to take on the shape and dimensions of an athletics stadium as we know it today, even if its spectator facilities – consisting of a corner stand and pavilion designed by RG Tyler of Bedford Square – were relatively basic. After the demise of the neighbouring Lillie Bridge, Stamford Bridge became the home of the Amateur Athletic Association's national championships whenever they were in London. (The AAA succeeded the AAC in 1880 as governing body for the sport.) In 1877, as now, the Brompton Cemetery, with its basilica-like chapel lay to the east (or right), while beyond the trees lay the rival Lillie Bridge. Built over by railway sidings in the 1890s, the site of Lillie Bridge is now a car park on Seagrave Road, but is destined to be redeveloped as housing.

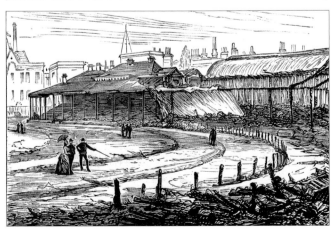

CHARLEY PERRY.
Groundman.

▲ Seen here in 1904, **Charley Perry** (1859-1928), west London born and bred, devoted his working life to the upkeep of **Stamford Bridge** and was also responsible for laying the tracks at four of the first six Olympic Games of the modern era.

At Athens in 1896 Perry acted as the official timer too, working alongside another Londoner, Charles Herbert, by then secretary of the Amateur Athletic Association.

Pierre de Coubertin described Herbert (1846-1924) as one of three pivotal figures in the formative years of the Olympics.

Noted athletics coach FAM Webster called Perry 'perhaps the greatest track-maker of all time'.

Here again was evidence of how a partnership between amateurs and professionals had created in London a pool of technical expertise unrivalled in the athletics world.

For Perry, athletics was in the blood. His father, Charles J Perry, known in his pedestrian days as 'Nat', served as the timekeeper at Lillie Bridge, then at Stamford Bridge. He was also a trainer, for example travelling with the England team for the first ever athletics

international, in Dublin, where his fellow trainer was Bob Rogers, the man who laid the original track at Stamford Bridge in 1877.

Clearly a chip off the old block, by the age of 33, in 1891, Charley was living opposite the main gate of Stamford Bridge, describing himself as 'a ground attendant'.

After Nat's death in 1899 he was described as 'ground manager'.

Before the advent of artificial surfaces in the 1960s, track construction and maintenance required skill and hard graft. It also required a lot of cinders.

A common by-product of coal burning, cinders came in different grades according to which part of the domestic grate, boiler or furnace they were retrieved from.

Most cinder tracks were made up of three layers, each of around 4-6 inches in depth.

The uppermost layer consisted of finely screened, or 'front end' cinders (that is, taken from the front end of the furnace), mixed with a binding agent. In Perry's day coal ash was the most readily available agent, but as more households and businesses turned to coke, gas or electricity for heating and cooking, other materials such as clay, sand or black loam were used.

The middle layer also consisted of cinders, but of a coarser grade.

FAM Webster described how in Stockholm in 1912 Perry took to pottering around the city, 'testing, smelling, and even tasting all kinds of soil' before settling on a top surface that included cinders from railway locomotives (50 per cent) and from an electricity power station (10 per cent), mixed with mould, sand and marl.

Some experts advocated the use of cement mixers, others preferred working in the binding with a rake. Too little and the surface became powdery. Too much and it would become sticky.

An example of a typical, everyday cinder track of this period was at the **Tufnell Park Grounds** on **Campdale Road**, seen here in the early 1900s at the start of a handicap race (*top right*).

Note that until the 1920s sprint lanes were demarcated by string rather than by line markings.

(Campdale Road staged athletics from 1871-1939, since when the ground has served as playing fields.)

Returning to track construction, for good drainage the bottom layer

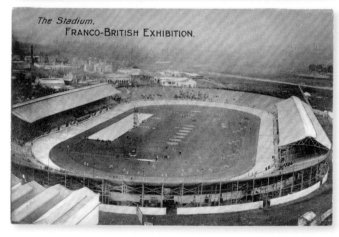

The Stadium,
FRANCO-BRITISH EXHIBITION.

consisted of crushed stones. This is the layer being prepared by boys at **Alleyn's School**, **Dulwich** in 1932 (*above centre*), where the same cinder track is still in use today.

One issue that took years to settle was that of track dimensions.

Perry's track at **White City** in 1908 (*above*) measured 586 yards, while those he did at Stockholm in 1912 and Antwerp in 1920 were 419.2 yards (383.33m) and

426.3 yards (389.8m) respectively. Paris in 1924 measured 500m.

Only after Amsterdam in 1928 did 400m become standard.

It may also be seen at White City that not only was there a swimming pool inside the track, but outside it lay a banked 660 yard cycle track.

As shown in the next chapter, joint cycling and running tracks were common in 1890s London, and yet only one has survived.

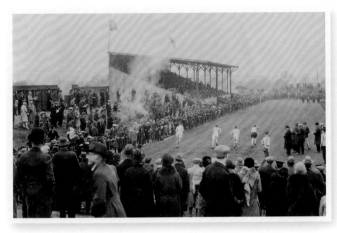

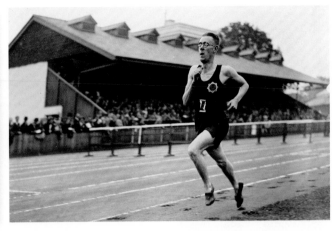

▲ A puff of smoke from the starter's pistol hangs in the air at the **Royal Military Academy's Garrison Athletic Ground** on **Woolwich Common**, during a meeting of the **Cambridge Harriers** in 1925.

Formed in 1890, despite their name Cambridge Harriers were, and remain, a south east London club. But like all athletic clubs of that era they were strictly men only, meaning that for London's growing number of female athletes there was only one option, to go it alone.

The Women's Amateur Athletic Association duly formed in 1922 and staged its first championships at the Oxo ground in Bromley in 1923. The Garrison ground staged the second, in 1924.

After the RMA departed Woolwich for Sandhurst in 1947 the track remained in use until the 1960s, before the ground was cleared between 1999 and 2011 to create a car park for the hospital across the road; **Stadium Road** in fact, a token reminder of the RMA's role in athletics history.

Overall, at least 41 cinder tracks within the boundaries of modern London were built on or grassed over during the 20th century, two of Charley Perry's among them.

Coincidentally or not, in May 1928, nine weeks after his death, the Stamford Bridge track staged the first of numerous speedway meetings, the effect of which can be imagined. From 1932-68 it was then reconfigured for greyhound racing. Like most ground owners, Stamford Bridge's directors found that athletics simply could not pay.

So it was that from the 1920s onwards, track provision in London was increasingly taken on by local authorities, as detailed overleaf, by companies (*see Chapter 12*) and by educational institutions.

At certain of these tracks there appeared some interesting examples of grandstand architecture, such as at the Polytechnic Stadium, Chiswick, the Queen Elizabeth Stadium, Enfield, and Motspur Park in south west London. These stands all feature in Chapter 10.

Motspur Park, opened by the **University of London** in 1931, is noteworthy in the present context, too. Sports writer James Audley described its manager, Archie McTaggart, as a 'track genius', and the track as the 'best kept in Britain... made for records'. One such occasion was on August 28 1937, when Camberwell born **Sydney Wooderson**, the 'Mighty Atom' of **Blackheath Harriers**, set

a world record for the mile with a time of 4 minutes 6.4 seconds (*above*). In the stand at Motspur Park was Walter George, breaker of the record in 1886 at Lillie Bridge. And when Wooderson raced at **White City** in 1945, in the crowd that day was 16 year old Roger Bannister, who in 1953 would lop four more seconds off the record, again at Motspur Park.

Even so, many still thought the track at White City was faster.

Not Charley Perry's 1908 track, that is. Since the First World War the Olympic stadium had lain unused until it was rescued by the Greyhound Racing Association in 1926. The AAA thus had reason to be thankful

to the dogs, and by extension, ironically, to London's gamblers, when, after Stamford Bridge's track had been rendered unusable, the GRA offered them White City.

For the laying of a new track, instead of the method outlined opposite, brushwood was laid on the foundations, with a top surface composed largely of powdered tiles. This gave the track the distinctive red hue that was to become its hallmark. Wembley's track for the 1948 Olympics was similarly red, but using cinders.

This new track was not a success, however, and had to be relaid in 1938 by a Swedish expert, AW Kreigsman. Like Perry in Stockholm, Kreigsman went off in search of local material to use as a binding agent and on the Great West Road found a light brown clay that proved perfect for the job.

White City went on to be the setting for countless epic moments in post war athletics history. True it was far too big and the viewing standards were poor. But it was centrally located, well equipped, and when the AAA finally moved its championships to Crystal Palace in 1971 there were many who felt London athletics lost its soul.

Perhaps what they sensed is that it had moved away from its spiritual heartland, west London.

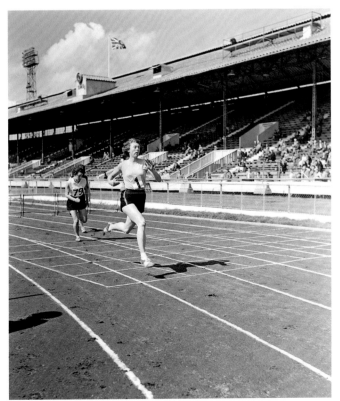

East Ham runner Pam Elliott wins the 80m hurdles at the WAAA Championships of 1956 at White City. Only in 1988 were the men's and women's events held together, before the two associations finally merged in 1991. Note the floodlight mast. Under the Greyhound Racing Association's control White City became Britain's first stadium to have permanent floodlights, in 1932.

◀ This is the badge of the oldest running club in London, the **Thames Hare & Hounds.** (The London Athletic Club ceased to be active in the 1980s.)

Originally for gentlemen only, Thames was formed by Walter Rye, also a member of the LAC, in 1868. This was a year after a group from the Thames Rowing Club (*see page 50*), inspired by *Tom Brown's School Days*, had organised London's first steeplechase, on Wimbledon Common.

As the name suggests, members were dedicated not to the track but to the paperchase, in which two 'hares' set off across country laying a paper trail, ten minutes or so in advance of the chasing 'hounds'.

Some chases extended 25 miles from the club's base at the King's Head in Roehampton (still extant).

In 1879 the hares were told to stop littering the Common, so flags were used instead. But in any case by the 1890s straightforward cross country running had caught on, and there were now 35 clubs in London calling themselves either Harriers or Beagles. Only Thames Hare & Hounds kept their original name, under which they continue to operate from the Richardson Evans Sports Ground at Kingston Vale.

On the second badge shown here, the interwoven blue squares are those of **Blackheath Harriers**, formed in 1869 as the Peckham Hare & Hounds and renamed Harriers in 1878. The Maltese Cross in the centre represents **Bromley AC**, which merged with Blackheath in 2003.

There were two reasons for keeping badges simple in the early days. Firstly, it made a runner's affiliation easier to identify during a race. Secondly, in the absence of official kit, members were expected to make and sew their own badges.

This homespun quality is best illustrated by the **South London Harriers**, seen posing shortly

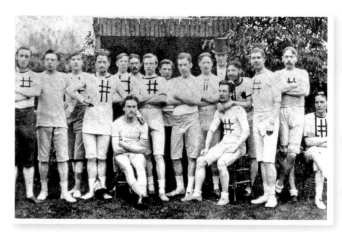

after their formation, also in Peckham, in 1871 (*above*). On the basis of this image it would be wonderful to credit the club with inventing the 'hashtag'. But alas, no link can be found.

South London are still up and running. Indeed in common with most of the capital's surviving Harriers and Beagles they have long been active on the track and field scene too. Their home track is at Crystal Palace, while since 1933 their clubhouse has been a former church hall in Coulsdon.

Belgrave Harriers, formed in Belgravia in 1887, are also based in a converted church hall, on Denmark Road, Wimbledon. Their home track is Battersea Park (*opposite*),

As for Blackheath & Bromley AC, Norman Park (opened 1981), is their home track, while their clubhouse, established in Hayes in 1926, is named after Blackheath's most celebrated member, Sydney Wooderson (seen sporting the badge on the previous page).

Another historic club is **Highgate Harriers**, formed in 1879 and often seen out running on Hampstead Heath. Based at the Parliament Hill Fields track (opened 1939), it is a longstanding tradition to display their club gate at all track meetings (*above left*).

Of course by far the largest running event in the capital today is the **London Marathon**.

Athens witnessed the world's first ever long distance race to be called a marathon at the 1896 Olympics. The city of Boston then started staging its own annual race in 1897. In London, meanwhile, regular long distance road races, once the province of running footmen and pedestrians, had for several years been organised by another leading club of the period, **Polytechnic Harriers**, formed in 1883.

It was the Polytechnic, under club secretary Jack Andrew, who organised Britain's first marathon, during the 1908 Olympics, a race from Windsor to White City best remembered for the dramatic finale involving the Italian, Pietri Dorando.

After the Olympics, in the hope of encouraging new British talent, Andrew persuaded the Sporting Life newspaper to put up £500 for a trophy for an annual marathon. At 4' 9" tall, the resulting silver and oak behemoth (*left*) stood barely six inches shorter than Dorando, and remains one of the largest sporting trophies ever created.

From 1909-32 **'the Poly'**, as the marathon became known, was routed between Windsor and Stamford Bridge. The finish was then moved to White City,

Marathon memories from 1908 – Pietri Dorando's name lives on in White City, and on a house in Eton High Street (*left*), the only one of 25 route markers to have survived. Note the Poly logo in the centre.

then in 1938 to the Polytechnic Stadium, Chiswick, the club's new home (see page 112). In 1962 Sporting Life withdrew its interest, and in 1973 growing traffic issues forced the route to be limited to Windsor, where 'the Poly' continued intermittently until 1996. By this time, however, it had been eclipsed by a new event.

Based on the model of mass participation pioneered in New York in 1970, the first London Marathon was organised in 1981 by former runner Chris Brasher and a Welsh athlete John Disley. Nearly 7,800 runners turned out. In 2012 the total exceeded 36,700.

During the interim the Sporting Life trophy became the focus of an unseemly wrangle over ownership. The Poly considered it theirs, the owners of Sporting Life argued otherwise. For years it went into storage. More recently, in 2003 it was renamed the **Chris Brasher Sporting Life Trophy**, with replicas of the upper section now being awarded to the first placed elite runners in both the men's and women's categories.

One other contentious aspect of the marathon's heritage concerns its length, the famous 26 miles and 385 yards.

For years and even in the present day, the story has been trotted out that those 385 yards were somehow extra yards, added so that the start could take place in front of the royal quarters at Windsor and the finish in front of the royal box in the Olympic Stadium.

But as Martin Polley (see Links) and other historians have repeatedly (and wearily) pointed out, this is a myth. All the IOC told Jack Andrew was that the race should measure approximately 40 kilometres, or 24.8 miles. Only when all the necessary adjustments were made, for logistical reasons only, was the final, random distance arrived at.

All this might have been forgotten had not the IOC decided, bizarrely, in 1921, that from then on the official marathon distance should be set at 26 miles and 385 yards.

Just another strand of athletics history whose trail leads us back to west London.

The **Polytechnic Harriers** and their distinctive logo (see opposite), we should add, live on, not at Chiswick but at the Kingsmeadow Stadium, following a merger with Kingston AC in 1985.

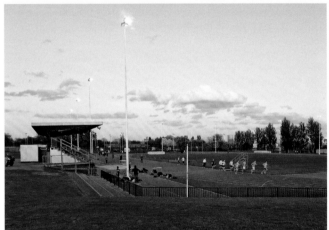

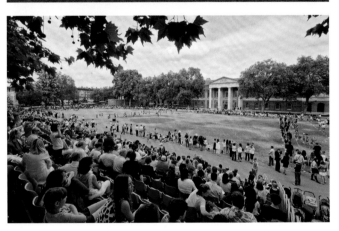

▲ There is much that is grand and old about the Duke of York's Royal Military School on King's Road, including on this occasion a grand stand for spectators at the sports day of the Hill House International Junior School. The Grade II* listed building was designed in 1801 as a school for children whose fathers were in the Regular Army. In 1910 it was taken over by the Territorial Army who, between the wars, laid a 360 yard cinder track. Messrs Bannister, Brasher and Chataway trained on it in advance of their four minute mile attempt in 1954. Other locals have pounded its now hard surface simply to stay fit. In 1999 the Ministry of Defence sold the site to Cadogan Estates. In 2008 the building reopened as the Saatchi Gallery. Art and athletics, a short hop from Sloane Square. Well, this is west London.

◀ In 1887 Montague Shearman predicted that three quarters of all champions would in future be drawn from 'the masses'. But where would these plebeian athletes train?

London's earliest public track was at the Paddington Rec in 1887 (see page 34). However not until the inter war period would athletics come to be regarded, like swimming, tennis or bowls, as a basic part of municipal provision.

By 1960 there were some 60 public tracks in the capital. However since then, largely as a result of the introduction of polyurethane based all-weather tracks in the late 1960s, the number has fallen to 34 tracks spread across 27 boroughs.

Although costly to lay, artificial surfaces are cheap to maintain yet are able to withstand much heavier use than conventional cinder tracks.

Seen top left is **Battersea Park**, where the first cinder track was laid in the 1920s. The current eight lane 400m track, along with the new corner pavilion, was completed in 2000, when the facility was renamed the **Millennium Arena**.

Five of today's other public tracks in London, all with modern artificial surfaces, also date from the inter war period; those at Ilford, Redbridge, Ladywell, Tooting Bec and Parliament Hill Fields.

Sixteen date from the 1950s and '60s, among them the **Linford Christie Stadium**, seen here on a typical midweek training night (centre left). Known originally as the West London Stadium, it was built in 1967 on a rifle range, the brick butts of which form the stadium's west end, facing Wormwood Scrubs (which coincidentally formed part of the route of the 1908 marathon).

Elsewhere in London, six public tracks have opened since 1973, the year in which a Sports Council report declared that, 'to produce an Olympic gold medallist from its municipal track is the dream of most local authority committees'.

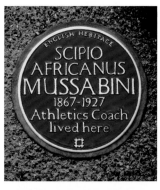

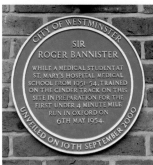

◀ So were the dreams of those London boroughs realised at the 2012 Olympics? Not quite. Of the 30 members of Team GB affiliated to London athletics clubs, only three won medals; Mo Farah, Christine Ohuruogu and Robert Grabarz, all members of the Newham & Essex Beagles, based at the Terence McMillan Stadium, Plaistow.

But it is one thing to win a race, another to sustain a lifetime of achievement.

Philip Noel-Baker, whose English Heritage blue plaque is at **16 South Eaton Place**, ran at the Olympics in 1912, and won a silver in the 1500m at the 1920 Games. Thereafter he became a Labour MP and dedicated himself to international relations, as a result of which in 1959 he became the first Olympian to be awarded the Nobel Peace Prize.

Harold Abrahams, the son of a Russian Jewish refugee, is best known for winning the 100m in Paris in 1924, a race immortalised in the 1981 film and subsequent stage play, *Chariots of Fire*. At the time of his triumph Abrahams was living at **2 Hodford Road, Golders Green**, where the blue plaque seen here was unveiled in 2007.

In later life Abrahams practised law, broadcast for the BBC, and was an avid statistician of track and field. He also redrafted the rules of athletics and rose to hold senior positions within the athletics world.

Eric Liddell, the Scot who famously refused to run on a Sunday during the 1924 Olympics, also had a London connection. It was as a pupil at **Eltham College** where his talents were first spotted, and where the bronze sculpture seen here (*top right*), by Emma Power, now stands in the lobby of the sports centre bearing his name.

Liddell undertook missionary work in China after his athletic career and died there in a Japanese internment camp, in 1945.

Scipio Africanus Mussabini, known better by his initials as Sam, was another high achiever.

Born in Blackheath to a Syrian-Italian father and French mother, he started out as a journalist covering athletics and billiards, before taking on a coaching role at the recently opened **Herne Hill Stadium** (*see page 320*), first for the Dunlop cycling team, then for members of both Polytechnic Harriers and the Polytechnic Cycling Club.

Overall, six of Mussabini's charges went on to win eleven medals at five Olympic Games. Harold Abrahams was the most prominent. The others included Leytonstone born Vera Palmer-Searle, whose father worked in the office at Stamford Bridge. With Mussabini's help she broke three world records in the 1920s and was also a founder of Middlesex Ladies AC.

Mussabini was a real innovator, using cine film to help athletes improve their style, and perfecting a swinging arm action that came to be known as the 'Poly Swing'. He also did much to break down the taboo of amateur athletes using professional coaches.

His plaque, unveiled shortly before the 2012 Games, can be seen at **84 Burbage Road**, on the house where he lived from 1911 to c.1916, backing onto the Herne Hill track.

Harrow born **Roger Bannister** said that it was seeing Sydney Wooderson at White City in 1945 that inspired him to take up running at Oxford the following year. As noted earlier, before his attempt to break the four minute mile in 1954 he and two fellow runners trained on the Duke of York track. They also trained at the **Paddington Rec**, close to St Mary's Hospital, where Bannister was a junior doctor, and where the plaque seen here (*below left*) was unveiled, by Bannister, in 2000.

When asked at the time if the sub-four minute mile was his greatest achievement, Sir Roger said that he was actually much prouder of his forty years of research in the field of neurology.

For the present generation of Olympians it is too early to judge how they might be remembered. But not so Sutton-based David Weir (*above right*) whose four golds at the 2012 Paralympics (to add to the four won in 2008) are each

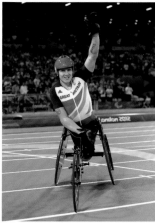

commemorated by gold post boxes in his local manor, Wallington, and who was made a freeman of the borough of Sutton. And now the local athletics stadium bears his name too. Opened as the Carshalton Sports Arena in 1953, the **David Weir Leisure Centre** in St Helier is one of London's leading competition venues.

Finally, notice any link between the individuals mentioned here?

As was noted earlier, it is the track that dominates the space in any modern athletics stadium.

Apparently it is track athletes who dominate when it comes to commemorations also.

Laid out in the 1980s on the former J Lyons sports ground at Sudbury Hill, Wood End Estate has eleven streets named after sportsmen and women. Lillian (*not* Lilian) Board, brought up in Ealing, won silver at the 1968 Olympics but died in 1970 from cancer. Mary Peters won a gold in 1972. Other athletes commemorated at Wood End are Chris Brasher, Roger Bannister and David Hemery.

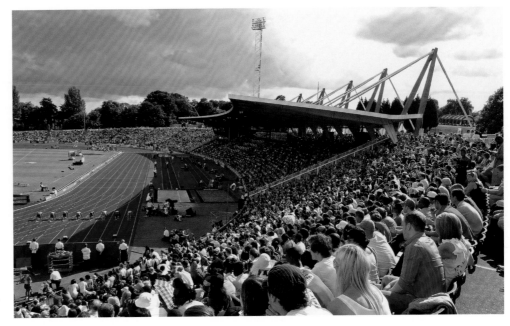

▶ A 22,000 sellout crowd at the **National Sports Centre (NSC)** in **Crystal Palace Park** in July 2009, attends the **Aviva London Grand Prix**, the high point of the capital's athletics calendar.

For it is a stark fact of life that, Olympics and World Championships apart, the annual Grand Prix is the only track based athletics meeting in London likely to draw more than a three or four figure attendance.

Which explains why, were all the seats at the 33 other publicly available tracks in London to be counted up, they would amount to fewer than 10,000.

Lack of spectator demand is also the reason why, since the creation of the capital's newest track, at **Stratford** (*below right*), the future of Crystal Palace hangs in the balance.

This is not a matter purely for athletics, however, or for the stadium's resident club, the **South London Harriers**. For as detailed in Chapter 4, the stadium occupies one of the most historic plots in sporting London.

Athletics has been staged in Crystal Palace Park since at least 1862 – one highlight, it will be recalled, was the NOA Games of 1866 – while the site on which the current stadium sits was, from 1895-1914, the venue for FA Cup Finals. The Cup was presented from a pavilion (*page 66*) that stood exactly where the hillside stand seen here was built, in 1964.

When planning for the National Recreation Centre, as the NSC was first known, started in the early 1950s, the Amateur Athletic Association's championships, the 'Three As', held since 1931 at White City, were still the biggest draw on the domestic front.

Yet by the 1960s attendances had dropped to under 10,000 and the AAA was mired in debt.

It was into this uncertain world that the NSC came into being, the first publicly funded national centre of its type in Britain, with a mission to train the elite, yet in a city crying out for the sort of modern facilities that many much smaller cities overseas took for granted.

The NSC certainly looked the part. It even managed to forge ahead of its rivals in 1968 when its 440 yard cinder track was replaced by a 400m 'Tartan' track; not only the first metric track in Britain but the first artificial surface in European athletics overall.

This led to Crystal Palace taking over as the venue for the Three As in 1971 (after the previous year's meeting at White City had drawn fewer than 5,000 spectators).

Soulless though White City had been, not everyone welcomed the move. 'Too far out!' was the commonest complaint. 'Lacks atmosphere'. 'Never the national hothouse it set out to be.' And expensive. By the mid 1990s Crystal Palace was running at an annual loss of £1.8m and, according to one estimate, only four per cent of its users were elite athletes. All the others were local.

Yet equally, here was a stadium that most English athletes came to see as their spiritual home, a stadium in which over 20 world records have been broken, by the likes of David Bedford in 1973, Steve Ovett in 1978 and Zola Budd in 1985; where Steve Cram bested Steve Ovett in an epic 1500m under floodlights in 1983; where in 2000, the Moroccan Hicham El Guerrouj ran a mile in 3.45.96, the fastest time ever recorded

on a British track, ironically in an event called the **Emsley Carr Mile**, first established in 1953 in the hope that British runners might break the four minute barrier. (Carr was a former editor of the *News of the World*.)

During these years the capacity (excluding temporary seats brought in for the Grand Prix) rose to 16,500 with the completion, in 1977, of the Jubilee Stand (*page 68*).

Yet within a decade of the stand's opening came the first of several threats to the track's existence.

Having been built under the auspices of the LCC, in 1986 ownership passed from the GLC to Bromley Borough Council, who argued that local interests would be better served by a centre designed for local, rather than national needs.

As the debate raged and the facilities deteriorated, the stadium lost the Three As to provincial stadiums, and for six years missed out on the Grand Prix too.

In 1997 Bromley proposed that the NSC be demolished.

But with each setback came a rescue plan. The Sports Council, later Sport England, who had run the NSC since the 1960s, came up with £3.5 million to patch it up in 1999, before their lease ran out in 2004 and the London Development Agency took it on.

And when the LDA was wound up in 2012, in stepped the GLA, who in turn brought in GLL to run the centre.

In the interim a further £20 million was spent to ensure that the centre would remain in use at least until 2012, when it served as the base for Brazil's Olympic contingent, and preferably until 2016, when the Olympic track at Stratford is scheduled to re-open, in time for the World Athletics Championships of 2017.

As for Crystal Palace, another phase beckons; most likely with the track remaining, but the stadium downgraded to a regional facility.

Because as ever in the provision of athletic facilities in London, when one door opens, another surely closes.

London's latest Olympic stadium (*left*) was originally designed to be downsized after 2012 from 80,000 to 25,000 (thereby replacing Crystal Palace), and to have a museum nearby. Now there is to be a 54,000 seat stadium shared with a football club, and no museum. This, in a city that has contributed so much to athletics history, and is the only one to have staged three Olympics...

Chapter Twenty Nine

Cycling

High on the wall of 75 Long Acre, a Westminster plaque co-funded by the Covent Garden Area Trust and the Veteran Cycle Club recalls the contribution of Denis Johnson (1760–1833) to the story of the bicycle. Johnson set up as a coachmaker on Long Acre in 1818, and the following year started making, selling and hiring out what he called 'a pedestrian curricle or velocipede'. He also set up a riding school for gentlemen. Better known subsequently as the 'hobby horse', Johnson's design was unashamedly based on what the French called a *Draisienne*, named after its German inventor, Karl von Drais. As pedals had yet to be invented, riders had to push against the ground with their feet in order to gain momentum. Hobby horses were briefly all the rage, especially amongst fit young dandies who took to racing them against each other and against horse drawn coaches. But they were soon banned from public thoroughfares and the craze died down, once most users concluded that the device was actually more strenuous than walking.

Nearly two hundred years on from the hobby horse and the capital's best known two wheeler is still a Mr Johnson.

Only nowadays the Mayor is one of thousands plying the roads.

In 2012 it was calculated that cyclists made on average 570,000 journeys per day in London, an almost 80 per cent increase since 2001. Truly, whether impelled by the need to get from A to B, or to emulate the feats of the kid from Kilburn Sir Bradley Wiggins on the road, or of Sutton girl Joanna Rowsell on the track, or simply just to enjoy the ride, London is in the midst of a cycling boom.

Of which, we should add, there have been several.

After the shortlived *Draisienne* fad, numerous blacksmiths, wheelwrights and mechanics in Britain and across Europe toyed with improved versions. But the one most credited with the breakthrough was a Frenchman, Pierre Michaux, who exhibited a pedal powered 'velocipede' at the Paris *Exposition Universelle* of 1867.

By later standards Michaux's design was rudimentary, being crafted from iron and wood, with pedals driving the front wheel. But the public took to it with gusto, even if, as reported by *The Orchestra*, a London weekly, each velocipede 'cost as much as a horse'.

Within months, as bicycle historian Andrew Ritchie has noted (*see* Links), rival companies were manufacturing their own versions, in Paris, New York, London and especially Coventry and Wolverhampton, where

engineering firms aplenty had the requisite expertise.

For some early adopters, such as at Britain's first velocipede club, formed at the Liverpool Gymnasium in late 1867, the machine was primarily a device for demonstrating gymnastic and acrobatic skills. But as would occur later in automobile and aeronautical engineering, it was the speed merchants who, with the support of manufacturers, really pushed the boundaries of design.

Velocipede racing was recorded first in December 1867, from Paris to Versailles, followed in May 1868 in the Bois de Boulogne. At a gathering on May 31 1868, at Parc St Cloud, west of Paris, one of the victors (although not the first victor, as often stated) was Suffolk born 19 year old James Moore, who had been brought up in Paris and would go on to become one of the early greats of cycle racing. A Michaux velocipede on which he raced is now at Ely Museum.

According to an article in *Cycling* magazine in 1919, London witnessed its first velocipede race on June 1 1868, the day after Parc St Cloud. Reportedly it took place at the Welsh Harp, Hendon (a venue also significant in greyhound racing), the winner being a 23 year old painter and glass stainer, Arthur Markham. In later years Markham opened cycle shops on Edgware Road and at Shepherd's Bush (neither building being extant). But alas no evidence of the Welsh Harp race can be found.

Instead, the earliest confirmed race was a 'Velocipede Derby'

held in the grounds of the Crystal Palace in May 1869. Overseen by Ernst Ravenstein of the German Gymnastic Society, 30 or so riders wearing racing colours and jockey caps raced around the fountains, a circuit of one mile.

In its report, the *Pall Mall Gazette* conceded that, racing apart, velocipedes appeared ideal for the conveyance of clerks or postmen, but not for higher ranks, as was occurring in France and Italy. 'Surely Cabinet Ministers (let us say) have no particular need of it?'

Also sceptical was a report in *The Field* of indoor cycling at the Agricultural Hall, Islington, where the manager had installed a wooden track costing £500. Up to 1,200 spectators turned up on a Saturday night to watch what was felt to be more of a circus than genuine sport.

By now the first clubs were starting to form in London, the only survivor of which is the Pickwick Bicycle Club. Established at the Downs Hotel, Hackney (now flats) in June 1870, it was named as such because its foundation came shortly after the death of Charles Dickens. That the term 'bicycle' rather than velocipede was preferred was also a sign of the times. The French word was generally held to be inaccurate and even vulgar by the London press.

By 1877, 22 other bicycle clubs had formed in London.

In those early days clubs rode mostly on roads, for pleasure or against the clock, often to the

With iron-rimmed wheels and no suspension, early velocipedes were aptly nicknamed 'boneshakers'. This 1869 example, made by KW Hedges at the Erith Iron Works, Kent, is held by the Science Museum. Another example forms part of the bicycle collection at the Museum of Harlow. The brake was applied by twisting the handlebars, thereby tightening a cord attached to the pad over the rear wheel.

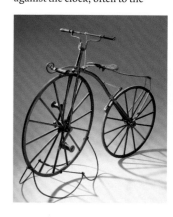

disapproval of other road users. Possibly the first Londoner fined for riding on a pavement was a Mr Buycott in Hammersmith in May 1869, while in January 1870 a man in Richmond was fined merely for riding on a public street.

The presence of cyclists would become still harder to ignore with the introduction of the 'high bicycle' or 'Ordinary' in the mid 1870s. Known subsequently as the Penny Farthing, this towering contraption, with its outsized front wheel and small back wheel, developed precisely because it was faster and lighter than earlier boneshakers, if not always safer.

It was during the reign of the Ordinary, from 1875-85, that serious track racing began under the auspices of the Amateur Athletic Club. Existing running tracks were used initially, such as Lillie Bridge (*see right*), Stamford Bridge, Surbiton and Balham.

Another approach was to lay tracks in parks. A mile long gravel track in the grounds of Alexandra Palace staged the first inter-Varsity 50 mile cycle race in 1876. At Crystal Palace the first of three tracks of differing configurations was laid in 1880; a cinder track circling the ornamental lake.

By then, cyclists had broken free of the athletics fraternity to form their own governing bodies. The Bicycle Union (later renamed the National Cycling Union), was formed at the Guildhall Tavern, Gresham Street, in 1878, to oversee competitive cycling. Also in 1878, but in Harrogate, the Bicycle Touring Club was formed to represent the growing number of cyclists travelling further afield.

As in other sports, tensions soon arose between London cyclists and those in the provinces, predictably over the question of amateurism. These tensions increased further when yet another leap forward in design ushered in a new era of mass ownership.

Launched in 1885, the Coventry-built Rover 'safety' bicycle revolutionised bicycle usage, not only in Britain but around the world. This was followed three years later by the all-important invention of pneumatic tyres, by John Boyd Dunlop (a Scottish vet who saw how uncomfortable his son's tricycle was to ride).

As numerous histories have chronicled, the availability of

mass produced, safer and more comfortable bicycles was to have wide ranging social, economic and cultural ramifications.

Women took up cycling in large numbers, so precipitating a radical shift in fashion and in gender politics. Touring clubs proliferated, giving rise to a new genre of guide book and road map. Even the upper classes embraced the bicycle, taking to Hyde Park and Battersea Park to parade in their finery. Commenting on this, *Country Life* made great fun of the cycling styles seen out and about – 'the angry cat' and 'the begging dog' – conceding even that 'it is possible for a lady to look as well on a bicycle as on a horse'.

But for racing cyclists, known as 'scorchers', there was a price to pay. So popular did cycling become that mass weekend gatherings were starting to cause a public nuisance. Even when the Rover was launched with a road race in 1885 the manufacturers had to keep the location secret in case of a police ban.

Finally, in order to protect their members and the reputation of cycling in general, the NCU placed a self-imposed blanket ban on all mass road racing in 1890.

In a direct echo of the situation that had faced pedestrians earlier in the century, there thus arose the need for a new kind of sports ground, akin to an athletics track, but with banked, smooth surfaces for the maximum possible speed.

Once again, it was to France that Britain's cycling pioneers turned.

Meaning 'bicycle racecourse', the term *vélodrome* had been coined by the French in the early 1880s. Its first known use in an English publication followed in 1884.

And what a brilliant coinage it was too, managing to convey both classical authenticity (even if, unlike the stadium, circus or arena, there obviously were no precedents), and palpable modernity (as in those other new wonders of 1890s London, the automobile and cinematograph).

According to Andrew Ritchie and Alex Poyer (*see Links*), the first tracks officially titled 'velodrome' were in Agen and Montpellier in 1885. This was after an English racing cyclist based in Montpellier, HO Duncan, had campaigned for their construction in his weekly magazine, *Le Véloceman*. »

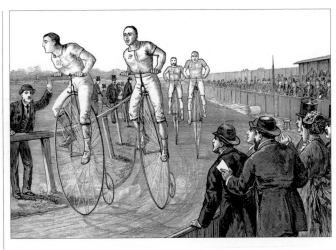

▲ September 1875 at **Lillie Bridge** and high fliers approach what the press would later dub 'hospital corner', partly because a hospital was indeed built at this southern end of the west London athletics ground – the railway, then as now, bordered the site's eastern flank, on the right (*see page 306*) – but also because so many riders came a 'cropper' on its tight angle. Tumbling over the front wheel, or doing a 'cropper', was not surprisingly the most common mishap to befall riders of Ordinaries.

Cycle racing proved a blessing to operators of commercial athletic grounds in the 1870s and '80s, drawing crowds of up to 15-18,000 at times. Certainly it was lucrative enough for Lillie Bridge to lay a 400 yard oval cinder cycle track inside the running track, in 1884.

Yet still the geometry was not ideal, especially once faster, lighter racing bikes emerged in the 1880s. At the same time, cyclists were now desperate to escape the clutches of the Amateur Athletic Association

and set up grounds of their own, as would happen in the 1890s.

Another consequence of the launch of safety cycles in the late 1880s was a boom in cycle-related products. The shelves of Gamages and other London stores now filled with accessories, clothing ranges, riding manuals, touring guides and of course bicycles as well.

This was echoed by the creation of cycle shops out in the suburbs.

Typical of these was the one at **126 High Street, Sutton**.

Established by Tom Pearson in 1860 originally as a blacksmiths (as were many of the early cycle shops), by 1900, as seen below, son Harry was selling and even manufacturing the family's own bicycles, known as the 'Pearson Endeavour'. The shop also offered riding lessons at one shilling per half hour.

The shop is still in business today, still on the same site and in the same buildings, run by the fifth generation of Pearsons. In fact it is now recognised as the oldest bicycle shop in the world.

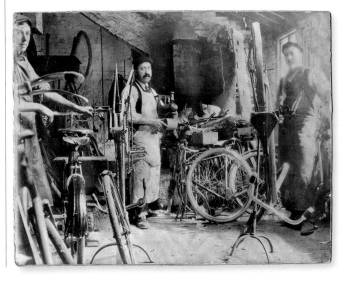

» Also in 1885 a track was laid in Erfurt, Germany, which remains in use, the oldest in the world.

From 1885-1900, at least 110 velodromes were built in France, plus dozens more elsewhere on the Continent and in the USA. No question, cycle racing was a global phenomenon. And if Britain cannot claim to have led the way, as it had in other sports, certainly it was among the early leaders.

Of around 40 purpose built tracks laid in Britain from 1886-1900 (as opposed to athletic tracks used also for cycling), eight were in London, followed in 1908 by the Olympic track at White City.

In addition, at least 20 other athletic grounds and parks in London hosted races at a lower level. A temporary indoor wooden track was also built at Olympia.

At the same time, by 1896 some 700 companies were turning out 750,000 bicycles a year, many for export. And while manufacturing was centred in the Midlands, London was the marketplace. In 1901, 22 showrooms were located in the Holborn area alone.

Of course not all new cyclists were keen on racing. But many were, if only as spectators (and as gamblers, despite a NCU ban), and briefly it seemed that velodromes might eclipse some of the capital's most popular sporting attractions.

Of this new generation of venues, the first, and only one located in a public area, was at the Paddington Recreation Ground in 1888 (page 34). This had a 502 yard track composed of burnt clay, brick dust, coal dust and cinder, and was initially home to the Polytechnic Cycling Club, the top club of the day. But privately funded velodromes would soon steal Paddington's thunder.

Their advantage was not simply to have a commercial approach.

Where they led was on the ground, or rather, on the track.

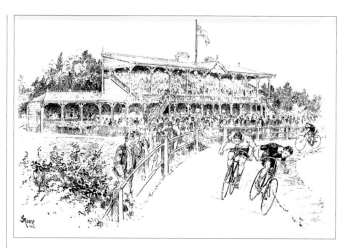

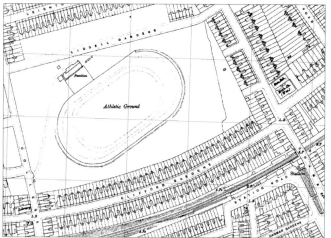

▲ Drawn by illustrator **George Moore** for *Bicycling News* in September 1890 (*top*), London's first commercial velodrome was in **Kensal Rise**, a mile and a half from Paddington and on that now familiar west London axis that leads from Chelsea Creek on the Thames via several sporting locations, up to Wembley Park (*see page 306*).

In common with most Victorian grounds it was designed as a multi-purpose venue, the difference being that cycling now took precedence. That is, its 586 yard, or three laps to a mile gravel track lay *outside* the 440 yard cinder athletics track.

When opened in May 1890 the ground was surrounded by acres of open land, with an entrance leading directly from Kensal Rise station. Buoyed with optimism, its proprietors unveiled it to the world as the **National Athletic Ground**.

Needless to add it did not live up to this billing, not least because it occupied such an exposed and windy site, and because within a decade or so, as shown on the 1915 Ordnance Survey map (*above*), it had become penned in by housing, with its station access cut off. The station, still extant, lies in the south east corner.

According to former Polytechnic cyclist Dick Swann (*see Links*), the first groundsman at Kensal Rise was Sam Wisdom, grandfather of the film actor Norman. More importantly, its first track manager was one James Barden.

As we shall note, Barden was to play a vital role in the modernisation of cycle tracks during the 1890s.

His 16 year old son Charley, meanwhile, went on from serving as a humble 'track boy' at Kensal Rise to become one of the leading professional riders of the decade.

Both Bardens had moved on by the time Kensal Rise's owners were declared bankrupt in 1896. Nevertheless the ground lived on longer than most of its rivals. Under new owners, calling themselves Uniquia (or the Universal Sports and Recreation Society Ltd), from 1897-1901 the ground hosted the games of **Queen's Park Rangers FC**. Indeed in 1900 QPR were keen to buy the ground, but failed to raise the cash (*see page 245*).

Finally the site was sold for housing in c.1920, on what is now **Whitmore** and **Leigh Gardens**.

After Paddington and Kensal Rise, London's third velodrome was at **Herne Hill** (*see opposite*).

However, we will follow James Barden by focusing on the fourth track, opened in Putney in August 1891, ten weeks after Herne Hill.

Built by local contractor John Davis and located at the then western end of Hotham Villas Road (now Hotham Road), the **Putney Athletic Ground**, was smaller in scale than Kensal Rise.

Its cycle track measured only 391 yards (or 4.5 laps to a mile), while its running track was 352 yards (five laps to a mile). Instead of accommodating a full size football pitch, as at Kensal Rise, the infield contained twelve tennis courts, a bowling green and a quoits pitch.

Patently, Davis intended the ground to appeal to a different clientele. Accordingly, as noted by Putney historian Pat Heery (*see Links*), he was hailed at the opening for 'his foresight in keeping up the muscularity of Englishmen by encouraging all manly sports'.

He won further favour by stipulating that two thirds of the committee should be made up of 'tradesmen in Putney and district'.

Even so, Davis knew that investing in a sports ground was a risky business. He therefore made sure that the modest 600 seat grandstand was planned in such a way that in the event of the venture failing, the building could easily be converted into houses.

Davis was equally foresighted when it came to track design.

Before his appointment at Kensal Rise, James Barden had been a farmer and builder in Essex. There, during the 1880s, he had taken son Charley to cycle racing at High Beech in Epping Forest (a venue later to stage Britain's first speedway race, *see page 333*).

At Kensal Rise Barden had started writing opinionated articles for *Sporting Life*. His most radical contribution, however, was, at the behest of John Davis, to experiment with track surfaces at Putney.

By 1891 it had become evident that banked tracks made from cinders and other residual materials, such as at Paddington, were not bringing out the best in the new, lighter and faster racing bikes. The more such tracks were used, the

more uneven their surface became. They were also slower when wet.

Whether it was Barden or one of his French counterparts who first tried out cement cannot be ascertained. According to a French cycling encyclopedia of 1912, compiled by Marcel Violette, its earliest known use in France was at a velodrome in Courbevoie, on the edge of Paris, in 1891.

This was then followed by the construction of a cement track at the Vélodrome Buffalo in Neuilly, Paris, opened in the spring of 1892, at the reported cost of £4,000.

At Putney, also in 1891, Barden's first trial was to lay three different surfaces in concentric bands.

As illustrated and described in *The Hub* magazine in September 1896 (*top right*), the outer band (darker in the photograph) consisted of 'well rolled gravel'. In the centre was a belt of cement, 'crossed by shallow corrugations', to increase traction, and on the inside (where the lead cyclists can be seen), smooth cement.

The central section, Davis told *The Hub*, had soon proved to be 'superfluous'. Riders agreed, the smooth cement surface was by far the quickest, an impression corroborated by the number of records now being broken in Paris.

Suitably encouraged, Barden cemented a section of Kensal Rise too, in 1892, before the entire track was cemented in 1894.

This breakthrough, wrote Swann, 'made Barden'. Now in demand, he left Kensal Rise, settled in Putney, and set up a business constructing roads, tennis courts and, inevitably, more cement cycle tracks. These included tracks at Northampton and Weston-super-Mare and, overseas, in Sweden and Denmark. On the track he laid at Copenhagen in 1894, son Charley achieved second place in the World Professional Championships of 1896.

Back in Putney, John Davis also had cause to feel satisfied. His ground was well used. Gates to certain cycling events had drawn as many as 9,000 spectators. In 1895 the ground was renamed 'The Putney Velodrome', the first track in Britain to formally adopt the title.

Best of all, from 1894 onwards Putney started to make its name as a track on which records were also being regularly broken.

But, as was to be the case at velodromes all over Britain, by the turn of the century public interest in cycle racing was on the wane – quite simply the novelty had worn off – and when his lease expired in 1905, Davis, now aged 73, opted to sell.

The following year **Landford Road**, **Earldom Road** and the western extension of **Hotham Road** were laid out, to form what would eventually become known as 'the Velodrome Estate'. Today it forms part of the Landford Road Conservation Area.

Herne Hill, meanwhile, lived on. We will return to its history later. But for now it is time to wrap up the battle of the track surfaces.

Opened in May 1891, Herne Hill (*right*) was, as recorded by John Watts (*see Links*), the pet project of a prominent cycle journalist and former amateur champion, George Lacy Hillier, who felt south London cyclists deserved a track better than the old circular one at Crystal Palace, which dated back to 1880.

Built on Dulwich Estate land (*see Chapter 7*) by the Peacock Brothers, building contractors in Brixton, with support from local cycle clubs – one of which, **Dulwich Paragon**, survives to this day – Herne Hill's original track consisted of 'rolled ballast', described as similar to the red crushed stone used in hard tennis courts. It was designed by Harry Swindley, an acknowledged track expert.

Alas for him and Lacy Hillier, within months of Herne Hill opening, reports from Putney suggested that their efforts had been eclipsed by James Barden.

Lacy Hillier nevertheless continued to question the qualities of cement. In *Sporting Life*, he argued, smooth concrete was fast, but too dangerous, as accidents in Paris and elsewhere had shown, especially in the wet. Too rough and it slowed down the riders.

In the 1896 edition of the Badminton Library book on cycling (*see Links*), he pointedly omitted Putney from a round up of the best tracks in Britain.

There were rumours that in response to criticisms of Herne Hill, its track was to be relaid using a mix of cement and cork, as had been trialled on certain London pavements. Yet when the track was indeed relaid, in 1893, it was on a bed of concrete and cement, but with a surface, surprisingly, made up of narrow

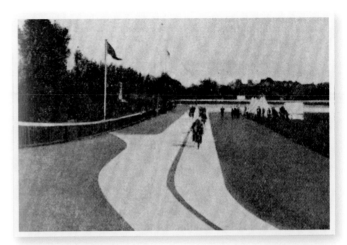

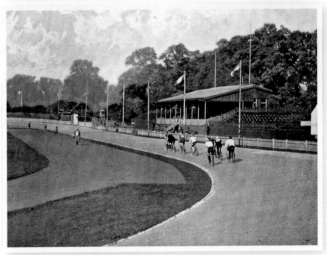

pine battens, bolted together with cork washers in between to allow for contraction and expansion.

For the first season all went well. Herne Hill and Putney now vied with each other for records. But in the second year the battens started to vibrate and become slippery. In 1896 they were therefore relaid, running lengthways rather than at an angle across the width.

Finally, as the accident toll rose, Lacy Hillier had to admit defeat.

Actually some battens did survive. For years at Herne Hill they served as duckboards or as fencing. Some, like the fragment below, preserved by former track manager, Keith Robins, have been kept for posterity.

Herne Hill's third track in six years was completed in June 1897. It was of course made of cement, but with a twist. It featured another new design trend advocated by Lacy Hillier, known as 'hog-backed' banking; steeper on the inside, flatter on the outside.

A year later it was then relaid a fourth time, this time with banking following a more conventional angle.

'Dear old Lacy Hillier...' as John Watts lamented in his history of the track. 'He had to be different.'

▶ London's next two velodromes, both opened in 1895, were too shortlived to have been recorded on any known maps. Both survived only five years. Their brief lives are however well recorded by cycling historians.

Seen here with its 1,000 seat grandstand, topped by an exotic, pagoda-style cupola, the **Catford Cycle and Athletic Ground** was laid out amid fields backing onto Brownhill Road, now part of the South Circular, but in 1895 a minor road in the village of Rushey Green. Close by was the Private Banks sports ground at Catford Bridge (*see page 125*).

The track was a joint venture between **Catford Cycling Club** (formed in 1886 by Charles Sisley, who went on to edit *Cycling* and other publications), and **Blackheath Harriers** (formed 1869).

Still going strong today, Catford CC were the Poly CC's main rivals for honours on the track. Charley Barden was a member, although the Catford track was designed not by his father James, who was about to switch careers by running a pub in Kingston Vale, but by Harry Swindley. It was built by Henry Woodham & Son, described as road builders of Catford.

Barden and other riders called Catford 'the fastest track in the world', and with good reason.

Since cement had proved its worth, track design had moved on to accommodate a new form of 'paced racing'. In this, a team of pro cyclists on a multi-cycle – such as a Dunlop quint (*top right*) – would pedal furiously in short bursts in order to set the pace so that an individual in their wake might achieve record speeds.

Supposedly capable of reaching up to 60 mph, these amazing teams became crowd pleasers in their own right. Because of the lengthy wheel base, however, cornering was more hazardous.

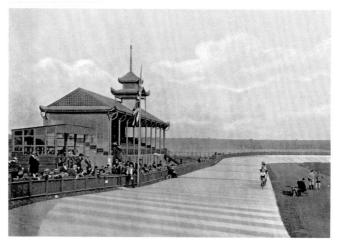

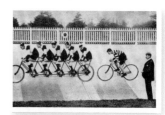

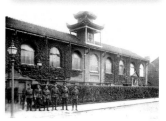

Thus Catford was the first track to have a type of banking – 8' at its highest point, compared with 5' 3" at Putney – that dropped down onto the straight at a measured incline, as seen above, so that quads and quints could keep their line.

For the epic 'Chain Races' of June 6 1896, in which rival chain makers sought to prove the superiority of their products, an estimated 18-20,000 packed into Catford.

Despite the ban on betting by the NCU, undercover bookies were said to have done a 'brisk business'. The day was however marred by a doping scandal (a tale wonderfully retold by Gerry Moore, *see Links*).

Shakier still was Catford's track record with the bank. In 1897, as at Kensal Rise, a new company was launched to inject funds into the ground, which its backers insisted was still profitable. One of the directors was John Oliver, a board member also at Tottenham Hotspur. One of the company's aims was to form a football club to play on the infield.

In the end, they had to settle for renting out the pitch for two years to **Harlequins** rugby club (*page 270*), not quite the earner they had hoped for. Nor did it help that a new track at nearby Crystal Palace (*see opposite*) was now thought

to be faster. So with housing steadily encircling the track, in November 1900 the site was sold.

Its brief existence was at least marked by the naming of one of the new roads **Sportsbank Road** (*see map on page 132*). The eccentric stand survived too, with a new brick frontage and re-use as a drill hall, called Sportsbank Hall.

Pictured in 1915 (*above right*), it stayed open until 1982, when the cupola came down. The hall then served as a builders' yard until its demolition in 1994. Modern housing tucked between two older terraces now marks its location on Sportsbank Road's north side.

Of the other London tracks to have operated from 1895-1900, at **Wood Green** (*below*), only one, indirect link remains. The track itself was laid out on **Bounds Green Road**, where **Braemar**, **Cornwall** and **Northcott Avenues** now stand.

Apparently professional riders at Wood Green frequented the Nightingale pub, which they called 'the Bird', on the nearby High Road. This was recently demolished. For their part amateur riders preferred the **Fishmongers Arms**, which does still stand, also on the High Road. Known latterly as a music venue, 'the Fish' is now a neighbourhood police station.

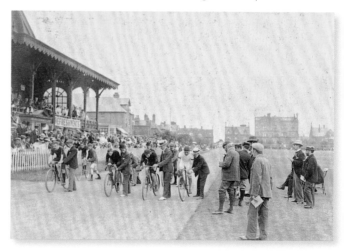

The £18,000 cost of the North London Cycling & Athletic Ground on Bounds Green Road, Wood Green, seen in August 1899, was financed largely by Albert Walter Gamage, proprietor of the 'People's Popular Emporium' on Holborn – the centre of the bicycle retail trade – himself a keen cyclist for the Poly CC and an NCU official. The Essex Cycling Association also chipped in with £2,000. As at Catford, Harry Swindley designed the cement track, which measured 502 yards (three and half laps to a mile) with 8' banking. Opened in June 1895, at its peak Wood Green drew crowds of up to 15,000 and was the first outdoor track to take women's cycling seriously (not least because it was such a draw). It was also, by a whisker, London's shortest-lived track, closing in August 1900.

▶ And so to track number seven of the great cycling boom of the 1890s; **Crystal Palace**, opened in September 1896 and seen here from its west side, in c.1900.

In the modern world, each velodrome that opens is expected to become the fastest ever on record, as lessons are learnt and technology improves. So it was in 1896.

The grounds of Crystal Palace, it may be recalled, had staged Britain's first cycle races in 1869, and in 1880 a cinder track had been laid around the twin fountain basins. By 1894 these had been filled in and adjoining sports arenas laid out in their place. On the South Basin was created the arena that from 1895-1914 would stage FA Cup Finals and many other football and rugby games (*see page 66*).

The more modest ground that we see here was, at the same time, laid out on the site of the **North Basin**.

Two iron and timber stands occupied the east side, backing onto the cricket pitch, while general visitors to the Palace grounds (paying 6d entry) could watch the action from surrounding slopes. But if this was not entirely satisfactory from a promoter's perspective, the track itself more than compensated.

Built by Henry Woodham of Catford and measuring 586 yards,

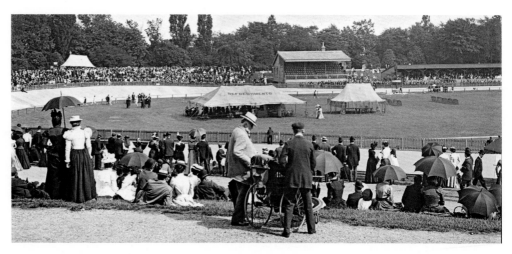

with 8' banking, it was cement, but laid on a timber subframe.

Immediately acclaimed as the fastest in the world, faster even than Catford, *Cycling* said of its early meetings, 'Records fell like the leaves in the Autumn gales'.

As a result, the Poly CC and both the Dunlop and the Gladiator pacing teams made it their base – although their role would soon be usurped by the introduction of motorcycle pacers – while British riders were galvanised into achieving a series of best ever performances.

Indeed with seven tracks now in place (plus an eighth after 1897, *see below*), for a few

heady years London became the world's hotbed of track cycling.

Nor was this boom confined to London. In 1897 Britain hosted its first World Cycling Championship, at Celtic Park in Glasgow.

Crystal Palace's turn came in 1904, when Paddington-based Leon Meredith won the first of his seven world titles. Meredith and his fellow British riders also picked up five of the six cycling gold medals at the 1908 Olympics. He later managed roller skating rinks at the Porchester Hall and Cricklewood.

But thereafter London's status steadily eroded. It was not only a case of declining public interest.

Formed in Paris in 1900, the Union Cycliste Internationale started to assume the dominant role. Interestingly, the UCI allocated votes according to the number of velodromes in each country. France had 18 votes, Germany and Italy each had 14, but Britain only eight.

Moreover, after 1904 there would not be another World Championship in Britain until it was staged in 1970, in Leicester.

As for the Palace, after the 1936 fire the track was replaced by sections of a motor racing circuit, and in 1964 the ground itself was built over by the **National Recreation Centre** (*page 69*).

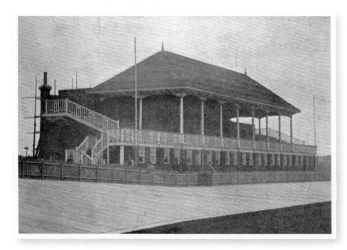

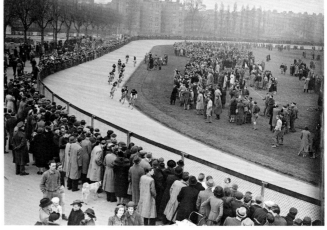

▲ Opened in June 1897, London's last new track of the decade was at the **Memorial Ground**, **Canning Town**, and was the steepest yet, measuring 9' 6" at its highest point

Built ostensibly for workers at the **Thames Ironworks** (*see page 126*), with a running track, tennis courts and outdoor swimming pool, its backer, the shipbuilder Arnold Hills, intended it to rival Crystal Palace. It failed, but did attract occasional

notice, such as in 1903 when the black American rider 'Major' Taylor outpaced his opponents in front of a 10,000 crowd.

West Ham United, the erstwhile Ironworks team, departed the following year. Hills' shipyard closed in 1912, after which the ground was placed in public ownership.

Track racing was last reported there in the 1920s, while a portion of the stand survived until 1979.

Today called **Memorial Park** and used mainly for football and rugby, it is just possible to make out the hint of a curved bank at one end. Modern changing rooms now occupy the site of the stand.

Back at **Paddington**, meanwhile, under the auspices of the LCC the cinder track from 1888 was replaced by a banked cement track in c.1893, as seen above in March 1940. But with no method

of charging admission, other than to the infield, it was never an ideal venue for major events.

Nevertheless, after the loss of the tracks at Kensal Rise, White City and then the Memorial Ground, all in the 1920s, Paddington was the only track left north of the river until finally it was cleared in 1987, one year short of its centenary, to make way for a cricket pitch (*page 106*).

Which left just one...

▶ When the construction of a new indoor velodrome for the 2012 Olympics was confirmed in 2005, **Herne Hill,** the last of London's Victorian tracks, appeared doomed.

That it had been losing money for decades, that in 2005 its gates had been locked for months, that its track needed replacing and that its creaking, 1891 grandstand had been boarded up, all appeared to offer strong grounds for pessimism.

As chronicled by John Watts (*see Links*), after the Peacock Brothers' lease expired in 1942, Herne Hill had come under a succession of operators. From 1942-60 it was leased by the NCU, there being no other takers. Thereafter the lease was transferred to the public realm, first under the LCC, then the GLC, and in 1986 to Southwark Borough Council, who then put out its management to tender.

Herne Hill Harriers, the main users of its athletics track, had left in 1937 for Tooting Bec. The last major winter tenant, **London Welsh** rugby club, departed in 1957.

Track number five, meanwhile, laid in 1898, had needed relaying in 1944, this time using a cold asphalt surface called Resmat.

It was on this new track that the track cycling at London's 'Austerity Olympics' took place in August 1948. Herne Hill is in fact the only surviving venue from those Games still in use for its original purpose.

In 1950 the track needed relaying again, a process repeated in 1970 and 1971. Eventually, in 1990, the world's leading track designer, Australian Ron Webb, was called in to undertake a complete overhaul, only to find that its dimensions and curves were neither as thought, nor even symmetrical.

Two years of reconstruction were required, most of it funded by the Sports Council, to create what was now a perfectly proportioned 450m track covered in the very latest epoxy resin surface.

Yet by 2005 even this was in need of replacement.

Throughout these years, track apart, Herne Hill had barely developed at all. Indeed it was hard to imagine that its single, discreet entrance (*above right*), tucked between houses on **Burbage Road** – one of them the former home of **Sam Mussabini** (*see page 312*) – had ever been capable of handling the crowds of up to 15,000 once common for the annual Good Friday meeting, a fixture on the British cycling calendar since 1903.

All this and more counted against Herne Hill. And yet it was saved.

It was saved firstly because it sits on land that is not only designated Metropolitan Open Land (*see page 91*) but is owned by the Dulwich Estate, a charitable trust that, fortunately, remains content for it to be used for sport.

Secondly, Herne Hill has friends; friends like Sir Bradley Wiggins, who in common with many other Olympians trained there in his youth, and political heavyweights like former mayor Ken Livingstone.

Just as importantly, cyclists and local residents also rallied to the cause, so that after years of campaigning, in 2011 **British Cycling** (successors to the NCU) and the newly formed **Herne Hill Velodrome Trust** were able to negotiate a 15 year lease with the Dulwich Estate, with the **Velo Club Londres** (formed in 1964) tasked with the ground's day-to-day management.

Track number eleven, a £500,000 MasterTrack surface consisting of fine granite and asphalt, duly went down in 2011.

In 2012-13 this was followed by a further £400,000 programme financed by the Southwark Council Olympic Legacy Project for a 250m junior track on the infield, plus, at long last, permanent lighting around the main track.

The next phase, it is intended, will see the 1891 grandstand – the oldest in London (albeit unused for decades) – replaced under plans drawn up by Mike Taylor of Hopkins Architects. If the name rings a bell it is because Taylor's best known design in London is over in the Olympic Park, where he worked alongside another familiar name, Ron Webb (*see opposite*).

Good Friday action on the new track in 2012 (*right*), while iron columns from London's oldest grandstand (*above*) await re-use within a proposed replacement.

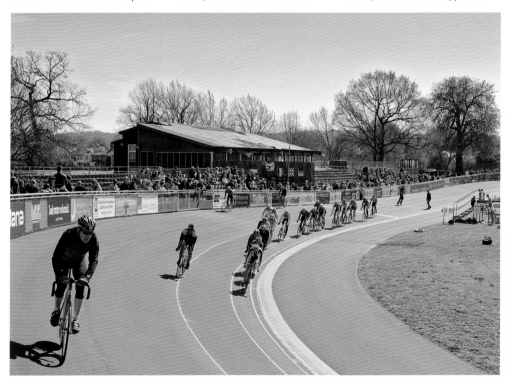

▲ While it is only recently that the heritage of Herne Hill has been secured for the immediate future, the conservation of British bicycles, as artefacts, has for many years been assured. Londoners wishing to see examples may go to the Science Museum or the Museum of Harlow. Further afield is the National Cycle Museum in Llandrindod Wells.

To see old bicycles in action, or to learn more about them from a comprehensive archive, there is the **Veteran Cycle Club**.

Formed in Mitcham in 1955, the club is made up of some 2,500 members, all of whom own and cherish vintage machines, from 1870s Ordinaries to 1950s Roadsters and 1970s Choppers,

and who can be seen riding them proudly on the club's annual New Year's Day parade through the streets of the capital, or on Good Fridays at Herne Hill.

Inevitably it is the Ordinaries that stand out on such occasions. Yet in the above image from **Herne Hill** in 2010, note how extraordinarily modern and minimalist they appear, 120 years or so since they were overtaken by the 'Safety' bicycle.

Moreover, Ordinaries remain in demand. Some 2-3,000 are thought to have survived, and in good condition can cost from £2,000 upwards. Even in a parlous, rusted state, such as one found in a Lincolnshire barn – being auctioned online as these

pages were being written – attract considerable interest. Ready-to-ride replicas are popular too.

London's historic cycling clubs, meanwhile, are also active guardians of heritage. In 2012, six of the 44 London clubs affiliated to British Cycling could trace their formation back to before 1900.

The aforementioned **Pickwick Bicycle Club**, established in 1870, is not only the oldest cycle club in the world, but also the oldest Dickensian association. One of its earliest club badges, made in 1876 from silver wire on a cloth backing, is held by the Brooklands Museum (*top right*).

Also still active is the **Catford Cycling Club**, formed in 1886 and best known for its annual Hill Climb, a gruelling test first staged on Westerham Hill, Kent, in 1887 and since 1935 held nearby on a 700 yard unpaved road up Yorks Hill. One rider who won this event eight times was Max Pendleton, father of Victoria.

Now based in Dulwich, the **De Laune Cycling Club** formed in 1889 at the De Laune Institute, set up in Newington by a south London landowner and philanthropist in the 1880s.

This was just as Ordinaries were going out of fashion. On which note, bidding for that rusting hulk has just ended at £1,219.99, the equivalent of 58,559 pennies and farthings.

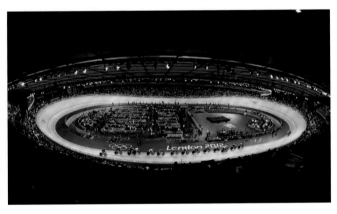

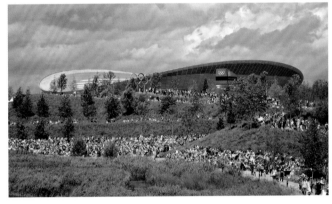

▲ As noted, London's first cycle track built since 1908 has at least two connections with Herne Hill. Completed in 2011 as part of the **Olympic Velopark** (*see page 82*), the award winning **Velodrome** was designed by a team led by Mike Taylor of **Hopkins Architects**, in conjunction with Expedition Engineering, ChapmanBDSP and Grant Associates, with a few design tips passed on by Sir Chris Hoy.

Seating 6,000, its track, the now standard length of 250m, was, like its Olympic predecessors at Athens and Sydney, designed by Ron Webb, using Siberian pine.

Timber characterises the exterior too (*above right*), in the form of Western Red Cedar cladding.

Team GB's cyclists performed well at the 2012 Games, winning seven of ten possible golds on the track, plus that of Bradley

Wiggins on the road and a further eight golds in the Paralympics.

No doubt, this haul was made possible by the availability of indoor velodromes in Manchester and Newport, joined since by Glasgow, also in 2012, with Derby due to open in 2014.

Not since the 1890s has Britain seen such cycle mania. Only this time, so far at least, it shows no signs of losing track.

Chapter Thirty

Greyhound racing

A night out at White City Stadium, noted *Tatler* in July 1937, was the height of fashion. Cossetted behind glass screens, diners could enjoy fine wines and a meal while placing bets from their tables. Out on the terraces crowds of 40,000 were common, peaking in June 1939 when 92,000 saw the race of the year, the Derby. The Prince of Wales attended one night, as did the King of Spain. Elsewhere, Hollywood's Talullah Bankhead opened the track at Wimbledon, while George Raft and Lana Turner were seen at Walthamstow. For the writer AP Herbert, a White City regular along with his wife, greyhound racing 'had at last made betting safe for democracy'. He might have added that the dogs had also saved White City, and Wembley, London's two largest stadiums, from almost certain ruin. Only football and the cinema drew larger audiences in Britain during the 1930s.

The ancient Greeks bred them for sport. The Isle of Dogs, it has often been claimed, derives its name from Edward III having his kennelled there, while it was his successor, Richard II, who prohibited 'low persons' from owning them unless they tied them up or removed their claws.

Prince Albert's favourite was called Eos and had his portrait painted by Landseer. Prince Philip's won the Derby in 1968.

Prized for their ability to hunt by sight, rather than by scent – hence the theory that originally they were called 'gazehounds', although 'greekhounds' is also possible – greyhounds have been part of the sporting scene for millennia.

Greyhound racing as we know it today, however, is a relatively modern construct, and while there has long been a debate as to whether it can truly be considered a sport, and there are many who oppose it on grounds of animal welfare, no history of 20th century popular culture can fail to acknowledge its impact; on the sporting map of London, on the evolution of stadium design and management, and on the narratives of other sports, such as speedway, football, rugby league, athletics and even baseball.

Greyhound racing in the 20th century was never just about dogs or gambling. It was about the embrace of technology, bright lights, of all things American, and along with dance halls, lidos, the talkies and the wireless, an expression of modernity in the wake of the Great War.

Before the 1920s greyhounds were chiefly bred for coursing, a sport in which two dogs would be released simultaneously in pursuit of a hare. According to the *Laws of the Leash,* laid down in 1561 at the behest of Elizabeth I, the winner was not necessarily the dog that caught the hare – for the hare often got away – but the one judged to have demonstrated the most agility and craft in its pursuit.

For centuries coursing was dominated by the gentry. They formed the first club at Swaffham, Norfolk, in 1776, and from 1836 onwards would gather at Altcar, near Liverpool, for the annual Waterloo Cup. At its peak in the late 19th century, crowds of up to 75,000 were reported, while such was the level of betting that the Stock Exchange was said to have closed early to await the results.

Clearly here was a sport with commercial potential, if only it could, in modern parlance, be commodified; that is, staged in a more spectator friendly setting and brought closer to the city.

One solution, arrived at in the 1880s, was to set up enclosed 'park' courses, the nearest to London being at Kempton. In these a course of around 600 yards was fenced off with an escape route at the end should the hare manage to elude the dogs.

Another idea was trialled by a Mr Geary in a field at the rear of the Welsh Harp pub, Hendon, in 1876. Here, instead of using live hares, a stuffed hare was propelled along a 400 yard long straight rail, by a hand operated windlass.

As one of the promoters told *The Times,* the mechanical hare would transform coursing into 'an innocent recreation' without the faintest shadow of cruelty. The *London Daily News* thought it as significant a breakthrough as the 'rink' had been to skating and the 'gyratory pigeon' to shooting.

But while at Welsh Harp and the park courses the dogs did indeed give chase, somehow neither set up brought out their natural intelligence or agility. Instead, the winning dog was invariably the fastest, and as only two ever competed at a time, gamblers were not overly impressed.

A form of dog racing did take root in Victorian Britain nevertheless. Using whippets, terriers or lurchers rather than more expensive greyhounds, 'rag races' – in which the dogs were drawn towards a finishing line by owners waving rags – commonly took place on short, 100-200 yard tracks laid out next to pubs or on wasteground. Popular east London venues included Canning Town, Millfields in Clapton, and at the Royal Standard pub in Walthamstow and the White Hart in Tottenham Hale (both of which, although rebuilt, still exist).

But if this form of racing was the province mainly of working class gamblers and Irish travellers – most of the dogs were imported from Ireland, and still are – over in Hot Springs, Dakota, another Irishman was having thoughts of his own. Owen Patrick Smith saw the potential of coursing but disliked its cruelty. As at the

Greyhound racing's first superstar, the Irish born Mick the Miller (1926-39) was so popular that his stuffed body was put on display at the Natural History Museum (it is now at the museum's centre in Tring). According to the *Boke of St Albans* in 1486, 'a greyhound should be headed like a snake, necked like a drake, footed like a cat and tailed like a rat'.

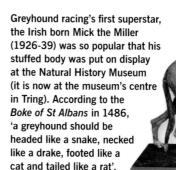

Welsh Harp he experimented with artificial hares, but made two simple, but crucial innovations.

Firstly, Smith used electricity to propel the hare. Secondly, and it seems so obvious with hindsight, instead of a straight course his rail formed an oval, just like a standard running track.

Thus was born modern greyhound racing. Smith's first track opened in California in 1919, the first of many. Six years later a Philadelphia businessman, Charles Munn, crossed the Atlantic, sales pitch at the ready.

The first to bite was Brigadier General Alfred Critchley, a Canadian born veteran of Ypres and director of the British Portland Cement Company (who, during the General Strike in May 1926, organised the distribution of the pro-government British Gazette).

After a round of golf at Lingfield Park, Surrey, Munn told Critchley that in the hope of finding backers he had been at the Buck's Club in Mayfair (birthplace of the Buck's Fizz), showing coursing enthusiasts photos of packed out tracks in Oklahoma City. The response, Munn admitted, had been 'not a bob, not a dog'.

Critchley, on the other hand, as he recalled in his memoirs (see Links), was already aware of the popularity of whippet racing amongst miners in the north east. He had also noticed how his valet, George, was always losing money with street bookmakers. Critchley had warned him not to bet on horses he had never seen in the flesh. George countered that he could not afford to go to the races, and in any case never had time (as most race meetings were midweek and meant taking a whole day off).

Critchley helped Munn raise £14,000 to make a start. They now needed some dogs, so Munn hired a cinema in Wardour Street and invited a coursing judge and vet, Major Leslie Lyne Dixson, to view a film taken at an American track.

Suitably impressed, Lyne Dixson promised to find some dogs, while Munn and Critchley set about laying their first track at Belle Vue, in Manchester, an area with a long tradition of coursing.

To get the track ready they had to borrow a further £8,000. They then printed 20,000 race cards for the opening night, on July 24 1926.

Accounts vary. Most say 1,700

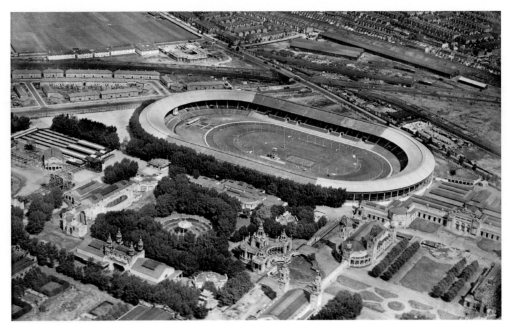

people turned up. Critchley put the figure at 2,555. The next two meetings drew even fewer. But then just as the Canadian and American appeared to be facing ruin, word spread, and by the end of the autumn, after 37 meetings attendances had risen to a more respectable average of 9,000.

Apparently one factor in the rise had been that as the nights had drawn in, so the allure of floodlit racing had magnified.

Encouraged by this, Munn and Critchley launched the Greyhound Racing Association (GRA), which, despite its name was a business venture rather than a governing body. Its first chairman was Sir William Gentle, a former chief constable of Brighton who had made his name combatting corruption in horse racing.

All parties knew that if the venture was to succeed, it would have to show itself to be absolutely above board and respectable.

Critchley now set his sights on the biggest audience of all, London, and in an act of supreme confidence, on one of the most famous venues of all.

Since it had been vacated by the War Department in 1921, the former Olympic Stadium at White City had lain vacant, two attempts to sell the site having failed. Critchley found that the grass had grown waist high, the steelwork was rusting and both stand roofs had been stripped. But although derelict, its scale and location suited his purposes perfectly, so

he started to negotiate with the leaseholders, the Kiralfy brothers, for a two year option.

Then, whilst the Kiralfys hesitated, Critchley took an option on another site in Harringay, making sure the brothers heard of this. Thus he was able to hurry them not into a two year deal but into selling him the remainder of their 90 year lease for £125,000.

That was in December 1926. Shortly after, Critchley's contractors, Humphreys of Knightsbridge, who had already worked on several London football grounds, moved in to prepare the stadium. By the time the works were complete, in June 1927, the costs had quadrupled.

Critchley, meanwhile, again according to his own account, received an approach. Would he like to buy another almost new stadium, also suitable for greyhound racing?

Critchley demurred. The stadium in question was too far out of town. Not so, insisted the seller, and to prove it he would drive him there in twenty minutes.

'You do that and I will buy it,' replied Critchley.

But the challenge was not met, and Critchley returned to White City, where, much to the amusement of the national press and the new BBC news service, 'Rupert' the mechanical hare, was proving somewhat unreliable. This meant that London's first modern greyhound race took place not on a Saturday night as planned, but »

▲ Flanked by the surviving and still functioning exhibition halls and gardens of the 1908 Franco-British Exhibition, the **Olympic Stadium** at **White City** found an unexpected saviour in greyhound racing.

Seen here in 1928 after its £120,000 makeover by the GRA, the new turf track sits inside the former concrete cycle track. A wider dirt track for speedway then forms an inner circuit. In the infield can be seen the shape of the former Olympic swimming pool, its tank now filled in. The roofs of the side stands have been renewed, and new roofs added at both ends.

Speedway lasted only two years, after which Critchley laid an athletics track instead (see page 309). He also tried out football and floodlit rugby league. But it was the dogs that kept White City alive until the bitter end in 1984.

Note behind the stadium a road running from left to right, forming a T junction at Wood Lane. This was a new dual carriageway called Westway, a route not completed until 1970 (see Chapter 8).

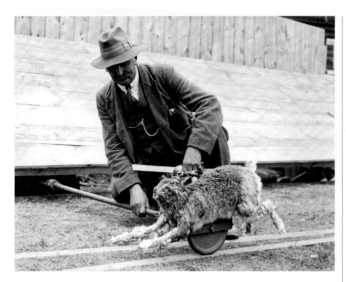

▲ As many a punter has jested, in greyhound racing the hare *always* wins. This was Rupert, White City's first **mechanical hare** in June 1927, formed by a real stuffed hare propelled by an electrically driven trolley (hidden behind the screen).

Clearly a coursing man, *The Times* reporter called it 'that dreary phantom'. Other pressmen called it 'the barmy bunny' and whipped up interest by reporting how in trials it went either too fast, too slow or not at all, causing the first meeting to be delayed by two days.

Rival versions using toy hares gradually appeared at other venues, placed either on the inside or outside of the tracks. Wembley installed a McWhirter Trackless, Wandsworth a Sumner Cable, while Wimbledon's McGee Scott replaced its original trolley driven hare, 'Gracie', which had featured an inbuilt wobble and squeak (both soon stopped once it became clear that the dogs were unimpressed).

In each case the hare's speed was controlled manually from a vantage point up in a stand or from a tower. This was a key role, for if so minded a corrupt controller could adjust the hare's speed to favour certain dogs at key points in a race.

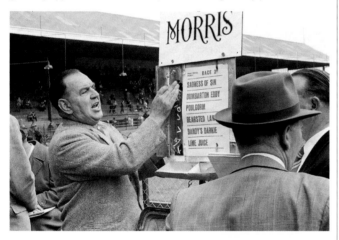

While off course bookmaking remained illegal until 1961, and horse racing at the likes of Alexandra Palace and Hurst Park took up a whole day and could be costly, popping into the local dog track was all too easy. Hence afternoon greyhound meetings, such as here at Park Royal in 1956, were often accused of causing absenteeism in neighbouring factories.

» on a sunny Monday evening, June 20 1927, in front of only 15,000 curious spectators (this in a stadium able to hold 80,000). The first winner was a Manchester dog, Charlie Cranston, whose owner took home £15 in prize money.

By the end of the evening, however, another 10,000 punters had wandered in and Rupert had performed impeccably. Two nights later 30,000 turned up. On the first Saturday this rose to 35,000.

Four days later came reports that the businessman who had tried to sell Critchley a stadium had committed suicide.

His name? Jimmy White. The stadium? Wembley.

Poor Jimmy. Labelled a racketeer by the press and mired in debt (from Wembley and a string of failed speculations), White had missed out on the bonanza that was about to take London by storm. On July 23 a record 65,000 crowd packed into White City, and by the end of the autumn season the average stood at 40,000.

By comparison, England's best supported football clubs at the time were averaging in the range of 30-37,000.

Make no mistake, the arrival of greyhound racing in London was an unprecedented phenomenon.

And it had only just begun.

Harringay Stadium opened on September 13 1927 in front of a 50,000 crowd and 796 bookmakers. Shilling shares in the GRA were now trading at £10, while a further share issue was so oversubscribed that it took two days for all the surplus cheques to be returned. By October 1927 there were 35 other tracks up and running around Britain. Then on December 10 London gained its third track... at where else but Wembley Stadium.

Unlike White City, Wembley was hardly derelict. But since, in the absence of any other interest, Jimmy White had bought the Empire Exhibition site from the liquidator for a knock down £300,000 (*see page 74*), there remained a possibility that the stadium might be demolished as a loss making enterprise. Holding only one guaranteed football match per year (the FA Cup Final) and one international every two years (England v. Scotland) was barely enough to pay for its upkeep, let alone cover the debt.

One man saw differently. Arthur Elvin had operated tobacco kiosks and souvenir outlets during the Empire Exhibition, and in 1926, with White's blessing, had started demolishing and selling off as many of the temporary buildings and fixtures as he could.

By mid 1927 Elvin had made enough from this to offer White £122,500 for the stadium. But then came White's death. Anxious to settle the matter, the Receiver then gave Elvin a fortnight to find the cash, or forfeit his deposit.

The story has been told many times. Facing potential ruin, Elvin not only managed to raise the money and clinch the deal, on August 17 1927, but he also formed a new company with a capital of £230,000 and, on the same evening, sold the stadium on to this company, thereby making an instant profit and installing himself as the stadium's new managing director.

He was aged 28 at the time.

Elvin took a massive gamble. But there can be no doubt as to why he acted as he did, and how he managed to get so many investors on board. It was not because Wembley was hallowed ground where Cup Finals took place. It was because everyone could see the enormous potential of greyhound racing.

First White City, now Wembley. Had it not been for the dogs, the entire landscape of sport in 20th century London might have been quite different.

Greyhound racing was also to have a transformative effect on stadium management.

At a typical meeting, then as now, races took place every fifteen minutes, but lasted barely 30 seconds. That left plenty of time to place bets or collect winnings. But promoters like Critchley and Elvin knew that they would have to offer extra amenities and entertainments, not least because, as several newspapers noted, a surprisingly high proportion of the crowds were women. (Thus AP Herbert wrote of a girl telling her beau, 'Don't let's go to the dogs tonight, for Mother will be there.')

As the historian Mike Huggins has shown (*see Links*), there was also a marked degree of middle class involvement in the sport, as punters, investors and as greyhound owners.

Moreover, as most meetings took place at night, tracks had to offer well-lit, warm places where spectators could mingle.

Combine all these factors and we begin to see at greyhound stadiums in the late 1920s and 1930s the birth of the modern spectator-friendly facility; that is, unlike most football, rugby and cricket grounds of the era, venues where there were adequate toilets for both sexes, terrace covers, bars, lounges and restaurants, some of them, as would soon be the case at White City and Wembley, with glass fronts so that punters could watch the action but remain in comfort. In short, the sort of hospitality areas that are nowadays taken for granted.

As at White City, it cost Arthur Elvin over £100,000 to prepare Wembley for the new sport. Sir Owen Williams, who had masterminded the Empire Exhibition, took on the job.

In addition to installing all the necessary greyhound racing equipment, buffets, Totalisator boards and counters (of which more later) and so on, the stadium's Banqueting Hall was converted into a 'Stadium Club' with a maple floor for dancing.

This was another new trend; the recognition that some people would prefer to pay extra and gain access to exclusive areas within a stadium. Hence at tracks all over Britain there appeared 'Gracing Clubs', 'Senior' and 'Junior Clubs' – ranked according to the facilities, not the age of the members – all members being issued with enamel badges (that are now highly collectable).

Elvin also bought extra land adjoining the stadium, where the Australian and Canadian exhibition halls had stood, for a car park holding 1,000 vehicles.

This not only helped to attract more well-heeled racegoers. It also added to the glamour of race nights that smart limousines and the odd sports car were to be seen parked outside. Some promoters, it is said, even paid for local car dealers to park their best cars in the stadium car parks, simply to make an impression.

On its first night Wembley drew 50,000. After three months the value of a one shilling share had risen tenfold. After five months the operation moved into profit.

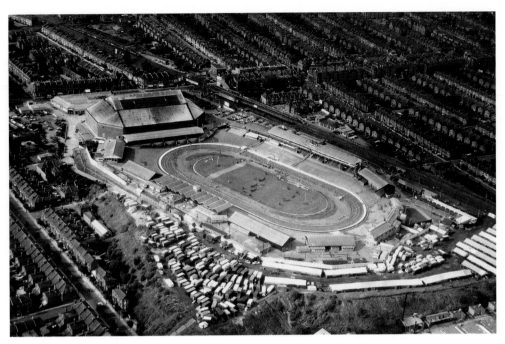

A whole industry was now in the making. Hundreds of staff had to be hired and trained, kennels built and run, dogs bred and reared, race cards designed and printed. Meanwhile engineers puzzled over how to improve the hares and trap release mechanisms. In time they would go on to perfect systems for photo-finish photography and electronic timing, again, all now part and parcel of modern sport.

Inevitably not all was sweetness and light. This was, after all, a sport founded largely on betting. The church, the Salvation Army and a host of indignant moralists staged protest meetings, wrote to the press and in several parts of the country tried to get their local track closed altogether.

Trade Unions and Friendly Societies claimed that the craze for greyhound racing was hampering their ability to collect subscriptions. The directors of football clubs and pub landlords also expressed concern.

In response, in 1928 the promoters banded together to form the National Greyhound Racing Club, the equivalent of horse racing's Jockey Club, to enforce a system of regulation and to pepper the press with articles and letters emphasising the positive aspects of the sport.

From then on there would be two classes of track; those licensed by the NGRC, and those, usually smaller tracks, often referred to as 'flapping' or 'flapper' tracks'. »

▲ Built on a 23 acre site that had been used to dump tons of earth excavated during construction of the Piccadilly Line, the 50,000 capacity **Harringay Stadium** on **Green Lanes** was London's second greyhound track when opened by the GRA in September 1927.

Critchley chose well. With a railway station on its doorstep and Manor House tube a five minute walk up the road, its location and catchment area were perfect.

In 1928, as at White City, a speedway track was added inside the 438 yard long turf greyhound track. Three speedway teams were based there at different times, the Canaries, Tigers and Racers, before in 1954 stock car racing took over.

But Critchley's biggest gamble was to build an **indoor arena** at the Green Lanes end of the track in 1936, thereby mirroring the set up at Wembley.

Ice hockey failed to take off as Critchley (and others) had hoped. Rather more successful was boxing, supplemented in 1949

by the arrival of a new attraction, the **Horse of the Year Show**.

Seen above, competitors at the show in 1955 are warming up outside before entering the arena.

After the arena closed in 1958, to become a food store, the show switched to Wembley, and as the increasingly hard pressed GRA started to focus more on property deals than on racing, Harringay's future became ever more uncertain, before its eventual closure in September 1987.

Fortunately shortly before this the National Monuments Record, now part of English Heritage, photographed it in detail (the image below left being one of several).

Clearly, here was a typically British hotchpotch of stands and terrace covers, ten in total.

On the arena site now stands the Arena Shopping Park. The railway side of the stadium is occupied by a supermarket, the remainder being a car park. Where the horse boxes can be seen on the embankment is now **Finsbury Park Avenue**.

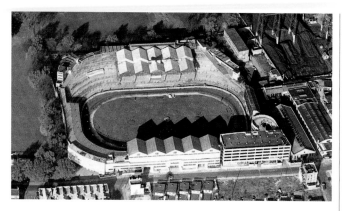

▲ With its easy curves and short straights, **Clapton Stadium,** on **Millfields Road,** seen here in 1949, had one of Britain's fastest tracks.

Also noteworthy was its hare, which uniquely ran along the centre line of the track, apparently to prevent dogs running wide and converging on the first bend.

But then Clapton was unusual in several respects. It had opened in 1900 as the ground of **Clapton Orient FC** and been expanded in 1923 by Humphreys, the contractors. This included a typical Humphreys multi-spanned stand on Millfields Road (closest to the camera). The £30,000 costs nearly ruined Orient, however, and in 1927 they relinquished the lease to a greyhound syndicate, which spent a further £80,000 on track installation, improvements and

raising the capacity to 37,000. The first race took place in April 1928.

Two years later Orient departed for Lea Bridge (*page 87*), whilst alongside the main stand was built the first multi-storey car park at a British sports venue, and also one of the first in Britain overall to have a helical ramp.

This was followed, on the west side of the main stand in 1939, by a strikingly modern corner stand (*below*), its upper terrace cantilevered over the lower terrace. Testament to the Clapton company's resolve to do things differently, the architects were G Grey Wornum, designer of the RIBA headquarters in Portland Place, and AC Tripe.

Clapton closed in 1974 and the site is now the **Millfields Estate,** with **Orient Way** in its midst (*page 82*).

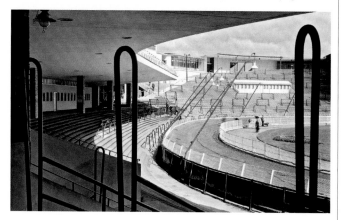

»In some cases flapping tracks were hardly more than an enclosed ground with few facilities and highly dubious practices. But even they had to be licensed by the local authority, as a result of which many were shortlived, for example at Battersea (*see opposite*), Brixton and Temple Mills.

As shown opposite, nine flapping and 18 NGRC tracks would operate in Greater London, all opened from 1926-39. There were also training tracks, such as the Edmonton Straights (*page 88*).

But there could have been more. In December 1927 alone plans were turned down for a 75,000 capacity stadium on Bridport Road, Edmonton, for an indoor track at Alexandra Palace, and for racing in the grounds of the Crystal Palace (stymied by the Bishop of Woolwich and a 43,000 signature petition).

Also abandoned were later plans for a 100,000 capacity track in Tooting and for racing at the Oval.

Typical of the sort of opprobrium expressed was that heard at Battersea in 1933, where the flapping track on Lombard Road (on the site of what had been the Star Athletics ground in the late 19th century), was described as 'a very grave menace to the social status of the borough'.

This came just as greyhound racing found itself subject to scrutiny by a Royal Commission, which in turn led to the 1934 Betting and Lotteries Act. Under the Act Sunday racing was banned and each venue was limited to 104 meetings per year. But in return, Totalisator, or Tote betting at greyhound tracks was granted the same legal status it had enjoyed at racecourses since 1928. The Act also allowed tracks to retain six per cent of all Tote takings.

Another crucial development concerned the entirely fortuitous arrival in Britain of yet another new sport, that of dirt track, or speedway racing, in 1928.

To the delight of promoters and investors alike, speedway tracks fitted perfectly inside existing dog tracks. For the likes of Wembley, West Ham, New Cross and Wimbledon, this extra business was heaven sent and reasonably long lasting (*see next chapter*).

At White City, Hackney Wick, Harringay and Walthamstow it proved more erratic.

As a result, the GRA, which had purchased White City outright in 1930, remained determined to bring in other sports. In 1932 it replaced the speedway track with an athletics track in order to accommodate the summer meetings of the Amateur Athletic Association.

This was after the AAA had been forced out of Chelsea's Stamford Bridge by speedway, which itself was then supplanted by greyhounds in 1932. Thus White City became for the next 40 years the *de facto* national stadium for athletics (*see Chapter 28*).

Also at White City, during the winter Queen's Park Rangers tried two seasons there before deciding the place was too large. In 1933–34 after a successful trial under floodlights – another of Critchley's ideas that football would take another two decades to embrace – the GRA then experimented with rugby league.

London Highfield RLFC played there only a year, but their gates persuaded another greyhound promoter, Sydney Parkes, to form new rugby league clubs at two of his venues in 1935. Acton & Willesden RLFC were to play at the Park Royal greyhound stadium, Streatham & Mitcham RLFC at the newly built Mitcham Stadium. But when Parkes failed to gain a licence for greyhound racing at Mitcham – a huge financial blow – the losses became too great and London's first dalliance with rugby league came to an end in 1937.

Another sport staged at dog tracks during the 1930s was baseball. Teams included the Romford Wasps, Catford Saints and West Ham Hammers.

But if, ultimately, only speedway proved to be a lasting bedfellow at a few greyhound stadiums, it was hardly pivotal. By 1939 attendances at Britain's 61 NGRC tracks had reached 26 million, and in the post war boom reached a peak of 34 million in 1946.

Again, this compared with 35.6 million in football, and helps to explain why, when Arthur Elvin put Wembley at the disposal of the International Olympic Committee in 1948, it was on condition that the athletics track would be dug up as soon as the closing ceremony ended so that greyhound racing could resume as soon as possible.

Similarly, when the FIFA World

Cup came to England in 1966, rather than host a group match, Uruguay v. France, Wembley insisted on staging its regular Friday night greyhound meeting. Ironically, the match was staged at White City instead.

Even so, greyhound racing was already in decline. By 1960 total attendances had halved over the previous decade to 14.2m. The total would thereafter fall more rapidly, largely owing to the provisions of the 1960 Betting and Gaming Act. By legalising betting shops for the first time, the public no longer needed to attend a track in order to bet. Nor did it help that the same Act unleashed a mania for bingo clubs.

To soften the blow tracks were allowed to stage more meetings. This resulted in most of them changing their tracks from turf to sand, which was easier to maintain and caused fewer injuries.

But extra meetings were no panacea. Greater London's first NGRC track closure was at Dagenham in 1965. Twelve more closed by the end of the century. Since 2003, the further closure of Catford and Walthamstow has left London with only three tracks.

In every case, a decline in attendances and income has been matched by the rising property value of the site. More recently the late opening of betting shops and the onset of online gambling have also hit hard, meaning that many tracks now depend on meetings held under the auspices of the British Afternoon Greyhound Service, staged purely to service off course betting.

This is not to say that greyhound racing is bound inevitably, in the timeworn words of the headline writers, to go to the dogs. Around 2m attend annually at the nation's remaining 25 licensed tracks. Some 10,000 people are still employed by the industry, which has been substantially reorganised following a 2007 review by Lord Donoughue.

But in London at least the fate of Wimbledon, the home of the Derby, is seen as pivotal. If it goes, London fans of the sport will have to travel out to Romford or Crayford, or in common with their counterparts in speedway, beyond the M25.

As for coursing, after the sport was banned by the Hunting Act, the last ever Waterloo Cup was contested in February 2005.

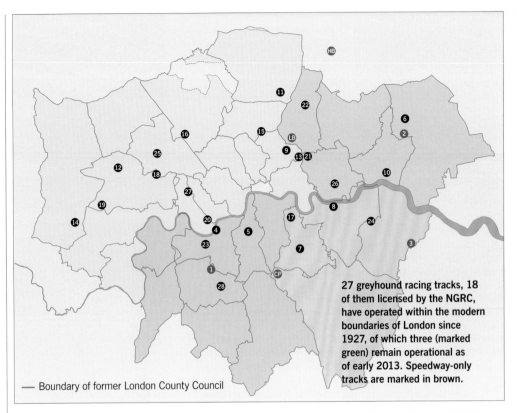

27 greyhound racing tracks, 18 of them licensed by the NGRC, have operated within the modern boundaries of London since 1927, of which three (marked green) remain operational as of early 2013. Speedway-only tracks are marked in brown.

— Boundary of former London County Council

Notes:

† 'flapping' track, ie not licensed by National Greyhound Racing Club (since 2009 Greyhound Board of Great Britain)

* also staged **speedway** racing

Current greyhound tracks:
1. **Wimbledon*** Plough Ln SW17 opened 1928
2. **Romford** Romford Rd RM7 opened 1931
3. **Crayford*** Stadium Way DA1 opened 1986, replacing earlier track 1930-85

Former greyhound tracks:
4. **Battersea**† Lombard Rd SW11 (1933-37) now Fred Wells Gardens (*below right*)
5. **Brixton**† Brixton Rd SW9 (1932-35) now St Helen's School
6. **Brooklands**†* Brooklands Rd Romford RM7 (greyhounds 1929-31; Romford FC 1929-77) now residential
7. **Catford*** Adenmore Road SE6 (1932-2003) housing planned
8. **Charlton** Woolwich Rd SE7 (1938-71) now Makro store
9. **Clapton** Millfields Rd E5 (1928-74) now Orient Way
10. **Dagenham*** Ripple Rd RM9 (1939-65) now distribution centre, Choats Manor Way
11. **Edmonton**† (c.1933-c.1948) now Barrowfield Close N9

12. **Greenford**†* Birkbeck Ave UB6 (1927-35) now Stanley Ave
13. **Hackney Wick*** Waterden Rd E15 (1932-97) now Queen Elizabeth Olympic Park
14. **Harlington**† Bath Rd UB3 (c.1932-59) now hotel and Airport Bowl
15. **Harringay*** Green Lanes N4 (1927-87) now Arena Shopping Park
16. **Hendon** Brent Cross NW4 (1935-72) now motorway slip road/shopping centre car park
17. **New Cross*** Hornshay St SE14 (1934-69) now Bridge House Meadows
18. **Park Royal** Abbey Rd NW10 (1931-69) now Abbey Road Industrial Park
19. **Southall**† Havelock Rd UB2 (1931-75) now primary school
20. **Stamford Bridge*** SW6 (greyhounds 1932-68)

21. **Temple Mills**† (c.1935-51) housing on site, now Queen Elizabeth Olympic Park
22. **Walthamstow*** Chingford Rd E4 (1931-2008)
23. **Wandsworth** Garratt Ln SW18 (1933-66) now Southside Shopping Centre
24. **Welling**† Wickham St DA16 (1932-39) now part of East Wickham Open Space
25. **Wembley Stadium*** HA9 (greyhounds 1927-98)
26. **West Ham** or **Custom House*** Nottingham Ave E16 (1928-72) now residential
27. **White City*** Wood Lane W12 (greyhounds 1927-84) now BBC Media Village

28. **Mitcham** Sandy Lane CR4 (track never operational but stadium open 1935-55) site now Ormerod/Guyatt Gdns

The following hosted **speedway** but not greyhounds (*see next chapter*):

HB. High Beech IG10 (1928-50) now Epping Forest Visitor Centre *see p333*
LB. Lea Bridge E10 (1928-39) now industrial estate *see p87*
CP. Crystal Palace SE19 (1928-40) now part of the National Sports Centre *see p67*

▲ In the rush to cash in on the greyhound boom few promoters bothered with architectural niceties. Clapton was one exception. Another, opened in 1935, was **Hendon Stadium**, whose fine Art Deco clocktower (architect unknown) commanded attention alongside the **North Circular Road,** a short distance east of the Welsh Harp.

Seen also in 1965 (*top right*), with the River Brent running behind, Hendon was London's smallest licensed venue, with a 5,000 capacity, and was owned in tandem with Hackney Wick.

It was demolished in 1972 to make way for a slip road from the M1, while the eastern half of the site became the car park of Brent Cross Shopping Centre (hence Stadium Road now forming the approach).

Wandsworth (*centre right*), opened in 1933, was the first of three tracks either built or improved by Sydney E Parkes (who also later took over Charlton).

Costing £100,000 and holding 20,000, the stadium, seen here in 1961, was built on an island site formed by two branches of the River Wandle, with a kennel area to the north and King George's Park to the west. To the south, beyond the Storm Relief Aquaduct (b. 1887, seen running from left to right), was the park's **Open Air Swimming Pool** (b. 1938).

With Young's Brewery, a gasworks and much other industry besides close to hand, plus a number of large LCC estates, the track appeared well placed. But its land value, and the proximity of south London's most prestigious track, Wimbledon, barely a mile south, down the Wandle Valley, meant that Wandsworth became the first major London track to close, in 1966. The site was then swallowed up by the gargantuan Arndale Shopping Centre (now **Southside**), leaving no trace, not even of the Wandle, which was now culverted. The park and lake to the west survive, however, as do the lido buildings seen in the foreground, now part of the **Wandle Recreation Centre** on Mapleton Road.

Catford Stadium was, by contrast, London's homeliest track, sandwiched between two railway lines serving Catford and Catford Bridge stations, as seen here also in 1961 (*below right*).

Built in 1932 and run by the Sutton family, its neat stands, Spion Kop terrace (nearest the camera) and tree-lined northern curve gave it a rare orderliness and intimacy. When sand took over from turf as the preferred track surface in the 1960s, the Suttons even tried using green dye to soften the visual impact.

Boxing Day meetings there, with the whiff of cigar smoke heavy in the air, were particularly celebrated.

In 1963 Catford was bought by the GRA. But as crowds dwindled and problems arose with the lease to the car park, the track finally closed in 2003.

Two years later an attempt to list the **Tote board**, seen below from Ladywell Park, was foiled when a suspected arson attack destroyed the structure. The site then lay vacant for several years before plans for 600 homes were finally confirmed in 2013.

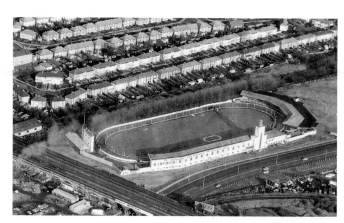

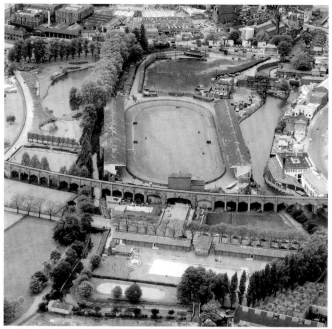

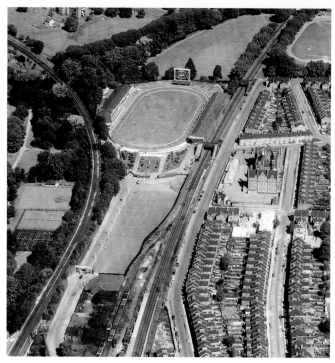

▲ Often the most prominent structure at a greyhound stadium was the **Totalisator**, or **Tote Board** for short, usually capping one end of the track, as at all three stadiums seen opposite and at **Walthamstow**, photographed above in the 1930s.

Baffling to anyone unfamiliar with the arcane ways of betting, the tote was essentially a huge mechanical calculator and display board used in the operation of pool betting (or *pari mutuel* as it was called by its Parisien inventor in 1867).

Where only a handful of pooled bets are involved the necessary calculations as to who wins what can readily be made using mental arithmetic. But in the fevered atmosphere of a racecourse, with thousands of bets being placed within a short burst between races, and where reliability and scrutiny (by the tax man) were to become legal requirements, automation emerged as the only way forward.

The first tote machines thus started to appear during the late 19th century, before one system prevailed; that of George Julius, a Norwich born engineer based in Sydney, Australia, and first installed in Auckland, New Zealand, in 1913. **Automatic Totalisators**, the

company set up by Julius, went on to supply several British racecourses after the tote was legalised in 1928, and at numerous greyhound tracks after the legislation was finally extended to dog tracks in 1934 (following complaints of there being 'one law for the rich...').

For the track operators, allowed to retain a percentage of takings, the tote in time became extremely profitable, reaching £200 million collectively in the late 1940s. But it also required a great deal of infrastructure, to house the baffling array of accumulators, commutators, epicyclic trains and veeders, cogs, wheels and counters, all of which made a tremendous racket.

Above right is just a small part of the equipment at **Harringay**, a 1930s Julius system that remained in use right up until the final race in 1987. It was photographed in detail by the National Monuments Record and also studied closely by the Greater London Industrial Archaeology Society (GLIAS). Their report and video clips are available online and worth perusing. Sections of the Harringay tote have also been preserved by the Science Museum.

Above in the 1930s, in the gloom of the stadium undercroft, is the tote board at **Wembley**, where staff at nearly 300 counters could each process up to 80 bets per minute.

The beginning of the end for Britain's Julius totalisators came in 1975 when the first computerised tote was installed at Sheffield.

But the shell of one does survive, even if it is better known for what there is on its reverse side...

▲ Glimpsed on the horizon by motorists heading east on the North Circular, the neon sign adorning the rear of **Walthamstow Greyhound Stadium's tote board**, on **Chingford Road**, was for over half a century one of London's choicest examples of urban bling. Some considered it the perfect gateway to Essex.

Although Art Deco in style, the sign was erected in 1951. But the stadium was very much a product of the 1930s.

In the 1920s the eastern half of the site had been occupied by Walthamstow Grange FC. The western half, on Chingford Road, was being used as a dump.

To the fury of local residents, flapper racing started on the sports ground in May 1931. One complained that it attracted 'some of the most reprehensible specimens of humanity'.

But that was only the start. Two years later an east London bookmaker, Bill Chandler, having fallen out with fellow shareholders at Hackney Wick Stadium, bought the site for £24,000, obtained a NGRC licence and invited Amy Johnson, the aviator, for a grand re-opening in June 1933.

A year later the legalisation of totes at greyhound tracks under the 1934 Betting Act gave Chandler the reassurance to start building.

First, up went a new steel frame main stand on the north side, followed in 1935 by two tote boards designed by the Woolwich contractors, Thomas & Edge; the one seen above and on the previous page, at the west end of the stadium, and a smaller board at the east end, flanked by two kennel blocks and two small octagonal pavilions with steeply pitched tiled roofs. Both tote boards, the neon sign included, the kennels and pavilions, plus a two storey car park added to the front of the western tote board in 1936 (partially seen

above) were listed Grade II in 1987, the first greyhound-related structures ever designated.

Finally in 1938 two concrete cantilevered stands – among the earliest of their kind (see Chapter 10) – one long, one short, in the corner, were erected on the south side, backing onto and bridging in part the narrow River Ching.

Chandler died in 1950 but his sons Charles and Percy took over (while another son Victor took over the family bookmaking company, which still bears his name today). Apart from a highly publicised battle for control involving other family members in the 1970s, the

grandchildren ran the stadium in its later years. In 1984 they built a nightclub, Charlie Chan's, in the north west corner, so that a night out at 'the Stow' became a favourite among celebrities and City slickers.

The assumption was that of all Britain's tracks, Walthamstow – family run, neat, tidy, steady crowds – appeared the most secure.

Then came the bombshell. Announcing that the track was losing £500,000 a year and with property prices still high, in 2008 the Chandlers sold the site to the L&Q Housing Trust for a reported £18 million. The final race was run on August 16.

Immediately a Save the Stow campaign formed, but after four years of lobbying and despite support from both local MPs, Labour and Conservative, at the time of going to press plans for housing on the site were going ahead, while behind locked gates the stands slowly rotted.

The only hope now was that, as at Highbury Stadium (see Chapter 22), the retention of the listed buildings, combined with a masterplan that honours the oval form of the track, would at least retain some vestige of the Stow's much vaunted sense of place.

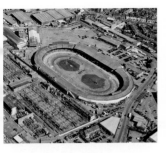

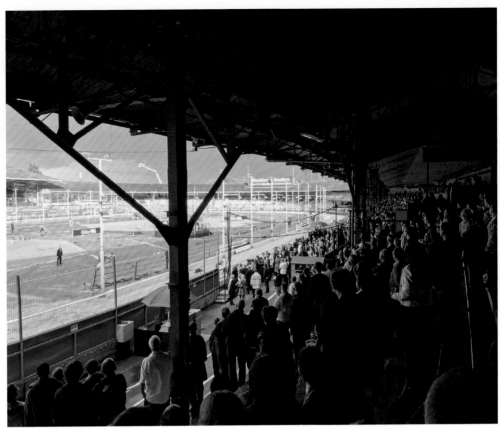

▲ And then there were three... Crayford and Romford, both still running on the outer edges of Bexley and Havering respectively, and **Wimbledon Stadium** (*above and right*) on **Plough Lane**.

The last of the pre war London bowls, Wimbledon opened in May 1928, as great a contrast to the Wimbledon of lawn tennis fame as Bovril is to Pimms.

Within months it had to be bailed out by the contractors, WJ Cearns, partly because it had been sited on marshy land alongside the River Wandle and the construction costs had overrun. But this turned out to be its saving grace. Bill Cearns, a director at West Ham United and a pioneer of speedway promotion at High Beech (*see next chapter*), turned Wimbledon into south London's answer to to Wembley and White City.

Although smaller, with a capacity of around 42,000, it was home to the Dons speedway team from 1928-2005, the longest run of any London speedway outfit, and to a regular schedule of high profile greyhound races. Cearns' son was the manager, his wife was a respected dog owner, and for a time Mick the Miller was kennelled there.

Wartime damage in 1944 required the complete rebuilding of the west side of the stadium in 1956. In 1972 it was taken over by the GRA, and in 1985, following the closure of White City, it became the venue for the Derby, greyhound racing's prime race of the year.

But by then its fabric had started to creak. Bit by bit sections of the end terracing, mostly timber, were closed, then one whole side, until by 2012 only the Mick the Miller Stand on the east side (with its blue roof, as seen above) remained open, with capacity limited to 3,500.

Meanwile, in 2005 the GRA, once the dominant force in British greyhounds, was taken over by a venture capital group, Risk Capital Partners, one of whose funding partners was Galliard Homes.

In 2011 Merton Borough Council insisted that any development of the site would have to include some sporting element, not only housing, as a result of which in 2012 two main proposals emerged.

The first was for a 10-15,000 seat football stadium designed to be a home for AFC Wimbledon, currently exiled in Kingston, with housing and retail filling the remainder of the site. The second was for a new greyhound stadium holding 6,000, proposed by an Irish businessman and greyhound lover, Paschal Taggart.

Not surprisingly these latter plans were supported by a campaign group, 'We Want Wimbledon', who expressed the view that for London not to have a major greyhound stadium would be unthinkable, not least because it would mean switching the Derby to another city.

They also noted how Taggart's investment had transfomed the Irish greyhound scene, resulting in the modernisation of several tracks and an increase in attendances.

Fans of stock car racing, also held weekly at Wimbledon during the winter, were equally in favour.

Meanwhile one model of a smaller greyhound track that has managed to survive can be found on the other side of town.

Romford Stadium (*below left*), opened in 1931 by a flamboyant sweet manufacturer and showman, Archer Leggett, who also staged cheetah racing and baseball at the stadium, has since 1976 been operated by Coral, the bookmakers.

With a modest 4,300 capacity, Romford survives courtesy of three restaurants, eight bars, four fast food outlets, two betting shops and six meetings a week (three in the afternoon).

So it is argued that Wimbledon, with a modern stadium, might be sustained in a similar fashion.

If not, one of the great social and sporting phenomena of the 20th century will almost certainly be lost to south London for ever. Just like speedway, in fact, last seen in the capital in 2005, also at Wimbledon.

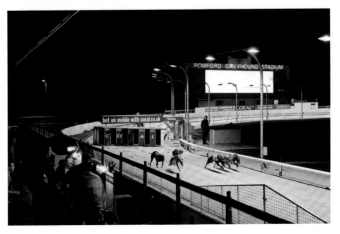

Chapter Thirty One

Speedway

All motorsports are fast, noisy and potentially dangerous. But what places speedway in a class of its own is that, rather than requiring a long, extended circuit, it is contained within a conventional track-based stadium. This is owing to a manoeuvre known as 'broadsiding', whereby riders are able to negotiate tight corners by swinging their rear wheels into a controlled skid, while still accelerating at speeds of up to 80 mph. Braking is not an option for the simple reason that the bikes have no brakes, and while an engine size of 500cc might not seem overly powerful, running as they do on methanol speedway bikes are capable of 0–60mph in 3.5 seconds, faster than a Formula One car. Each race sees four riders compete over four laps of the track, a contest that takes less than a minute. Not a sport for the faint-hearted.

Considering its history, one of the most surprising aspects of speedway is that it is no longer staged anywhere in the capital.

In Sheffield, yes, in Manchester, Birmingham, Newcastle and Stoke; in Buxton and Berwick, in Peterborough and Poole; indeed in 29 British locations, all told, and in dozens of other cities across northern and eastern Europe.

Yet in London, a city ostensibly hooked on spectacle, speed, bright lights and celebrity, speedway has recently spluttered and skidded to a dispiriting halt. As noted on the previous page, it was last staged in the capital in October 2005, at Wimbledon Stadium, and according to most experts, is unlikely ever to return.

But if London speedway is to be consigned to the annals of sporting history, what can be said of its heritage? As it happens, a good deal, if heritage can be said to reside in the plethora of books, images, archive footage and ephemera, in the maintenance of websites and in the organisation of reunions to honour former heroes.

And what ripping yarns they tell.

Having arrived from Australia in 1927 (with added grit from American pioneers), speedway made its official debut in Britain at High Beech in Epping Forest in 1928 (*see opposite*), and was instantly embraced by Londoners.

It was fast, it was noisy, it was modern, and best of all it was often staged under floodlights, then still a novelty. The dashing riders also attracted a strong fan base amongst women.

During the mid 1930s, six of the seven clubs in speedway's First Division were London based. From 1947-53 a devotee could take in Wimbledon on Monday nights, West Ham on Tuesdays, New Cross on Wednesdays, Wembley on Thursdays and Harringay on Fridays.

In total speedway was staged, at one time or another, at 16 venues within the boundaries of what is now modern London, with attendances from 40-60,000 at the major tracks frequently rivalling even those at top football clubs. As recently as 1981, the last World Championships to have been staged at Wembley attracted a sell out crowd of nearly 93,000.

Yet for all the ardour of its fans, speedway never gained more than a tenuous foothold in the mainstream. Like the broadsiding riders themselves, with their steel-capped boots trailing in the cinders, the sport seemed always to veer unsteadily between triumph and disaster.

That it could be deadly was of course part of its appeal. Over 20 riders were killed before 1939 alone, among them the much mourned Tom Farndon at New Cross Stadium in 1935.

That the sport was a foreign import, and an unashamedly professional one at that, may also have gained it enemies. Nurtured on the rural dirt tracks of Ohio and New South Wales, speedway never quite shook off its buccaneering, outback image.

But then Londoners were used to having quixotic entertainments

sold to them with stunts and hoopla. From the very start in the late 1920s, rival promoters, such as the inveterate showman Johnnie Hoskins, fresh from establishing speedway in Australia, jostled with each other for the best venues and celebrity endorsements, while the riders themselves moved around like hired gun-slingers, earning fees beyond the dreams of any footballer or factory worker. For a glimpse of this world the 1948 film *Once a Jolly Swagman*, shot at New Cross and starring Dirk Bogarde, is well worth viewing.

A further factor in defining speedway's status was that it remained largely dependent on greyhound stadium operators to lease their venues. In most cases the fit was ideal, physically as well as commercially, and while the going was good, the two sports enjoyed a symbiotic bonanza.

But if ever the host directors withdrew support, as happened at Wembley for example, the teams had either to take over someone else's patch, or disband altogether.

In fact only one track in London was ever built specifically for speedway. Lea Bridge Stadium, Leyton (*page 87*), opened in July 1928, closed in 1934, re-opened in 1938, and was decommissioned soon after.

It was at Lea Bridge, incidentally, in an attempt to rescue the track's finances, that betting was allowed for a brief period, much to the horror of speedway's governing body, which had always been, and remains still, implacably opposed to gambling.

'...there is not much beauty about the dirt-track; and yet it has a kind of modern, macabre, Stravinskian, Capekian beauty. The vast stadium by night, the track lit brightly at the rim... the starry sky of London above... Heavens, the noise! It is like ten million mechanical drills performing in unison. It swells and falls as the riders take the corners; it echoes about the cavernous concrete halls, drowning the feeble acclamations of the crowd; it dies slowly as the riders stop, and the end of a race seems like the end of a battle. It is titanic and terrible and monstrous; and yet in that enormous place, made by those monsters, it seems appropriate and right. And I do believe I rather liked it.'

AP Herbert *Punch*, October 3 1928

Meanwhile the first existing London stadium to host speedway was Stamford Bridge, where a young showman, Claude Langdon, who had watched that first meeting at High Beech from a tree, ran a profitable operation from 1928-32. Despite this the Chelsea chairman Joe Mears opted to restore the track for the use of athletics. (He later changed tack again by introducing greyhounds.)

Crystal Palace also staged speedway from 1928-33 but lost out when the promoter moved to New Cross, where existed a greater concentration of working class support. Even there, the New Cross Rangers, as they became, closed down between 1953-59, before disbanding in 1963. One reason cited for this failure was that during the post war boom, controversially, speedway had been subject to Entertainment Tax at a level higher than other sports.

Similarly fragmented was the record at White City. There the former Olympic Stadium hosted speedway during five separate spells between 1928 and 1983.

With the exception of West Ham, where racing continued annually until the stadium itself was demolished in 1972, such stops and starts were common at London tracks, making it hard for the public and press alike to develop loyalty. Furthermore, as each greyhound stadium closed, so speedway's own options became increasingly limited.

By the 1990s only two London venues remained. At Hackney Wick, where speedway had operated from 1935-39 and from 1963-91, a revival in 1995 lasted only a year. The site was then absorbed into the Olympic Park.

That left just Wimbledon (page 331), where the 'Dons' were able to claim a longer unbroken spell than any other British speedway club apart from Manchester's Belle Vue Aces, having competed in every season from 1928-91. The Dons were then revived in 2002, and managed three more years before the stadium finally pulled the plug, as mentioned earlier, in 2005. A tarmac track for stock car racing now takes the place of the shale.

So it is that today, London fans must seek their thrills beyond the M25, the two nearest tracks being in Hoddesdon, Hertfordshire, and Thurrock, Essex.

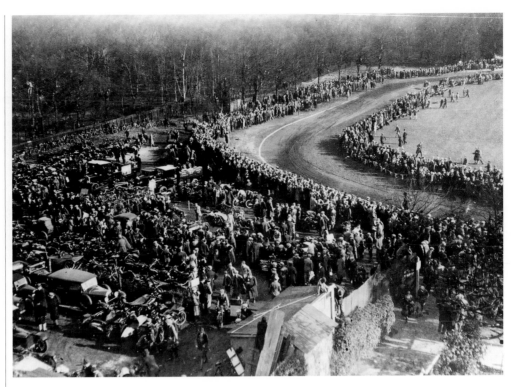

▲ Deprived of speedway in their own manor, nostalgic Londoners are wont to head out to Epping Forest to pay homage to the place where it all began, a clearing behind the **King's Oak Hotel**, **High Beech**, where this was the scene on that auspicious day, **February 19 1928**.

It was an unlikely, isolated spot, used previously as a cycling and running track by Loughton Athletic Club and for football and hockey. Carved out of the forest, the cinder track was almost circular and there were virtually no spectator facilities. But then the organisers had only expected around 3,000 spectators.

Instead, an estimated ten times that figure turned up, spilling dangerously onto the infield and perching in the surrounding trees.

Thankfully no mishaps ensued, and the day's rip-roaring displays of derring-do were given front page treatment in the *Daily Mirror*.

Within weeks venues all over Britain were preparing tracks.

For example **WJ 'Bill' Cearns**, a director of West Ham United, was impressed enough to invest in the upgrade of High Beech, as well as deciding that speedway should also be catered for at the stadium his company was building, and indeed largely financing, at Plough Lane in Wimbledon (ironically the very last place that speedway would be seen in the capital).

Pictured at High Beech in 1929 (*below*), Cearns stands on the far left, along with the Australian riders Vic Huxley and 'Cyclone'

Billy Lamont (in the suit), and the American, Cecil Brown.

As it transpired, High Beech never developed into a fully fledged senior track, although speedway continued there until 1950.

It then closed, partly because the proprietors of the King's Oak were fed up with cinders drifting into their new outdoor swimming pool.

Both the hotel and its pool remain in business, while to the rear, the now wooded area where the track once lay houses the **Epping Forest Visitors Centre**.

As its staff have frequently to explain, no trace of the track remains (although a minor hump is usually pointed out to ease the disappointment). Yet still pilgrims turn up, especially on the anniversary of the inaugural meeting, a day on which in some years thousands of speedway fans have turned up for parades.

But it is not only on the anniversary that they come. Visit High Beech on almost any Sunday and, a few hundred yards down the forest lane, at a green roadside cabin known as Miller's Tea Hut – a family run concern since it first set up to serve speedway fans in 1930 – there is invariably an assortment of motorbikers and cyclists.

Nowhere in Epping Forest can a finer bacon sandwich be found, or better tales be heard of the glory days of London speedway.

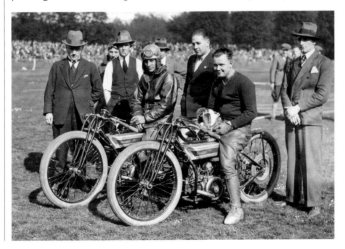

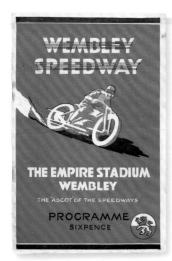

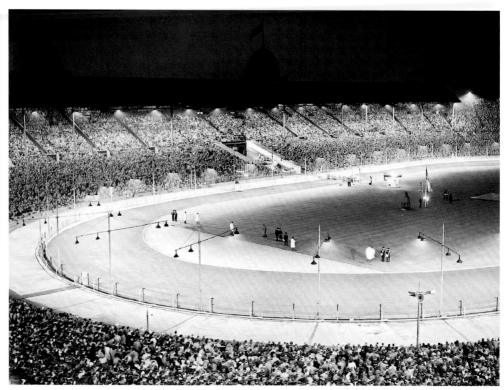

▶ Monday night speedway in September 1946, so it must be **Wembley Stadium**, home of the all conquering **Wembley Lions**. In austerity Britain the public flocked to sporting events in unprecedented numbers. But even against this background the Lions were a phenomenon, often attracting gates from 60–80,000, higher than any of the leading football clubs. For their last meeting of the season, in October 1946, v. Wimbledon, a full house of 85,000 was recorded, with 20,000 locked outside being kept informed by a commentary broadcast over loudspeakers.

By any standards the Lions rank amongst the most successful sporting outfits ever in London. They won seven National League Championships in the first eight post war seasons, missing out only in 1948 when the staging of the Olympics forced them to decamp to Wimbledon.

Backed by the Wembley Stadium chairman Arthur Elvin, during the 1930s they were the first speedway team to set up a supporters' club, with the incentive of reduced prices to watch Elvin's other 'Lions' play ice hockey at the new Empire Pool (*page 72*). By 1948 membership of this club topped 60,000.

Not all Wembley's directors were keen, however, and when Elvin died in 1957 the stadium dropped the Lions, and although World Championships continued to be staged on an occasional basis, complaints from the Football Association about the pitch – the corners of which had be cut away to accommodate speedway – hastened the end, which finally came in 1981.

In contrast to Wembley, **New Cross Stadium**, just off the Old Kent Road (*seen right in 1946*), opened for both greyhound and speedway racing in 1934, and with a capacity of around 25,000 was a more typical mix of utilitarian stands and terraces. The electronic starting gate shown here had been invented by the New Cross promoter Fred Mockford, at Crystal Palace in 1933, and became compulsory at all licensed tracks.

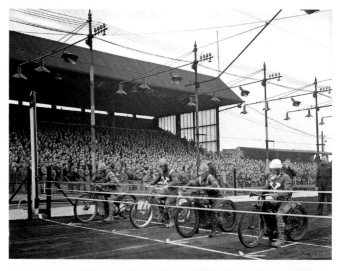

Known to speedway riders as the 'The Frying Pan', New Cross Stadium (*right*) was separated only by a railway embankment from Millwall FC's Den, whose terracing and clock is just visible top right. Since the track's demolition in 1969 the site, renamed Bridge House Meadows, has remained open, and now forms part of the multi million pound Surrey Canal regeneration scheme.

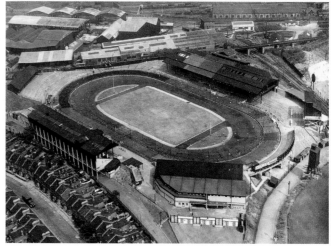

▲ Undoubtedly the most ambitious of all the speculative stadiums built during the boom years of greyhound and speedway racing, the **West Ham Stadium** at **Custom House E16**, was intended to become the Wembley of the Docklands.

Fronted by Sir Louis Dane – an unlikely figure given his previous career as Lieutenant Governor of the Punjab – its backers hired the top stadium designer of the era, Archibald Leitch (architect of six major football grounds in the capital, *see Links*). They also leased the pitch to a specially formed professional football club, Thames Association, even though West Ham's Upton Park was barely a mile away.

Press reports claimed the stadium, seen below in the 1930s, could hold 100,000. Even so, gates of 56,000 for the first greyhound race in July 1928, and of 82,400, for a speedway Test Match against Australia in 1933, suggested that there was indeed huge potential. Stock car racing

and baseball were also staged.

On the other hand a famously low all-time Football League record of 469 for a Thames match proved that there was no appetite for another football club in the east London area. By comparison, the Hammers speedway team regularly drew crowds of 50-60,000 during the late 1940s.

But the boom did not last and the Greyhound Racing Association eventually decided to sell the site for housing, the final meeting taking place in May 1972 (an event filmed, it should be noted, by Pathé News).

Alas the 1930s gateway on Nottingham Avenue (*above*) was not saved, and today the only reminders of this vast colosseum, apart from a dedicated website, are the streets on the site, named after the one time Hammers' promoter Johnnie Hoskins, and the riders Tommy Croombs, Arthur Atkinson, Jack Young and 'Bluey' Wilkinson.

As we shall learn overleaf, however, there is still one form of speedway in the vicinity...

▲ The wheels may have come off London speedway, but there is a corner of Hertfordshire where devotees may remind themselves of what has been lost.

Located, curiously enough, within the **Paradise Wildlife Park, Broxbourne**, the **National Speedway Museum** was set up in 2007 by the park's owner, Pete Sampson, a former rider with various teams, Hackney included, during the 1960s.

Packed with a wonderfully evocative array of bikes, bibs, bits and bobs, naturally the museum is at its busiest during the aforementioned annual gathering of the speedway fraternity, held every February to commemorate that first official dirt track meeting in 1928, at High Beech (which lies around ten miles to the south east, across the Lea Valley).

If wealthy and lucky enough, visitors to the gathering might find an ultra rare programme from that 1928 meeting on sale at one of the many memorabilia stalls set up for the occasion. If they do, it will set them back at least a grand.

Or they might prefer to kowtow to one of their former speedway heroes, and if brave enough, risk having their hand shaken by the monkey-wrench grip that is the trademark of the old riders.

Mingling among these enthusiasts, it seems impossible

to imagine that there is insufficient interest to support at least one team in the largest city in Europe. After all, London speedway has gone into hibernation once before, during the 1990s.

Yet the current hiatus is now nine years and counting, and with Wimbledon Stadium seemingly out of contention, that leaves nowhere for future promoters to consider.

Unless of course, as one wag has put it mischievously, there happens to arise spare capacity at a certain stadium recently built in east London, one with an especially wide track area.

A stadium, moreover, built only yards from the site of the famous track on Waterden Road, Hackney Wick.

Plus, he adds, there is an historical precedent. 'Don't forget the Olympics were staged at White City in 1908, and 20 years later speedway followed...'

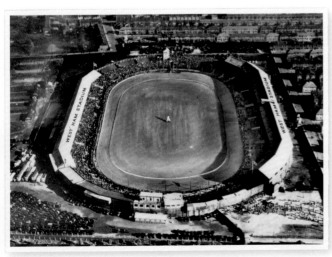

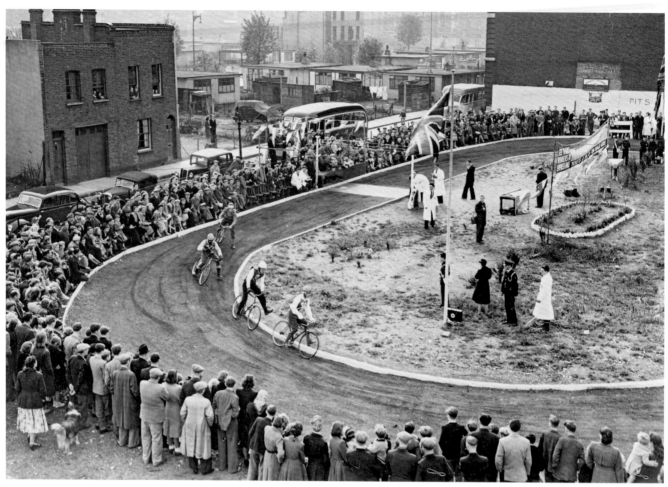

▲ It was not only the big boys who liked to kick up some dirt.

Photographed in October 1950, this was the makeshift track on **Larnaca Street SE1**, home of the **Bermondsey Greyhounds**, one of at least 200 **cycle speedway** teams to have formed in London between the early days of the sport in 1945 and the mid 1950s.

From the Acton Acorns to the Woolwich Vampires, with 20 teams formed in Walthamstow alone, here was a make-do-and-mend sport which grew up on bombsites – some say in south east London in particular – before spreading across the whole of Britain. Thus cycle speedway may be considered one of the nation's earliest teen crazes (and as its pioneers were always keen to acknowledge, one of their number, Rory Blackwell, of the Battersea-based London Aces, went on to form one of Britain's first rock and roll bands, the Blackjacks, in 1956).

Like skiffle, much of the appeal lay in emulating the professionals, and in making the best use of limited resources. One rider recalls that his frame had been rescued from a canal, and that a gas pipe performed as handlebars, another that one of the mothers donated knicker elastic for starting gates.

But then in most areas parents and local businesses encouraged the sport. Regional leagues formed, trophies were presented by the *News Chronicle*, and by the early 1950s cycle speedway had its own governing body, and a monthly magazine and annual (*left*).

In 1953 the Children's Film Foundation released *Skid Kids*, a Saturday feature shot in Camberwell and Bermondsey (extracts of which can be viewed on the internet).

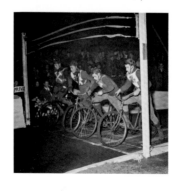

But as tracks became more sophisticated, as at **Woodford** (*below left*), with floodlights and loudspeakers, not all Londoners were enamoured. There were complaints about noise and bad language, and as the *Sunday Pictorial* reported, in April 1951 members of one Paddington team had to fight back the tears as council workers tore up their carefully prepared track. There was equal dismay when, having erected a fence around their Camberwell track, the Peckham Stars and Ruskin Flyers were charged rates.

Inevitably, as London's bomb sites were redeveloped – the Bermondsey track and pre-fab homes to become the St Saviour's Estate, on Maltby Street – teams became beholden to local authorities to create tracks in parks or on open spaces. A new generation of older riders with better bicycles also changed the character of the sport.

But even they could not defy the most damaging trend, and that was the diminishing popularity of speedway itself.

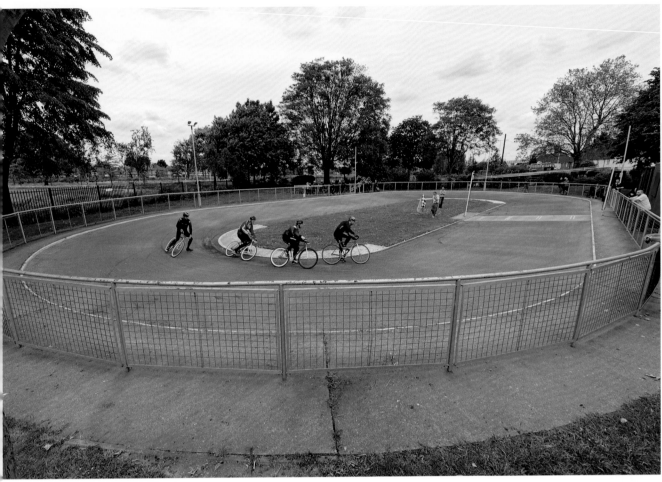

▲ In **Canning Town Recreation Ground**, Prince Regent Lane, this is the capital's last functioning cycle speedway track, home of the **East London Cycle Speedway Club**.

By a random quirk of fate it lies barely 200 yards from the site of the West Ham greyhound and speedway stadium, where so many east London 'skid kids' were inspired to emulate their heroes.

Adjacent to the track is also the site of a former 1930s lido (*see page 158*), yet another casualty of shifting recreational trends.

On the plus side, of the 38 or so cycle speedway tracks still operating in Britain, Canning Town is one of the best. Measuring 74m in length and with a slightly banked surface of 'quarter inch dust shale' imported from Scotland, it was laid out in 1985 by the London Docklands Development Corporation to replace the tracks of the Bow Monarchs at Three Mills and the Newham Rebels at Little Ilford Park. At that time there were still around 15 clubs competing in a London League, some attracting crowds of 500 or more to local derbies. One of the most popular was a track laid in 1955 in Garratt Park, Wandsworth. Home at various times to the Tooting Tigers, South London Rangers (whose president was Winifred Atwell) and most recently the Wimbledon Rangers, it still exists but has not staged racing since the 1990s.

Other late 20th century tracks, such as on Well Street Common, Hackney, and at the Welsh Harp, Hendon, have meanwhile been grassed over, meaning that today, the East London club's nearest rivals are in Ipswich.

Given the revival in popularity of various other forms of cycling

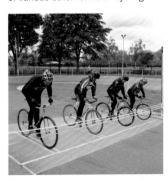

in modern Britain, as witnessed at east London's new Olympic Velodrome and Velopark, two miles to the west, it seems baffling that cycle speedway has not also enjoyed a resurgence.

One factor may be that the sport is surprisingly rough and tumble, with a good deal of jostling taking place between the four riders who, like their motorised counterparts, complete four circuits of the track in each race. Furthermore, it requires considerable strength and stamina to be able to sprint in short bursts, on bicycles that have no brakes and only one gear.

In common with speedway, the more concern there is for the future of cycle speedway, the more treasured its heritage becomes. Charting its journey from 1940s bombsites to 21st century websites, there exists a plethora of publications, forums and, among the veterans' association, a camaraderie that matches any other sport in its intensity.

But will all this goodwill be enough to save the sport in the city which gave it life?

From the National Speedway Museum, a bib from one of London's most successful cycle speedway teams of the 1950s.

Chapter Thirty Two

Conclusions

Why are there so many trainers dangling from a tree next to the skateboard park at Kings Field in Hampton Wick? Is it because skateboarders need somewhere handy to discard their old ones, or is it anti-social behaviour with a twist, like the recent fad for locking padlocks to bridges? Perhaps the shoe tree is a piece of guerilla art? Or maybe, like skateboarding itself, it is just another craze imported from the USA, where the tossing of old shoes onto overhead wires and trees has become enough of a phenomenon for it to have its own name, 'shoefiti'? Throughout the ages footwear has been invested with all manner of cultural meanings. So will future generations of skateboarders see the Kings Field tree as part of their heritage? Or will the world move on and this become just another footnote in history?

Along with every other aspect of cultural life in the capital, more than ever sport finds itself caught between the past and the future. How can London maintain its status as a world leader, as demonstrated so powerfully during the 2012 Olympics, and yet hang on to the very sportscapes and traditions that have given the city so much of its appeal in the first place?

Having sought in this book to establish the central role played by sport in the cultural life and fabric of London, and hopefully to have met Joseph Strutt's avowed aim to have been at least illuminating in the process, how might *Played in London* meet Strutt's other requirement, namely that its contents also be deemed useful?

Heritage protection

Can more be done to protect the built heritage of sport and recreation? Certainly it is true that in the early years of the conservation movement there was little appreciation of sport's place in the historic environment. Starting in 1952 with the listing of the real tennis court at Hampton Court, by 1990 only 20 sports-related buildings and structures in the London area had been listed.

Since 1990 that number has grown to 70 (as of March 2014), at 59 different locations, 33 of them relating to swimming. Of this total, 41 remain in use for sport.

Alone, these figures surely confirm that the field of sports and recreation has at last come to receive its due vigilance.

As illustrated by the demolition of the once listed entrance block and twin towers at Wembley Stadium in 2003, listing *per se* is not an absolute guarantee against loss. But in the last 25 years statutory protection has without doubt helped save a number of the buildings that would otherwise almost certainly have been lost in the capital.

Heritage protection has also, in the last decade or so, started to prove effective in making sure that, in the event of operators closing an historic venue for commercial reasons, the dignity of the listed structure or structures and their sporting context have at least been honoured in subsequent developments. Examples of this include the grandstands at Arsenal's Highbury stadium and the Tote board at Walthamstow Greyhound Stadium, in both instances the buildings finding new life as components in residential developments.

Inevitably for many sports fans this approach may not fully compensate for the losses. But it represents a considerable advance on previous decades when so many former sites were redeveloped in their entirety with, at best, only a plaque or street name marking the spot.

Are there any historic sports buildings in London that merit protection but which have yet to gain it? As a result of the research conducted for *Played in London*, five more buildings and structures have been listed since 2012, with a further three yet to be evaluated,

one of which is the Rom Skatepark in Hornchurch, dating from 1978 (*see page 153*).

Of course it is always possible that buildings do slip through the net. But bearing in mind that currently the 'youngest' sports related building to have been listed in London is the Pools on the Park in Richmond, completed in 1966, future contenders are more likely to date from the latter decades of the 20th century.

There would certainly be a lively debate should, for example, the Brixton Rec (*page 185*), opened in 1984, be put forward.

In the meantime, news of all listings relating to sport and recreation, both winners and losers, will be relayed via the *Played in Britain* website.

Protection for non-listed sites

One common characteristic of sportscapes is that whilst their associated buildings may in themselves not be of any architectural or historical merit, the ground itself, or its context, may be of significance.

Locations such as Richmond Green and Mitcham Green, where cricket has been played for over three hundred years, already enjoy a high level of protection in their own right. Each is designated as Metropolitan Open Land, each falls within a Conservation Area and each is registered as a village green under the Commons Act (the latest version of which dates from 2006).

An open space can be registered as a 'village green' if it can be

Much has changed since Old Father Time was gifted to the MCC by architect Herbert Baker in 1926, and not only in the architectural composition of Lord's. As social values shift, who dares predict which aspects of sporting heritage will be held dear in the future. Even the MCC had to bend to the times in 1998 by admitting women as members. Will Old Mother Time yet have her say?

demonstrated that a significant number of local inhabitants 'have indulged as of right in lawful sports and pastimes on the land for a period of at least 20 years'.

As such, around sixty greens in London have been registered, of which around half stage formal games (mostly cricket).

But what of grounds, enclosed or otherwise, that are in private ownership and which, in the heated cauldron of London's current property market, may be vulnerable to development?

Planning law already offers a certain measure of protection for private open spaces.

In addition, in 2011 the Localism Act introduced the notion of an 'Asset of Community Value' (ACV).

An ACV might be a site (such as a bowling green) or a building (such as a swimming pool or a pub) that is deemed to 'further the social wellbeing or social interests of the local community'.

If the owner of the property decides to sell the freehold or lease hold of an ACV, the Act gives the community six months to come up with its own plan to put in a bid.

There are a number of caveats to this provision. For example ACV status lasts only five years. But ACV status does at least offer a possible extra layer of protection, and as such has been applied for successfully by a number of parties in London seeking to secure the future of their grounds and open spaces. Sites with ACV status so far include Champion Hill (home of Dulwich Hamlet FC), Underhill (Barnet Cricket Club), and at the professional level, The Valley (home to Charlton Athletic).

In an unusual twist, residents in Dartmouth Park have gained ACV status for an open space that has been threatened with development by the sports club which owns it, the Mansfield Bowling Club.

As noted in Chapter 15, ACV status has also been secured by skateboarders for the undercroft of the Southbank Centre.

One avenue of protection that has so far not been extended to sports grounds *per se*, in London or anywhere in England, is that of being added to the Register of Historic Parks and Gardens.

Just over 150 sites in the capital are on the Register, including several that happen to have sports facilities within their boundaries,

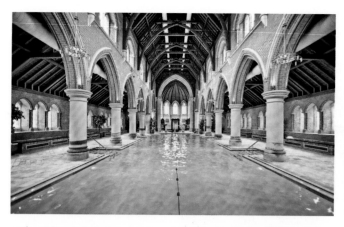

such as Victoria Park, Brockwell Park and West Ham Park, plus Wanstead Park, which contains a golf course. But could there be a case for the inclusion, for example, of the Artillery Garden, London's oldest enclosed sports ground, or the green of the Barnes Bowling Club, in use since at least the early 19th century?

Under the current criteria it would appear unlikely, and in any case both spaces fall within Conservation Areas. But again the issue of eligibility for historic sportscapes – golf courses being another oft-cited category – will no doubt continue to be debated.

Sporting culture at risk

In the same way that English Heritage maintains a Heritage at Risk Register for endangered buildings (*see right*), updated every year, if there were such a thing as a 'Sports at Risk Register', which sports, or aspects of sporting life as we know it today, might be worthy of inclusion?

There are those, for example, who fear greatly that outdoor flat green bowling may not survive in London other than at a casual level, without an infusion of interest from younger players.

Golfers in the capital, as we noted in Chapter 21, are equally concerned that as more individuals opt to 'pay and play' rather than to seek active engagement as members, the traditional club ethos, both at a competiton and a social level, is increasingly at risk.

In team sports, a particular area of concern is the long term effect of rising costs, most especially the rising costs of pitch hire. Faced in some instances with cuts of up to 60 per cent of their budgets, local authorities have not only had to put up hire charges, they have »

▲ Between the year 2002, when research for the *Played in Britain* series began, and 2012, when the effects of public spending cuts started to bite, historic swimming pools and lidos in nine London boroughs were rescued from the brink, a level of restoration and commitment that already, writing in 2014, seems like a long time ago.

During those years the capital even gained an historic pool, of sorts, thanks to the unusual and rather splendid conversion of the chapel at **Claybury Hospital** in **Woodford Green** (a Grade II former asylum by GT Hine), into what is now a Virgin Active Health Club.

All over Britain historic baths have been converted to a variety of non-sporting uses, such as theatres or faith centres. Woodford Green shows that the pendulum can swing the other way too.

Countering the success stories, London's overall stock of historic sports related buildings nevertheless continues to diminish.

Streatham Ice Rink on **Streatham High Road** (*above right*), designed by the cinema specialist Robert Cromie and opened in 1931, was demolished in 2011 to make way for a superstore and flats.

A few doors down, Streatham Baths, dating from 1928, was also demolished, one of six historic baths to have been lost in the capital since 2000.

Once again however, London's wealth has told, because all six have been replaced, most co-funded by residential developments. In Streatham's case, a £26 million leisure centre opened on the site of the old baths in 2013. Two stained glass windows from the original pool have been incorporated into its 25m successor, which, uniquely in Britain, has, on the floor above, the replacement ice rink

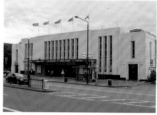

(an Olympic sized pad with 1,000 seats, home now to the **Streatham Redskins** ice hockey team).

By its entrance are mounted three of the 'Snowcrete' decorative panels that had adorned the exterior of the original ice rink (*top*).

Another landmark building from the 1930s also now destined for demolition is the **Earls Court Exhibition Centre** (*below*). Opened in 1937 with a vast swimming pool under a moveable floor, Earls Court hosted action in both the 1948 and 2012 Olympics. Its full story can be found in a sister publication, *Great Lengths* (*see Links*).

Meanwhile the futures of three other historic baths listed on the Heritage at Risk register for 2013, at Ladywell, Haggerston and Poplar, remain in the balance, each currently subject to development proposals.

In recent years both Kentish Town baths and the National Sports Centre at Crystal Palace have been removed from the Register. There is always hope.

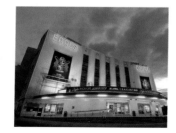

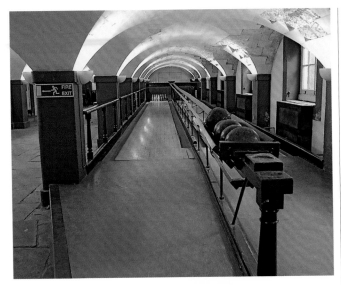

▲ London's first tenpin bowling alley of the modern era opened in Stamford Hill in 1960. However the original non-mechanised version of the game was an earlier import. Vauxhall Gardens had an American Bowling Alley in 1849. There was another on the Strand, with a bar serving American drinks and cigars. Sandringham had one too, installed by the Prince of Wales in c.1870.

None of these survive, but three other double alleys do; at a pub near Edinburgh, dating from 1882, at the Moorpool Skittles Club in Birmingham, laid in 1913, and this one, in the former morgue of Christopher Wren's **Royal Hospital for Seamen** at **Greenwich.**

Built in c.1865 for the amusement of retired seamen, it was made from the timbers of old ships broken up at Deptford, with *lignum vitae* balls said originally to have been practice cannonballs.

The alley continued in use after the buildings were taken over by the **Royal Naval College**, but since this closed in 1997 it is used mainly by the more adventurous members of tour parties (whose first realisation on being invited to have a go is usually just how hard it is to propel

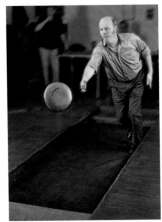

a heavy ball which has no finger holes, as is the modern way).

In **Old English Skittles** (as it was known to distinguish it from variants in the West Country and East Midlands), instead of rolling a ball at ten pins, participants throw a *lignum vitae* 'cheese' at nine pins.

Dozens of London pubs and clubs had alleys of this type in the early 20th century. They competed for the **Dewar Challenge Shield**, won by Barnes in 1931 (*left*).

But now only one Old English alley remains, at the **Freemasons Arms** in **Hampstead** (*above*).

In Greenwich, even if no-one plays, the American alley will survive, as part of the listed building's fittings. But at the Freemasons its regulars know they must hang on, or else the alley, and therefore the game, will disappear.

You can read more about Old English Skittles in *Played at the Pub* (see Links). Even better, have a go yourself on Tuesday nights, 8-11pm. Tell them that *Played in Britain* sent you.

also cut back on maintenance, resulting in fewer pitches being available, particularly in winter.

In football alone, Sport England reports that the number of 16 year olds and over playing the game has gone down from 2.02m to 1.84m since 2005. Undoubtedly other factors have contributed to this fall, but during a period of economic hardship, the mounting costs of simply playing the game cannot help but affect numbers.

So while football itself is patently not endangered – five-a-side centres are booming in the capital – serious concerns exist for the future of the traditional eleven-a-side game played on a full sized natural pitch. The same concerns also exist in the world of cricket.

Football and cricket are, of course, two of our most popular, and longest established team games. Yet most senior football clubs in London, Chelsea, Arsenal and Tottenham especially, regularly field teams with few, and sometimes even no English players at all, let alone Londoners.

This lack of homegrown talent emerging is even more evident during Wimbledon fortnight.

And so to our hypothetical Sports at Risk Register, might we also need to add the high achieving sporting Londoner?

Club archives

The recents losses of priceless archives at Brentham Bowling Club (owing to a fire) and at the Manor Club in Merton Park (owing to misfortune) highlight an issue that plagues club sport in all parts of the country.

All too often, with no malice intended, important documents are left exposed, or stored in damp conditions. Or are simply thrown away by mistake or even 'borrowed' and then broken up and sold on the private market.

That is why, with respect, *Played in Britain* continues to advise clubs that archives need to be curated by a responsible person and in a safe and secure manner.

If this is not possible, the archives should be copied, and the originals deposited with an appropriate third party, such as the London Metropolitan Archives, the local studies department of the relevant borough, or a library, institute or university with a particular interest in that sport or

area of London (as was the case with the records of the Eton Manor Boys Club in Hackney Wick, now in the safe keeping of the Bishopsgate Institute).

But this issue leads on to another, wider concern, and that is the future capacity of local studies departments in most London boroughs at a time of stringent cuts in local authority spending.

Suffice it to say that without their resources and knowledge, this book, and indeed most books touching on local history, would be much the poorer.

The internet is a magnificent gateway. *Played in Britain* would suffer greatly without it. But it cannot and never will be able to replace local archivists, with their decades of accumulated experience and personal contacts.

The concern then is that the ongoing collection and preservation of those vital components of sporting history, not only of club archives but of those random bits of everyday ephemera that do so much to inform historians, will suffer and even come to a halt, leaving future historians of today's sporting scene largely dependent upon the internet, with all its vagaries, and official, approved sources.

Further research

As readers will be aware, many areas of sporting heritage in the capital have been barely touched upon in this book. Conscious of this, and the above caveat concerning the limitations of the internet notwithstanding, it is hoped that if funding can be secured, other areas of research on sport in London will be added to the *Played in Britain* website (for example on lost ice rinks, roller skating rinks, and former temperance billiard halls).

At the same time it is hoped that partners will come forward to take advantage of the research accumulated by English Heritage and *Played in Britain*. Initiatives might include further mapping of London's historic sportscapes, oral histories of sporting lives, and further research into lost or threatened sporting cultures.

For sure there is no lack of subject matter, and no lack of new material. For in London, the games seldom let up, and history is forever in the making.

▲ Finally, the thorny issue of how London might commemorate the 2012 Olympics and Paralympics.

In February 2012 much worthy applause greeted news that an Olympic Museum was to be created in the Queen Elizabeth Olympic Park, designed to 'celebrate London's unique place in the Olympic Movement as it becomes the first city in the world to host the Olympic Games three times.'

Rather less fanfare followed 17 months later when the plans were quietly shelved.

When it comes to staging Olympic Games, it is true, London has an unrivalled record. But when it comes to commemorating them?

As reported in *The British Olympics* (see Links), concerning the 1908 Games, there is a memorial on the site of the **Great Stadium** in **White City**, now occupied by the **BBC's Media Village**. This was unveiled in 2005, 97 years after the event (*top*).

Near this the location of the stadium's finishing line has also been marked, by an inscription, while around the corner (*below left*), a short back street bears the name of the marathon hero who stumbled across that line, **Dorando Pietri**.

The 1948 Games fared little better. At Wembley Stadium there are the Olympic rolls of honour, and the torch pedestal (*see page 75*).

Also, in south west London is another, unlikely remnant.

When members of the **Malden Rifle and Pistol Club** heard in 1965 that the army huts which formed the athletes' village in Richmond Park were being sold off, they drove over in a van and brought half of one back. Re-erected amongst the allotments on **Alric Avenue**, **New Malden**, the hut has served as their clubhouse ever since (*top right*).

As for 2012, it could be said that London already has five sports museums (*see page 12*), and that there are in any case 75 museums elsewhere in the world with an Olympic theme. Besides which, surely the Games' real legacy consists of the new venues in Stratford and the Lea Valley, and not least, the **Queen Elizabeth Olympic Park** itself.

Plus, cast in steel on Alfred's Meadow in the midst of the park, a set of Olympic rings – the only ones allowed to remain in London post 2012 by the IOC – make a perfect backdrop for family group shots.

Not to mention all the artworks kept on after the Games, such as Monica Bonvicini's RUN (*below left*), outside the Copper Box, and all those golden postboxes dotted around the nation (*page 11*).

Or perhaps the single most powerful embodiment of Olympic heritage is the **Great British Garden** next to the stadium (*right*), where amidst the winding paths and canalside walks stands an oak tree. This was grown from an acorn taken from the oak planted by **Pierre de Coubertin** in Much Wenlock in 1890, during the visit that was to prove such a turning point in modern Olympic history.

Maybe, compared with how other former Olympic venues have been left, for example in Athens and Beijing, London has got this right after all. A park and a garden, not a museum. An oak and an artwork, not a plaque.

Of course in another 50 years, maybe someone will decide that

a museum would, after all, serve a useful purpose, because names like Jessica Ennis and Mo Farah have been all but forgotten.

But for now they are not, and while the wildflowers and lawns take root in London's newest open space, this being the capital, there is always something new to look forward to on the sporting horizon.

So, London 2012. Damn fine show and all that, but, what's next?

Links

Note: Where no publisher listed assume self-published by organisation or author
Where no publication date listed assume published on final date within title, ie.
1860–1960 means published 1960

London general
Heritage at Risk Register English Heritage (2013)
Abercrombie P & Forshaw JH *The County of London Plan* (1943)
Abercrombie P, Stephenson G, Shepheard P *The Greater London Plan* (1944)
Barker F & Jackson P *The Pleasures of London* London Topographical Society (2008)
Dickens C Jnr *Dickens's Dictionary of London* C Dickens & Evans (1879)
Fletcher B *The London Building Acts* BT Batsford (various editions 1894-1914)
Harvey AD *London's Boroughs* History Today Vol 49 (July 7 1999)
Hibbert C & Weinreb B *The London Encyclopedia* Macmillan (2008)
Hone W *The Everyday Book* William Tegg (1826)
Horrall A *Popular Culture in London c.1890-1918* Manchester Univ Press (2001)
Hyde R *The A-Z of Georgian London* Harrry Margary/Guildhall Library (1981)
Hyde R *The A-Z of Victorian London* Harry Margary/Guildhall Library (1987)
Inwood S *A History of London* Macmillan (1998)
Mitchell RJ & Leys MDR *A History of London Life* Pelican (1964)
Morley H *Memoirs of Bartholomew Fair* Chatto & Windus (1880)
Pevsner Architectural Guides: Buildings of England Yale University Press
 London Vol 1 City of London Bradley S (1997)
 London Vol 2 South Cherry B (1983)
 London Vol 3 North West Cherry B, Pevsner N (1991)
 London Vol 4 , North Cherry B, Pevsner N (1998)
 London Vol 5 East Cherry B, O'Brien C and Pevsner N (2005)
 London Vol 6 Westminster Bradley S, Pevsner N (2003)
Prockter A & Taylor R *The A-Z of Elizabethan London* Margary/Guildhall (1979)
Rasmussen SE *London: The Unique City* Pelican Books (1960)
Saint A (ed) *The Survey of London Vols 1–50* English Heritage/Yale University Press
 (various dates 1900-2013) see also www.british-history.ac.uk
Saunders A & Port MH *A-Z of Edwardian London* Harry Margary (2007)
Saussure C de & Mme Van Muyden *A Foreign View of England in the Reigns of
 George I and II* Ed Dutton & Co (1902)
Shelley HC *Inns and Taverns of Old London* LC Page & Co (1909)
Smith JE *Parochial Memorials: St John the Evangelist Westminster* Whiteman (1892)
Stow J *The Survey of London* (1598) various editions
Taine H *Notes on England* H Holt & Co New York (1876)
Thornbury W and Walford E *Old and New London: Vols 1-6* Cassell (1878)
Victoria County History series: various vols covering Essex, Kent, Middlesex, and
 Surrey (1902-2004) see www.british-history.ac.uk
Welch C *History of The Tower Bridge and of the other bridges built by the
 Corporation of London, including an account of the Bridge House Trust from
 the Twelfth Century* Smith, Elder and Co. (1894)
Whitfield P *London: A Life in Maps* British Library (2006)
Williams WB *The Amusements of Old London* Muller (1901)
Wisdom J & Laxton P *A-Z of Regency London* Margary/Guildhall (1985)

Sport general
Arlott J *The Oxford Companion to Sports and Games* Oxford University Press (1976)
Chaplin P *Darts in England 1900–39: A Social History* Manchester Univ Press (2009)
Griffin E *England's Revelry: A History of Popular Sports and Pastimes 1660-1830*
 British Academy/Oxford University Press (2005)
Henricks TS *Disputed Pleasures: Sport and Society in Preindustrial England*
 Greenwood Press (1991)
Hill J, Moore K & Wood J *Sport, History and Heritage: Studies in Public
 Representation* Boydell Press (2012)
Holt R *Sport and the British* Oxford University Press (1990)
Polley M *The British Olympics, Britain's Olympic Heritage 1612-2012*
 English Heritage (2011)

Polley M *Sports History: A Practical Guide* Palgrave (2007)
Strutt J *The Sports and Pastimes of the People of England* Methuen (1801)

London areas and London sport general
Bacon's Map of the Environs of London, showing Sports Clubs GW Bacon (1939)
Official Report of the Organising Committee for the XIV Olympiad
 Organising Committee for the XwwIV Olympiad (1948)
*Old Deer Park; being a history of the royal and ancient park, and of the well-known
 sporting clubs associated with it* Richmond Cricket Club (1951)
Sporting Chelsea: A Story of People, Places and Sports in Chelsea Chelsea History
 Society (2004)
Sports, Pastimes and Customs of London, Ancient and Modern Cradock & Co (1847)
The Story of Clapham Common Clapham Society (1995)
Astley JD *Fifty Years of My Life in the World of Sport* Hurst & Blackett (1894)
Baker K *The 1908 Olympics* SportsBooks (2008)
Boulton WB *The amusements of old London* Vols 1 & 2 Nimmo (1901)
Browner JA *Wrong Side of the River: London's disreputable South Bank in the 16th
 and 17th century* Essays in History Vol 36 University of Virginia (1994)
Clarke J *The Way to White City* English Heritage (2001)
Clegg G *Duke's Meadows; the threats to its rural survival* Brentford & Chiswick Local
 History Journal No 16 (2007)
Cook T *Official Report of the Olympic Games in 1908* British Olympic Council (1908)
Cromwell T *History and description of the Parish of Clerkenwell* Longman (1828)
Evans B *Romford, Collier Row and Gidea Park* Phillimore (1994)
Feret CJ *Fulham Old and New* Vol 2 Leadenhall (1900)
Flanagan R *West Norwood Cemetery's Sportsmen* Friends of WNC (1995)
Glanfield J *Earl's Court and Olympia* Sutton (2003)
Hampton J *The Austerity Olympics: When the Games Came to London in 1948*
 Aurum (2008)
Hedgcock M *Sport in Twickenham* Borough of Twickenham Local History Soc (2012)
Hodges NJM *Old Deer Park Study: Conservation Area No 57*
 Richmond-upon-Thames (1990)
Jenkins R *The First London Olympics 1908* Piatkus (2008)
Knight D *The Exhibitions, Great White City 1908–1978* Barnard & Westwood (1978)
Manley B *Islington Entertained* Islington Libraries (1990)
Milward R *Wimbledon Two Hundred Years Ago* Milward Press (1996)
Peake RB *Snobson's Seasons: being annals of cockney sport* MA Nuttali (1833)
Petrie N *Hendon and Golders Green Past* Historical Publications (2005)
Tames R *Sporting London: A Race Through Time* Historical Publications (2005)
Stevens Curl J *Spas, Wells & Pleasure Gardens of London* Historical Publications (2010)
Tanner LE *Westminster School: Its Buildings and their Associations* PE Allen (1923)
Tayerman C *A History of Harrow School* Oxford University Press (2000)
Wadsworth C *Brent Stadiums, Swimming Baths and Skating Rinks* Willesden Local
 History Society (2007)
Wilkie K *Old Deer Park, Richmond: Landscape Strategy* Crown Estate (1999)
Winter A *They Made Today: a history of the 100 years of the Polytechnic Sports
 Clubs and Societies* Vols 1-4 University of Westminster Archives (1976-80)

Chapter 1. Played in London
Kempton Park 1878-1978 United Racecourses (1978)
The Youngest County, a description of London as a county and its public services
 London County Council (1951)
Bateman N *Gladiators at the Guildhall* Mus of London Archaeology Service (2000)
Bateman N, Cowan C & Wroe-Brown R *London's Roman Amphitheatre* Museum of
 London Archaeology Service, Monograph 35 (2008)
Beavis J *The Croydon Races* Local History Publications (1999)
Brooks C *Burying Tom Sayers: Heroism, Class and the Victorian Cemetery*
 Victorian Society Annual (1989)
Brown JW *Streatham Races* Local History Publications (1990)
Connell JA & Willats E *The Royal Agricultural Hall* Islington Libraries (1973)

Creighton S *The Edwardian Roller Skating Boom* British Soc of Spts History 11 (1991)

Egan P *Book of Sports* Tegg (1832)

Egan P *Boxiana, or, Sketches of ancient and modern pugilism* (1812) facsimile edition Vance Harvey (1971)

Fitzstephen W *Norman London* (c.1170s) facsimile edition Italica Press (1990)

Gilbey W *Sport in the Olden Times* Vinton (1912)

Green HJM & Thurley Dr SJ *Excavations on the West Side of Whitehall 1960-2 Part 1* London & Middlesex Archaeological Society Transactions Vol 38 (1987)

Howells MK *The Romance of Hockey's History* Teddington Hockey Club (1996)

Huggins M *Reading the Funeral Rite: A Cultural Analysis of the Funeral Ceremonials and Burial of Selected Leading Sportsmen in Victorian England, 1864-88* Journal of Sport History, Vol 38, No 3

Johnes M & Taylor M (eds) *Boxing History and Culture* Sport in History Vol 31 No 4 (2011)

Malcolmson RW *Popular Recreations in English Society 1700-1850* Cambridge University Press (1973)

Pitt C *A Long Time Gone* Portway Press (2007)

Pout R *The Early Years of English Roller Hockey 1885-1914* (1993)

St Aubyn F *Ackermann's Illustrated London* Arrowhead (1985)

Seddon J *Queen Elizabeth's Hunting Lodge: a brief history* Corp of London (2003)

Simpson S *Sir Henry Lee: Elizabethan Courtier Gentleman* PhD thesis on Elizabethan Tournaments Southampton University (2008)

Thurley S *The Lost Palace of Whitehall* RIBA (1998)

Young A *Tudor and Jacobean Tournaments* George Philip (1987)

www.londonexboxers.org.uk

Chapter 2. Open space

Down with the Fences! Battles for the Commons in South London Past Tense (2004)

Green Spaces: The Benefits for London Corp of London and BOP Consulting (2013)

Ilford Golf Club, the story of a club that refused to die (2007)

King George's Fields Foundation: Final Report KGFF (1965)

LCC Parks Department records 1892-1965 London Metropolitan Archives holdings

Bale J *Sports Geography* Taylor & Francis (2003)

Brett Young T (ed) *The Six Acre Standard - Minimum Standards for Outdoor Playing Space* National Playing Fields Association (1992)

Carrington R *Alexandra Park & Palace, A History* GLC (1975)

Cecil E *London Parks and Gardens* Dutton (1907)

Chadwick GF *The Park and the Town* Architectural Press (1966)

Cline R *Regent's Park and Primrose Hill* Westminster Local Studies (April 1991)

Conway H *People's Parks* Cambridge University Press (1991)

Gay K *Palace on the Hill* Hornsey Historical Society (2005)

Greenhalgh L, Worpole K (eds) *Park Life - Urban Parks and Social Renewal* Comedia in association with Demos (1995)

Harris J *Alexandra Palace, a hidden history* Tempus (2005)

Hewlett G *Welsh Harp Reservoir Through Time* Amberley Publishing (2011)

Holman B *Good Old George: the life of George Lansbury* Lion Publishing (1990)

Nisbet J *Story of the One Tree Hill Agitation* Honor Oak Hill Protest Committee (1905)

Peters HW deB *London Playing Fields Society Centenary History 1890-1990* LPFS

Rhind N *The Heath* Bookshop Blackheath (2002)

Rhind N & Marshall R *Walking the Heath* The Blackheath Society (2013)

Ruck SK *Municipal Entertainment & The Arts in G'tr London* Allen & Unwin (1965)

Sexby JJ *The Municipal Parks, Gardens & Open Spaces of London* Eliot Stock (1898)

Stuart Sir Campbell *Memorial to a King* Batchworth Press (1954)

Weindling D *The Fight for Fortune Green* Camden History Review No 10 (1982)

Whipham T *The Battle for Paddington Recreation Ground* in Norton H (ed) *Glimpses into the Past: Paddington, Little Venice and Maida Vale Over the Years* PWMVS Local History Group (2005)

Winterman MA *Croydon's Parks, an illustrated history* LB Croydon (1988)

www.fieldsintrust.org

www.londongardensonline.org.uk

http://lpff.org.uk (London Playing Fields Foundation)

www.oss.org.uk (Open Spaces Society)

www.parksandgardens.org

Chapter 3. River Thames

Ackroyd P *Thames: Sacred River* Chatto & Windus (2007)

Carter E *A History of Furnivall Sculling Club 1896-2004* Elmore Press (2006)

Chaplin PH *The Thames from Source to Tideway* Whittet Books (1998)

Clasper D *Harry Clasper, Hero of the North* Gateshead Books (1990)

Crouch RG *The Coat* Trafford Publishing (2005)

Dickens C Jnr *Dickens's Dictionary of the Thames* Macmillan (1883)

Dodd C *Water Boiling Aft, London Rowing Club the first 150 years 1856-2006*

Dodd C & Marks J (eds) *Battle of the Blues, the Oxford and Cambridge Boat Race from 1829* PtoM (2004)

Herbert J *London Corinthian Sailing Club Centenary History 1894-1994*

Holford I *A Century of Sailing on the Thames* Thames Sailing Club (1968)

Osborne K *Boat Racing in Britain 1715-1975* Amateur Rowing Association (1975)

Page G *Hear the Boat Sing, the history of Thames Rowing Club and Tideway rowing* Kingswood Press (1991)

Pearson L *Played in Tyne and Wear* English Heritage (2010)

Philp IE *History of the Thames Watermen* Guildhall Historical Assoc lecture (1957)

Phillips-Birt D *The Cumberland Fleet, Two Hundred Years of Yachting 1775-1975* Royal Thames Yacht Club (1978)

Ritchie B *The History of Tamesis Club* (2002)

Rivington R *Punts and Punting* Oxford (1983)

Rowe RPP & Pitman CM *Badminton Library: Rowing* Longmans, Green & Co (1898)

Ruddle A *Given the expansion of London during the second half of the 19th century, and the changes in patterns of leisure, to what extent did rowing on the Thames Tideway evolve in response?* Open University MA History thesis (2000)

Sampson A *Winning Waters, the Homes of Rowing* Robert Hale (1986)

Schneer J *The Thames, England's River* Abacus (2006)

Ward Capt AR *The Chronicles of the Royal Thames Yacht Club* Fernhurst (1999)

Wells HB *Vesta Rowing Club, a centenary history* (1969)

Woodhead P *The Yacht Club, Greenwich 1908-2000* Crown Int News (2000)

www.doggettsrace.org.uk

www.traditionalrowing.com

http://hear-the-boat-sing.blogspot.co.uk

Chapter 4. Crystal Palace Park

Crystal Palace Foundation News (various)

New Crystal Palace Matters; The Journal of the Crystal Palace Foundation (various)

Bevan I, Hibberd S & Gilbert M *To Palace for the Cup* Replay Publishing (1999)

Chaddock SEB & Feuerstein D *Crystal Palace Park Conservation Plan* for LDA (2004)

Collins SS *Motor Racing at Crystal Palace: London's Own Circuit* Veloce (2005)

Gordon I & Inglis S *Great Lengths, the historic indoor swimming pools of Britain* English Heritage (2009)

Jacobs N *Crystal Palace Speedway: A History of the Glaziers* Fonthill Media (2012)

Latz+Partner & Meadowcroft Griffin *Crystal Palace Park Masterplan* for LDA (2007)

Milton H *Cricket Grounds of Kent* Association of Cricket Statisticians (1992)

Parfitt P *Racing at Crystal Palace: London's Own Motor Racing Circuit, 1927-72* Motor Racing Publications (1991)

Pearce B *Cricket at the Crystal Palace: WG Grace and the London CCC* (2004)

Chapter 5. Wembley Park

British Empire Exhibition 1924: handbook of general information BEE (1924)

The British Empire Exhibition Fleetwood Press (1925)

Wembley 1923-1973, the Official Wembley Story of 50 years Wembley (1973)

Bass H *Glorious Wembley* Guiness Superlatives (1982)

Cottam D *Sir Owen Williams 1890-1969* Architectural Association (1986)

Foster N & Inglis S *Wembley Stadium* Foster + Partners / Prestel Publishing (2012)

Hewlett G (ed) *A History of Wembley* Brent Library Services (1979)

Knight DR & Sabey AD *The Lion Roars at Wembley: British Empire Exhibition 60th anniversary* Barnes & Westwood (1984)

Low AM *Wonderful Wembley* Stanley Paul & Co (1953)

Sabey A *Remains of the British Empire Exhibition* www.postcard.co.uk/esg/remains.htm

Tomsett P & Brand C *Wembley, Stadium of Legends* Dewi Lewis Media (2007)

Watt T & Palmer K *Wembley, The Greatest Stage* Simon & Schuster (1998)

Chapter 6. Lea Valley

A Lea Valley Regional Park: an essay in the use of neglected land for recreation and leisure Civic Trust (1964)

Lee Valley Regional Park Authority 10th anniversary brochure 1967-77 LVRPA

Park Development Framework: Area Proposals for Lee Valley Regional Park LVRPA (2011)

Abrahams T *The Stadium* Machine Books (2012)

Barson S & Lewis J *London's Lea Valley, the Olympic Park Story* English Heritage leaflet (2012)

Chadwick GF *The Park and the Town* Architectural Press (1966)

Crump A *A History of Amateur Rowing on the River Lee* (1913)

Donoughue B & Jones GW *Herbert Morrison, Portrait of a Politician* Weidenfeld (1973)

Dower M *The Challenge of Leisure* The Architects' Journal (January 20 1965)
Dyckhoff T & Barrett C *The Architecture of London 2012* Wiley (2012)
Elks L *Lee Valley: time for a re-think* Lee Valley Association (1980)
Elks L *Lee Valley Regional Park: a historical perspective* Hackney History Vol 14 (2008)
Fraser N *Over the Border: The Other East End* Function Books (2012)
Heard P *The First 100 Years of the Old Parmiterians FC 1898-1998*
Hillman E (ed) *Essays in Local Government Enterprise Vol 2* Merlin Press (1965)
Johansen M *Adventures in the Wild East: The Early Years of the Eton Manor Boys' Clubs* Villiers Park Educational Trust (2008)
Kerrigan C *Football Missionaries at Hackney Wick 1880-1913* Hackney History Vol 6 (2000)
Lewis J *From Eton Manor to the Olympics* Libri Publishing (2010)
Lewis J *London's Lea Valley* Phillimore (1999)
Protz C *Tottenham: A History* Phillimore (2009)
Saint A (ed) *Politics and the People of London: LCC 1889-1965* Hambledon (1989)
Shearman L *The Lee Valley Regional Park* in Hillman E (ed) *Essays in Local Government Enterprise* Vol 2 Merlin Press (1965)
Sinclair I *Ghost Milk: Calling Time on the Grand Project* Penguin (2012)
www.bishopsgate.org.uk (Eton Manor archive)
www.leavalleyfederation.org
www.leevalleypark.org.uk
www.villierspark.org.uk

Chapter 7. Dulwich

Dulwich Cricket Club Centenary History 1867-1967
Dulwich Park 1888-1988 Southwark Council leaflet (1988)
Blundell NH *Old Alleynian RFC, 1891-1948* Dulwich College (1950)
Brennand T *Dulwich and Sydenham Hill: centenary history 1894-1994*
Green B *Dulwich, a History* College Press (2002)
Green B *The Decline and Fall of Farming in Dulwich* Dulwich Society Journal (2012)
www.dulwichestate.co.uk
www.dulwich.org.uk (Dulwich College)
www.dulwichsociety.com
www.ideal-homes.org.uk (a history of south east London suburbs)

Chapter 8. Westway

40 Years As An Asset To Our Community 1971-2011 Westway Development Trust
Clack J *Something's in the Air* www.umbrellamagazine.co.uk 4 (August 2011)
Duncan A *Taking on the Motorway: North Kensington Amenity Trust 21 Years* Kensington and Chelsea Community History Group (1991)
www.westway.org

Chapter 9. Pavilions

Pavilions and Clubhouses Design Guidance Note, Sport England (1999)
Records of George Brettle and Company Limited, hosiery manufacturers of Belper, Derbyshire, 1799-1984 University of Nottingham
Gerrie PA *From Quill to Computer: a History of the Royal Toxophilite Society* (2006)
Sudell R & Waters DT *Sports Buildings and Playing Fields* Batsford (1957)
Webster FAM *Sports Grounds and Buildings* Pitman (1940)

Chapter 10. Grandstands

Finchley Urban District Council Minutes 1928-31 Barnet Local Studies & Archives
UCS Old Boys RFC Centenary Season Centenary souvenir magazine (1992)
Bill ER *Racecourse Stands* The Architects' Journal (August 3 1927)
Faber J *Oscar Faber, his work, his firm & afterwards* Quiller Press (1989)
Inglis S *Engineering Archie* English Heritage (2005)
Jayne L *Pony Racing* Hutchinson's Library of Sports and Pastimes (1949)
John G, Sheard R & Vickery B *Stadia - a Design and Development Guide* Architectural Press (2007)
Keene CH *Northolt Park Racecourse and the Racecourse Estate* Northolt Archaeological Historical Research Group (Report February 1980)
Richards CR *Racing Under Pony Turf Club Rules - a short history of Northolt Park Racecourse 1928-55* (Report September 1994)
Roberts P & Taylor I *Racecourse Architecture* Turnberry Consulting/Acanthus (2013)
Sheard R *Sports Architecture* Spon Press (2001)
Smith J *Liquid Assets, the lidos and open air swimming pools of Britain* English Heritage (2005)
Whiddon H *One Hundred Years of Playing the Game 1874-1974: featuring the history of the Finchley Football Club* Hillside (1974)

Chapter 11. Membership clubs and institutes

Albemarle Report – The Youth Service in England and Wales HMSO (1960)
Baker N *Public Need versus Private Interest: the case of the Hurlingham Club 1945-1948* The London Journal Vol 34 No 2 (July 2009)
Berenger Baron de *Defensive Gymnastics* T Hurst (1835)
Bozeat R *Buildings for Youth* Schoolmaster Publishing (1966)
Clapson M *An Education in Sport* University of Westminster (2012)
Clark P *British Clubs and Societies 1580-1800* Oxford University Press (2000)
Dale TF *Polo, Past and Present* George Newnes (1905)
Darwin B *British Clubs* William Collins (1943)
Dawes F *A Cry From The Streets; the boys club movement in Britain* Wayland (1975)
Dorling Capt T *The Hurlingham Club 1869-1953*
Eagar W McG *Making Men; the history of Boys Clubs and Related Movements in Great Britain* University of London Press (1953)
Hennessy E *A History of Roehampton Club 1901-2001*
Kay J *Maintaining the Traditions of British Sport: The Private Sports Club in the 20th Century* International Journal of the History of Sport Vol 30 No 14 (2013)
Laffaye HA *Polo in Britain: a History* McFarland (2012)
McKelvie R *The Queen's Club Story 1886-1986* Stanley Paul (1986)
Pelham THW *London Working Boys. Past and Present* James Nisbet (1921)
Reid A *Brentham: history of the pioneer garden suburb* Brentham Heritage Soc (2006)
Timbs J *Club Life of London* Richard Bentley (1866)
Vamplew W *Theories and Typologies: A Historical Exploration of the Sports Club in Britain* International Journal of the History of Sport Vol 30 No 14 (2013)
Wroth W *Cremorne and the Later London Gardens* Eliot Stock (1907)

Chapter 12. Company sports clubs

A Guide to Sport and Recreation in the Metropolitan Police Service (2012)
A Hundred Years of Rugby 1886-1986 National Westminster Bank RFC
The First Hundred Years 1866-1966 National Provincial Bank Cricket Club
The Inside Story on Outside Hours Westminster Bank booklet (c.1970)
National Westminster Bank Bowling Club Centenary 1899-1999
Bird P *The First Food Empire: a History of J.Lyons & Co* Phillimore (2000)
Bond AJN & Doughty MOH *The House, A History of the Bank of England Sports Club 1908-1983* (1984)
Dennett L *A Sense of Security: 150 Years of Prudential* Granta Editions (1998)
Gray N & Bishop J (ed) *A Century of Pearl Assurance Cricket Club 1883-1983*
Hedgcock M (ed) *Hand in Hand: Watney's Mortlake World* Barnes and Mortlake History Society (2007)
Hedgcock M *The Sporting Bankers of Roehampton* Lecture to Barnes and Mortlake History Society (March 2008)
Heller M *Sport, Bureaucracies and London Clerks 1880-1939* International Journal of Sport Vol 25 Issue 5 (2008)
Jones SG *Workers at Play: Social and Economic History of Leisure, 1918-39* Routledge (1986)
Roberts D *Midland Bank Cricket Club: a centenary history* Batsford (1970)
Sélincourt H de *Westminster Bank Sports Club* (c.1936)
Watson N *Lloyd's Register, 250 Years of Service* (2010)
Company journals: *The Britannia Quarterly* (Bank of England Printing Works), *Civil Service Sports Journal*, *Ford Times*, *Great Western Railway Magazine*, *Hand in Hand* (Watney's), *The Ibis Magazine* (Prudential), *The Old Lady* (Bank of England), *Searchlight* (Osram), *The Spread Eagle* (Barclays), *Yarns* (Brettle)

Chapter 13. Gymnasiums and drill halls

Sport for all in Converted Buildings Sports Council (1975)
Bourne JM *The East India Company's Military Seminary, Addiscombe 1809-58* Journal of the Society for Army Historical Research Vol 57 (1979)
Gibbs D *The Skinners' Company's School for Girls, Education in Hackney 1890-2010* Skinners' Company (2010)
Goulstone J *The London Gymnastic Institute* Sports History 6 (1985)
MacLaren A *A System of Physical Education, Theoretical and Practical* Clarendon Press (1885)
May J *Madame Bergman Osterberg: Pioneer of Physical Education and Games for Girls and Women* Harrap (1969)
Osborne M *Always Ready, the Drill Halls of Britain's Volunteer Forces* Partizan Press (2006)
Prestidge J *The History of British Gymnastics* Amateur Gymnastic Association (1988)
Todd J *Physical Culture and the Body Beautiful* Mercer University Press (1998)
Vibart Colonel HM *Addiscombe: Its Heroes and Men of Note* Constable (1894)

Chapter 14. Billiard halls

The Billiard Monthly and The Billiard Player (various issues 1914-35)

Clare N Billiards and Snooker Bygones Shire Publications (1985)

Davison A Try the Alternative: the built heritage of the temperance movement
Journal of the Brewery History Society No 123 (Summer 2006)

Girouard M Victorian Pubs Yale University Press (1984)

Mitchell JR Billiards & Snooker, A Trade History British Spts & Allied Industries (1981)

Priestley JB Self-Selected Essays Heinemann (1932)

Taylor A Played at the Pub English Heritage (2009)

www.snookerheritage.co.uk

Chapter 15. Skateparks

Borden I Skateboarding, Space and the City: Architecture and the Body Berg (2001)

Pennell H Skateboarding, London Topics No 24 GLC Intelligence Unit (1978)

www.llsb.com (Long Live Southbank)

www.londonskateparks.co.uk

www.britishskateboardmuseum.i8.com

www.vintageskateboardmagazines.com

Chapter 16. Outdoor swimming pools

Bradley P Out of the Blue, A Celebration of Brockwell Park Lido 1937-2007 BLU

Davies C Downstream: A Social History of Swimming the Thames Aurum (2015 tbc)

Davies C Taking the Water, A Swim Around Hampstead Heath Frances Lincoln (2012)

Deakin R Waterlog Chatto & Windus (1999)

Powers A (ed) Farewell My Lido Thirties Society (1991)

Smith J Liquid Assets English Heritage (2005)

Smith J Tooting Bec Lido South London Swimming Club (1996)

Titmuss A (ed) Breaking the Ice Serpentine SC (1964 & 2006)

www.lidos.org.uk

Chapter 17. Indoor swimming pools

Forest Hill Pools: Historic Buildings Report Doug Insall Associates (2008)

Haggerston Baths: Conservation Statement Architectural History Practice (2005)

Ironmonger Row Baths: Conservation Statement Architectural History Practice (2007)

Kentish Town Sports Centre: PPG15 Assessment Alan Baxter Associates (2008)

Otter Swimming Club Centenary 1869-1969 Crawley McNichol (1969)

Provision of Public Swimming Pools and Diving Facilities in London Economic
Development, Culture, Sport & Tourism Committee report for London Assembly (2008)

Binney M Taking the Plunge: The Architecture of Bathing Save Britain's Heritage (1982)

Bird P Making a splash: the history of Dulwich Baths (1993)

Campbell A Report on Public Baths and Wash-houses Carnegie UK Trust (1918)

Cape GA Baths and Wash-houses Simpkin, Marshall (1854)

Copeman M The Public Baths and Wash-Houses of London: 1840-1914
Heriot-Watt Univ MSc dissertation (1994)

Cross AWS Public Baths and Wash-houses Batsford (1906)

Cross KMB Modern Public Baths Simpkin Marshall (1938)

Dudgeon RE The Swimming Baths of London (1870)

Gordon I & Inglis S Great Lengths English Heritage (2009)

Love C (ed) A Social History of Swimming in England 1800-1918 Routledge (2008)

Sinclair A & Henry W Badminton Library: Swimming Longman Green (1916)

Teague SJ The City University – a History City University, London (1980)

Chapter 18. Bowls

Crystal Palace Indoor Bowling Club 1905-2005

Ealing & District Bowling Association: Its Story 1945-1970

Nurcombe VJ Croydon Bowling Club 1749-1999

Pilley P (ed) The Story of Bowls: from Drake to Bryant Stanley Paul (1987)

Rigby T The Paddington Sports Club Centenary 1905-2005

Chapter 19. Archery

Society of Finsbury Archers 1653-1761 London Metropolitan Archive holdings

Armstrong GR, Goold Walker G Honourable Artillery Company 1537-1987 (1986)

Credland A The General Meetings of Archers at Blackheath and Dulwich, 1789-1795
Society of Archer-Antiquaries Vol 44 (2001)

Gerrie PA From Quill to Computer: a History of the Royal Toxophilite Society (2006)

Johnes M Archery, Romance and Elite Culture in England and Wales c.1780-1840
History Vol 89 No 294 (April 2004)

Kench T various lectures for Company of Bowyers available via www.bowyers.com

Partridge J Ayme for Finsburie Archers (1628) republished WC Books (1998)

Soar HDH The Romance of Archery: a History of the Recreational Longbow
Westholme (2008)

Tomlins TE A Perambulation of Islington JS Hodson (1858)

Wood W The Bowman's Glory, or Archery Revived (1682, SR Publishers edition 1969)

www.askarts.co.uk (British Longbow Society)

www.bowyers.com

www.societyofarcher-antiquaries.org

Chapter 20. Cricket

Allen DR The Second Lord's Cricket Ground MCC (2006)

Alverstone, Lord & CW Alcock CW (eds) Surrey Cricket: its History and Associations
Longmans Green (1902)

Bennett ACL The Weekend Cricketer Hutchinson (1951)

Birley D A Social History of English Cricket Aurum Press (1999)

Burns M Caught in Time: Malden Wanderers CC 1879-2004 Nightwatchman Books

Chadwick A A Portrait of Lord's, 200 Years of Cricket History Scala Arts/Heritage (2013)

Chalke S Five Five Five, Holmes and Sutcliffe in 1932 Fairfield Books (2007)

D'O Monro FR A History of The Hampstead Cricket Club Home & Van Thal (1949)

Eames G Bromley Cricket Club 1820-1970

Green S Lord's, The Cathedral of Cricket Tempus (2003)

Harragan B Cricket Grounds of Essex Association of Cricket Statisticians (2007)

Hart-Davis D Pavilions of Splendour: an Architectural History of Lord's
Methuen (2004)

Heald T The Character of Cricket Faber & Faber (1986)

Higgs T Three Hundred Years of Mitcham Cricket 1685-1985

Hill R History of Bexley Cricket Club (1990)

Jenkins D Mound Stand Lord's Architecture Design & Technology Press (1991)

Jones AE The Story of Carshalton House Hyperion (1980)

Kynaston D WG's Birthday Party Bloomsbury (2010)

Marshall J Lord's Sportsmans Book Club (1970)

Maun I From Commons to Lord's Vol 1 1700-1750 Roger Heavens (2009)

Milton H Cricket Grounds of Kent Association of Cricket Statisticians (1992)

Montagu EN The Cricket Green (Mitcham) Merton Historical Society (2001)

Norrie D The Oval Reflections Vision Sports (2005)

Paine P Innings Complete: the Final Resting Place of some of those associated
with cricket Mischief Makers (2001)

Powell WA Cricket Grounds Then and Now Dial Press (1994)

Powell WA Cricket Grounds of Middlesex Assoc of Cricket Statisticians (1990)

Powell WA Cricket Grounds of Surrey Assoc of Cricket Statisticians (2001)

Powell WA The Official ECB Guide to Cricket Grounds Sutton Publishing (2003)

Rice J The Pavilion Book of Pavilions Pavilion (1991)

Rice T Treasures of Lord's Willow Books (1989)

Sampson A Grounds of Appeal, The Homes of First-Class Cricket Robert Hale (1981)

Slatter W Recollections Of Lord's And The Marylebone Cricket Club
John MacKenzie (1914, reproduced 1989)

Waghorn HT Cricket Scores, Notes, &c. from 1730-1773 Wm Blackwood (1899)

Walker D Games and Sports Thomas Hurst (1837)

Warner P Lord's 1787-1945 Harrap (1946)

Yapp N A History of The Foster's Oval Pelham Books (1990)

Yardley NWD & Kilburn JM Homes of Sport: Cricket Peter Garnett (1952)

Chapter 21. Golf

Golf Courses as Designed Landscapes of Historic Interest European Institute of
Golf Course Architects for English Heritage (2008)

Golf in Historic Parks & Landscapes English Heritage (2007)

Wimbledon Common Golf Club 1908-2008

Cameron DM Social Links – The Golf Boom in Victorian England Social Links (2010)

Cruickshank C The History of the Royal Wimbledon Golf Club (1986)

Darwin B The Golf Courses of The British Isles Duckworth (1910)

Downs J History of the London Scottish Golf Club LSGC (2004)

Henderson IT & Stirk DI Royal Blackheath (1995)

Holt R Stanmore Golf Club 1893-1993, a social history

Mitchell WM Chislehurst Golf Club: 100 Years of Golf at Camden Place Grant (1994)

Pennink F Homes of Sport: Golf Peter Garnett (1952)

Poole A The Formation of the Aquarius Golf Club (2008)

Scaife N Four Hundred Years of the Blackheath Goffer 1608-2008 (2010)

Smith J Acton Golf Club, A History (1981)

http://golfinlondon.co.uk

www.golfsmissinglinks.co.uk

Chapter 22. Football

Attwood T, Kelly A & Andrews M *Woolwich Arsenal FC: 1893-1915: The Club that Changed Football* Hamilton House (2012)

Bailey M *From Cloisters to Cup Finals, a History of Charterhouse Football* Quiller Press (2008)

Benson C *The Bridge: the History of Stamford Bridge* Chelsea FC (1987)

Booth K *The Father of Modern Sport: the Life and Times of Charles W Alcock* Parrs Wood Press (2002)

Dowlen J & Goringe P *Forever Amber: Cray Wanderers FC 1860-2010* (2011)

Everitt R *Battle for the Valley* Voice of the Valley (1991)

Floate M *Football Grounds of South East London* Newlands Photographic (2008)

Floate M *Football Grounds Frenzy: Kent* Newlands Photographic (2012)

Gill R *Ebenezer Morley: The Grand Old Sportsman of Barnes* Barnes & Mortlake History Society Newsletter No 63 (December 1977)

Glanvill R *Chelsea FC: The Official Biography* Headline (2006)

Glinert E *The London Football Companion* Bloomsbury (2009)

Goulstone J *The Working Class Origins of Modern Football* International Journal of the History of Sport Vol 17 No 1 (March 2000)

Harvey A *Football: The First Hundred Years* Routledge (2005)

Hornby H *Uppies and Downies, the extraordinary football games of Britain* English Heritage (2008)

Inglis S *Engineering Archie* English Heritage (2005)

Inglis S *Football Grounds of Britain* Harper Collins (1996)

Kelly A & Attwood T *Dial Square to Woolwich Arsenal* Arsenal Independent Supporters' Association (2011)

Korr C *West Ham United, The Making of a Football Club* Duckworth (1986)

Lupson P *Thank God for Football* Azure (2006)

McDonald E and Smith DJ *Artizans and Avenues: a history of the Queen's Park Estate* City of Westminster Libraries (1990)

Macey G *Queen's Park Rangers: the Complete Record* Breedon Books (2009)

Mitchell A *Arthur Kinnaird, First Lord of Football* (2011)

Murray J *Millwall: Lions of the South* Indispensable Publications/Millwall FC (1988)

Porter D *Coming on with Leap and Bounds in the Metropolis: London Football in the Era of the 1908 Olympics* The London Journal Vol 34 No 2 (July 2009)

Soar P & Tyler M *Arsenal 1886-1986* Hamlyn (1986)

Southwick M *England's First Football Captain, a biography of Cuthbert Ottaway 1850-1878* Soccerdata/Tony Brown (2009)

Spurling J *Highbury, The Story of Arsenal in N5* Orion Books (2006)

Twydell D *Football League Grounds for a Change* Yore (1991)

Twydell D *Gone But Not Forgotten* (various editions 1992-2012)

Weaver J *The Football Grounds of Essex Metropolitan* Newlands Photographic (2006)

Weaver J *The Lost Football Grounds of Essex* Newlands Photographic (2009)

White A & Lilliman R *Football Grounds of London* Tempus (2005)

www.eyesofchange.com/standsalone (Simone Novotny's Highbury Square gallery)

www.footballmonthlyarchives.co.uk

www.sportingstatues.com

http://pws.prserv.net/Roger_Wright/Norris (Sally Davis's life of Henry Norris)

Chapter 23. Rugby

Alston AR (ed) *100 Years of Rugby football: a history of Rosslyn Park FC 1879-1979*

Beken P & Jones S *Dragon in Exile: the Centenary History of London Welsh* RFC Springwood Books (1985)

Brown P & Allen M *Milestones from the 150 Years of the History of the Oldest Independent Rugby Club in the World* Blackheath RFC (2012)

Collins T *A Social History of English Rugby Union* Routledge (2009)

Cleary M & Rhys C *A Hundred Years of Twickenham 1910-2010* Twickenham (2009)

Cooper I *Immortal Harlequin: the story of Adrian Stoop* History Press (2004)

Ereaut EJ *Richmond FC 1861-1925* Howlett & Son (1925)

Farrar D, Lush P & O'Hare M *Touch and Go - A History of Professional Rugby League in London* London League Publications (1995)

Farrar D & Lush P *From Fulham to Wembley - 20 years of Rugby League in London* London League Publications (2000)

Hammond D *Blackheath FC Rugby Club* Tempus (1999)

Hammond D *The Club – Life and Times of Blackheath FC* MacAitch (1999)

Harris E *Twickenham, The History of the Cathedral of Rugby* Sports Books (2005)

Hoyer Millar CC *Fifty Years of Rosslyn Park* Wyman & Sons (1929)

Huntley R *Saracens: 125 Years of Rugby 1876-2001* (2001)

Macrory J *Running with the Ball: the birth of rugby football* Collins Willow (1991)

O'Brien G *Played in Glasgow* Malavan Media (2010)

Reyburn W *Twickenham, the story of a rugby ground* Allen & Unwin (1976)

Rhind N *Blackheath Football Club 1862-70* Transactions of the Greenwich & Lewisham Antiquarian Society No 10 (1985)

Rider TS & Munks WCO *Richmond Football Club 1925-1961*

Tunnicliffe N *History of Sports Facility Development: Twickenham* Report for RFU (2001)

Tyson D *London's Oldest Rugby Clubs* JJG Publishing (2008)

Wakelam HBT *The Harlequin Story* Phoenix House (1953)

Warner P *The Harlequins: 125 Years of Rugby Football* Breedon Books (1991)

Wills D *History of the Club at the 120th season* Wasps Football Club (1987)

Chapter 24. Real tennis

Aberdare Lord *The JT Faber Book of Tennis & Rackets* Quiller Press (2001)

Best D *The Royal Tennis Court* Ironbark Ronaldson (2002)

Best D & Rich B *Disturb'd with Chaces, Tennis Courts, Celebrities and Scandals of Yesteryear* Ronaldson (2009)

Garnett M *A Chase Down Under: A History of Royal Tennis in Australia* Historical Publications (1999)

Inglis S *A Load of Old Balls* English Heritage (2005)

Morgan R *Tennis, The Development of the European Ball Game* Ronaldson (1995)

Morgan R *Tudor Tennis, A Miscellany* Ironbark Ronaldson Publications (2001)

Thurley S *The Lost Palace of Whitehall* RIBA (1998)

Thurley S *The Royal Palaces of Tudor England* Yale University Press (1993)

Thurley S *Whitehall Palace: The Official Illustrated History* Merrell (2008)

Chapter 25. Fives

Vargas D & Knowles P *A History of Eton Fives* JJG Publishing (2012)

Chapter 26. Rackets and squash

Early Squash Courts National Trust Research Report (1997)

Notes on Rackets and Squash at Harrow School The Tyro/The Harrovian (various issues 1863-1962)

The Building of the Crosby Rackets Court Harrow School Report (1964)

Cassidy R *Copped Hall, A Short History* Waltham Abbey Historical Society (1997)

Heathcote JM & CG, Bouverie EOP & Ainger AC *The Badminton Library: Tennis: Lawn Tennis, Racquets: Fives* Longmans Green & Co (1903)

Horry J *The History of Squash Rackets* ACM Webb (1979)

Sheppard J *Mystery Sculptor Revealed (at Upper Latymer School Squash Court)* Hammersmith & Fulham Historic Buildings Group Newsletter No 14 (Spring 2006)

Zug J *Squash: A History of the Game* Scribner (2003)

Chapter 27. Lawn tennis

Lawn Tennis Annual (various from 1882)

Lawn Tennis and Badminton periodical (various)

Tennis in London London Assembly, Culture Sport and Tourism Committee (2005)

Beachampé S & Inglis S *Played in Birmingham* English Heritage (2006)

Gillmeister H *Tennis: A Cultural History* Leicester University Press (1997)

Gurney G *Tennis, Squash and Badminton Bygones* Shire (1984)

Gurney G *On the Origins of Lawn Tennis: evolution of the court* Tennis Collector 66 (Summer 2009)

Gurney G *Early Tennis: the Darwinian Connection* Tennis Collector 67 (Winter 2009)

Henderson J *The Last Champion: the life of Fred Perry* Yellow Jersey (2009)

Lewis D *Rethinking Tennis for the Big Society* Economic Policy Centre (June 2011)

Little A *Wimbledon 1869-1921 The Changing Face of Worple Road* Wimbledon Lawn Tennis Museum (2003)

Little A *Wimbledon 1922-2005 The Changing Face of Church Road* Wimbledon Lawn Tennis Museum (2005)

Paine LHW *Beckenham Lawn Tennis Tournament 1886-1986* Faley (1986)

Perry F *Fred Perry, an autobiography* Hutchinson (1984)

Rigby T *The Paddington Sports Club Centenary 1905-2005*

Sumner A *Court on Canvas: Tennis in Art* Philip Wilson (2011)

Wallis Myers A (ed) *Lawn Tennis at Home and Abroad* Charles Scribner (1903)

Wallis Myers A *Twenty Years of Lawn Tennis* Methuen (1921)

Chapter 28. Athletics

A Strategy for Specialist Facilities: Athletics in London Greater London and South East Sports Council (Nov 1973)

Benson C *The Bridge: The History of Stamford Bridge* Chelsea FC (1987)

Bryant J *The Marathon Makers* John Blake (2008)

Clapson M *An Education in Sport* University of Westminster (2012)

Collins P & Dempster N *The London Marathon* Queen Anne Press (1993)

Collins W *Man and Wife* Oxford University Press (1995)

Everson G *Victoria Park Harriers: History of an East London Athletics Club 1926-76*

Goulstone J *A Brief History of Athletics from Anglo-Saxons to Early Victorians* (2009)

Goulstone J *The First Running Grounds c.1835-70* Sports History No 8 (1986)

Guggisberg FG *The Shop: The Story of the Royal Military Academy* Cassell & Co (1900)

Kelly K *Herne Hill Harriers Into the Millennium: 1889-2001* (2002)

Kelly K *Robert Sadler and the lost Copenhagen Running Grounds, Garratt Lane, Wandsworth* Local History Publications (2013)

Lockwood B *The Early History of Athletics in Ilford* Ilford Historical Society (undated)

Lovesey P *The Official Centenary History of the Amateur Athletic Association* Guinness Superlatives (1979)

Lovesey P *Wobble to Death* Macmillan (1970)

Molden S (ed) *Follow the Saltire: annals of the Thames Hare & Hounds 1868-2012*

Radford P *The Celebrated Captain Barclay: Sport, Gambling and Adventure in Regency Times* Headline (2001)

Roe W *Front Runners: The First Athletic Track Champions 1857-1875* The Book Guild (2002)

Roe W & Kelly K (eds) *A Selection of Victorian Athletic Clubs from the pages of The Illustrated Sporting & Dramatic News* (2008)

Shearman M *Badminton Library: Athletics & Football* Longmans Green (1887)

Timbers K (ed) *The Royal Artillery Woolwich, A Celebration* Third Millennium (2008)

www.arrs.net (Association of Road Racing Statisticians)

www.runtrackdir.com (UK Running Track Directory)

Chapter 29. Cycling

Albemarle, Earl of & Lacy Hillier G *Badminton Library: Cycling* Longmans Green (1896)

Creighton, S *Organized cycling and politics: the 1890s and 1900s in Battersea* The Sports Historian No 15 (1995)

Firth M *The Evolution of Cycling in Britain* Assoc of British Cycling Coaches (2012)

Hancock CJ *The Veteran-Cycle Club 1955-2005* John Pinkerton Memorial Publishing Fund (2010)

Heery P *The Putney Velodrome & the Putney Velodrome Estate* (1999)

Moore G *The Little Black Bottle* Cycle Publishing/Van der Plas Publications (2011)

Penn R *It's All About the Bike* Particular Books (2010)

Pinching A *Wood Green Past* Historical Publications (2000)

Poyer A *Les Premiers Temps des Veloce-Clubs: apparition et diffusion du cyclisme associatif francais entre 1867 et 1914* Editions L'Harmattan (2003)

Rabbetts M *A Century Awheel: a history of the De Laune Cycling Club 1889-1989*

Ritchie A *King of the Road: An Illustrated History of Cycling* Wildwood House/ Ten Speed Press (1975)

Ritchie A *Quest for Speed: A History of Early Bicycle Racing 1868-1903* Cycle Publishing/Van der Plas Publications (2011)

Ritchie A *The Origins of Bicycle Racing in England: Technology, Entertainment, Sponsorship and Advertising in the Early History of the Sport* Journal of Sport History, Vol 26, No 3 (1999)

Southcott EJ *First 50 Years of the Catford Cycling Club* (1939)

Swann D *The Life and Times of Charley Barden* Wunlap Publications (1965)

Watts JF *Herne Hill Stadium to Herne Hill Velodrome: A History from 1891-2007*

Chapter 30. Greyhound racing

Farewell The Stow: Walthamstow Dog Stadium 1931-2008 Walthamstow Guardian Souvenir Edition (August 16 2008)

Greyhound Racing Encyclopedia 2nd edition Fleet (1948)

Wembley 1923-73: The official Wembley story of 50 years Wembley (1973)

Belton B *When West Ham Went to the Dogs* The History Press (2002)

Critchley AC *Critch! The Memoirs of Brigadier-General AC Critchley CMG, CBE, DSO* Hutchinson (1961)

Cronin M *Arthur Elvin and the Dogs of Wembley* Sports Historian Vol 22 (May 2002)

Genders R *The Encyclopedia of Greyhound Racing* Pelham (1981)

Genders R *The NGRC Book of Greyhound Racing* Pelham (1990)

Hawthorn FH & Price R *The Soulless Stadium: A Memoir of London's White City* 3-2 Books (2001)

Huggins M *Everybody's Going to the Dogs? The Middle Classes and Greyhound Racing in Britain between the Wars* Journal of Sport History Vol 34, No 1 (2007)

James G *London, The Western Reaches* Robert Hale (1950)

Knight DR *The Exhibitions 1908-1978* Barnard & Westwood (1978)

Norris C *Harringay Greyhound Stadium Totalisator and George Alfred Julius* London's Industrial Archaeology No 5 G'ter London Industrial Archaeology Soc (1988)

Thompson L *The Dogs* Vintage (1994)

Ticher M *The Story of the Harringay Stadium and Arena* Hornsey Historical Society (2002)

Chapter 31. Speedway

The Track Record Veteran Cycle Speedway Riders Association (various volumes)

Bamford R & Jarvis J *Homes of British Speedway* Stadia/Tempus (2006)

Chaplin J *The Birth of a Sport Vintage* Speedway Magazine (2000)

Chaplin J *A Fistful of Twistgrip: the story of the birth of Speedway Racing at High Beech* Pengrove Books (1995)

Cook P *The 'dirt track' in the Forest* Loughton & District Historical Society Newsletter No 182 (Sept-Oct 2009)

Jacobs N *Out of the Frying Pan: The Story of New Cross Speedway* History Press (2008)

Jacobs N *Speedway in London* Tempus (2001)

Rogers M *The Ilustrated History of Speedway* Studio Publications (1978)

Silver L & Douglas P *The Speedway Annual* Pelham Books (1969)

Williams J *A Wild Orgy of Speed: Responses to Speedway in Britain before the Second World War* Sport in History Vol 19 No 1 (1999)

www.cyclespeedwayhistory.org.uk

www.retro-speedway.com

Chapter 32. Conclusions

Capital Values: The Contribution of the Historic Environment to London English Heritage (2006)

Sporting Heritage Conservation Bulletin Issue 68 Summer 20

Newspapers & journals

Architect & Building News, Architects' Journal, Architectural Review, Baily's Magazine, Barnet Press, Baths & Baths Engineering, Bell's Life in London & Sporting Chronicle, Brixton Times, The Builder, Building, Building Design, Chiswick Times, Country Life, Croydon Advertiser, Cycling, Daily Graphic, Daily Herald, Daily News, The Daily Telegraph, Design & Construction, East London Advertiser, The Era, Essex County Chronicle, Evening News, Evening Standard, The Field, Finchley Press, Fulham Chronicle, Golders Green Gazette, The Graphic, Groundtastic, The Guardian, Hampstead & Highgate Express, Ilford Recorder, Illustrated London News, Illustrated Police News, The Illustrated Sporting and Theatrical News, The Independent, Islington Gazette, Leisure Management, The Licensed Victualler & Catering Trades Journal, London Gazette, The London Journal, Malden Gazette, Middlesex Chronicle, Lloyd's Weekly, The Mirror of Literature, Amusement and Instruction, Morning Post, The Observer, Pall Mall Gazette, Panstadia International, Pastime, Penny Illustrated, The Polytechnic Magazine, Punch, Racing Post, Reynold's News, RIBA Journal, Richmond & Twickenham Times, Romford Recorder, South London Press, Southern Daily Echo, Southwark News, The Spectator, The Sphere, Sporting Life, Sports History, Sports Management, Sports Quarterly Magazine, Sports Weekly, The Sporting Magazine, The Sportsman, The Standard, Stratford Express, Surrey Comet, Sutton Journal, Swimming Times, The Telegraphic Journal and Electrical Review, The Times, The Times Online Digital Archive 1785–1985, Time Out, Twentieth Century Magazine, Wallington & Carshalton Times, Walthamstow Guardian, Wimbledon Guardian, Wood Green Herald, Woolwich Gazette

General websites

Google Earth

www.british-history.ac.uk

www.britishnewspaperarchive.co.uk

www.c20society.org.uk (Twentieth Century Society)

www.gracesguide.co.uk (company histories)

www.insidethegames.biz

www.lamas.org.uk (London & Middlesex Archaeological Society)

www.londonhistorians.org

www.londongardenstrust.org

www.museumoflondon.org.uk

www.old-maps.co.uk

www.oxforddnb.com (Oxford Dictionary of National Biography)

http://sportheritagereview.com

www.sportingstatues.com

www.victoriansociety.org.uk

www.wikipedia.org

Credits

Photographs and images

All English Heritage photographs listed are © English Heritage or © Crown Copyright, English Heritage. Application for the reproduction of these images should be made to: English Heritage Archive, The Engine House, Fire Fly Avenue, Swindon SN2 2EH

Ordnance Survey data: contemporary maps © Crown Copyright and database right (2014); archive maps © and database right Crown Copyright and Landmark Information Group Ltd (All rights reserved 2014)

Charles Cundall's painting on page 147 is © The Artist's Estate/Bridgeman Art Libary

Note that where more than one photograph appears on a page, each photograph is identified by a letter, starting with 'a' in the top left hand corner of the page, or at the top, and continuing thereafter in a *clockwise* direction.

English Heritage Archive / © Crown copyright, English Heritage
57c, 73c, 74b, 81b, 87c, 122a, 140a, 141a, 230b, 239d, 279a, 312h, 325b, 329b; **Aerofilms Collection:** 72b, 110b, 155a, 201a, 237c, 266b, 294b, 323, 325a, 326a, 327b, 328bcd; **Nigel Corrie:** 6, 13b, 15c, 16c, 18a, 19ae, 49b, 56ab, 57a, 59b, 73e, 76a, 104abcd, 105, 114a, 138a, 140b, 149b, 166b, 176c, 177b, 178bcd, 188a, 190ac, 196a, 200b, 201bc, 210bd, 276bc, 277, 279b, 280ab, 281ab, 283a, 284a, 286a, 288ab, 295c, 311c, 317c, 320abc, 321a, 340bc; **James O Davies:** 303ae, 312g; **Damian Grady:** 21ac, 26, 29, 31a, 32ab, 33ab, 34a, 68a, 85a, 89b, 91, 97a, 118c, 133, 137a, 174c, 202b, 219a, 228c, 231a, 232c, 241a, 247a, 248c, 251c, 252a, 264d, 295b, 299a, 331a; **Derek Kendall:** 9, 19c, 36a, 38a, 40bcd, 41c, 43ab, 44, 47b, 52b, 118a, 145c, 150abc, 151ag, 189b, 310d, 312ade, 341a; **Jane Stone:** 246a

Simon Inglis photographs
back cover abcd, back flap b, front flap, 1, 4, 7ab, 10b, 11a, 13c, 16a, 17ace, 19bdfg, 20ab, 21d, 24a, 28ab, 30, 35bc, 38bc, 39b, 40a, 41ab, 42bc, 47a, 48c, 50b, 51bc, 52a, 53bcde, 54bc, 57b, 58a, 59a, 60ab, 61c, 62ab, 63ab, 64b, 67b, 68bc, 69ab, 74ad, 75abcd, 77abc, 78ab, 82a, 83bce, 84bcd, 85e, 86c, 87ab, 90b, 93bcd, 94a, 95abc, 99b, 100, 102, 103b, 106abd, 107abcd, 108a, 109abcd, 111bc, 112bcd, 113ac, 114b, 115abc, 116, 117b, 121abc, 122d, 123abc, 126ab, 127ab, 134b, 135abc, 136ab, 137bc, 139a, 141bc, 142abcde, 143, 145bd, 146abc, 148abcd, 150d, 151bcef, 152a, 153abc, 154b, 156d, 158b, 159abc, 160abcd, 161abcde, 162bd, 163abd, 164cd, 165bcd, 166a, 167abc, 168, 170b, 171bcd, 172bde, 173acd, 174a, 175abcd, 176abdefg, 177d, 178a, 179abd, 180acdef, 181bcde, 182, 183ac, 184bc, 185abcde, 186, 188b, 189c, 191abc, 192ab, 193a, 195abcd, 196b, 197, 198bc, 199bc, 200ac, 202c, 203bc, 205cd, 206abcd, 207a, 208a, 209a, 210ac, 211abce, 212abcdef, 213abcdefg, 214a, 215ab, 216ab, 217c, 218abd, 220ab, 221bc, 222b, 224c, 225ade, 227b, 228a, 235bc, 236bd, 237b, 238abcdef, 239abc, 240ace, 241bc, 242ab, 243bcd, 244b, 249b, 251ab, 252b, 253a, 254d, 255a, 256abcd, 257ad, 258, 259ab, 260acd, 261ab, 262ab, 263abcd, 264ab, 265ab, 266ac, 269ac, 271b, 273c, 275bc, 276ad, 278a, 282ab, 283b, 285abc, 288c, 289ab, 291, 292ab, 293ab, 294a, 295d, 297ab, 299b, 303bcd, 310cf, 311ab, 312b, 313a, 314a, 330ab, 331b, 335bc, 337abc, 338b, 339bc, 340a, 341bcde

Photographers
Steve Bargeron: 94b; Philip Barker: 74c; Tony Barrett/barrettphoto.com: 61b; Richard Bryant/arcaidimages.com: 76b; Neil Clasper: 163c; Arthur Cole/Le Roye Productions: 297c; David Crampton: 209b; Ben Curwen Photography/Parkour Generations: 99c; Jacques Demarthon/AFP/Getty Images: 122c; Emma Durnford Photography: 338a; Patrick Eagar: 203a, 205b; Patrick Eager/Getty Images: 203d; Tony Gamble: 118b; John Gay/English Heritage/Mary Evans Picture Library: 129; Simon Gill: 23c, 51ad, 54a, 55b, 72a, 77d, 85bcd, 89a, 97b, 98abc, 99ad, 103c, 106c, 113b, 136c, 144, 145a, 149a, 151d, 217b, 219c, 227ac, 229a, 230a, 231bc, 233a, 246b, 247c,

248b, 252c, 255b, 257ce, 270a, 271c, 283c, 284b, 312f, 331c; Roger Haines: 60cd; Jason Hawkes/Getty Images: 81a; Murray Hedgcock: 225c; John Helliar/West Ham Utd FC: 248d, 250abc; Peter Holme: 223; Matthew Impey/wiredphotos.co.uk: inside back cover; Dave Jackson: 209c; Simon Joseph 120a; Mike Lambert/Gridshots: 67c; Stuart MacFarlane/Arsenal FC: 240d, 242c; John Maltby/RIBA Library Photographs Collection: 326b; GerryMcManus.co.uk: 104a; Simon Molden: 310a; Nathaniel Moore/Hopkins Architects: 321e; Simone Novotny/eyesofchange.com/standsalone: 240b; Jaap Oepkes/Thames Rowing Club: 50ac; Lynn Pearson: 211d; Michael Philpot: 198a; Mark Sadlier/Roberts Limbrick: 174bd; Clive Sherlock Photography/Roberts Limbrick: 172a; Carl de Souza/AFP/Getty Images: 321f; Jonathan Spence/jonathanspence.co.uk: 218c; Jackie Spreckley: back flap a; Ben Stansall/AFP/Getty Images: 313c; Architectural photographer CharlesSturge.com: 179ce; Tom Sullam Photography: 302a; Natalie Tepper/arcaidimages.com: 268b; Iain Weir: 49a; David Whyte: 190b; Matt Yanez: 83d

Agencies
Action Images: 233bc; Architectural Press Archive/RIBA Library Photographs Collection: 298a; Bentley Archive/Popperfoto/Getty Images: 84a; ©The British Library Board: 14ab (578b.1), 274a (G.6180), 308a; Colorsport/Andrew Cowie: 114d; Colorsport/Charlie Forgham-Bailey: 268a; Colorsport/Kieran Galvin: 207b; ©Daily Herald Archive/National Media Museum/Science & Society Picture Library: 45a, 67a, 156c, 319b, 336ab; Evening News/Rex Features: 72c; Getty Images: front cover, 2, 16b, 35a, 66c, 119b, 152b, 157c, 202a, 230c, 243a, 254c, 273a, 309bc, 324a; Getty Images/FA: 84a, 273b; Hobbs Golf Collection: 219bd; ©Illustrated London News/Mary Evans Picture Library: 22b, 138b, 165a; 272, 287b, 290, 306b, 307a, 315a, 322a; Mary Evans Picture Library: 17b, 128ab, 139b, 224a; ©Museum of London: 189a, 274b, 319a, 324b ; ©National Portrait Gallery, London: 12a; ©Natural History Museum, London: 322b; Press Association Images: 114c, 269d, 302b, 312c, 334bc; Rex Features: 88a, 164a; RIBA Library Photographs Collection: 110a, 120b, 298b; Science Museum/Science & Society Picture Library: 314b; ©TfL/London Transport Museum collection: 24b, 229b; ©Victoria & Albert Museum, London: 193b

The following are reproduced by kind permission
All England Lawn Tennis Club/Tom Lovelock: 300a; All England Lawn Tennis Club/Neal Simpson: 300b; Alleyn's School, Dulwich: 308c; Nick Barber/nickbarbermemorabilia.co.uk: 332; Barnet Local Studies & Archive: 111a; David Best: 15d; Bexley Local Studies & Archive Centre: 296a; Bishopsgate Library, London Collection: 80, 86ab; Blackheath & Bromley Harriers AC: 310g; Colin Booth: 336c; Brent Archives: 70ab, 73d, 131bc, 157b, 245b; ©The Trustees of the British Museum: 16d; Brooklands Museum/Harold Scott Collection: 321b; Bruce Castle Museum (Haringey Culture, Libraries & Learning): 157a; Business Design Centre: 22c; Camberwell Baths Campaign: 173b; Catford Cycling Club: 318a, 321c; Stephen Chalke: 208b; John Chaplin: 333ab, 334ad; John Chapman: 253b; Charles Buchan's Football Monthly Archives: 247b; Headmaster & Governors Charterhouse School: 224b; Chiswick Library Local Collection: 55ac, 124a, 130b, 131a; City of London Corporation: 184d; City University London: 177c; Civil Service FC: 124b; Peter Clare: 147ab; Creed-Miles & Co: 61a; Crystal Palace Foundation: 64a, 65; De Laune Cycling Club: 321d; Judith Dobie/Museum of London Archaeology: 13a; Jerry Dowlen: 222a; The Governors of Dulwich College: 93a; The Trustees of Dulwich Picture Gallery: 90a; EC&O Venues: 339d; Clino d'Eletto: 245a; Laurie Elks: 236a; Enfield Local Studies Library & Archive: 221a, 318d; Everyone Active/Chris Spencer: 184a; Reg Fearman: 335d; Flag-Soprema UK: 164b; Mike Floate: 318c; Furnivall Sculling Club: 52c, 53a; Fusion Lifestyle/Girts Gailans: 164e; GLL/Andrew Baker: 178e, 180b; GMJ/Tottenham Hotspur FC: 234; Ian Gordon: 155b, 169bd; Grainger plc: 171a; Michael Green: 15b; Greenwich Heritage Centre: 31b; Hammersmith & Fulham Archives & Local History Centre: 150e; ©Historic Royal Palaces: 15a; Simon Inglis: 73b, 237a, 249a, 254a, 305ab, 307b; Islington Local History Centre: 194, 287a; Kevin Kelly: 308b, 310b, 317b, 319c; London Borough of Lambeth, Archives Department: 296b (PC/SP/4077); Landmark Information Group Ltd: 71ab, 119a, 204b, 235a, 236c, 316b; Lawn Tennis Association: 302c; Lee Valley Regional Park Authority/Doug Blanks:

83a; Lewisham Local History & Archives Centre: 18b, 125, 172c, 214b; London Metropolitan Archives, City of London: inside front cover, 48b, 183b, 229c, 275a, 286b; London Metropolitan Archives/City of London Collage Collection: 17d, 117a, 248a; London Rowing Club: 225b; Merton Library & Heritage Service: 199a; John Moore: 134a; Newham Archives & Local Studies Library: 8, 335a; North London Bowling Club: 67d, 211g; Old Parmiterians FC: 257b; Otter Swimming Club/Martin Flash: 169a; Pearson Cycle Specialists: 315b; Andy Porter: 232a; Roger Pout: 23a; Punch Ltd/punch.co.uk: 21b; Queen's Club: 295a; Ian Ridpath: 310e; River & Rowing Museum/courtesy of the Company of Watermen and Lightermen: 45b; Keith Robins: 316a; Rosslyn Park FC: 10a; Bob Rowe: 328a, 329c; Royal Automobile Club: 181a; Royal Thames Yacht Club: 37; Royal Toxophilite Society: 103a; S+P Architects: 162ac; St Bride Foundation Library & Archives: 122b, 177a; Saracens RFC: 264c; Ed Sears: 304b; Serpentine Swimming Club: 154a, 156a; ©Crown copyright, Sheffield Libraries: 278b; The Skinners' Company: 139c; David B Smith: 23b; Smith of Derby: 243e; Society of Olympic Collectors/Jack Murray: 308d; Southwark Local History Library & Archive: 254b; Streatham-Croydon RFC: 108b; Surrey County Cricket Club: 22a, 204ac, 205ae, 211f; Vince Taylor: 253c; Alan Titmuss: 156b; Richard Toley: 34b; Dennis Turner: 228b; The Twentieth Century Society: 328e; Twickenham Museum: 271a; Virgin Active: 339a; University of Westminster Archive: 112a; London Borough of Waltham Forest, Vestry House Museum: 329a; Wandsworth Heritage Service: 48a; Ian Weller/Football Postcard Collectors Club: 66b; Wembley Arena: 73a; West London Penguin Swimming Club: 169c; Westway Development Trust: 96ab, 97c; Kevin White: 309a ; White's Club: 147c; Wimbledon Lawn Tennis Museum: 294c, 301abcd; World Rugby Museum: 260b, 267ab, 269b, 270b

Print sources

A Lea Valley Regional Park Civic Trust (1964): 79; *CB Fry's Magazine* Vol III (June 1905): 130a; *The Book of Football* Amalgamated Press (1906): 66a; Scaife N *Four Hundred Years of the Blackheath Goffer 1608-2008* (2010): 216c; Shearman M *The Badminton Library: Athletics and Football* Longmans, Green & Co (1887): 304a; Strutt J *The Sports and Pastimes of the People of England* (1903): 12b, 36b; Swann D *The Life and Times of Charley Barden* Wunlap Pubns (1965): 317a, 318b; Wagstaffe Simmons G *History of Tottenham Hotspur FC 1882-1946* (1947): 232b

Acknowledgements

It is often said that it takes a whole library to write one book. Over the last five years or so, *Played in London* has called upon the resources of almost 50 libraries and archives, backed up by a capital network of organisations and individuals.

Simon Inglis and Jackie Spreckley wish to express their sincere thanks to English Heritage for helping to fund the *Played in Britain* series since its launch in 2004, and in particular to John Hudson and Clare Blick in English Heritage Publications, for their wisdom, patience and trust, and to Tory Lyne-Pirkis and her team at Midas PR for representing the series so admirably. At English Heritage our map maker Mark Fenton has been a vital member of the team at all times. We wish also to thank the many historians, researchers and staff at English Heritage, present and past, who have assisted, including those at the Survey of London team under Andrew Saint, plus Susie Barson, Alan Brodie, Jonathan Clarke, Tim Cromack, Veronica Fiorato, David Garrard, Elain Harwood, Richard Parish, Barney Sloane, Howard Spencer, Robert Thorne and Jennifer White, together with Nigel Barker, Richard Dumville and Samantha Johnson.

We have also been lucky to work with four great photographers, Nigel Corrie, Derek Kendall and Simon Gill on the ground and Damian Grady up in the air.

We and English Heritage are also grateful to Rod Sheard and all the team at Populous architects for their generous support of this book, and to Jason Wood, who in many respects paved the way for *Played in Britain* by masterminding the original pilot study, *A Sporting Chance,* back in 2001 in Manchester.

A host of London local studies libraries and archives has provided information for *Played in London*, several going beyond the call of duty, despite in all too many cases finding themselves stretched and under-resourced.

Thanks go to Jeremy Smith and all the staff at the London Metropolitan Archives, and to the local studies and archive departments of the following London boroughs: Barking and Dagenham, Barnet, Bexley, Brent, Bromley, Camden, the City of Westminster, Croydon, Ealing, Enfield, Greenwich, Hackney, Hammersmith & Fulham, Haringey, Harrow, Havering, Hillingdon, Hounslow, Islington, Kensington & Chelsea, Kingston upon Thames, Lambeth, Lewisham, Merton, Newham, Redbridge, Richmond upon Thames, Southwark, Sutton, Tower Hamlets, Waltham Forest and Wandsworth. Not forgetting the Guildhall Library too.

Thanks also to the following libraries, museums and archives: the British Library and former Newspaper Library at Colindale (can it really be no more?), the Museum of London, the library of the St Bride Foundation, the Twickenham Museum, the Museum

of Wimbledon, the British Postal Museum and Archive, the Institution of Engineering and Technology and the University of London Archives.

In the world of sport we have received tremendous support from Honor Godfrey and her staff at the Lawn Tennis Museum at Wimbledon and their colleagues in the Kenneth Ritchie Wimbledon Library, from Michael Rowe and his staff at the World Rugby Museum, Twickenham, from Adam Chadwick at the MCC Museum and Neil Robinson in the MCC Library at Lord's, from Chris Dodd at the River & Rowing Museum in Henley and Samir Singh at the Arsenal FC Museum.

Other archivists and individuals whose assistance we appreciate are Neil French (Alleyn's School), John Keyworth (Bank of England), Stefan Dickers (Bishopsgate Institute), Prue MacGibbon (Brewers' Company), Catherine Smith (Charterhouse School), Terry Heard (City of London School), Matt Shipton (City University London), Calista Lucy and Jamie King (Dulwich College), Anne Archer (Lloyds Bank), Susan Snell (Freemasons Hall), Angharad Meredith (Harrow School), Stephen Freeth (Merchant Taylor's Company), Pamela Taylor (Mill Hill School), John Porter (Prudential), Laura Yeoman (Royal Bank of Scotland), Mike Fitt (Royal Parks), Matthew Wood (Thames Water), Christine Reynolds (Westminster Abbey Muniment Room and Library), Elizabeth Wells (Westminster School) and Elaine Penn (University of Westminster).

We are equally grateful to all the contributors to *Played in Britain*, several of whose areas of expertise touch on London; Ian Gordon (aquatics), Hugh Hornby (bowls), Lynn Pearson (ceramics and 20th century art), Ray Physick (boxing), Janet Smith (lidos) Arthur Taylor (pub games) and Dr Martin Polley, who apart from his knowledge of Olympic history has advised on numerous matters relating to sporting history.

The following individuals have also contributed with their time, knowledge and materials: Tim Koch (Auriol Kensington RC), Peter Clegg & James Buddell (Beckenham LTC), Tony Kench (Bowyers' Company), Alan Cox (Copped Hall Trust), Melvyn Harrison (Crystal Palace Foundation), Mark Williams (Eton College), Don Earley (Fields in Trust), Dylan Evans and David Barber (Football Association), Carmelo Mifsud (Fulham FC), Bob Rowe (Greyhound Racing Association), Vince Taylor (Groundtastic), Basil Lambert (Harlequins), John Eaton and Charles Swallow (Harrow School), Anthony Brunner (Highgate School), Cathy Bryant (Hurlingham Club), Paul Fairweather (LEBA), Jamie Buck (Leisure Database Company), Robert Gordon Clark (London Communications Agency), David Fowkes (London FA), Alex Welsh & Jack Miller (London Playing Fields Foundation), Julian Ebsworth (London Rowing Club), Paul McFarland (London Scottish FC), Tony Kerpel (North London Bowls Club), Mick Dunne (Old Deer Park), Nicky How (Queen's Club), Jen Gadsby Peet (Richmond Athletic Association), John Moore (RBS Bowls Club), Charlie Addiman & David Whittam (Rosslyn Park FC), David Freeman (Royal Thames Yacht Club), the Royal Toxophilite Society, Alan Gordon (St Dunstan's College), Mike Olizar & Stephen Greenbury (Serpentine Swimming Club), Hugh Soar (Society of Archer Antiquaries), Chris Davies (Tennis & Rackets Association), James Elder (Thames Rowing Club), Peter Clare (Thurston), Colin Middlemiss (Watermen's Hall), Chris Bailey (Westway Development Trust) and Nick Morgan (Whitgift School).

Among the many architects and engineers whom we have consulted, special thanks to Alan Baxter Associates, John Cutlack, Ian Eggleton (Finch Forman), Stephen Limbrick (Roberts Limbrick), Tim Metcalfe (PTEa), and Keith Ashton (S+P Architects).

In addition, all the following have offered tips, read bits of text, sent information or have been supportive in providing access: David Ballheimer, David Barnes, Brian Belton, Jerry Birtles, Bob Boag, Colin Booth, Geoff Boxer, Hannah Brown, Peter Brown, Graham Budd, Dick Cargill, Simon Carter, Martin Cearns, John Chapman, Neil Clasper, Paul Collier, Malcolm Cook, Dennis Daniel, Bob Dolby, Don Dorling, Peter Elliott, Steve Embleton, Terry Finney, Tony Francis, Bill Gadsby, Andre Gailani, Alison Gale, Frank Galligan, Martin Garside, Robin Gill, Rick Glanvill, Phil Grant, Gerald and Joan Gurney, Roger Haines, Ed Harris, Gary Hartin, Eleanor Heaton Armstrong, Murray Hedgcock, John Helliar, Tim Hinchliff, David Holland, Terry Humphreys, Peter Hunter, Ian Jordan, Kevin Kelly, Orhan Kephalas, John Kinder, Bill King, John Lloyd, George Loureda, Peter Lovesey, Peter Luck-Hille, Peter Lupson, Peter Makower, Brian Mooyart, Ian Muir, Mike Mulligan, Sara Nanayakkara, Hans Norton, Benedict O'Looney, Mark O'Sullivan, Nina Padwick, Robert Page, Matt Payne, John Pearson, Martin Percival, Alan Poole, Andy Porter, Ian Ridpath, Adam Ritchie, Keith Robins, Clive Robinson, Freddie Rowe, Dr Andrew Ruddle, Neil Scaife, Keith Sears, Colin Sinclair, Brian Sinden, Howard Smith, Chris Spencer, Deano Standing, Richard Steele, James Stewart, Dr Christiane Swinbank, Wes Taylor, Dave Terry, Dave Thrilling, Philip Truett, Jim Tuite, Sarah Tuvey, Dave Twydell, Johnnie Walker, Ian Weller, Peter Wells, Kevin White, David Whyte, Brendan Williams, Martin Williams, Peter Williams, Alan Willingham, Alex Wilson, Howard Wiseman, Rod Witham, David Wood, Nick Wood, Brian Woods, Richard Woolley and Chris Yalland.

The responsibility for any mistakes or omissions, needless to add, lies entirely with us.

Finally, huge thanks to our esteemed series designer Doug Cheeseman, the third man in the *Played in Britain* team. After this epic adventure, we may all be worn out, but tired of London, never!

Index

The series

For more information **www.playedinbritain.co.uk**

Played in Manchester
Simon Inglis (2004)

Played in Birmingham
Steve Beauchampé and
Simon Inglis (2006)

Played in Liverpool
Ray Physick (2007)

Played in Glasgow
Ged O'Brien (2010)

Played in Tyne and Wear
Lynn Pearson (2010)

Engineering Archie
Simon Inglis (2005)
SOLD OUT

Liquid Assets
Janet Smith (2005)
SOLD OUT

Great Lengths
Dr Ian Gordon and
Simon Inglis (2009)

Uppies and Downies
Hugh Hornby (2008)

Played at the Pub
Arthur Taylor (2009)

The British Olympics
Martin Polley (2011)

Future titles
*Bowled Over – the
bowling greens of Britain*
Hugh Hornby (2015)

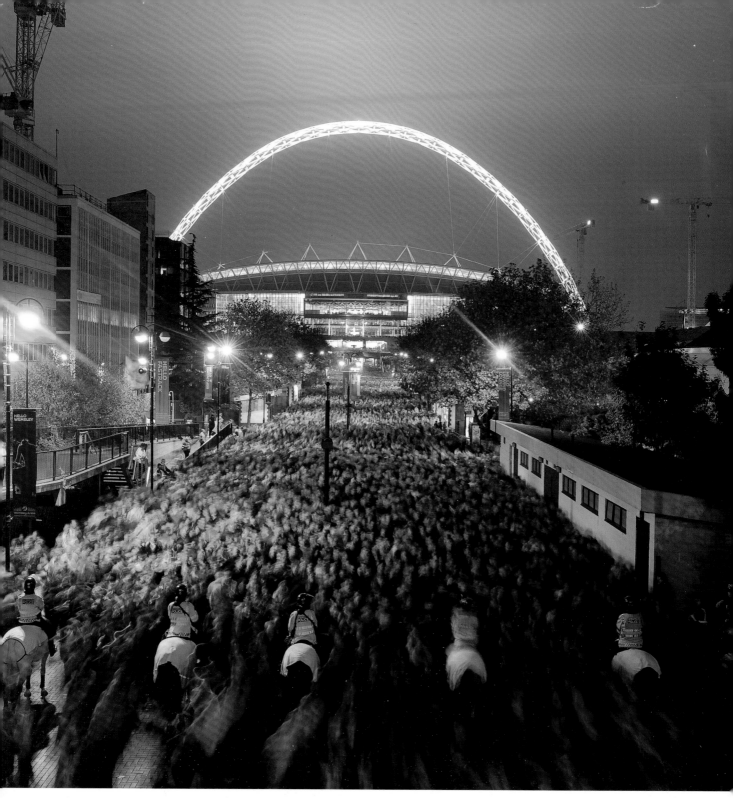

▲ By all accounts, a good night at **Wembley**. England v. Spain. True, a friendly, but not that friendly. They were world champions after all.

Spain, obviously. Not England.

Still, 1-0 to the Lions it finished, 88,000 on the gate, and *six* local lads in the starting eleven. Not often you see that at Wembley. 'England Reserves' someone called them, but they still beat the champs.

Ashley at the back, on the left as ever. Stepney lad. Now Chelsea.

Glen on the right. Now Liverpool, but Greenwich born, made his name with the Hammers, then Chelsea.

Frankie in the middle, Romford boy, also ex Hammer, now a Blue.

Got the goal, as ever. Frankie!

Next to him Scotty, Lambeth boy. Started Charlton, now West Ham (though Spurs and Fulham since). Then up front the lad from Tooting, Darren. He was at Charlton, then Spurs. Fulham now, like Scotty.

Londoner number six, that was

Theo. Born Stanmore, went south. But he's back now, with the Arsenal.

And don't forget 'Psycho', coach's right hand man. Shepherd's Bush. A sparks in Wealdstone before he made the big time.

Saturday, November 12 2011.

Tubes all running. Spirits high. And as they kicked off early, if this lot gets a move on, should make the West End by eight.

Now, where's that white horse when you need him?